AP*

ART HISTORY

2nd EDITION

John B. Nici, M.A.
Adjunct Lecturer in Art History
Queens College
Flushing, New York

Teacher, Advanced Placement Art History
Lawrence High School
Cedarhurst, New York

BARRON'S

for Judy, Laura, and Andrew
and all my art history students—past, present, and future

About the author:
John B. Nici has a master's degree in art history and teaches at Lawrence High School in Cedarhurst, New York, and at Queens College in Flushing, New York. In 2004 he was the recipient of Queens College's President's Award for Excellence in Teaching by Adjunct Faculty. He has published extensively on art history pedagogy and has presented and published scholarly papers on topics that include Byzantine art, Gothic art, Raphael, and Delacroix.

All inquiries should be addressed to:
Barron's Educational Series, Inc.
250 Wireless Boulevard
Hauppauge, New York 11788
www.barronseduc.com

ISBN: 978-0-7641-4691-6
ISBN (with CD-ROM): 978-1-4380-7125-1

ISSN (print only): 2164-6597
ISSN (print w-CD-ROM): 2164-6600

PRINTED IN THE UNITED STATES OF AMERICA

9 8 7 6 5 4 3 2 1

10%
POST-CONSUMER WASTE
Paper contains a minimum of 10% post-consumer waste (PCW). Paper used in this book was derived from certified, sustainable forestlands.

Contents

As you review the content in this book and work toward earning that **5** on your APAH Exam, here are five things that you **MUST** know above everything else:

Barron's Essential 5

1

Study two cultures beyond the European tradition in depth. Prepare for the first essay (12% of the grade) by studying works from two cultures beyond the European tradition. Choose a wide variety of works from each, and make sure to include architecture. Choose from these areas: Egypt, Ancient Near East, Islam, China, India, Japan, Africa, Pre-Columbian America, and the Pacific. Apply these works to frequently asked questions on

- Power and Authority
- Nature and Landscape
- Heavenly Beings or Deities
- Sacred Spaces
- The Family
- The Human Body
- Propaganda
- Violence in Art
- Women in Art
- Portraits

2

Study works of art in context. It is important to know the names of the artists and the titles of the works, but it is *required* to know how these were meant to be seen and understood. You must know a given work's context to understand how the work can be interpreted. Works in which the context is important to its interpretation include **but are not limited to**:

- *The Sarcophagus from Cerveteri* (p. 129)
- A. Lorenzetti, *Peaceful City and Peaceful Country* (p. 236)
- Grünewald, *Isenheim Altarpiece* (p. 304)
- El Greco, *The Burial of Count Orgaz* (p. 307)
- Picasso, *Guernica* (p. 400)

3

Practice preparing for the document-based question. The DBQ is a standard on the APAH exam, and usually involves an image and a quotation. Follow the directions! If they say to reference both the image and the quotation—do so! You will be penalized if you do not! This is only a ten-minute question, so be prepared to think quickly and write as completely as possible about the given subject.

4

Learn vocabulary! Most of the multiple-choice questions require you to know the basic terms art historians use to discuss great works of art. This is particularly important when discussing ancient and medieval art. Study the vocabulary sections at the end of each chapter. The most common vocabulary terms include **but are not limited to**:
- Painting techniques (including Greek pottery)
- Parts of architectural monuments (like ancient temples and medieval churches)
- Types of printmaking (etching, woodcut, engraving, etc.)
- Methods of sculpture (lost wax process, repoussé, etc.)

5

Don't forget the Middle Ages! Traditionally this has been the lowest scoring part of the APAH exam. A good score on these questions will raise you well above average when the scores are compared to other students. Medieval material includes Chapters 9, 11–14:

- Byzantine Art
- Early Medieval Art
- Romanesque Art
- Gothic Art
- Late Gothic Art in Italy

Acknowledgments

I have a number of people to thank for their contributions, good wishes, and general support, but the most important is my editor Linda Turner, whom I suspect Barron's does not pay enough for the job she ably does. I also wish to thank the two anonymous readers who offered criticism in a spirit of constructive frankness and were greatly influential in the shaping of this book.

I would like to express my appreciation to a number of important scholars who have contributed their thoughts to the formation of some of the chapters in this edition. They include William Clark on Gothic Art; Juilee Decker on Romanticism; Joni Hand on Northern European Renaissance Art; Jack Jarzavek on Late Antique and Romanesque Art; Eileen Krest on Japanese Art; William Levin on Gothic Art in Italy and Early Renaissance in Italy; Carol Lewine on the High Renaissance; Kimberly Mastellar on Islamic and Indian Art, and Brian Percival on Chinese Art. I am also deeply grateful to Carlos Rodriguez who rendered all the architectural drawings and diagrams for this book.

A personal thank you is extended to the large number of students who enthusiastically contributed model essays for this book. Some of them are my current students; others have gone on to major in art history in college and are happily pursuing a lifelong interest in the subject. These remarkable individuals are Chris Ahn, Rene Alpert, Zach Ballas, Michelle Bang, Nicole Benvin, Samson Bialostok, Stephanie Biron, Puja Chabra, Albert Chen, Farhan Contractor, Alex Drangsland, Samantha Dunn, Arthur Egbuchulam, Eric Engelman, Jessica Engelman, Maren Epstein, Daniel Faynblut, Marsha Gaspard, Karen Ginsburg, Alex Gold, Katyann Gonzalez, Barbara Hall, Mehak Ilyas, Shafak Ilyas, Lauren Jurgrau, Kaynat Khalid, Michael Klein, Sergey Kolchinskiy, Nicole Locoteta, Patrick Locoteta, Neha Madhusoodanan, Dylan Mandelbaum, Kari Matulewicz, Brittany McCormick, Kerri McHugh, Leonid Mikinberg, Anna Ng, Julie Obregon, Nicole O'Rourke, Ashley Pagliaro, Jaclyn Palermo, Pamela Pincow, Danielle Polsinelli, Stephanie Polsinelli, Tara Prout, Maya Rubin, Monica Rzewski, Gabriel Samaroo, Harly Sander, Katherine Schneider, Gillian Schrieber, Caryn Schuster, Jake Shauli, Lucas Siegel, Evan Silverstein, Gabriel Sloyer, Merrick Stone, Jordan Szenicer, Sara Tariq, Amy Turcios, Alexander Ulianov, Nader Uthman, Ozioma Uwazurike, Christopher Vacchio, Rishi Vohra, Connie Vollmer, and Ryan Zim.

PART ONE

GETTING TO KNOW THE AP EXAM IN ART HISTORY

Introduction

HOW TO USE THIS BOOK

Students who come to Advance Placement Art History, unlike students who take almost any other AP exam, approach the material afresh at the beginning of the school year, with no prior study and no prior understanding of the subject. This is an extraordinary opportunity for the teacher as well as the student to confront a new subject with no preestablished prejudices. However, because the student has no background and must learn everything from scratch, the course can seem unusually daunting. All those works of art! All those images! All those foreign names! All those vocabulary words! Civilizations rise and fall in only a week's time in an art history classroom. There is definitely a need for this Barron's book.

Ideally, this book serves as a refresher to complement a complete art history survey course. It does not function to replace any of the excellent survey texts available on the subject, nor does it pretend to duplicate any of the materials available through the College Board. However, it is a good way to easily organize study patterns for students who must deal with hundreds of images and must learn to discuss them in an intelligent way. This book can also double as a ready reference for teachers, students, and devotees of the subject as an educational resource.

Unlike textbooks in math, science, or social studies, art history books do not have review questions at the end of each chapter, and do not summarize what the student has learned. To meet this need, the teacher may wish to use the assignments here as homework, or to use the practice exams as a warm-up to the actual test. The more familiar students are with the actual exam, the more likely they are to score well on it.

A Note to the Student

You should be aware that this book is not a magic bullet to solve a year's worth of lethargy. Optimally it should be used as a complement to the course, but it will also serve well as a systematic study program to prepare you for the exam. By March you should be reviewing the earliest material, slowly going over one art period after another. It is highly unlikely that your teacher has chosen every work in this book, and he or she may have substituted others not illustrated here, because there is no prescribed list of images to know for the exam. Nevertheless, it is worthwhile going over every image in the book, whether or not it is familiar to you. The more breadth of experience you have, and the greater your understanding of the subject, the more likely you will be able to handle any question that comes your way.

THE ADVANCED PLACEMENT EXAMINATION IN THE HISTORY OF ART: AN OVERVIEW

The Advanced Placement Examination in Art History is a 3-hour test composed of an hour of multiple-choice, followed by a short break, and then 2 hours of free-response. The format is as follows:

Section I, Part A: *Multiple-Choice Questions Based on Illustrations.* Twenty minutes.

This section features five sets of images, viewable for 4 minutes apiece. A series of eight questions are directed at these images. Although this section is timed, students can move freely among the different illustrations and questions, spending more time on those that require greater effort, and speeding through those that are easy. However, they may not exceed the 20-minute time frame for the entire section.

Section I, Part B: *Multiple-Choice Questions in the Booklet.* Forty minutes.

Part B contains about 78 multiple-choice questions that run the entire gamut of art history, including the Western tradition and art beyond the Western tradition. This section tests the body of work studied during the year. The multiple-choice section is 40 percent of the total grade.

Section II: *Free-Response Section.* Two hours.

This section is composed of eight free-response questions, most associated with illustrations. There are two 30-minute essays and six short paragraph-type essays that are timed at 10 minutes apiece. A text-based question is in this section.

The two 30-minute essays usually allow students to choose from a wide array of options spanning much of the course. More rarely, they address one or two periods. Question 1 is reserved for non-Western art and tests what the student has learned in this area. Usually, non-Western examples can be used in Question 2 as well, unless a particular period is called for.

The six short essays are worth 30 percent of the total grade. The two 30-minute essays are worth another 30 percent. Students can move freely among the six questions, but they cannot exceed the 1-hour limit.

HOW THE TEST IS GRADED

A complicated series of calculations converts the combined raw score of the multiple-choice questions and the free-response essays into a grade of 1–5. A general rule of thumb is that three-quarters of correct responses will earn the candidate a top score of a 5. Two-thirds is a 4, and a little over half is a 3. These are guidelines, of course, but useful benchmarks nonetheless.

The five-point scoring system is standard among all AP exams:

> 5: Extremely well qualified. Almost all colleges and universities accept this score.
> 4. Well qualified. Accepted by most colleges and universities.
> 3. Qualified. Accepted by many colleges and universities.
> 2. Possibly qualified. Accepted by few colleges and universities.
> 1. No recommendation. Not accepted anywhere.

There is no score of 0, although, believe it or not, there are students who submit completely blank exams. Good for the curve.

As with every Advanced Placement exam, a predetermined percentage of students get a final score of a 1, 2, 3, 4, or 5. Care is taken to adjust scores according to the difficulty of the exam. Sometimes an examination that seems fair going into the process turns out to be difficult when students actually take it. Adjustments are made in the final scoring to balance a test that is unintentionally too easy or too difficult.

In May 2011, 22,311 students took the Advanced Placement Examination in Art History. Although that may sound like a huge number, it pales in comparison to most exams; Advanced Placement English Literature gathered 367,962 students. However, art history, unlike most exams, has eight written responses, all of which have to be individually read and scored over the course of one week of intensive grading.

A team of dedicated professionals (balanced in favor of college professors, but including a significant number of high school teachers) form a leadership team that sets the standards for the exam before marking. Art historians from all over the United States, indeed from some parts of the world, then gather in Salt Lake City in June to mark the eight free-response sections of the test. A hundred or so teachers use the standards set by the leadership team as guidelines for scoring. All graders are supervised, and teachers even self-check their own work. Even supervisors are monitored. Readers are encouraged to consult one another if a question comes up about the worthiness of an essay. Everything is done to ensure equality of grading across the spectrum. All of this checking and rechecking has made art history one of the most reliable Advanced Placement exams for consistency of scoring.

To the greatest extent possible, every paper is given just consideration. You should know that everything you write is taken very seriously and is considered fairly.

BALANCE OF SUBJECT MATTER

According to the College Board, Ancient and Medieval art account for 30 percent of the exam. Of that total, the highest concentration of material is on the art of Ancient Greece and Rome (10–15 percent), with a significant percentage of questions from the Gothic period (7–10 percent). Other topics are more marginal in their coverage: Aegean, Byzantine, Early Christian, Early Medieval, Etruscan, and Romanesque.

Twenty percent of the exam involves art beyond the European tradition, although that total is misleading. Non-Western art includes areas traditionally thought of as part of the Western canon of art history: Egypt, the Ancient Near East, and Islam. Additional non-Western areas include China, Japan, India, Ancient America, Africa, and the Pacific. In recent years many students—the College Board feels too many students—have been using only Egyptian or Ancient Near Eastern examples for the Art Beyond the European Tradition question. Starting with the 2010 exam, students are strongly discouraged from using these options, although it is not yet prohibited. Therefore, students who use Egypt or the Ancient Near East cannot be penalized. If your teacher does not have time to cover art beyond the European tradition, it is advised that you use this book as a supplement to the text and learn the material for yourself. Your scores will improve.

Fifty percent of the exam is from the Renaissance to the present, with the questions fairly equally spread through each century, although there is a slight concentration on the Renaissance.

EXAM NOMENCLATURE

The efforts to find precise and inoffensive terms to describe commonly held ideas have been a labor at the College Board. Instead of B.C. and A.D., which have been used as standard abbreviations in the Western world, a substitution of B.C.E. and C.E. ("Before the Common Era" and "Common Era") has been introduced. While this removes the potentially biased word "Christian," it creates the paradox of using a Christian numbering system without recognizing it.

Also, several terms like "non-Western," "Pre-Columbian," and "primitive," once standard in discussing art history, have been replaced by terms that are less exact, such as "art beyond the European tradition," the "art of the Americas," and "Oceanic art"—terms that are occasionally problematic.

Whenever possible, I have tried to use standard English in the naming of famous works of art, a practice that textbooks sometimes use and sometimes do not. It does not seem reasonable to make the art history student, with so much to learn, worry about the spelling of "Apoxyomenos," when the "Scraper" is the same thing and will do as well. Occasionally some works are so famous in a foreign language that it seems unwise to translate them, for fear that the student may think it is another object. For a limited number of objects, then, the original language has been maintained, as *Les Demoiselles d'Avignon* or *Las Meninas*. Most other objects have been translated.

You should also note that there are several ways of spelling names and objects that come from non-Roman scripts. In cases such as Mohammed/Muhammad, there is little to fear. But Dong QiChang is Tung Chi'Chang, depending on the method of translation used by a textbook. Every effort has been made to use the standard appearing across the spectrum of textbooks likely to be used in this class.

DATES

You have to study hundreds of works of art, and are required to know myriad facts about each. Unfortunately, the dates leave the head almost immediately upon finishing the examination. The 2009 released exam has only two multiple-choice questions that ask for dates. Instead of learning a huge number of dates, concentrate on centuries: for example, the Baroque is seventeenth century, Rococo is early eighteenth, Neoclassicism is late eighteenth, and so on. Only when the artwork approaches the late nineteenth century is it likely that the exam will ask for decades rather than centuries. Here, general dates will help to serve you best: early twentieth century has movements such as Cubism and Fauvism. Mid-twentieth century has movements such as Abstract Expressionism and Social Realism. Late twentieth century has movements such as Digital Art and Computer Graphics.

Sometimes historical events can help place an art-historical period. Columbus "discovered" America in 1492—in the middle of the Renaissance, which extends one hundred years in either direction.

HOW MANY IMAGES SHOULD I KNOW?

The major art history textbooks have about 1,200 illustrations. No one should be foolish enough to study, let alone teach, all of them. Even if you were to memorize every illustration—that is, every illustration in all of the textbooks—this would be no guarantee that you would recognize every picture on the exam.

The exam tests both factual knowledge and interpretation. To that end, you can expect it to contain a number of works that you are not likely to immediately recognize. On the 2008 exam, students were presented with a relatively unknown Van Gogh, and were asked if they could identify the artist based on their visual memory. Then they were asked to support their identification by comparing this Van Gogh to one they already knew. In order to answer this question appropriately, you have to be well versed in Van Gogh's style. This becomes increasingly unlikely if you are memorizing hundreds of miscellaneous artists and are treating Van Gogh as if he were a minor artist.

What to study? Go into the test knowing at least 300 objects with the most basic background. Choose some from every period, trying to cover at least a few works of painting, architecture, and sculpture in each. You should also learn a few objects from the so-called minor arts: photography, pottery, textiles, and so on. A student who enters the test with this broad range of experience is prepared to encounter most of the questions the College Board is likely to ask.

Answering the Multiple-Choice Questions

The Advanced Placement Examination in Art History requires the student to correctly answer as many of the 115 multiple-choices as possible. Each question has four possible responses, and you are asked to find the BEST answer. Often a case can be made for a second choice, but it does not fit as well as the first.

As with all multiple-choice questions, be careful to scan for terms such as

- Except
- None of the above
- All of the above
- Always
- Never
- Sometimes, often, frequently

These terms indicate that the question has to be analyzed more carefully, since the possibilities are more complicated. In that regard, you should always do the following when approaching an AP multiple-choice question:

- Read each question twice.
- Remember that guessing is now permissible on all AP exams. Therefore, there should be no blanks on your paper!

Types of Multiple-Choice Questions

Typically, multiple-choice questions ask for the following information	Study recommendations
Name of artist	Absolutely essential
Name of work	Absolutely essential
Period or movement of a work	Absolutely essential
Medium of the work	Important, but not essential. This becomes important when it is something other than oil on canvas.
Date of the work	Century only
Location	Absolutely essential only for architecture; for paintings and sculpture, it is not necessary to know the names of museums they are currently in.
Identification of key figures in the work	Absolutely essential
Art history vocabulary, and how these terms can be seen in an individual work	Absolutely essential
Influences on the artist	Important, and often asked
How the work fits in/does not fit in with its times	Increasingly stressed. Works that have a political or cultural message are more apt to be used for questions like this.
Original setting of the work	Sometimes asked, especially if the setting is important to the interpretation of the work.
Patron	Asked if the patron had a great influence on the outcome of the work
Symbolism/Subject matter	Sometimes asked, but increasingly this has fallen from favor. Symbols are mutable and subject to interpretation.
Key formal characteristics	A mainstay of traditional art history books

As you can see, there is much to know about each object, and each object raises individual concerns expressed independently from this chart.

What you might be expected to know about each work depends on the work itself. Here are some examples of what might be considered important for a given work of painting, sculpture, and architecture. Gray areas are facts that would not be asked on the AP exam.

	Example 1: Painting	Example 2: Sculpture	Example 3: Architecture
Name of artist	Diego Velázquez	unknown	Frank Lloyd Wright
Name of work	*Las Meninas*	*Tell Asmar Statue*	Robie House
Period or movement of a work	Baroque	Sumerian	Prairie School
Medium of the work	oil on canvas	limestone, alabaster, and gypsum	brick, glass, wood, and concrete
Date of the work (usually in centuries, rather than years)	1656; 17th century is good enough	c. 2700 B.C.E.	1907–1909; early 20th century is good enough
Original location	The King of Spain's study	In a temple at Tell Asmar, Iraq	Chicago, Illinois
Current location	Prado Museum, Madrid	Oriental Institute, Chicago	Chicago, Illinois; building is in situ
Original setting of the work	King's study; Velázquez seems to be challenging the king to understand this work	Placed in a temple, representing worshippers praying to the god; inscribed on back: "It offers prayers"	Flat planes of building match the Illinois prairie and stick out from the Victorian houses surrounding it.
Identification of key figures in the work	Painter at easel; Infanta of Spain in center; meninas attending her; king and queen reflected in the mirror		
Art history vocabulary, and how these terms can be seen in an individual work	Impasto (thick brush work visible on such things as the sleeves of the main figures)	Hierarchy of scale (the importance of each statue is relative to its size)	Cantilever (roofs extend over the outdoor porches)
Influences on the artist	Caravaggio		Horizontal nature of the prairie influenced the artist.

How the work fits in/ does not fit in with its times	The Baroque seeks pleasure in a complex structure and layering of meanings in a work.	Gender roles are stressed by the various treatments of male and female statuettes.	Avant-garde construction for its time, with wide, long window spaces and set-back porches
Patron	King Phillip IV of Spain	unknown	Frederick Robie
Symbolism	Velázquez wears the cross of the Royal Order of Santiago, elevating him to knighthood.	Flowing beards on men symbolize their wisdom.	Long, low horizontal bricks symbolize the building itself and the prairie that inspired it.
Key Formal Characteristics	Linear perspective reaches deeply into the picture plane	Compact figure with limited negative space	Numerous outdoor porches with protective overhanging eaves

Examples of Multiple-Choice Questions

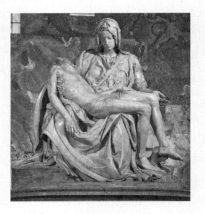

Name of artist question:

The artist who sculpted this work is

(A) Michelangelo
(B) Raphael
(C) Titian
(D) Leonardo

Answer: (A) Michelangelo is the artist of this work.

Title of work question:

The title of this sculpture is

(A) *Whistler's Mother*
(B) *Mona Lisa*
(C) *Last Judgment*
(D) *Pietà*

Answer: (D) This work is known as the *Pietà*.

Period or movement question:

The period in which this work was done is

(A) Mannerism
(B) Baroque
(C) High Renaissance
(D) International Gothic

Answer: (C) This work is from the High Renaissance.

Date question:

This sculpture was carved around

(A) 1200
(B) 1300
(C) 1500
(D) 1800

Answer: (C) The work is from around 1500.

Artist's medium question:

This sculpture is carved in

(A) granite
(B) marble
(C) wood
(D) limestone

Answer: (B) This work is made of marble.

Key figures question:

The two figures in the work are

(A) Virgin Mary and Jesus
(B) Ekkehard and Uta
(C) Abelard and Heloise
(D) Tristan and Isolde

Answer: (A) The two figures in this work are the Virgin Mary and Jesus.

Vocabulary question:

This work has a limited amount of negative space, meaning that it

(A) is meant to be viewed only from the front
(B) is placed in an area that has limited sight-lines
(C) is carved in a triangular format
(D) has few openings between the limbs

Answer: (D) In a work of sculpture, negative space refers to the openings between limbs that are often carved away. This work has little negative space.

Influences on the artist question:

The artist found inspiration in works such as

(A) sculpture on Gothic cathedrals
(B) Byzantine icons
(C) works from classical Greece and Rome
(D) Early Christian sculpture

Answer: (C) Michelangelo's works were inspired by classical sculptures from Greece and Rome.

Original setting question:

The original location of this work was intended to be

(A) Old Saint Peter's
(B) the Tempietto
(C) the School of Athens
(D) the Medici Palace

Answer: (A) This sculpture was originally carved for a tomb in Old Saint Peter's.

How the work fits in/does not fit in with its times question:

A key characteristic of this work that is similar to other works done at this time is the

(A) pyramidal composition
(B) distorted limbs
(C) agonized expressions
(D) use of multimedia

Answer: (A) A typical High Renaissance work, like the *Pietà* or the *Mona Lisa*, has a pyramidal composition.

Patron question:

Who is the patron of this work?

(A) A condottiere
(B) A member of the Medici family
(C) A Pope
(D) A French cardinal

Answer: (D) A French cardinal living in Rome commissioned the sculpture and had it placed in Old Saint Peter's.

Symbolism question:

According to the artist, the youthfulness of the young mother in this sculpture symbolizes her

(A) innocence
(B) naïveté
(C) virginity
(D) tragedy

Answer: (C) When confronted with criticism about the age of the Virgin Mary, Michelangelo said that virgins never grow old.

Formal analysis question:

The proportions of the figures are slightly altered in that

(A) Mary's head is too small for her body
(B) Christ's body is too elongated
(C) Mary's body is larger than Christ's
(D) Mary's head and arms are elongated

Answer: (C) Mary's body stabilizes the sculpture and is larger than Christ's. Moreover, Mary is sometimes represented as the Catholic Church holding and cradling Jesus.

Answering the Free-Response Questions

There are two types of essays on the Advanced Placement Art History Examination: the six short essays of 10 minutes each and the two longer, more comprehensive essays that take 30 minutes each to write. Each essay type has a different function. Short essays concentrate on a particular work of art or architecture, asking specific questions and demanding concise responses.

The 30-minute essays generally span great oceans of time, asking the student to call upon images that may have similarities but are expressed by different civilizations at different times.

APPROACHING THE SHORT ESSAY

Your short essays are marked on a scale of 0–4, based on a rubric that is agreed on before the marking session by a leadership committee of teachers and experts in the various fields of art history. It may seem simplistic to say, but the key ingredient in getting a good mark on the written essays is to read the question completely and thoroughly, and to fully answer each part. Although readers do not bean count the responses, they are looking for how well you addressed the question, not for how well you may know everything there is to know about the image. If you are including information about an object that is not called for in the question, it will be ignored by the reader. You MUST answer the question completely and directly in order to earn the highest grade possible.

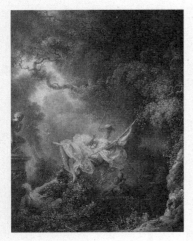

For example, a question could read as follows:

Name the art-historical period of this painting. Discuss how the characteristics of this work differentiate it from paintings of the period immediately preceding it.

The right way to approach this question is to immediately tell the reader that the art-historical period is Rococo, and that the preceding period is Baroque. Even if you write nothing else, you have already earned a minimum number of points. It is irrelevant if you know the work is Fragonard's *The Swing*, because this is not asked in the question. Conversely, if you do not know the name of the painting, or if you misname it, it does not count against you.

Your next task is to tell the reader how the characteristics of this work differentiate it from the Baroque. Here you have a choice of responses because it is not required of students to memorize a prescribed list of characteristics.

Because the marking is based on a scale of 0–4, and because a point has already been earned for knowing that the period is Rococo, it seems logical that the next three points should be earned by describing characteristics. **Do not list them. Do not use bullet points.** Write complete sentences.

For example, you could discuss the lighter colored palette of Rococo paintings, as opposed to the heavier and richer colors of the Baroque. Be sure to point out where in the painting this is true. You could also discuss the light-hearted subject matter that the Rococo is known for, again pointing out how this is true in the painting. Perhaps you might want to discuss how the figures are thin and delicate, in sharp contrast to the heavier and more ponderous figures of Baroque artists like Rubens.

If you know that the image is Rococo and you discuss three characteristics that differentiate it from the Baroque, you will earn full credit.

Questions at times give the name of the artist, or other kinds of information.

The architect of this building is Leon Battista Alberti. What period is this work from? How did the architect adapt classical forms onto a Christian church?

The question supplies the name of the architect, although not the name of the building, which is not required. You do not have to give the name of the building, and you certainly should not attempt to do so if you are likely to misname it.

You have two tasks: Name the period that this work is from, and then discuss how the classical forms have been adapted onto a Christian church.

You should immediately reveal that this work is from the Renaissance.

The next step is to discuss the elements on the façade that would have been found in classical architecture, and to discuss how these elements have been adapted onto a church. Since the answer that the work is Renaissance counts for one point, it is advised that you then name at least three classical characteristics (e.g., the pediment, the pilasters, the barrel vault, the triumphal arch, the capitals), discuss how they would have been placed on a classical building (like the Arch of Constatine or the Pantheon), and discuss how they have been placed on this building.

GENERAL RULES ABOUT ESSAYS

1. Never use value judgments or matters of taste or opinion in an essay. For example, never say that a work of art is "better" than another, or that the artist used perspective "better" or color "better." Instead, express differences in terms of values that few can object to, such as: "Painting A has more vivid colors than painting B, as can be seen in the figure on the left"; "sculpture A is more classically composed than sculpture B, as can be seen in the contrapposto in the figure on the left"; "building A is located in a city square, whereas building B was built in a rural area."

2. Never use the word "perfect" or say that a work of art is, for example, "the perfect expression of Christian belief."

3. Never use "able" or "unable," as in "The artist was unable to capture the feelings of sorrow in..." Also don't use "attempt," as in "The artist attempts to show foreshortening." What precisely does this mean?

4. Never express a preference. Don't tell the reader that you like one work more than another. It is irrelevant to the exam.

5. Be careful of the word "unique"—it means one of a kind. It does not mean special. If a work of art is unique, it means that there is no other work like it. Use it sparingly. Avoid redundant expressions like "very unique."

6. Avoid complimenting the artist on the work he or she has done. Do not say that "Michelangelo did a good job of showing perspective..."

7. People in works of art are "figures," not "characters." Characters are parts in plays.

8. Avoid phrases like "piece of art." Use "work of art" or "work."

9. It is permissible in questions with two illustrations to simply refer to them as right and left, rather than repeating a title. Once you have established what they are, left and right, or even L and R, are sufficient.

10. It is correct form to underline the titles of works of art, with the exception of the names of buildings. In this book, italics have been substituted for underlining.

11. Always identify a work of art clearly, not generically. For example, don't identify by simply using the word "icon." There are so many! Say, instead, "the Ohrid icon of the Annunciation." Similarly, don't use words such as "cathedral" or "pyramid" as a method of identification. Use instead "Pisa Cathedral in Pisa, Italy" or "the Pyramid of the Sun in Teotihuacán, Mexico."

THE TEXT-BASED QUESTION

In compliance with a general movement across the Advanced Placement spectrum, the College Board has implemented text-based questions in many exams. For social studies tests, these are often found in DBQs (Data-Based Questions); for art history, there is a textual source.

The source can be from anything art related: the words of an artist, the evaluations of a critic, the writings of an art historian, or the analysis of a museum curator. In any case, the goal is to take those words and firmly apply it to a work of art. In most cases, the student is asked to defend or reject these assertions, more rarely to interpret them. On occasion, the question is accompanied by an illustration, but more recently the movement has been to make the text stand on its own, and to have the student supply an image.

For example,

> *Salvador Dalí once said, "People love mystery, and that is why they love my paintings." What art-historical period was Dalí associated with? Choose a work from this period and discuss how this work applies to this quotation.*

In order to answer this question, you must know that Dalí is a Surrealist, and be able to identify and understand the sense of mystery that pervades the work. It would be very difficult to prove the opposite, since so many Surrealist works are crafted in layers of imagery. The Dalí painting of choice in most high school classrooms is *The Persistence of Memory*, a work overloaded with mysterious symbols and odd juxtapositions. A full discussion of this painting is in order.

Whatever your approach to this question, it is imperative to address the quotation directly and apply it to the image. If the answer does not directly respond to both the quotation and the illustration, you will without hesitation receive a failing grade for this question.

THE TWO THIRTY-MINUTE ESSAYS

The questions that give you the freest range of expression—and the most challenges—are the two 30-minute questions. These questions give students great latitude in choice, but correspondingly ask for a more complete understanding of a work.

Each 30-minute essay is scored on a scale of 0–9. Blank papers or essays on a summer vacation merit a 0. Most students who attempt something coming close to a response will earn at least a 1. Scores of 8 and 9 are difficult to earn, requiring you to present a polished essay on a given topic.

General Rules About Longer Essays

The first step is to read the question carefully, being sure to note any qualifiers to the essay. Qualifiers may be words like "works from two different periods" or "works of architecture," which will limit your choices.

Then think about the question by clearly stating the issue in a thesis statement that directs the reader's attention to a focused response. For example, if the question reads:

> *Often the original context of a work of art is essential to its interpretation. Choose two works of art from two different periods in which the original context is known, explain the context, and discuss how it contributes to its meaning.*

To focus the reader's attention, an opening statement rephrases the question with the answers in mind:

> The original context of a work can add significantly to its meaning—artists often having been commissioned to create works for a particular place or function. Two works that create this impression are the High Renaissance painting of the <u>Last Supper</u> by Leonardo da Vinci and Robert Smithson's Site Art work called <u>Spiral Jetty</u> in Great Salt Lake, Utah.

While the question insists on two works of art from two different periods, it does not state that the works have to have been removed from their contexts. Be alert for qualifiers that influence your options.

Often what the questions really ask for are two separate essays on two different works united only in theme. It is all right if you conceive of your essay this way—just make sure to unite the sections in the opening and closing paragraphs.

Thirty-minute essays should be of sizable length. Although readers are told not to judge an essay by its length, long essays in general have more to say than short ones. There is no need to fill the booklet with words, but a carefully written essay will require explanations, and explanations imply length.

Write neatly. The reader will read thousands of essays this week. Don't make him or her spend a long time just trying to figure out your handwriting. If you have particularly difficult script, skip a line when you write so that it will appear clearer.

If you finish early, proofread. Too many students spend the balance of the time during the exam counting ceiling tiles. Cross out phrases that are awkward. Rewrite if necessary. Indent paragraphs. Add punctuation.

Question 1 is the "art beyond the European tradition" question. In essence, it asks you to consider non-Western works and compare an aspect of their art to either another non-Western work, or to a Western work.

What is art beyond the European tradition? For now, it is Egypt, the Ancient Near East, Islam, India, China, Japan, Ancient America, Africa, and the Pacific. However, the College Board would prefer if students did not choose the Egyptian or Ancient Near Eastern options. The spirit of the question is to broaden the scope of the course to cover objects that are not normally covered in art history classes. Avoid using these examples.

Art Beyond the European Tradition Question

Acceptable responses	Good to use, but less stressed	Commonly mistaken for non-Western; Do NOT Use
Africa	Ancient Near East	Aegean
Ancient America	Egypt	Etruscan
China		Prehistoric European
India		
Islam		
Japan		
Pacific		

Formerly prehistoric European art had been considered non-Western, because it was done at a time when Europe was not yet Europe. It is strongly advised to stay away from this option. The winds of change are blowing directly at Stonehenge, and it would be unwise to write a beautiful essay that could be dismissed as unacceptable by the graders. One reader has rightfully remarked, "The Venus of Willendorf haunts this test," because so many students use it for Question 1. Do not do this! It is rare that this object can form the basis for a solid essay.

The penalties are high for those who choose two Western works. The highest you can earn is a 5 out of 9, in the best-case scenario. It is far better to use two non-Western than two Western works.

Question 2 asks you to compare two images in a similar context. Sometimes architectural settings are stressed, sometimes body forms, sometimes images of power. Whatever the relationships, you usually have free range across the curriculum to choose any work that applies. Once again, you are not limited to the Western canon, and you can choose non-Western works.

Almost always you are asked to choose two works from two different periods. Be careful! Two different periods means two DIFFERENT periods. In other words, don't assume the readers of the exam will take Mannerism and Renaissance as two different periods. Don't assume that Cubism and Futurism are different periods; they may fall under the umbrella of "modern." It is much safer, and more desirable, to choose periods far removed from one another, like Baroque and Romantic, or Gothic and Rococo.

Use the following questions for practice on how to begin an essay:

Question 1:

A. Human heads have often been a focus for artists, sometimes depicted independently from bodies, sometimes in disproportion to the bodies on which they are placed. Choose two works of art from two different cultures— at least one of which must be from beyond the European tradition—and discuss the relationship of the head to the rest of the body.

 a. Which two works would you choose? Fully identify them so that they cannot be confused with other works.

 i. _____

 ii. _____

 b. Write a thesis statement:

B. Artists have often been inspired by nature and have used landscape painting as a way to express their feelings. Choose two works of art from two different cultures—at least one of which must be from beyond the European tradition—that expressively uses landscape painting. Explain how each approach to landscape is different, and how those differences reflect a cultural statement about landscapes and nature.

 a. Which two works would you choose? Fully identify them so that they cannot be confused with other works.

 i. _____

 ii. _____

 b. Write a thesis statement:

C. Cultures often require that artists create images of the divine expressed in human form. Choose two works of art in which a human has been invested with divine qualities, and explain how the artist rendered the divine qualities that the human image possesses. At least one work must be from beyond the European tradition.

 a. Which two works would you choose? Fully identify them so that they cannot be confused with other works.

 i. _____

 ii. _____

 b. Write a thesis statement:

Question 2:

A. Buildings are often built on sacred religious sites. Choose two buildings that are located on important sites and discuss how the buildings take into consideration the importance of the site in its construction.

 a. Which two works would you choose? Fully identify them so that they cannot be confused with other works:

 i. _____

 ii. _____

 b. Write a thesis statement:

B. For various reasons, painters have often included themselves in their works of art. Choose two works that are not independent self-portraits from two different periods and explain where the artist has placed himself or herself in the composition and discuss the relationship this artist has with the rest of the painting.

 a. Which two works would you choose? Fully identify them so that they cannot be confused with other works.

 i. _____

 ii. _____

 b. Write a thesis statement:

C. Perspective has been a principal tool used by painters since the Renaissance. Sometimes artists strictly adhere to the formulas of perspective; other times they deviate widely from it. Choose two works, one which faithfully uses perspective and one which deviates from the formula, and explain the effects the artist wanted to achieve with each.

 a. Which two works would you choose? Fully identify them so that they cannot be confused with other works.

 i. _____

 ii. _____

 b. Write a thesis statement:

PART TWO

DIAGNOSTIC TEST

Answer Sheet
DIAGNOSTIC TEST

Section I, Part A

1. Ⓐ Ⓑ Ⓒ Ⓓ
2. Ⓐ Ⓑ Ⓒ Ⓓ
3. Ⓐ Ⓑ Ⓒ Ⓓ
4. Ⓐ Ⓑ Ⓒ Ⓓ
5. Ⓐ Ⓑ Ⓒ Ⓓ
6. Ⓐ Ⓑ Ⓒ Ⓓ
7. Ⓐ Ⓑ Ⓒ Ⓓ
8. Ⓐ Ⓑ Ⓒ Ⓓ
9. Ⓐ Ⓑ Ⓒ Ⓓ
10. Ⓐ Ⓑ Ⓒ Ⓓ

11. Ⓐ Ⓑ Ⓒ Ⓓ
12. Ⓐ Ⓑ Ⓒ Ⓓ
13. Ⓐ Ⓑ Ⓒ Ⓓ
14. Ⓐ Ⓑ Ⓒ Ⓓ
15. Ⓐ Ⓑ Ⓒ Ⓓ
16. Ⓐ Ⓑ Ⓒ Ⓓ
17. Ⓐ Ⓑ Ⓒ Ⓓ
18. Ⓐ Ⓑ Ⓒ Ⓓ
19. Ⓐ Ⓑ Ⓒ Ⓓ
20. Ⓐ Ⓑ Ⓒ Ⓓ

21. Ⓐ Ⓑ Ⓒ Ⓓ
22. Ⓐ Ⓑ Ⓒ Ⓓ
23. Ⓐ Ⓑ Ⓒ Ⓓ
24. Ⓐ Ⓑ Ⓒ Ⓓ
25. Ⓐ Ⓑ Ⓒ Ⓓ
26. Ⓐ Ⓑ Ⓒ Ⓓ
27. Ⓐ Ⓑ Ⓒ Ⓓ
28. Ⓐ Ⓑ Ⓒ Ⓓ
29. Ⓐ Ⓑ Ⓒ Ⓓ
30. Ⓐ Ⓑ Ⓒ Ⓓ

31. Ⓐ Ⓑ Ⓒ Ⓓ
32. Ⓐ Ⓑ Ⓒ Ⓓ
33. Ⓐ Ⓑ Ⓒ Ⓓ
34. Ⓐ Ⓑ Ⓒ Ⓓ
35. Ⓐ Ⓑ Ⓒ Ⓓ
36. Ⓐ Ⓑ Ⓒ Ⓓ
37. Ⓐ Ⓑ Ⓒ Ⓓ

Section I, Part B

38. Ⓐ Ⓑ Ⓒ Ⓓ
39. Ⓐ Ⓑ Ⓒ Ⓓ
40. Ⓐ Ⓑ Ⓒ Ⓓ
41. Ⓐ Ⓑ Ⓒ Ⓓ
42. Ⓐ Ⓑ Ⓒ Ⓓ
43. Ⓐ Ⓑ Ⓒ Ⓓ
44. Ⓐ Ⓑ Ⓒ Ⓓ
45. Ⓐ Ⓑ Ⓒ Ⓓ
46. Ⓐ Ⓑ Ⓒ Ⓓ
47. Ⓐ Ⓑ Ⓒ Ⓓ
48. Ⓐ Ⓑ Ⓒ Ⓓ
49. Ⓐ Ⓑ Ⓒ Ⓓ
50. Ⓐ Ⓑ Ⓒ Ⓓ
51. Ⓐ Ⓑ Ⓒ Ⓓ
52. Ⓐ Ⓑ Ⓒ Ⓓ
53. Ⓐ Ⓑ Ⓒ Ⓓ
54. Ⓐ Ⓑ Ⓒ Ⓓ
55. Ⓐ Ⓑ Ⓒ Ⓓ
56. Ⓐ Ⓑ Ⓒ Ⓓ
57. Ⓐ Ⓑ Ⓒ Ⓓ

58. Ⓐ Ⓑ Ⓒ Ⓓ
59. Ⓐ Ⓑ Ⓒ Ⓓ
60. Ⓐ Ⓑ Ⓒ Ⓓ
61. Ⓐ Ⓑ Ⓒ Ⓓ
62. Ⓐ Ⓑ Ⓒ Ⓓ
63. Ⓐ Ⓑ Ⓒ Ⓓ
64. Ⓐ Ⓑ Ⓒ Ⓓ
65. Ⓐ Ⓑ Ⓒ Ⓓ
66. Ⓐ Ⓑ Ⓒ Ⓓ
67. Ⓐ Ⓑ Ⓒ Ⓓ
68. Ⓐ Ⓑ Ⓒ Ⓓ
69. Ⓐ Ⓑ Ⓒ Ⓓ
70. Ⓐ Ⓑ Ⓒ Ⓓ
71. Ⓐ Ⓑ Ⓒ Ⓓ
72. Ⓐ Ⓑ Ⓒ Ⓓ
73. Ⓐ Ⓑ Ⓒ Ⓓ
74. Ⓐ Ⓑ Ⓒ Ⓓ
75. Ⓐ Ⓑ Ⓒ Ⓓ
76. Ⓐ Ⓑ Ⓒ Ⓓ
77. Ⓐ Ⓑ Ⓒ Ⓓ

78. Ⓐ Ⓑ Ⓒ Ⓓ
79. Ⓐ Ⓑ Ⓒ Ⓓ
80. Ⓐ Ⓑ Ⓒ Ⓓ
81. Ⓐ Ⓑ Ⓒ Ⓓ
82. Ⓐ Ⓑ Ⓒ Ⓓ
83. Ⓐ Ⓑ Ⓒ Ⓓ
84. Ⓐ Ⓑ Ⓒ Ⓓ
85. Ⓐ Ⓑ Ⓒ Ⓓ
86. Ⓐ Ⓑ Ⓒ Ⓓ
87. Ⓐ Ⓑ Ⓒ Ⓓ
88. Ⓐ Ⓑ Ⓒ Ⓓ
89. Ⓐ Ⓑ Ⓒ Ⓓ
90. Ⓐ Ⓑ Ⓒ Ⓓ
91. Ⓐ Ⓑ Ⓒ Ⓓ
92. Ⓐ Ⓑ Ⓒ Ⓓ
93. Ⓐ Ⓑ Ⓒ Ⓓ
94. Ⓐ Ⓑ Ⓒ Ⓓ
95. Ⓐ Ⓑ Ⓒ Ⓓ
96. Ⓐ Ⓑ Ⓒ Ⓓ
97. Ⓐ Ⓑ Ⓒ Ⓓ

98. Ⓐ Ⓑ Ⓒ Ⓓ
99. Ⓐ Ⓑ Ⓒ Ⓓ
100. Ⓐ Ⓑ Ⓒ Ⓓ
101. Ⓐ Ⓑ Ⓒ Ⓓ
102. Ⓐ Ⓑ Ⓒ Ⓓ
103. Ⓐ Ⓑ Ⓒ Ⓓ
104. Ⓐ Ⓑ Ⓒ Ⓓ
105. Ⓐ Ⓑ Ⓒ Ⓓ
106. Ⓐ Ⓑ Ⓒ Ⓓ
107. Ⓐ Ⓑ Ⓒ Ⓓ
108. Ⓐ Ⓑ Ⓒ Ⓓ
109. Ⓐ Ⓑ Ⓒ Ⓓ
110. Ⓐ Ⓑ Ⓒ Ⓓ
111. Ⓐ Ⓑ Ⓒ Ⓓ
112. Ⓐ Ⓑ Ⓒ Ⓓ
113. Ⓐ Ⓑ Ⓒ Ⓓ
114. Ⓐ Ⓑ Ⓒ Ⓓ
115. Ⓐ Ⓑ Ⓒ Ⓓ

Diagnostic Test

SECTION I

Part A

Directions: Questions 1–37 are divided into five sets of questions based on color pictures in a separate booklet. In this book the questions are illustrated by black-and-white photographs at the top of each set. Select the multiple-choice response that best completes each sentence, and put the correct response on your answer sheet. You will have 20 minutes to answer the questions in Part A. You are advised to spend 4 minutes on each set of questions, although you may move freely among each set of questions.

Questions 1–9 are based on Figures 1 and 2. Four minutes.

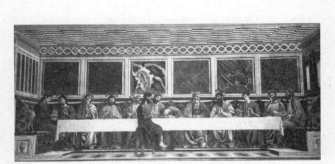

Figure 1

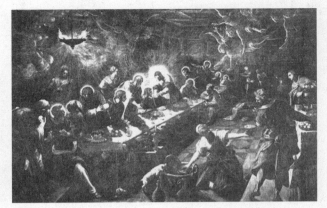

Figure 2

1. The work on the left was painted by

 (A) Andrea del Castagno
 (B) Sandro Botticelli
 (C) Luca Signorelli
 (D) Giotto di Bondone

2. The work on the left dates from the middle of which century?

 (A) Twelfth
 (B) Fifteenth
 (C) Seventeenth
 (D) Nineteenth

3. The patrons of the work on the left were

 (A) a group of cloistered nuns
 (B) the Medici family
 (C) a guild of merchants
 (D) friars of the Franciscan order

4. In the work on the left, the figure on our side of the table is

 (A) Jesus
 (B) Saint John the Baptist
 (C) Judas
 (D) Saint Peter

5. The painting on the right is by

 (A) Paolo Veronese
 (B) Titian
 (C) Jacopo Tintoretto
 (D) El Greco

6. In contrast to the work on the left, the work on the right was painted

 (A) earlier
 (B) later
 (C) around the same time in a different city
 (D) around the same time in the same city

7. The elongated figures on the right are characteristic of which of the following styles?

 (A) Baroque
 (B) Rococo
 (C) Mannerism
 (D) High Renaissance

8. These paintings represent the

 (A) Last Supper
 (B) meeting of confraternity members
 (C) Wedding at Cana
 (D) Supper at Emmaus

9. Both paintings are noteworthy for their

 (A) geometric stylization
 (B) abstract patterns
 (C) illusion of fading objects in the distance
 (D) use of linear perspective

Questions 10–16 are based on Figures 3 and 4. Four minutes.

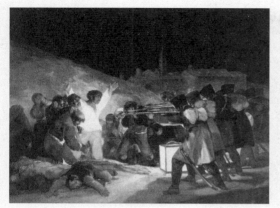

Figure 3 Figure 4

10. Both of these artists painted these works about events that took place in the

 (A) artist's own times in his own country
 (B) artist's own times in another country
 (C) distant past
 (D) Bible

11. The principal figure in the work on the right represents

 (A) War
 (B) Liberty
 (C) Intemperance
 (D) Capitalism

12. The flag carried by the figure in the work on the right is that of

 (A) Great Britain
 (B) Italy
 (C) Spain
 (D) France

13. The artist of the work on the left is

 (A) Théodore Géricault
 (B) Eugène Delacroix
 (C) Jean-Antoine Gros
 (D) Francisco de Goya

14. The principal figure in the left painting is in a pose that is symbolic of

 (A) Moses
 (B) Buddha
 (C) Confucius
 (D) Jesus

15. The artist of the work on the left probably sympathized with

 (A) the man with his hands up
 (B) the soldiers on the right
 (C) no one in the painting
 (D) everyone in the painting

16. The period most closely identified with these works is

 (A) Neoclassicism
 (B) Rococo
 (C) Realism
 (D) Romanticism

Questions: 17–23 are based on Figure 5. Four minutes.

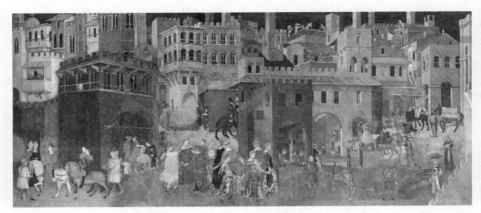

Figure 5

17. The work shown was painted in approximately what year?

 (A) 1100
 (B) 1300
 (C) 1500
 (D) 1700

18. This work is typical of the style of painting produced in

 (A) Venice
 (B) Siena
 (C) Florence
 (D) Rome

19. This is a selection from a fresco dealing with

 (A) the book of Genesis
 (B) parables from the life of Christ
 (C) the end of the world and the rise of the anti-Christ
 (D) the virtues of good government and vices of bad government

20. This work is an example of which of the following styles?

 (A) Baroque
 (B) Romanesque
 (C) Ottonian
 (D) Gothic

21. Key to understanding this work is its location in a

 (A) church
 (B) banqueting house
 (C) city hall
 (D) school

22. The work was painted by

 (A) Ambrogio Lorenzetti
 (B) Masaccio
 (C) Simone Martini
 (D) Luca Signorelli

23. Works like this are related in style to which of the following artists?

 (A) Cimabue
 (B) Duccio
 (C) Rogier van der Weyden
 (D) Pietro Perugino

Questions: 24–30 are based on Figures 6 and 7. Four minutes.

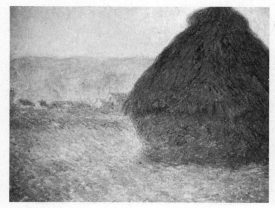

Figure 6

Figure 7

24. These two paintings are from which movement in art history?

 (A) Symbolism
 (B) Realism
 (C) Impressionism
 (D) Post-Impressionism

25. The artist associated with these works is

 (A) Paul Cézanne
 (B) Henri de Toulouse-Lautrec
 (C) Pierre-Auguste Renoir
 (D) Claude Monet

26. Both of these works were done in the manner typical of that time, which means that the artist

 (A) went into the field and sketched disparate subjects and put them together in his studio
 (B) copied and reworked the paintings of old masters
 (C) painted outdoors directly from the subject
 (D) collaborated with many other artists on one painting

27. These works are unusual in art history because

 (A) the artist made many views of the same subject from different points of view
 (B) the artist ignored tradition by painting landscapes
 (C) these paintings were meant to be exhibited together and always remain together
 (D) both of these paintings were painted from a boat

28. The date for these paintings is around

 (A) 1830
 (B) 1850
 (C) 1870
 (D) 1890

29. The artist who painted these works also painted in a series views of

 (A) Tahiti
 (B) Mont St-Victoire
 (C) Rouen Cathedral
 (D) horses galloping

30. The subject of the work on the right is

 (A) oaks in a grove
 (B) poplar trees
 (C) floods along the Loire River
 (D) landscapes at Giverny

Questions: 31–37 are based on Figures 8 and 9. Four minutes.

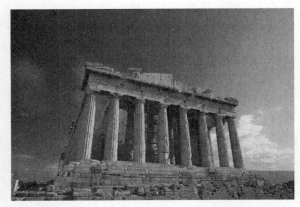

Figure 8

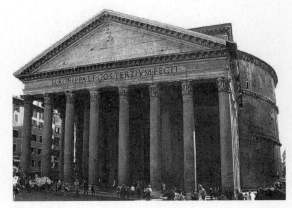

Figure 9

31. Both of these works are ancient temples. The building on the left was dedicated to

 (A) Zeus
 (B) Apollo
 (C) Athena
 (D) Poseidon

32. The building on the right was constructed

 (A) to ensure a successful hunt
 (B) so that the Vestal Virgins would have someplace to worship
 (C) so that all the gods could be celebrated
 (D) as a thank you for a military victory

33. The architectural system that was used to construct the building on the left is called

 (A) barrel vault
 (B) post and lintel
 (C) skeleton
 (D) cantilever

34. The patron of the building on the left was

 (A) Socrates
 (B) Pericles
 (C) Phidias
 (D) Alexander the Great

35. Among the architectural innovations that appear in the work on the right

 (A) is concrete
 (B) are Tuscan columns
 (C) are metopes
 (D) are rib vaults

36. The triangular feature at the top of both temples is called a

 (A) triglyph
 (B) cornice
 (C) pediment
 (D) architrave

37. The interior of the building on the right can be characterized as

 (A) containing a coffers and an oculus
 (B) a hypostyle hall
 (C) dark and mysterious
 (D) filled with stained glass

Part B

TIME: 40 MINUTES

Directions: You have 40 minutes for Questions 38–115. Select the multiple-choice response that best completes each sentence, and put the correct response on the answer sheet.

38. Which of the following art forms were specialties of the Gothic period?

 (A) Encaustic
 (B) Stained glass
 (C) Printmaking
 (D) Pottery

39. The *Bayeux Tapestry* chronicles the accomplishments of

 (A) William the Conqueror
 (B) Richard the Lionhearted
 (C) George III
 (D) Catherine the Great

40. English Gothic buildings are different from French Gothic in that the English have

 (A) large central spires
 (B) sculpture on the façade
 (C) flying buttresses
 (D) rib vaults

41. The sculptor who designed two sets of bronze doors for the Florence Baptistery was

 (A) Filippo Brunelleschi
 (B) Donatello
 (C) Nanni di Banco
 (D) Lorenzo Ghiberti

42. Which of the following artists was a contemporary of Leonardo and Raphael?

 (A) Andrea del Castagno
 (B) El Greco
 (C) Donato Bramante
 (D) Paolo Veronese

Questions 43–46 refer to Figure 10.

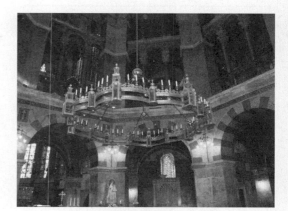

Figure 10

43. This building is located in

 (A) Germany
 (B) France
 (C) Italy
 (D) Russia

44. The building is a

 (A) church
 (B) monastery
 (C) hall in a university
 (D) mosque

45. The style of this work is

 (A) Early Christian
 (B) Carolingian
 (C) Ottonian
 (D) Romanesque

46. The columns within the arches

 (A) are from ancient Greek buildings and have been removed to this site
 (B) are in Doric, Ionic, and Corinthian styles
 (C) have no support function and are placed to fill the space
 (D) are inspired by Islamic columns in Spain

Questions 47–49 refer to Figure 11.

Figure 11

47. This work is from

 (A) France
 (B) Japan
 (C) China
 (D) Korea

48. The technique used to create this work is called

 (A) fresco
 (B) engraving
 (C) woodblock printing
 (D) tempera

49. Works such as this influenced which of the following painters?

 (A) James McNeill Whistler
 (B) Eugène Delacroix
 (C) Pablo Picasso
 (D) Auguste Rodin

Questions 50–53 refer to Figure 12.

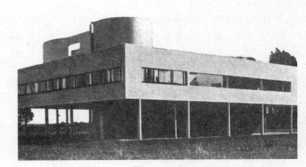

Figure 12

50. This house was designed by

 (A) Le Corbusier
 (B) Walter Gropius
 (C) Frank Gehry
 (D) Rogers and Piano

51. The architect's philosophy of building is expressed by the idea that

 (A) construction should be environmentally friendly
 (B) only the use of natural material would be permitted
 (C) less is more
 (D) a house is a machine for living

52. Some of the functional aspects of the house that were unusual for that time include all of the following EXCEPT the

 (A) carport
 (B) roof patio
 (C) house held up on stilts
 (D) use of glass in a home

53. The approximate date for this building is

 (A) 1910
 (B) 1930
 (C) 1950
 (D) 1970

Question 54 refers to Figure 13.

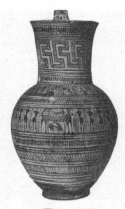

Figure 13

54. Greek pots such as these functioned primarily as

(A) grave markers
(B) drinking cups
(C) a vessel for mixing water and wine
(D) storage vessels

55. The Romans extensively copied examples of works of art from

(A) the Ancient Near East
(B) Byzantium
(C) the Aegean
(D) Greece

56. The general Muslim and Jewish ban on religious images influenced the destruction of images in which period?

(A) Byzantine
(B) Romanesque
(C) Gothic
(D) Carolingian

57. Illuminated manuscripts were a specialty of medieval artists in all of the following places EXCEPT

(A) Ireland
(B) Norway
(C) India
(D) Persia

58. Abbot Suger was the patron responsible for the remodeling of

(A) Notre Dame, Paris
(B) Pisa Cathedral
(C) St.-Denis
(D) Amiens Cathedral

59. Northern European altarpieces are different from Italian ones in that the Northern ones

(A) have predellas
(B) have fanciful frames
(C) are located in a church
(D) are cupboards with wings that close

60. Which of the following is a characteristic of a Romanesque church?

(A) Ambulatory
(B) Triglyph
(C) Pediment
(D) Double domes

61. Titian's *Madonna of the Pesaro Family* symbolizes

(A) the Pope's position as head of the church
(B) the Medici influence in the fine arts
(C) Venice's victory over the Turks
(D) the power of the city of Florence

62. The discovery of the caves at Lascaux solidified the opinion that

(A) the Trojan epics were retellings of actual events
(B) Pompeii was buried by volcanic ash
(C) Stonehenge was a unique ancient monument
(D) prehistoric cave paintings are genuine and not the work of modern forgers

63. Figures of Jesus placed in the apse or in the dome of Byzantine buildings have him depicted as

(A) Theotokos
(B) Pendentive
(C) Pantocrator
(D) Maestà

64. The Alhambra was built as a

 (A) mosque
 (B) crypt
 (C) church
 (D) palace

65. All of the following families were important patrons of great paintings EXCEPT the

 (A) Portinari
 (B) Signorelli
 (C) Lenzi
 (D) Medici

66. Which of the following is set in a chapel with other paintings based on the same theme?

 (A) Parmigianino's *Madonna with a Long Neck*
 (B) Caravaggio's *Calling of Saint Matthew*
 (C) Veronese's *Christ in the House of Levi*
 (D) Leonardo da Vinci's *Last Supper*

67. Eighteenth-century painting specializes in satirical works on contemporary subjects by artists such as

 (A) Thomas Gainsborough
 (B) Joshua Reynolds
 (C) Jean-Honoré Fragonard
 (D) William Hogarth

68. Der Blaue Reiter is a modern movement closely associated with

 (A) Expressionism
 (B) Cubism
 (C) Futurism
 (D) DeStijl

Question 69 refers to Figure 14.

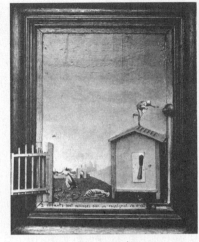

Figure 14

69. This work is an example of

 (A) Pop Art
 (B) Surrealism
 (C) Op Art
 (D) Organic art

70. The Hudson River School was

 (A) set up to train New York artists
 (B) a school of arts and crafts
 (C) a group of landscape painters
 (D) closed during World War II by the Nazis

71. The term "squinch" describes

 (A) a transitional element between the dome and a wall
 (B) a series of arches one atop the other
 (C) an opening in the center of a dome
 (D) a type of capital on an ancient column

Question 72 refers to Figure 15.

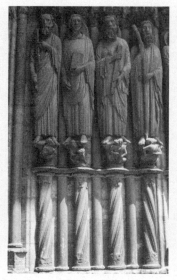

Figure 15

72. The compositional arrangement of these figures is influenced by

(A) Byzantine art
(B) Roman wall paintings
(C) the architecture of the building the works are attached to
(D) manuscripts from this period

Questions 73 and 74 refer to Figure 16.

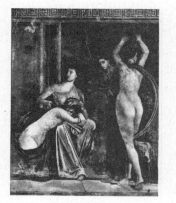

Figure 16

73. This room and its wall decoration are from which culture?

(A) Cycladic
(B) Mycenaean
(C) Greek
(D) Pompeiian

74. The medium is

(A) mosaic
(B) fresco
(C) acrylic
(D) oil

Question 75 refers to Figure 17.

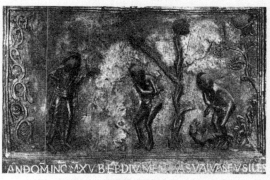

Figure 17

75. This detail is taken from a much larger work called

(A) *The Gates of Paradise*
(B) *The Gates of Hell*
(C) Bishop Bernward's doors
(D) *The Well of Moses*

76. Many Byzantine icons

(A) were meant to be touched and handled
(B) represented the real world and our approach to everyday problems
(C) were painted by ivory carvers
(D) were kept in isolation so that few could see them

77. A mudra is

(A) a sculpture of Buddha
(B) a gesture in Buddhist art
(C) a Buddhist temple
(D) the direction Buddhists face in prayer

78. French Gothic architecture has its accent on the

 (A) vertical rise of the building
 (B) horizontal pull of the main aisle
 (C) circular plan of its buildings
 (D) roundness of the barrel vaults

79. Antonio Canova's sculptures are known for their

 (A) opulence and grandeur
 (B) Mannerist characteristics
 (C) smooth surface texture
 (D) use of mixed media

Question 80 refers to Figure 18.

Figure 18

80. This self-portrait shows an artist working on a portrait of

 (A) Catherine the Great
 (B) Elizabeth I
 (C) Queen Isabella
 (D) Marie Antoinette

Questions 81–84 refer to Figure 19.

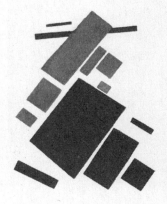

Figure 19

81. The artist of this work is

 (A) Meret Oppenheim
 (B) Andy Warhol
 (C) Kasimir Malevich
 (D) Georges Braque

82. This work was painted in the

 (A) 1890s
 (B) 1910s
 (C) 1940s
 (D) 1970s

83. The artist of this work was associated with

 (A) DeStijl
 (B) Cubism
 (C) Surrealism
 (D) Suprematism

84. This work is an artistic rendition of

 (A) a car
 (B) a railroad
 (C) an airplane
 (D) a figure

85. Roy Lichtenstein's art is inspired by

 (A) ready-mades
 (B) comic strips
 (C) still lives
 (D) portraits based on photography

Questions 86 and 87 refer to Figure 20.

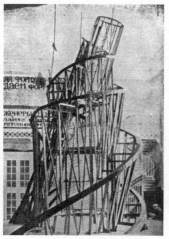

Figure 20

86. This work is a model for

 (A) an observatory
 (B) a factory
 (C) a government building
 (D) a department store

87. This work was designed to be built in

 (A) Russia
 (B) Germany
 (C) France
 (D) Japan

88. The Rosetta Stone was important to ancient art because it

 (A) led to the discovery of King Tutankhamen's tomb
 (B) unraveled the mystery of the pyramids
 (C) listed the order of Egyptian pharaohs
 (D) led to the deciphering of hieroglyphics

89. Which of the following was a twentieth-century art movement dubbed the "Wild Beasts"?

 (A) Performance art
 (B) Conceptual art
 (C) Fauvism
 (D) Symbolism

Question 90 refers to Figure 21.

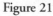

Figure 21

90. This capital is from which of the following orders?

 (A) Doric
 (B) Ionic
 (C) Corinthian
 (D) Tuscan

91. The statue by Praxiteles from the fourth century B.C.E. that represents the ideals of late classical sculpture is called

 (A) *The Spear Bearer*
 (B) *The Scraper*
 (C) *Hermes and Dionysos*
 (D) *Nike of Samothrace*

92. Cylinder seals are most commonly found in ancient

 (A) Rome
 (B) Near East
 (C) Greece
 (D) Egypt

93. The lost wax process, sometimes called *cire perdue*, is a method of sculpture seen in which of the following?

 (A) Greek marble sculpture
 (B) Byzantine ivories
 (C) Northwest Coast Indian totem poles
 (D) Benin brasses and bronzes

94. The Parthenon was dedicated to

 (A) Poseidon
 (B) Athena
 (C) Zeus
 (D) Jesus

95. It is said that Old Saint Peter's was built over

 (A) the place where Saint Peter died
 (B) the place where Saint Peter was buried
 (C) both of the above
 (D) none of the above

Question 96 refers to Figure 22.

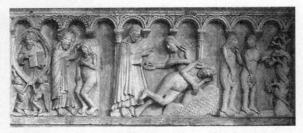

Figure 22

96. This sculpture is from which period?

 (A) Gothic
 (B) Roman Republican
 (C) Roman Imperial
 (D) Romanesque

97. The frescoes in the Sistine Chapel were painted by all of the following artists EXCEPT

 (A) Sandro Botticelli
 (B) Pietro Perugino
 (C) Masaccio
 (D) Michelangelo

98. All of the following are characteristic of the Colosseum in Rome EXCEPT

 (A) the use of groin and barrel vaults
 (B) it once had a retractable canvas roof
 (C) it was built of concrete and brick and faced with marble
 (D) it was used for chariot races

99. Who was a prominent patron of modern art?

 (A) Pope Pius XII
 (B) Charles de Gaulle
 (C) Ernest Hemingway
 (D) Gertrude Stein

Question 100 refers to Figure 23.

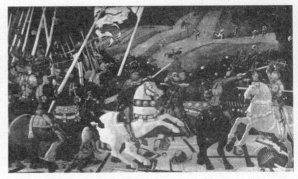

Figure 23

100. The subject of this work derives from

 (A) the artist's own times
 (B) the Bible
 (C) Greek mythology
 (D) medieval legends

101. The patron of Versailles was

 (A) Francis I
 (B) Louis XIV
 (C) Louis Philippe
 (D) Louis IX

Questions 102–105 refer to Figure 24.

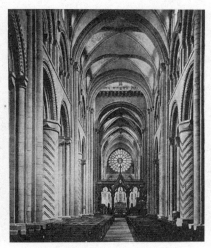

Figure 24

102. This building was built in the

 (A) sixth century
 (B) ninth century
 (C) eleventh century
 (D) fifteenth century

103. The vaults on the ceiling are

 (A) barrel
 (B) groin
 (C) rib
 (D) fan

104. The style of this building is

 (A) Byzantine
 (B) Islamic
 (C) Renaissance
 (D) Romanesque

105. The chevron designs on the piers were inspired by

 (A) Early Medieval manuscript designs
 (B) Early Christian mosaics
 (C) Roman wall paintings
 (D) Gothic sculpture

106. In addition to painting, Francisco de Goya achieved success in

 (A) woodcarving
 (B) printmaking
 (C) mosaics
 (D) marble carving

107. Which of the following artists worked in the Neoclassical tradition?

 (A) Artemisia Gentileschi
 (B) Mary Cassatt
 (C) Angelica Kauffmann
 (D) Frida Kahlo

Questions 108–110 refer to Figure 25.

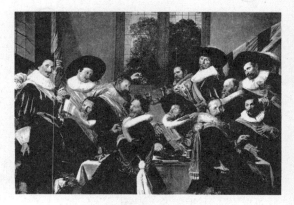

Figure 25

108. This painter's contemporaries include

 (A) Rembrandt van Rijn
 (B) Vincent Van Gogh
 (C) Pieter Bruegel
 (D) Jan Van Eyck

109. The painting is a group portrait of

 (A) doctors
 (B) politicians
 (C) civil guards
 (D) flag makers

110. Characteristic of this artist's work is his devotion to

 (A) imposing religious imagery on a group portrait
 (B) having each sitter equally represented
 (C) turning the heads so that the group appears to be united in one conversation
 (D) a sitter's individuality in a crowd

111. A period of late-nineteenth-century art that concentrated on works that were characterized by floral and vegetal patterns was known as

 (A) Post-Impressionism
 (B) Realism
 (C) Cubism
 (D) Art Nouveau

112. Art Deco architecture and design often used imagery derived from

 (A) computers and graphics
 (B) machines
 (C) atmospheric effects
 (D) curvilinear patterns

113. A twentieth-century art movement that is characterized by hard-edged geometry and stylized shapes is called

 (A) Conceptual art
 (B) Op Art
 (C) Dada
 (D) Abstract Expressionism

114. All of the following are examples of fresco painting EXCEPT

 (A) Masaccio's *Expulsion from the Garden of Eden*
 (B) Fra Angelico's *Annunciation*
 (C) Théodore Géricault's *Raft of the Medusa*
 (D) Domenico Ghirlandaio's *Birth of the Virgin*

Question 115 refers to Figure 26.

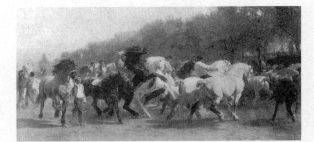

Figure 26

115. Who painted this picture?

 (A) Rosa Bonheur
 (B) Berthe Morisot
 (C) Edouard Manet
 (D) Gustave Courbet

SECTION II
Part A

TIME: 60 MINUTES
9 QUESTIONS

> **Directions:** You have 1 hour to answer the two questions in Part A; you are advised to spend 30 minutes on each question. Use lined paper for your responses; a 30-minute essay generally fills three pages.

Question 1: Many works of art have been designed to commemorate the dead. Choose two works, at least one of which must be from beyond the European tradition, that memorialize a dead person, and discuss how the artist's interpretation of the subject's life creates a fitting memorial for him or her. (30 minutes)

Question 2: Private homes have been fertile ground for architectural expression. Select and fully identify two buildings from two different art-historical periods and discuss the ways in which the architect designed the home to reflect the time in which it was built. (30 minutes)

SECTION II
Part B

TIME: 60 MINUTES
6 QUESTIONS

> **Directions:** The six questions in Part B are based on color photographs in a separate booklet. In this book the questions are illustrated by black-and-white photographs adjacent to each question. Each question is timed at 10 minutes, but you may move freely among all the questions in this part. The total time for all these essays is 1 hour. Use lined paper for your responses; each response should be about a page.

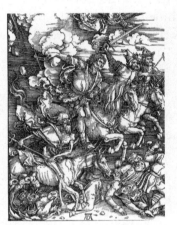

Figure 27

Question 3: What medium is the work in Figure 27 done in? How does this technique reflect a revolution in the creation of works of art? (10 minutes)

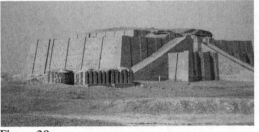

Figure 28

Question 4: Name the building in Figure 28. Discuss how its design was inspired by the function it was meant to have. (10 minutes)

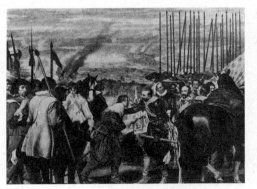

Figure 29

Question 5: Velázquez painted this work to commemorate a specific event from the artist's lifetime.

What is the event depicted in Figure 29? How does Velázquez interpret this scene? (10 minutes)

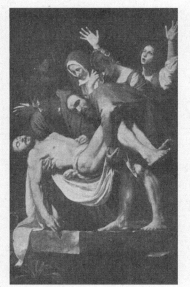

Figure 30

Question 6: Pioneering nineteenth-century art historian John Ruskin said the following about the painter Caravaggio,

"...we find others on whose works there are definite signs of evil mind, ill repressed, and then inability to avoid, and at least perpetual seeking for and feeding upon horror and ugliness, and filthiness of sin, as eminently as in ... Caravaggio."

Discuss why Caravaggio's work, as seen in Figure 30, caused Ruskin to react so strongly. (10 minutes)

Figure 31

Question 7: What art-historical period does the painting in Figure 31 belong to?

What characteristics from this work lead you to this conclusion? (10 minutes)

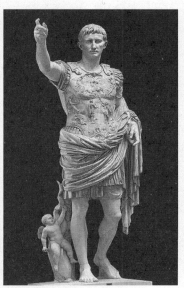

Figure 32

Question 8: Identify this sculpture and the art-historical period associated with it. Discuss the characteristics that place the sculpture in this period and how it differs from sculpture of the preceding period. (10 minutes)

Answer Key
DIAGNOSTIC TEST

Section I, Part A

1. A	11. B	21. C	31. C
2. B	12. D	22. A	32. C
3. A	13. D	23. B	33. B
4. C	14. D	24. C	34. B
5. C	15. A	25. D	35. A
6. B	16. D	26. C	36. C
7. C	17. B	27. A	37. A
8. A	18. B	28. D	
9. D	19. D	29. C	
10. A	20. D	30. B	

Section I, Part B

38. B	58. C	78. A	98. D
39. A	59. D	79. C	99. D
40. A	60. A	80. D	100. A
41. D	61. C	81. C	101. B
42. C	62. D	82. B	102. C
43. A	63. C	83. D	103. C
44. A	64. D	84. C	104. D
45. B	65. B	85. B	105. A
46. C	66. B	86. C	106. B
47. B	67. D	87. A	107. C
48. C	68. A	88. D	108. A
49. A	69. B	89. C	109. C
50. A	70. C	90. D	110. D
51. D	71. A	91. C	111. D
52. D	72. C	92. B	112. B
53. B	73. D	93. D	113. B
54. A	74. B	94. B	114. C
55. D	75. C	95. B	115. A
56. A	76. A	96. D	
57. B	77. B	97. C	

ANSWERS EXPLAINED

Section I

1. **(A)** The work on the left is Castagno's *Last Supper*.

2. **(B)** Castagno's *Last Supper* dates from the middle of the fifteenth century.

3. **(A)** This painting was painted for a refectory, or dining hall, for cloistered nuns in Florence, where it still resides.

4. **(C)** The figure on our side of the table is Judas, symbolically separate from the faithful apostles on Jesus' side of the table.

5. **(C)** The painting on the right is by Jacopo Tintoretto.

6. **(B)** The painting on the right was painted more than one hundred years later than the one on the left.

7. **(C)** The elongated style of the figures is characteristic of Mannerist art.

8. **(A)** Both of these paintings are versions of the *Last Supper*.

9. **(D)** Both of these paintings use linear perspective as a technique. The Castagno has an elaborately paneled room that creates another dimension on the wall where it is painted. On the right, the table extends our view into the rear of the room.

10. **(A)** Both of these artists are portraying contemporary events about their own country. On the left is a Spanish uprising in 1808; on the right is a French revolution in 1830.

11. **(B)** The principal figure on the right is Liberty.

12. **(D)** The flag is French.

13. **(D)** The artist of the *Third of May 1808* is Goya.

14. **(D)** The pose is the crucifixion pose of Jesus.

15. **(A)** As a Spanish artist, Goya would have sympathized with the Spanish man holding up his hands.

16. **(D)** These works are both Romantic.

17. **(B)** This painting dates from about 1340.

18. **(B)** This painting was produced in Siena.

19. **(D)** The painting is part of a series on the virtues and vices of government.

20. **(D)** This painting was done in the Gothic era.

21. **(C)** The location of the work is a city hall in Siena, where laws about government and judicial responsibilities take place.

22. **(A)** This painting is by Ambrogio Lorenzetti.

23. **(B)** The style of this painting is closest to that of another great Sienese painter, Duccio.

24. **(C)** These two paintings are Impressionist works.

25. **(D)** The artist is Claude Monet.

26. **(C)** Impressionists were known for painting outdoors directly from nature.

27. **(A)** Monet painted these subjects in a series from many points of view.

28. **(D)** The paintings date from 1891.

29. **(C)** Monet also did a series on Rouen Cathedral around the same time.

30. **(B)** The work on the right is one of a series about poplar trees.

31. **(C)** The temple on the left is the Parthenon in Athens. It is dedicated to the Greek goddess Athena.

32. **(C)** The building on the right is the Pantheon in Rome. As the name suggests (pan = all, theo = gods) the building was built to worship all the gods.

33. **(B)** Post and lintel is an architectural system that involves two upright posts holding up a horizontal beam, as in the Parthenon.

34. **(B)** Pericles started construction on the Parthenon and other buildings on the Acropolis in Athens.

35. **(A)** The Pantheon's design could be achieved by the innovation of concrete construction.

36. **(C)** Pediments are the triangular features over the row of columns on Greek and Roman temples.

37. **(A)** The Pantheon has a round interior with a majestic dome. The dome has an opening, called an oculus, to allow light and air to enter. Surrounding the oculus are many rows of coffers, which are square-shaped indentations in the roof.

38. **(B)** Gothic art specialized in stained glass windows.

39. **(A)** The main focus of the *Bayeux Tapestry* is Normandy's conquering of England under William the Conqueror.

40. **(A)** English Gothic buildings have large central spires. French buildings have much smaller ones. All the other characteristics are the same for both.

41. **(D)** The second and third sets of doors for Florence Baptistery were designed by Lorenzo Ghiberti.

42. **(C)** Leonardo and Raphael were rough contemporaries of Bramante.

43. **(A)** Charlemagne's Palatine Chapel is located in Aachen, Germany.

44. **(A)** This building is a church.

45. **(B)** This building was constructed in the Carolingian era.

46. **(C)** The columns are uniquely placed, filling up the spaces between the arches. They do not support the arches; they do not even touch them.

47. **(B)** This work is from Japan.

48. **(C)** The Japanese used woodblock prints to create works such as these.

49. **(A)** Japanese prints were the rage in late nineteenth-century Europe and dramatically influenced Whistler's work.

50. **(A)** Le Corbusier designed the Villa Savoye.

51. **(D)** Le Corbusier often said that a house should be "a machine for living."

52. **(D)** The use of glass in homes is almost as old as homes themselves; however, carports are a feature of modern architecture, as are the stilts used to hold up the house, and the roof patio.

53. **(B)** The building dates from around 1930.

54. **(A)** Greek pots such as these were used as grave markers. They even have scenes of the funerals painted on them.

55. **(D)** The Romans copied so many Greek works that we know the history of Greek sculpture seen through their eyes.

56. **(A)** Byzantine art had a ban on images that was at least partly inspired by the similar general ban among Muslims and Jews.

57. **(B)** Norway has a limited illuminated manuscript tradition.

58. **(C)** Abbot Suger was the patron who brought artists together to recreate St.-Denis.

59. **(D)** Northern European altarpieces, such as the *Ghent Altarpiece* by Jan van Eyck, are cupboards with wings that close upon a central scene. Italian altarpieces are usually one main scene with smaller scenes placed below, but always open to view.

60. **(A)** Romanesque buildings developed the ambulatory to house relics.

61. **(C)** Titian's *Madonna of the Pesaro Family* celebrates the Venetian victory over the Turks. Jacopo Pesaro was instrumental in that naval battle.

62. **(D)** When cave paintings were discovered in the late nineteenth century, they were assumed to be the clever trick of modern forgers. With the discovery of Lascaux, it became apparent that these were genuine prehistoric finds.

63. **(C)** Jesus appears as the Pantocrator, or ruler of the world, in the apse or dome of these churches.

64. **(D)** The Alhambra is a palace in Granada, Spain.

65. **(B)** Signorelli was an artist, not a patron. The Portinari were responsible for the van der Goes masterpiece, *The Portinari Altarpiece*. The Lenzi were patrons of Masaccio's *Tribute Money*. The Medici patronized much of Florentine painting in the quattrocento.

66. **(B)** Caravaggio's *Calling of Saint Matthew* is part of a suite of paintings dedicated to Saint Matthew in a chapel in a church in Rome.

67. **(D)** William Hogarth's paintings often took a satirical view of English society in the eighteenth century.

68. **(A)** Der Blaue Reiter is a German Expressionist movement.

69. **(B)** Max Ernst's *Two Children Are Threatened by a Nightingale* is a major work of Surrealism.

70. **(C)** The Hudson River School was not a formal institution but a loosely knit group of landscape painters sharing the same ideals.

71. **(A)** A squinch forms a transitional stage between the round dome and a flat wall.

72. **(C)** Portal sculptures from the Gothic period often reflect the verticality of the buildings behind them.

73. **(D)** The Villa of Mysteries frescoes are from Pompeii.

74. **(B)** The Villa of Mysteries wall paintings are frescoes.

75. **(C)** This detail is from the great bronze doors commissioned by Bishop Bernward in Hildesheim, Germany.

76. **(A)** Byzantine icons were meant to touched, handled, kissed, and set before candles.

77. **(B)** A mudra is a symbolic gesture seen in Buddhist or Hindu works of art.

78. **(A)** French Gothic architecture accents the vertical.

79. **(C)** Antonio Canova's sculptures, such as the *Pauline Borghese* or the *Cupid and Psyche,* have a smooth, glossy surface texture.

80. **(D)** Élisabeth Vigée-Lebrun is painting a portrait of her greatest patron, Marie Antoinette.

81. **(C)** Kasimir Malevich is the artist.

82. **(B)** The work, from the 1910s, is an early example of Abstraction.

83. **(D)** Kasimir Malevich called his abstractions Suprematist paintings because he believed that their abstraction placed them above all other forms of painting.

84. **(C)** This is a creative rendition of an airplane.

85. **(B)** Roy Lichtenstein's works are inspired by comic strips.

86. **(C)** Vladimir Tatlin's construction was for an office building (which was never built) that was to house various government bureaus.

87. **(A)** Vladimir Tatlin's work was designed for Moscow, Russia.

88. **(D)** The Rosetta Stone was important because it aided in the deciphering of Egyptian hieroglyphics.

89. **(C)** The "Wild Beasts" was the nickname of the Fauve painters.

90. **(D)** This capital is from a Tuscan column.

91. **(C)** Praxiteles was the sculptor of *Hermes and Dionysos*. This work, with its smaller heads and lanky bodies, represents the ideals of the late Classical period.

92. **(B)** Cylinder seals, used for sealing messages, were common in the Ancient Near East.

93. **(D)** The lost wax process was commonly used to create metal sculptures, such as Benin brasses and bronzes.

94. **(B)** The Parthenon housed a gigantic sculpture of Athena.

95. **(B)** Old Saint Peter's was built over the place where, it is said, Saint Peter was buried.

96. **(D)** Wiligelmo's sculpture is Romanesque.

97. **(C)** There are no works by Masaccio in the Sistine Chapel. The paintings on the ceiling and the altar wall are by Michelangelo; the horizontal frescoes on the walls are by Perugino, Botticelli, and others.

98. **(D)** Chariot races could not take place in the Colosseum: The stage was too small. They were held nearby at the Circus Maximus.

99. **(D)** Gertrude Stein encouraged many modern painters, including Pablo Picasso and Joan Miró.

100. **(A)** The Battle of San Romano was a contemporary event.

101. **(B)** Louis XIV built Versailles.

102. **(C)** Durham Cathedral was built in the eleventh century.

103. **(C)** Rib vaults are on the ceiling.

104. **(D)** Durham Cathedral was built in the Romanesque period.

105. **(A)** The chevron designs were inspired by Early Medieval manuscript designs.

106. **(B)** Francisco de Goya was an excellent printmaker as well as painter.

107. **(C)** Angelica Kauffmann was a Neoclassical artist.

108. **(A)** Rembrandt was a contemporary of Frans Hals.

109. **(C)** This is a painting of the officers of the civil guards.

110. **(D)** Even though this is a crowded scene, it does depict the features and expressions of the individual sitters.

111. **(D)** Art Nouveau is designed with floral and vegetal patterns.

112. **(B)** Art Deco is a celebration of the machine motif.

113. **(B)** Op Art used hard-edged geometric designs.

114. **(C)** Théodore Géricault's *Raft of the Medusa* is an oil on canvas.

115. **(A)** Rosa Bonheur is the artist of the *Horse Fair*.

Section II

| **Rubric for Question 1** |

9–8: The student selects two appropriate works and identifies them by title and artist. The discussion renders a focused essay on how each work commemorates the individual deceased person. There are no major errors. The lower mark is given in the case of a slightly unbalanced discussion.

7–6: The student selects two appropriate works and identifies them by title and artist. The discussion may be unfocused or hurried, but addresses how the work commemorates the deceased. There may be minor errors.

5: This is the highest mark a student can receive if one of the selections is inappropriate, often meaning that the student has not selected a work that is outside the European tradition. A grade of 5 also indicates an unbalanced discussion in which one good answer is paralleled with a very weak second response. There may be minor errors.

3–4: Either this student has selected only one appropriate work and has written a fair account of the question OR the student has made two appropriate selections and offered a weak analysis. There may be major errors.

1–2: To earn a 2, a student has offered either two appropriate selections and received a point for each OR one appropriate selection and offered a little information. A score of 1 is for one appropriate choice. There may be major errors.

0: The student makes an attempt, but the response is without merit.

Model Response for Question 1

Throughout history, art has been used as a means to commemorate the dead. Two notable works which serve this function are the Taj Mahal and El Greco's Burial of Count Orgaz. *Both works contain a number of elements that reflect the lives of its subjects, ultimately forming fitting memorials.*

El Greco's work was a product of the Mannerist period and can be found in the church of St. Tome in Toledo, Spain. This work reflects the grace, elegance, and mysticism that are characteristic of the Mannerist period. El Greco depicts the burial of the work's benefactor, who was a philanthropist and apparently so pious that his body was lowered into a grave by two saints

who are also surrounded by clergymen. The artist's and the subject's devotion to religion and mysticism is emphasized repeatedly throughout the work. While observing the work in its original setting, the viewer sees Count Orgaz being lowered into what one would assume to be his grave. As we proceed beyond the lower boundary of the work, a plaque is set into the wall that represents the front of the sarcophagus, solidifying the notion of a burial. Directly above the assembly of funeral attendants is an ethereal portrayal of Christ and the Virgin Mary surrounded by angels and devotees of Christ. The layout of this work seems to suggest that Christ is looking over Count Orgaz and may even be going as far as to say that the holy spirit of the count is already ascending to heaven, which is represented by a man rising up directly below and to the right of the image of Christ. This work certainly reflects the piety and high status of Count Orgaz among the believers of Christ.

The Taj Mahal may possibly be the most well-known work in history commemorating the dead. This work was ordered by Shah Jahan, an Indian emperor, to serve as a tomb for one of his beloved wives. The influence of Islam thoroughly permeates all aspects of the Taj Mahal. Located in India, the Taj Mahal is a massive building whose onion-shaped dome and four minarets are typical of all major Islamic architecture. In addition, there is Arabic calligraphy on the walls of the building as well as many geometric patterns, because it is forbidden in Islam to produce depictions of animals. The high status of the Shah's wife is apparent in this work since it is composed of marble and, prior to invasion by sepoys, it contained many rare and valuable stones. The purity of the color matched the love the shah had for his wife. Undoubtedly, the grandeur and beauty of the Taj Mahal are indeed a reflection of his devotion.

Both the Taj Mahal and <u>The Burial of Count Orgaz</u> transcend the traditional roles of art. They are aesthetic masterpieces and emotionally impact their viewers. They not only reflect the skill of their artists but also honor the lives of those who have passed away.

—Farhan C.

Analysis of Model Response for Question 1

Farhan's response presents two good choices: *The Burial of Count Orgaz* and the Taj Mahal. The discussion of the El Greco painting is solid, pointing out the relationship of the life of the deceased to the depiction in the painting. Farhan also mentions the placement of the painting over the tomb of Count Orgaz. The discussion of the Taj Mahal is less balanced, offering some generalities about Islam but not applying them to the Shah's wife. There are points scored about the nature of the marble used for the tomb and how the purity of the color was emblematic of the Shah's devotion. **This essay merits a 7.**

Rubric for Question 2

8–9: The student fully identifies two appropriate choices by the name of the architect (if known), the name of the building, and the place where the building is located. The student presents a solid answer to the question by addressing the home as a reflection of the time in which it was created. A lower score is given when the student introduces minor errors or the discussion is not as complete as would merit a 9. There are no major errors.

6–7: The student identifies two appropriate choices, although the locations may be missing. The student presents a discussion of these two buildings as reflections of their time, but there may be an unevenness in the coverage. Some errors of fact or misrepresentations may be obvious. The lower score is received when the student has confused or conflated two buildings or two styles.

5: This is the highest score a student can earn if only one good choice is offered, OR if the student offers two poorly identified choices and speaks in a roundabout manner about the building and the society in which it was created. There may be minor errors.

3–4: The student writes an essay that has buildings that are either poorly identified or partly identified. The choices may be inappropriate (e.g., using a palace instead of a private home). There may be major errors. A lower score is received when the discussion is significantly uneven.

1–2: The student makes an attempt but can only identify pertinent works, OR the student knows only a few details about one of the choices. The lower score is received when only one identification is given. There may be major errors.

0: The student makes an attempt, but the response is without merit.

Model Response for Question 2

Private homes have been fertile ground for architects to plan their designs. These designs often reflect the time period in which they were created. Two examples are Chiswick House in London, England, by Boyle and Kent and Frank Lloyd Wright's Falling Water in Pennsylvania.

Boyle and Kent's Chiswick House embodies 18th century British architecture. At the time, the Palladian style, a recreation of both the style and proportions of ancient Roman buildings, became popular. The most obvious representation of this style is the octagonal dome on top of the structure. This is typical of the Palladian style. The Corinthian columns and pediment also exemplify Boyle and Kent's reflection of 18th century British architecture in

Chiswick House. The portico, or porch, of the structure uses rustication, which resembles a harsh tooling of the surface causing the joints to be shown. This was often used by Palladio as well as the Roman Renaissance. The surrounding garden of Chiswick House frames the main building in an Italian style garden containing avenues, geometric pools, an amphitheatre, and several small pavilions. Boyle and Kent's Chiswick House reflects the Palladian style of 18ᵗʰ century British architecture.

Frank Lloyd Wright's Falling Water also reflects the time period in which it was built. Built in 1937, the private home is an example of modern architecture. A more scientific understanding of materials came to be known. As a result, forces led to strong horizontal constructions instead of vertical support. The suspended concrete terraces illustrate this transition. This freedom gave rise to an "open plan" of modern architecture using cantilevers, which act as the suspension of concrete masses over the water, making them appear weightless. The structure also has flat roofs and unornamented surfaces. Modern architecture brought with it an appreciation of nature. This explains the way Wright imitates the waterfall with the massive slabs of rock. It looks as if the rock is falling in the same way water would. Falling Water thoroughly complements the surrounding nature.

Chiswick House and Falling Water are private homes reflecting the time periods in which they were built. Chiswick House represents the Palladian style of the 18ᵗʰ century while Falling Water embodies the transformations being made in modern architecture. Although these structures are private homes, they are capable of illustrating contemporary styles that left lasting impressions on various societies.

—Ashley P.

Analysis of Model Response for Question 2

Ashley's two choices are appropriate and fully identified. The first part of the essay addresses Chiswick House as a reflection of Palladian taste in eighteenth-century England. The second part deals, less convincingly, with Falling Water, having it fall under the umbrella of "modern architecture." It also stumbles a bit in addressing the modern movement as "horizontal." Wright's work, in some ways, is a rejection of the International style and the modern aesthetic. However, the essay does express an understanding of how Falling Water relates to its site, how it uses modern materials, and Wright's interest in technological innovations. **This essay merits a 7.**

Rubric for Question 3

4: The student correctly identifies this work as an example of a woodcut. The student expresses an understanding of how this type of artwork is a radical change from the past. There are no major errors.

3: The student correctly identifies this work as a woodcut. The student expresses some understanding of how this work expresses a departure from the kinds of artwork that appeared before this. Discussion is less full than a 4. There may be minor errors.

2: The student does not identify the work as a woodcut but characterizes it as a print. The student expresses a limited understanding of how this work could be mass produced. There may be major errors.

1: The student makes a passing reference to the medium this work is done in and expresses a limited understanding of how prints function. There may be major errors.

0: The student makes an attempt, but the response is without merit.

Model Response for Question 3

Albrecht Durer was a famous artist not only because of the sheer volume of work he produced in his life but because of his innovative fusing of Italian size and proportion with Gothic detail. In his wood carving, Four Horsemen of the Apocalypse, he depicts the biblical scene of the end of the world, where the four horsemen (death, famine, war, and pestilence) each symbolized will come and level the earth. Durer's work is unique with its large scaled figures and meticulous detail. Durer's work was also revolutionary for its time because of its medium. Albrecht Durer was a master wood cutter, etcher, and engraver, skills which became immensely useful and popular in the early 16th century. Etchings and carvings enabled prints to be made, thus allowing common people as well as the nobility to own original works of art and giving birth to mass production.

—Caryn S.

Analysis of Model Response for Question 3

Caryn's essay fails to identify the medium as a woodcut, but it does show an understanding of how the work functions as a mass-produced item. No points are earned for knowing the artist or the name of the work, since that is not asked for in the question. The student does not express how revolutionary the medium was in comparison to what came before. Certain inaccuracies, like "master wood cutter," seem to suggest a knowledge of woodcuts, but lack of precise terminology holds the score down to a 2. In addition, students should avoid using "unique" unless the work of art is truly one of a kind. **This essay merits a 2.**

Rubric for Question 4

4: The student correctly identifies the building as the Ziggurat at Ur. The student tells in considerable detail how its design was inspired by its function. There are no major errors.

3: The student correctly identifies the building as the Ziggurat at Ur. The student tells how its design was inspired by its function but does not provide as detailed an answer as a 4. A 3 is the highest score a student can earn if the building cannot be identified as the Ziggurat. There may be minor errors.

2: The student does not recognize the Ziggurat at Ur but does understand how the building's design is influenced by its function, OR the student recognizes the name of the building but can only provide marginal details about its function. There may be major errors.

1: The student identifies the building correctly but the discussion is without merit, OR the student does not recognize the building but has a marginal understanding of function and form. There may be major errors.

0: The student makes an attempt, but the response is without merit.

Model Response for Question 4

This building is a ziggurat. It was a pyramid-like structure that was used for worship. There was no interior. It was built by the Sumerians in what is now Ur, Iraq. The façade of the building had holes that flags were placed in to make it attractive. It was also probably painted. They built this structure for worship, and held a small temple at the top which is now gone. It has ramps that people probably went up to go and worship. It was once surrounded by walks and since it was a temple these walls helped to keep the temple safe from outsiders. The ziggurat was designed as a building just for worshipping gods.

—Ozioma U.

Analysis of Model Response for Question 4

Ozioma generically identifies the building as a ziggurat, but further indicates which ziggurat, the one at Ur, Iraq, two sentences later. Giving a generic identification, like "cathedral" or "pyramid" is not good enough as an ID. This essay describes its function, as a temple, and names several components of the temple: small temple at the top, ramps, flagstaffs, and so on. This essay is disorganized and reflects the pressure of writing in a short amount of time, but enough of the question is answered. **This essay merits a 4.**

Rubric for Question 5

4: The student identifies the title of the painting, and hence the historical event that is represented. The student names at least two pictorial devices Velázquez uses to memorialize this scene and discusses these devices with great specificity. There are no major errors.

3: The student identifies the title of the painting, and hence the historical event that is represented. The student names at least two pictorial devices but is superficial in his or her response. There may be minor errors.

2: The student does not identify the title or the historical event but tries to assess Velázquez's pictorial methods, OR the student identifies the title but can only explain one way in which the artist uses pictorial devices to illustrate this scene. There are no major errors.

1: The student identifies only the title or one pictorial device used to illustrate this scene. There are no major errors.

0: The student makes an attempt, but the response is without merit.

Model Response for Question 5

The event depicted in Velazquez's <u>Surrender at Breda</u> is the Dutch surrender to the Spanish. The Dutch are placed on the left, which was thought to be the side of evil. The scene shows the two armies agreeing to stop fighting with the Dutch yielding to the Spanish. Velazquez portrays the Spanish a superior by having the Spanish army well organized. All the weapons are straight in the air and the soldiers are arranged in a military fashion. The Dutch are not as organized which portrays them as weaker. Velazquez also subtly includes a cross in the background in a lake to reinforce Catholic superiority and a divine mission. Velazquez interprets the scene as an example of Spanish military and religious superiority.

—Jake S.

Analysis of Model Response for Question 5

Jake's response mentions the title of the painting, and by inference, the event taking place. He understands that it was a conflict between the Dutch and the Spanish, and the Spanish are victors. He discusses two pieces of imagery that interpret this scene: the appearance of the cross in the background, and the military precision of the Spanish soldiers, contrasted with the Dutch irregular arrangement. **This essay merits a 4.**

Rubric for Question 6

4: The student comments on both the quotation and the painting. A high-level response displays a familiarity with Caravaggio's style, can point to specific illustrations of that style in the painting, and discusses how Ruskin would have been revolted by Caravaggio's approach to religious painting. There are no major errors.

3: The student comments on both the quotation and the painting. Although the student understands some stylistic traits of Caravaggio's work, he or she does not combine specific instances of that style in this painting with Ruskin's commentary. There may be minor errors.

2: The student fails to comment directly on either the quotation or the painting. Instead, general remarks are offered about Caravaggio or Ruskin. There may be major errors.

1: The student makes an attempt, but achieves only a passing reference to Caravaggio's style. There may be major errors.

0: The student makes an attempt, but the response is without merit.

Model Response for Question 6

Ruskin may have reacted so strongly to Caravaggio's work because of Caravaggio's lack of "holiness" to the painting. Caravaggio makes this painting, The Entombment, to show the burial of Christ. This painting was meant to be placed on an altar because the painting seeks to go into our realm. But what Caravaggio did not do is make the figures "holy." There are no halos of any sort and Jesus, along with other people in the painting such as Nicodemus aren't holy like. Christ is half-naked complete with dirty feet. Mary is painted as a common old woman, not a young virgin. This does not seem to be a truly religious painting according to Ruskin, and may have caused him to react so strongly.

—Chris A.

Analysis of Model Response for Question 6

Chris analyzes the painting pointing out aspects that reinforce Ruskin's reaction: the commonness of the figures, the lack of halos, the half-naked and dirty figures, and the fact that Christ seems to be placed in our own realm. Had he made a clearer connection to the quotation, the essay would have merited a 4. **This essay merits a 3.**

Rubric for Question 7

4: The student identifies this period as DeStijl. The term *Neoplasticism*, used in some textbooks, is acceptable. The student identifies the characteristics of DeStijl painting with great specificity. There are no major errors.

3: The student identifies this period as DeStijl. The term *Neoplasticism*, used in some textbooks, is acceptable. The student identifies some of the characteristics of DeStijl art as seen in this painting. There may be minor errors.

2: The student does not identify the period, perhaps using a term like "modern" or "abstract." The student makes a general attempt at discussing DeStijl painting. There may be major errors.

1: The student makes an attempt but achieves only a passing reference to DeStijl or modern art. There may be major errors.

0: The student makes an attempt, but the response is without merit.

Model Response for Question 7

The art period is DeStijl and the work is by Mondrian. This work contains geometric shapes, right angles, and the use of mainly primary colors. The composition rejects diagonals or other elements except lines that form right angles. The plain use of colors also is another characteristic of DeStijl style. Primary colors, such as red, blue and yellow are displayed on a white background. Another reason this work is of the DeStijl style is because it uses rectangular shapes also noticed in the Schröder House by Rietveld. The house in comparison to the work shown by Mondrian also uses white, red, blue and yellow as its only colors, as well as its extensive use of rectangles and squares, and continuous right angle technique.

—Julie O.

Analysis of Model Response for Question 7

This essay immediately identifies DeStijl as the art-historical movement in question. Julie lists several characteristics that define this style: use of right angles, squares and rectangles, and a limited color range. Some of the essay is repetitive. There are errors as well, including the remarks about the color scheme containing yellow (which DeStijl paintings do, but this one does not) and the lack of mentioning that black is a color used extensively throughout this painting and other DeStijl works. The comparison with the Schröder House is correct, but irrelevant to the question. **This essay merits a 3.**

Rubric for Question 8

4: The student identifies the sculpture as *Augustus of Primaporta*, or *Augustus*. The student identifies the art-historical period as Roman Early Imperial, or Roman High Imperial; the designation Roman is not enough, because the differences between the Republican and Early Imperial periods are stressed in classes. The student goes on to compare Augustus to the Republican art that precedes it, highlighting the ideal and imperial imagery Augustus has, in distinction to the veristic portraits of the Republican period. There are no major errors.

3: The student identifies the sculpture as *Augustus of Primaporta*, or *Augustus*. The student labels the period as Roman Early Imperial, or an acceptable variation, but is less specific on the differences between Republican and Early Imperial art. There may be minor errors.

2: The student cannot identify the name of the sculpture, but can provide details differentiating Early Imperial from Republican art OR the student can identify the sculpture but provides only minimal discussion of merit. There may be major errors.

1: The student can either identify the work OR provide minimal details differentiating Early Imperial from Republican art. There may be major errors.

0: The student makes an attempt, but the discussion is without merit.

Model Response for Question 8

The sculpture shown is <u>Augustus of Primaporta</u> and was created during the Early Imperial period of Roman art. The statue of Augustus is very idealized because it was created during the Early Imperial period which differed from the preceding Veristic period. The Veristic period showed age as being honorable and glorified age in the head busts that were created. However, the Early Imperial strongly contrasted the characteristics of the Veristic period by showing Augustus as a young leader even though the sculpture was created when Augustus was 76 years old.

Augustus has one of his arms raised and most likely held an olive branch as a symbol of peace. In his other hand, he probably had a sword symbolizing that the Roman Empire wanted peace but would use force to achieve it. The breastplate that Augustus is wearing has many Gods on it to show the warrior-like qualities of Augustus. The robe that he holds around him most likely symbolized that Augustus was noble and a judge. On the bottom of the statue near the foot of Augustus, Cupid is pulling on the robe which showed

that Augustus was a direct descendant from Venus. The idealized nature of Augustus clearly separates it from the Veristic period that proceeded this period.

—Alex G.

Analysis of Model Response for Question 8

Even though Alex addresses more than the question asks for, he provides a solid response. First, he identifies the object as the *Augustus of Primaporta.* Then he shows how it was created in the Early Imperial Roman period. Although he does not use the word "Republican" to identify the preceding period, there is nothing in the question to suggest that he must. His knowledge of the veristic busts of earlier Roman art is enough to establish that he understands the chronology and stylistic development of this period. The material in the second paragraph is largely irrelevant to the question. Except for the last line, it does not advance the discussion. **This essay merits a 4.**

EVALUATION OF DIAGNOSTIC TEST
Multiple-Choice Section

Your diagnostic test score can now be computed. The multiple-choice section of the actual test is scored by computer, but it uses the same method you will use to compute your score manually. Each correct answer earns one point. Each incorrect answer has no value, and cannot earn or lose points. Omitted questions or questions that the computer cannot read because of smudges or double entries are not scored at all. Go over your answers and mark the ones correct with a "C" and the ones incorrect with an "X."

Enter the total number of correct answers: _____

Conversion of Raw Score to Scaled Score

Your raw score is computed from a total of 115 questions. In order to coordinate the raw score of the multiple-choice section with the free-response section, the multiple-choice section is multiplied by a factor of .69565. For example, if the raw score is 90, the weighted score is 62.6. Enter your weighted score in the box on the right.

Enter your weighted multiple-choice score:

Long-Essay Section

When grading your long-essay section, be careful to follow the rubric so that you accurately assess your achievement. Grade each essay on a scale of 0–9 and total the scores for this section. The highest point total for this section is 18.

Score on Question 1: _____

Score on Question 2: _____

Total Raw Score on Long-Essay Question: _____

In order to weight this score appropriately, multiply your score by 2.7778. For example, a raw score of 15 will yield a weighted score of 41.7. Total possible scoring for this section is 50.

Enter your weighted long-essay score:

Short-Essay Section

When grading your short-essay section, be careful to follow the rubric so that you accurately assess your achievement. Grade each essay on a scale of 0–4 and total the scores for this section. The highest point total for this section is 28.

Score on Question 3: _____

Score on Question 4: _____

Score on Question 5: _____

Score on Question 6: _____

Score on Question 7: _____

Score on Question 8: _____

Total Raw Score on Short-Essay Section: _____

In order to weight this section appropriately, the raw score is multiplied by 2.92, so that the highest weighted score is 70.

Enter your weighted short-essay score:

Final Scoring

Add your weighted scores. A perfect score is 200. Although the weighting changes from year to year, a general rule of thumb is that 75% correct is a 5, 67% is a 4, and 56% is a 3. Use the following table as an estimate of your achievement.

5	150 points
4	133 points
3	112 points
2	91 points
1	74 points

Enter your total weighted score:

Enter your AP score:

PART THREE

CONTENT REVIEW

Prehistoric Art

Paleolithic Art 30,000 B.C.E.–8000 B.C.E. in the Near East
 30,000 B.C.E.–4000 B.C.E. in Europe
Neolithic Art 8000 B.C.E.–3000 B.C.E. in the Near East
 4000 B.C.E.–2000 B.C.E. in Europe

KEY IDEAS

- The earliest surviving works of art are cave paintings and portable sculptures of humans or animals.
- Little is known about the original intention or meaning of prehistoric works.
- Buildings such as Stonehenge show the ability of prehistoric people to build elaborate religious structures using the post-and-lintel system of construction.

PREHISTORIC BACKGROUND

Although prehistoric people did not read and write, it is a mistake to think of them as primitive, ignorant, or even nontechnological. Some of their accomplishments, like Stonehenge, continue to amaze us forty centuries later.

Archaeologists divide the prehistoric era into periods, of which the two most relevant to the study of art history are Paleolithic (the Old Stone Age) and Neolithic (the New Stone Age). These categories roughly correspond to methods of gathering food: In the Paleolithic period people were hunter-gatherers; those in the Neolithic period cultivated the earth and raised livestock. Neolithic people lived in organized settlements, divided labor into occupations, and constructed the first homes.

ARTISTIC INNOVATIONS

People painted before they had the ability to write, cipher math, raise crops, domesticate animals, invent the wheel, or use metal. They painted before they had anything that could be called clothes or lived in anything that resembled a house. The need to create is among the strongest of human impulses.

Unfortunately, it is not known why these early people painted. Since no written records survive, all attempts to explain prehistoric motivations are founded on

speculation. From the first, however, art seems to have a function. These works do not merely decorate or amuse, they are designed with a purpose in mind.

Characteristics of Prehistoric Sculpture

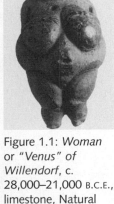

All prehistoric sculpture is portable; indeed, most are very small. Images of humans, particularly females like the *Woman* or *"Venus" of Willendorf* (Figure 1.1), have enlarged sexual organs and diminutive feet and arms. Carvings on cave walls make use of the natural modulations in the wall surface to enhance the image. More rarely, sculptures are built from clay and lean upon slanted surfaces.

Major Work of Prehistoric Sculpture

Woman or *"Venus" of Willendorf,* c. 28,000–21,000 B.C.E., limestone, Natural History Museum, Vienna (Figure 1.1)

Figure 1.1: *Woman or "Venus" of Willendorf,* c. 28,000–21,000 B.C.E., limestone, Natural History Museum, Vienna

- Reproductive organs emphasized; huge breasts, belly, buttocks, navel
- Hair in clumps arranged in rows, or perhaps a woven hat
- Deemphasized arms, face, legs; no feet—she was never meant to stand up
- Face may have been painted; traces of paint on the body
- Fertility symbol?
- Small, only 4⅜ inches long, meant to be handheld
- Venus is a name given to the object after its discovery as a way of comparing it to the ancient goddess of beauty; its true purpose is unknown

Characteristics of Prehistoric Painting

Most prehistoric paintings that survive exist in caves, sometimes deeply recessed from their openings. Images of animals dominate with black outlines emphasizing their contours. Paintings appear to be scattered about the cave surface with no relationship to one another. Indeed, cave paintings may have been executed over the centuries by various groups who wanted to establish a presence in a given location.

Although animals are realistically represented with a palpable three-dimensionality, humans are depicted as stick figures with little anatomical detail.

Handprints abound in cave paintings, most of them as negative prints, meaning that a hand was placed on the wall and paint blown or splattered over it, leaving a silhouette. Since most people are right-handed, the handprints are of left hands, the right being used to apply the paint. Handprints occasionally show missing joints or fingers, perhaps indicating that prehistoric people practiced voluntary mutilation. However, the thumb, the most essential finger, is never harmed.

Major Work of Prehistoric Painting

Lascaux Caves, 15,000–13,000 B.C.E., Dordogne, France (Figure 1.2)

- Natural products used to make paint: charcoal, iron ore, plants
- 650 paintings: most common are cows, bulls, horses, and deer
- Animals placed deep inside cave, some hundreds of feet from the entrance
- Bodies seen in profile; frontal or diagonal view of horns, eyes, and hooves; some animals appear pregnant

- Many overlapping figures
- Evidence still visible of scaffolding erected to get to higher areas of the caves
- Negative handprints: are these signatures?
- Caves were not dwellings because prehistoric people led migratory lives following herds of animals; some evidence exists that people sought shelter at the mouths of caves
- Walls were scraped to an even surface; paint colors were bound with animal fat; lamps light the interior of caves
- Well scene: narrative art? Bison's bowels hanging as if slaughtered; male figure (masked?) with outstretched hands of four fingers—is he wounded? in a trance? dead? Contrast of the realistic rendering of the animals to stick-figure humans (not illustrated)
- Many theories about reasons for the paintings:
 o Traditional view that they were used to ensure a successful hunt
 o Ancestral animal worship
 o Shamanism: a religion based on the idea that the forces of nature can be contacted by intermediaries, called shamans, who go into a trancelike state to reach another state of consciousness

Figure 1.2: Lascaux Caves, 15,000–13,000 B.C.E., Dordogne, France

Characteristics of Prehistoric Architecture

Prehistoric people were known to build shelters out of large animal bones heaped in the shape of a semicircular hut. However, the most famous structures were not for habitation but almost certainly for worship. Sometimes **menhirs**, or large individual stones, were erected singularly or in long rows stretching into the distance. Menhirs cut into rectangular shapes and used in the construction of a prehistoric complex are called **megaliths**. A circle of megaliths, usually with lintels placed on top, is called a **cromlech**. These were no small accomplishments, since these Neolithic structures were built to align with the important dates in the calendar. Prehistoric people built structures in which two uprights were used to support a horizontal beam, thereby establishing **post-and-lintel** (Figure 1.3) architecture, the most fundamental type of architecture in history.

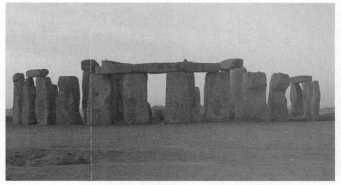

Figure 1.3: Post-and-lintel construction

Major Work of Prehistoric Architecture

Stonehenge, c. 2100 B.C.E., Wiltshire, England (Figure 1.4)

- Perhaps took a thousand years to build, gradually redeveloped by each succeeding generation
- Post-and-lintel building; lintels grooved in place by the mortise-and-tenon system of construction
- Large megaliths in center are over 20 feet tall and form a horseshoe surrounding a central flat stone
- Ring of megaliths, originally all united by lintels, surrounds central horseshoe

Figure 1.4: Stonehenge, c. 2100 B.C.E., Wiltshire, England

- Some stones over 50 tons
- Hundreds of smaller stones of unknown purpose placed around monument
- Some stones imported from over 200 miles away
- Generally thought to be oriented toward sunrise on the longest day of the year; may also predict eclipses
- One of many henges in southern England; the most recently discovered in July 2009 is called Bluehenge

VOCABULARY

Archaeology: the scientific study of ancient people and cultures principally revealed through excavation

Cromlech: a circle of megaliths (Figure 1.4)

Henge: a Neolithic monument, characterized by a circular ground plan. Used for rituals and marking astronomical events (Figure 1.4)

Megalith: a stone of great size used in the construction of a prehistoric structure

Menhir: a large uncut stone erected as a monument in the prehistoric era

Mortise-and-tenon: a groove cut into stone or wood, called a mortise, that is shaped to receive a tenon, or projection, of the same dimensions

Post-and-lintel: a method of construction in which two posts support a horizontal beam, called a lintel (Figure 1.3)

Summary

Prehistoric works of art have the power to amaze and intrigue viewers in the modern world, even though so little is known about their original intention, creation, or meaning. The creative impulse exists with the earliest of human endeavors, as is evidenced by the cave paintings from Lascaux and sculptures such as the *Woman* or *"Venus" of Willendorf.* The first type of construction, the post-and-lintel method, was developed during the Neolithic period to build monumental structures like Stonehenge.

Ancient Near Eastern Art

CHAPTER 2

TIME PERIOD: 3500 B.C.E.–641 C.E.

The main periods are these:

Civilization	Time Period	Location
Sumerian Art	c. 3500–2340 B.C.E.	Iraq
• Neo-Sumerian Art	2150–2000 B.C.E.	Iraq
Akkadian Art	2340–2180 B.C.E.	Iraq
Babylonian Art	1792–1750 B.C.E.	Iraq
• Neo-Babylonian Art	c. 612–539 B.C.E.	Iraq
Hittite Art	c. 1600–1200 B.C.E.	Turkey
Assyrian Art	c. 1000–612 B.C.E.	Iraq
Persian Art	c. 559–331 B.C.E.	Iran

An easy way to remember this list is to make a nonsense word out of the first letters: SABHAP. This way you will remember each civilization in chronological order.

KEY IDEAS

- The Ancient Near East brought about the birth of art in the service of the state and religion. Combined with writing, Mesopotamian objects give us the first systematic record of human development.
- Ancient Near Eastern buildings were created for religion, as were the ziggurats, or the state, as were the palaces. They were built of mud-brick, and were either painted or faced with tile or stone.
- Large stelai commemorating the achievements of ancient rulers were erected throughout Mesopotamia.
- Guardian figures that are usually hybrids of men and animals protected the entrances to important sites.
- Assyrian lion reliefs are among the first organized narrative works of art in history.

HISTORICAL BACKGROUND

The Ancient Near East is where almost everything began first: writing, cities, organized religion, organized government, laws, agriculture, bronze casting, even the wheel. It is hard to think of any other civilization that gave the world as much as the ancient Mesopotamians.

Large populations emerged in the fertile river valleys that lie between the Tigris and Euphrates rivers. City centers boomed as urbanization began to take hold. Each group of people vied to control the central valleys, taking turns occupying the land and eventually relinquishing it to others. This layering of civilizations has made for a rich archaeological repository of successive cultures whose entire history has yet to be uncovered.

Patronage and Artistic Life

Kings sensed from the beginning that artists could help glorify their careers. Artists could aggrandize images, bring the gods to life, and sculpt narrative tales that would outlast a king's lifetime. They could also write in cuneiform and imprint royal names on everything from cylinder seals to grand relief sculptures. This was the start of one of the most symbiotic relationships in art history between patron and artist.

INNOVATIONS IN ANCIENT NEAR EASTERN ARCHITECTURE

One of the most fundamental differences between the prehistoric world and the civilizations of the Ancient Near East is the latter's need to urbanize; buildings were constructed to live, govern, and worship in. However, in the Near East, stone was at a premium and wood was scarce but earth was in abundant supply. The first great buildings of the ancient world, **ziggurats**, were made of baked mud, and they were tall, solid structures that dominated the flat landscape. Although mud needed care to protect it from erosion, it was a cheap material that could be resupplied easily.

INNOVATIONS IN ANCIENT NEAR EASTERN PAINTING AND SCULPTURE

Human beings did not play a central role in prehistoric art. Lascaux has precisely one male figure but six hundred cave paintings of animals. A few human figures like the *Woman* or *"Venus" of Willendorf* populated a sculptural world full of animals and spirals. However, in the Near East artists were more likely to depict clothed humans with anatomical precision. Near Eastern figures are actively engaged in doing something: Hunting, praying, performing a ritual.

One of the characteristics of civilizations that settle down rather than nomadically wander is the size of the sculpture they produce. Nomadic people cannot carry large objects on their migrations, but cities retain monumental objects as a sign of their permanence. Near Eastern sculptures could be very large—the **lamassus**, man-headed winged bulls, at Persepolis are gigantic. The interiors of palaces were filled with large-scale relief sculptures gently carved into stone surfaces.

The invention of writing enabled people to permanently record business transactions in a wedge-shaped script called **cuneiform**. Laws were written down, taxes were accounted for and collected, and the first written epic, *Gilgamesh*, was copied onto a

series of tablets. Stories needed to be illustrated, making narrative painting a necessity. Walls of ancient palaces not only had sculptures of rulers and gods but also had narratives of their exploits.

Private communication between people was achieved with the invention of the **cylinder seal** (Figure 2.1). A document could be written, folded, and sealed with an imperial stamp, made from clay impressed by the maker's seal. If the document arrived with the seal intact, it meant that it was unviolated.

Figure 2.1: *Cylinder Seal*. The seal itself is on the roller at the left. The clay impression is on the right.

Near Eastern art begins a popular ancient tradition of representing animals with human characteristics and emotions. Sumerian animals, as in the *Lyre* (c. 2600 B.C.E.) (Figure 2.4), have human heads. The personification of animals was continued by the Egyptians (the Sphinx) and the Greeks (the Minotaur), sometimes producing dreadful and harmful creations. There was also a trend to combine animal parts, as in the *Lamassu* (c. 700 B.C.E.) (Figure 2.14), with the human head at the top of a hoofed winged animal.

CHARACTERISTICS OF SUMERIAN ART

Sumerian art, as contrasted with prehistoric art, has realistic looking figures acting out identifiable narratives. Figures are cut from stone, with **negative space** hollowed out under their arms and between their legs. Eyes are always wide open; men are bare-chested and wear a kilt. Women have their left shoulder covered; their right is exposed. Nudity is a sign of debasement; only slaves and prisoners are nude. Sculptures were placed on stands to hold them upright. There was a free intermixing of animal and human forms, so it is common to see human heads on animal bodies, and vice versa. Sculpture depicted virtually emotionless humans.

Important figures are the largest and most centrally placed in a given composition. Such an arrangement is called **hierarchy of scale** and can be seen in the *Standard of Ur* (c. 2600 B.C.E.) (Figure 2.3), in which the king is the tallest figure, located in the middle of the top register.

In the Sumerian world the gods symbolized powers that were manifest in nature. The local god was an advocate for a given city in the assembly of gods. Thus, it was incumbent upon the city to preserve the god and his representative, the king, as well as possible. The temple, therefore, became the center point of both civic and religious pride.

Major Works of Sumerian Art

Tell Asmar Statues, c. 2700 B.C.E., limestone, alabaster, and gypsum, Iraq Museum, Baghdad, and the University of Chicago (Figure 2.2)

- Figures are of different heights, denoting hierarchy of scale
- Hands are folded in gesture of prayer
- Huge eyes in awe, spellbound, perhaps staring at the deity
- Men: bare upper chest; skirt from waist down; beard flows in ripple patterns; wear a belt

Figure 2.2: *Tell Asmar Statue*, c. 2700 B.C.E., limestone, alabaster, and gypsum, Iraq Museum, Baghdad, and the University of Chicago

- Women: dress draped over one shoulder
- Arms and feet cut away
- Pinkie in a spiral; chin a wedge shape; ear a double volute
- Inscribed on back: "It offers prayers"

- Figures represent mortals, placed in a temple and praying—perhaps to the god Abu
- Figures held either cups or branches in their hands

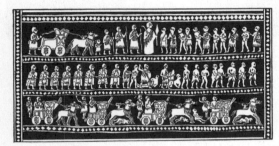

Figure 2.3: *Standard of Ur*, c. 2600 B.C.E., panel inlayed with shell, lapis lazuli, and limestone, British Museum, London

***Standard of Ur*, c. 2600 B.C.E., panel inlayed with shell, lapis lazuli, and limestone, British Museum, London (Figure 2.3)**

- Two sides: war side and peace side; may have been two halves of a narrative; early example of a historical narrative
- Perhaps used as part of soundbox for a musical instrument
- War side: Sumerian king half a head taller, has descended from his chariot to inspect captives brought before him, some debased by their nakedness; chariots advance over the dead in lowest register
- Figures have broad frontal shoulders, body in profile
- Emphasized eyes, eyebrows, ears
- Organized in registers; reads from bottom to top

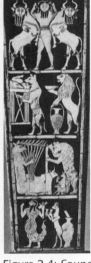

***Soundbox of a Lyre*, c. 2600 B.C.E., wood with inlay of gold, shell, and lapis lazuli, University of Pennsylvania Museum, Philadelphia (Figure 2.4)**

- *Lyre* has a bull's head (not illustrated)
- Four panels on side of the soundbox:
 - Top: Sumerian wrestling two man-headed bulls
 - 2nd level: wolf carries a table with animal parts, preparing for a ceremony; lion bears wine, jug, cup
 - 3rd level: donkey plays a bull-harp; bear dances; seated fox plays a rattle
 - 4th level: jackal (?) waves rattles; scorpion-man
- Animals in profile; people have frontal shoulders
- Animals take on human characteristics
- Animal and human composite figures a characteristic of Ancient Near Eastern art
- *Lyre* found in a royal grave, probably a funerary object

Figure 2.4: *Soundbox of a Lyre*, c. 2600 B.C.E., wood with inlay of gold, shell, and lapis lazuli, University of Pennsylvania Museum, Philadelphia

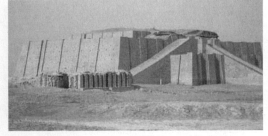

Ziggurat, c. 2100 B.C.E., Ur, Iraq (Figure 2.5)

- Mud-brick building on a colossal scale
- Buttresses spaced across the surface to create a light and shadow pattern
- Whitewash used to disguise the mud appearance, perhaps the holes in the surface were for flags or banners to animate the façade
- Tapers down so that rainwater washes off

Figure 2.5: Ziggurat, c. 2100 B.C.E., Ur, Iraq

- Temple on top was small, set back, and removed from the populace
- Entire form resembles a mountain
- Four corners oriented to the compass
- Three large staircases lead to the upper story entrance from three different directions; guardhouse at point where the staircases meet
- Dedicated to the moon god Nanna

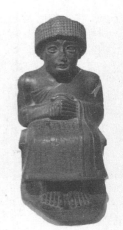

***Gudea*, c. 2100 B.C.E., diorite, Louvre, Paris (Figure 2.6)**

- Folded hands; long, fine fingers
- Right arm bare
- Broad shoulders, narrow waist, simple contours
- Sense of calm, peaceful
- Diorite, an expensive stone, proclaims the wealth of the owner and importance of the subject
- Gudea was the ruler of Lagash; he commissioned many temples to the gods

Figure 2.6: *Gudea*, c. 2100 B.C.E., diorite, Louvre, Paris

CHARACTERISTICS OF AKKADIAN ART

One major change from Sumerian to Akkadian art is the deification of the king, who rules with the gods' approval, but without their assistance. Akkadian art is typical of Ancient Near Eastern cultures in its interest in erecting permanent stone markers, called **stelai** ("stele" is the singular), to denote important religious or civic sites, or to be used as burial markers.

Major Work of Akkadian Art

***Victory Stele of Naram-Sin*, 2254–2218 B.C.E., sandstone, Louvre, Paris (Figures 2.7 and 2.8)**

- Naram-Sin deifies himself as the composition leads him up the mountain to the heavens, indicated by the three stars above him
- Victory blessed by the gods, represented as suns, but he acts independently
- King wears horned crown of divinity, bow in one hand, arrow in the other, battle axe in hollow of arm
- Defeated soldiers beg for mercy, one with a lance through his throat, another thrown over the side of the mountain
- Spatial isolation of king, hierarchy of scale
- Figures are in composite views
- Depicts his victory over the Lullubi, a rebellious mountain people
- Commemorates his victory; not an actual scene of his victory

Figure 2.7: *Victory Stele of Naram-Sin*, 2254–2218 B.C.E., sandstone, Louvre, Paris

Figure 2.8: Detail of Figure 2.7

CHARACTERISTICS OF BABYLONIAN ART

Because of the survival of the famous ***Stele of Hammurabi*** (c. 1780 B.C.E.) (Figure 2.9), Babylon comes down to us as a seemingly well-ordered state with a set of strict laws handed down from the god, Shamash, himself. Nothing was spared in the decoration of the capital, Babylon, covered with its legendary hanging gardens and walls of glazed tile.

Figure 2.9: *Stele of Hammurabi*, c. 1780 B.C.E., basalt, Louvre, Paris

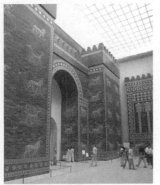

Figure 2.10: Ishtar Gate, c. 575 B.C.E., glazed brick, State Museum, Berlin

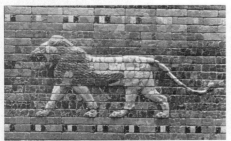

Figure 2.11: Detail of Figure 2.10

Figure 2.12: Lion Gate, c. 1400 B.C.E., Boghazköy, Turkey

Major Works of Babylonian Art

Stele of Hammurabi, c. 1780 B.C.E., basalt, Louvre, Paris (Figure 2.9)

- Contains one of the earliest law codes ever written below the main scene and on the reverse
- Sun god, Shamash, enthroned on a ziggurat and handing Hammurabi a rope, a ring, and a rod of kingship
- Hammurabi with a speaking/greeting gesture
- Shamash: frontal and profile at the same time, headdress in profile; rays (wings?) from behind his shoulder
- Shamash's beard is fuller than Hammurabi's
- They stare at one another directly, even though their shoulders are frontal; composite views
- 300 law entries placed below the grouping, symbolically given from Shamash himself to Hammurabi

Ishtar Gate, c. 575 B.C.E., glazed brick, State Museum, Berlin (Figure 2.10)

- Glazed brick covers mud walls of the city
- Animals guard the entrance to the city
- Lions sacred to the goddess Ishtar; dragons sacred to the gods Marduk and Nabu; bulls sacred to the god Adad
- Crenellations give a warlike appearance to gate
- Reconstructed in Berlin from ruins in Babylon

CHARACTERISTICS OF HITTITE ART

The Hittites used stone rather than mud-brick as building material. Large uncut boulders are set in place as impressive fortifications.

Major Work of Hittite Art

Lion Gate, c. 1400 B.C.E., Boghazköy, Turkey (Figure 2.12)

- Gates to the city
- Guardian lions
- Huge boulders used in construction of city, cf. Mesopotamian mud-brick
- Massive impression

CHARACTERISTICS OF ASSYRIAN ART

Assyrian artists praised the greatness of their king, his ability to kill his enemies, his valor at hunting, and his masculinity. Figures are stoic, even while hunting lions or defeating an enemy. Animals, however, possess considerable emotion. Lions are in anguish and cry out for help. This domination over a mighty wild beast expressed the authority of the king over his people and the powerful forces of nature.

Cuneiform appears everywhere in Assyrian art; it is common to see words written across a scene, even over the bodies of figures. Shallow **relief sculpture** is an Assyrian specialty, although the lamassus are virtually three-dimensional as they project noticeably from the walls they are attached to.

Major Works of Assyrian Art

Palace of Sargon II, 720–705 B.C.E., Khorsabad, Iraq (Figure 2.13)

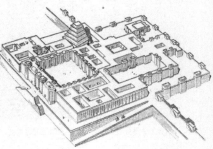

Figure 2.13: Palace of Sargon II, 720–705 B.C.E., Khorsabad, Iraq

- City on a platform 50-feet high
- Made of mud-brick
- Contains a ziggurat
- Huge palace complex: 25 acres, 30 courtyards, 200 rooms
- High exterior walls protected city from attack

***Lamassu,* c. 700 B.C.E., limestone, Louvre, Paris (Figure 2.14)**

- Human-headed animal guardian figures
- Winged
- 5 legs: when seen from front seems to be standing at attention; when seen from side, seems to be walking by you as you walk by it
- Meant to ward off enemies both visible and invisible
- Has a feeling of harmony and stability

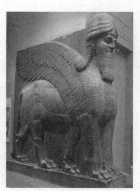

Figure 2.14: *Lamassu,* c. 700 B.C.E., limestone, Louvre, Paris

***Lion Hunt,* c. 640 B.C.E., gypsum, British Museum, London (Figure 2.15)**

- Among the oldest surviving narratives in art
- Bold contours
- Emotions in animals, not humans
- Narrative takes place on a projecting ledge acting as a ground line
- Lion: representative of the most fearsome of beasts, domination by the king is an act of power over nature

CHARACTERISTICS OF PERSIAN ART

Persia was the largest empire the world had seen up to this time. As the first great empire in history, it needed an appropriate capital as a grand stage to impress people at home and dignitaries from abroad. The Persians erected monumental architecture, huge audience halls, and massive subsidiary buildings for grand ceremonies that glorified their country and their rulers (Figure 2.16). Persian architecture is characterized by columns topped by two bull-shaped **capitals** holding up a wooden roof (Figure 2.17).

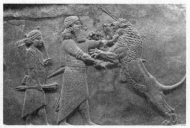

Figure 2.15: *Lion Hunt,* c. 640 B.C.E., gypsum, British Museum, London

Major Works of Persian Art

Persepolis, c. 500 B.C.E., Iran (Figure 2.16)

- Built by Darius I and Xerxes I; destroyed by Alexander the Great
- Built not so much as a complex of palaces but rather as a seat for spectacular receptions and festivals

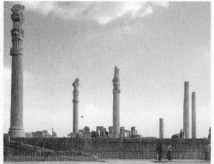

Figure 2.16: Palace at Persepolis, c. 500 B.C.E., Iran

Figure 2.17: Bull capital, c. 500 B.C.E., Persepolis, Iran

- Built on artificial terraces, as is most Mesopotamian architecture
- Mud-brick with stone facing
- Giant lamassu gates
- Relief sculptures depict delegations from all parts of the empire bringing gifts to be stored in the local treasury; Darius selected this central location in Persia to ensure protection of the treasury
- Audience hall: apadana, had 36 columns covered by a wooden roof; held thousands of people; used for the king's receptions; stairways adorned with reliefs of the New Year's festival and a procession of representatives of 23 subject nations
- Columns had a bell-shaped base that is an inverted lotus blossom, capitals are bulls or lions (Figure 2.17)
- Carved onto the stairs are the Immortals, the King's Guard, who were so-called because they always numbered 10,000
- Many cultures (i.e., Greeks, Egyptians, Babylonians) contributed to the building of the site

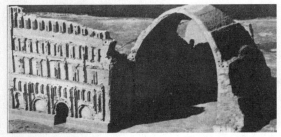

Figure 2.18: Palace of Shapur I, c. 250 C.E., Ctesiphon, Iraq

Palace of Shapur I, c. 250 C.E., Ctesiphon, Iraq (Figure 2.18)

- Built by Sassanian Persian rulers
- Brick audience hall
- Influence of Roman architecture in the barrel vault and arches
- Blind arcades, that is, arches with a wall immediately behind them, are a Roman feature

VOCABULARY

Apadana: an audience hall in a Persian palace (Figure 2.16)

Capital: the top element of a column (Figure 2.17)

Cuneiform: a system of writing in which the strokes are formed in a wedge or arrowhead shape

Cylinder seal: a round piece of carved stone that when rolled onto clay produces an image (Figure 2.1)

Façade: the front of a building. Sometimes, more poetically, a speaker can refer to a "side façade" or a "rear façade"

Ground plan: the map of a floor of a building

Hierarchy of scale: a system of representation that expresses a person's importance by the size of his or her representation in a work of art (Figure 2.8)

Lamassu: a colossal winged human-headed bull in Assyrian art (Figure 2.14)

Negative space: empty space around an object or a person, such as the cut-out areas between a figure's legs or arms of a sculpture

Relief sculpture: sculpture that projects from a flat background. A very shallow relief sculpture is called a **bas-relief** (pronounced: bah-relief) (Figure 2.7)

Stele (plural: **stelai**): a stone slab used to mark a grave or a site (Figure 2.9)

Ziggurat: a pyramid-like building made of several stories that indent as the building gets taller; thus, ziggurats have terraces at each level (Figure 2.5)

Summary

The Ancient Near East saw the birth of world civilizations, symbolized by the first works of art that were used in the service of religion and the state. Rulers were quick to see that their image could be permanently emblazoned on stelai that celebrated their achievements for posterity to admire. The new invention of writing was combined with the creative image to create a systematic historical and artistic record of human achievement.

Common characteristics of Ancient Near Eastern art include the union of human and animal elements in a single figure, the use of hierarchy of scale, and the deification of rulers.

Because the Mesopotamian river valleys were poor in stone, most buildings in this region were made of mud-brick and were either painted or faced with tile or stone. Entranceways to cities and palaces were important: Fantastic animals acted as guardian figures to protect the occupants and ward off the evil intentions of outsiders.

Practice Exercises

Questions 1 and 2 refer to Figure 2.19.

1. Which of the following civilizations produced this monument?

 (A) Assyrian
 (B) Hittite
 (C) Sumerian
 (D) Babylonian

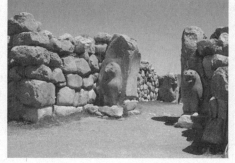

Figure 2.19

2. This building is unusual in Near Eastern art because

 (A) it has lions on the outside
 (B) the animals act as guardian figures
 (C) stone is used in the construction of the palace
 (D) the animals are in high relief emerging from the rock behind

CHALLENGE

3. A stele

 (A) is made of steel
 (B) marks an important site
 (C) is placed on a ziggurat
 (D) is in the shape of worshippers

4. A bas-relief is formed when

(A) the relief sculpture is carved from the back side of the work and hammered out
(B) a sculptor uses metal tools
(C) a sculptor sinks the relief into the surface of the sculpture behind the picture plane
(D) the relief is shallow and slightly raised above the picture plane

Questions 5–7 refer Figure 2.20

5. This building was used for

(A) civic ceremonies
(B) military defense
(C) grain storage
(D) religious rituals

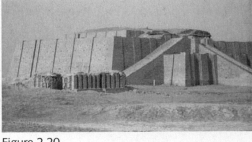

Figure 2.20

6. This building is called

(A) a ziggurat
(B) an apadana
(C) an arch
(D) a lamassu

7. Which Near Eastern society built this monument?

(A) Sumerian
(B) Akkadian
(C) Persian
(D) Babylonian

8. It is common in Ancient Near Eastern art to have figures that are

(A) facing front except for their shoulders
(B) part animal and part human
(C) arranged in size order
(D) emotional and dramatic

9. Glazed brick tile was used at

(A) the Palace of Shapur I
(B) the Ishtar Gate
(C) *the Standard of Ur*
(D) scenes of the *Lion Hunt*

CHALLENGE 10. Naram-Sin was the first ancient ruler to

(A) make himself a god
(B) be represented in a work of art
(C) be seen in a relief sculpture
(D) build a ziggurat

Short Essay

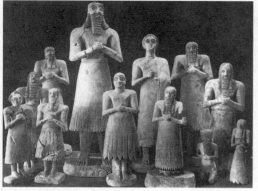

Figure 2.21

Identify the civilization that produced the work in Figure 2.21. What characteristics of this civilization's style are evident in this figure? Use one side of a sheet of lined paper to write your essay.

Answer Key

1. **(B)**	3. **(B)**	5. **(D)**	7. **(A)**	9. **(B)**
2. **(C)**	4. **(D)**	6. **(A)**	8. **(B)**	10. **(A)**

Answers Explained

Multiple-Choice

1. **(B)** The Hittites built the Lion Gate.

2. **(C)** Most Near Eastern buildings are built of mud-brick, although they may be faced with stone or tile to disguise that fact. This one is made of stone.

3. **(B)** Stelai mark an important site, usually in commemoration to someone.

4. **(D)** Bas-reliefs are slightly raised above the picture plane. They are difficult to sculpt because it means that the artist has only a shallow space to work with.

5. **(D)** This building was used for religious rituals in support of the local god.

6. **(A)** This building is called a ziggurat.

7. **(A)** This monument was first built by Sumerians, although succeeding civilizations built these monuments as well.

8. **(B)** It is common to have figures that are part animal and part human, as on the Sumerian *Lyre.*

9. **(B)** Glazed brick was used to enhance the exterior of the Ishtar Gate.

10. **(A)** Naram-Sin was the first ruler in recorded history to make himself a god. There have been many since.

Rubric for Short Essay

4: The student identifies this work as Sumerian and lists at least three characteristics of Sumerian art that can be seen in this statuette. There are no major errors.

3: The student identifies this work as Sumerian and lists two characteristics of Sumerian art that can be seen in this statuette. There may be minor errors.

2: The student labels the work as coming from a civilization in the Ancient Near East and gives one characteristic of Ancient Near Eastern art that can be seen here. A 2 is the highest score one can earn without naming the civilization correctly. There may be major errors.

1: The student identifies the civilization as Sumerian or Ancient Near Eastern but offers no support, OR the student gives one characteristic of Sumerian art without naming the civilization. There may be major errors.

0: The student makes an attempt, but the response is without merit.

Short Essay Model Response

The statuettes of Tell Asmar are from the ancient Sumerian civilizations. The Sumerian priests cast a spell on these objects so that the statuette would "become" the person it was made to represent. These statuettes were placed in temples so that they could constantly be praying to the god Abu.

The figure is shown with bulging eyes, a characteristic of Sumerian art. The statuette is a man, which is evident because of his beard and his bare torso. As with other figures like this one, the man's hands are in a praying position. His pinky is twisted, a characteristic of the Sumerian way to pray. He also seems to be in awe of the power of Abu, and the statuettes were placed in a room where Abu was supposed to be residing. The characteristics of the sculpture make it evident to be a Sumerian sculpture.

—Michael K.

Analysis of Model Response

This is a good example of an essay that does not need to be completely polished to earn a high grade. Michael knows the name of the civilization and understands how the piece functioned as a representation of Sumerian art. He lists a number of characteristics, including the "bulging eyes," the males with nude torsos, and the hands in praying positions. **This essay merits a 4.**

Egyptian Art

The most important artistic periods in Egyptian art are the following:

Old Kingdom	2575–2134 B.C.E.
Middle Kingdom	2040–1640 B.C.E.
New Kingdom	1550–1070 B.C.E.

KEY IDEAS

- Egyptian art spans a 3,000-year history
- Elaborate funerary practices led to the erection of mastabas, pyramids, and rock-cut tombs in sacred imperial precincts throughout Egypt.
- Egyptian figures generally have broad frontal shoulders and profiled heads, torsos, and legs.
- Old Kingdom figures show an unyielding stance and formidable expression; Middle Kingdom works have more relaxed figures and emotional faces; the New Kingdom is characterized by rounded and elongated figures that betray an intimacy hitherto unknown.

HISTORICAL BACKGROUND

Egypt gives the appearance of being a monolithic civilization whose history stretches steadily into the past with little change or fluctuation. However, Egyptian history is a constant ebb and flow of dynastic fortunes, at times at the height of its powers, other times invaded by jealous neighbors or wracked by internal feuds.

Historical Egypt begins with the unification of the country under King Narmer in predynastic times, an event celebrated on the *Narmer Palette* (3000–2920 B.C.E.) (Figure 3.4). The subsequent early dynasties, known as the Old Kingdom, featured massively built monuments to the dead, called **pyramids**, which are emblematic of Egypt today.

After a period of anarchy, Mentihotep II unified Egypt for a second time in a period called the Middle Kingdom. Pyramid building was abandoned in favor of smaller and certainly less expensive rock-cut tombs.

More anarchy followed the breakdown of the Middle Kingdom. Invaders from Asia swept through, bringing technological advances along with their domination. Soon enough, Egyptians righted their political ship, removed the foreigners, and embarked upon the New Kingdom, a period of unparalleled splendor.

One New Kingdom pharaoh, Akhenaton, markedly altered Egyptian society by abandoning the worship of the many gods and substituting one god, Aton, with himself portrayed as his representative on Earth. Aton was different from prior Egyptian gods because he was represented as a sun disk emanating rays, instead of gods that were human and/or animal symbols. This new religion ushered in a dramatic change in artistic style called the **Amarna Period**. Although Akhenaton's religious innovations did not survive him, the artistic changes he promoted were long lasting.

After the demise of the New Kingdom, Egypt felt prey to the ambitions of Persia, Assyria, and Greece, ultimately undoing itself at the hands of Rome in 30 B.C.E.

Modern Egyptology began with the 1799 discovery of the Rosetta Stone, from which hieroglyphics could, for the first time, be translated into modern languages. Egyptian paintings and sculpture, often laden with text, can now be read and understood.

The feverish scramble to uncover Egyptian artifacts culminated in 1922 with the discovery of King Tutankhamen's tomb by Howard Carter. This is one of the most spectacular archaeological finds in history because it is the only royal tomb that has come down to us undisturbed.

Patronage and Artistic Life

Egyptian architecture was designed and executed by highly skilled craftsmen and artisans, not by slaves, as tradition often alleges. The process of mummification, which became a national industry, was handled by embalming experts who were paid handsomely for their exacting and laborious work.

Most artists like **Imhotep**, history's first recorded artist, should more properly be called artistic overseers, who supervised all work under their direction. They were likely ordained high priests of Ptah, the god who created the world in Egyptian mythology.

As the royal builder for King Djoser, Imhotep erected the first and largest pyramid ever built, the **Stepped Pyramid** (2630–2611 B.C.E.) (Figure 3.5). Indeed, Imhotep's reputation as a master builder so fascinated later Egyptians that he was deified and worshipped as the god of wisdom, astronomy, architecture, and medicine. Few other Egyptian artists' names come down to us.

ARTISTIC INNOVATIONS IN EGYPTIAN ARCHITECTURE

The iconic image of Egyptian art is the **pyramid**, sitting as it does adrift in the sands of the Sahara. Pyramids were never built alone but as part of great complexes, called **necropolises**, dedicated to the worship of the spirits of the dead and the preservation of an individual's **ka**, or soul.

At first, Egyptians buried their dead in more unassuming places called **mastabas** (Figure 3.1). A mastaba is a simple tomb that has four sloping sides and an entrance for mourners to bring offerings to the deceased. The body was buried beneath the mastaba in an inaccessible area that only the spirit could enter.

Later rulers with grander ambitions began to build larger monuments, heaping the mastaba form one atop the other in smaller dimensions until a pyramid was achieved. The first such example of this is the **Stepped**

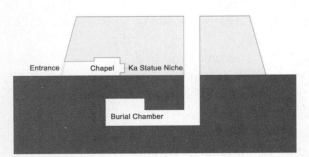

Figure 3.1: Diagram of a mastaba

Pyramid of King Djoser (Figure 3.5). Imhotep's complex included temples with **engaged columns** (Figure 3.2).

After several experiments with the pyramid form, the archetypal pyramids such as the ones at Giza (Figure 3.6) evolved with sleek prismatic surfaces. Interiors included false doors so that the ka could come and go when summoned by the faithful.

An Egyptian specialty is carving from living rock. Huge monuments such as the **Great Sphinx** (c. 2500 B.C.E.) (Figure 3.8) were hewn out of a single great rock; tombs like those at **Beni Hasan** (c. 1950 B.C.E.) (Figure 3.14) were carved into hillsides, hollowing out chambers filled with **reserve columns**.

Figure 3.2: Engaged columns

In the New Kingdom, temples continued to be built into the sides of rock formations, as at **Abu Simbel** (1290–1224 B.C.E.) (Figure 3.17). However, this period also produced free-standing monuments as at **Amen-Re** (Figure 3.18), which had massive **pylons** on the outside protecting the sanctuary. Behind the pylons lay a central courtyard that greeted the worshipper. The god was housed in a sacred area just beyond, which was surrounded by a forest of columns, called a **hypostyle** hall. Here, in a sanctuary submerged in the half-light of the closely placed columns, the god was sheltered so completely that only the high priest could enter.

Characteristics of Egyptian Architecture

Egyptian pyramids are known for their sleek solid surfaces and their monumental scale. They are made from stone blocks and built without mortar. Once the dead were interred, no one was permitted entry into these sealed structures. The sides of the pyramids are oriented to the four cardinal points of the compass. The benben (coming from a root meaning to "swell up") was a pyramid-like stone at Heliopolis, Egypt, which formed the prototype for the capstone of the pyramids and/or the pyramids themselves. Pyramid Texts, the oldest religious texts in existence, confirm that the pharaoh's body could be reenergized after death and ascend to the heavens using ramps, stairs, or ladders. He could even become airborne.

The pyramids do not exist in isolation, but are part of a vast temple complex that was strictly organized. The complexes are on the west side of the Nile, so that the pharaoh was interred in the direction of the setting sun. The temples are on the east side of the pyramids, facing the rising sun.

Like the pyramids, most Egyptian temples have an astronomical orientation—the **Temple of Ramses II** admits light into its deepest recesses at dawn on Ramses' birthday.

Columns used in New Kingdom temples were based on plant shapes: The lotus, the palm, and the papyrus. These column types reflected early construction methods done at a time when Egyptian buildings were supported by perishable materials (Figure 3.3).

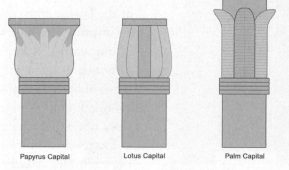

Papyrus Capital Lotus Capital Palm Capital

Figure 3.3: Papyrus, Lotus, and Palm Capitals

ARTISTIC INNOVATIONS IN EGYPTIAN PAINTING AND SCULPTURE

The monumentality of stone sculpture, unseen in ancient Sumeria, is new to art history. Even Egyptian **sarcophagi** were hewn from enormous stones and placed in tombs to protect the dead from vandals.

Hieroglyphics describe the deceased and his or her accomplishments in great detail, without which the dead would have incomplete afterlives. Writing appears both on relief sculpture and on sculpture in the round, as well as on a paper surface called **papyrus**. Hieroglyphics help modern Egyptologists rediscover some of the original intentions of works of art.

Characteristics of Egyptian Painting

Egyptians believed superhuman forces were constantly at work and needed continuous worship. Egyptian funerary art was dedicated to the premise that things that were buried were to last forever and that this life must continue uninterrupted into the next world. To that end, artists affirmed this belief by representing the human figure as completely as possible.

The Egyptian canon of proportions allows for little individuality. Shoulders are seen frontally, while the rest of the body, except the eye, is turned in profile. Often, heads face one direction while the legs face another. Men are taller than women and are painted a ruddy brown or red. Women are shorter—children shorter still—and are painted with a yellowish tinge. Shading is rare.

The ideal is to represent successful men and women acting in a calm, rational manner. Episodes of violence and disorder are limited only to scenes of slaughtering animals for sacrifices or overthrowing the forces of evil; otherwise, Egyptian art is a picture of contentment and stability.

Figures rest on a horizon line often at the front of the picture plane. When figures are placed on a line above, they are thought to be receding into the distance.

Because Egyptians believed in a canon of proportions, artists placed a grid over the areas to be painted and outlined the figures accordingly. Unfinished figures rendered the subject's existence incomplete in the afterlife. Even animals had to be drawn as completely as possible.

In the **Amarna Period** there is a general relaxation of canon rules. Figures are depicted as softer, with slack jaws and protruding stomachs over low-lying belts. Arms become thinner and limbs more flexible, as in the sculpture of *Akhenaton* (Figure 3.19) in the fourteenth century B.C.E.

Characteristics of Egyptian Sculpture

Egyptian sculpture ranges in size from the most intimate pieces of jewelry to some of the largest stone sculptures ever created. Huge portraits of the pharaohs are meant to impress and overwhelm; individualization and sophistication are sacrificed for monumentality and grandeur. The stone of choice is limestone from Memphis. Other stones, like gypsum and sandstone, are also used, but hard stones like granite are avoided when possible because of the difficulty in carving with soft metal tools. Wooden sculpture is painted unless made of exceptionally fine material. Metal sculptures of copper and iron also exist.

Large-scale sculptures are rarely entirely cut free of the rock they were carved from. For example, *Khafre* (2500 B.C.E.) (Figure 3.9) has his legs attached to the front of the throne, making the figure seem more permanent and solid. Colossal sculptures, like the *Great Sphinx*, are carved on the site, or **in situ**, from the local available rock.

Relief sculptures follow the same figural formula as paintings. When relief sculptures are carved for outdoor display, they are often cut into the rock so that shadows

showed up more dramatically, and the figures thereby become more visible. When carved indoors, reliefs are raised from the surface for visibility in a dark interior.

Major Works of Predynastic and Old Kingdom Art

Narmer Palette, 3000–2920 B.C.E., slate, Egyptian Museum, Cairo (Figure 3.4)

- Relief sculpture depicting King Narmer uniting Upper and Lower Egypt
- Hathor, a god as a cow with a woman's face, depicted four times at the top register
- Figures stand on a ground line
- Hierarchy of scale
- On front:

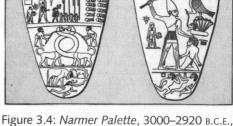

Figure 3.4: *Narmer Palette*, 3000–2920 B.C.E., slate, Egyptian Museum, Cairo

 o Narmer, who is the largest figure, wears the cobra crown of lower Egypt and is reviewing the beheaded bodies of the enemy, bodies that are seen from above, with heads carefully placed between their legs
 o Narmer is preceded by four standard bearers and a priest and followed by his foot washer or sandal bearer
 o In the center are harnessed lionesses with elongated necks, possibly symbolizing unification; at the bottom is a symbol of a bull knocking down a city fortress—Narmer knocking over his enemies
- On back:
 o Hawk is Horus, god of Egypt; triumphs over Narmer's foes; Horus holds a rope around a man's head and a papyrus plant, symbols of Lower Egypt
 o Narmer has a symbol of strength, the bull's tail, at his waist; wears a bowling pin-shaped crown as king of united Egypt, beating down an enemy
 o Servant holds Narmer's sandals because he stands on the sacred ground as a divine king
 o Defeated Egyptians lie beneath his feet
- Schematic lines delineate Narmer's muscle structure: forearm veins and thigh muscles are represented by straight lines; half circles for the kneecaps
- Palette used to prepare eye make-up for the blinding sun, although this palette was probably commemorative, or ceremonial
- Hieroglyphics explain and add to the meaning
- Narrative

Imhotep, Stepped Pyramid of King Djoser, c. 2630–2611 B.C.E., Saqqara, Egypt (Figure 3.5)

- By Imhotep, first known artist in history
- First complex of buildings constructed entirely of stone
- Consists of six unequal steps, like a giant staircase
- Gives the impression of being a huge staircase to the heavens
- Appears like a stack of mastabas, one atop the other
- Burial is below ground, as in a mastaba. Stepped Pyramid is solid.
- Part of a complex called a necropolis

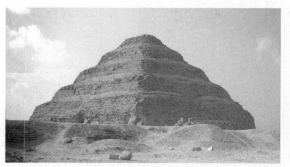

Figure 3.5: Imhotep, Stepped Pyramid of King Djoser, c. 2630–2611 B.C.E., Saqqara, Egypt

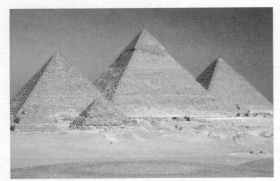

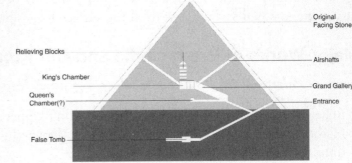

Figure 3.6: Great Pyramids, c. 2500 B.C.E., Giza, Egypt

Figure 3.7: Sectional diagram of a pyramid

Great Pyramids, c. 2500 B.C.E., Giza, Egypt (Figures 3.6 and 3.7)

- Giant monuments to dead pharaohs
- Each pyramid has an enjoining mortuary temple
- Huge pile of limestone with minimal interior for the deceased; pharaoh buried within the pyramid, unlike at the Stepped Pyramid, in which the pharaoh is buried under the building
- Each side of the pyramid oriented toward a point on the compass
- Great Pyramids are faced with stone; these are without their outer layer

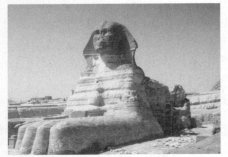

Figure 3.8: *Great Sphinx*, c. 2500 B.C.E., Giza, Egypt

Great Sphinx, c. 2500 B.C.E., Giza, Egypt (Figure 3.8)

- Very generalized features, although some say it may be a portrait of Khafre, whose pyramid stands behind the Sphinx
- Carved in situ from a huge rock, symbol of the sun god
- Body of a lion, head of a pharaoh and/or god
- Sphinx seems to protect the pyramids behind it
- Originally brightly painted to stand out in the desert
- Cats are royal animals in ancient Egypt, probably because they saved the grain supply from mice
- Head of the Sphinx badly mauled in the Middle Ages
- Beard of the Sphinx in the British Museum

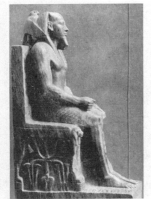

Figure 3.9: *Khafre*, c. 2500 B.C.E., diorite, Egyptian Museum, Cairo

Khafre, c. 2500 B.C.E., diorite, Egyptian Museum, Cairo (Figure 3.9)

- Idealized features and body
- Falcon god Horus is behind Khafre's head, protecting him; Khafre is an incarnation of Horus; pharaoh divinely appointed
- Symbol of a united Egypt in the interlocking of lotus and papyrus plants at the base
- Frontal, symmetrical, rigid, motionless, cubic
- Figure not cut away from the stone: legs attached, no negative space between arms and stomach
- Strict adherence to Egyptian canon of proportions

Menkaure and His Queen, 2490–2472 B.C.E., slate, Museum of Fine Arts, Boston (Figure 3.10)

- Figures attached to the block of stone. Arms and legs not cut free
- Figures stare out into space
- Wife's simple and affectionate gesture, and/or presenting him to the gods
- Menkaure's powerful physique and stride symbolize his kingship
- Society's view of women expressed in the ankle length and tightly draped gown revealing her form covering her body; men and women the same height, indicating equality

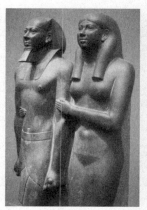

Figure 3.10: Menkaure and His Queen, 2490–2472 B.C.E., slate, Museum of Fine Arts, Boston

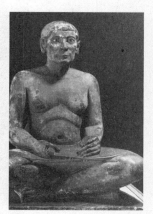

Figure 3.11: *Seated Scribe*, c. 2400 B.C.E., limestone, Louvre, Paris

Seated Scribe, c. 2400 B.C.E., limestone, Louvre, Paris (Figure 3.11)

- Created for a tomb at Saqqara as a provision for the ka
- Not a pharaoh: sagging chest and realistic rather than idealistic features
- Color still remains on the sculpture
- Amazingly lifelike, but not a portrait—rather, a conventional image of a scribe
- Attentive expression; thin, angular face
- Contrasts with the ideally portrayed pharaoh

Ti Watching the Hippopotamus Hunt, c. 2400 B.C.E., painted limestone, Tomb of Ti, Saqqara, Egypt (Figure 3.12)

- Painted relief in the mastaba of Ti, a government official
- Ti's boat glides through the gigantic papyri, which flower into a fan of birds and foxes; papyrus was a symbol of rebirth
- Hunt takes place as a memorial to the deceased; success in the hunt is a parallel with the fight against evil
- Servants hunt as a tribute to the deceased Ti, also to destroy animals, like hippopotami, which were pests that damaged crops and were considered agents of the god of darkness
- Ti stands on, rather than in, the boat and is double anyone else's size to show his status
- Boat symbolizes the journey to the afterlife

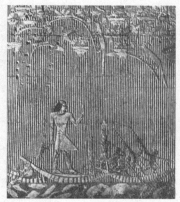

Figure 3.12: *Ti Watching the Hippopotamus Hunt*, c. 2400 B.C.E., painted limestone, Tomb of Ti, Saqqara, Egypt

Major Works of Middle Kingdom Art

Senusret III, c.1860 B.C.E., stone (Figure 3.13)

- Moody look in the eyes and mouth: depressed, rather than the heroic figures seen in the Old Kingdom
- Figures reflect the period of civil unrest
- Introspective
- Firm chin
- Carefully delineated lines and folds of flesh between the brows and at the corners of nose and mouth

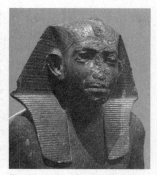

Figure 3.13: *Senusret III*, c. 1860 B.C.E., stone

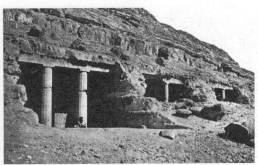

Figure 3.14: Rock Cut Tombs of Beni Hasan, c. 1950–1900 B.C.E., Egypt

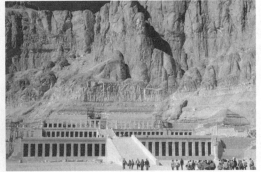

Figure 3.15: Mortuary Temple of Hatshepsut, c. 1473–1458 B.C.E., Deir el-Bahri, Egypt

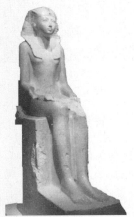

Figure 3.16: *Queen Hatshepsut*, c. 1473–1458 B.C.E., granite, Metropolitan Museum of Art, New York

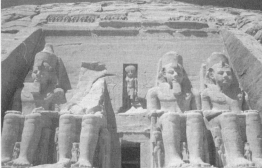

Figure 3.17: Temple of Ramses II, 1290–1224 B.C.E., Abu Simbel, Egypt

Rock Cut Tombs of Beni Hasan, c. 1950–1900 B.C.E., Egypt (Figure 3.14)

- Cliff walls hollowed out to reveal small burial chambers
- Reserve columns cut away from the interior chamber to create the look of conventional columns
- Columns are not round but fluted
- Façade shows shallow columned porch

Major Works of New Kingdom Art

Mortuary Temple of Hatshepsut, c. 1473–1458 B.C.E., Deir el-Bahri, Egypt (Figure 3.15)

- 3 colonnaded terraces and 2 ramps
- Visually coordinated with the natural setting; long horizontals and verticals of the terraces and colonnades repeat the patterns of the cliffs behind; patterns of dark and light in the colonnade are reflected in the cliffs
- Terraces were originally planted as gardens with exotic trees
- First time the achievements of a woman are celebrated in art history; her body is interred elsewhere

Queen Hatshepsut, c. 1473–1458 B.C.E., granite, Metropolitan Museum of Art, New York (Figure 3.16)

- Queen represented in male costume of a pharaoh, yet slender proportions and slight breasts indicate femininity
- Often portrayed as a sphinx
- Headdress, false beard, and traces of the cobra on the crown show her affinity with male pharaoh role
- Some 200 sculptures exist, many smashed by her successor Thutmose III

Temple of Ramses II, 1290–1224 B.C.E., Abu Simbel, Egypt (Figure 3.17)

- Rock-cut tomb resembles a pylon
- Huge seated quartet of statues of Ramses on the façade, carved in situ
 - Sun god placed over the entrance
 - Façade at one time was brightly painted
 - Royal family located between Ramses' legs
 - Sun enters the center door of the tomb on Ramses' birthday, October 21, lighting up his statue deep in the interior
 - Interior sculptures of Ramses are carved in reserve
 - Interior stretches 200 feet into the mountain

Temple of Amen-Re, 1290–1224 B.C.E., Karnak, Egypt (Figure 3.18)

- Huge columns, tightly packed together, admitting little light into the sanctuary
- Hypostyle halls
- Columns elaborately painted
- Massive lintels bind the columns together
- Axial plan

Figure 3.18: Temple of Amen-Re, 1290–1224 B.C.E., Karnak, Egypt

Akhenaton, c. 1353–1335 B.C.E., sandstone, Egyptian Museum, Cairo (Figure 3.19)

- Body has same pose as in Old Kingdom sculptures, but features are smoother, more relaxed; new image of a pharaoh
- Curving contours
- Epicene body
- Slack lips, long face
- Heavy-lidded eyes
- Tight clothes accentuate big hips
- Stomach protrudes over elastic, hanging waistline
- Thin arms
- Amarna style

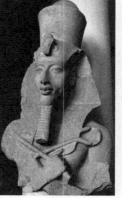

Figure 3.19: *Akhenaton*, c. 1353–1335 B.C.E., sandstone, Egyptian Museum, Cairo

Figure 3.20: Thutmose, *Nefertiti*, 1353–1335 B.C.E., limestone, Egyptian Museum, Berlin

Thutmose, *Nefertiti*, 1353–1335 B.C.E., limestone, Egyptian Museum, Berlin (Figure 3.20)

- Long, elegant neck
- Realistic face; soft, delicate New Kingdom features
- Perhaps the sculpture was a demonstration model for copying
- Wife of Akhenaton
- Amarna style

Mask of King Tutankhamen, c. 1323 B.C.E., gold, enamel, semiprecious stones, Egyptian Museum, Cairo (Figure 3.21)

- Famous tomb discovered by Howard Carter in 1922
- Mummified body of King Tutankhamen buried with 143 objects on his head, neck, abdomen, and limbs; gold mask placed over head
- Gold coffin 6'7" long containing the body of the pharaoh (not illustrated)
- Golden mask has smoothly idealized features of the boy–king

Figure 3.21: *Mask of King Tutankhamen*, c. 1323 B.C.E., gold, enamel, semiprecious stones, Egyptian Museum, Cairo

Judgment before Osiris, c. 1290–1280 B.C.E., papyrus, British Museum, London (Figure 3.22)

- Illustration from the *Book of the Dead*, an Egyptian book of spells and charms
- The god of embalming, Anubis, has a jackal's head. He leads the deceased named Hu-Nefer into a hall where his soul is being weighed against a feather. If the sins weigh more than a feather, he will be condemned.

Figure 3.22: *Judgment before Osiris*, c. 1290–1280 B.C.E., papyrus, British Museum, London

- The hippopotamus/lion figure between the scales will eat the heart of an evil soul.
- The god Thoth has the head of a bird. He is the stenographer writing down these events in the hieroglyphics that he invented.
- Osiris, god of the underworld, appears enthroned on the right to subject the deceased to a day of judgment.

VOCABULARY

Amarna style: Art created during the reign of Akhenaton, which features a more relaxed figure style than in Old and Middle Kingdom art

Engaged column: a column that is not freestanding but attached to a wall (Figure 3.2)

Hierarchy of scale: a system of representation that expresses a person's importance by the size of his or her representation in a work of art (Figure 3.4)

Hieroglyphics: Egyptian writing using symbols or pictures as characters (Figure 3.22)

Hypostyle: a hall in an Egyptian temple that has a roof supported by a dense thicket of columns (Figure 3.18)

In situ: a Latin expression that means that something is in its original location

Ka: the soul, or spiritual essence, of a human being that either ascends to heaven or can live in an Egyptian statue of itself

Mastaba: Arabic for "bench," a low, flat-roofed Egyptian tomb with sides sloping down to the ground (Figure 3.1)

Necropolis: literally, a "city of the dead," a large burial area

Papyrus: a tall aquatic plant whose fiber is used as a writing surface in ancient Egypt (Figure 3.22)

Pharaoh: a king of ancient Egypt (Figure 3.19)

Pylon: a monumental gateway to an Egyptian temple marked by two flat, sloping walls between which is a smaller entrance

Reserve column: a column that is cut away from rock but has no support function

Sarcophagus (plural, **sarcophagi):** a stone coffin

Summary

Egyptian civilization covers a huge expanse of time that is marked by the building of monumental funerary monuments and expansive temple complexes. The earliest remains of Egyptian civilization show an interest in elaborate funerary practices, which resulted in the building of the great stone pyramids.

Egyptian figural style remained constant throughout much of its history, with its emphasis on broad frontal shoulders and profiled heads, torso, and legs. In the Old Kingdom the figures appear static and imperturbable. Later, in the Middle Kingdom, the faces show more naturalistic poses and introspective expressions. In the Amarna period the figures lose their motionless stances and have body types that are softer and increasingly androgynous.

The contents of the tomb of the short-lived King Tutankhamen give the modern world a glimpse into the spectacular richness of Egyptian tombs. One wonders how much more lavish the tomb of Ramses II must have been.

Practice Exercises

1. Many works of Egyptian sculpture were carved in situ, meaning they were

 (A) made of stone
 (B) carved on the spot where the stone was found
 (C) painted to stand out from the desert
 (D) monumental in size

2. A dramatic change in Egyptian art took place during the Amarna period under the reign of

 (A) Akhenaton
 (B) Ramses
 (C) Djoser
 (D) Hatshepsut

3. Mastabas are an early form of an Egyptian

 (A) temple
 (B) palace
 (C) book made of papyrus
 (D) tomb

4. Egyptian columns come in all of the following forms EXCEPT:

 (A) palm
 (B) lotus
 (C) bull's heads
 (D) papyrus

5. The historical event of the unification of Upper and Lower Egypt is depicted in the

 (A) Temple of Ramses II
 (B) *Great Sphinx*
 (C) *Senusret III*
 (D) *Narmer Palette*

6. The Egyptian canon of proportions believed that while most of the body should be portrayed in profile, frontal views were permitted of the shoulders and the

 (A) feet
 (B) face
 (C) eye
 (D) hands

7. The difference between a reserve column and an engaged column is that the reserve column is

(A) attached to a wall behind it
(B) made up of individual stones cut into round shapes and fitted together
(C) held in reserve and used at a later date
(D) cut out of rock

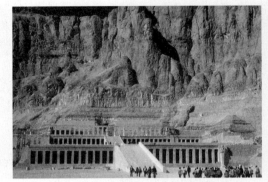

Questions 8 and 9 refer to Figure 3.23

8. The temple depicted here is meant to

(A) harmonize with its landscape
(B) reflect the sun and provide a cool place for visitors to enter
(C) entrap those who try to plunder it
(D) be a platform that doubles for defense in times of war.

Figure 3.23

9. This building is dedicated to

(A) Narmer
(B) Tutankhamen
(C) Ramses
(D) Hatshepsut

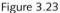

CHALLENGE 10. In Egyptian art, hippopotami are often seen as

(A) agents of evil
(B) forces of positive energy
(C) uniting spirits
(D) water gods

Figure 3.24

Short Essay

Which art-historical period does this group sculpture come from? Explain why it belongs to this period, and what its likely purpose was.

Answer Key

1. **(B)**	3. **(D)**	5. **(D)**	7. **(D)**	9. **(D)**
2. **(A)**	4. **(C)**	6. **(C)**	8. **(A)**	10. **(A)**

Answers Explained

Multiple-Choice

1. **(B)** Works of art like the Temple of Ramses and the Great Sphinx were carved in situ, that is, on the spot from the available rock.

2. **(A)** The Amarna period occurred under the reign of Akhenaton, when a dramatic shift took place in religious practices and artistic style.

3. **(D)** Mastabas are small Egyptian tombs.

4. **(C)** The bull's head capitals are from ancient Persia.

5. **(D)** The *Narmer Palette* depicts, among other things, the unification of Egypt by King Narmer.

6. **(C)** The shoulders and the eye are represented frontally in Egyptian art.

7. **(D)** A reserve column is hollowed out of rock to resemble a column.

8. **(A)** This temple's horizontal and vertical elements match the surrounding cliffs.

9. **(D)** Hatshepsut had this temple built.

10. **(A)** Hippopotami forage on carefully maintained fields of grain and thus were thought to have been sent by agents of evil.

Rubric for Short Essay

4: The student chooses Old Kingdom correctly and discusses the work's likely purpose. Discussion is full and has no major errors.

3: The student chooses Old Kingdom correctly and provides some account of its purpose. Discussion is less full and there may be minor errors.

2: The student chooses incorrectly but the essay reveals a knowledge of works from the Old Kingdom, OR the student chooses Old Kingdom and provides minimal discussion of its purpose. There may be major errors.

1: The student chooses the Old Kingdom correctly but gives no indication of its purpose, OR the student chooses incorrectly and gives some idea of its purpose. There may be major errors.

0: The student makes an attempt, but the response is without merit.

Short Essay Model Response

This work is most definitely from the Old Kingdom of ancient Egypt. Like the New and Middle Kingdoms, these sculptures are both attached to the stone they're made out of. However, this work has a very strong resemblance to the statue of Khafre, also from the Old Kingdom. Both sit in their chairs staring into the next world. Both are attached to the rock to metaphorically give a look of permanence.

These statues most likely held the ka of the people they're made after. Also, notice the dark complexion of the man, as opposed to the light complexion of the woman, typical in the Old Kingdom, separating men from women. Dark skin showed they went out in the world, while light skin showed women stayed home. In later works in the New Kingdom, sculptures like Queen Tiye were much darker. Also, much New Kingdom work looks androgynous, women standing independently of men, such as Hatshepsut. This work has two fit and trim figures with little or none of the softness and sagging quality of New Kingdom works, nor the thoughtful introspective nature of Middle Kingdom art.

—Jordan S.

Analysis of Model Response

Jordan identifies the period correctly as Old Kingdom. He understands general characteristics of Egyptian art, and is able to make a connection between this work and *Khafre*. He differentiates among Old, Middle, and New Kingdom styles of sculpture. However, the comments about New Kingdom works, while true, argue the question in reverse. The question asks how this is an Old Kingdom work, not why it could not be New Kingdom. Other than to state that the sculpture held the ka of the people, the essay does not discuss the sculpture's purpose in depth. **This essay merits a 2.**

Aegean Art

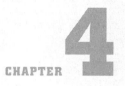

TIME PERIOD

Civilization	Time Period	Location
Cycladic	3000–1600 B.C.E.	Cycladic islands in the Aegean Sea
Minoan	1900–1375 B.C.E.	Crete
Mycenaean	1600–1100 B.C.E.	Greece

KEY IDEAS

- The Cycladic civilization of the Greek islands produced stylized statuettes of nude standing females and nude males playing musical instruments.
- The Minoans from the island of Crete built mixed-use palaces with complex ground plans.
- Mycenaeans from mainland Greece were noted for massive citadels marked by cyclopean masonry and corbelled vaulting.

HISTORICAL BACKGROUND

At the height of the Bronze Age, three successive civilizations arose in what is today southern Greece. First, the seafarers of the Greek islands built a culture we call Cycladic, named after the islands they lived on. They were overlapped somewhat by a high culture on the island of Crete, the Minoans. Lastly, the Mycenaeans established a Greek culture on the Peloponnesian Peninsula.

At the end of the nineteenth century, two energetic archaeologists uncovered the remains of these civilizations. Heinrich Schliemann from Germany dug through the ruins of ancient Troy and Mycenae to discover the bulk of Mycenaean culture. Sir Arthur Evans from England excavated Minoan palaces on the island of Crete in 1900. Most archaeologists today claim that these men did more harm than good in the way they uncovered these sites and established conjectural restorations. However, their names are still recorded as pioneering archaeologists.

INNOVATIONS IN AEGEAN ARCHITECTURE

Aegean people used **cyclopean masonry**; they placed minimally cut blocks of stone atop one another to create walls and buildings without using mortar. The Mycenaeans excelled at the **corbelled arch** (Figure 4.1), a type of vaulted space in which the blocks of stone are gradually placed closer together as the building rises, forming an inverted V-shaped roof.

Figure 4.1: Corbelled arch

INNOVATIONS IN AEGEAN PAINTING

In Egypt, artists painted in a technique known as *fresco secco* (or dry fresco), in which the paint is applied to a dry wall. This impermanent bond leads to a chipped surface. Aegean artists used *buon fresco* (or true fresco), which renders a more durable product because a freshly applied layer of plaster easily adheres to a coat of paint. The long-lasting benefits of buon fresco appealed to the Minoans; however, there were concerns. The technique required quick brushwork and spontaneous execution. In this way, Minoan artists achieved a fluidity to their work that the more studied Egyptian paintings of the same period cannot match.

INNOVATIONS IN AEGEAN SCULPTURE

Minoans and Mycenaeans were particularly adept at sculpting in **repoussé**, a technique that involves fitting a sheet of thin metal, gold or bronze, onto a surface. The metal is then incised with small hammers from the backside of the plate. A design is beaten on the inside of the object, leaving a raised surface on the exterior. In a sense, the work of art is being made in reverse, with the artist working on the back only. The Mycenaean *Funerary Mask* (Figure 4.12) from 1600 B.C.E. was worked in repoussé. The opposite technique, that is, working the metal from the front, is called **chasing**.

CHARACTERISTICS OF CYCLADIC ART

Most of what survives from Cycladic culture has been found in grave sites on the Greek islands. Figurines, some of them as small as two inches, were placed near the dead. Women are always carved standing and nude; men are playing harps. Both have back-tilted heads and are rendered in simple geometric shapes, which make them look amazingly modern. Scholars debate the extent to which they were painted, because only traces of paint have been found.

Major Works of Cycladic Art

Cycladic Female Figure, c. 2500 B.C.E., marble, National Archaeological Museum, Athens (Figure 4.2)

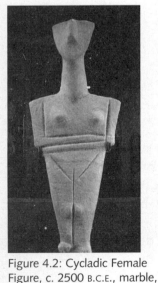

Figure 4.2: Cycladic Female Figure, c. 2500 B.C.E., marble, National Archaeological Museum, Athens

- Nude women, arms folded about waists
- Very thin figures with prominent heads
- Feet too small to support the sculpture, meant to be placed on their straight backs, lying down, next to the deceased
- Wedge-shaped pelvis and body

- Triangular groin area, modest breasts
- Painted facial features, heads tilted back
- Found in graves
- Varied sizes, from small to large

Harpist, c. 2500 B.C.E., marble, National Archaeological Museum, Athens (Figure 4.3)

- Male figures
- Simple geometric shapes
- Large flat planes
- Head tilted back
- Not playing the harp so much as holding it

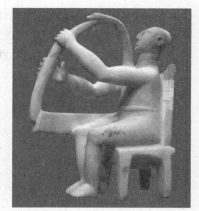

Figure 4.3: Harpist, c. 2500 B.C.E., marble, National Archaeological Museum, Athens

CHARACTERISTICS OF MINOAN ART

The fluidity that Minoan figures possess is unique in art history to this point. Figures are not riveted to a ground line; they enjoy a liquidity of movement and dynamic vigor. Curved lines dominate compositions, with slow, long S-shaped curves most common. Figures have impossibly small waists and are usually depicted in the Egyptian format of frontal shoulders and profile bodies. However, a number of groundbreaking works, like the *Toreador Fresco* (c. 1400 B.C.E.) (Figure 4.6) have figures in true profile.

As is common with other ancient cultures, men are painted a darker color than women. However, uncharacteristic for ancient art, the Minoans had a taste for pure landscape; frescoes have been discovered in which lush vegetation grows without a human presence.

Minoan architecture is unusual in its complicated ground plan, with rooms stretching out next to long corridors and spacious courtyards. The **megaron** is the main audience chamber of a Minoan palace, featuring unusual wooden columns that taper inward as they go down. Columns are painted red or white, both for aesthetic effect and for preservation. The capitals are uniquely bulbous and painted black.

Figure 4.4: Palace at Knossos, c. 1700–1400 B.C.E., Crete

Major Works of Minoan Art

Palace at Knossos, c. 1700–1400 B.C.E., Crete (Figures 4.4 and 4.5)

- Central courtyard with flanking rooms
- Open-air chambers flood interior with light
- Labyrinthine ground plan
- Columns painted mostly red or white and made of wood; unusual that columns taper smaller at the bottom than at the top

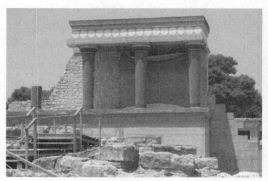

Figure 4.5: Palace at Knossos, c. 1700–1400 B.C.E., Crete

- Capitals painted black and sit like a cushion on the top of the column
- In addition to being a palace, also a center for business, religion, trade, manufacturing, and politics; however, "restorations" have obscured some of the original intentions

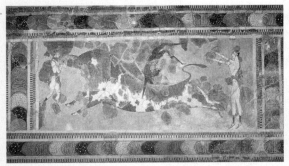

Figure 4.6: *Toreador Fresco*, c. 1400 B.C.E., fresco, Archaeological Museum, Herakleion, Crete

Toreador Fresco, c. 1400 B.C.E., fresco, Archaeological Museum, Herakleion, Crete (Figure 4.6)

- Possibly a ritual showing two women and a man jumping over a bull
- Woman on left grabs the horns, the man is jumping over the bull, the woman on the right has just landed
- As in Egyptian Art, males have darker skin than females
- Figures have extremely thin waists; here they stand in profile but otherwise reflect an Egyptian figure style
- Figures have a floating quality with no ground line
- Sweeping curved lines; S-shaped curves of bull's underside and tail
- Painting not in situ

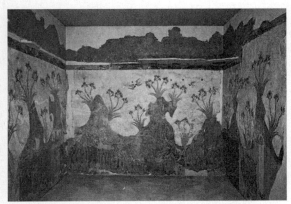

Figure 4.7: *Spring Fresco*, c. 1650 B.C.E., fresco, National Archaeology Museum, Athens

Spring Fresco, c. 1650 B.C.E., fresco, National Archaeology Museum, Athens (Figure 4.7)

- One of the earliest pure landscapes in existence
- Joyful patterns of undulating lines and fanciful plant forms dominate composition
- Cheerful application of color in biomorphic bands
- Geometrically simplified swallows fly through the air

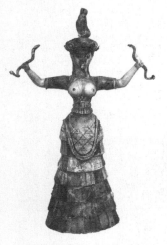

Snake Goddess, c. 1600 B.C.E., gold, ivory, Archaeological Museum, Herakleion, Crete (Figure 4.8)

- Goddess? Fertility image? Assistant to the goddess?
- Minoan thin waists, exposed breasts
- Flounced skirt in layers; apron layered over top
- Wide-eyed expression
- Cat image on headdress
- Holds a snake in each hand

Figure 4.8: *Snake Goddess*, c. 1600 B.C.E., gold, ivory, Archaeological Museum, Herakleion, Crete

CHARACTERISTICS OF MYCENAEAN ART

Cyclopean masonry (Figure 4.9) and **corbelled arches** (Figure 4.1) are key characteristics of Mycenaean architecture. The influence of Minoan painting is very strong; figures have narrow waists and broad shoulders. However, there is an overall movement away from the delicate Minoan forms to a more realistic concept, as in the *Funerary Mask* (c. 1600 B.C.E.) (Figure 4.12).

Major Works of Mycenaean Art

Corbelled Gallery, 1400–1200 B.C.E., Tiryns, Greece (Figure 4.9)

- Cyclopean masonry, projects power
- Corbel vault
- Walls have a massive appearance but hallway is claustrophobic

Lion Gate, c. 1300 B.C.E., limestone, Mycenae, Greece (Figure 4.10)

- Triangular group over doorway, an early pediment on a post-and-lintel gate
- Minoan column between two lions(?) whose heads have fallen off; the heads were turned to face the observer
- Narrow, tall passageway leading to gate, built for defensive purposes
- Cf. Hittite *Lion Gate*

Figure 4.9: Corbelled Gallery, 1400–1200 B.C.E., Tiryns, Greece

Figure 4.10: Lion Gate, c. 1300 B.C.E., limestone, Mycenae, Greece

Treasury of Atreus, c. 1300 B.C.E., Mycenae, Greece (Figure 4.11)

- Misnamed in the belief it was a repository for treasures; probably originally a tomb
- Long entranceway
- Corbel vaulted interior, largest interior domed space until the Romans
- Precision cutting of stones
- Tholos tomb

Figure 4.11: Treasury of Atreus, c. 1300 B.C.E., Mycenae, Greece

***Funerary Mask*, c. 1600 B.C.E., gold, National Archaeological Museum, Athens (Figure 4.12)**

- Gold, worked in repoussé
- Found in a royal shaft grave
- Mask placed on the deceased's face: cf. Egyptian burial practices
- Curlicue ears
- Eyes rendered as slits
- Hair detailed with long, thin incised marks

Figure 4.12: *Funerary Mask*, c. 1600 B.C.E., gold, National Archaeological Museum, Athens

VOCABULARY

Corbel arch: a vault formed by layers of stone that gradually grow closer together as they rise until they eventually meet (Figure 4.1)

Cyclopean masonry: a type of construction that uses rough, massive blocks of stone piled one atop the other without mortar. Named for the mythical Cyclops (Figure 4.9).

Fresco: a painting technique that involves applying water-based paint onto a freshly plastered wall. The paint forms a bond with the plaster that is durable and long-lasting (Figure 4.6)

Megaron: a rectangular audience hall in Aegean art that has a two-column porch and four columns around a central air well

Repoussé: French, "to push back"; a type of metal relief sculpture in which the back side of a plate is hammered to form a raised relief on the front (Figure 4.12)

Tholos tomb: an ancient Mycenaean circular tomb in a beehive shape (Figure 4.11)

Summary

The first civilizations in Europe emerged around the Aegean Sea, across the Mediterranean from Egypt. Although distinct cultures that spoke different languages, they shared the same seafaring lifestyle.

The Cycladic people, who lived on the Greek islands, produced portable sculptures of stylized standing women and seated men playing musical instruments. These statuettes are characterized by a linear abstraction and clean, crisp lines that deemphasize details that may have been painted on.

The Minoans, who lived on the island of Crete, built rambling palaces characterized by columns with bulbous capitals that taper down to the floor. Minoan fresco painting features figures with long, sinuous curves and exaggeratedly narrow waists.

The Mycenaeans lived on the Greek mainland and, unlike the other Aegean civilizations, spoke an early form of the Greek language. Their large citadels were built of cyclopean masonry marked by corbelled vaulting. Shaft graves reveal opulent burial practices inspired by their Egyptian counterparts.

Practice Exercises

Questions 1–3 are based on Figure 4.13.

1. This photo illustrates a corridor in a building that must have been designed

 (A) with engaged columns
 (B) as a corbel vault
 (C) as a treasury for ancient art
 (D) for a tomb

2. The type of stonework seen here is called

 (A) cyclopean
 (B) megaron
 (C) repoussé
 (D) reserve

3. Which of the following civilizations probably built this?

 (A) Cycladic
 (B) Minoan
 (C) Mycenaean
 (D) Egyptian

Figure 4.13

4. The difference between *buon fresco* and *fresco secco* is that *buon fresco* is

 (A) good
 (B) portable
 (C) better because it allows the artist to take his or her time
 (D) applied to a wet wall

 CHALLENGE

5. Sir Arthur Evans was an archaeologist who uncovered the ruins at

 (A) Mycenae
 (B) Troy
 (C) Rhodes
 (D) Knossos

 CHALLENGE

6. Minoan columns are unusual in that they

 (A) are not meant to hold up buildings
 (B) are made of concrete
 (C) have cushion-like bases
 (D) are wider at the top than at the bottom

7. Minoan culture was centered

(A) in Egypt
(B) on Crete
(C) in the Greek islands
(D) near Athens on the Greek mainland

8. The Minoan painting called the *Spring Fresco* is unusual for a landscape because

(A) it has no human activity
(B) it does not depict land
(C) all the plants are dead
(D) creatures from the sea are shown in bright colors

9. Cycladic figures are known for their

(A) imagery
(B) stylization
(C) repoussé technique
(D) depiction of rituals

10. The Minoans followed the Egyptian figure style except that the

(A) Minoans painted men and women different colors
(B) Egyptians exposed the breasts of women
(C) Egyptians are known for more fluid movement
(D) Minoans have some figures in true profile

Short Essay

Name the civilization that produced the painting in Figure 4.14. Discuss how the characteristics that place this painting in this civilization mark a contrast with the period immediately preceding it. Use one side of a sheet of lined paper to write your essay.

Figure 4.14

Answer Key

1. **(B)**	3. **(C)**	5. **(D)**	7. **(B)**	9. **(B)**
2. **(A)**	4. **(D)**	6. **(D)**	8. **(A)**	10. **(D)**

Answers Explained

Multiple-Choice

1. **(B)** This structure is a remnant of a corbelled vault.

2. **(A)** The large relatively uncut stones are called cyclopean masonry.

3. **(C)** The Mycenaeans produced structures of cyclopean masonry in corbelled vaulting.

4. **(D)** Buon fresco is painted on a wet wall. Fresco secco is painted on a dry wall.

5. **(D)** Sir Arthur Evans worked on the Palace at Knossos, on Crete.

6. **(D)** Minoan columns are wider at the top than at the bottom.

7. **(B)** Minoan culture was centered on the island of Crete.

8. **(A)** This is one of the first landscapes in art history in which the humans are unseen.

9. **(B)** Cycladic sculptures are heavily stylized.

10. **(D)** There are some figures in Minoan art that are drawn in true profile, as in the case of the *Toreador Fresco*.

Rubric for Short Essay

4: The student correctly identifies this piece as Minoan, understands characteristics of Minoan art, and points to two characteristics in this illustration. The student also explains how Egyptian art, which both preceded Minoan and was its contemporary, looks different, yet inspired Minoan art forms. There are no major errors.

3: The student correctly identifies this work as Minoan, explains characteristics of Minoan art, and points to one characteristic in this illustration. The student also identifies the preceding period as Egyptian and connects the artwork of the two civilizations. There may be minor errors.

2: The student incorrectly identifies Minoan or Egyptian art but makes an attempt at connecting one civilization to another. There may be major errors.

1: The student incorrectly identifies both Minoan and Egyptian art; however, some general terms about ancient art show a minimal understanding of figure types. There may be major errors.

0: The student makes an attempt, but the response is without merit.

Short Essay Model Response

The civilization that produced this painting was the Minoan civilization during the Aegean period. In this painting, the figure has a very thin waist, frontal shoulders, and a side profile. The feet are in profile and the eye is frontal. All of these characteristics are traits of Minoan figure drawing.

In the preceding period, Egyptian artists followed a canon of proportions that was a scale of measures used to determine every figure's size. This made Egyptian artwork appear somewhat lifeless with little emotion or motion. The Minoans look much flowier and appear to have a lifelike quality. The Egyptian waist was a little thicker than the Minoans but they both have broad shoulders.

—Jaclyn P.

Analysis of Model Response

Jaclyn's response is typical of answers given on the AP exam. All of the material is in the student's head, but often the pressure of the exam and time constraints of the questions force students to have much of it come out in a jumble. No doubt Jaclyn knows there is no such word as "flowier"; however, the essence of the answer is conveyed. There are no deductions for grammar or spelling on the AP Art History exam, nor are essays judged on their construction. Jaclyn understands the fact that this is a Minoan work, can address some of the characteristics of Egyptian art, and can see the differences between the two. **This essay merits a 4.**

Greek Art

TIME PERIOD

Geometric Art	900–700 B.C.E.
Orientalizing Art	700–600 B.C.E.
Archaic Art	600–480 B.C.E.
Classical Art	480–400 B.C.E.
Late Classical Art	400–323 B.C.E.
Hellenistic Art	323–30 B.C.E.

KEY IDEAS

- Greek art introduces the concept of classical art.
- Greek sculpture is characterized by the idealizing of the human form, the beauty of the nude body, and the ability of figures to express a great range of emotions.
- Greek temples become extremely influential in the development of European architecture.
- Greek pottery echoes the development of Greek sculpture and forms virtually all our knowledge about Greek painting.

HISTORICAL BACKGROUND

The collapse of Mycenaean society around 1100 B.C.E. left a vacuum in the Greek world until a reorganization took place around 900 B.C.E. in the form of city–states. Places like Sparta, Corinth, and Athens defined Greek civilization in that they were small, competing political entities that were united only in language and the fear of outsiders.

In the fifth century B.C.E. the Persians threatened to swallow Greece, and the city–states rallied behind Athens' leadership to expel them. This was accomplished, but not before Athens itself was destroyed in 480 B.C.E. When the Persians were effectively neutralized, the Greeks then turned, once again, to bickering and trying to dominate one another. The worst of these internal struggles happened during the Peloponnesian War (431–404 B.C.E.) when Athens was crushed by Sparta. Without an effective core, Greek states continued to struggle for another century.

This did not end until the reign of Alexander the Great, who, in the fourth century B.C.E., briefly united Macedonians and Greeks, by establishing a mighty empire

that eventually toppled the Persians. But because Alexander died young and left no clear successor, his empire crumbled away soon after his death. The remnants of Greek civilization lasted for another hundred years or so, until it was eventually absorbed by Rome.

Patronage and Artistic Life

So many names of artists have come down to us that it is tempting to think that Greek artists achieved a distinguished status hitherto unknown in the ancient world. Artists signed their work, both as a symbol of accomplishment and as a bit of advertisement. Greek potters and painters signed their vases, usually in a formula that resembles "so and so made it" or "so and so decorated it."

Many artists were theoreticians as well as sculptors or architects. **Polykleitos** wrote a famous (no longer existing) book on the canon of human proportions. **Iktinos** wrote on the nature of ideal architecture. Phidias, who was responsible for the artistic program on the Acropolis, supervised hundreds of workers in a mammoth workshop and yet still managed to construct a complex with a single unifying artistic expression. This was a golden age for artists, indeed.

INNOVATIONS OF GREEK SCULPTURE

There are three ways in which Greek sculpture stands as a departure from the civilizations that have preceded it:

1. Greek sculpture is unafraid of nudity. Unlike the Egyptians, who felt that nudity was debasing, the Greeks gloried in the perfection of the human body. At first, only men are shown as nude; gradually women are also depicted, although there is a reluctance to fully accept female nudity, even at the end of the Greek period.

2. Large Greek marble sculptures are cut away from the stone behind them. Large-scale bronze works were particularly treasured; their lighter weight made compositional experiments more ambitious.

3. Greek art in the Classical and Hellenistic periods use **contrapposto**, which is a relaxed way of standing with knees bent and shoulders tilted. The immobile look of Egyptian art is replaced by a more informal and fluid stance, enabling the figures to appear to move.

Characteristics of Greek Archaic Sculpture

What survives of Greek Archaic art is limited to grave monuments, such as **kouros** and **kore** figures, or sculpture from Greek temples. Marble is the stone of choice, although Greek works survive in a variety of materials: bronze, limestone, terra cotta, wood, gold—even iron. Sculpture was often painted, especially if it were to be located high on the temple façade. Backgrounds are highlighted in red; lips, eyes, hair, and drapery are routinely painted. Sculpture often has metallic accessories: thunderbolts, harps, and various other attributes.

Bronze sculpture is hollow. Eyes are inlaid with stone or glass, and lips, nipples, and teeth could be made of copper or silver highlights.

Kouros and **kore** figures stand frontally, bolt upright, and with squarish shoulders. Hair is knotted, and the ears are a curlicue. Figures are cut free from the stone as much as possible, although arms are sometimes attached to thighs. As in Egyptian works, kouros figures have one foot placed in front of the other, as if they were in mid-stride. The shins have a neat crease down the front, as Egyptian works do. To give the figures a sense of life, most kouros and kore figures smile.

Major Works of Greek Archaic Sculpture

Kouros, c. 600 B.C.E., marble, Metropolitan Museum of Art, New York (Figure 5.1)

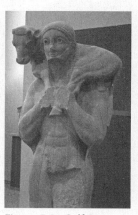

- Grave marker, replacing huge vases of the Geometric period
- Not a real portrait, but a general representation of the dead
- Rigidly frontal
- Emulates stance of Egyptian sculpture, but is nude; arms and legs largely cut free from the stone
- Freestanding with legs appearing to stride forward, in contrast to many Egyptian works that are reliefs or are attached to stone
- Hair is knotted and falls in neatly braided rows down the back
- Eyes wide open; squarish shoulders; V-shaped pelvis
- Face is masklike

Figure 5.1: *Kouros,* c. 600 B.C.E., marble, Metropolitan Museum of Art, New York

West Pediment from the Temple of Artemis, Corfu, 600–580 B.C.E., limestone, Archaeological Museum, Corfu, Greece (Figure 5.2)

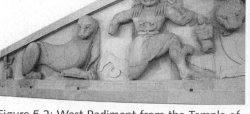

- Sculpture fits into the pediment shape of the Greek temple, with the Medusa's head overlapping the top frame
- The Gorgon Medusa appears in the center flanked by two large felines (leopards? panthers?) that protect the temple; she is protectress of animals

Figure 5.2: West Pediment from the Temple of Artemis, Corfu, 600–580 B.C.E., limestone, Archaeological Museum, Corfu, Greece

- Medusa turns people to stone by one glance from her eyes. She has snakes for hair and an ugly face. With these powers she frightens enemies away from the temple
- Medusa appears to be running with the head facing the spectator and the legs in profile; curiously turned body typical of Archaic art
- On the right is Medusa's son Chrysaor, who was born from her blood after she was decapitated by Perseus; story of the Medusa conflated in this scene
- Cf. Lion Gate at Mycenae (Figure 4.10) and Boghazköy (Figure 2.12)

Calf Bearer, c. 560 B.C.E., marble, Acropolis Museum, Athens (Figure 5.3)

- Rhonbos the Calf Bearer bringing an offering to Athena in thanksgiving for his prosperity
- Thin coat draped over figure; originally painted
- Two figures are united; tightly woven composition emphasized by a central x-shape in the composition
- Archaic smile, possibly to show that he's alive; knotted hair

Figure 5.3: *Calf Bearer,* c. 560 B.C.E., marble, Acropolis Museum, Athens

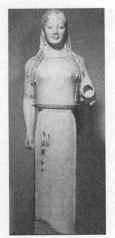

Figure 5.4: *Peplos Kore*, c. 530 B.C.E., marble, Acropolis Museum, Athens

***Peplos Kore*, c. 530 B.C.E., marble, Acropolis Museum, Athens (Figure 5.4)**

- Broken hand used to carry offering to Athena, or perhaps to pour a libation, or to hold an attribute
- Hand emerges into our own space, breaks out of the mold of static Archaic statues
- Tightened waist
- Breasts revealed beneath drapery
- So-called because she is named for the *peplos*, one of four garments she is wearing
- Rounded and naturalistic face
- Much of the paint still remains, animating the face and hair
- Hair falls naturally along her body

***Gods and Giants* from the Siphnian Treasury, c. 530 B.C.E., marble, Archaeological Museum, Delphi, Greece (Figure 5.5)**

- Mythic battle between the Greek gods and the giants, called a *gigantomachy*
- Shows contemporary military tactics and weapons
- Undercutting of forms creates shadows around legs
 - Varying relief depth; attempt at placing figures one behind the other; however, they are all on the same ground line
 - Frieze placed around the exterior of the Siphnian Treasury

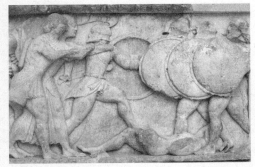

Figure 5.5: *Gods and Giants* from the Siphnian Treasury, c. 530 B.C.E., marble, Archaeological Museum, Delphi, Greece

***Dying Warrior* from the Temple of Aphaia, Aegina, c. 500–490 B.C.E., marble, Glyptothek, Munich, Germany (Figure 5.6)**

- Warrior dying, fits neatly into the corner of a pediment to a temple
- Hair in rows of tight curls
- Rigid musculature
 - Pose of the crossed legs is awkward and unnatural, especially given the life-and-death struggle the dying warrior is undergoing
 - Archaic smile

Characteristics of Greek Classical Sculpture

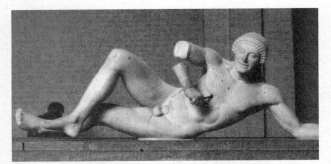

Figure 5.6: *Dying Warrior* from the Temple of Aphaia, Aegina, c. 500–490 B.C.E., marble, Glyptothek, Munich, Germany

Classical sculpture is distinct from Archaic in the use of **contrapposto**, that is, the fluid body movement and relaxed stance that was unknown in freestanding sculpture before this. In addition, forms became highly idealized; even sculptures depicting older people have heroic bodies. In the fifth century B.C.E., this heroic form was defined by **Polykleitos**, a sculptor whose **canon** of proportions of the human figure had far-reaching effects. Polykleitos wrote that the head should be one-seventh of the body. He also favored a heavy musculature with a body expressing alternating stances of relaxed and stressed muscles. Thus, on his ***Spear Bearer*** (450–440 B.C.E.) (Figure

5.12), the right arm and the left leg are flexed, and the left arm and right leg are relaxed.

The crushing of Athens during the Peloponnesian War had a dramatic impact on the arts, which turned away from the idealizing canon of the fifth century B.C.E. In the Late Classical period of the fourth century B.C.E., gods were sculpted in a more humanized way. **Praxiteles**, the greatest sculptor of his age, carved figures with a sensuous and languorous appeal, and favored a lanky look to the bodies. Hallmarks of fourth-century work include heads that are one-eighth of the body and a sensuous S-curve to the frame.

Major Works of Greek Classical Sculpture

Kritios Boy, **c. 480 B.C.E., marble, Acropolis Museum, Athens (Figure 5.7)**

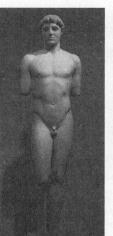

Figure 5.7: *Kritios Boy*, c. 480 B.C.E., marble, Acropolis Museum, Athens

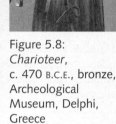

Figure 5.8: *Charioteer*, c. 470 B.C.E., bronze, Archeological Museum, Delphi, Greece

- Introduction of contrapposto, body standing naturally, he seems able to move
- Slight turn to the body, head not strictly frontal but a bit to one side
- Transitional piece between Archaic and Classical art
- So-called because it was attributed to the Greek sculptor Kritios

Charioteer, **c. 470 B.C.E., bronze, Archaeological Museum, Delphi, Greece (Figure 5.8)**

- Originally part of a group representing a team of horses pulling a chariot driven by this charioteer
- Bronze sculpture with copper lips and eyelashes; glass paste eyes enlivened face
- Slightly turned head and separated feet
- Dedicated by Polyzalos, a tyrant, who wanted to commemorate a chariot race victory at the games at Delphi

Figure 5.9: *Athena, Herakles, and Atlas* from the Temple of Zeus, c. 470–456 B.C.E., marble, Archaeological Museum, Olympia

Athena, Herakles, and Atlas **from the Temple of Zeus, c. 470–456 B.C.E., marble, Archaeological Museum, Olympia (Figure 5.9)**

- Atlas returning to Herakles with the apples of the Hesperides; Herakles held the world (with a cushion to soften the discomfort) for Atlas while he was gone
- Transitional phase between the stiff Archaic and the more relaxed Classical forms
- Athena's body revealed under her clothes; idealized forms on the bodies of Herakles and Atlas
- Archaic smile gone

Figure 5.10: Myron, *The Discus Thrower*, c. 450 B.C.E., marble copy from a bronze original, National Roman Museum, Rome

Myron, *The Discus Thrower*, **c. 450 B.C.E., marble copy from a bronze original, National Roman Museum, Rome (Figure 5.10)**

- Greek name: *Diskobolos*
- Weight shift, contrapposto

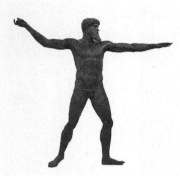

- In-between motion, mid-swing
- Impossible to throw the discus this way, but optically the pose works
- Viewpoint mainly from the front
- Expressionless face, or perhaps thinking
- Use of negative space opens large areas in the sculpture
- Idealized heroic body

Figure 5.11: *Zeus* or *Poseidon*, c. 460–450 B.C.E., bronze, National Archaeological Museum, Athens

Zeus or *Poseidon*, c. 460–450 B.C.E., bronze, National Archaeological Museum, Athens (Figure 5.11)

- Either Zeus (holding a thunderbolt) or Poseidon (holding a trident)
- Graceful turn of the body with uplifted back foot
- Idealized expression of the body; older head

Polykleitos, *Spear Bearer*, c. 450–440 B.C.E., marble copy from a bronze original, National Archaeological Museum, Naples (Figure 5.12)

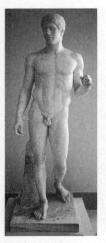

- Greek name: *Doryphoros*
- Closed stance
- Alternating tense and relaxed elements of the body; left arm and right leg are relaxed, right arm and left leg are tensed
- Blocklike solidity
- Broad shoulders, thick torso, muscular body
- Movement restrained, Spartan ideal of body
- Warrior and athlete
- Hand once held a spear
- He averts his gaze; you may admire him, but he does not recognize the admiration

Figure 5.12: Polykleitos, *Spear Bearer*, c. 450–440 B.C.E., marble copy from a bronze original, National Archaeological Museum, Naples

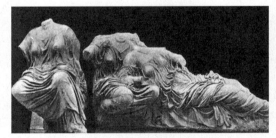

Figure 5.13: *Three Goddesses*, from the Parthenon, c. 438–432 B.C.E., marble, British Museum, London

Three Goddesses, from the Parthenon, c. 438–432 B.C.E., marble, British Museum, London (Figure 5.13)

- Figures are related to one another in their poses, positions, and interconnected meaning
- Clinging, "wet" drapery reveals the voluptuous bodies beneath; deeply cut drapery
- Figures sit naturally within the framework of the pediment

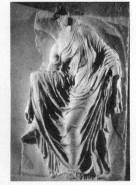

Figure 5.14: *Nike Adjusting Her Sandal*, from the Temple of Athena Nike, c. 410 B.C.E., marble, Acropolis Museum, Athens

Nike Adjusting Her Sandal, from the Temple of Athena Nike, c. 410 B.C.E., marble, Acropolis Museum, Athens (Figure 5.14)

- Graceful winged figure modeled in high relief
- Deeply incised drapery lines reveal body, wet drapery

Praxiteles, *Aphrodite of Knidos*, marble copy, c. 350–340 B.C.E., Vatican Museums, Rome (Figure 5.15)

- Statue once was housed in a round temple and could only have been seen by someone peeking through columns; voyeuristic view
- Novel in its approach to nudity for females; not openly erotic, but sensual
- Aphrodite steps into a bath
- She is admired, but averts her gaze
- She is taking a cloak off a water jar
- Sensuous S-curve to the body
- Gentle, dreamy quality
- Modest—hand covers her pelvis
- Composite of two Roman copies
- A god performing a human task of bathing

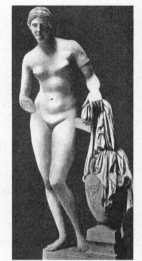

Figure 5.15: Praxiteles, *Aphrodite of Knidos*, marble copy, c. 350–340 B.C.E., Vatican Museums, Rome

Praxiteles, *Hermes and the Infant Dionysos*, from the Temple of Hera, Olympia, marble copy, c. 340 B.C.E., Archaeological Museum, Olympia (Figure 5.16)

- Shallow S-shaped curve; subtle modeling of musculature
- Soft shadows play on body surface
- Dionysos perhaps reaching for grapes once held by Hermes
- Hermes with a dreamy expression, a deep reverie

Lysippos, *Scraper*, marble copy from a bronze original, c. 330 B.C.E., Vatican Museums, Rome (Figure 5.17)

- Greek name: *Apoxyomenos*
- Encourages the viewer to walk around the sculpture; frontal view no longer the preferred view of a sculpture
- Thin forms, smaller heads, elongated bodies, sleek lanky look, eyes closely set
- Athlete is scraping off oil after a competition
- Arms are straight out, extended into space
- Head one-eighth of the body
- Twist of the knee, torsion of the body; leans back into a contrapposto stance
- Far-away look on the face

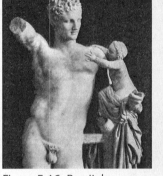

Figure 5.16: Praxiteles, *Hermes and the Infant Dionysos*, from the Temple of Hera, Olympia, marble copy, c. 340 B.C.E., Archaeological Museum, Olympia

Figure 5.17: Lysippos, *Scraper*, marble copy from a bronze original, c. 330 B.C.E., Vatican Museums, Rome

Characteristics of Greek Hellenistic Sculpture

Hellenistic sculptors offer a wider range of realistic modeling and a willingness to show more movement than their classical colleagues. Figures have a great variety of expression from sadness to joy. Themes untouched before, such as childhood, old age, despair, anger, and drunkenness, are common subjects in Hellenistic art. To be certain, there are still Hellenistic beauties, like the ***Venus de Milo*** (150–125 B.C.E.) (Figure 5.22), but the accent is on a variety of expressions sweeping across the range of human emotion. Moreover, sculptors carve with greater flexibility, employing negative space

more freely. The viewer is meant to walk around a Hellenistic sculpture and see it from many sides; hence, the work is often not meant to be placed against a wall.

Figure 5.18: Epigonos (?) *Dying Gaul* from Pergamon, 230–220 B.C.E., marble copy of a bronze original, Capitoline Museum, Rome

Figure 5.19: *Athena Battling Alkyoneos*, from the Pergamon Altar, c. 175 B.C.E., marble, State Museum, Berlin

Figure 5.20: *Nike of Samothrace*, c. 190 B.C.E., marble, Louvre, Paris

Major Works of Greek Hellenistic Sculpture

Epigonos (?), *Dying Gaul,* **from Pergamon, 230–220 B.C.E., marble copy of a bronze original, Capitoline Museum, Rome (Figure 5.18)**

- Trumpeter from Gaul collapsing on his instrument; blood oozing from his wound; shows defeat of the Gauls
- Seen as a hero by the Greeks, which in turn glorifies their conquest; part of a larger group celebrating the victory of Attalos I over the Gauls (cf. Figure 5.31)
- Represents a barbarian foe: hair kept in an uncultivated manner
- Figure meant to be seen in the round
- Negative space
- Great emotion shown on face

Athena Battling Alkyoneos, **from the Pergamon Altar, c. 175 B.C.E., marble, State Museum, Berlin (Figure 5.19)**

- Describes the battle between the gods and the giants; the giants, as helpless tools, were dragged up the stairs to worship the gods
- The gods' victory over the giants offers a parallel to Alexander the Great's defeat of the Persians
- Deeply carved figures overlap one another; masterful handling of spatial illusion
- Dramatic intensity of figures, movement; heroic musculature

Nike of Samothrace, **c. 190 B.C.E., marble, Louvre, Paris (Figure 5.20)**

- Meant to stand in or above a fountain representing a figurehead of a boat
- Wet drapery look imitates the water playing on the wet body
- Shows evidence of invisible wind on her body
- Probably built to commemorate a naval victory in 191 B.C.E.
- Dramatic twist and contrapposto of the torso
- Monumentality of the figure
- Her missing right arm may have raised a victory crown or held an open hand in greeting; perhaps she was landing on the prow of a ship
- The boat at the base is a battleship with oarboxes and traces of a ram

Statue of an Old Woman, **called the** *Old Market Woman,* **150–100 B.C.E., marble, Roman copy of a Greek original, Metropolitan Museum, New York (Figure 5.21)**

- Hellenistic work in its extreme realism and interest in old age
- Unknown function

- Some interpret the work as a woman presenting gifts of birds and fruit as an offering perhaps for a festival; dress is surprisingly elegant and is in contrast to the inelegant way it is worn; may have been an elderly worshipper of the god of wine, Dionysos
- Alternate interpretation is that she is an old market woman; poor, crippled with infirmities, returning from market with provisions

Alexandros, *Venus de Milo* (*Aphrodite of Melos*), c. 150–125 B.C.E., marble, Louvre, Paris (Figure 5.22)

- Elegance of pose, long S-shaped curve; sensuous; erotic
- One hand perhaps held an apple, her symbol or a mirror to admire herself with; the other hand probably held up her robes
- Softly modeled forms; light and shadow softly play on surface

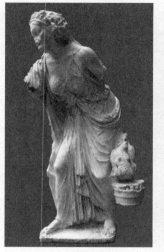 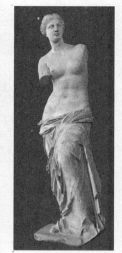

Figure 5.21: *Statue of an Old Woman*, called the *Old Market Woman*, 150–100 B.C.E., marble, Roman copy of a Greek original, Metropolitan Museum, New York

Figure 5.22: Alexandros, *Venus de Milo (Aphrodite of Melos)*, c. 150–125 B.C.E., marble, Louvre, Paris

Rhodes Sculptors, *Laocoön and His Sons*, First century, Vatican Museums, Rome (Figure 5.23)

- Story from the *Aeneid* of the Trojan priest who tried to warn his people of the dangers lurking inside the horse given to Troy by the Greeks; snakes were sent by the gods to prevent him from speaking
- High drama; emotional
- Twisting, curving forms; the eye cannot rest, wanders around the composition; viewing the composition from many angles is encouraged
- Heightened musculature accentuates pathos of the moment
- Negative space

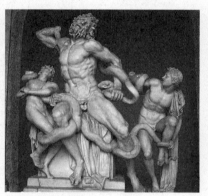

Figure 5.23: Rhodes Sculptors, *Laocoön and His Sons*, First century, marble, Vatican Museums, Rome

INNOVATIONS IN GREEK ARCHITECTURE

Like the Egyptians, the Greeks designed their temples to be the earthly homes of the gods. Also like the Egyptians, the Greeks preferred limited access to the deity. This is one reason why such grand temples had doors that were removed from public view. In fact, architecturally the front and back of Greek temples look almost identical; only the sculptural ornament is different. When Greeks came to worship they congregated at a temple near the building. Interiors of temples held huge statues whose forbidding presence allowed only those with appropriate credentials to enter.

There are three types of Greek temples: Doric, Ionic, and Corinthian (Figure 5.24). Greeks in mainland Greece and in the places they settled, like Sicily, preferred the Doric

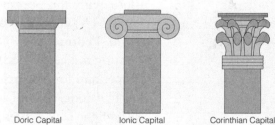

Doric Capital Ionic Capital Corinthian Capital

Figure 5.24: Greek orders of columns

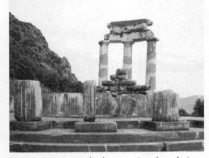

Figure 5.25: A tholos, a circular shrine

style, with its simplified capitals and columns with tapered **shafts** that sit, without a base, directly on the floor of the temple. Doric temples have unadorned **architraves** and alternating **triglyphs** and **metopes**, the latter depicting episodes from Greek mythology. Greek island architects preferred the Ionic style, with its volutelike capitals, columns that sit on bases, and **friezes** of sculpture placed along the **entablature**. Later, the Corinthian order was introduced, in which the capitals had leaves and the straight columns had bases that transitioned to the floor. The different orders of Greek architecture were occasionally freely mixed, as in the case of the **Parthenon**, where a Doric temple has Ionic features, like a frieze, introduced on the inside.

Elaborate Greek temple complexes were placed on a high hill, or **acropolis**, overlooking the city. Gateways, called **propylaea**, prepared the visitor for his or her entrance into the complex.

Greek temple architecture shows a reliance on few forms and develops these. However, there are two innovations of note. The first was the circular shrine, called a **tholos** (Figure 5.25), which represents perfection to the geometry-minded Greeks.

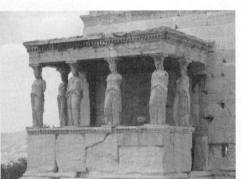

Figure 5.26: Caryatids act as columns holding up a building

The second is the introduction of columns carved as figures, the female version of which are called **caryatids** (Figure 5.26). These columns have to be carefully executed because the weight of the building rests on the thin points of a body's structure: the neck and the legs. This means that all caryatids have long hair and solid gowns in order to stabilize the building above.

Besides temples, the Greeks built a number of other important buildings, such as shopping centers, called stoas, and theaters for the presentation of Greek plays. The theaters are marvels of construction, possessing incredible acoustics, especially considering that the performances were held in the open air. Some 12,000 people seated at the theater at **Epidauros** (Figure 5.30) could hear every word, even if they were seated 55 rows back.

Characteristics of Greek Architecture

Except for the rare **tholos** shrines, Greek temples are rectangular and organized on an inventive, although rigid, set of geometric principles, which tantalized Greek thinkers and philosophers. Temples are

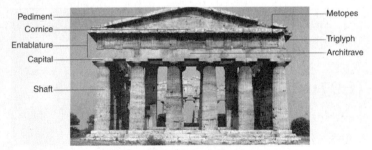

Figure 5.27: Parts of a Doric Greek temple

built with the post-and-lintel system in mind, the columns never too widely set apart. The columns completely surround the temple core in a design called a **peristyle**. **Pediments**, which project over the tops of columns, contain sculpture representing the heroic deeds of the god or goddess housed inside. A **cornice** separates the upper and lower parts of a Greek temple (Figure 5.27).

The doors are set back from the façade, sometimes by two rows of columns, so that little light could enter these generally windowless buildings. This increases the sense of mystery about the interior, where few could go and the deity serenely reigned.

Major Works of Greek Architecture

Iktinos and Kallikrates, The Parthenon, 447–438 B.C.E., Athens, Greece (Figure 5.28)

- Constructed under the leadership of Pericles after the Persian sack of Athens in 480 B.C.E. destroyed the original Acropolis
- Pericles used the extra funds in the Persian war treasury to build the Acropolis; Greek allies were furious
- Greek predilection for algebra and geometry omnipresent in the design of this building: Parts can be expressed as $x = 2y + 1$; thus, there are 17 columns on the side (x) and 8 columns in the front (y), and the ratio of the length to the width is 9:4; proportions are the same for the cella
- Unusually light interior had two windows in the cella
- Floor curves upward in the center of the façade to drain off rain water and to deflect appearance of sagging at the ends
- The columns at the ends are surrounded by light, which alters their appearance, so they are made thicker in order to look the same as the other columns
- Ionic elements in a Doric temple: rear room contains Ionic capitals, frieze on interior is Ionic
- Interior built to house a massive statue of Athena, to whom the building was dedicated

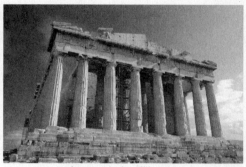

Figure 5.28: Iktinos and Kallikrates, The Parthenon, 447–438 B.C.E., Athens, Greece

The Erechtheion, 421–405 B.C.E., Athens, Greece (Figure 5.29)

- Honors Erechtheus, a legendary early king of Athens, during whose reign an ancient wooden idol of Athena was said to have fallen from the heavens, and who promoted devotion to Athena
- Also marks the spot where Athena and Poseidon competed to be patrons of the city of Athens
- Because it incorporated a few sites, the building has an irregular, asymmetrical plan, unusual in Greek architecture
- Caryatids walk toward the Parthenon in a procession
- Ionic temple

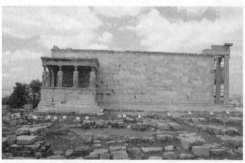

Figure 5.29: The Erechtheion, 421–405 B.C.E., Athens, Greece

Polykleitos, Theater, c. 350 B.C.E., Epidauros, Greece (Figure 5.30)

- Theaters often had a view of the sea; the sea plays an important role in Greek drama
- Acoustics were excellent; every one of the 12,000 spectators could hear
- Stage juts out and is encircled by the audience on three sides
- Stage had removable and modest sets
- Plays typically held on feast days and as part of contests

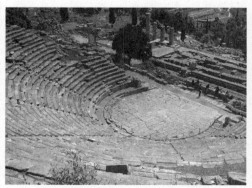

Figure 5.30: Polykleitos, Theater, c. 350 B.C.E., Epidauros, Greece

Pergamon Altar, c. 175 B.C.E., State Museum, Berlin (Figure 5.31)

- Altar placed on an elevated platform up a dramatic flight of stairs
- Conscious effort to be in dialogue with the Panathenatic Frieze on the Parthenon
- 7½-foot-high frieze over 400 feet long wraps around monument
 - Contains an altar dedicated to Zeus
 - Ionic columns frame monument
 - Parallels made between King Attalos I's victories over the Gauls in a recent war, Alexander the Great's defeat of the Persians, and the gods' defeat over the giants in mythology

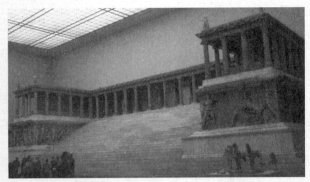

Figure 5.31: Pergamon Altar, c. 175 B.C.E., State Museum, Berlin

INNOVATIONS OF GREEK POTTERY

Much of what is known about Greek painting comes from pottery, which survives in surprising quantities, even though mural painting has almost totally disappeared. Professional pottery had been practiced in Greece from its origins in Aegean society throughout the entire span of the Greek period. Some vessels are everyday items, others serve as tomb monuments. Massive kraters have holes at the bottom so that when libations are poured liquid could run out the bottom of the pot and onto the grave itself. Pots that were used for these purposes often have a scene of the deceased lying on a bier surrounded by mourners. Chariots and warriors complete the grieving procession (Figure 5.32).

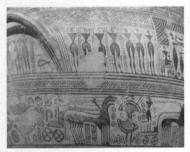

Figure 5.32: Funeral procession from a black figure krater.

Form followed function in Greek pottery. Most pots were designed for a particular purpose and were so shaped. The portable **amphora** (Figure 5.33) stored provisions like oil or wine with an opening large enough to admit a ladle. The **krater** (Figure 5.34) was a bowl for mixing water and wine because the Greeks never drank their wine straight. A **kylix** (Figure 5.35), with its wide mouth and shallow dimensions, was a drinking cup, ideal for the display of scenes on the relatively flat bottom.

Painters wrote a myriad of inscriptions that were sometimes literally addressed to the viewer of the pot, saying things like "I greet you." Inscriptions could explain the narrative scene represented, or identify people or objects. The underside of vases usually indicated the selling transaction of the pot.

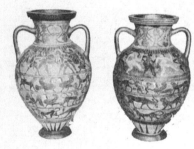

Figure 5.33: Amphoras

Characteristics of Greek Pottery

Earliest pots done during the Geometric period are largely composed of horizontal lines with minimal figures (Figure 5.34).

In the next period, called Orientalizing, there is much influence from Egyptian and Mesopotamian art, so eastern floral motifs and exotic animals take their place next to the geometric bands of ornament (Figure 5.36).

In the Archaic period, artists painted in a style called **black figure**, which emphasized large figures drawn in black on the red natural surface of the clay. Other colors would burn in the high temperature of the **kiln**, so after the pot had been fired, details

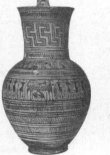

Figure 5.34: Geometric krater

Figure 5.35: Kylix

were added in highlighting colors. The bright glazing of Greek pottery gives the surface a lustrous shine. At the end of the Archaic period, **red figure** vases were introduced by Andokides; in effect, they are the reversal of black figure style pots. The backgrounds were painted in black, and the natural red of the clay detailed the forms.

Archaic pottery has the same stiffness and monumentality of Archaic sculpture. Achievements in Classical sculpture, such as **contrapposto**, were paralleled in pottery as well. Similarly the dynamic movements of the Hellenistic period were reflected in Greek Hellenistic pottery.

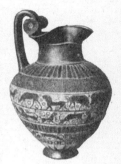

Figure 5.36: Orientalizing style

Major Works of Greek Pottery

Klietias, *François Vase*, c. 570 B.C.E., ceramic, Archaeological Museum, Florence (Figure 5.37)

- Signed by the potter and the painter twice
- More than two hundred figures represented in six superimposed rows and two rows on each handle
- Nearly every feature is labeled, even horses, dogs, and water jars
- Mythological subjects, among which are a boar hunt, a dance of maidens rescued from the minotaur by Theseus, a chariot race at the funeral of Patroklos, arrival of the gods at the wedding of Peleus and Thetis, a row of animals and monsters, and Ajax carrying the dead body of Achilles (on the handle)
- Separate themes on each band of the vase echo one another; parallels draw meaning from various mythological episodes
- Said to have every Greek god on the vase

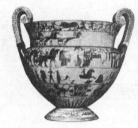

Figure 5.37: Klietias, *François Vase*, c. 570 B.C.E., Archaeological Museum, Florence

Exekias, *Ajax and Achilles Playing Dice*, c. 540–530 B.C.E., ceramic, Vatican Museums, Rome (Figure 5.38)

- Concentration on two competing figures on a Greek amphora
- Subdued emotions portrayed
- Spears suggest depth; spears at the ready, enemies will not catch them unaware
- Legs mirror the reflective pose
- Black figure style with decorative band of geometric designs
- Left: Achilles wins by saying "four"; Right: Ajax says "three"; it is ironic that Ajax will live and bury his dead friend Achilles, who will eventually lose in a battle

Figure 5.38: Exekias, *Ajax and Achilles Playing Dice*, c. 540–530 B.C.E., Vatican Museums, Rome

Euphronios, *Death of Sarpedon*, 515 B.C.E., ceramic, Etruscan Museum, Rome (Figure 5.39)

- Illustrates a moment in Homer's *Iliad* when the Greek warrior Sarpedon, who was allied with Trojans, was killed by Patroclus
- Flanking figures of Sleep and Death carry the body to its final resting place
- Hermes with his caduceus and strangely disembodied legs watches the scene
- Strong diagonal lines dominate the composition
- Interest in exaggerated anatomical detail

Figure 5.39: Euphronios, *Death of Sarpedon*, 515 B.C.E., ceramic, Etruscan Museum, Rome

Major Work of Greek Painting

Battle of Issus, c. 310 B.C.E., Roman copy of c. 100 B.C.E., mosaic, National Archaeological Museum, Naples (Figure 5.40)

- Alexander at left: young, brave, forthright, assured of success
- Darius in center right on chariot: horrified, weakly ceding the victory; his charioteer commands the horses to make their escape
- Crowded, with nervous excitement

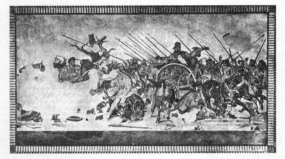

Figure 5.40: *Battle of Issus,* c. 310 B.C.E., Roman copy of c. 100 B.C.E., mosaic, National Archaeological Museum, Naples

- Roman floor mosaic based on an original Greek mural (?) painting, found at Pompeii
- Extremely complex interweaving of figures

VOCABULARY

Acropolis: literally, a "high city," a Greek temple complex built on a hill over a city

Amphora: a two-handled Greek storage jar (Figure 5.33)

Architrave: a plain, unornamented lintel on the entablature (Figure 5.27)

Canon: a body of rules or laws; in Greek art, the ideal mathematical proportion of a figure

Caryatid (male: **atlantid):** a building column that is shaped like a female figure (Figure 5.26)

Cella: the main room of a Greek temple where the god is housed

Contrapposto: a graceful arrangement of the body based on tilted shoulders and hips and bent knees (Figure 5.12)

Cornice: a projecting ledge over a wall (Figure 5.27)

Entablature: the upper story of a Greek temple (Figure 5.27)

Frieze: a horizontal band of sculpture

Kiln: an oven used for making pottery

Kouros (female: **kore):** an archaic Greek sculpture of a standing youth (Figures 5.1 and 5.4)

Krater: a large Greek bowl used for mixing water and wine (Figure 5.34)

Kylix: a Greek drinking cup (Figure 5.35)

Metope: a small relief sculpture on the façade of a Greek temple (Figure 5.27)

Mosaic: a decoration using pieces of stone, marble, or colored glass, called **tesserae,** that are cemented to a wall or a floor (Figure 5.40)

Pediment: the triangular top of a temple that contains sculpture (Figure 5.27)

Peristyle: a colonnade surrounding a Greek temple (Figure 5.28)

Propylaeum (plural: **propylaea):** a gateway leading to a Greek temple

Relief sculpture: sculpture that projects from a flat background. A very shallow relief sculpture is called a **bas-relief** (pronounced: bah-relief) (Figure 5.14)

Shaft: the body of a column (Figure 5.27)

Tholos: an ancient Greek circular shrine (Figure 5.25)

Trigylph: a projecting grooved element alternating with a metope on a Greek temple (Figure 5.27)

Summary

The Greeks have had such a powerful influence on history that we have dubbed their art "classical," a word that means, among many other things, a standard of authority.

Greek temples are typically surrounded by an imposing set of columns that embrace the cella where the god is housed. The temple itself is often set apart from the rest of the city, sometimes located on an adjoining hill called an acropolis. Greek theaters, like the temples, are built of cut stone carefully carved into an important site.

Greek sculpture and pottery (little painting survives) is divided into a number of periods. Geometric pottery is characterized by linear designs and abstract patterns. The next style, called Orientalizing, shows an influence of Egyptian and Mesopotamian art.

Greek Archaic art is known for its bolt upright figures and animating smiles. The Classical period is characterized by the use of contrapposto, a figure placed in a relaxed pose and standing naturally. Fifth century B.C.E. art is known for its idealized body types; however, more humanizing expressions characterize fourth century B.C.E. work.

The last phase, called Hellenistic, shows figures with a greater range of expression and movement. Often sculptures look beyond themselves, at an approaching enemy perhaps, or in the face of an unseen wind.

Whatever the period, Greek art has provided a standard against which other classicizing trends in art history have been measured.

Practice Exercises

Questions 1 and 2 refer to Figure 5.41.

1. What period in Greek art is this sculpture from?

 (A) Geometric
 (B) Archaic
 (C) Classical
 (D) Hellenistic

2. This work can best be described as

 (A) influenced by Egyptian art
 (B) a relief sculpture
 (C) a work that was mounted on top of a Greek temple
 (D) meant to be seen from several viewpoints

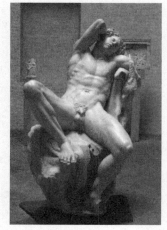

Figure 5.41

3. Caryatids were figures that can be found on

 (A) the Parthenon
 (B) the Erechtheion
 (C) the theatre at Epidaurus
 (D) in the Battle of Issus

CHALLENGE 4. Polykleitos was the famous sculptor of the *Spear Bearer*, but he also

 (A) constructed the works on the Parthenon
 (B) oversaw the artistic decoration of the Erechtheion
 (C) wrote a canon of human proportions
 (D) organized Greek artists into unions

Question 5 refers to Figure 5.42.

5. What order of Greek architecture is this building?

 (A) Doric
 (B) Ionic
 (C) Corinthian
 (D) Tuscan

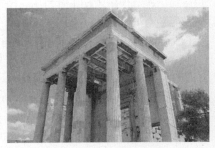

Figure 5.42

Questions 6 and 7 refer to Figure 5.43.

CHALLENGE 6. This figure is an example of what kind of Greek vase?

 (A) Amphora
 (B) Kylix
 (C) Pitcher
 (D) Krater

7. What style of Greek pottery was this vase done in?

 (A) Red figure
 (B) Black figure
 (C) Geometric
 (D) Orientalizing

Figure 5.43

Questions 8 and 9 refer to Figure 5.44.

8. This selection from the Pergamon Altar shows the

 (A) gods rejoicing
 (B) gods dragging the giants up the stairs
 (C) gods kneeling before Zeus
 (D) kouros figures in action

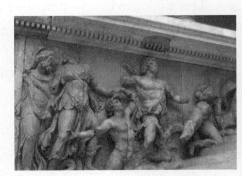

Figure 5.44

9. The Pergamon Altar was designed to parallel the gods' victories with those of

 (A) Apollo
 (B) Alexander the Great
 (C) Darius
 (D) Plato

10. A metope

 (A) contains sculpture
 (B) has grooved ridges on it
 (C) is a type of Greek pottery
 (D) can be seen in a frieze

Short Essay

Identify the sculpture in Figure 5.45. Tell which period of Greek art it comes from, and compare it with the style of works from the immediately preceding period. Use one side of a sheet of lined paper to write your essay.

Figure 5.45

Answer Key

| 1. **(D)** | 3. **(B)** | 5. **(B)** | 7. **(B)** | 9. **(B)** |
| 2. **(D)** | 4. **(C)** | 6. **(A)** | 8. **(B)** | 10. **(A)** |

Answers Explained

Multiple-Choice

1. **(D)** *The Barberini Faun* is a Hellenistic work, which can be seen by the extremely expressive and emotional way it is rendered.

2. **(D)** As a Hellenistic piece the work is meant to be seen from many sides.

3. **(B)** The famous caryatids are on the Erechtheion.

4. **(C)** Polykleitos was also a theoretician who wrote a famous canon of human proportions.

5. **(B)** The voluted capitals reveal this to be an Ionic building.

6. **(A)** This vase is an amphora.

7. **(B)** The piece is a black figure vase. The black areas represent the figures, and the natural red clay highlights them.

8. **(B)** The Pergamon Altar unifies the sculpture and the architecture. The real stairs act as a set for the gods' victory over the giants.

9. **(B)** Alexander the Great's smashing of the Persian Empire is one of the parallels drawn here.

10. **(A)** A metope is a small panel on a Greek temple that contains sculpture.

Rubric for Short Essay

4: The student identifies the work as the *Laocoön and His Sons*, from the Hellenistic period, and discusses the characteristics that contrast it to the previous Classical period. There are no major errors.

3: The student identifies the work as the *Laocoön and His Sons*, from the Hellenistic period, and discusses, perhaps in a superficial way, the characteristics that contrast it to the previous Classical period. There may be minor errors.

2: The student does not identify the work but knows it is Hellenistic and discusses something about the relationship of Hellenistic art to the Classical period. There may be major errors.

1: The student simply identifies the work and adds little else, OR the student identifies the work as Hellenistic and discusses little else about the relationship of Hellenistic art to Classical art. There may be major errors.

0: The student makes an attempt, but the response is without merit.

Short Essay Model Response

The sculpture represented is <u>Laocoön and His Son</u>, which was done by three Rhodes sculptors. The three sculptors, Anthanadoros, Hagesandros, and Polydoros, sculpted this piece during the Hellenistic period. The Hellenistic period is the period right after the Classical period, although its artwork was sculpted very differently from Classical art.

Classical and Hellenistic artwork both have contrapposto, which are bends and curves of the body similar to actual human stances. However, Hellenistic work has a lot of negative space, unlike Classical art. Also, it can be viewed from many perspectives. Classical art commonly has one and only one point of view, such as seen in the <u>Kritios Boy</u>.

One of the biggest changes in the Hellenistic art is the emotion shown on the face. Classical art shows few emotions, even when the figures are doing strenuous activities, giving them a godlike appearance. This is the case in the <u>Discus Thrower</u> by Myron, in which no expression is expressed. In Hellenistic art, many emotions and feelings are expressed. The many differences in Classical and Hellenistic art make it easy to differentiate between the artwork of the two periods.

—Gabe Sa.

Analysis of Model Response

Gabe identifies the name of the sculpture, including the artists' names. He goes on to classify it correctly as Hellenistic, and he provides several important ways in which Hellenistic art differs from Classical, that is, changes in the emotion of the figures, increased use of negative space, and the shifting viewpoint of the observer. **This essay merits a 4.**

Etruscan Art

TIME PERIOD

Tenth century B.C.E. to c. 270 B.C.E.
Height: seventh–sixth centuries B.C.E.

KEY IDEAS

- Most of what is known about Etruscan civilization comes down to us in elaborate necropoli filled with tombs that resemble large rooms in a home.
- Etruscan sculptures and temples are heavily influenced by Archaic Greek works.
- Etruscan sculptors excel in bronze and terra-cotta production.

HISTORICAL BACKGROUND

The Etruscans are the people who lived in Italy before the arrival of the Romans. Although they heavily influenced the Romans, their language and customs were different. The ravages of time have destroyed much of what the Etruscans accomplished, but fortunately their sophisticated tombs in huge **necropoli** still survive in sufficient numbers to give us some idea of Etruscan life and art. Eventually the Romans swallowed Etruscan culture whole, taking from it what they could use.

CHARACTERISTICS OF ETRUSCAN ARCHITECTURE

Much of what is known about the Etruscans comes from their tombs, which are arranged in densely packed **necropoli** throughout the Italian region of Tuscany, an area named for the Etruscans. Most tombs are round structures with a door leading to a large interior chamber that is brightly painted to reflect the interior of an Etruscan house. These tombs frequently have symbols of the Etruscan lifestyle on their walls. Entire families, with their servants, are often buried in one tomb.

Little is known about Etruscan temples, except what can be gleaned from the Roman architect Vitruvius, who wrote about them extensively. Superficially, they seem to be inspired by Greek buildings, with their pediments and columns, and the cella behind the porch. But Etruscan buildings were made of wood and **terra-cotta**, not stone. Moreover, there is a flight of stairs leading up to the principal entrance, not a uniform set of steps surrounding the whole building. Sculptures were placed on the rooftops, unlike in Greek temples, to announce the presence of the deity within.

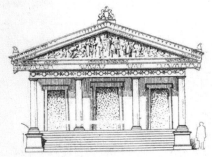

Figure 6.1: Model of an Etruscan Temple

Major Work of Etruscan Architecture

Model of an Etruscan Temple (Figure 6.1)

- Not much architecture survives; this model is drawn from descriptions by Vitruvius, a Roman architect during the first century B.C.E.
- Temple made of mud-brick and wood
- Steps in front direct your attention to the deep porch
- Influences of Greek architecture in the columns and capitals; columns are unfluted
- Raised on a podium
- Three doors represent three gods

Tomb of the Seats and Shields, seventh–sixth centuries B.C.E., Cerveteri, Italy (Figure 6.2)

- Underground rock-cut tombs reflect Etruscan domestic architecture
- Ceiling cut as if a series of rafters held it up
- Large armchairs frame doorways
 - Windows, furniture, and objects are eternalized in stone, cut into the rock; objects cater to the dead in the afterlife
 - Large circular shields hang from walls

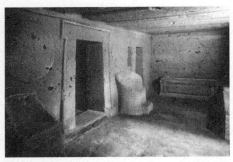

Figure 6.2: Tomb of the Seats and Shields, seventh–sixth centuries B.C.E., Cerveteri, Italy

CHARACTERISTICS OF ETRUSCAN PAINTING

What survives of Etruscan painting is funerary, done on the walls and ceilings of tombs—some 280 painted chambers are still extant. Brightly painted frescoes reveal a world full of cheerful Etruscans celebrating, dancing, eating, and playing musical instruments. Much of the influence is probably Greek, but even less Greek painting from this period survives, so it is hard to draw firm parallels.

Major Work of Etruscan Painting

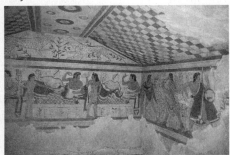

Figure 6.3: Tomb of the Leopards, c. 480–470 B.C.E., Tarquinia, Italy

Tomb of the Leopards, c. 480–470 B.C.E., Tarquinia, Italy (Figure 6.3)

- Banqueting couples recline, eating in the ancient manner
- Ancient convention of men painted in darker colors than women
- Trees spring up between the main figures, and shrubbery grows beneath the reclining couches—perhaps suggesting a rural setting
- Perhaps a funeral banquet is intended, but the emotions are of celebration
- Ceiling has polychrome checkerboard pattern; circles may symbolize time
- Dancing figures on right play musical instruments in festive celebration of the dead

CHARACTERISTICS OF ETRUSCAN SCULPTURE

Terra-cotta, **stucco**, and bronze were the preferred media for Etruscan sculpture; on occasion, stonework was introduced. Terra-cotta sculptures were modeled rather than carved. The firing of large-scale works in a kiln betray great technological prowess.

Most Etruscan sculpture, like the ***Apollo from Veii*** from c. 510 B.C.E. (Figure 6.5), shows an awareness of Greek Archaic art, although the comparisons go only so far. In Greece, kouros figures were carved as stoic and proud, with an occasional smile to give life. For the Etruscans, whose terra-cotta work is brilliantly painted, figures move dynamically in space, aware of the world around them. Both cultures emphasize the broad shoulders of men and a stylization of the hair; however, the Etruscans avoid nudity.

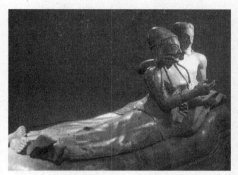

Figure 6.4: *Sarcophagus from Cerveteri*, c. 520 B.C.E., terra-cotta, Museo Nazionale di Villa Giulia, Rome

Major Works of Etruscan Sculpture

Sarcophagus from Cerveteri, c. 520 B.C.E., terra-cotta, Museo Nazionale di Villa Giulia, Rome (Figure 6.4)

- Sarcophagus of a married couple, whose ashes were placed inside
- Full-length portraits
- Both once held objects in their hands—perhaps an egg to symbolize life after death
- Great concentration on the upper body; less on the legs
- Bodies make an unrealistic L-turn to the legs
- Ancient tradition of reclining while eating; represents a banquet couch
- Symbiotic relationship: man has a protective gesture around the woman; the woman feeds the man; reflects the high standing women had in Etruscan society
- Broad shoulders; little anatomical modeling
- Emaciated hands
- Made in separate pieces and joined together

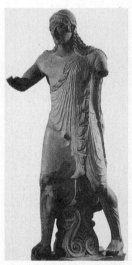

Figure 6.5: *Apollo from Veii*, c. 510 B.C.E., terra cotta, Museo Nazionale di Villa Giulia, Rome

Apollo from Veii, c. 510 B.C.E., terra-cotta, Museo Nazionale di Villa Giulia, Rome (Figure 6.5)

- One of four large figures that once stood on the Temple at Veii
- Figure has spirit, moves quickly as it strides forward
- Stood on the roof of the temple: an Etruscan innovation; meant to be seen from below
- Archaic smile

Capitoline Wolf, c. 500 B.C.E., bronze, Medieval copy (?), Capitoline Museum, Rome (Figure 6.6)

- Alert, snarling, protective, aware, tense, watchful, fierce
- Very thin body
- Wolves have no manes or curly ringlets of hair

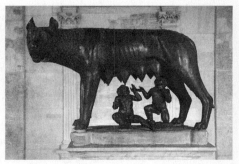

Figure 6.6: *Capitoline Wolf*, c. 500 B.C.E., bronze, Capitoline Museum, Rome

- Face is not wolflike
- Story of Romulus and Remus suckled by the She-Wolf; later became founders of Rome

 - Children added later in the Renaissance
 - Scholarly debate over the dating of this object; may be Medieval copy

Chimera of Arezzo, **400–350 B.C.E., bronze, National Archaeological Museum, Florence (Figure 6.7)**

- Composite ancient animal with a lion's head and body, a goat's neck springing from the spine, and a snake for a tail
- Angry, snarling, wounded, the chimera is posed for attack
- Richly articulated anatomy; spikelike mane; hurt defensive posture

Figure 6.7: *Chimera of Arezzo,* 400–350 B.C.E., bronze, National Archaeological Museum, Florence

VOCABULARY

Necropolis (plural: **necropoli**): literally, a "city of the dead," a large burial area
Stucco: a fine plaster used for wall decorations or moldings
Terra-cotta: a hard ceramic clay used for building or for making pottery (Figures 6.4 and 6.5)
Tumulus (plural: **tumuli**): an artificial mound of earth and stones placed over a grave

Summary

The Etruscans were a people who occupied central Italy before the arrival of the Romans—indeed, the region Tuscany is named for them. The remains of their civilization can be gleaned from written sources of later historians like Vitruvius or from what was buried in their expansive necropoli.

The Etruscans erected large mound-shaped tombs that contained a single large room in which the deceased were interred. The wall murals and stucco designs on the interior of the tombs are thought to parallel the interior of Etruscan homes. Large sarcophagi, made of terra-cotta, were placed within the tomb, usually containing the ashes of the deceased. The style of these works betrays a knowledge of Archaic Greek works from around the same time.

The Etruscans were eventually overwhelmed by the Romans, who continued to employ Etruscan artists well into the Roman Republic.

Practice Exercises

1. Etruscan sculpture is different from Greek sculpture in that in Etruscan art

 (A) figures smile
 (B) heads are proportionally smaller
 (C) terra-cotta is favored
 (D) relief sculpture is more common than sculpture in the round

2. A tumulus marks a

 (A) grave
 (B) temple
 (C) forum
 (D) terra-cotta god or goddess

3. Etruscan temples resemble Greek temples in that they both

 CHALLENGE

 (A) have sculptures on the roof
 (B) are made of wood and mud-brick
 (C) have pediments
 (D) have a central flight of stairs

4. Etruscan tombs are unusual in that they

 (A) are carved from the living rock
 (B) are made of terra-cotta
 (C) have a number of occupants
 (D) look like a domestic interior

5. Etruscan sculptures are unusual in that they are

 (A) very heavy
 (B) placed on the roofs of temples
 (C) located in pediments and in cellas
 (D) small and delicately carved

Short Essay

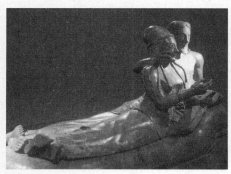

Identify this work from the Etruscan civilization. How does the artist reflect society's view of Etruscan relationships in this sculpture? Use one side of a sheet of lined paper to write your essay.

Figure 6.8

Answer Key

1. **(C)** 3. **(C)** 5. **(B)**
2. **(A)** 4. **(D)**

Answers Explained

Multiple-Choice

1. **(C)** Terra-cotta is a specialty of Etruscan art.

2. **(A)** A tumulus is an artificial mound of earth or stones placed over a grave.

3. **(C)** Etruscan temples have characteristics in each answer choice. Only pediments are characteristic of both Etruscan and Greek temples.

4. **(D)** Etruscan tombs were probably constructed to resemble the interiors of many homes, complete with stucco versions of implements commonly found in kitchens.

5. **(B)** Etruscan sculptures, even the life-size ones, are sometimes placed on the roofs of temples.

Rubric for Short Essay

4: The student identifies the work and understands how the partnering of the man and the woman expresses an equality unusual in ancient art. Discussion is full and without major errors.

3: The student identifies the work and understands how the partnering of the man and the woman expresses an equality unusual in ancient art. Discussion is less full than a 4 and may contain minor errors.

2: This is the highest grade a student can earn if he or she does not identify the name of the work. Discussion is superficial and may contain major errors.

1: The student identifies only the work, OR the student expresses only a superficial understanding of the relationships between the figures. Discussion may contain major errors.

0: The student makes an attempt, but the response is without merit.

Short Essay Model Response

This work is the <u>Sarcophagus from Cerveteri</u>. It is an Etruscan piece made out of terra-cotta. This sculpture reflects the Etruscans' view on the relationships between men and women and their place in Etruscan society. The figures are depicted eating while reclining on a couch, as was the ancient custom. Both figures are smiling—enjoying themselves—although their bodies are in an abnormal position, that is, their legs are at a right angle to their chests. The woman is feeding the man, providing sustenance, and eating as well. The man has his hands around the woman, showing that he is protecting her. Based on the actions and positions of the man and woman, one can conclude that the Etruscans viewed men and women as virtual equals. The sculpture indicates a symbiotic relationship between the two: she provides the food, he provides the protection. This Etruscan portrayal of equality of the sexes was a concept that civilizations much later in time would develop, and was absent from the mindset of Greeks, Romans, and other ancients.

—Eric E.

Analysis of Model Response

Eric identifies the work immediately. Although extraneous information, such as the medium being terra-cotta, does not contribute to the score, it expresses a greater understanding of the sculpture in the context of Etruscan art. Eric goes on to show how the arrangement of the figures and their symbolic gestures can be interpreted to mean a "symbiotic relationship" is expressed. **This essay merits a 4.**

Roman Art

TIME PERIOD: 753 B.C.E.–fifth century C.E.

Legendary founding of Rome by Romulus and Remus	753 B.C.E.
Roman Republic	509 B.C.E.–27 B.C.E.
Early and High Roman Empire	27 B.C.E.–192 C.E.
Late Roman Empire	192 C.E.–410 C.E.

KEY IDEAS

- Roman art reflects the ambitions of a powerful empire—monumental buildings and sculptures reflect the glory of the gods and the state.
- Roman architecture is revolutionary in its understanding of the powers of the arch, the vault, and concrete.
- A history of Roman painting survives on the walls of Pompeiian villas.
- Romans show an interest in the basic elements of perspective and foreshortening.
- Roman sculpture is greatly indebted to Greek models.

HISTORICAL BACKGROUND

From hillside village to world power, Rome rose to glory by diplomacy and military might. The effects of Roman civilization are still felt today in the fields of law, literature, and the fine arts.

According to legend, Romulus and Remus, abandoned twins, were suckled by a She-Wolf, and later established the city of Rome on its fabled seven hills. At first the state was ruled by kings, who were later overthrown and replaced by a Senate. The Romans then established a democracy of a sort, with magistrates ruling the country in concert with the Senate, an elected body of privileged Roman men.

Variously well-executed wars increased Rome's fortunes and boundaries. In 211 B.C.E., the Greek colony of Syracuse in Sicily was annexed. This was followed, in 146 B.C.E., by the absorption of Greece. The Romans valued Greek cultural riches and imported boatloads of sculpture, pottery, and jewelry to adorn the capital. Moreover, a general movement took hold to reproduce Greek art by establishing workshops that did little more than make copies of Greek sculpture.

Civil war in the late Republic caused a power vacuum that was filled by Octavian, later called Augustus Caesar, who became emperor in 27 B.C.E. From that time, Rome was ruled by a series of emperors as it expanded to faraway Mesopotamia and then retracted to a shadow of itself when it was sacked in 410 C.E.

The single most important archaeological site in the Roman world is the city of Pompeii, which was buried by volcanic ash from Mount Vesuvius in 79 C.E. In 1748, systematic excavation—actually more like fortune hunting—was begun. Because of Pompeii, we know more about daily life in ancient Rome than we know about any other civilization in history.

Patronage and Artistic Life

The Roman state and its wealthiest individuals were the major patrons of the arts. They could be known to spend lavishly on themselves and their homes, but they also felt a dedication to the general good and generously patronized public projects as well. The demand for Greek works was so great that huge workshops were established throughout the Roman world to meet the demand. Many items were imported from Greece itself to give their works an air of authenticity.

The homes of wealthy Romans, such as the ones that survive at Pompeii (Figure 7.8), were stage sets in which the influential could demonstrate their power and privilege. Elaborate social rituals inspired Romans to build their houses in order to impress and entertain. Consequently, Romans designed lavishly appointed interiors containing everything from finely executed fresco paintings (Figure 7.24) to marble plumbing fixtures. Thus the interiors were grand domestic spaces that announced the importance of the owner. Artists, considered low members of the social scale, were treated poorly. Many were slaves who toiled in anonymity.

INNOVATIONS IN ROMAN ARCHITECTURE

The Romans were master builders. Improving upon nascent architectural techniques, they forged great roads and massive aqueducts as an efficient way of connecting their empire and making cities livable. Their temples were hymns to the gods and symbols of civic pride. Their arenas awed spectators both by their size and their engineering genius.

The Romans understood the possibilities of the arch, an architectural device known before but little used. Because arches could span huge spaces, they do not need the constant support of the post-and-lintel system. Each wedge-shaped stone of a Roman arch is smaller at the bottom and wider at the top. This seemingly simple development allowed a stable arch to stand indefinitely because the wider top could not pass through the narrower bottom. Mortar is not needed because the shape of stones in the arch supports the structure unaided.

Figure 7.1: Barrel vault

Roman architects understood that arches could be extended in space and form a continuous tunnel-like construction called a **barrel vault** (Figure 7.1). When two barrel vaults intersect, a larger, more open space is formed, called a **groin vault** (Figure 7.2). The latter is particularly important because the groin vault could be supported with only four corner **piers,** rather than requiring a continuous wall space that a barrel vault needed (Figure 7.3). The spaces between the arches on the piers are called **spandrels** (Figure 7.4).

Figure 7.2: Groin vault

Arches and vaults make enormous buildings possible, like the **Pont du Gard** (c. 16 B.C.E.) (Figure 7.10) and the **Colosseum** (72–80 C.E.) (Figure 7.12), and they also make feasible vast interior spaces like the **Pantheon** (118–125 C.E.) (Figures 7.14 and 7.15). Concrete walls are very heavy. To prevent the weight of a dome from cracking the walls beneath it, **coffers** (Figure 7.5) are carved into ceilings to lighten the load.

Figure 7.3: Piers

Figure 7.4: Spandrels are in the light areas

The Romans used concrete in constructing many of their oversized buildings. Although not their invention, once again they made this technique workable, using it initially as filler in buildings and then as the main support element. Romans thought that concrete was ugly and its aesthetics seemed displeasing, so although its flexibility and low cost were desirable, all concrete buildings were cloaked with another material, like marble, which seemed more attractive to their eye.

Figure 7.5: Coffers

Characteristics of Roman Architecture

Much is known about Roman domestic architecture, principally because of what has been excavated at Pompeii. The exteriors of Roman houses have few windows, keeping the world at bay. The single entrance is usually flanked by stores that face the street. Stepping through the doorway one enters an open-air courtyard called an **atrium**, which has an **impluvium** to capture rainwater. Private bedrooms, called **cubicula**, radiate around the atrium. The atrium provides the only light and air to these windowless, but beautifully decorated, rooms.

The Romans placed their studies and dining rooms deeper into the house. Eventually another atrium, perhaps held up by columns called a **peristyle**, provided access to a garden flanked by more cubicula.

Grander Roman buildings, such as the **Colosseum** (Figure 7.12) and the **Pantheon** (Figure 7.14) use concrete, arches, and the various kinds of vaulting techniques to achieve grand and spacious effects.

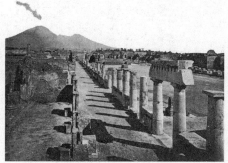

Figure 7.6: Forum at Pompeii

The center of the Roman business world was the **forum** (Figure 7.6), a large public square framed by the principal civic buildings. The gods needed to be worshipped and appeased; therefore, the focus of all fora is the temple dedicated to the locally favorite god. Around the sides of the forum are bath houses, markets, and administrative buildings dealing with life's everyday essentials.

Although the Romans sometimes use Greek and Etruscan columns in their architecture, they are just as likely to use adapted forms that were inspired by their earlier counterparts. **Composite columns** first seen in the Arch of Titus have a mix of Ionic (the volute) and Corinthian (the leaf) motifs in the capitals. **Tuscan columns** as seen on the Colosseum are unfluted with severe Doric-style capitals (Figure 7.7). Both columns are

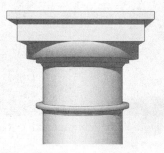

Figure 7.7: Tuscan capital

raised on large pedestals to diminish the size of the viewers and increasing their sense of awe.

Greek architecture remained a strong influence throughout Roman history. It was common for Roman temples to be fronted by Greek porches of columns and pediments, as in the **Pantheon**, even if the core of the building is completely Roman with its yawning domed interior. When Greek buildings are more faithfully copied, as in the **Maison Carrée** (Figure 7.9), there are still Roman adaptations. For example, the entrance is indicated by a flight of stairs. The walls of the cella are pushed out to meet the engaged columns, creating a larger interior.

Major Works of Roman Architecture

House of the Vettii, second century B.C.E.–first century C.E., Pompeii, Italy (Figure 7.8)

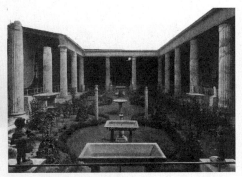

Figure 7.8: House of the Vettii, 2nd century B.C.E.–1st century C.E., Pompeii, Italy

- Narrow entrance sandwiched between several shops
- Large reception area, called the atrium, that is open to the sky and has a catch basin called an impluvium in the center; cubicula radiate around the atrium
- Peristyle garden in rear, with fountain, statuary and more cubicula; this is the private area of the house
- Axial symmetry of house; someone entering the house can see all the way through to the peristyle garden in the rear
- Exterior of house lacks windows; interior lighting comes from the atrium and the peristyle

Maison Carrée, c. 1 C.E., Nîmes, France (Figure 7.9)

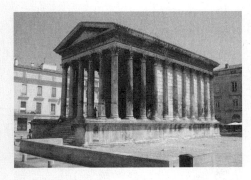

Figure 7.9: Maison Carrée, c. 1 C.E. Nîmes, France

- Corinthian capitals
- Set on a high podium
- Front entrance emphasized
- Walls of cella pushed out to meet the engaged columns, interior expanded to the maximum size allowed beyond the porch
- Used as a model for Jefferson's State Capitol in Richmond, Virginia

Pont du Gard, c. 16 B.C.E., Nîmes, France (Figure 7.10)

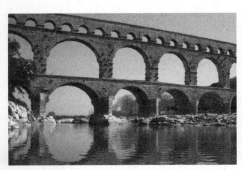

Figure 7.10: Pont du Gard, c. 16 B.C.E., Nîmes, France

- Ashlar masonry
- Aqueduct meant to bring water to the city of Nîmes; Roman cities had large populations because of the Roman's ability to bring water to city centers
- Heavy, squat arches on bottom level; thinner arches on second level; lighter rhythm of smaller arches on top level, which carries the water of the aqueduct

Ara Pacis, 13–9 B.C.E., Rome (Figure 7.11)

- Altar of Augustan Peace
- Exhibits the virtues of peace and its long-lasting effects on society as a whole
- Built after Augustus's return from Gaul
- Original altar located so that an Egyptian obelisk set in a giant sundial pointed to the open door on the first day of fall

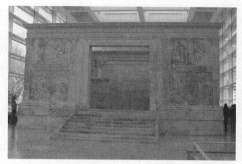

Figure 7.11: Ara Pacis, 13–9 B.C.E., Rome

The Colosseum, 72–80 C.E., Rome (Figure 7.12)

- Real name is the Flavian Amphitheatre
- Accommodated 50,000 spectators
- Concrete core, brick casing, travertine facing
- 76 entrances and exits circle the façade
- Interplay of barrel vaults, groin vaults, arches
- Meant for wild and dangerous spectacles—gladiator combat, animal hunts, naval battles—but not, as tradition suggests, religious persecution
- Façade has engaged columns: first story Tuscan, second floor Ionic, third floor Corinthian, top flattened Corinthian; each thought of as lighter than the order below
- Above squared windows at top level are small brackets that are meant to hold flagstaffs; these staffs are the anchors for a retractable canvas roof used to protect the crowd on hot days
- Much of the marble was pulled off in the Middle Ages

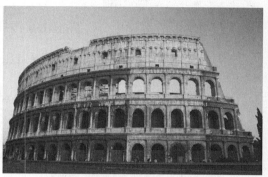

Figure 7.12: The Colosseum, 72–80 C.E., Rome

Market of Trajan, 100–112 C.E., Rome (Figure 7.13)

- Original market had 150 shops
- Multilevel mall
- Semicircular building held several levels of shops
- Main space groin-vaulted; barrel-vaulted shops

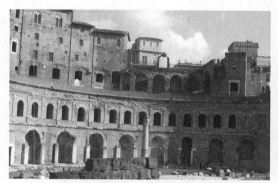

Figure 7.13: Market of Trajan, 100–112 C.E., Rome

Pantheon, 118–125 C.E., Rome (Figures 7.14 and 7.15)

- Dedicated to all the gods
- Inscription: "Marcus Agrippa, son of Lucius, having been consul three times, built it."
- Corinthian capital porch in front of building
- Façade has two pediments, one deeply recessed behind the other
- Square panels in floor and in coffers contrast with roundness of walls
- Coffers may have been filled with rosette designs to simulate stars
- Cupola walls are enormously thick: 20 feet at base

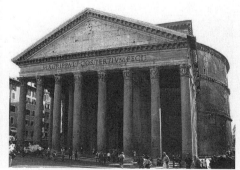

Figure 7.14: Pantheon, 118–125 C.E., Rome

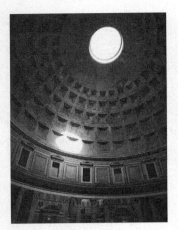

Figure 7.15: Pantheon, 118–125 C.E., Rome

- Oculus 27 feet across: allows for sunlight and air; acts as a moving spotlight across the interior
- Height of building equals its width; interior of building based on the circle, a hemisphere
- Walls have seven niches for statues of the gods
- Thickness of walls thinned at top, coffers take some weight pressure off walls
- Triumph of concrete construction
- Was brilliantly decorated
- Originally had a large atrium before it; originally built on a high podium; modern Rome has risen up to it

Hadrian's Villa, 125–128 C.E., Tivoli, Italy (Figure 7.16)

- Huge complex for the delight of Emperor Hadrian
- Highest quality workmanship lavished on the mosaics, murals, and architectural settings
- Canopus: colonnade with a cornice connecting the tops of columns; alternating rounded with flattened lines; sculpture placed inside the rounded arches; framing a reflecting pool

Figure 7.16: Hadrian's Villa, 125–128 C.E., Tivoli, Italy

Arch of Constantine, 312–315 C.E., Rome, Italy (Figure 7.17)

- Built to commemorate Constantine's victory over Maxentius at the Battle of the Milvian Bridge in 312
- Friezes and sculpture taken from monuments to older emperors: Trajan, Hadrian, Marcus Aurelius; Constantine draws a parallel between their accomplishments and his
- New friezes are done in situ
- Renunciation of the classical ideal in contemporary sculpture; heads too large for their bodies; squat figures; lack of space; large eyes; frontal stare; mechanical and repeated stances and gestures; shallow relief; heads not distinguished from one another
- Placed at this location so that the central arch would, at a distance, frame a 100-foot-tall statue of the Sun god, Sol

Figure 7.17: Arch of Constantine, 312–315 C.E., Rome, Italy

Basilica Nova (Basilica of Constantine), c. 306–312 C.E., Rome (Figure 7.18)

- Once housed giant sculpture of Constantine (Figure 7.40)
- Massive building with great window paces for maximum light
- Large groin-vaulted main aisle; barrel-vaulted and coffered side aisles
- Begun by Constantine's rival, Maxentius; completed by Constantine

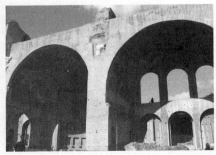

Figure 7.18: Basilica Nova (Basilica of Constantine), c. 306–312, C.E., Rome

Aula Palatina, early fourth century C.E., Trier, Germany (Figure 7.19)

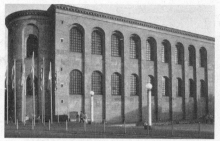

Figure 7.19: Aula Palatina, early 4th century C.E., Trier, Germany

- Solid brick; plain audience hall once covered with marble on the interior
- Semicircular triumphal arch in apse
- Basilican architectural plan inspired Christian churches of the Middle Ages
- Hall is heated by hypocausts, a space under the floor that retained heat from a furnace
- Exterior: buttresses arch as two-story arches embraced windows
- Large windows used lead to bind glass panes together

INNOVATIONS IN ROMAN PAINTING

Interior wall paintings, created to liven up windowless Roman **cubicula**, were frescoed with mythological scenes, landscapes, and city plazas. Mosaics were favorite floor decorations—stone kept feet cool in summer. **Encaustics** from Egypt provided lively individual portraits of the deceased.

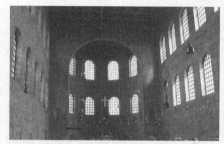

Figure 7.20: Aula Palatina, early 4th century C.E., Trier, Germany

Murals were painted with some knowledge of **linear perspective**—spatial relationships in landscape paintings appeared somewhat consistent. **Orthogonals** recede to multiple **vanishing points** in the distance. Sometimes, to present an object in the far distance, an artist used **atmospheric perspective**, a technique that employs cool pastel colors to create the illusion of deep recession. Figures were painted in **foreshortening** (Figures 7.21 and 7.22), where they are seen at an oblique angle and seem to recede into space.

Figure 7.21: Figure seen in foreshortening

Characteristics of Roman Painting

So much Pompeian wall painting survives that an early history of Roman painting can be reconstructed.

- First Pompeian Style is characterized by painted rectangular squares meant to resemble marble facing.
- Second Pompeian Style had large mythological scenes and/or landscapes dominating the wall surface. Painted stucco decoration of the First Style appears beneath in horizontal bands. The **Villa of Mysteries** (Figure 7.24) and **Boscoreale** (Figure 7.23) frescoes are in the Second Style.

Figure 7.22: Figure seen in foreshortening

- Third Pompeian Style is characterized by small scenes set in a field of color and framed by delicate columns of tracery.
- Fourth Pompeian Style combine elements from the previous three: The painted marble of the First Style is at the base, the large scenes of the Second Style and the delicate small scenes of the Third Style are intricately interwoven. The *Still Life with Peaches* (Figure 7.25) and the **Ixion Room** (Figure 7.26) are from the Fourth Style.

Figure 7.23: Boscoreale Frescoes, 50–40 B.C.E., fresco, Metropolitan Museum of Art, New York

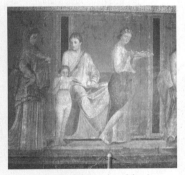

Figure 7.24: Dionysiac Mystery Frieze, c. 60–50 B.C.E., fresco, Villa of Mysteries, Pompeii

Figure 7.25: *Still Life with Peaches*, c. 50 C.E., fresco from Herculaneum, National Archaeological Museum, Naples

Figure 7.26: Detail of Ixion Room, c. 70 C.E., fresco, Pompeii

Major Works of Roman Painting

Boscoreale Frescoes, 50–40 B.C.E., fresco, Metropolitan Museum of Art, New York (Figure 7.23)

- From an aristocratic villa outside Pompeii
- Second Style Pompeian Art, with the First Style painted masonry panels at the bottom
- Wall paintings open up spaces to reveal painted versions of great vistas
- Great architectural views feature colonnaded atria, distant landscapes, and architectural visions
- A central tholos is embraced by a columned atrium and fronted by a pediment
- Cooler colors are used to show architectural members in recession

Dionysiac Mystery Frieze, c. 60–50 B.C.E., fresco, Villa of Mysteries, Pompeii (Figure 7.24)

- Cycle is in one room of a ninety-room mansion at Pompeii
- Scholarly debate over the exact meaning of the frescoes; perhaps shows the initiation rites of a novice into the cult of Dionysos
- In center is god Dionysos, drunk, in the lap of his wife (not shown in this illustration)
- Figures act out rituals and rites on a very narrow green stage before Pompeian red walls that propel them close to the picture plane
- Figures modeled convincingly; contrapposto

***Still Life with Peaches*, c. 50 C.E., fresco from Herculaneum, National Archaeological Museum, Naples (Figure 7.25)**

- Arrangement of peaches, stem, and half-filled pitcher of water
- Concentration on the different textures of the surfaces, roundness of the peaches and the pitcher
- Reflective surface of the glass emphasized
- Composition emphasizes curves and arcs
- Delight in showing how light plays on a given surface
- Shows interest in creating spatial depth as represented on the water pitcher

Ixion Room, c. 70 C.E., fresco, Pompeii (Figure 7.26)

- Painting set in fields of red and white
- Ixion: murdered his father-in-law and planned to seduce Hera; prevented by Zeus, who created a cloud in the shape of Hera, which Ixion made love to; Ixion then fathered a race of centaurs; Zeus ordered Hermes to tie him to a ceaselessly revolving wheel in hell
- Strong Classical Greek influence in the contrapposto, heroic musculature, and Greek themes

INNOVATIONS IN ROMAN SCULPTURE

The Romans erected commemorative arches to celebrate military victories. After the arch was constructed, sculpture was applied to the surface to animate the architecture as well as to recount the story of Roman victories. A combination of painted relief and free-standing works was integrated into a coherent didactic program. Later arches, such as the **Arch of Constantine** (312–315 C.E.) (Figure 7.17), used works from contemporary artists, as well as sculptures removed from arches of previous emperors, some two hundred years older. In this way the glory of the past was linked to the accomplishments of the present.

Another Roman innovation was the hollowed-out column with banded narrative relief sculptures spiraling around the exterior. The first, the ***Column of Trajan*** (112 C.E.) (Figure 7.34), had an entrance at the base, from which the visitor could ascend a spiral staircase and emerge onto a porch, where Trajan's architectural accomplishments would be revealed in all their glory. A statue of the emperor, which no longer exists, crowned the ensemble. The banded reliefs tell the story of Trajan's conquest of the Dacians. The spiraling turn of the narratives made the story difficult to read; scholars have suggested a number of theories that would have made the Column, and works like it, legible to the viewer.

Characteristics of Roman Sculpture

There is a definite evolution of sculptural styles in Roman art that broadly follows the eras of Roman history.

Republican Sculpture

Republican busts of noblemen, called **veristic** sculptures, are strikingly and unflatteringly realistic, with the age of the sitter seemingly enhanced. This may have been a form of idealization: Republicans valued virtues such as wisdom, determination, and experience, which these works seem to possess.

Republican full-length statues concentrate on the heads, some of which are removed from one work and placed on another. The bodies were occasionally classically idealized, symbolizing valor and strength. The Romans had great respect for ancestors: Figures can sometimes be seen holding busts of their ancestors in their hands as a sign of their patrician heritage.

Major Works of Roman Republican Sculpture

Veristic Roman Busts (Figures 7.27 and 7.28)

- Realism of the portrayal shows influence of Greek Hellenistic art; late Etruscan art
- Extremely realistic face, called a veristic portrait
- Bulldog-like tenacity of features; overhanging flesh; deep crevices in face
- Full of experience and wisdom—traits Roman patricians would have desired
- Features may have been exaggerated by artist to enhance adherence to Republican virtues

Figure 7.27: *Man of the Roman Republic*, c. 50 B.C.E. terra-cotta, Museum of Fine Arts, Boston

Figure 7.28: *Veristic Male Portrait*, c. 1st century B.C.E., marble, Vatican Museum, Rome

Characteristics of Early and High Imperial Sculpture

While busts of senators conveyed the gruff virtues of Republican Rome, emperors, whose divinity descended from the gods themselves, were portrayed differently. Here, inspiration came from Classical Greece, and Roman sculptors adopted the contrapposto, ideal proportions, and heroic poses of Greek statuary. Forms became less individualized, iconography more associated with the divine.

Figure 7.29: *Augustus of Primaporta*, 20 C.E., marble copy of a bronze original, Vatican Museum, Rome

Major Works of Early and High Imperial Sculpture

Augustus of Primaporta, **20 C.E., marble, copy of a bronze original, Vatican Museums, Rome (Figure 7.29)**

- Idealized view of the Roman emperor
- Contrapposto, cf. *Spear Bearer* (Figure 5.12)
- Confusion between god and man intentional; sense of divine rule
- Standing barefoot indicates he is on sacred ground
- On his breastplate there are a number of gods participating in the return of Roman standards from the Parthians
- Breastplate indicates he is a warrior; judge's robes show him as a civic ruler
- Back not carved, meant to be placed against a wall
- Characteristic of Augustus is the part in the hair over the left eye, and two locks over the right
 - May have carried a sword, pointing down, in his left hand
 - Right hand in Roman orator pose, perhaps held laurel branches
 - At base: Cupid on the back of a dolphin—a reference of Augustus's divine descent from Venus

Figure 7.30: *Tellus Relief(?)* from the Ara Pacis, 13–9 B.C.E., marble, Rome

Tellus Relief (?) and *Procession of the Imperial Family* **from the Ara Pacis, 13–9 B.C.E., marble, Rome (Figures 7.30 and 7.31)**

- From the Ara Pacis, or "Altar of Peace"
- *Tellus:* Mother Earth breastfeeds newborns; symbols of the four elements abound: bird is air; cow and sheep are earth; dragon is fire; seawater at bottom right; fresh water in a jug bottom left; Greek classical composition and modeling of figures
- Everything is bountiful and fruitful when all is at peace
- *Procession:* Romans appear as the ruling class, not as gods, in a procession; figures have natural gestures and relaxed poses; celebrates a specific event of the inauguration of the altar; actual people depicted; Augustus promoted marriage, and so children are prominently placed; informality

Figure 7.31: *Procession of the Imperial Family* from the Ara Pacis, 13–9 B.C.E., marble, Rome

Flavian Woman, **90** C.E., **marble, Capitoline Museum, Rome (Figure 7.32)**

- Idealized beauty with graceful long neck and tilted head
- Cutting-edge fashionable coiffure
- Hair creates a dramatic interplay of light and shadow
- Hair created with a drill instead of a chisel

Spoils from the Temple of Jerusalem **from the Arch of Titus, c. 81** C.E., **marble, Rome (Figure 7.33)**

- Triumphal parade celebrates the conquest of Judea in 70 C.E.
- Romans carry off splendors from the Temple of Solomon
- Procession proclaims the Roman victory moving through an arch, much like the Arch of Titus
- Repeated rhythmic movement of soldiers from left to right
- Deep carving casts strong shadows

Column of Trajan, **112** C.E., **marble, Rome (Figure 7.34)**

- Burial chamber of Trajan, whose ashes were placed in the base
- Stood amid Trajan's Forum
- 128-feet high, 625-foot narrative cycle wrapped around the column, telling the story of Trajan's defeat of the Dacians
- Crowded composition
- Low relief, few shadows to cloud what must have been a very difficult object to view in its entirety
- Scholarly debate over the way it was meant to be viewed
- Column meant to be entered; visitor to wander up the interior spiral staircase to the viewing platform at the top where a heroic statue of the Emperor was placed (now St. Peter has replaced him)
- View would impress visitor with Trajan's accomplishments, including his forum and his markets

Hadrian, **after 117** C.E., **marble, National Roman Museum, Rome (Figure 7.35)**

- Hadrian was enamored of Greek culture; Greek influence in the growth of a beard that symbolizes an ancient philosopher

Marcus Aurelius, **c. 175** C.E., **bronze, Capitoline Museum, Rome (Figure 7.36)**

- On parade, passing before his people
- Gesture is benignly authoritative

Figure 7.32: *Flavian Woman*, 90 C.E., marble, Capitoline Museum, Rome

Figure 7.33: *Spoils from the Temple of Jerusalem* from the Arch of Titus, c. 81 C.E., marble, Rome

Figure 7.34: *Column of Trajan*, 112 C.E., marble, Rome, Italy

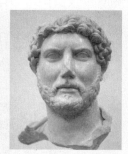

Figure 7.35: *Hadrian*, after 117 C.E., marble, National Roman Museum, Rome

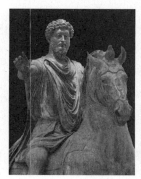

Figure 7.36: *Marcus Aurelius*, c. 175 C.E., bronze, Capitoline Museum, Rome

- Horse is spirited, hard to control, but Marcus has mastery over man and beast
- Characteristic Roman oratorical gesture
- Rider is larger than the horse
- May have been a figure of a defeated king under the horse's upraised hoof
- Mistaken for Constantine in the Middle Ages, which is the reason why it was not melted down

Characteristics of Late Imperial Sculpture

At the end of the Early Imperial period, a stylistic shift begins to take place that transitions into the Late Imperial style. Perhaps reflecting the dissolution and anarchy of the Roman state, the classical tradition, so willingly embraced by previous emperors, is slowly abandoned by Late Imperial artists. Compositions are marked by figures that lack individuality and are crowded tightly together. Everything is pushed forward on the picture plane, as depth and recession were rejected along with the classicism they symbolize. Proportions are truncated—contrapposto ignored; bodies are almost lifeless behind masking drapery. Emperors are increasingly represented as military figures rather than civilian rulers.

Major Works of Late Imperial Sculpture

Caracalla, c. 211–217 C.E., marble, National Archeological Museum, Naples (Figure 7.37)

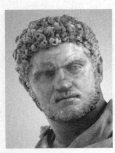

Figure 7.37: *Caracalla,* c. 211–217 C.E., marble, National Archeological Museum, Naples

- Portrait bust renders physical likeness as well as character portrayal
- In life a ruthless tyrant, in sculpture a hard-nosed, stern, and suspicious face
 - Brutal ruler who ordered the death of his opponents, including his brother and wife
 - Downturned moustache and lines over eyes contribute to harsh characterization

Ludovisi Battle Sarcophagus, c. 250–260 C.E., marble, National Roman Museum, Rome (Figure 7.38)

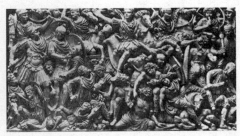

Figure 7.38: *Ludovisi Battle Sarcophagus,* c. 250–260 C.E., marble, National Roman Museum, Rome

- Extremely crowded surface with figures piled on top of one another
- Figures lack individuality
- Confusion of battle is echoed by congested composition
- Roman army trounces bearded and defeated barbarians
- Youthful Roman general appears center top with no weapons, and is the only Roman with no helmet indicating that he is invincible and needs no protection

The Tetrarchs, c. 305 C.E., porphyry, Saint Mark's, Venice (Figure 7.39)

- Porphyry sculpture quarried in Egypt; purple is the royal color
- Tetrarchs illustrate a period in which the Roman Empire was ruled by four men, each equal, each dividing the state; explains the uniformity of gesture, movement, forms; a harmony among the four men is implied even if it did not exist in practice
- Faces are types, not individuals; emotionless

Figure 7.39: *The Tetrarchs,* c. 305 C.E., porphyry, Saint Mark's, Venice

- Shapeless bodies beneath cloaking drapery
- Each pair was originally attached to a large column in Constantinople; later the images were united in Rome

Constantine, 315–330 C.E., marble, Conservatori Palace, Rome (Figure 7.40)

- 8'6" head, whole statue must have been over 30' seated
- Part of an enormous figure that sat as the focal point of the Basilica Nova in Rome
- Parts of the body that show were done in marble (head, knee cap, arms, hand, feet); lost now are the wooden elements that represented the torso—perhaps covered in bronze
- Colossal size meant to have a reference to Jupiter
- Idealized portrait; timelessness
- Hair sits on the head like a hat

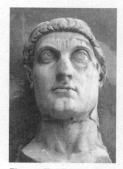

Figure 7.40: *Constantine*, 315–330 C.E., marble, Conservatori Palace, Rome

VOCABULARY

Aqueduct: an overground water system (Figure 7.10)

Ashlar masonry: carefully cut and grooved stones that support a building without the use of concrete or other kinds of masonry (Figure 7.10)

Atrium (plural: atria): a courtyard in a Roman house or before a Christian church

Basilica: in Roman architecture, a large axially planned building with a nave, side aisles, and apses (Figure 7.18)

Bust: a sculpture depicting a head, neck, and upper chest of a figure (Figures 7.27 and 7.28)

Coffer: in architecture, a sunken panel in a ceiling (Figure 7.5)

Contrapposto: a graceful arrangement of the body based on tilted shoulders and hips and bent knees (Figure 7.29)

Cubiculum (plural: cubicula): a Roman bedroom flanking an atrium; in Early Christian art, a mortuary chapel in a catacomb

Cupola: a small dome rising over the roof of a building; in architecture, a cupola is achieved by rotating an arch on its axis

Encaustic: an ancient method of painting that uses colored waxes burned into a wooden surface

Foreshortening: a visual effect in which an object is shortened and turned deeper into the picture plane to give the effect of receding in space (Figures 7.21 and 7.22)

Forum (plural: fora): a public square or market place in a Roman city

Fresco: a painting technique that involves applying water-based paint onto a freshly plastered wall. The paint forms a bond with the plaster that is durable and long-lasting (Figure 7.25)

Impluvium: a rectangular basin in a Roman house that is placed in the open-air atrium in order to collect rainwater (Figure 7.8)

Keystone: the center stone of an arch that holds the others in place

Oculus: a circular window in a church, or a round opening at the top of a dome (Figure 7.15)

Peristyle: an atrium surrounded by columns in a Roman house (Figure 7.8)

Perspective: depth and recession in a painting or a relief sculpture. Objects shown in **linear perspective** achieve a three-dimensionality in the two-dimensional

world of the picture plane. All lines, called **orthogonals**, draw the viewer back in space to a common point, called the **vanishing point**. Paintings, however, may have more than one vanishing point, with orthogonals leading the eye to several parts of the work. Landscapes that give the illusion of distance are in **atmospheric** or **aerial perspective**

Pier: a vertical support that holds up an arch or a vault (Figure 7.3)

Spandrel: a triangular space enclosed by the curves of arches (Figure 7.4)

Vault: a roof constructed with arches. When an arch is extended in space, forming a tunnel, it is called a **barrel vault** (Figure 7.1). When two barrel vaults intersect at right angles, it is called a **groin vault** (Figure 7.2)

Veristic: sculptures from the Roman Republic characterized by extreme realism of facial features (Figures 7.27 and 7.28)

Summary

Art was used to emphasize the power of the state in a society in which empire building was a specialty. Monumental buildings and sculptures graced the great cities of the Roman world. The introduction of new methods of vaulting and the use of new construction materials, like concrete, enabled the Romans to build structures that not only had impressive exteriors but also had unparalleled interiors of great spaciousness.

Much is known about Roman art because of the destruction of the city of Pompeii by the volcanic explosion of Vesuvius in 79 C.E. Remains of Roman paintings betray some knowledge of linear perspective and foreshortening. Frescoes dominate the walls of elaborate villas in this seaside resort.

The Romans greatly admired Greek sculpture and were inspired by it throughout their history; indeed, much is known about Greek art from Roman copies that survive. Republican veristic works were influenced by Hellenistic Greek art; Imperial sculptures are modeled more on the Greek Classical age. Even though Roman portraits retained a grandeur until the end of the Empire, they increasingly took on a military character, as in works such as *The Tetrarchs*.

Practice Exercises

1. A spandrel is the part of a building that

 (A) forms a window
 (B) is defined by the space between two arches
 (C) supports piers
 (D) has an oculus

2. An example of a veristic portrait is

 (A) *Augustus of Primaporta*
 (B) *Flavian Woman*
 (C) *Marcus Aurelius*
 (D) *Man of the Roman Republic*

Questions: 3–5 refer to Figure 7.41.

3. This is a Roman building that is inspired by the Greeks in that

 (A) the columns are not fluted
 (B) the pediment is empty
 (C) there is an inscription over the columns
 (D) the pediment and columns appear on the front of the temple

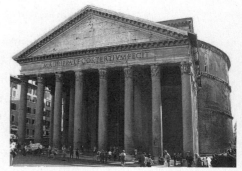

Figure 7.41

4. This building is dedicated to

 (A) Athena
 (B) Zeus
 (C) Ixion
 (D) all the gods

5. This building's interior and exterior is a contrast of

 (A) white and black
 (B) rectangles and circles
 (C) marble and sand
 (D) barrel vaults and groin vaults

CHALLENGE

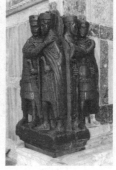

Figure 7.42

Questions 6–8 refer to Figure 7.42.

6. What period is this sculpture from?

 (A) Republican Rome
 (B) Early Imperial
 (C) Late Imperial
 (D) Etruscan

7. This sculpture is typical of the period in which it was done because the

 (A) men are embracing
 (B) faces are individualized
 (C) figures have squat physical proportions
 (D) figures are wearing military attire

CHALLENGE

8. This work represents

 (A) the rulers of Rome
 (B) soldiers in the service of the emperor
 (C) figures giving a salute before entering battle
 (D) twins embracing

9. An atrium can have

(A) an impluvium
(B) a cubicula
(C) an orthogonal
(D) a forum

10. *The Column of Trajan* functioned as all of the following EXCEPT a:

(A) viewing stage to see Trajan's accomplishments
(B) narrative of Trajan's victories
(C) grave site for the emperor
(D) library to house Trajan's writings

Short Essay

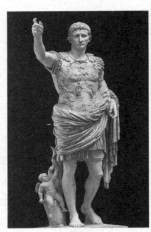

Figure 7.43

Identify this sculpture and the art-historical period associated with it. Discuss the characteristics that place the sculpture in this period and how it differs from sculpture of the preceding period. Use one side of a sheet of lined paper to write your essay.

Answer Key

1. **(B)**	3. **(D)**	5. **(B)**	7. **(C)**	9. **(A)**
2. **(D)**	4. **(D)**	6. **(C)**	8. **(A)**	10. **(D)**

Answers Explained

Multiple-Choice

1. **(B)** A spandrel is the space between arches of a colonnade.

2. **(D)** The intense realism of the portrait *Man of the Roman Republic* is in the veristic style of the Republican period.

3. **(D)** Like Greek temples, the Pantheon has a columned porch in front of the main body of the building. It is not in the Greek style to have an inscription above the columns. The pediment was never meant to be empty—the sculptures were taken down in the seventeenth century.

4. **(D)** As the name suggests, the Pantheon means "all the gods."

5. **(B)** The rectangles appear in many places, including the marble flooring and the coffers of the ceiling. The entire building is based on the circle; its height equals its width. The oculus is the dominant circle in the room.

6. **(C)** *The Tetrarchs* are from the Late Imperial period.

7. **(C)** The squat proportions are typical of Late Imperial sculpture. There is a rejection of classicism at this time, and the graceful contrapposto disappears.

8. **(A)** These are the four tetrarchs or rulers of Rome.

9. **(A)** An impluvium is a catch basin used to collect rainwater in an atrium.

10. **(D)** *The Column of Trajan* had many purposes, including as a grave for Trajan's remains, as a viewing platform to see his accomplishments, and as a storytelling device to narrate his victories. It was not used to house his writings.

Rubric for Short Essay

4: The student identifies the sculpture as *Augustus of Primaporta* or *Augustus* and the art-historical period as Roman Early Imperial or Roman High Imperial; the designation *Roman* is not enough because the differences between the Republican and Early Imperial periods are stressed in classes. The student compares *Augustus* to the Republican art that precedes it, highlighting the ideal and imperial imagery *Augustus* has, as distinct from the veristic portraits of the Republican period. There are no major errors.

3: The student labels the sculpture as *Augustus of Primaporta* or *Augustus* and the period as Roman Early Imperial, but is less specific on the differences between Republican and Early Imperial art. This is the highest score a student can earn without naming *Augustus*. There may be minor errors.

2: The student names either the period or the title and provides details differentiating Early Imperial from Republican. There may be major errors.

1: The student labels only Early Imperial, OR the title OR knows only one distinction between Early Imperial and Republican art. There may be major errors.

0: The student makes an attempt, but the response is without merit.

Short Essay Model Response

The sculpture shown is <u>Augustus of Primaporta</u> and was created during the Early Imperial period of Roman art. The statue of Augustus is very idealized because it was created during the Early Imperial period which differed from the preceding Veristic period. The Veristic period showed age as being honorable and glorified age in the head busts that were created. However, the Early Imperial strongly contrasted the characteristics of the Veristic period by showing Augustus as a young leader even though the sculpture was created when Augustus was 76 years old.

Augustus has one of his arms raised and most likely held an olive branch as a symbol of peace. In his other hand, he probably had a sword symbolizing that the Roman Empire wanted peace but would use force to achieve it. The breastplate that Augustus is wearing has many Gods on it to show the warrior-like qualities of Augustus. The robe that he holds around him most likely symbolized that Augustus was noble and a judge. On the bottom of the statue near the foot of Augustus, Cupid is pulling on the robe which showed that Augustus was a direct descendant from Venus. The idealized nature of Augustus clearly separates it from the Veristic period that proceeded this period.

—Alex G.

Analysis of Model Response

Even though Alex addresses more than the question asks for, he provides a solid response. First, he identifies the object as the *Augustus of Primaporta*. Then he shows how it was created in the Early Imperial Roman period. While he does not use the word "Republican" to identify the preceding period, there is nothing in the question to suggest that he must. His knowledge of the Veristic busts of earlier Roman art is enough to establish that he understands the chronology and stylistic development of this period. The material in the second paragraph is largely irrelevant to the question. Except for the last line, it does not advance the discussion. **This essay merits a 4.**

Late Antique Art

Early Christian Art, Early Jewish Art

TIME PERIOD: 200–500 C.E.

KEY IDEAS

- Christianity begins as a prohibited and therefore underground religion. Its earliest works appear in the catacombs and on sarcophagi.
- Christian images are inspired by the classical past but are also influenced by Constantinian artwork from the Late Roman Empire; for the most part the subject matter is taken from the Old and New Testaments.
- Christian buildings use both the axially planned Roman basilicas and the centrally planned Roman temple forms.
- Other cultures flourish during the Late Antique world, such as the Early Jews, who generally prohibit a narrative artistic tradition. Occasionally figurative work appears in such places as Dura Europos.

HISTORICAL BACKGROUND

Christianity, in the first century C.E., was founded by Jesus Christ, whose energetic preaching and mesmerizing message encouraged devoted followers like Saints Peter and Paul to spread the message of Christian faith and forgiveness across the Roman world through active missionary work. Influential books and letters, which today make up the New Testament, were powerful tools that fired the imagination of everyone from the peasant to the philosopher.

Literally an underground religion, Christianity had to hide in the corners of the Roman Empire to escape harsh persecutions, but the number of converts could not be denied, and gradually they became a majority in Rome. With Constantine's triumph at the Milvian Bridge in 312 C.E.. came the Peace of the Church. Constantine granted restitution to Christians of state-confiscated property in the 313 C.E. Edict of Milan, which also granted religious toleration throughout the Empire. Constantine also favored Christians for government positions and constructed a series of religious buildings honoring Christian sites. Christianity was well on its way to becoming a state religion, with Emperor Constantine's blessing.

After emerging from the shadows, Christians began to build churches of considerable merit to rival the accomplishments of pagan Rome. However, pagan beliefs were by no means eradicated by the stroke of a pen, and ironically paganism took its turn as an underground religion in the Late Antique period.

Patronage and Artistic Life

It was not easy being a Christian in the first through third centuries. Persecutions were frequent; most of the early popes, including Saint Peter, were martyred. Those artists who preferred working for the more lucrative official government were blessed with great commissions in public places. Those who worked for Christians had to be satisfied with private church houses and burial chambers.

Most Christian art in the early centuries survives in the catacombs, buried beneath the city of Rome and other places scattered throughout the Empire. Christians were mostly poor—society's underclass. Artists imitated Roman works, but sometimes in a sketchy and unsophisticated manner. Once Christianity became recognized as an official religion, however, the doors of patronage sprang open. Christian artists then took their place alongside their pagan colleagues, eventually supplanting them.

ARTISTIC INNOVATIONS OF EARLY CHRISTIAN ARCHITECTURE

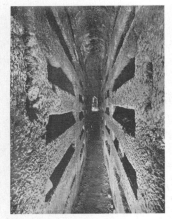

Figure 8.1: Catacombs with loculi

Under the city of Rome can be found a hundred miles of **catacombs** (Figure 8.1), sometimes five stories deep, with millions of interred bodies. Christians, Jews, and pagans used these burial grounds because they found this a cheaper alternative to aboveground interment. Finding the Roman practice of cremation repugnant, Christians preferred burial because it symbolized Jesus's, as well as their own, rising from the dead—body and soul.

Catacombs were dug from the earth in a maze of passageways that radiated out endlessly from the starting point. The poor were placed in **loculi**, which were holes cut in the walls of the catacombs meant to receive the bodies of the dead. Usually the bodies were folded over to take up less room. The wealthy had their bodies blessed in mortuary chapels, called **cubicula**, and then often placed in extravagant sarcophagi, like the one dedicated to **Junius Bassus** (359 C.E.) (Figure 8.11).

After the Peace of the Church in 313 C.E., Christians understood how they could adapt Roman architecture to their use. Basilicas, with their large, groin-vaulted interiors and impressive naves, were meeting places for the influential under the watchful gaze of the emperor's statue. Christians reordered the basilica, turning the entrance to face the far end instead of the side, and focused attention directly on the priest, whose altar (meaning "high place") was elevated in the **apse** (Figure 8.4). The clergy occupied the perpendicular aisle next to the apse, called the **transept**. Male worshippers stood in the long main aisle called the **nave**; females were relegated to the side aisles with partial views of the ceremony. In this way, Christians were inspired by Jewish communities in which this sexual division was (and still is, in many cases) standard (Figure 8.2).

A **narthex**, or vestibule, was positioned as a transitional zone in the front of the church. An atrium was constructed in front of the building, framing the façade. Atria also housed the *catechumens*, those who expressed a desire to convert to Christianity but had not yet gone through the initiation rites. They were at once inside the

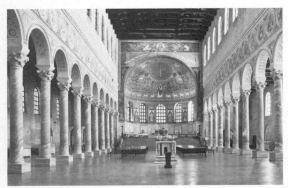

Figure 8.2: Early Christian basilica of Sant'Apollinare in Classe showing a long nave. Wall spaces have arches on the first floor and a clerestory containing windows. The apse is surmounted by a Roman triumphal arch and filled with glittering mosaics.

church precincts but outside the main building. On occasion this overall design had the symbolic effect of turning the church into a cross shape.

Characteristics of Early Christian Architecture

Early Christian art has a "love/hate" relationship with its Roman predecessors. On the one hand, these were the people who mercilessly cemented Christians into giant flowerpots, covered them with tar, ignited them, and used them to light the streets at night. On the other hand, this was the world they knew: the grandeur, the excitement, the eternal quality suggested by mythical Rome.

Early Christian art shows an adaptation of Roman elements—taking from their predecessors the ideas that best expressed Christianity, and using the remnants of their monuments to embellish the new faith. In this way, Christianity, like most religions, expressed dominance over the older forms of worship by forcing pagan architectural elements, like columns, to do service to a new god. **Old Saint Peter's** (c. 320) (Figures 8.3 and 8.4) employed a number of Roman columns from pagan temples. This type of reuse of architectural or sculptural elements is called **spolia**.

Early Christian churches come in two types, both inspired by Roman architecture: **centrally planned** and **axially planned** buildings. The exteriors of both church structures avoided decoration and sculpture that recall the façade of pagan temples.

The more numerous axially planned buildings, like **Old Saint Peter's**, had a long naves focusing on an apse. The nave, used for processional space, was usually flanked by two side aisles, two on each side. The first floor had columns lining the nave; the second floor contained a space decorated with mosaics; and the third floor had the **clerestory**, the window space. Early Christian **basilicas** have wooden roofs with coffered ceilings (Figure 8.2).

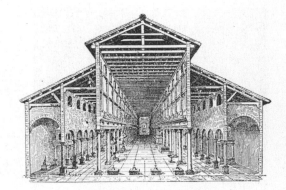

Figure 8.3: Old Saint Peter's, c. 320, Rome

Centrally planned buildings, like **Santa Costanza** (Figures 8.5, 8.6, and 8.7), were inspired by Roman buildings such as the Pantheon. The altar was placed in the middle of the building beneath a dome ringed with windows. Men stood around the altar, women in the side aisle, called an **ambulatory**.

Major Works of Early Christian Architecture

Old Saint Peter's, c. 320, Rome (Figures 8.3 and 8.4)

- Built on the spot where it is believed Saint Peter was buried
- Axially planned building, inspired by Roman basilicas like the Aula Palatina (Figure 7.19)
- Columns are spoils from Roman buildings, a political statement of the triumph of Christianity over paganism
- Bare exterior, richly appointed interior: representing the Christian whose exterior is gross but whose soul is beautiful
- As in the Jewish tradition, men and women stood separately; the men stood in the main aisle, the women in the side aisles with a partial view
- The interior wall space was transformed into a glittering immaterial spiritual realm by glass mosaic rather than Roman stone mosaics

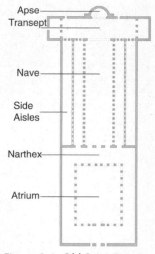

Figure 8.4: Old Saint Peter's ground plan

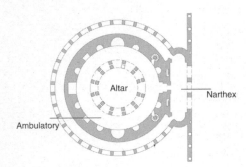

Figure 8.5: Ground plan of Santa Costanza, Rome

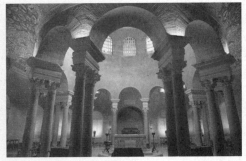

Figure 8.6: Santa Costanza, 337–351, Rome

Figure 8.7: Santa Costanza, 337–351, Rome

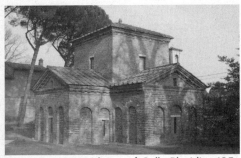

Figure 8.8: Mausoleum of Galla Placidia, 425, Ravenna, Italy

- Those not fully initiated stood in the atrium, the courtyard that was embraced by the church precincts but not inside the church itself
- Wooden roof, coffered ceiling

Santa Costanza, 337–351, Rome (Figures 8.5, 8.6, and 8.7)

- Centrally planned buildings usually used for mausoleums in the ancient world; this building may have originally been the mausoleum of Costantina, Emperor Constantine's daughter
- Domed main space; barrel-vaulted side aisle
- Double ring of 12 paired columns, symbolizes the 12 apostles
- Austere exterior
- Centrally planned, cf. Pantheon (Figure 7.15)
- Mosaics inside: putti harvesting grapes, producing wine; Christian message of turning wine into the blood of Christ; pagans would see it as the followers of Bacchus in a pagan ritual

Mausoleum of Galla Placidia, 425, Ravenna, Italy (Figure 8.8)

- Probably originally a chapel to Saint Lawrence
- Fusion of central plan and axial plan
- Exterior: brick façade represents the gross exterior world, minimal windows, cornice runs around building, pediments on all sides
- Interior: brilliantly colored mosaics; represents the soul
- Iconographic program stresses a Christian's path to redemption

INNOVATIONS IN EARLY CHRISTIAN PAINTING AND SCULPTURE

Christianity is an intensely narrative religion deriving its images from the various books of the New Testament. Christians were also inspired by parallel stories from the Old Testament, and they illustrated these to complement Christian ideology. Since there are no written accounts of what the men and women of the Bible looked like, artists recreated the episodes by relying on their imagination. The following episodes from the New Testament are most often depicted:

- *The Annunciation*: the Angel Gabriel announces to Mary that she will be the virgin mother of Jesus (Figure 15.4).
- *The Visitation*: Mary visits her cousin Elizabeth to tell her the news that she is pregnant with Jesus. Because she is elderly, Elizabeth's announcement of her own pregnancy is greeted as a miracle. Elizabeth gives birth to Saint John the Baptist (Figure 13.19).

- *Christmas* or *the Nativity*: the birth of Jesus in Bethlehem. Mary gives birth in a stable; her husband, Joseph, is her sole companion. Soon after, angels announce the birth to shepherds.
- *Adoration of the Magi*: Traditionally, three kings, who are also astrologers, are attracted by a star that shines over Jesus's manger. They come to worship him and present gifts (Figure 16.8).
- *Massacre of the Innocents*: After Jesus is born, King Herod issues an order to execute all male infants in the hope of killing him. His family takes him to safety in an episode called *The Flight into Egypt* (Figure 14.18).
- *Baptism of Jesus*: John the Baptist, Jesus's cousin, baptizes him in the Jordan River. Jesus's ministry officially begins.
- *Calling of the Apostles*: Jesus gathers his followers, including St. Matthew and St. Peter, as he proceeds in his ministry (Figure 20.15).
- *Miracles:* to prove his divinity, Jesus performs a number of miracles, like multiplying loaves and fishes, resurrecting the deceased Lazarus, and changing water into wine at the Wedding at Cana.
- *Giving the Keys*: sensing his own death, Jesus gives St. Peter the keys to the kingdom of Heaven, in effect installing him as his leader when he is gone, and therefore the first pope (Figure 16.18).
- *Transfiguration*: Jesus transfigures himself into God before the eyes of his apostles; this is the high point of his ministry.
- *Palm Sunday*: Jesus enters Jerusalem in triumph, greeted by throngs with palm branches.
- *Last Supper*: before Jesus is arrested he has a final meal with his disciples in which he institutes the Eucharist—that is, his body and blood in the form of bread and wine; at this meal he reveals that he knows that one of his apostles, Judas, has betrayed him for 30 pieces of silver (Figure 16.14).
- *Crucifixion*: after a brief series of trials, Jesus is sentenced to death for sedition. He is crowned with thorns, whipped with lashes, and forced to carry his cross through the streets of Jerusalem. At the top of a hill called Golgotha he is nailed to the cross and left to die. (Figure 11.14)
- *Deposition/Lamentation/Entombment*: Jesus's body is removed from the cross by his relatives, cleaned, mourned over, and buried (Figures 13.22, 14.6, and 17.17).
- *Resurrection*: On Easter Sunday, three days later, Jesus rises from the dead. On Ascension Day he goes to Heaven (Figure 16.16).

Also important are four author portraits of the Evangelists, who are the writers of the principal books, or gospels, of the New Testament. These books are arranged in the order in which it was believed they were written: Matthew, Mark, Luke, and John. Evangelist portraits appear often in Medieval and Renaissance art, each associated with an attribute:

- Matthew: angel or a man (Figure 11.2)
- Mark: lion
- Luke: ox
- John: eagle

These attributes derive from the Bible (Ezekiel 1:5–14; Revelations 4:6–8) and were assigned to the four evangelists by great philosophers of the early church such as St. Jerome.

Characteristics of Early Christian Painting

Catacomb paintings, like the ones at **Saints Peter and Marcellino** (Figure 8.9) from the fourth century, show a sensitivity toward artistic programs rather than random images. Jesus always maintains a position of centrality and dominance, but grouped around him are images that are carefully chosen either as Old Testament prefigurings or as subsidiary New Testament events. Early Christians learned from ancient paintings to frame figures in either **lunettes** or niches.

When Christianity was recognized as the official religion of the Roman Empire in 380 C.E., Christ was no longer depicted as the humble Good Shepherd; instead he took on imperial imagery. His robes become the imperial purple and gold, his crook a staff, his halo a symbol of the sun-king. The mosaics at **Galla Placidia** (c. 425) (Figure 8.10) are examples of this later phase of Early Christian art.

Unlike Roman mosaics, which are made of rock, Christian mosaics are often of gold or precious materials and faced with glass. Christian mosaics glimmer with the flickering of mysterious candlelight to create an other-worldly effect.

Major Works of Early Christian Painting

Good Shepherd, **fourth century, fresco, Catacomb of Saints Peter and Marcellino, Rome (Figure 8.9)**

Figure 8.9: *Good Shepherd*, 4th century, fresco, Catacomb of Saints Peter and Marcellino, Rome

- Catacombs beneath Rome have 4 million dead, and extend for about 100 miles
- Restrained portrait of Christ as a Good Shepherd, a pastoral motif in ancient art going back to the Greek *Calf Bearer* (Figure 5.3)
- Symbolism of the Good Shepherd: rescues individual sinners in his flock who stray
- Stories of the life of the Old Testament prophet Jonah often appear in the lunettes (not illustrated); Jonah's regurgitation from the mouth of a big fish is seen as prefiguring Christ's resurrection
- Parallels between Old and New Testament stories feature prominently in Early Christian art; Christians see this as a fulfillment of the Hebrew Scriptures
- Orant figures, standing figures with arms outstretched in prayer, appear between the lunettes (not illustrated)
- Roman influence: sketchy painterly brushstrokes evoke Pompeian painting

Good Shepherd **mosaic from the Mausoleum of Galla Placidia, 425, Ravenna, Italy (Figure 8.10)**

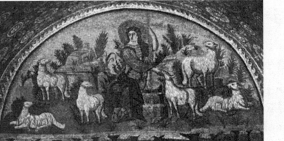

Figure 8.10: *Good Shepherd* mosaic from the Mausoleum of Galla Placidia, 425, Ravenna, Italy

- Regal version of Christ appears in a lunette
- Christ as imperial: golden halo, purple and gold robes, imperial standard instead of a crook
- Golden cross shows Christ's victory over death
- Rich landscape
- Three-dimensional figures that cast shadows
- Balanced group of sheep

- Pagan interpretation could indicate that Christ is Orpheus
- Refers to the parable of the lost sheep, Luke 15:3–7
- Roman illusionism

Characteristics of Early Christian Sculpture

Sculpture is the last traditional medium to be adapted to Early Christian needs. There was a reluctance among Christians to have themselves identified with pagan religions and their idols; therefore, large scale sculptures of Jesus and his apostles were avoided. Instead, ivories and marbles were carved on a more personal scale. Christians sculpted in the late Roman style: short figures with uniform height and squat proportions. Christians were less interested in individuality of expression and the proportional relationships of figures to buildings and background settings than they were in the spiritual message and powerful narratives that Bible stories inspire.

Major Work of Early Christian Sculpture

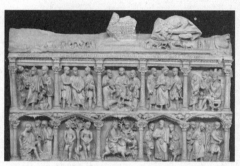

Figure 8.11: *Sarcophagus of Junius Bassus, 359, marble, Museo Storico del Tesoro della Basilica di San Pietro, Rome*

***Sarcophagus of Junius Bassus*, 359, marble, Museo Storico del Tesoro della Basilica di San Pietro, Rome (Figure 8.11)**

- Junius Bassus was prefect of Rome, baptized just before his death
- Scenes from the Bible in separate niches on the front
- Center top: Christ enthroned like an emperor, feet placed on the sky god; Saints Peter and Paul flanking; Christ's position is a symbol of the Christian god dominating the pagan
- Junius Bassus's redemption through Christ is seen as a parallel to the redemption scenes on the sarcophagus
- Christ wears a pallium, symbol of a philosopher, but has a youthful adolescent face like a young Apollo, who may have served as a model
- Uniform height of the figures regardless of whether they are sitting or standing
- Biblical episodes freely mixed, not in order; most Old Testament episodes prefigure Christian New Testament events
- Carved on three sides, meant to be placed against a wall
- Influenced by Roman architectural elements and figure style

Characteristics of Early Jewish Art

Although Jews almost universally ban images in temples today, their ancient brethren had a number of interpretations of this prohibition. Even though the second commandment warns the faithful not to worship other gods (i.e., idols), the Old Testament mentions a number of incidents in which images would be valid; for example, in Exodus 25:18–22, God orders Moses to install two cherubim above the Arc of the Covenant in the Holy of Holies.

Ancient Jews living in a Greco–Roman world, surrounded by narratives of the pagan gods and their heroic deeds, must have influenced Jewish artists in the town of Dura Europos, a military frontier community with provincial craftsmen working for a poor congregation in a synagogue that was a converted house. Although these paintings from 245–256 C.E. have a refreshing directness, they betray an unschooled

approach by having only frontally faced figures and a lack of a true narrative sequence. However, they could not have existed in isolation, and strongly suggest that Early Jewish art must have had a rich tradition of representational artwork.

Major Work of Early Jewish Art

Synagogue of Dura Europos, 245–256, frescoes, National Museum, Damascus (Figure 8.12)

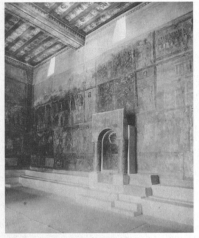

Figure 8.12: Synagogue of Dura Europos, 245–256, frescoes, National Museum, Damascus

- Originally a private home, then converted into a synagogue
- Old Testament stories illustrated; all Bible figures are represented except God, who appears as a hand
- Torah niche in the center
- Paintings are not in narrative order
- Stylized gestures, expressionless figures, frontal arrangement, huge eyes, strongly detailed outlines, hierarchy of scale
- Figures lack volume and shadow; some lack legs
- No action or story; an assembly of forms
- Many scenes avoid classical illusionism

VOCABULARY

Ambulatory: a passageway around the apse or altar of a church (Figure 8.5)

Apse: the endpoint of a church where the altar is located

Atrium (plural: **atria**): a courtyard in a Roman house or before a Christian church

Axial plan (Basilican plan, Longitudinal plan): a church with a long nave whose focus is the apse, so-called because it is designed along an axis (Figure 8.4)

Basilica: In Christian architecture, an axially planned church with a long nave, side aisles, and an apse for the altar (Figure 8.4)

Catacomb: an underground passageway used for burial (Figure 8.1)

Central plan: a church having a circular plan with the altar in the middle (Figure 8.5)

Chalice: a cup used in a Christian ceremony

Clerestory: the third, or window, story of a church (Figure 8.2)

Coffer: in architecture, a sunken panel in a ceiling

Cubicula: small underground rooms in catacombs serving as mortuary chapels

Gospels: the first four books of the New Testament that chronicle the life of Jesus

Loculi: openings in the walls of catacombs to receive the dead (Figure 8.1)

Lunette: a crescent-shaped space, sometimes over a doorway, that contains sculpture or painting (Figure 8.10)

Narthex: the closest part of the atrium to the basilica, it serves as vestibule, or lobby, of a church (Figure 8.4)

Nave: the main aisle of a church (Figure 8.2)

Orant figure: a figure with its hands raised in prayer (Figure 9.15)

Spolia: in art history, the reuse of architectural or sculptural pieces in buildings generally different from their original contexts

Synagogue: a Jewish house of worship (Figure 8.12)

Torah: first five books of the Old Testament traditionally ascribed to Moses

Transept: an aisle in a church perpendicular to the nave, where the clergy originally stood (Figure 8.4)

Summary

Christianity was an underground religion for the first three hundred years of its existence. The earliest surviving artwork produced by Christians was buried in the catacombs far from the average Roman's view.

Imagery for Christian objects was derived from Roman precedents. Classical techniques such as fresco and mosaic flourished under Christian patronage, as did Roman figural compositions sometimes employing contrapposto. Moreover, Roman centrally and axially planned buildings found new life in Christian churches.

Other Late Antique religions flourished as the Roman Empire waned, including Judaism, in which pictorial tradition was usually banned. Even so, a limited number of biblical narrative works survive, most famously at Dura Europos.

Practice Exercises

Questions 1–3 refer to Figure 8.13.

1. Works like this, which are located in Early Christian churches, can be interpreted in a pagan context. This interpretation comes from the

 (A) placement of a large head in the center, which is reminiscent of Imperial Rome
 (B) vine leaves, which can symbolize Bacchus
 (C) process of wine making, which is only a pagan pursuit
 (D) barrel vault, which is only used in a pagan basilica

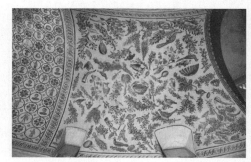

Figure 8.13

2. The medium for this work is

 (A) fresco
 (B) encaustic
 (C) mosaic
 (D) oil

3. This work is located in

 (A) Old Saint Peter's
 (B) the Catacombs
 (C) Galla Placidia
 (D) Santa Costanza

4. Orant figures

 (A) pray
 (B) work
 (C) offer sacrifices
 (D) build catacombs

5. Typical depictions of Jesus in the Catacombs show him

 (A) as a miracle worker
 (B) crucified
 (C) as an imperial ruler
 (D) as a good shepherd

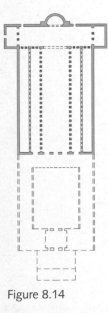

Figure 8.14

Questions 6–8 refer to Figure 8.14.

6. This diagram shows the layout of

 (A) a centrally planned building
 (B) an axially planned building
 (C) a narthex
 (D) a mausoleum

7. In the front of this building is an open-air courtyard called

 (A) an atrium
 (B) a clerestory
 (C) a loculi
 (D) a lunette

8. This courtyard functioned as a space for

 (A) mourners to the tomb
 (B) commemorating the life of Jesus
 (C) a community meeting center
 (D) a place for catechumens to gather during a Christian ceremony

9. The frescoes at Dura Europos show Jewish scenes

 (A) in a sophisticated hierarchical manner
 (B) that combine Old and New Testament scenes in a parallel arrangement
 (C) in a church
 (D) in random order

10. The reuse of pagan columns in Christian churches symbolically means that

 (A) Christians wanted the pagans to pay for their persecutions
 (B) Christians were making pagan objects do service to a new god
 (C) money was short and the Christians used columns wherever they could find them
 (D) pagans had no alternative but to turn their buildings over to the Christians

Short Essay

This work is from the Early Christian period. How does it combine Christian, Jewish, and/or Roman style or subject matter?

Figure 8.15

Answer Key

1. **(B)**	3. **(D)**	5. **(D)**	7. **(A)**	9. **(D)**
2. **(C)**	4. **(A)**	6. **(B)**	8. **(D)**	10. **(B)**

Answers Explained

Multiple-Choice

1. **(B)** A pagan would see the vine leaves as a symbol of the rites of Bacchus.

2. **(C)** This work was done in mosaic.

3. **(D)** This work is located in Santa Costanza, Rome.

4. **(A)** Orant figures, like those in the catacombs, pray.

5. **(D)** Jesus is first depicted as a good shepherd in the catacomb paintings. Later he takes on many other roles.

6. **(B)** The long nave reveals this to be an axially planned building. Mausoleums were generally centrally planned. A narthex is an open-air lobby that leads to the nave.

7. **(A)** Atria were built in front of Christian churches, much as they were built in front of Roman temples.

8. **(D)** The atrium functioned as a place where initiates to the Christian faith, catechumens, could gather before they had the right to join the faithful in the church for the entire ceremony.

9. **(D)** The Dura Europos frescoes are not in the narrative sequence of the Old Testament.

10. **(B)** Christians felt a certain glory in the reuse of Roman columns to do service to a new religion.

Rubric for Short Essay

4: The student can identify three major ways in which this work contains Christian, Jewish, and/or Roman style or subject matter. Each instance is given an example and explained. There are no major errors.

3: The student can identify two major ways in which this work contains Christian, Jewish, and/or Roman style or subject matter. Each instance is given an example and explained. There may be some errors.

2: The student gives a superficial account of Christian, Jewish, and/or Roman elements in this work, but the discussion is without substance.

1: The student has only the most cursory discussion of the material, making one valid point. There may be major errors.

0: The student makes an attempt, but the response is without merit.

Short Essay Model Response

The work shown is the Sarcophagus of Junius Bassis. It has a combined style of Christian, Jewish, and Roman art. The sarcophagus shows ten scenes from both the Old and New Testament in no specific order. Among the scenes is Adam and Eve eating from the tree of knowledge, a scene taken from the Jewish Old Testament. One of the main scenes is in the middle of the top level of the sarcophagus is of Jesus with his foot on Zeus's head. This was a way for Christians to glorify Jesus, by having him triumph over Zeus—the Christian religion has triumphed over the pagan. Here Jesus is flanked by Saints Peter and Paul. A style portrayed on the sarcophagus which is similar to the art of the Romans is the pediments and the arches. Romans were known for their arches and for their pediments in architectures such as the Pantheon. The columns are also similar to Roman columns in that they are Corinthian.

—Lucas S.

Analysis of Model Response

Although not required in the question, Lucas identifies the name of this sarcophagus. He then addresses each part of the question. The sarcophagus is inspired by Judaism because it contains scenes from the Old Testament, including Adam and Eve; it is Christian because it has Jesus with his foot resting on the head of Zeus, and flanked by saints, showing the domination of Christianity over paganism. Roman architecture is echoed in the use of pediments and Corinthian columns. **This essay merits a 4.**

Byzantine Art

TIME PERIODS:

Early Byzantine	500–726
Iconoclastic Controversy	726–843
Middle or High Byzantine	843–1204
Late Byzantine	1204–1453, and beyond

KEY IDEAS

- The Byzantine Empire was born out of the remains of the Roman Empire, and continued many elements of the Roman classical tradition, but in a Christian framework.
- Byzantine painting specialized in mosaics, icons, and manuscript illumination.
- Byzantine art has two traditions: one reflecting the classical past and a second interested in a hieratic medieval style—often in the same work.
- Byzantine architects invented the pendentive and squinch for buildings known for their mysterious and shadowy interiors.

HISTORICAL BACKGROUND

The term "Byzantine" would have sounded strange to residents of the Empire—they called themselves Romans. The Byzantine Empire was born from a split in the Roman world that occurred in the fifth century, when the size of the Roman Empire became too unwieldy for one ruler to manage effectively. The fortunes of the two halves of the Roman Empire could not have been more different. The western half dissolved into barbarian chaos, succumbing to hordes of migrating peoples. The eastern half, founded by Roman Emperor Constantine the Great at Constantinople (modern-day Istanbul), flourished for one-thousand years beyond the collapse of its western counterparts. Culturally different from their Roman cousins, the Byzantines spoke Greek rather than Latin, and promoted orthodox Christianity, as opposed to western Christianity, which was centered in Rome.

The porous borders of the Empire expanded and contracted during the Middle Ages, reacting to external pressures from invading armies, seemingly coming from all directions. The Empire had only itself to blame: The capital, with its unparalleled

wealth and opulence, was the envy of every other culture. Its buildings and public spaces awed ambassadors from around the known world. Constantinople was the trading center of early medieval Europe, directing traffic in the Mediterranean and controlling the shipment of goods nearly everywhere.

The orthodox Christian faith spread throughout eastern Europe, first to neighboring countries such as Romania and Armenia, then as far afield as Russia and Ethiopia, where it remains active today. The influence of Byzantine art spread everywhere Byzantine missionaries or merchants went. Precious objects with their accompanying iconography were carried across the Mediterranean. Medieval artists had a special reverence for Byzantine works; in contrast, the Byzantines rarely thought western objects were anything other than barbaric. In western Europe, Byzantine ivories were deeply cherished, often set as centerpieces in gem-encrusted book covers.

Icon production was a Byzantine specialty (Figure 9.19). Devout Christians attest that **icons** are images that act as reminders to the faithful; they are not intended to actually be the sacred persons themselves. However, by the eighth century, Byzantines became embroiled in a heated debate over icons; some even worshipped them as idols. In order to stop this practice, which many considered sacrilegious, the emperor banned all image production, forcing artistic output to grind to a halt. Not content with stopping images from being produced, iconoclasts smashed previously created works. Perhaps the iconoclasts were inspired by religions, such as Judaism and Islam, which discouraged images of sacred figures for much the same reasons. The unfortunate result of this activity is that art from the early Byzantine period (500–726) is almost completely lost. The artists themselves fled to parts of Europe where iconoclasm was unknown and Byzantine artists welcome. This so-called Iconoclastic Controversy serves as a division between the Early and Middle Byzantine art periods.

Despite the early successes of the iconoclasts, it became increasingly hard to suppress images in a Mediterranean culture such as Byzantium that had such a long tradition of creating paintings and sculptures of gods, going back to before the Greeks. In 843, iconoclasm was repealed and images were reinstated. This meant that every church and monastery had to be redecorated, causing a burst of creative energy throughout Byzantium.

Medieval Crusaders, some more interested in the spoils of war than the restoration of the Holy Land, conquered Constantinople in 1204, setting up a Latin kingdom in the east. This political event marks the transition between the Middle and Late Byzantine periods. Eventually the Latin invaders were expelled, but not before they brought untold damage to the capital, carrying off to Europe precious artwork that was simultaneously booty and artistic inspiration. The invaders also succeeded in permanently weakening the Empire, making it ripe for the Ottoman conquest in 1453. Even so, Late Byzantine artists continued to flourish both inside what was left of the Empire and in areas beyond its borders that accepted orthodoxy. A particularly strong tradition was established in Russia, where it remained until the 1917 Russian Revolution ended most religious activity. Even rival states, like Sicily and Venice, were known for their vibrant schools of Byzantine art, importing artists from the capital itself.

Patronage and Artistic Life

The church and state were one in the Byzantine Empire, so that many of the greatest works of art were commissioned, in effect, by both institutions at the same time. Monasteries were particularly influential, commissioning a great number of works for their private spaces. Interiors of Byzantine buildings were crowded with religious works competing with each other for space.

A strong court atelier developed around a royal household interested in luxury objects. This atelier specialized in extravagant works in ivory, manuscripts, and precious metals.

Individual artists worked with great piety and felt they were executing works for the glory of God. They rarely signed their names, some feeling that pride was a sin. Many artists were monks, priests, or nuns whose artistic production was an expression of their religious devotion and sincerity.

INNOVATIONS IN BYZANTINE ARCHITECTURE

Byzantine architecture shows great innovation, beginning with the construction of the **Hagia Sophia** in 532 in Istanbul (Figures 9.4 and 9.5). The architects, Anthemius of Tralles and Isidorus of Miletus (actually a mathematician and a physicist rather than true architects), examined the issue of how a round dome, such as the one built for the Pantheon in Rome (Figure 7.14), could be placed on flat walls. Their solution was the invention of the **pendentive** (Figure 9.1), a triangle-shaped piece of masonry with the dome resting on one long side, and the other two sides channeling the weight down to a pier below. A pendentive allows the dome to be supported by four piers, one in each corner of the building. Since the walls between the piers do not support the dome, they can be opened up for greater window space. Thus the Hagia Sophia has walls of windows that flank the building on each side, unlike the Pantheon, which lacks windows, having only an oculus in the dome.

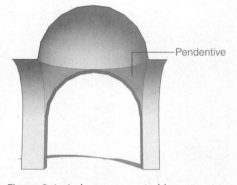

Figure 9.1: A dome supported by pendentives

Middle and Late Byzantine architects introduced a variation on the pendentive called the **squinch** (Figure 9.2). Although fulfilling the same function as a pendentive, that is, transitioning the weight of a dome onto a flat rather than a rounded wall, a squinch can take a number of shapes and forms, some corbelling from the wall behind, others arching into the center space, as do the ones at **Hosios Loukas** (Figure 9.8.). Architects designed pendentives and squinches so that artists could later use these broad and protruding surfaces as painted spaces.

The Hagia Sophia's dome is composed of a set of ribs meeting at the top. The spaces between those ribs do not support the dome and are opened for window space. The Hagia Sophia has forty windows around the base of the dome, forming a great circle of light (or halo) over the congregation.

A further innovation in the Hagia Sophia involves its ground plan (Figure 9.3). Churches in the Early Christian era concentrate on one of two forms: the circular building

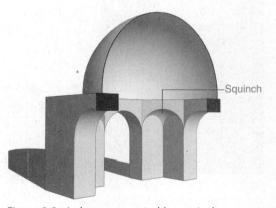

Figure 9.2: A dome supported by squinches

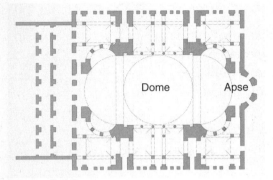

Figure 9.3: Ground plan of Hagia Sophia

containing a centrally planned apse and the longer basilica with an axially planned nave facing an altar. The Hagia Sophia shows a marriage of these two forms, with the dome emphasizing a centrally planned core and the long nave directing focus toward the apse.

Characteristics of Byzantine Architecture

Except for the Hagia Sophia, Byzantine architecture is not known for its size. Buildings in the Early period (500–726) have plain exteriors made of brick or concrete. In the Middle and Late periods (843–1453), the exteriors are richly articulated with a provocative use of various colors of brick, stone, and marble, often with contrasting vertical and horizontal elements. The domes are smaller, but there are more of them, sometimes forming a cross shape. The **monastery churches of Hosios Loukas** (Figures 9.7, 9.8, and 9.9) are good examples of the Middle Byzantine tradition.

Interiors are marked by extensive use of variously colored marbles on the lower floors and mosaics or frescoes in the elevated portions of the buildings. Domes tend to be low rather than soaring, having windows around the base. Middle and Late buildings, such as those at Hosios Loukas, have a relatively small floor space but pos-

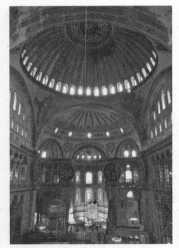

Figure 9.4: Anthemius of Tralles and Isidorus of Miletus, Hagia Sophia, 532–537, Istanbul

sess a strong vertical emphasis. Interior arches reach into space, creating mysterious areas clouded by half-lights and shimmering mosaics. These buildings usually set the domes on more elevated drums.

Greek Orthodox tradition dictates that important parts of the Mass take place behind a curtain or screen. In some buildings this screen is composed of a wall of icons called an **iconostasis**, such as the one before the main altar in the eleventh-century cathedral of **Saint Mark's** in Venice (Figures 9.10 and 9.11).

Major Works of Byzantine Architecture

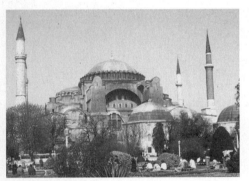

Figure 9.5: Anthemius of Tralles and Isidorus of Miletus, Hagia Sophia, 532–537, Istanbul

Anthemius of Tralles and Isidorus of Miletus, Hagia Sophia, 532–537, Istanbul (Figures 9.4 and 9.5)

- Combination of centrally planned and axially planned church
- Exterior: plain and massive, little decoration
- Altar at end of nave, but emphasis placed over the area covered by the dome
- Dome supported by pendentives
- Large central dome, with forty windows at base symbolically acting as a halo over the congregation when filled with light
- Cornice unifies space
- Arcade decoration: wall and capitals are flat and thin but richly ornamented
- Large fields for mosaic decoration; at one time had four acres of gold mosaics on walls
- Many windows punctuate wall spaces

- Minarets added in Islamic period, when Hagia Sophia functioned as a mosque
- Walls were whitewashed with plaster; today, walls are being cleaned to reveal wall decorations
- Patrons were Emperor Justinian and Empress Theodora, who commissioned the work after the burning of the original building in the Nike Revolt

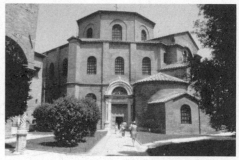

Figure 9.6: San Vitale, 526–547, Ravenna, Italy

San Vitale, 526–547, Ravenna, Italy (Figure 9.6)

- Eight-sided church
- Plain exterior except porch added later in Renaissance
- Large windows for illuminating interior designs
- Interior has thin columns and open arched spaces
- Interior elements dematerialize the mass of the structure

Monastery Churches, tenth to eleventh centuries, Hosios Loukas, Greece (Figures 9.7, 9.8, and 9.9)

- Exterior shows decorative placement of stonework and soft interplay of horizontal and vertical elements
- Large windows areas punctuated by smaller holes, creating a sense of mystery in the interior
- Interior wall areas dissolve into delicate arches
- Small dome with windows at drum; dome supported by squinches
- Church has a light interior filled with sparkling mosaics and frescoes

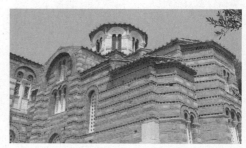

Figure 9.7: Monastery Churches, 10th–11th centuries, Hosios Loukas, Greece

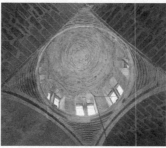

Figure 9.8: Dome supported on squinches, Monastery Churches, 10th–11th centuries, Hosios Loukas, Greece

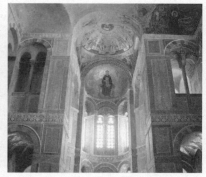

Figure 9.9: Monastery Churches, 10th–11th centuries, Hosios Loukas, Greece

Saint Mark's Cathedral, 1063 and ff. Venice, Italy (Figures 9.10 and 9.11)

- Five domes placed in a cross pattern
- Windows at base of dome illuminate brilliant mosaics that cover every wall space above the first floor
- Figures are weightless in a field of gold mosaics
- Prominent iconostasis separates apse from nave
- Compartmentalized space of Middle Byzantine architecture, cf. more open and spacious Hagia Sophia
- Church contains relics of the Saint Mark, the evangelist

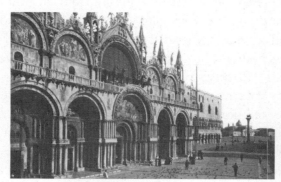

Figure 9.10: Saint Mark's Cathedral, 1063 and ff. Venice, Italy

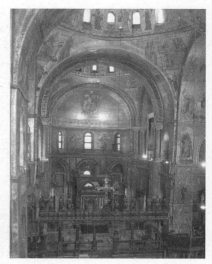

Figure 9.11: Saint Mark's Cathedral, 1063 and ff. Venice, Italy

Figure 9.12: Barma and Postnik, Saint Basil's Cathedral, 1555–1561, Moscow, Russia

Barma and Postnik, Saint Basil's Cathedral, 1555–1561, Moscow, Russia (Figure 9.12)

- Commissioned by Ivan the Terrible
- Tall, slender pyramidlike central tower crowned by small, onion-shaped dome
- Central spire surrounded by eight smaller domes of various sizes with fanciful decorative surfaces
- Low, flat, rounded arches intermix with triangular forms and tall slender windowlike shallow spaces

INNOVATIONS IN BYZANTINE PAINTING

The most characteristic work of Byzantine art is the **icon**, a religious devotional image usually of portable size and hanging in a place of honor either at home or in a religious institution. An icon has a wooden foundation covered by preparatory undercoats of paint, sometimes composed of such things as fish glue or putty. Cloth is placed over this base, and successive layers of stucco are gently applied. A perforated paper sketch is placed on the surface, so that the image can be traced and then gilded and painted. The artist then applies varnish to make the icon shine, as well as to protect it, because icons are often touched, handled, and embraced. The faithful were encouraged to kiss icons and burn votive candles beneath them; as a result, icons have become blackened by candle soot and incense, their frames singed by flames. Consequently, many icons have been repainted and no longer have their original surface texture.

Icons were paraded in religious processions on feast days, and sometimes exhibited on city walls in times of invasion. Frequently they were believed to possess spiritual powers, and they held a sacred place in the hearts of Byzantine worshippers.

Characteristics of Byzantine Painting

Byzantine painting is marked by a combination of the classical heritage of ancient Greece and Rome with a more formal and hieratic medieval style. Artists are trained in one tradition or the other, and it is common to see a single work of art done by a number of artists, some inspired by the classical tradition, and others by medieval formalism. Illustrations from the tenth-century *Paris Psalter* (Figure 9.16) show both styles.

Those artists who were classically trained used a painterly brushstroke and an innovative way of representing a figure—typically from an unusual angle. These artists employed soft transitions between color areas and showed a more relaxed figure stance.

Those trained in the medieval tradition favored frontal poses, symmetry, and almost weightless bodies. The drapery is emphasized, so there is little effort to reveal the body beneath. Perspective is unimportant because figures occupy a timeless space, marked by golden backgrounds and heavily highlighted halos.

Whatever the tradition, Byzantine art, like all medieval art, avoids nudity whenever possible, deeming it debasing. Nudity also had a pagan association, connected with the mythological religions of ancient Greece and Rome.

One of the glories of Byzantine art is its jewel-like treatment of manuscript painting. The manuscript painter had to possess a fine eye for detail, and so was trained to work with great precision, rendering minute details carefully. Byzantine manu-

scripts are meticulously executed; most employ the same use of gold seen in icons and mosaics. Because so few people could read, the possession of manuscripts was a status symbol, and libraries were true temples of learning. The ***Paris Psalter*** is an excellent example of the sophisticated court style of manuscript painting.

Byzantine art continues the ancient traditions of fresco and mosaic painting, bringing the latter to new heights. Interior church walls are covered in shimmering tesserae made of gold, colored stones, and glass. Each piece of tesserae is placed at an odd angle to catch the flickering of candles or the oblique rays of sunlight; the interior then resembles a vast glittering world of floating golden shapes, perhaps echoing what the Byzantines thought heaven itself would resemble.

Byzantine ensembles are arranged in hierarchal order. Jesus is largest, placed at the top of a composition, sometimes in the role of the **Pantocrator**, or ruler of the world. Angels either flank or appear beneath him, wearing robes similar to the ones the emperor wore at court. Beneath the angels are people with special religious significance—Mary, Jesus's mother, being the most prominent. Saints appear next, followed by less august religious figures. This type of program can be seen at Hosios Loukas and **Monreale** (Figure 9.18).

Court customs play an important role in Byzantine art. Purple, the color usually reserved for Byzantine royalty, can be seen in the mosaics of Emperor Justinian and Empress Theodora. However, in an act of transference, purple is sometimes used on the garments of Jesus himself. Custom at court prescribed that courtiers approach the emperor with their hands covered as a sign of respect. As a result, nearly every figure has at least one hand covered before someone of higher station, sometimes even when he or she is holding something. **Justinian** himself (Figure 9.13), in his famous mosaic in San Vitale, holds a bowl with his covered hand.

Facial types are fairly standardized. There is no attempt at psychological penetration or individual insight: Portraits in the modern sense of the word are unknown. Continuing a tradition from Roman art, eyes are characteristically large and wide open. Noses tend to be long and thin, mouths short and closed. The Christ Child, who is a fixture in Byzantine art, is more like a little man than a child, perhaps showing his wisdom and majesty. Medieval art generally labels the names of figures the viewer is observing, and Byzantine art is no exception.

Typically, most paintings have flattened backgrounds, often with just a single layer of gold to symbolize an eternal space. This becomes increasingly pronounced in the Middle and Late Byzantine periods in which figures stand before a monochromatic of golden opulence, perhaps illustrating a heavenly world.

Major Works of Byzantine Painting and Mosaic

Justinian and Attendants, c. 547, mosaic from San Vitale, Ravenna (Figure 9.13)

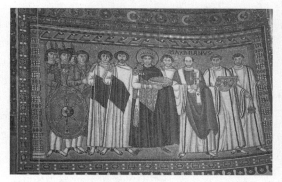

Figure 9.13: *Justinian and Attendants*, c. 547, mosaic from San Vitale, Ravenna

- To his left the clergy, to his right the military
- Dressed in royal purple and gold
- Symmetry, frontality
- Holds a paten, a shallow bowl or plate, for the Eucharist
- Slight impression of procession forward; cf. Roman Imperial works

- Figures have no volume, seem to float, and overlap each other's feet
- Minimal background: green base at feet, golden background indicates timelessness
- Maximianus identified, patron of San Vitale
- Halo indicates saintliness, a semidivinity as head of church and state
- Justinian and Theodora are actively participating in the Mass—their position over the altar enhances this allusion

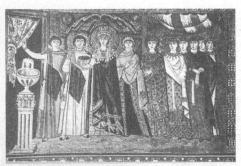

Figure 9.14: *Theodora and Attendants*, c. 547, mosaic from San Vitale, Ravenna

Theodora and Attendants, c. 547, mosaic from San Vitale, Ravenna (Figure 9.14)

- Slight displacement of absolute symmetry with Theodora—she plays a secondary role to her husband
- Richly robed empress and ladies at court
- She stands in an architectural framework, holding a chalice for the mass, and is about to go behind the curtain
- Figures are flattened and weightless, barely a hint of a body can be detected beneath the drapery
- Three Magi, who bring gifts to the baby Jesus, are depicted on the hem of her dress. This reference draws parallels between Theodora and the Magi.

Sant'Apollinare in Classe, 549, apse mosaic, Ravenna, Italy (Figure 9.15)

Figure 9.15: Sant'Apollinare in Classe, 549, apse mosaic, Ravenna, Italy

- Stark unadorned exterior brickwork echoes the crudeness of the outside world
- Interior richly decorated symbolizes the soul
- Saint Apollinaris, the first bishop of Ravenna, has his hands raised in an orant position, and is dressed in bishop's garb
- Twelve sheep represent the 12 apostles and/or the 12 tribes of Israel and/or parishioners in the church with the bishop as the symbolic leader of his flock
- Three sheep are the apostles who witnessed Jesus's Transfiguration—the moment when he is revealed to be divine (Matthew 17:1–8); sheep can also represent the Trinity
- Moses and Elijah flank the cross, they are Old Testament prophets present at the Transfiguration
- The hand of God comes down from the clouds to bless the scene
- Increasing flatness of forms, moving away from classical naturalistic depictions

Figure 9.16: *David Composing the Psalms* from the *Paris Psalter*, c. 950–970, tempera on vellum, Bibliothèque Nationale, Paris

David Composing the Psalms from the *Paris Psalter*, c. 950–970, tempera on vellum, Bibliothèque Nationale, Paris (Figure 9.16)

- Psalter, book of Psalms from the Bible
- Figures and landscape based on classical models
- Brilliant and balanced color
- Dynamic contrast between muscular bodies and stiff drapery

- David playing the harp inspired by Melody (upper body is classical in inspiration, lower body is medieval)
- Personification of Echo(?) behind a loving cup given as a prize for the best singer
- Muscular, classically inspired figure symbolizing Mountains of Bethlehem in lower right
- Arcs and curves dominate composition
- Jewel-like border frames scene

Pantocrator, late eleventh century, Church of the Dormition, Daphni, Greece (Figure 9.17)

Figure 9.17: *Pantocrator*, late 11th century, Church of the Dormition, Daphni, Greece

- In the dome over the nave of the church Christ sees and understands all as he looks down from heaven
- Christ as stern, severe, awesome, and almost menacing; owl-like eyes, forked beard, gap in beard above chin, two curls of hair dangle on forehead
- Monumental form set in a sea of gold
- Christ as Pantocrator: half-length pose, hand on Bible, right hand blessing
- Christ's name written in Greek

Pantocrator, 1180–1190, mosaic, Cathedral, Monreale, Sicily (Figure 9.18)

- Mosaics arranged in an elaborate hierarchy: Jesus at top
- Solidity of figure; monumental scale
- Sternness, severeness, awesome grandeur
- Blessing gesture in his right hand; left hand holds a Bible inscribed in Latin and Greek
- Image suggests a combination of Jesus Christ and God the Father
- Pointed arches suggest the beginnings of the Gothic style
- Largest Byzantine mosaic cycle extant, over one acre of gold mosaic; dazzling recreation of a heavenly realm on earth

Figure 9.18: *Pantocrator*, 1180–1190, mosaic, Cathedral, Monreale, Sicily

Andrei Rüblev, *Old Testament Trinity*, c. 1410, tempera on wood, Tretyakov Gallery, Moscow (Figure 9.19)

- Byzantine affinity for repeating forms from older art
- Heads of angels nearly identical
- Poses are mirror images
- Luminous appeal of colors
- Deep color harmonies of draperies
- Extensive use of gold
- Nearly spaceless background
- Three Old Testament angels who appear to Abraham and Sarah in Genesis; parallel relationship to the Christian Trinity

Figure 9.19: Andrei Rüblev, *Old Testament Trinity*, c. 1410, tempera on wood, Tretyakov Gallery, Moscow

CHARACTERISTICS OF BYZANTINE SCULPTURE

Figure 9.20: *Saint Michael the Archangel*, early 6th century, ivory, British Museum, London

Large-scale sculpture, the kind that graced the plazas and palaces of ancient Egypt, Greece, and Rome, were mostly avoided. Byzantine sculptors preferred working in ivory or precious metals, creating works of unparalleled richness and technical virtuosity. Some ivories are marked by deep undercutting so that the figures stand out prominently before the base of the work. The *Saint Michael the Archangel* (Figure 9.20) and *Harbaville Triptych* (Figure 9.21 are excellent examples of ivory carving.

Saint Michael the Archangel, early sixth century, ivory, British Museum, London (Figure 9.20)

- One leaf of an ivory diptych
- Roman coiffure, classical drapery, facial type
- Subtle relief folds; body articulated beneath drapery
- Delicately detailed classical architecture
- Imperial imagery in the orb and the scepter
- Saint Michael hovers in front of arch, with wings before the columns
- Spatial ambiguity: feet placed on several steps behind the columns

Figure 9.21: *Harbaville Triptych*, c. 950, ivory, Louvre, Paris

Harbaville Triptych, c. 950, ivory, Louvre, Paris (Figure 9.21)

- Individualized heads
- Frontality broken up by slight turns of body
- Sharp crisp lines
- Very hieratic composition
- Angels appear in medallions
- Jewel-like delicacy of carving
- Many have their hands covered, a symbol of respect in Byzantine art; also a symbol of approaching someone of higher rank
- Medieval interest in labeling names of figures in works of art
- Figures are the same size, many dressed alike and symmetrically arranged

VOCABULARY

Cathedral: the principal church of a diocese, where a bishop sits (Figure 9.10)

Codex (plural: codices): a manuscript book (Figure 9.16)

Icon: a devotional panel depicting a sacred image (Figure 9.19)

Iconostasis: a screen decorated with icons, which separates the apse from the transept of a church (Figure 9.11)

Mosaic: a decoration using pieces of stone, marble or colored glass, called **tesserae**, that are cemented to a wall or a floor (Figure 9.13)

Pantocrator: literally, "ruler of the world," a term that alludes to a figure of Christ placed above the altar or in the center of a dome in a Byzantine church (Figure 9.17)

Pendentive: a construction shaped like a triangle that transitions the space between flat walls and the base of a round dome (Figure 9.1)

Psalter: a book of the Psalms or sacred sung poems from the Bible (Figure 9.16)

Squinch: the polygonal base of a dome that makes a transition from the round dome to a flat wall (Figure 9.2)

Triptych: a three-paneled painting or sculpture (Figure 9.21)

Summary

The Eastern half of the Roman Empire lived for another one thousand years beyond the fall of Rome under a name we today call Byzantine. The Empire produced lavish works of art for a splendid court that resided in Constantinople—one of the most resplendent cities in history.

Byzantine art specialized in a number of diverse art forms. Walls were covered in shimmering gold mosaic that reflected a heavenly world of great opulence. Icons that were sometimes thought to have spiritual powers were painted of religious figures. Ivories were carved with consummate precision and skill.

Byzantine builders invented the pendentive, first seen at the Hagia Sophia. However, in later buildings the squinch was preferred.

The death of the Empire in 1453 did not mean the end of Byzantine art. Indeed, a second life developed in Russia, eastern Europe, and in occupied Greece lasting into the twentieth century.

Practice Exercises

1. All of the following are architectural innovations at the Hagia Sophia EXCEPT

 `CHALLENGE`

 (A) a circle of windows appears at the base of the dome
 (B) pendentives are used to support the dome
 (C) the ground plan is a mix of the axial and centrally planned church
 (D) frescoes cover the wall spaces

2. Fears of idolatry caused the Byzantines to

 (A) stop the production of icons
 (B) invade surrounding countries they considered heathen
 (C) decorate the interior of their churches with abstract symbols
 (D) turn to ivory as a principal source of carving

3. After the fall of the Byzantine Empire, artistic production continued in

 (A) France
 (B) Egypt
 (C) Russia
 (D) England

4. An iconostasis was used to

 (A) allow artists to paint icons in place
 (B) separate the apse from the transept and the nave of a church
 (C) offer support for a squinch
 (D) allow light into a church

5. Characteristically, icons

 (A) were handled and kissed by the faithful
 (B) were used by the Byzantine emperor to deliver messages
 (C) had images of the emperor or members of his court on them
 (D) symbolized Byzantium's link to its classical past

Questions 6 and 7 refer to Figure 9.22.

6. This Byzantine panel shows the influence of classical art in its

 (A) spatial placement of the angel on the steps and in the arch
 (B) modeling of the body
 (C) Christian symbolism
 (D) relationship of the figure to the architectural setting

7. This Byzantine panel is made of

 (A) terra-cotta
 (B) marble
 (C) limestone
 (D) ivory

Figure 9.22

8. Byzantine churches have artistic programs that feature Jesus as the central figure in the role of Pantocrator, meaning he is the

 (A) savior
 (B) son of God
 (C) ruler of the world
 (D) unifier of all

9. The Hagia Sophia was built under the patronage of

 (A) Emperor Trajan
 (B) Emperor Justinian and Empress Theodora
 (C) Emperor Basil I
 (D) Constantine the Great

Question 10 refers to Figure 9.23.

10. The subject of this painting draws a parallel
between

 (A) the Bible and Greek mythology
 (B) Homer's *The Iliad* and *The Odyssey*
 (C) Early and Late Byzantine art
 (D) the Hebrew and Christian scriptures

CHALLENGE

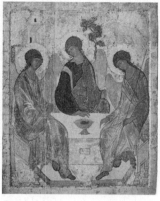

Figure 9.23

Short Essay

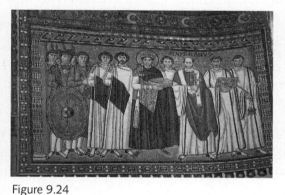

Figure 9.24

Identify the central figure in
Figure 9.24. What pictorial
and stylistic devices are used
to communicate this person's
majesty and importance?
Use one side of a sheet of lined
paper to write your essay.

Answer Key

1. **(D)**	3. **(C)**	5. **(A)**	7. **(D)**	9. **(B)**
2. **(A)**	4. **(B)**	6. **(B)**	8. **(C)**	10. **(D)**

Answers Explained

Multiple-Choice

1. **(D)** All of the following are innovations first seen in the Hagia Sophia: the cir-
cle of windows at the base of the dome, the pendentives supporting the dome,
and the combination of the centrally planned and axially planned nave. There
are no frescoes on the walls of the Hagia Sophia; they are covered with mosaics
and marble.

2. **(A)** The Byzantines stopped the production of icons because of idolatry. This movement is called the Iconoclastic Controversy.

3. **(C)** While western Europe did continue to be influenced by Byzantine art, it did not adopt this style. The Egyptians were Islamic at this point, and were producing non-figural compositions. The Russians assumed Byzantine culture wholeheartedly.

4. **(B)** The very purpose of the iconostasis is to separate the apse from the transept and the nave with a wall of icons. In this way orthodox Christian priests can remove themselves from the congregation during important parts of the Christian ceremony.

5. **(A)** Icons have a long history of being adored by the faithful, and that includes handling and kissing.

6. **(B)** The modeling of the angel is brilliantly rendered in the classical tradition.

7. **(D)** This Byzantine panel is made of ivory.

8. **(C)** Pantocrator is Greek for "ruler of the world."

9. **(B)** Emperor Justinian and Empress Theodora were the patrons of the Hagia Sophia.

10. **(D)** The *Old Testament Trinity* shows an episode from Genesis in the Hebrew sculptures in which Abraham and Sarah entertain three angels. A parallel with the Christian Trinity is implied.

Rubric for Short Essay

4: The student identifies the central figure in the mosaic as Emperor Justinian I. At least three pictorial and stylistic devices that communicate Justinian's importance are mentioned. The discussion of these devices is full. There are no major errors.

3: The student identifies the central figure, but only two characteristics are discussed, OR the student does not identify the figure, but three characteristics are discussed. There may be minor errors.

2: The student identifies the central figure, but discusses only one characteristic, OR the student does not identify the central figure, but two characteristics are discussed. There may be major errors.

1: The student identifies the central figure, but there is no discussion of merit, OR the central figure is misidentified or unidentified, but one stylistic device is discussed. The discussion may be superficial. There may be major errors.

0: The student makes an attempt, but the response is without merit.

Short Essay Model Response

The central figure here is Byzantine Emperor Justinian I. He stands out as the most important presence in the mosaic, as he is centrally located, crowned, haloed, and wearing the purple robes of royalty. The dark, commanding color of this robe sets him apart from the relatively white attire of the flanking attendants and clergy. Additionally, the pattern delineating the perimeter of the mosaic breaks down above Justinian's head, an indication that his majesty extends beyond his person. This majestic aura, highlighted by a halo, is so powerful that it cannot be contained by the same patterns that define the space of others. The keystone insertion in the pattern also suggests that Justinian is the sine qua non of the group, the unifying part of the whole. This distinction is confirmed by the presence of military and clergy on either side of him, portraying Justinian as the unifier of secular and religious realms. The vertical emphasis in this mosaic, resulting from the lines on the robe, the cross, shield-pattern, and spears also affirms the rigidity and strength of the group, while the gilded Byzantine background confers spiritual authority to complement its hegemony. The placement of the mosaic in the apse also indicates the interrelatedness of church and state—representing Justinian as a divinely appointed ruler whose presence is always felt. This mixing of church and state, of religiosity and military prowess, is most prevalent in the haloed figure of Justinian, central nexus between both worlds, rightful leader of men.

—Gabriel Sl.

Analysis of Model Response

The model response correctly identifies Emperor Justinian I as the central figure. The discussion then goes on to reveal an intimate knowledge of this mosaic through a listing of various stylistic components that indicate Justinian's majesty and importance. Gabriel conveys a convincing argument by integrating the various stylistic elements with their relevance to the artistic structure of the piece as well as an understanding of the interrelatedness of the mosaic and the political and religious interconnections the artist makes. **This essay merits a 4.**

Islamic Art

CHAPTER 10

TIME PERIOD: 650 C.E. to the present

KEY IDEAS

- The chief building for Muslim worship is the mosque, which directs the worshipper's attention to Mecca through a niche called a mihrab.
- Calligraphy is the most prized art form, appearing on most Islamic works of art.
- Both figural and nonfigural works incorporate calligraphy with arabesques and tessellations.
- Persian manuscripts are fine examples of Islamic figural art.

HISTORICAL BACKGROUND

The Prophet Muhammad's powerful religious message resonated deeply with Arabs in the seventh century, and so by the end of the Umayyad Dynasty in 750 C.E., North Africa, the Middle East and parts of Spain, India, and Central Asia were converted to Islam or were under the control of Islamic dynasties. The Islamic world expanded under the Abbasid Caliphate, which ruled a vast empire from their capital in Baghdad. After the Mongol sack of Baghdad in 1258, the Islamic world split into two great cultural divisions, the East, consisting of South and Central Asia, Iran, and Turkey; and the West, which included the Near East and the Arabic peninsula, North Africa, parts of Sicily and Spain.

Islam exists in two principal divisions, Shiite and Sunni, each based on a differing claim of leadership after Muhammad's death. Even though millions practice and continue to share a similar faith, there is great diversity of Islamic artistic traditions.

Patronage and Artistic Life

Major monuments and artistic movements in the Islamic world are the result of patronage by rulers and the social elite. Other objects much valued today, such as textiles, metalwork, and ceramics were produced for the art market, both at home and abroad.

One of the most popular art forms in the Islamic world is **calligraphy**, which is based upon the Arabic script and varies in form depending on the period and region of its production. Calligraphy is considered to be the highest art form in the Islamic world as it is used to transmit the texts revealed from God to Muhammad. Calligraphers therefore were the most respected Islamic artists. Most early artists were

humble handmaidens to the art form—and to God—therefore many remained anonymous. However, by the fourteenth and fifteenth centuries, one begins to find writing examples that are signed or attributed to specific calligraphers. Even royalty dabbled in calligraphy, raising the art form to new heights. Apprenticeships were exacting, making students master everything including the manufacture of ink and the correct posture for sitting while writing.

INNOVATIONS IN ISLAMIC ARCHITECTURE

All mosques are oriented toward Mecca because Muslims must pray five times a day facing the holy city. The **qiblah**, or direction, to Mecca is marked by the **mihrab** (Figure 10.1), an empty niche, which directs the worshipper's attention.

To remind the faithful of the times to pray, great **minarets** (Figure 10.12) are constructed in every corner of the Muslim world, from which the call to prayer is recited to the faithful. Minarets are composed of a base, a tall shaft with an internal staircase, and a gallery from which **muezzins** call people to prayer. Galleries are often covered with canopies to protect the occupants from the weather.

Figure 10.1:
A mihrab

INNOVATIONS IN ISLAMIC PAINTING AND SCULPTURE

Islamic art features three types of patterns—**arabesques**, **calligraphy**, and **tessellation** (Figures 10.2, 10.3, and 10.4, respectively)—used on everything from great monuments to simple earthenware plates; sometimes all three are used on the same item.

Favorite arabesque motifs include acanthus and split leaves, scrolling vines, spirals, wheels, and zigzags. Calligraphy is highly specialized, and comes in a number of recognized scripts, including **Kufic**. The Arabic alphabet has 28 letters from 17 different shapes, and is written from right to left. Arabic numerals, however, are written left to right as they are in the West. **Kufic** is highly distinguished, and has been reserved for official texts, indeed has been the traditional, but not the only, script for the Koran. It has evolved into a highly ornamental style, and therefore is difficult for the average reader to decipher. Tessellations, or the repetition of geometric designs, demonstrate the Islamic belief that there is unity in multiplicity. Their use can be found on objects as disparate as open metalwork and stone decorations. Perforated ornamental stone screens, called **jali**, were a particular Islamic specialty.

Figure 10.2: Arabesque

All of these designs, no matter how complicated, were achieved with only a straightedge and a compass. Islamic mathematicians were thinkers of the highest order; geometric elements reinforced their idea that the universe is based on logic and a clear design. Patterns seem to radiate from a central point, although any point can be thought of as the start. These patterns are not designed to fit a frame, rather to repeat until they reach the edge, and then by inference go beyond that.

Figure 10.3: Islamic calligraphy with arabesque

Figure 10.4: Tessellation

Islamic textiles, carpets in particular, are especially treasured (Figure 10.5). The composition of this medallion carpet from Persia is centrally organized with a vase motif in the corners. Elaborate prayer rugs, often bearing the mihrab motif, are placed on mosque floors to provide a clean and comfortable spot for the worshipper to kneel on. Royal factories made elaborate carpets, in which it was usual to have hundreds of knots per square inch. In tribal villages, women were often the manufacturers of smaller carpets with designs created by either the knotting or the flat-weave technique.

Figure 10.5: Islamic carpet

Characteristics of Islamic Art

Islamic art is intellectual, refined, and decorative; it contains no strong emotions and no pathos, but exhibits serene harmony.

Although the Koran does not ban images, there is an active tradition in many Islamic countries to avoid religious imagery whenever possible. Some societies strictly adhere to the prohibition, others allow floral designs and animal motifs, still others disregard the traditional ban. Sometimes, even within the same monument, as at the **Frieze of Mshatta** (c. 740–750) (Figure 10.9), there is animal imagery on the domestic side of the building, and none on the religious side.

Mosques come in many varieties. The most common designs are either the hypostyle halls like the **Great Mosque at Córdoba** (eighth–tenth centuries) (Figure 10.8) or the unified open interior as the **Mosque of Selim II** (1568–1575) (Figure 10.12). The former is characterized by an interior that is a forest of columns, sometimes invested with an open central courtyard. The arches at Córdoba are horseshoe-shaped with alternating striped stonework. The focus of all prayer is the mihrab, which points the direction to Mecca.

In contrast, the Mosque of Selim II has a unified central core with a brilliant dome surmounting a centrally organized ground plan. Works like this were inspired by Byzantine architecture. The domes of mosques and tombs employ squinches, which in Islamic hands can be made to form an elaborate orchestration of suspended facets called **muqarnas**.

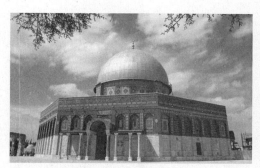

Figure 10.6: Dome of the Rock, c. 687–691, Jerusalem, Israel

Major Works of Islamic Art

Dome of the Rock, c. 687–691, Jerusalem, Israel (Figure 10.6 and 10.7)

- Domed wooden octagon
- Influenced by centrally planned buildings, cf. Santa Costanza (Figure 8.5)
- Columns from Roman monuments
- Sacred rock where Adam was buried, Abraham nearly sacrificed Isaac, Muhammad ascended to heaven, Temple of Jerusalem was located

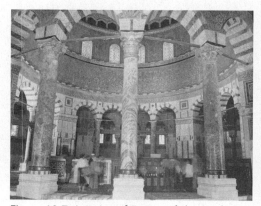

Figure 10.7: Interior of Dome of the Rock, c. 687–691, Jerusalem, Israel

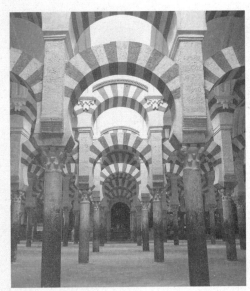

Figure 10.8: Great Mosque, 8th–10th centuries, Córdoba, Spain

Figure 10.9: Frieze from Mshatta, Jordan, c. 740–750, limestone, State Museum, Berlin

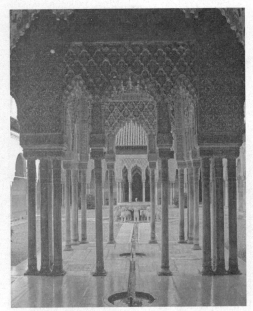

Figure 10.10: Court of the Lions, Alhambra, 1354–1391, Granada, Spain

Great Mosque, Eighth–Tenth Centuries, Córdoba, Spain (Figure 10.8)

- Double-arched columns, brilliantly articulated in alternating bands of color
- A light and airy interior
- Horseshoe-shaped arches
- Hypostyle mosque: no central focus, no congregational worship
- Original wooden ceiling replaced by vaulting
- Complex dome over mihrab with elaborate squinches
- Columns are spolia from ancient Roman structures

Frieze from Mshatta, Jordan, c. 740–750, limestone, State Museum, Berlin (Figure 10.9)

- From a palace in Jordan
- Richly carved stone walls 16-feet high
- Triangle pattern, rosettes placed in each triangle
- Vegetal designs, intricate scrolls
- Birds, vines, and animals on secular side of palace; mosque side has no animal patterns
- Walls 16 ½ feet tall, meant to keep out bandits and give privacy to the occupants

Court of the Lions, Alhambra, 1354–1391, Granada, Spain (Figure 10.10 and 10.11)

- Palace of the Nasrid sultans of southern Spain
- Light, airy interiors
- 16 windows at top of hall, light dissolves into a honeycomb of stalactites that dangle from the ceiling
- Abstract patterns, abstraction of forms
- 5,000 muqarnas refract light
- Highly sophisticated and refined interior

Figure 10.11: Muqarnas Dome from the Hall of the Two Sisters, Palace of the Lions, Alhambra, 1354–1391, Granada, Spain

Sinan, Mosque of Selim II, 1568–1575, Edirne, Turkey (Figures 10.12 and 10.13)

- Extremely thin soaring minarets
- Abundant window space makes for a brilliantly lit interior
- Decorative display of mosaic and tile work
- Inspired by Hagia Sophia (Figure 9.4), but a centrally planned building
- Octagonal interior, with 8 pillars resting on a square set of walls
- Open airy interior contrasts with conventional mosques that have partitioned interiors
- Part of a complex including a hospital, school, library, etc.

Persian Manuscripts

Persian painting descends from a rich and diverse heritage, including illustrated manuscripts from the western Islamic world and figural ceramics from pre-Mongol Iran. The Mongolian rulers who conquered Iran in 1258 introduced exotic Chinese painting to the Iranian court in the late Middle Ages. Persian manuscript paintings (sometimes called miniatures) gave a visual image to a literary plot, rendering a more enjoyable and easier-to-understand text. A number of diverse schools of manuscript painting were cultivated throughout Persia, some more, others less, under the spell of Chinese painting. Centuries after the Mongols, Chinese elements survive in the Asiatic appearance of figures, the incorporation of Chinese rocks and clouds, and the appearance of motifs such as dragons and chrysanthemums. Persian miniatures, in turn, influenced Mughal manuscripts in India (see Chapter 27).

Characteristics of many Persian manuscripts include a portrayal of figures in a relatively shadowless world, usually sumptuously dressed and occupying a richly decorative environment. Persian artists admire intricate details and multicolored geometric patterns. Space is divided into a series of flat planes. The marriage of text and calligraphy is especially stressed, as the words are often written with consummate precision in spaces reserved for them on the page.

The viewer's point of view shifts in a world perceived at various angles—sometimes looking directly at some figures, while also looking down at the floor and carpets. Artists depict a lavishly ornamented architectural setting with crowded compositions of doll-like figures distinguishable by a brilliant color palette. In the painting illustrated here (Figure 10.14), calligraphy on the top and bottom explains the text, and the warlike scene is conveyed as decorative and fanciful.

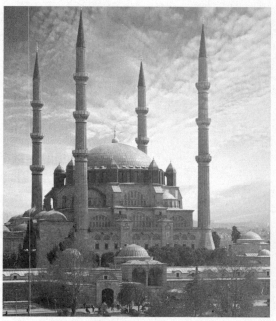

Figure 10.12: Sinan, Mosque of Selim II, 1568–1575, Edirne, Turkey

Figure 10.13: Sinan, Mosque of Selim II interior, 1568–1575, Edirne, Turkey

Figure 10.14: Persian manuscript showing the battles of Alexander the Great

VOCABULARY

Arabesque: a flowing, intricate, and symmetrical pattern deriving from floral motifs (Figure 10.2)

Calligraphy: decorative or beautiful handwriting (Figure 10.3)

Jali: perforated ornamental stone screens in Islamic art

Koran: the Islamic sacred text, dictated to the Prophet Muhammad by the Angel Gabriel

Kufic: a highly ornamental Islamic script

Mecca, Medina: Islamic holy cities; Mecca is the birthplace of Muhammad and the city all Muslims turn to in prayer; Medina is where Muhammad was first accepted as the Prophet, and where his tomb is located

Mihrab: a central niche in a mosque, which indicates the direction to Mecca (Figure 10.1)

Minaret: a tall, slender column used to call people to prayer (Figure 10.12)

Minbar: a pulpit from which sermons are given

Mosque: a Muslim house of worship (Figure 10.8)

Muezzin: an Islamic official who calls people to prayer traditionally from a minaret

Muhammad (570?–632): The Prophet whose revelations and teachings form the foundation of Islam

Muqarna: a honeycomb-like decoration often applied in Islamic buildings to domes, niches, capitals, or vaults. The surface resembles intricate stalactites (Figure 10.11)

Qiblah: the direction toward Mecca which Muslims face in prayer

Tessellation: decoration using polygonal shapes with no gaps (Figure 10.4)

Summary

Although not specifically banned by the Koran, a traditional prohibition against figural art dominates much of the Islamic movement. This did not prove to be an impediment for Muslim artists, who formed an endless creative expression of abstract designs based on calligraphy, arabesques, and tessellations. Figural art occurs mostly in Persian manuscripts that depict lavishly costumed courtiers recreating famous stories from Arabic literature.

Islamic architecture borrows freely from Byzantine, Sassanian, and Early Christian sources. Mosques all have niches, called mihrabs, which direct the worshipper's attention to Mecca. Religious symbolism dominates mosques, but is also richly represented in secular buildings such as tombs or palaces.

Practice Exercises

1. Persian manuscripts are unusual in Islamic art because they

 (A) have great emotional range
 (B) resist the ban on images
 (C) incorporate arabesques into their artwork
 (D) use a painterly brushstroke

CHALLENGE

2. Minarets are used to

 (A) balance architectural members
 (B) display calligraphy
 (C) direct people's attention to Mecca
 (D) call people to prayer

3. The Dome of the Rock marks the site where

 (A) Jesus was born
 (B) the Koran was written
 (C) Muhammad was born
 (D) Muhammad ascended to heaven

Questions 4–6 refer to Figure 10.15.

4. This building is located in

 (A) Jerusalem, Israel
 (B) Córdoba, Spain
 (C) Granada, Span
 (D) Istanbul, Turkey

5. Like some other Islamic mosques this building

 (A) has many windows
 (B) has a wooden dome
 (C) is centrally planned
 (D) has a hypostyle hall

6. Although it cannot be seen in this photo, this mosque must have

 (A) a mihrab
 (B) mythical beasts
 (C) a bell tower
 (D) a frieze

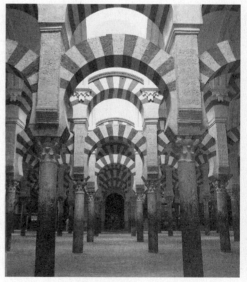

Figure 10.15: Great Mosque, 8th–10th centuries, Córdoba, Spain

7. The highest calling for an Islamic artist is to be

 (A) a calligrapher
 (B) a painter
 (C) a sculptor
 (D) an architect

CHALLENGE

8. The Mosque of Selim II was inspired by

 (A) Santa Costanza
 (B) the Hagia Sophia
 (C) San Vitale
 (D) the Dome of the Rock

9. The Alhambra was a

 (A) mosque
 (B) palace
 (C) shrine
 (D) frieze

10. Arabesques are based on

 (A) calligraphy
 (B) geometric patterns
 (C) animal motifs
 (D) floral designs

Short Essay

CHALLENGE

Figure 10.16

Figure 10.16 is an Islamic work of art. Where in the Islamic world does this painting come from? What characteristics place it within this culture? Use one side of a sheet of lined paper to write your essay.

Answer Key

| 1. **(B)** | 3. **(D)** | 5. **(D)** | 7. **(A)** | 9. **(B)** |
| 2. **(D)** | 4. **(B)** | 6. **(A)** | 8. **(B)** | 10. **(D)** |

Answers Explained

Multiple-Choice

1. **(B)** Persian art uses images, unlike most other Islamic forms.

2. **(D)** Minarets are used to call people to prayer.

3. **(D)** It is believed that Muhammad ascended to heaven on the site of the Dome of the Rock.

4. **(B)** This mosque is located in Córdoba, Spain.

5. **(D)** This mosque is a hypostyle hall, meaning that it is supported by a forest of columns.

6. **(A)** Every mosque has a mihrab.

7. **(A)** The highest calling for an Islamic artist is to be a calligrapher.

8. **(B)** The Mosque of Selim II was inspired by, and sought to exceed, the Hagia Sophia.

9. **(B)** The Alhambra was a palace in Granada, Spain.

10. **(D)** Arabesques are floral designs. Tessellations are geometric patterns.

Rubric for Short Essay

4: The student identifies this manuscript as Persian. The student names three ways in which this work exhibits Islamic characteristics (i.e., calligraphy, tessellation, arabesque, multiple perspectives, and so on). There are no major errors.

3: The student identifies this manuscript as Persian. The student names two ways in which this work exhibits Islamic characteristics. There may be minor errors.

2: This is the highest score a student can earn if he or she identifies the manuscript as Persian. The student gives at least one reason why the work is Islamic. There may be major errors.

1: The student identifies this manuscript as Persian, OR the student names at least one characteristic of Islamic art seen in this manuscript. There is no discussion.

0: The student makes an attempt, but the response is without merit.

Short Essay Model Response

This manuscript comes from Persia. Traditionally, Islamic art does not have figures, but the Persian tradition, with its rich artistic past of representational art, incorporates figures into its work. There are many characteristics that place it firmly in Islamic culture.

The most obvious sign that the manuscript is Islamic is the Arabic calligraphy, which appears at the top of the page and explains the story taking place in the illustration. Another very distinctive characteristic is that every surface is covered with design, whether it be calligraphy, arabesques (floral motifs on the carpet) or tessellations (polygonal decorations on the tile floor).

Perspective is manipulated in a Persian composition. We look horizontally at the figures but down at the carpets and the bed. This was an Islamic technique used so that the viewer could see things as completely as possible.

All these characteristics place this work in the Islamic period and in Persian Art.

—Christopher V.

Analysis of Model Response

Christopher's response immediately states that the manuscript page is Persian, and then goes on to name the typical Islamic characteristics seen in this manuscript. Importantly, Christopher not only names the characteristics, but mentions where they are located in the composition: for example, arabesques (floral motifs on the carpet). Since he discusses more than three characteristics and knows the manuscript is Persian, he earns the highest grade. **This essay merits a 4.**

Early Medieval Art

Civilization	Date	Location
TIME PERIOD: 450–1050		
Hiberno-Saxon Art	6th–8th centuries	British Isles
Viking Art	8th–11th centuries	Scandinavia
Carolingian Art	8th–9th centuries	France, Germany
Ottonian Art	10th–early 11th centuries	Germany

KEY IDEAS

- The Migration period of the Early Middle Ages featured portable works that were done in the animal style.
- Characteristics of Early Medieval art include horror vacui and interlacing patterns.
- Art at the court of Charlemagne begins the first of many western European revivals of ancient Rome.
- Ottonian art revives large scale sculpture and architecture.

HISTORICAL BACKGROUND

In the year 600, almost everything that was known was old. The great technological breakthroughs of the Romans were either lost to history or beyond the capabilities of the migratory people of the seventh century. This was the age of mass migrations sweeping across Europe, an age epitomized by the fifth-century king, Attila the Hun, whose hordes were famous for despoiling all before them.

Certainly Attila was not alone. The Vikings from Scandinavia, in their speedy boats, flew across the North Sea and invaded the British Isles and colonized parts of France.

Other groups, like the notorious Vandals, did much to destroy the remains of Roman civilization. So desperate was this era that historians named it the "Dark Ages," a term that more reflects our knowledge of the times than the times themselves.

However, stability in Europe was reached at the end of the eighth century when a group of Frankish kings, most notably Charlemagne, built an impressive empire whose capital was centered in Aachen, Germany.

In the tenth century, a dynasty of three German kings, all named Otto, established the Ottonian Empire, again reuniting central Europe.

Patronage and Artistic Life

Monasteries were the principal centers of learning in an age when even the emperor, Charlemagne, could read, but not write more than his name. Therefore, artists who could both write and draw were particularly honored for the creation of manuscripts.

The modern idea that artists should be original and say something fresh or new in each work is a notion that was largely unknown in the Middle Ages. Scribes copied great works of ancient literature, like the Bible or medical treatises; they did not record contemporary literature or folk tales. Scribes were expected to maintain the wording of the original, while illustrators painted important scenes, keeping one eye on traditional approaches, and another on his or her own creative powers. Therefore, the text of a manuscript is generally an exact copy of a continuously recopied book, the illustrations allow the artist some freedom of expression.

INNOVATIONS IN EARLY MEDIEVAL PAINTING

One of the great glories of Medieval art is the decoration of manuscript books, called **codices**, which were improvements over ancient scrolls both for ease of use and durability. A codex was made of resilient antelope or calf hide, called vellum, or sheep or goat hide, called parchment. These hides were more durable than the friable papyrus used in making ancient scrolls. Hides were cut into sheets and soaked in lime in order to free them from oil and hair. The skin was then dried and perhaps chalk was added to whiten the surface. Artisans then prepared the skins by scraping them down to an even thickness with a sharp knife; each page had to be rubbed smooth to remove impurities. The hides were then folded to form small booklets of eight pages, called quires. Parchment was so valued as a writing surface that it continued to be used for manuscripts even after paper became standard.

The backbone of the hide was arranged so that the spine of the animal ran across the page horizontally. This minimized movement when the hide dried and tried to return to the shape of the animal, perhaps causing the paint to flake.

Illuminations were painted mostly by monks or nuns who wrote in rooms called **scriptoria**, or writing places, that had no heat or light, to prevent fires. Vows of silence were maintained to limit mistakes. A team often worked on one book; scribes copied the text and illustrators drew capital letters as painters illustrated scenes from the Bible. Eventually, the quires were sewn together to create the book.

Manuscript books had a sacred quality. This was the word of God, and had to be treated with appropriate deference. The books were covered with bindings of wood or leather, and gold leaf was lavished on the surfaces. Finally, precious gems were inset on the cover.

CHARACTERISTICS OF SAXON ART

A spectacular hoard of medieval gold and silverwork was discovered on a farm in Shropshire, England, in 2009. This find is so large that it has forced scholars to reconsider everything that is known about the Anglo-Saxon kingdoms of medieval Britain.

Objects done in **cloisonné** dominate, with **horror vacui** designs featuring **animal style** decoration. Interlace patternings are common. Images enjoy an elaborate symmetry, with animals alternating with geometric designs. Most of the objects that survive are portable. The 1939 discovery of a ship burial at Sutton Hoo, England, has revealed some of the richest works from this period.

Major Work of Saxon Art

Purse Cover **from Sutton Hoo Ship Burial, 600–650, gold, garnet, enamels, British Museum, London (Figure 11.1)**

- Sutton Hoo was the scene of a ship burial, possibly for King Raedwald of East Anglia
- Purse cover designs survive, backing of ivory or bone disintegrated, bag of leather also disintegrated
- Animal style; hawks attacking ducks
- Animals bite the heads of the men they flank
- Interlacing patterns of ornamental designs
- Legs and arms intertwined
- Cloisonné technique

Figure 11.1: *Purse Cover* from Sutton Hoo Ship Burial, 600–650, gold, garnet, enamels, British Museum, London

CHARACTERISTICS OF HIBERNO-SAXON ART

Hiberno-Saxon art refers to the art of the British Isles in the Early Medieval period; Hibernia is the ancient name for Ireland. The main artistic expression is illuminated manuscripts, of which a particularly rich collection still survives.

Hiberno-Saxon art relies on complicated interlace patterns in a frenzy of horror vacui. The borders of these pages harbor animals in stylized combat patterns, sometimes called the animal style. Each section of the illustrated text opens with huge initials that are rich fields for ornamentation. The Irish artists who worked on these books had an exceptional handling of color and form, featuring a brilliant transference of polychrome techniques to manuscripts.

Major Works of Hiberno-Saxon Art

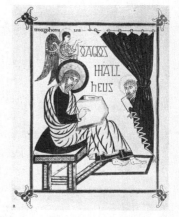

Saint Matthew **from the** *Book of Lindisfarne,* **c. 700, tempera on vellum, British Library, London (Figure 11.2)**

- Saint Matthew is seated on a cushioned bench, book on his lap, writing his book of the Bible
- Man behind the curtain may be inspiration from God, or perhaps Moses or Christ
- Matthew's symbolic angel is above him, Latin words "image of a man"
- Byzantine influence
 o Greek words "Saint Matthew" in Latin characters
 o Angel's hand covered
- Flattened, linear elements
- Soft modeling of Byzantine art turned into crisp cusp-shaped lines in Saint Matthew's drapery
- According to the colophon, the gospels were painted and inscribed by Bishop Eadfrith of Lindisfarne

Figure 11.2: *Saint Matthew* from the *Book of Lindisfarne,* c. 700, tempera on vellum, British Library, London

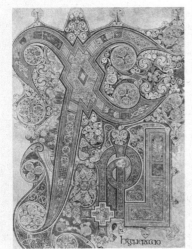

Figure 11.3: *Chi-Rho-Iota Page* from the *Book of Kells*, c. 800, ink on vellum, Trinity College Library, London

Chi-Rho-Iota Page from the *Book of Matthew* in the *Book of Kells*, c. 800, ink on vellum, Trinity College Library, London (Figure 11.3)

- Lavish, richly illustrated book with great complexity of design
- Interlacing patterns dominate
- Heads and figures of people appear in the elaborate patterning
- Initials are dominant motifs
- *Chi* and *rho* are the first two letters of Christ's name in Greek (Christos), and is often presented as a monogram in Christian art
- Created by monks working in a scriptorium
- Painted on vellum—a rich and costly material; sumptuousness of decoration

CHARACTERISTICS OF VIKING ART

A population explosion in Scandinavia caused an expansion of Viking culture throughout northern Europe. Viking artists were inspired by prehistoric models that emphasized animals and spirals in elaborate interlacing patterns. Viking art can be characterized as mostly applied art, art that is engraved or incised onto functional objects. Typically, works are in **animal style** filled with **horror vacui**.

Major Work of Viking Art

Animal Head Post from the Oseberg Ship Burial, 834, wood, University of Oslo, Norway (Figure 11.4)

Figure 11.4: *Animal Head Post* from the Oseberg Ship Burial, 834, wood, University of Oslo, Norway

- Part of a ship burial was for two highly placed women in the Viking court
- Snarling mouth, eyes staring wildly
- Head filled with interlacing animal patterns
- Nostrils flaring
- Unknown purpose of the head post, may have been used in a procession or on the prow of a boat

CHARACTERISTICS OF CAROLINGIAN ART

Carolingian art, the art of Charlemagne and his times, can be seen as the first revival of classical art beyond the ancient world. Charlemagne, anxious to be emperor in a new Rome, planned bath houses, theatres, and a forum in Aachen for his new capital. Roman imagery was revived on everything from coins to architecture.

Carolingian churches are characterized by elaborate **westworks**, consisting of a centralized entrance beneath a second story chapel, flanked by impressive towers. Churches were sometimes accompanied by monastic buildings, which housed the religious in a self-sufficient community. Monks and nuns ate, slept, and worked around an open-air courtyard called a **cloister**, which was generally placed immediately adjacent to the church. All this can be seen in the plan for the ninth-century monastery at **St. Gall** (Figure 11.9). Buildings like the **Lorsch Gatehouse** (Figure 11.5) show the influence of Roman triumphal arches, and the **Palatine Chapel** (c. 800) (Figure 11.8) at Aachen is inspired by Byzantine buildings such as **San Vitale** (Figure 9.6).

Although some Carolingian murals and mosaics were created, these art forms were not in the Frankish taste. Instead they continued the medieval tradition of manu-

script painting, drawing inspiration from both Roman sources and contemporary Byzantine iconography.

Major Works of Carolingian Art

Lorsch Gatehouse, c. 760, Lorsch, Germany (Figure 11.5)

- Three arched openings are divided by engaged columns, cf. the Arch of Constantine (Figure 7.17)
- Fluted pilasters on the second story
- Carolingian patterning motifs cover the walls
- Chapel on upper story, perhaps originally a reception room for guests
- Building stood in an atrium
- Turrets on left and right house stairwells
- Placed before the entrance to a monastery

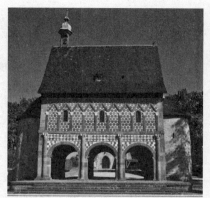

Figure 11.5: Lorsch Gatehouse, c. 760, Lorsch, Germany

Equestrian Statue of a Carolingian Ruler, ninth century, bronze, Louvre, Paris (Figure 11.6)

- Stresses imperial imagery of holding the orb, a symbol of the world in the rider's hands
- Influenced by Roman equestrian statues, cf. *Marcus Aurelius* (Figure 7.36)
- Rider much larger than the horse he sits on
- Sits bolt upright, with little attention to the natural movement of the horse
- Perhaps represents Charlemagne or Charles the Bald

Figure 11.6: *Equestrian Statue of a Carolingian Ruler*, 9th century, bronze, Louvre, Paris

Utrecht Psalter, 820–832, ink on vellum, University Library, Utrecht, Netherlands (Figure 11.7)

- Richly illustrated ink drawings of the psalms of the Bible
- Monochrome
- Highly legible script
- Visual richness of imagery
- Literal translation of the psalms
- Style characterized by agitated gestures, active violence

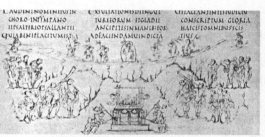

Figure 11.7: *Utrecht Psalter*, 820–832, ink on vellum, University Library, Utrecht, Netherlands

Odo of Metz, Palatine Chapel, 792–805, Aachen, Germany (Figure 11.8)

- Centrally planned chapel built for Charlemagne
- Superficial resemblance to San Vitale in its ground plan, Charlemagne imported capitals and columns from Revenna
- Dome composed of spherical triangles
- Charlemagne's throne is in gallery, halfway between earth and heaven
- Unusual in that the largest arches are on the second floor, not the first; the columns that fill the arches do not support the arch, they fill in space

Figure 11.8: Odo of Metz, Palatine Chapel, 792–805, Aachen, Germany

Figure 11.9: Plan of St. Gall, c. 820, ink on parchment, Stiftsbibliothek, St. Gall, Switzerland

Plan of St. Gall, c. 820, ink on parchment, Stiftsbibliothek, St. Gall, Switzerland (Figure 11.9)

- Plan of an ideal self-sufficient monastic community of about 3000 people
- Church symbolically and literally in the center
- Cloistered monks never leave except to go into the fields
- Daily activities surround the cloister: sleeping, eating
- Workshops for making leather, pottery
- Houses made of timber, serfs live with their animals
- Carolingian church typical of the time, having two apses and an elaborate westwork
- No realization of these plans has come to light

CHARACTERISTICS OF OTTONIAN ART

Ottonian art is influenced by the Roman and Early Christian past, as well as reaffirming the commitment to imperial imagery seen in Carolingian art. Large stone churches epitomize existing Ottonian architecture. Bronze doors were inspired by Roman and Carolingian equivalents.

A common theme of Ottonian architecture is that interior arches and windows do not line up one atop the other. Interior walls are generally flat and unadorned, with very little interruption in the large expanses of blank space. Arches are characterized by alternating red- and cream-colored stones on the exterior of the arches.

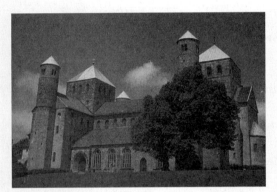

Figure 11.10: Abbey Church of Saint Michael's, 1001–1033, Hildesheim, Germany

Major Works of Ottonian Art

Abbey Church of Saint Michael's, 1001–1033, Hildesheim, Germany (Figures 11.10 and 11.11)

- Church has two transepts, each with two crossing towers and two stair turrets
- Lateral entrances through the side aisles; exterior side aisles act as narthexes or lobbies to the building
- Support of nave arcade alternates pairs of columns and square piers
- Windows in clerestory do not line up with arches below: ten windows placed over nine arches
- Sweeping transept arch is subdivided by two lower round arches, and four smaller second-story arches

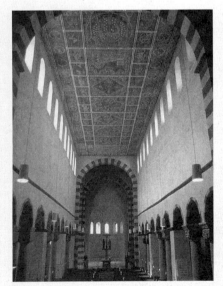

Figure 11.11: Abbey Church of Saint Michael's, 1001–1033, Hildesheim, Germany

Bishop Bernward Doors, c. 1015, bronze, Saint Michael's, Hildesheim, Germany (Figures 11.12 and 11.13)

- Two 15-feet-tall bronze doors
- Imperial overtones: Pantheon had bronze doors, now gone; Aachen has bronze doors, but with no decoration
- Subject: on left the Fall of Man, on right the Redemption of Man
- Rectangular panels with few figures, bare landscapes, emphasis on lively gestures
- Bony figures, vitality and liveliness
- Emphasis on extremities—hands, feet, heads

Gero Crucifix, **970, wood, Cologne Cathedral (Figure 11.14)**

- Return of large monumental sculpture
- Life-size wooden work
- Emotional suffering
- Rounded forms
- Jesus Christ hanging from a cross for the first time, seen as a human suffering crucifixion
- Commissioned by Archbishop Gero for the cathedral in Cologne, Germany

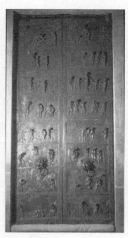

Figure 11.12: Bishop Bernward Doors, c. 1015, bronze, Saint Michael's, Hildesheim, Germany

VOCABULARY

Animal style: a medieval art form in which animals are depicted in a stylized and often complicated pattern, usually seen fighting with one another (Figure 11.1)

Cloisonné: enamelwork in which colored areas are separated by thin bands of metal, usually gold or bronze (Figure 11.1)

Cloister: a rectangular open-air monastery courtyard with a covered arcade surrounding it

Codex (plural: **codices**): a manuscript book (Figures 11.2 and 11.3)

Colophon: 1) a commentary on the end panel of a Chinese scroll, 2) an inscription at the end of a manuscript containing relevant information on its publication (Figure 11.2)

Gospels: the first four books of the New Testament that chronicle the life of Jesus Christ (Figure 11.3)

Horror vacui: (Latin, meaning "fear of empty spaces") a type of artwork in which the entire surface is filled with objects, people, designs, and ornaments in a crowded, sometimes congested way (Figure 11.3)

Psalter: a book containing the Psalms, or sacred sung poems, of the Bible (Figure 11.7)

Scriptorium (plural: **scriptoria**): a place in a monastery where monks wrote manuscripts

Westwork: a monumental entrance to a Carolingian church in which two towers flank a lower central entrance

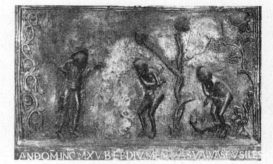

Figure 11.13: *Expulsion from the Garden of Eden* from Bishop Bernward Doors, c. 1015, bronze, Saint Michael's, Hildesheim, Germany

Figure 11.14: *Gero Crucifix*, 970, wood, Cologne Cathedral

Summary

The political chaos resulting from the Fall of Rome set in motion a period of migrations. The unifying force in Europe was Christianity, whose adherents established powerful centers of learning, particularly in places like Ireland.

Artists concentrated on portable objects that intermixed the animal style of Germanic art with horror vacui and strong interlacing patterns.

Two short-lived empires flourished under Charlemagne and the three Ottos of the Holy Roman Empire. Both sought to revive Roman imperial imagery in their works.

Practice Exercises

Figure 11.15

Questions 1 and 2 refer to Figure 11.15.

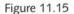

CHALLENGE

1. This plan reflects an ideal

 (A) palace
 (B) fortification
 (C) city
 (D) monastery

2. A key characteristic of Carolingian architecture that can be seen in this plan is

 (A) the use of pilasters
 (B) a westwork
 (C) a reliance on the post-and-lintel technique
 (D) the misalignment of windows and arches

3. Hiberno-Saxon art refers to art produced in

 (A) Scandinavia
 (B) France
 (C) Germany
 (D) the British Isles

4. A work that could be characterized as having horror vacui would be

 (A) the *Book of Kells*
 (B) the *Equestrian Statue of a Carolingian Ruler*
 (C) Bishop Bernward's doors
 (D) the *Gero Crucifix*

Questions 5 and 6 refer to Figure 11.16

5. This work shows the influence of Byzantine art in the

 CHALLENGE

 (A) curtain placed to the right
 (B) frame around the painting
 (C) seated evangelist
 (D) Greek words

6. This is a figure of Saint Matthew, who can be identified as such because

 (A) of his halo
 (B) he is writing a book
 (C) a man is hiding behind the curtain
 (D) the angel symbolizes Matthew

Figure 11.16

7. Pages from medieval books are made from

 (A) paper
 (B) wood
 (C) animal hide
 (D) papyrus

8. Ottonian art started a revival in

 (A) monumental works of sculpture
 (B) manuscript painting
 (C) using cloisters in building plans
 (D) murals and mosaics

9. Viking works are typically applied art, meaning that

 (A) frescoes were applied to walls
 (B) decoration was added to utilitarian items
 (C) enamel work was applied to wood
 (D) Viking ships were elaborately decorated

10. Aachen, Germany was

 (A) Charlemagne's capital
 (B) an Ottonian center
 (C) a Hiberno-Saxon monastery
 (D) a ship burial

Short Essay

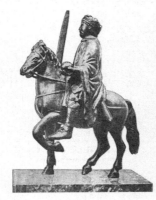

Figure 11.17

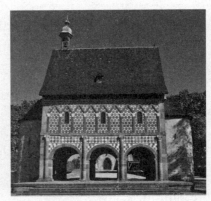

Figure 11.18

Identify the art-historical period of the works in Figures 11.17 and 11.18.
Using examples, discuss how they were inspired by ancient works of art.
Use one side of a sheet of lined paper to write your essay.

Answer Key

1. (D)	3. (D)	5. (D)	7. (C)	9. (B)
2. (B)	4. (A)	6. (D)	8. (A)	10. (A)

Answers Explained

Multiple-Choice

1. **(D)** This is the plan for the monastery at St. Gall.

2. **(B)** Carolingian buildings are noted for an elaborate westwork, in this case, towers built into the entrance of the church.

3. **(D)** Hiberno-Saxon art refers to the art of the British Isles from the sixth to eighth centuries.

4. **(A)** The crowded compositions in the *Book of Kells* are the ideal representation of horror vacui.

5. **(D)** In a place where almost no one spoke Greek, the Greek reference is a special homage to Byzantium.

6. **(D)** Although Saint Matthew is often seated and writing his gospel, he is not the only saint to be depicted in this way. However, Saint Matthew's symbol is an angel or a man, making choice D the preferred answer.

7. **(C)** Medieval manuscripts are painted on prepared animal hide.

8. **(A)** Ottonian works, like the *Gero Crucifix* and the bronze doors at Hildesheim, are examples of the revitalization of large scale works.

9. **(B)** Viking art specializes in decoration applied to utilitarian objects, or applied art.

10. **(A)** Aachen was Charlemagne's capital.

Rubric for Short Essay

4: The student identifies the period as Carolingian or Early Medieval and can give a Roman equivalent to each piece. The most likely parallels are between the Carolingian ruler and Marcus Aurelius and the Lorsch Gatehouse and the Arch of Constantine. The discussion is full and there are no major errors.

3: The student identifies the period as Carolingian, Early Medieval, or Medieval and can give a Roman equivalent to the Carolingian piece. Discussion is not as full as a 4. There may be minor errors.

2: The student misidentifies the period but supplies Roman equivalents, OR supplies only one Roman work and identifies the period. There may be major errors.

1: The student names only the period, OR supplies only a Roman equivalent.

0: The student makes an attempt, but the response is without merit.

Short Essay Model Response

The style of both these works is Early Medieval from the Carolingian period. They are both inspired by Roman works of art. The piece on the left is the <u>Equestrian Statue of a Carolingian Ruler</u>, and may have been modeled on the equestrian statue of <u>Marcus Aurelius</u>. Equestrian statues often have imperial significance; both statues have an imperial rider in a procession. The rider, however, is holding a sphere that represents the world. The building on the right is the Lorsch Gatehouse, and may have been inspired by arches such as the Arch of Constantine. Both buildings have three arches with engaged columns attached to the surface.

—Lauren J.

Analysis of Model Response

Lauren identifies the period correctly, and gives Roman parallels to the Carolingian piece. A stronger discussion of the connection between the two Carolingian and Roman inspirations would have merited a higher grade. The difference is in the depth of the details. **This essay merits a 3.**

Romanesque Art

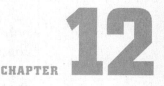

> ## TIME PERIOD: 1050–1150, some objects date as early as 1000 and as late as 1200

To nineteenth-century art historians, Romanesque architecture looked like a derivative of ancient Roman art, and they titled the period "Romanesque," or "in the Roman manner." Although there are some superficial resemblances in the roundness of architectural forms, the Romanesque period is very different from its namesake.

KEY IDEAS

- Romanesque art shows a revitalization of large-scale architecture and sculpture.
- Pilgrimages to sacred European shrines increase the flow of people and ideas around the continent.
- Romanesque architects develop the apses of churches to accommodate large crowds of pilgrims.
- Church portal sculptures stress themes of the Last Judgment and the need for salvation.
- Manuscript painting and weaving flourish as art forms.

HISTORICAL BACKGROUND

By 1000, Europe had begun to settle down from the great migration that characterized the Early Medieval period. Wandering seafarers like the Vikings were Christianized, and their descendants colonized Normandy, France, and southern Italy and Sicily. Islamic incursions from Spain and North Africa were neutralized; in fact, Europeans began a counterinvasion of Muslim lands called the Crusades. The universal triumph of Christianity in Europe with the pope cast as its leader was a spiritual empire not unlike the Roman secular one.

Even though Europeans fought with equal ardor among themselves, enough stability was reached so that trade and the arts could flourish; cities, for the first time in centuries, expanded. People began to crisscross Europe on religious pilgrimages to Rome and even Jerusalem. The most popular destination was the shrine dedicated to Saint James in the northwestern Spanish town of Santiago de Compostela. A magnificent Romanesque cathedral was built as the endpoint of western European pilgrimages.

The journey to Santiago took perhaps a year or longer to make. Shrines were established at key points along the road, so that pilgrims could enjoy additional other

holy places, many of which still survive today. This pilgrimage movement, with its consequent building boom, is one of the great revitalizations in history.

Patronage and Artistic Life

Medieval society centered on feudalism, which can be expressed as a symbiotic relationship between lords and peasants. Peasants worked the land, sustaining all with their labor. Lords owned the land, and they guaranteed peasants security. Someplace between these stations, artists lived in what eventually became a middle class. Painting was considered a higher calling compared to sculpture or architecture because painters worked less with their hands.

Women were generally confined to the "feminine arts" such as ceramics, weaving, or manuscript decoration. Powerful and wealthy women (queens, abbesses, and so on) were active patrons of the arts, sponsoring the construction of nunneries or commissioning illuminated manuscripts. Hrotswitha of Gandersheim, a nun, wrote plays that were reminiscent of Roman playwrights and poets. One of the most brilliant people of the period was **Hildegard von Bingen**, who was a renowned author, composer, and patroness of the arts.

Although Christian works dominate the artistic production of the Romanesque period, a significant number of beautifully crafted secular works also survives. The line between secular and religious works in medieval society was not so finely drawn, as objects for one often contain symbolism of the other.

The primary focus of medieval architecture is on the construction of castles, manor houses, monasteries, and churches. These were conceived not by architects in the modern sense of the word, but by master builders, who oversaw the whole operation from designing the building to contracting the employees. These master builders were often accompanied by master artists, such as **Gislebertus**, who supervised the artistic design of the building. ·

INNOVATIONS IN ROMANESQUE ARCHITECTURE

Cathedrals were sources of civic pride as well as artistic expression and spiritual devotion. Since they sometimes took hundreds of years to build and were extremely expensive, great care was lavished on their construction and maintenance. Church leaders sought to preserve structures from the threat of fire and moved away from wood to stone roofs. Those that were originally conceived with wood were sometimes retrofitted. This revival of structures entirely in stone is one reason for the period's name, "Romanesque."

But stone caused problems. It is heavy—which means that the walls have to be extra thick to sustain the weight of the roof. Windows are small, so that there are as few holes in the walls as possible. The interiors are correspondingly dark. To bring more light into the buildings, the exterior of the windows are often narrow and the interior of the window wider—this way the light would come in through the window and ricochet off its thick walls and appear more luminous. However, the introduction of stained glass darkened attempts at lightening the interiors.

To help support the roofs of these massive buildings, master builders designed a new device called the **rib vault** (Figure 12.1), first seen at **Durham Cathedral** (begun c. 1093). At first, these ribs were decorative moldings placed on top of groin

vaults, but eventually they became a new way of looking at roof support. While they do not carry its full weight, they help channel the stresses of its load down to the walls and onto the massive piers below, which serve as functional buttresses. Rib vaults also open up the ceiling spaces more dramatically, allowing for larger windows to be placed in the clerestory. During construction, rib vaults were the first part of the roof to be built, the stones in the spaces between were added later (Figure 12.1).

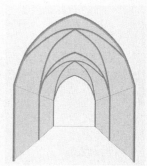

Figure 12.1: Rib vaults

Besides the advantage of being fireproof, stone has several other positive properties. It is easy to maintain, durable, and generally weatherproof. It also conducts sound very well, so that medieval music, characterized by Gregorian chant, could be performed, enabling even those in the rear of these vast buildings to hear the service.

The basic unit of medieval construction is called the **bay**. This spatial unit contains an arch on the first floor, a triforium with smaller arches on the second, and windows in a clerestory on the third. The bay became a model for the total expression of the cathedral—its form is repeated throughout the building to render an artistic whole (Figure 12.2).

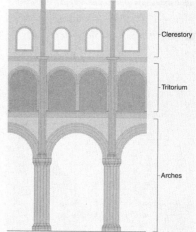

Figure 12.2: A bay is a vertical section of a church often containing arches, a triforium, and a clerestory.

In order to accommodate large crowds who came to Romanesque buildings during feast days or for pilgrimages, master builders designed an addition to the east end of the building, called an **ambulatory**, a feature that was also present in Early Christian churches such as Santa Costanza (Figure 8.5). This walkway had the benefit of directing crowds around the church without disturbing the ceremonies taking place in the apse. Chapels were placed at measured intervals around the ambulatory so that pilgrims could admire the displays of relics and other sacred items housed there. The ambulatory at **St. Sernin** (Figure 12.3) is a good example of how they work in this context.

Characteristics of Romanesque Architecture

After six hundred years of relatively small buildings, Romanesque architecture with its massive display of cut stone comes as a surprise. The buildings are characterized as being uniformly large, displaying monumentality and solidity. Round arches, often used as **arcades**, are prominent features on façades. Concrete technology, a favorite of the ancient Romans, was forgotten by the tenth century.

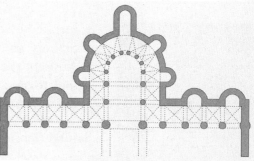

Figure 12.3: An ambulatory is the passageway that winds around an apse. Romanesque buildings often have chapels that radiate from them. Ambulatories can be found in buildings as early as Santa Costanza in the Early Christian period.

There are many regional variations to Romanesque architecture, from the austere simple and dignified interiors sponsored by Cistercian monks to the opulently decorated and massive buildings of the Cluniac order. Italian buildings look back to the Early Christian models of horizontal naves and long main aisles, and French and English buildings forecast the Gothic with their verticality.

Interiors are dark; façades are sometimes punctured with round oculus-type windows.

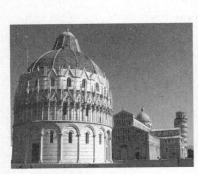

Figure 12.4: Pisa Cathedral, begun 1063, Pisa, Italy

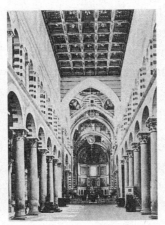

Figure 12.5: Pisa Cathedral, begun 1063, Pisa, Italy

Although some buildings, such as **Pisa Cathedral** (Figures 12.4 and 12.5), were built with wood ceilings, the tendency outside Italy is to use Roman stone-vaulting techniques, such as the barrel and groin vault to cover the interior spaces as at **Saint-Sernin** (Figures 12.8 and 12.9). However, later buildings, like **Saint-Ètienne** (Figures 12.6 and 12.7) and **Durham Cathedral** (Figure 12.10), employ rib-covered groin vaults to make interiors seem taller and lighter.

Italian buildings, like **Pisa Cathedral**, have separate bell towers called **campaniles** to summon people to prayer. Northern European buildings incorporate this tower into the fabric of the building often over the crossing (as at **Durham**).

Major Works of Romanesque Architecture

Pisa Cathedral, begun 1063, Pisa, Italy (Figures 12.4 and 12.5)

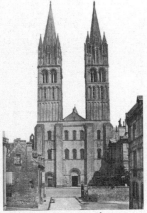

Figure 12.6: Saint-Étienne, 1067 and ff., Caen, France

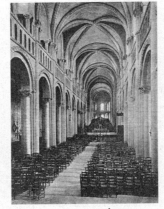

Figure 12.7: Saint-Étienne, 1067 and ff., Caen, France

- Arcades and blind arcades used on façade
- Separate campanile, famous for its unintended lean
- Wooden roof over nave continues tradition of Early Christian churches
- Groin vaults over side aisles
- Inspired by classical architecture in the use of arches, columns, and capitals; granite columns in nave taken from a Roman temple in Elba
- Transept is actually a second basilica with apses intersecting the nave at the crossing
- Exterior marble facing typical of Romanesque architecture in Tuscany

Saint-Étienne, 1067 and ff., Caen, France (Figures 12.6 and 12.7)

- Façade looks forward to verticality of Gothic; spires are a Gothic feature added later

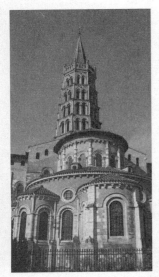

Figure 12.8: Saint-Sernin, c. 1070–1120, France

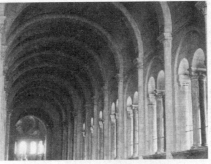

Figure 12.9: Saint-Sernin, c. 1070–1120, Toulouse, France

- Originally had a timber roof, replaced by sexpartite rib vaults; added engaged columns
- Piers are uniformly articulated

Saint-Sernin, c. 1070–1120, Toulouse, France (Figures 12.8 and 12.9)

- Pilgrimage church containing ambulatory around apse with radiating chapels for relics

- Barrel-vaulted interior with demarcated ribs; corresponding buttresses on the exterior
- Buttress strips on exterior mark the internal structure of the bays
- Double side aisles
- *Square schematism:* a church plan in which the crossing square is used as a module for all parts of the design—each nave bay ½ central square; each said aisle ¼ central square
- Very dark, lacks a clerestory

Durham Cathedral, begun c. 1093, Durham, England (Figure 12.10)

- First use of rib vaults
- English tradition: very long nave
- Abstract patterns on the piers derived from metalwork from Early Medieval art
- Alternating rhythm of piers
- Slightly pointed arches foreshadows the Gothic

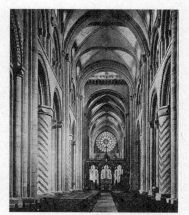

Figure 12.10: Durham Cathedral, begun c. 1093, Durham, England

INNOVATIONS IN ROMANESQUE SCULPTURE

Large-scale stone sculpture was generally unknown in the Early Medieval period—its revitalization is one of the hallmarks of the Romanesque. Sculptors took their inspiration from goldsmiths and other metal workers, but expanded the scale to almost life-size works. Most characteristically, sculpture was placed around the portals of medieval churches (such as the one by **Gislebertus**) so that worshippers could understand, among other things, the theme of a particular building (Figure 12.11). Small-scale works, such as ivories, wooden objects, and metalwork continued to flourish as they did in earlier periods.

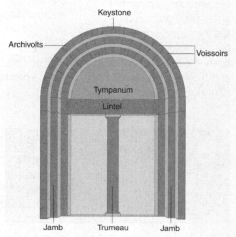

Figure 12.11: A Romanesque portal

Characteristics of Romanesque Painting and Sculpture

Most of what we know about Romanesque painting comes from illuminated manuscripts and an occasional surviving ceiling or wall mural. Characteristically, figures tend to be outlined in black and then vibrantly colored. Gestures are emphatic; emotions are exaggerated—therefore, heads and hands are proportionally the largest features. Figures fill a blank surface rather than occupy a three-dimensional reality; hence they seem to float. Sometimes they are on tiptoe or glide across a surface, as they do in the **Bayeux Tapestry** (Figure 12.19). People are most important; they dominate buildings which seem like props or stage sets in the background of most Romanesque illustrations.

Painted stone sculpture is a trademark of Romanesque churches. Capitals are elaborately, and often fancifully, carved with scenes from the Bible. The chief glory of Romanesque sculpture is the portal. These are works of so prominent a location that sculptors vied for the honor of carving in so important a site. As artists became famous for their work, towns competed to hire them. Some, like **Gislebertus** and **Wiligelmo**, have prominently placed inscriptions that proclaim their glory.

Figure 12.12: This figure of Saint Peter from St. Pierre at Moissac shows some of the characteristics of Romanesque sculpture: the unusually elongated anatomical proportions, the zigzagging of the drapery folds, the hand pushed back on the body, and the figure having a dancelike posture.

Figure 12.13: The lions from the trumeau of St. Pierre at Moissac

Although there are regional variations, there are some broad characteristics that generally define Romanesque sculpture. Figures tend to have a flattened look (such as Christ in **Gislebertus**'s work), with zigzagging drapery that often hides body form rather than defines it. Scale is carefully articulated, with a hierarchy of figures being presented according to their importance. Legs are crossed in a graceful, almost dancelike arrangement. Figures are placed within borders, usually using them as isolated frames for scenes to be acted out in. They rarely push against these frames, preferring to be defined by them. Faces offer prominent cheekbones and a wide variety of expression.

Romanesque artists delighted in rendering fantastic animals and mythical beasts. One of the most creative expressions is seen in the skillful and spectacular way the artist interprets animals he or she has never seen before—such as the lions at Moissac (Figure 12.13).

Smaller, independent sculptures were also produced at this time. Among the most significant are **reliquaries** (Figure 12.17) that contain venerated objects, like the bones of saints; they are richly adorned and highly prized.

Figure 12.14: Wiligelmo, *Creation and Temptation of Adam and Eve*, c. 1110, marble, Modena Cathedral, Modena, Italy

Major Works of Romanesque Painting and Sculpture

Wiligelmo, *Creation and Temptation of Adam and Eve*, c. 1110, marble, Modena Cathedral, Modena, Italy (Figure 12.14)

- Inscription: "Among sculptors, your work shines forth, Wiligelmo" illustrates the pride the donors felt in having such a significant artist work for them
- Composition inspired by Early Christian sarcophagi
- Figures dominate architectural setting; narrative breaks the frame
- High relief
- Faithful enter the church with a reminder of Original Sin, which is the fall of Adam and Eve and the corresponding redemption of humankind through Christ's sacrifice

Figure 12.15: Gislebertus, *Last Judgment*, 1120–1135, marble, St. Lazare, Autun, France

Gislebertus, *Last Judgment*, 1120–1135, marble, St. Lazare, Autun, France (Figures 12.15 and 12.16)

- Scene of the Last Judgment: Jesus at the Second Coming, with those saved on his right and those damned on his left
- To enter the church, people walk through the door on the right below the scene of the condemned, and exit out the door on the left where the saved are depicted
- Figures are linear, twisting, and writhing; they have an emaciated appearance

- Souls are weighed to determine the fate of the deceased—heavy souls fall to hell, light souls rise to heaven; weighing souls is a tradition that goes back to ancient Egypt
- Hierarchy of scale ranks importance of figures
- Horror of the evils of hell are vividly contrasted with the sanctity of the angels

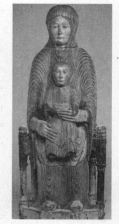

Figure 12.16: Gislebertus, *Last Judgment*, 1120–1135, marble, St. Lazare, Autun, France

Figure 12.17: *Virgin and Child in Majesty* or *The Morgan Madonna*, 1150–1200, wood, Metropolitan Museum of Art, New York

Virgin and Child in Majesty or *The Morgan Madonna*, 1150–1200, wood, Metropolitan Museum of Art, New York (Figure 12.17)

- Mary appears as the Throne of Wisdom, holding Jesus in her lap
- Jesus's great wisdom is reflected in his adult head, which appears on a small person's body
- Jesus would have held a Bible, a symbol of his spiritual authority
- Chambers in the back of the two figures would have held relics; this functioned as a reliquary
- They sit emotionless and erect
- Wooden sculpture at one time brilliantly painted

Hildegard von Bingen's Vision, 1050–1079, now destroyed, exists as a copy, manuscript (Figure 12.18)

- Bingen's divine visions come from heaven and pour down on her as if they were flames
- She sits as an author portrait recording her vision
- Her scribe, Volmar, waits by her side with a book
- Heavy black outline defines the forms
- Figures dominate architectural setting
- Expressive drapery folds indicate legs and arms but little other body form
- Hildegard as patroness of this book

Figure 12.18: *Hildegard von Bingen's Vision*, 1050–1079, now destroyed, exists as a copy, manuscript

Bayeux Tapestry, 1070–1080, embroidery, wool on linen, Bayeux (Figure 12.19)

- Tapestry a misnomer; actually an embroidery
- Probably designed by a man; executed by women
- Commissioned by Bishop Odo, half-brother of William the Conqueror
- Tells the story (in Latin) of William's conquest of England at the Battle of Hastings in 1066
- Fanciful beasts in upper and lower registers
- Borders sometimes comment on the main scenes, or show scenes of everyday life

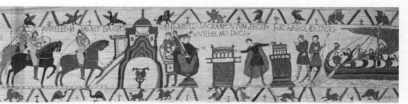

Figure 12.19: *Bayeux Tapestry*, 1070–1080, embroidery, wool on linen, Bayeux

- Color used in a non-natural manner; different parts of a horse are colored variously
- Neutral background
- Flatness of figures; no shadows
- Narrative tradition going back to the *Column of Trajan* (Figure 7.34)
- 75 scenes, over 600 people
- 230-feet long; continues narrative tradition of Medieval art
- Uncertainty over how this work was meant to be displayed

Eadwine the Scribe from the *Eadwine Psalter*, c. 1160–1170, illuminated manuscript, Trinity College, Cambridge, England (Figure 12.20)

- Self-portrait of one of many monks who worked as a scribe on this Psalter; a generic portrait rather than a realistic likeness; rare Romanesque portrait
- Comparison with evangelist portraits of the New Testament
- Dressed as a monk with tonsured hair and great swirling cape
- Enthroned on an architecturally sophisticated throne
- Right hand holds a paintbrush, left hand holds a scraper to erase errors on the page

Figure 12.20: *Eadwine the Scribe* from the *Eadwine Psalter*, c. 1160–1170, illuminated manuscript, Trinity College, Cambridge, England

VOCABULARY

Ambulatory: a passageway around the apse of a church (Figure 12.3)

Apse: the end point of a church where the altar is (Figure 12.3)

Arcade: a series of arches supported by columns (Figure 12.4). When the arches face a wall and are not self-supporting, they are called a **blind arcade**

Archivolt: a series of concentric moldings around an arch (Figure 12.11)

Axial plan (Basilican plan, Longitundinal plan): a church with a long nave whose focus is the apse, so-called because it is designed along an axis (Figure 12.7)

Baptistery: in medieval architecture, a separate chapel or building in front of a church used for baptisms (Figure 12.4)

Bay: a vertical section of a church that is embraced by a set of columns and is usually composed of arches and aligned windows (Figure 12.2)

Campanile: a bell tower of an Italian building (Figure 12.4)

Cathedral: the principal church of a diocese, where a bishop sits (Figure 12.4)

Clerestory: the third, or window, story of a church (Figure 12.2)

Embroidery: a woven product in which the design is stitched into a premade fabric (Figure 12.19)

Jamb: the side posts of a medieval portal (Figure 12.11)

Narthex: the vestibule, or lobby, of a church

Portal: a doorway. In Medieval art they can be significantly decorated (Figure 12.11)

Psalter: a book containing the Psalms, or sacred sung poems, of the Bible (Figure 12.20)

Reliquary: a vessel for holding a sacred relic. Often reliquaries took the shape of the objects they held. Precious metals and stones were the common material

Rib vault: a vault in which diagonal arches form riblike patterns. These arches partially support a roof, in some cases forming a weblike design (Figure 12.1)

Tapestry: a woven product in which the design and the backing are produced at the same time on a device called a **loom** (Figure 12.19)

Transept: an aisle in a church perpendicular to the nave (Figure 12.3)

Triforium: A narrow passageway with arches opening onto a nave, usually directly below a clerestory (Figure 12.2)

Trumeau (plural: **trumeaux**): the central pillar of a portal that stabilizes the structure. It is often elaborately decorated (Figure 12.11)

Tympanum (plural: **tympana**): a rounded sculpture placed over the portal of a medieval church (Figure 12.11)

Voussoir (pronounced "view-swar"): a wedge-shaped stone that forms the curved part of an arch. The central voussoir is called a **keystone** (Figure 12.11)

Summary

In a way, the monumentality, rounded arches, and heavy walls of Roman architecture are reflected in the Romanesque tradition. However, the liturgical purpose of Romanesque buildings, their use of ambulatories and radiating chapels and their dark interiors give these churches a religious feeling quite different from their Roman predecessors.

Romanesque builders reacted to the increased mobility of Europeans, many of whom were now traveling on pilgrimages, by enlarging the size of their buildings. As Romanesque art progresses increasingly sophisticated vaulting techniques are developed. Hallmarks of the Romanesque style include thick walls and piers that give the buildings a monumentality and massiveness lacking in Early Medieval art.

Most great Romanesque sculpture was done around the main portals of churches, usually on themes related to the Last Judgment and the punishment of the bad alongside the salvation of the good. French sculptors carved energetic and elongated figures that often look flattened against the surface of the stone. Although regional variations are common, most Romanesque sculpture is content within the frame of the work it is conceived in, and rarely presses against the sides or emerges forward.

Although religious themes dominate Romanesque art, occasionally works of secular interest, like the *Bayeux Tapestry*, were created.

212 AP Art History

Practice Exercises

CHALLENGE

1. The first surviving example of the use of rib vaults occurrs in

 (A) Pisa Cathedral
 (B) Saint-Ètienne
 (C) Durham Cathedral
 (D) Autun Cathedral

2. Pilgrimages account for the architectural development of

 (A) the campanile
 (B) portal sculpture
 (C) the arcade
 (D) radiating chapels

3. Romanesque architecture is characterized by its

 (A) light and airy quality
 (B) massiveness and solidity
 (C) heavily decorated interiors
 (D) many window spaces

4. The difference between an embroidery and a tapestry is that an embroidery is

 (A) quilted
 (B) stitched on a premade background
 (C) knitted
 (D) made on a loom

5. A tapestry is

 (A) quilted
 (B) stitched on a pre-made background
 (C) knitted
 (D) made on a loom

6. The *Bayeux Tapestry* celebrates the

 (A) conquering of England by William the Conqueror
 (B) fall of the Roman Empire
 (C) Crusades
 (D) reconquest of Spain

CHALLENGE

7. *The Virgin and Child in Majesty,* or *The Morgan Madonna* depicts Mary and Jesus in a relationship that stresses

 (A) that Jesus will be crucified
 (B) Mary's position as the Throne of Wisdom
 (C) Jesus's role as author of the Bible
 (D) Mary's concern for the welfare of all mothers

8. A trumeau is located

 (A) between the doors of a portal
 (B) above the portal
 (C) on the side doors of a portal
 (D) on a capital

9. Hildegard von Bingen was a

 (A) sculptor
 (B) master builder
 (C) author
 (D) tapestry weaver

10. All of the following are important to the spread of Romanesque art EXCEPT

 (A) pilgrimage roads
 (B) churches
 (C) monasteries
 (D) theaters

Short Essay

Figure 12.21

Figure 12.22

The building in Figures 12.21 and 12.22 is Romanesque. Identify the building. Using examples from both the interior and the exterior, discuss the characteristics of this work that reveal its classical past, and the characteristics that place it in the Romanesque period. Use one side of a sheet of lined paper to write your essay.

Answer Key

1. **(C)**	3. **(B)**	5. **(D)**	7. **(B)**	9. **(C)**
2. **(D)**	4. **(B)**	6. **(A)**	8. **(A)**	10. **(D)**

Answers Explained

Multiple-Choice

1. **(C)** Durham Cathedral is the first building to use rib vaults. Saint-Ètienne's was retrofitted later.
2. **(D)** Radiating chapels were added to the apse end of Romanesque churches to accommodate the crowds coming to see religious relics and other artifacts.
3. **(B)** Romanesque architecture is heavy, solid-looking, and relatively dark.
4. **(B)** An embroidery is a design stitched onto a premade background.
5. **(D)** A tapestry is made on a loom by weaving the backing of the fabric and the design at the same time.
6. **(A)** The *Bayeux Tapestry* depicts the invasion of England under William the Conqueror in 1066.
7. **(B)** Mary is seen as the Throne of Wisdom, holding Jesus in her lap.
8. **(A)** A trumeau is a post between the doors of a cathedral. It holds up the lintel above.
9. **(C)** Hildegard von Bingen was, among many things, an author of her own mystical visions.
10. **(D)** The Romanesque style was carried along the pilgrimage roads crisscrossing Europe. Monasteries were important centers of artistic production. Theaters, if they existed at all, were distinctly minor.

Rubric for Short Essay

4: The student identifies the building as Pisa Cathedral. The student then discusses exterior and interior elements that place the work as Romanesque AND reflect the classical past. Discussion is specific and contains no major errors.

3: The student identifies the building as Pisa Cathedral, and then discusses exterior and interior elements that place the work as Romanesque OR reflects the classical past. Discussion is less full and may contain errors.

2: The student cannot identify the building but does have some discussion of merit about either the interior or exterior as being classical and/or Romanesque. There may be major errors. This is the highest score a student can earn if he or she does not identify the building by name.

1: The student can only identify the building OR the student cannot identify the building but the discussion has minimal merit. There may be major errors.

0: The student makes an attempt, but the response is without merit.

Short Essay Model Response

The Romanesque building being shown is the Pisa Cathedral. Both its interior and exterior have characteristics that indicate to us its classical past and Romanesque features. The interior has coffers and uses an interchanging pattern on its arches which indicates its classical past. But its columns are also decorated and there are barrel vaults both of which are characteristics of Romanesque architecture. The thick, heavy walls and tiny windows are also very common in the Romanesque period. The columns and arches on the exterior are classical but the use of a rounded dome-like ceiling with a sort of bulge at the top is Romanesque. The use of groin vaults on the interior is also Romanesque.

—Albert C.

Analysis of Model Response

Albert identifies the building as Pisa Cathedral, earning a point. It is true that the coffered ceiling refers to the classical past; it is also true that the "thick, heavy walls and tiny windows are also very common in the Romanesque period." The columns and the arches on the exterior are also inspired by the Romanesque period. However, there are many comments that are irrelevant, or plain wrong. There are no groin vaults on the interior, nor is it known what Albert means by "interchanging pattern on its arches." There are errors of fact in this essay. **This essay merits a 2.**

Gothic Art

Style	Dates	Location
TIME PERIOD: 1140–1400,		
up to 1550 in some sections of Europe		

Style	Dates	Location
Early Gothic	1140–1194	France
High Gothic, Rayonnant Gothic	1194–1300	France
Late Gothic, Flamboyant Gothic	After 1300	France
Perpendicular Gothic	After 1350	England

KEY IDEAS

- Gothic architecture built on developments made in the Romanesque: the rib vault, the pointed arch, and the bay system of construction.
- Gothic architecture reached new vertical heights through the use of flying buttresses that carry the weight of the roof to the walls outside the building and deflect wind pressure.
- Gothic sculpture, particularly on portals, is more three-dimensional than its Romanesque counterparts, emerging from the wall, and emphasizing the verticality of the structure.
- Gothic manuscript painting is influenced by the luminosity and richness of stained glass windows.

HISTORICAL BACKGROUND

The beginning of the Gothic period cannot be dated precisely, although the place of its creation, Paris, can. The change in thinking that we call "Gothic" is the result of a number of factors:

1. An era of peace and prosperity in the region around Paris, owing to an increasingly centralized monarchy, new definition of the concepts of "king" and "kingship," together with the peaceful succession of kings from 987 to 1328.

2. Increasing growth and wealth of cities and towns, encouraged by the sale of royal charters that bound the cities to the king rather than to local lords and the increased wealth of the king.

217

3. The gradual development of a money economy in which cities played a role in converting agricultural products to goods and services.

4. The emergence of the schools in Paris as the intellectual center of western Europe that brought together the teachers and scholars who transformed western thinking by changing the way questions were asked and by arguing using logic.

The late Gothic period is marked by three crucial historical events:

1. The Hundred Years' War between France and England (1337–1453). This conflict devastated both countries socially and economically, and left vast regions of France ruined.

2. The Babylonian Captivity (1304–1377). French popes moved the headquarters of the Christian church to Avignon, France, creating a spiritual crisis that had far-reaching effects on European society, and on Rome in particular. With the popes away, there was little reason to maintain Saint Peter's; indeed Rome itself began to decay. When the pope finally returned to Rome in 1377, a schism developed as rival popes set up competing claims of authority, none of which was resolved until 1409. This did much to undermine the authority of the church in general.

3. The Black Death of 1348. This was the greatest cataclysm in human history: A quarter to a third of the world perished in a misdiagnosed pulmonary plague. The consequences for art history were enormous; in many towns there were not enough living to bury the dead: Consequently, architecture came to a standstill. Artists interpreted the plague as a punishment from God, thus painting became conservative and began to look backward to earlier styles. Europe spent generations recovering from the plague's devastating effects.

Patronage and Artistic Life

Master builders coordinated hundreds of laborers and artisans—masons, stonecutters, sculptors, haulers, carpenters—in the building of a cathedral. Indeed, the cathedral was the public works project of its day, keeping the local economies humming and importing artists as needed from everywhere.

Similarly, manuscripts were organized by a chef d'atelier who was responsible for establishing an overall plan or vision of a book so that the workshop could execute his or her designs. A scribe copied the text, but in so doing left room for decorative touches, such as initials, borders, and narrative scenes. Embellishments were added by artists who could express themselves more fully than scribes, who had to stick to the text. Artists often rendered fanciful designs to an initial or a border. Lastly, a bookbinder had the manuscript bound.

INNOVATIONS IN GOTHIC ARCHITECTURE

Gothic architecture developed advances made in the Romanesque:

1. The rib vault. Invented at the end of the Romanesque period (the earliest example is at Durham [Figure 12.11]) and became the standard vaulting practice of the Gothic period.

2. Bays. The Romanesque use of repeated vertical elements in bays also became standard in the Gothic period.

3. The rose window. Begun as an oculus on such buildings as St.-Sernin at Toulouse, the rose window becomes an elaborate circular feature that opens up wall spaces by allowing more light in through the façade and transepts.

4. The pointed arch. First seen in Islamic Spain, this arch directs thrusts down to the floor more efficiently than rounded arches.

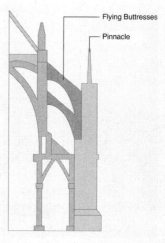

Figure 13.1: Flying buttress and pinnacle on a Gothic cathedral

What is new in the Gothic period is the **flying buttress** (Figure 13.1); the earliest surviving example is on **Notre Dame** in Paris (begun 1150s). These stone arches support a roof by having the weight bypass the walls and travel down to piers outside the building. This enabled the building to be opened up for more window space and to display more stained glass. Most importantly, flying buttresses also help to stabilize the building, preventing wind stresses from damaging these very vertical and narrow structures.

Ground plans of Gothic buildings denote innovations in the east end, or **chevet** (Figure 13.2). Increasingly elaborate ceremonies called for a larger space to be introduced between the transept and the apse, called the **choir**. While allowing for greater clergy participation, it also had the side effect of removing the public further from the main altar and keeping the ceremony at arm's length.

Another innovation is the introduction of decorative **pinnacles** on the roof of Gothic churches. Long thought to be mere ornaments on flying buttresses, pinnacles are now understood to be essential architectural components that act as stabilizing forces in a wind storm.

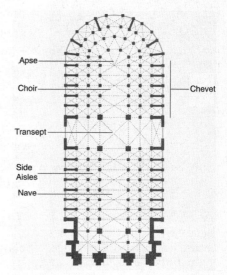

Figure 13.2: Plan of Notre Dame, Paris

Characteristics of Gothic Architecture

Gothic buildings are tall and narrow, causing the worshipper to look up upon entering. The architecture, therefore, reinforces the religious symbolism of the building.

French Gothic buildings tend to be nestled downtown, surrounded by other buildings, and rising above the city landscape as a point of civic and religious pride. In sort of a competition, each town built successively taller buildings, seeking to outdo its neighbors.

There are four periods of French Gothic architecture:

1. **Early:** characterized by round columns in the interior. Rib vaults start at the ceiling but travel down only to the top of the column capitals. **Notre Dame** (Figures 13.6 and 13.7) and **Saint-Denis** (Figure 13.5) are Early Gothic.

2. **High:** articulated columns in the interior. Rib vaults travel from the ceiling down to the floor; there are larger window spaces, choirs and chevets; compound piers are common; more sculpture adorns on the façade. **Amiens** (Figures 13.10 and 13.11) and the interior of **Chartres** (Figures 13.8 and 13.9) are High Gothic.

3. **Rayonnant:** (meaning "radiating") characterized by a dissolution of wall space with great sheets of stained-glass; thin groups of column shafts, and refined tracery used throughout. **Saint-Chapelle** (Figure 13.14) is Rayonnant Gothic.

4. **Late/Flamboyant:** (meaning "flaming") highly decorative. Characterized by a mass of pinnacles and tracery. The decoration acts as a see-through screen in which the forms are revealed. **Ogee** arches (Figure 13.3) are used. **Saint-Maclou** (Figure 13.15) is a flamboyant Gothic building.

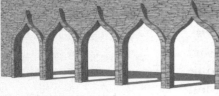

Figure 13.3: Ogee arches

By contrast, English Gothic buildings, like **Salisbury** (Figures 13.12 and 13.13) are constructed in a gardenlike setting called a **close**, inspired by cloistered areas in medieval monasteries. Compared to the French buildings, the English Gothic buildings have extremely pronounced central spires, smaller flying buttresses, diminutive portals, lower façade towers, and wide screen-like façades containing sculpture everywhere. Also, English Gothic buildings prefer a long horizontal view down the nave terminating in a square rather than rounded apse, with corners meeting at right angles. Finally, an English Gothic building frequently enjoys two transepts instead of the French one, and both prominently stick out from the main body of the building.

The English develop a unique variation of Gothic architecture around 1350 called **Perpendicular Gothic**. This style is characterized by enormous window spaces interlaced with elaborate decorative vertical patterns of stone tracery. Clusters of vertical shafts rise dramatically and unimpeded to the ceiling where they burst open in a wide pattern called a **fan vault** (Figure 13.4).

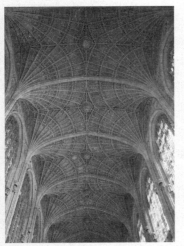

Figure 13.4: King's College Chapel, begun 1446, Cambridge, England. The vertical thrust, enormous windows, and fan vaults are characteristic of Perpendicular Gothic.

Major Works of Gothic Architecture

Saint-Denis, 1140–1144, Saint-Denis, France (Figure 13.5)

- First Gothic building
- Abbot Suger, the patron, wanted light filtered by stained glass to saturate the inside of the building; represents divine light or God's presence inside the church
- Rib vaults start at the ceiling and go down as far as the capitals on the columns; the columns are round and unarticulated
- Pointed arches
- Moves away from the demarcation of spaces in the Romanesque period; radiating chapels open up and one continuous space is created; spaces in the chapels flow from one to the other
- Minimizes the effect of mass and weight on the interior
- Burial site of French royalty

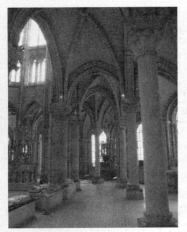

Figure 13.5: Saint-Denis, 1140–1144, Saint-Denis, France

Notre Dame, Paris, begun 1150s, Paris (Figures 13.6 and 13.7)

- Flying buttresses first used on a large scale here
- Façade
 - First floor portal sculpture
 - Second floor: a gallery of 28 kings from the Old Testament
 - Third floor: a rose window 30-feet-plus across
 - Fourth floor: hanging space for cathedral bells
 - Fifth floor: bell towers
- Early Gothic building: rib vaults start at the ceiling and go down as far as the capitals on the columns
- Sexpartite or six part vaults
- Vaults span two bays

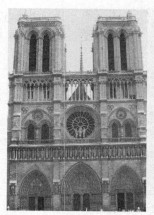 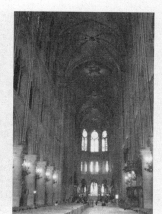

Figure 13.6: Notre Dame, Paris, begun 1150s, Paris

Figure 13.7: Notre Dame, Paris, begun 1150s, Paris

Chartres Cathedral, begun 1134, Chartres, France (Figures 13.8 and 3.9)

- High Gothic nave
- Each vault spans one bay
- Large windows
- Legendary stained glass
- Façade: south tower, on right, from 1160; north tower, on left, 1507–1513

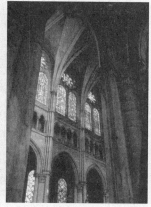 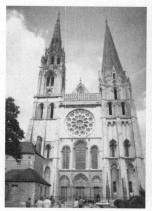

Figure 13.8: Chartres Cathedral, begun 1134, Chartres, France

Figure 13.9: Chartres Cathedral, begun 1134, Chartres, France

Amiens Cathedral, begun 1220, Amiens, France (Figures 13.10 and 13.11)

- High Gothic
- Four-part rib vaults
- Vaults extremely high, 148 feet above floor
- Large expanse of windows
- Façade: more extravagant use of sculpture; muscular concentration of dark and light architectural projections
- Sculpture above the doors in the arches
- Narrowing of nave enhances verticality

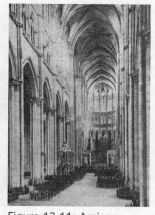 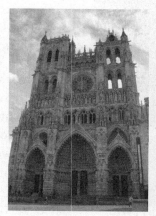

Figure 13.10: Amiens Cathedral, begun 1220, Amiens, France

Figure 13.11: Amiens Cathedral, begun 1220, Amiens, France

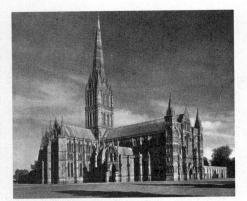

Figure 13.12: Salisbury Cathedral, begun 1220, Salisbury, England

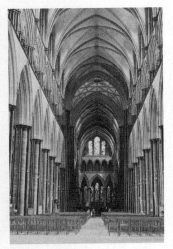

Figure 13.13: Salisbury Cathedral, begun 1220, Salisbury, England

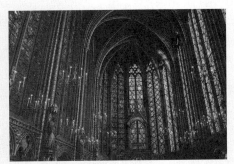

Figure 13.14: Saint-Chapelle, 1243–1248, Paris, France

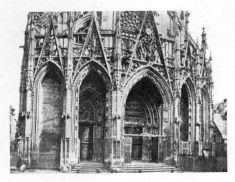

Figure 13.15: Saint-Maclou, 1500–1514, Rouen, France

Salisbury Cathedral, begun 1220, Salisbury, England (Figures 13.12 and 13.13)

- Early English Gothic Style
- Wide façade; sculpture placed everywhere
- Subdued flying buttresses
- Two transepts
- Square apse
- Situated in a close
- Tall central spire rises from the crossing added in nineteeth century
- Long horizontal emphasis down the nave

Saint-Chapelle, 1243–1248, Paris, France (Figure 13.14)

- Rayonnant style
- Dissolution of wall space: ¾ of the wall space is windows
- Slenderness of columns
- Sheets of glass
- Built to house sacred artifacts collected by Louis IX, including Christ's Crown of Thorns
- Symbolizes a giant reliquary
- Adjoins Royal Palace
- 1,113 scenes depicted in 15 stained glass windows telling the Biblical stories from Genesis through Christ's crucifixion

Saint-Maclou, 1500–1514, Rouen, France (Figure 13.15)

- Late Gothic, flamboyant style
- Five portals, of which two are blind, that is, they frame blank spaces rather than portals
 - Skeletal gables over arches
 - Complexity of design, profusion of ornament

INNOVATIONS IN GOTHIC PAINTING

Although stained glass had existed for centuries, it became an industry in the Gothic period. Craftsmen made the glass, while glaziers cut the big panels into the desired shapes, wrapping the leading around them. Details (i.e., facial expressions or folds of drapery) were then painted on the glass before it was refired and then set into the window frame.

Stained glass windows became the illustrations of a sophisticated theological program. Generally, larger images of saints appeared in the clerestory so that they could be read from the floor. Narratives appeared in side aisle windows where they could be read more clearly at a closer distance.

Characteristics of Gothic Painting

Illuminated manuscripts continue to be important, some seeking to emulate the luminous colors of stained glass windows. Forms have borders much like the leading of windows, and are painted in brilliant colors.

Major Work of Gothic Painting

Blanche of Castile and Louis IX, 1226–1234, manuscript, Morgan Library, New York (Figure 13.16)

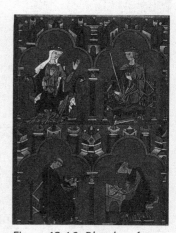

- Moralized Bible
- Top left: Blanche of Castile, mother and regent
- Top right: teenage king Louis IX
- Bottom: older monk dictates to younger scribe
- Luminosity of stained glass windows, strong black outlining of forms
- Modeling is minimal, color restricted

Figure 13.16: *Blanche of Castile and Louis IX*, 1226–1234, manuscript, Morgan Library, New York

INNOVATIONS IN GOTHIC SCULPTURE

Although Romanesque buildings had sculpture on the portals and on parts of building façades, its role was subsidiary to architecture. In the Gothic period, sculpture begins to emerge more forcefully on church façades.

Saint-Denis (c.1140–1144) was the first building to have statue columns on the jambs, now mostly destroyed. Although still attached to the columns, jamb figures have rounded volumes that set them apart from their architectural background. The statue columns at the **Royal Portals** at Chartres (1145–1155) appear to imitate the verticality of the church itself, but contain a robust three-dimensionality lacking in the Romanesque period. As the Gothic period progressed, statue columns developed naturally, indeed seeming to interact with one another, as in the *Visitation* (c. 1230) at Reims.

There is also a change in the subject matter from the Romanesque to the Gothic portals. Romanesque sculptural programs stress the Last Judgment and the threat of being damned to hell. Gothic sculpture concentrates on the possibility of salvation; the believer is empowered with the choice of salvation.

Characteristics of Gothic Sculpture

In Romanesque sculpture, figures are flattened into the wall space of tympana or jambs, being content to be defined by that space. In Gothic sculpture, the statue columns progress away from the wall, building a space seemingly independent of the wall surface. The **Royal Portals of Chartres** (1145–1155) begin this process by bringing figures forward, although they are still columnar.

As Gothic art advances the columns become increasingly three-dimensional and freestanding. In the thirteenth century, the figures are defining their own space, turning to one another with humanizing expressions and engaging in a narrative interplay.

By the fourteenth century, Gothic sculpture and painting develops a courtly S-curve to the bodies.

Major Works of Gothic Sculpture

Royal Portals, 1145–1155, Cathedral, Chartres, France (Figure 13.17)

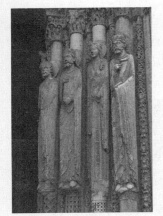

Figure 13.17: Royal Portals, 1145–1155, Cathedral, Chartres, France

- So-called because the jamb sculptures depict kings and queens from the Old Testament
- Stand in front of the wall, no longer flat up against it as in the Romanesque
- Upright and rigid; reflects the vertical columns behind and the vertical nature of the cathedral itself
- Robes are almost hypnotic in their concentric composition; no nervous excitement as in Romanesque sculpture
- Modulation of surface textures
- Heads: serenity, slightly heavy eyes, benevolent; humanized faces
- Heads lined up in a row, but feet of different lengths

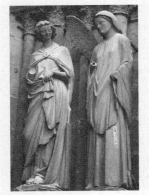

Figure 13.18: *Annunciation*

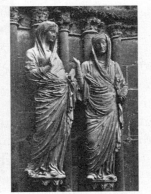

Figure 13.19: *Visitation*, Reims Cathedral, c. 1230, Reims, France

Annunciation and *Visitation*, Reims, France (Figures 13.18 and 13.19)

- Figures, left to right: Gabriel c. 1255, Mary c. 1245; Mary and Elizabeth c. 1230
- Left group not meant to be placed together but were arranged here as work on the cathedral progressed
- Figures stand free of the wall and interact with one another
- *Annunciation*
 - Gabriel at left, missing one wing and one hand, smiles knowingly as he announces that Mary will be the mother of Christ
 - Gabriel has a relatively small head; body sways elegantly in an S-curve
 - Mary is more column-like in form; thinking deeply about the news; appears courtly and aristocratic in style
- *Visitation*
 - Classical influence in drapery, stances; contrapposto
 - Heads look inspired by Roman portraits
 - Narrative quality of the interaction of figures
 - Mary announces her pregnancy to her cousin Saint Elizabeth who is much older; Elizabeth, despite her age, will have a child as well, Saint John the Baptist
 - Columns recede into the background behind the figures

Death of the Virgin, c. 1230, Strasbourg Cathedral, Strasbourg, France (Figure 13.20)

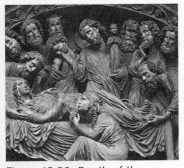

Figure 13.20: *Death of the Virgin*, c. 1230, Strasbourg Cathedral, Strasbourg, France

- Large heads
- Deeply chiseled figures in high relief
- Mary dies in her sleep, Christ receives her soul
- Wide range of human emotions

Ekkehard and Uta, 1249–1255, Naumburg Cathedral, Naumburg, Germany (Figure 13.21)

- Two of twelve statues of benefactors of an eleventh-century church on this site; founder "portraits" done for a fund-raising activity for the current thirteenth-century building
- Bodies revealed beneath drapery
- Medieval lady picks up her long elegant dress, too long to walk in
- Realistic looking faces with definite personalities: Ekkehard is blunt and efficient; Uta is coy and retiring
- Much of the paint still remains

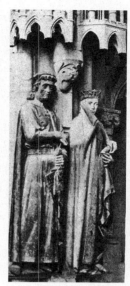

Figure 13.21: *Ekkehard and Uta*, 1249–1255, limestone, Naumburg Cathedral, Naumburg, Germany

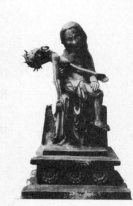

Figure 13.22: *Röttgen Pietà*, 1300–1325, wood, Rheinisches Landesmuseum, Bonn, Germany

Röttgen Pietà, 1300–1325, wood, Rheinisches Landesmuseum, Bonn, Germany (Figure 13.22)

- Christ emaciated, drained of all blood, all tissue, all muscle
- Horror of the Crucifixion manifest
- Humanizing of religious themes

Virgin of Paris, early fourteenth century, stone, Notre Dame, Paris (Figure 13.23)

- Worldly queen, crown full of gems
- Cf. *Hermes and Dionysos* (Figure 5.16)
- S-curve of the body common in fourteenth-century sculpture and painting
- Anatomy disguised under the drapery
- Inorganic stance

VOCABULARY

Chevet: the east end of a Gothic church (Figure 13.2)

Choir: a space in a church between the transept and the apse for a choir or clergymen (Figure 13.2)

Close: an enclosed gardenlike area around a cathedral (Figure 13.12)

Compound pier: a pier that appears to be a group or gathering of smaller piers put together (Figure 13.11)

Fan vault: a type of vault so-called because a fanlike shape is created when the vaults spring from the floor to the ceiling, nearly touching in the space directly over the center of the nave. They are usually highly decorated and filled with rib patterns (Figure 13.4)

Flying buttress: a stone arch and its pier that support a roof from a pillar outside the building. Flying buttresses also stabilize a building and protect it from wind sheer (Figure 13.1)

Moralized Bible: a Bible in which the Old and New Testament stories are paralleled with one another in illustrations, text, and commentary (Figure 13.16)

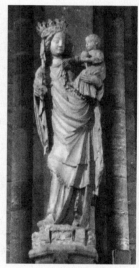

Figure 13.23: *Virgin of Paris*, early 14th century, stone, Notre Dame, Paris

Ogee arch: an arch formed by two S-shaped curves that meet at the top (Figure 13.3)

Pietà: a painting or sculpture of a crucified Christ lying on the lap of a grieving Mary (Figure 13.22)

Pinnacle: a pointed sculpture on piers or flying buttresses

Portal: a doorway. In medieval art they can be significantly decorated (Figure 13.17)

Rib vault: a vault in which diagonal arches form riblike patterns. These arches partially support a roof, in some cases forming a weblike design (13.11)

Rose window: a circular window, filled with stained glass, placed at the end of a transept or on the façade of a church (Figure 13.6)

Summary

A century of peace and prosperity brought architectural greatness to Northern France, where the Gothic style of architecture exploded on the scene around 1140. New buildings were built with great verticality, pointed arches, and large expanses of stained glass windows. The introduction of flying buttresses made taller and thinner buildings possible.

Gothic portal sculpture became more humanized than its Romanesque counterparts, stressing salvation and resurrection rather than judgment and fear. Figures are still attached to the wall space, but emerge as more three-dimensional. As Gothic sculpture progresses, the body is increasingly revealed beneath the drapery. In the fourteenth century, an elegant S-shaped curve characterizes Gothic painting and sculpture.

Practice Exercises

Questions 1–3 refer to Figure 13.24.

1. This building is an example of

 (A) Early Gothic
 (B) High Gothic
 (C) Flamboyant
 (D) Rayonnant

Figure 13.24

2. The ceiling of this building is designed with

 (A) barrel vaults
 (B) groin vaults
 (C) rib vaults
 (D) fan vaults

3. This Gothic building is French, unlike English churches that have

 (A) the accent on the horizontal
 (B) the altar in the apse
 (C) the rose window over the doorway
 (D) no place for the worshipper to sit

4. The aristocratic taste for courtly Medieval art finds expression in which of the following works?

 (A) *Röttgen Pietà*
 (B) *Blanche of Castile and Louis IX*
 (C) The *Visitation* from Reims
 (D) *Ekkehard and Uta*

5. Unlike Romanesque sculpture, Gothic works

 (A) are detached from the wall
 (B) no longer appear on church portals
 (C) are no longer made of stone
 (D) become more three-dimensional

Questions 6 and 7 refer to Figure 13.25.

6. This work shows the fourteenth-century tendency to

 (A) dress everyone in robes
 (B) naturally represent the human form
 (C) turn the bodies in an S-like curve
 (D) reveal the body beneath the drapery

7. This sculpture is called

 (A) the *Virgin of Paris*
 (B) *Blanche of Castile and Louis IX*
 (C) *Madonna of the Torch*
 (D) *Crowned Madonna*

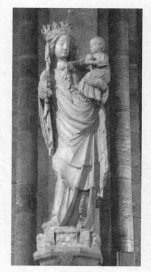

Figure 13.25

8. The close in English Gothic architecture was inspired by

 (A) cathedral crypts
 (B) pinnacles and flying buttresses
 (C) an increased chevet
 (D) monastery cloisters

9. An ogee arch is a characteristic of which of the following styles of architecture?

 (A) Early Gothic
 (B) High Gothic
 (C) Rayonnant
 (D) Flamboyant

10. Pinnacles were once thought to be decorative elements on buildings. It is now known that they were used for

 (A) weather forecasts
 (B) stabilizing structures against the wind
 (C) helping rib vaults balance the building
 (D) water spouts

Short Essay

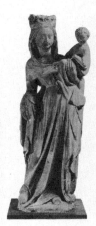

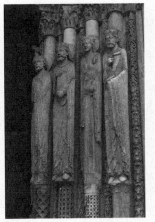

These two sculptures are Gothic. One comes from the beginning of the Gothic tradition, the other from the end. Discuss which is early Gothic, which is late, and tell why. Use one side of a sheet of lined paper to write your essay.

Figure 13.26 Figure 13.27

Answer Key

1. (B)	3. (A)	5. (D)	7. (A)	9. (D)
2. (C)	4. (B)	6. (C)	8. (D)	10. (B)

Answers Explained

Multiple-Choice

1. **(B)** This is a High Gothic building, the nave of the cathedral at Reims. It is easy to tell it is High Gothic because the rib vaults fall straight down to the floor articulating the columns.

2. **(C)** This ceiling uses rib vaults. The lines in the ceiling are the ribs.

3. **(A)** English Gothic buildings, in contrast to their French counterparts, have their accent on the horizontal.

4. **(B)** *Blanche of Castile and Louis IX* is done with brilliant gold color in sumptuous aristocratic taste.

5. **(D)** Gothic sculpture is far more three-dimensional than Romanesque sculpture, which appears flattened against the wall surface.

6. **(C)** Fourteenth-century sculpture can be characterized by the S-curve in the body.

7. **(A)** This sculpture is the *Virgin of Paris*.

8. **(D)** A close has its origins in monastery cloisters. English buildings are set back from the street surrounded by walls and an expansive garden or lawn.

9. **(D)** Flamboyant Gothic buildings use the ogee arch.

10. **(B)** Pinnacles stabilize Gothic buildings against wind forces.

Rubric for Short Essay

4: The student identifies Figure 13.26 as Late Gothic and Figure 13.27 as Early Gothic, and gives substantial reasons to support each claim. There are no major errors.

3: The student identifies Figure 13.26 as Late Gothic and Figure 13.27 as Early Gothic, and gives reasons to support each claim. Discussion is less substantial and may contain minor errors.

2: The student fails to identify the correct period for each sculpture, but describes characteristics of that period, OR the student identifies the correct periods but offers almost no support. There may be major errors.

1: The student fails to identify the correct period for each sculpture, but minimally explains the difference between Early Gothic and Late Gothic. There may be major errors.

0: The student makes an attempt, but the response is without merit.

Short Essay Model Response

The sculpture on the right is the Royal Portal from Chartres Cathedral in Chartres, France. The Cathedral itself is early Gothic and the sculpture was sculpted at the same time period of the building's creation and is also of the early Gothic style. Other indictors of this fact are that the statues are elongated and represent the verticality of the building, the clothes are straight with few ripples that do not define the body, and the sculpture doesn't come out far from the column (flat looking, not rounded).

The piece on the left is the <u>Virgin of Paris</u> located in Notre-Dame, Paris. France. The <u>Virgin of Paris</u> is from the late Gothic period expressed so by the unnatural S-curve given to her body imitating contrapposto, but not yet natural. The <u>Virgin of Paris</u> is dressed finely as from the court life as became popular with the International Gothic Style of the Late Gothic period, as well as the definition of some of her body like the chest to give her more form.

—Samantha D.

Analysis of Model Response

Samantha correctly identifies Figure 13.27 as Early Gothic and Figure 13.26 as Late Gothic. She supports these designations by alluding to the characteristics of each as expressed in each illustration. For example, she indicates that the Early Gothic sculptures are "elongated and represent the verticality of the building" and that "the clothes are straight with few ripples." Although she does identify the piece correctly, it is not asked for in the question, and thus cannot contribute to an overall score. Samantha's claim that the Royal Portal is "flat looking" can be considered a minor error, one that would not affect her grade. Her indication that 13.26 is Late Gothic is appropriate, and her discussion of the Late Gothic style is also cogent, indicating important facts such as the "unnatural S-curve" and the Virgin "dressed finely as from the court life" of the time. **This essay merits a 4.**

Gothic Art in Italy

TIME PERIOD: 1250–1400

This chapter concerns Italian Gothic art in Pisa, Florence, and Siena.

KEY IDEAS

- Gothic art in Italy forms a bridge between Medieval and Renaissance art.
- The artist becomes an important historical personality whose life story can be traced and recorded.
- Aspects of ancient sculpture are revitalized under the artistic leadership of the Pisani family.
- The Sienese and Florentine schools of painting dominate trecento art.

HISTORICAL BACKGROUND

Italy did not exist as a unified entity the way it does today. The peninsula was divided into a spectrum of city-states, some quite small, ruled by an assortment of princes, prelates, and the occasional republic, like Venice. Citizens identified themselves as Sienese or Florentines, not as Italians. The varied topography and differences in the local dialects of the Italian language often made the distinction from one state to another even more profound. Sometimes, as in the case of modern Sicilian, the linguistic differences are enough to be classified as a separate language.

Nothing seems more complicated to the modern viewer than Italian medieval politics, characterized as it is by routinely shifting allegiances that break into splinter groups and reform into new alliances. Those who lost power were either killed or driven from their city. Sometimes they regrouped and returned for revenge. Add to this the pressure and even military interventions from outside forces, such as the Holy Roman Empire or France, and medieval Italy becomes a complicated network of splintering associations.

With such instability it is a wonder that any works of art were completed, but this behavior does explain why many pieces come down to us in fragmentary condition, and why artists who were favored by one monarch may not have completed a work when another ruler came to power.

Patronage and Artistic Life

Medieval artists worked within an elaborate network called the guild system, in which artwork was regulated as an industry like any other. Guilds were artist associations that determined, among other things, how long apprenticeships should take, how many apprentices an artist could have, and what the proper route would be for an artist trying to establish him- or herself on his or her own. However, female artists were rare, because apprentices lived with their teacher, creating a situation unthinkable for females.

After a successful internship, former apprentices entered the guild as mature artists and full members. The guild helped to regulate commissions as well as ensure that not too many people entered the field, a situation that would have driven down the prices. The guild system remained in effect until replaced by the free-market approach that took hold in the eighteenth century.

Artistic patronage was particularly strong among preaching orders of friars, such as the Franciscans, the devoted followers of St. Francis of Assisi, and the Dominicans, the faithful followers of St. Dominic de Guzman. Coalescing early in the thirteenth century, both groups abstained from material concerns and committed themselves to helping the poor and the sick. Since the Dominicans stressed teaching, they were instrumental in commissioning narrative pulpits and altarpieces for their churches so that the faithful could learn important Christian tenets. The Franciscan mother church in Assisi has a program of frescoes unequalled in **trecento** art, in part devoted to the life of the charismatic St. Francis.

Italian citizens had a strong devotional attachment to their local church, sometimes being buried inside. Families commissioned artists to decorate private chapels, occasionally with members of the family serving as models in a religious scene. If a family could not afford a whole chapel, they perhaps could sponsor a sculpture or an altarpiece. Analogously, rulers, church leaders, and civic-minded institutions led by laypersons commissioned works for public display, using them to legitimize their reign or express their public generosity.

The modern approach to art, as a business run by professionals, has its origins in the late Gothic period. Contracts between artists and patrons were drawn up, bookkeeping records of transactions between the two were maintained, and artists self-consciously and confidently began signing works more regularly. With **Cimabue** and **Nicola Pisano** the first traceable and coherent artistic careers begin to emerge. Artists' signatures indicate their rising status—a radical break from the general anonymity in which earlier medieval artists had toiled—and a self-conscious need publicly to associate their names with works of art of which they were particularly proud.

CHARACTERISTICS OF ITALIAN GOTHIC ARCHITECTURE

Unlike Northern Gothic buildings, Italian buildings stress width as well as height. Even though most Italian churches are as tall as their French counterparts, the horizontal emphasis is so strong that the height seems restrained. Interiors feature one story of arches and a second of windows. Intermediary stories, so prominent in Early Christian and French Gothic church buildings, are sometimes abandoned. Wide naves focus attention on apses backlit by tall windows. Clearly articulated rib vaults

open up the clerestory to admit volumes of light filtered by thin masses of pastel-colored stained glass windows.

Major Work of Italian Gothic Architecture

Arnolfo di Cambio and others, Florence Cathedral, begun 1296, Florence, Italy; Giotto designed the campanile, perhaps altered after his death (Figures 14.1 and 14.2)

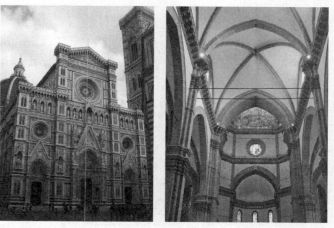

Figures 14.1 and 14.2: Arnolfo di Cambio and others, Florence Cathedral, begun 1296, Florence, Italy; Giotto designed the campanile, perhaps altered after his death.

- Wide, open, expansive interior
- Broad, heavy piers allow side aisle spaces to flow into nave; very widely spaced arches
- Dark interiors of French Gothic are answered by a lighter interior
- Campanile: crisply divided horizontal sections stack floors one above the other; variously colored marbles inspired by Italian Romanesque buildings; patterns of rectangular blocks of marble cover the surface
- Façade finished in the nineteenth century

Palazzo Pubblico, 1288–1309, Siena, Italy (Figure 14.3)
- Center of Siena's civic government
- Fortresslike exterior gives the impression of an impenetrable building
- Huge bell tower—called a campanile—dominates the façade, the city square, and the city as a whole
- Symbolically puts the building in competition with the cathedral

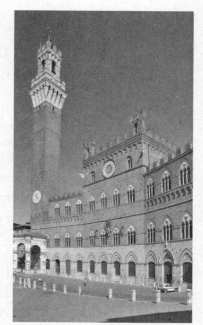

Figure 14.3: Palazzo Pubblico, 1288–1309, Siena, Italy

CHARACTERISTICS OF FLORENTINE PAINTING

The trend in Gothic sculpture is to liberate works from the wall, allowing them to occupy space independent of their architectural framework. Concurrently, Italian painting of the late Gothic period is characterized by large scale panels that stand on their own.

Wall paintings in the Middle Ages, including frescoes and mosaics, emphasize the flatness of the wall surface, encouraging artists to produce compositions that are frontal and linear. Late Gothic artists prefer fresco and tempera, techniques that enabled them to shade figures convincingly and reach for a three-dimensional reality.

At first, artists like **Cimabue** accepted Byzantine formulas for pictorial representation, commonly referred to as the **maniera greca**. Subsequent Florentine painters, however, particularly under the guidance of **Giotto** and his followers, began to move away from this tradition and toward a different concept of reality that substantiated masses and anchored figures to ground lines. Through expressive faces and meaningful gestures, emotions become more palpable and dynamic. Florentine painting dares to experiment with compositional arrangements, moving the focus away from the center of the painting.

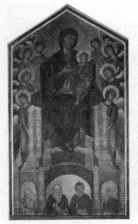

Figure 14.4: Cimabue, *Madonna Enthroned*, 1280–1290, tempera on panel, Uffizi, Florence

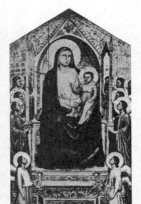

Figure 14.5: Giotto, *Madonna Enthroned*, c. 1310, tempera on panel, Uffizi, Florence

Major Works of Florentine Painting

Cimabue, *Madonna Enthroned*, 1280–1290, tempera on panel, Uffizi, Florence (Figure 14.4)

- Maniera greca; figures rise in a hieratic Byzantine manner
- Emphasis on flatness of forms; angels hover around throne
- Long, thin elegant figures; strong verticality
- Flecks of gold define drapery folds
- Virgin Mary as the Throne of Wisdom points to Christ as the way to salvation
- Mary with Byzantine-shaped face and stylized features
- Not Byzantine in size; Byzantine icons are portable
- Figures on bottom represent a changing style; figures have weight, solidity, bulk

Giotto, *Madonna Enthroned*, c. 1310, tempera on panel, Uffizi, Florence (Figure 14.5)

- Weight, size, solidity, three-dimensionality, bulk
- Mary's breasts and knees revealed beneath drapery
- Angels stand more naturally around the Gothic throne
- Perspective indicated in the positioning of the side panels of the throne and the shadowing of the steps
- Some faces turn away from the picture plane
- Mary as the mother of Christ, but also becomes more human

Giotto, *Lamentation* from the Arena Chapel, 1305–1306, fresco, Padua, Italy (Figure 14.6)

- Arena Chapel built by Enrico Scrovegni to expiate the sin of usury through which his father had amassed a fortune; some narrative scenes chosen for the chapel illustrate Biblical episodes of ill-gotten gains
 - *Lamentation:*
 - o Shallow stage, figures occupy a palpable space pushed forward toward the picture plane
 - o Diagonal cliff formation points to main action daringly placed in lower left-hand corner
 - o Modeling indicates direction of light, light falls from above right
 - o Range of emotions: heavy sadness, quiet resignation, flaming outbursts, despair
 - o Sadness of scene emphasized by grieving angels, barrenness of tree
 - o Figures on the lower left are seen from the back and isolate the main action
 - o Clear foreground, middle ground, and background

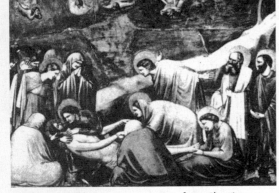

Figure 14.6: Giotto, *Lamentation* from the Arena Chapel, 1305–1306, fresco, Padua, Italy

CHARACTERISTICS OF SIENESE PAINTING

Unlike their Florentine contemporaries, Sienese painters opt for a decorative style of painting, more reminiscent of Northern European art. Figures are thinner, elegant, and courtly. Colors are richly decorative. Drapery in Sienese art is less defined by mass than by the thin fluttering of draperies and the zigzagging of complex linear patterns. Instead of falling straight to the ground, drapery is more likely to curve artistically in a flouncing series of ripples. Sienese painters like to imitate marble patterning on thrones or pavements. Even though hierarchy of scale remains, figures are more likely than in Northern European art to be in proportion to one another, although as in Florentine painting, they still dominate architectural settings. Italian altarpieces reflect the construction of the Gothic churches which embrace them, as explained in Figure 14.7.

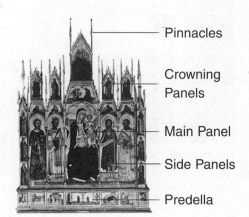

Figure 14.7: This Sienese Gothic altarpiece by Andrea Vanni has its original components in place. The forms parallel elements of a Gothic cathedral: the main panel acts as the nave, the side panels as side aisles, the pinnacles as the roof and the predella as the crypt.

Like Florentines, Sienese artists explore three-dimensionality, although they reached more deeply into the picture plane by expressing deeper interiors. A favorite Sienese motif is the opening of a door frame or a room wall, revealing what lies beyond, recalling the effect of a set on a theatrical stage. Attempts are made, as in Pietro Lorenzetti's *Birth of the Virgin* (Figure 14.10) to include two continuous scenes in one unified view.

Sienese artists such as **Simone Martini** began the **International Gothic** style of painting. Because Martini resided in France later in life, and because of the aristocratic tenor of these works, which found favor among élite patrons, the style spread quickly to the rest of Europe.

Major Works of Sienese Painting

Duccio, *Maestà*, main panel: 1308–1311, tempera on panel, Museum of the Works of the Cathedral, Siena (Figure 14.8)

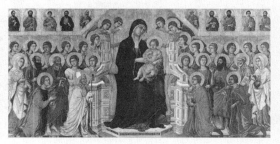

Figure 14.8: Duccio, *Maestà*, main panel: 1308–1311, tempera on panel, Museum of the Works of the Cathedral, Siena

- For the main altar of Siena Cathedral, the centerpiece of a cluster of Marian works
- Richest and most complex altarpiece of its time
- Hieratic arrangement of figures in three horizontal registers, with Mary and Jesus in the center, saints kneeling below and standing on either side, and angels looming between saints' halos in top row
- Fluttering, light drapery lines fall in zigzag patterns
- Decoratively patterned throne folds outward to reveal Mary and Jesus enthroned
- Only signed and documented work by Duccio to have survived

Simone Martini, *Annunciation*, 1333, tempera on panel, Uffizi, Florence (Figure 14.9)

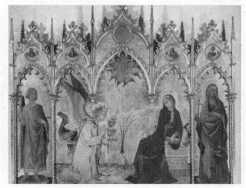

Figure 14.9: Simone Martini, *Annunciation*, 1333, tempera on panel, Uffizi, Florence

- Grain of marble floor retreats in perspective
- Elegant figures, drapery, ornament

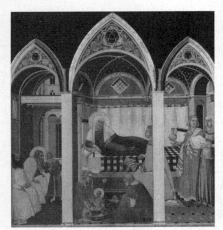

Figure 14.10: Pietro Lorenzetti, *Birth of the Virgin*, 1342, tempera on panel, Museum of the Works of the Cathedral, Siena

- Use of gold abounds
- Angel: white brocade with floating plaid-lined mantle; beautifully and subtly modeled
- Mary: shrinks back in modesty, the figure of a courtly medieval woman
- Vase of white lilies symbolizes Mary's purity
- Traditional gold wall background in effect becomes the rear wall of this room
- Gestures are courtly and aristocratic
- International Gothic style of painting

Pietro Lorenzetti, *Birth of the Virgin*, 1342, tempera on panel, Museum of the Works of the Cathedral, Siena (Figure 14.10)

- Part of the Marian cycle of paintings in Siena Cathedral
- Pioneering attempt at building an interior space, with the three parts of the triptych suggesting a single common viewpoint
- St. Anne gives birth inside a Sienese home; everyday items depicted
- St. Anne reclining, as women wash newborn Mary in a basin
- At left, St. Joachim, Mary's father, is in an antechamber hearing the news of the birth of his daughter
- Windows open up to reveal further arches and walled spaces beyond, expressing depth; innovative use of pier that establishes picture plane and does not separate the space of the center and right-hand panels

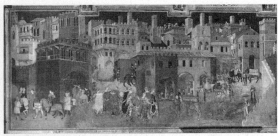

Figure 14.11: Ambrogio Lorenzetti, *Good Government in the City*, 1338–1340, fresco, Public Palace, Siena

Ambrogio Lorenzetti, *Good Government in the City and the Country*, 1338–1340, fresco, Public Palace, Siena (Figures 14.11 and 14.12)

- Located in the Public Palace in Siena where judges met to adjudicate issues of Sienese law
- Highly literate society for its time; inscriptions on the paintings are in Latin and Italian; Ambrogio Lorenzetti's signature prominently displayed
- City: cityscape scene from a high viewpoint, perhaps a tower, overlooking a prosperous town run by efficient laws; dancing in the street (technically illegal in Siena) symbolizes the success of good government and the peacefulness and joy it brings; crafts and trades flourish; schools are open; new buildings under construction; emphasis placed on food being brought into the city
- Country: peaceful villas set in landscape again surveyed from above, filled with vineyards, orchards, and bountiful harvests; distant port in the background for the shipment of goods; figure of Security holding a gallows insures fair justice for all; aristocrats leave town to go falconing; farmers bring livestock and grain to market

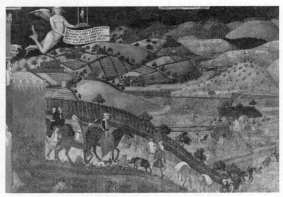

Figure 14.12: Ambrogio Lorenzetti, *Good Government in the Country*, 1338–1340, fresco, Public Palace, Siena

- Broadly lit painting signifying daytime, with an incongruous blue–black sky to offset the colors

CHARACTERISTICS OF ITALIAN GOTHIC SCULPTURE

Italian Gothic sculpture is more influenced by classical models than was the case for Northern contemporaries. Although the classic never passed from Italian art (i.e., Romanesque sculptor Antelami), **Nicola Pisano** strengthened an attachment to Roman forms by building figures of solid mass with realistically arranged drapery. There is still a tendency, however, to create compositions that are crowded, with various episodes represented in horror vacui, stacked one above another. The principal scene dominates by its size, but subsidiary scenes compete for attention in available spaces.

Figure 14.13: Nicola Pisano, The Pisa Pulpit, 1259–1260, Pisa Baptistery, Pisa, Italy

Major Works of Italian Gothic Sculpture

Nicola Pisano, The Pisa Pulpit, 1259–1260, Pisa Baptistery, Pisa, Italy (Figures 14.13 and 14.14)

- Pulpit: five panels circle around the elevated pulpit; Gothic Corinthian capitals closer in design to ancient capitals than to contemporary French; round arches cusp in French Gothic style; antique lions at the base; nude heroic figure of Hercules symbolizing Christian bravery and strength
- *Annunciation and Nativity:* very crowded composition of figures layered atop one another; massive drapery that forms logically around bodies that are stocky and solidly conceived; as in Italian painting, facial expressions and gestures enliven figures who communicate with one another

Figure 14.14: Nicola Pisano, *The Annunciation and Nativity* from the Pisa Pulpit, 1259–1260, Pisa Baptistery, Pisa, Italy

Giovanni Pisano, Pisa Pulpit, 1302–1310, marble, Pisa Cathedral (Figure 14.15)

- Figures are widely spaced and scenes separated
- Dynamic movement of figures, they are not as static as Nicola Pisano's
- Deeply cut sculpture creates shadows
- Inspired by French Gothic models more than classical Roman ones

VOCABULARY

Allegory: work of art which possesses a symbolic meaning in addition to a literal interpretation. In literature, a fable is an example of an allegory (Figure 14.11)

Altarpiece: a painted or sculpted panel set on an altar of a church (Figure 14.7, among others)

Campanile: a bell tower for an Italian building

Figure 14.15: Giovanni Pisano, Pisa Pulpit, 1302–1310, marble, Pisa Cathedral

International Gothic Style: a style of fourteenth- and fifteenth-century painting, begun by Simone Martini. The style is characterized by elegant and intricate interpretations of naturalistic subjects, and minute detailing and patterning in drapery and color, catering to an aristocratic taste (Figure 14.9)

Maestà: a painting of the Virgin Mary as enthroned Queen of Heaven surrounded by angels and saints (Figure 14.8)

Maniera greca: (Italian for "Greek manner") a style of painting based on Byzantine models that was popular in Italy in the twelfth and thirteenth centuries (Figure 14.4)

Predella: the base of an altarpiece that is filled with small paintings, often narrative scenes (Figure 14.7)

Tempera: a type of paint employing egg yolk as the binding medium that is noted for its quick drying rate and flat opaque colors

Trecento: the 1300s, or fourteenth century, in Italian art

Summary

It is not degrading to trecento artists to say that Late Gothic art in Italy is a bridge period between the Middle Ages and the Renaissance. Italian artists were inspired by Roman works, broke away from Byzantine traditions, and established two strong schools of painting in the trecento: The Sienese and the Florentine.

Sienese art is marked by figures that are closer aligned to French Gothic art: Thin, elegant, aristocratic, and decorative—all aspects of the International Gothic style. These artists explore the three-dimensional possibilities that a two-dimensional surface can have. Florentine artists concentrate on mass and solidity, often using shading to create the suggestion of three dimensions.

Practice Exercises

1. Which of the following painters is closest to the spirit of maniera greca?

 (A) Cimabue
 (B) Giotto
 (C) Duccio
 (D) Simone Martini

Questions 2–5 refer to Figure 14.16.

2. This painting is an example of International Gothic because

 (A) it has a predella
 (B) it is a religious scene
 (C) it is dedicated to Mary
 (D) the costumes are lavish

Figure 14.16

3. This painting is from the Sienese Gothic school because

 (A) there is no exploration of depth
 (B) the altarpiece has large gables
 (C) the drapery falls in elegant, complex patterns
 (D) there are saints in the side panels

4. The artist of this work is

 (A) Giotto
 (B) Simone Martini
 (C) Duccio
 (D) Pietro Lorenzetti

5. Unlike earlier medieval works this large painting

 (A) is done in mosaic
 (B) stands independently
 (C) contains symbolism
 (D) is an allegory

6. Paintings, even major altarpieces, are grouped around a theme. The ones executed for Siena Cathedral were centered on

 | CHALLENGE |

 (A) the life of Jesus
 (B) the Annunciation and Nativity
 (C) the life of Mary
 (D) a peaceful city

Figure 14.17

Questions 7–9 refer to Figure 14.17.

7. Paintings often are done for a particular location. This work is a fresco painted for

 (A) Siena Cathedral
 (B) the Palazzo Pubblico in Siena
 (C) Florence Cathedral
 (D) Pisa Cathedral Baptistery

8. The significance of the location of this work lies in its message that

 (A) faithful people go to heaven
 (B) happy people live lives of charity and love
 (C) good government leads to a happy citizenry
 (D) the morally correct will prosper no matter what the city government does

9. The artist who signed this work is

(A) Duccio
(B) Simone Martini
(C) Ambrogio Lorenzetti
(D) Nicola Pisano

10. When artists left their apprenticeships, their careers were directed by

(A) patrons
(B) the Church
(C) guilds
(D) master artists

Short Essay

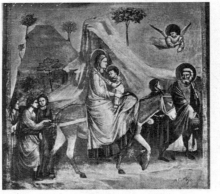

Figure 14.18

This work was done in Late Gothic Italy in either the Florentine or the Sienese tradition. In which tradition would you place this painting, and why? Use one side of a sheet of lined paper to write your essay.

Answer Key

1. **(A)**	3. **(C)**	5. **(B)**	7. **(B)**	9. **(C)**
2. **(D)**	4. **(B)**	6. **(C)**	8. **(C)**	10. **(C)**

Answers Explained

Multiple-Choice

1. (**A**) Cimabue's linear flatness is the closest to approximating Byzantine painting in a style called maniera greca.

2. (**D**) One of the characteristics of International Gothic paintings is the lavish costuming of figures.

3. (**C**) A characteristic of Sienese painting is the curving and flowing drapery lines as seen in the angel's garments.

4. (**B**) This is the *Annunciation* by Simone Martini.

5. (**B**) One of the characteristics of late Gothic painting in Italy is its independence from the wall.

6. (**C**) Paintings like Duccio's *Maestà* and Pietro Lorenzetti's *Birth of the Virgin* were painted for Siena Cathedral and are based on the life of Mary.

7. (**B**) This painting was done for the Palazzo Pubblico in Siena.

8. (**C**) Among the messages in this allegory is the idea that an effective government helps to ensure a happy citizenry.

9. (**C**) Ambrogio Lorenzetti signed this work.

10. (**C**) Guilds helped direct the careers of budding artists.

Rubric for Short Essay

4: Student identifies this work as Florentine and gives three substantial reasons for this claim. There are no major errors.

3: Student identifies this work as Florentine and gives two reasons for this claim. There may be minor errors.

2: Student identifies this work as Florentine but gives only one reason, OR student identifies the work as Sienese and gives some support for the claim. There may be major errors.

1: Student identifies the work as Florentine, but provides no other support, OR student misidentifies the work as Sienese, but provides some support for the Florentine school. There may be major errors.

0: The student makes an attempt, but the response is without merit.

Short Essay Model Response

This work is part of the Arena Chapel paintings by Giotto, which were done for a family who acquired their fortune by usury. This work has large simple figures that are characteristic of the Florentine tradition. The drapery falls down realistically on the figures, who are modeled in large convincing shapes that betray a solidness and monumentality.

This work could not be Sienese, because in Sienese art the figures are thin and wear stylish clothing. Sienese art was modeled after the aristocracy. There is also a greater exploration of depth in Sienese painting. This painting has limited depth with the figures only placed in the foreground.

—Danielle P.

Analysis of Model Response

Danielle's response is correct in claiming that this work is by Giotto and from the Arena Chapel; however, no points can be earned for this information, since it is not in the question. She is also correct in labeling the work as Florentine, and goes on to explain that the monumentality and solidness of the forms are characteristic of Florentine art but does not address other issues such as drapery or shading. She knows that Giotto's work is less likely to explore spatial depth than Sienese art. However, since the question does not ask for a comparison of Sienese painting, no points can be earned for descriptions of this school of painting. Students should answer a question directly rather than answer it in the negative; in other words, it is better to argue why this work is Florentine rather than to explain why it is *not* Sienese. **This essay merits a 2.**

Early Renaissance in Northern Europe: Fifteenth Century

TIME PERIOD: 1400–1500

The early Renaissance in Northern Europe takes place in the mercantile centers of Flanders (Belgium), Holland, Germany, and France.

KEY IDEAS

- An active and prosperous capitalist society inspired a cultural ferment in fifteenth-century Flanders and Holland.
- Important secular works of fifteenth-century architecture are influenced by Gothic church architecture.
- The International Gothic style dominates Northern European painting in the early fifteenth century.
- Flemish painting is characterized by symbolically rich layers of meaning applied to crowded compositions with high horizon lines.
- Secular art becomes increasingly important.
- The introduction of printmaking, the first mass-produced art form, radically transforms art history.

HISTORICAL BACKGROUND

The prosperous commercial and mercantile interests in the affluent trading towns of Flanders stimulated interest in the arts. Emerging capitalism was visible everywhere, from the first stock exchange established in Antwerp in 1460 to the marketing and trading of works of art. Cities vied with one another for the most sumptuously designed cathedrals, town halls, and altarpieces—in short, the best Europe had to offer.

CHARACTERISTICS OF EARLY NORTHERN RENAISSANCE ARCHITECTURE

The popularity of the flamboyant Gothic style extended beyond church architecture into the secular realm by the fifteenth century. Elements of Gothic church architecture were grafted onto secular buildings, turning them into monastically inspired buildings for the rich and famous.

Major Work of Fifteenth Century Architecture in Northern Europe

House of Jacques Coeur, 1443–1451, Bourges, France (Figures 15.1 and 15.2)

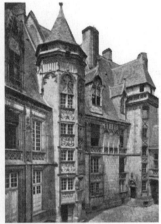

Figure 15.1: Interior courtyard of House of Jacques Coeur, 1443–1451, Bourges, France

- Home of a rich entrepreneurial merchant who amassed a fortune
- First floor: business section of the house; storage areas, servant quarters, shops
- Upper floors for family and entertaining
- Many Gothic details in window frames, tracery, arches
- House surrounds an open interior courtyard
- Uneven, irregular plan
- Expression of new spirit of capitalism and development

INNOVATIONS IN NORTHERN RENAISSANCE PAINTING

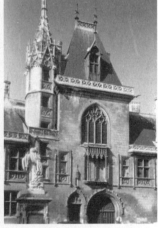

Figure 15.2: Street façade of House of Jacques Coeur, 1443–1451, Bourges, France

One of the most important inventions in the last thousand years, if not history, is the development of movable type by Johann Gutenberg. The impact was enormous. This device could mass produce books, make them available to almost anyone, and have them circulated on a wide scale.

However, mechanically printed books looked cheap and artificial to those who were used to having their books handmade over the course of years, as the **Limbourg Brothers** (Figure 15.3) did for the super-wealthy patrons. Gutenberg's first book, *The Bible*, was printed mechanically, but the decorative flourishes—mostly initial letters before each chapter—were hand painted by calligraphers. Meanwhile, a similar mechanical process gave birth to the print, first as a **woodcut**, then as an **engraving** and later as **etching**. Prints were mass produced and relatively inexpensive, since the artist made a prototype that was reprinted many times. Although individually cheaper than a painting, the artist made his profit on the number of reproductions. Indeed, fame could spread more quickly with prints, because these products went everywhere, whereas paintings were in the hands of single owners.

The second important development in the fifteenth century was the widespread use of oil paint. Prior to this, wall paintings were done in fresco and panel paintings in tempera. Oil paint was developed as an alternative in a part of Europe in which fresco was never that popular.

Oil paint produces exceptionally rich colors, having the notable ability to accurately imitate natural hues and tones. It can generate enamel-like surfaces and sharp details. It also preserves well in wet climates, retaining its luster for a long time.

Unlike tempera and fresco, oil paint is not quick drying and requires time to set properly, thereby allowing artists to make changes onto what they previously painted. With all these advantages, oil paint has emerged as the medium of choice for most artists since its development in Flanders in the early Renaissance.

Characteristics of Northern Renaissance Painting and Sculpture

The great painted altarpieces of medieval art were the pride of accomplished painters whose works were on public view in the most conspicuous locations. Italian altarpieces from the age of Giotto tend to be flat paintings that stand directly behind an altar, often with gabled tops, as in Cimabue's *Madonna Enthroned* (Figure 14.4). Sometimes Italian altarpieces had reverse sides that were illustrated with stories from the New Testament, as does Duccio's *Maestà* (Figure 14.8). Those scenes, however, appear behind an altar piece and were accessible to few; the principal viewpoint is the main image, large enough so that it could be appreciated at a distance.

Northern European altarpieces are cupboards rather than screens, with wings that opened and close, folding neatly into one another. The large central scene is the most important, sometimes carved rather than painted; sculpture was considered a higher art form. Small paintings such as ***The Mérode Triptych*** of 1425–1428 (Figure 15.4) were designed for portability. Larger works such as ***The Ghent Altarpiece*** of 1432 (Figures 15.5 and 15.6) were meant to be housed in an elaborate Gothic frame that enclosed the main scenes. Sometimes the frame alluded to the architecture of the building in which the painting resided.

Altarpieces usually have a scene painted on the outside, visible during the week. On Sundays, during key services, the interior of the altarpiece is exposed to view. Particularly elaborate altarpieces may have had a third view for holidays.

Northern European artisits were heavily influenced by International Gothic Painting, a courtly elegant art form, begun by Italian artists such as Simone Martini in the fourteenth century. This style of painting features thin, graceful figures that usually have an S-shaped curve as does Late Gothic sculpture. Natural details abound in small bits of reality that are carefully rendered. Costumes are splendidly depicted with the latest fashions and most stylish fabrics. Gold is used in abundance to indicate the wealth of the figures and the patrons who sponsored these works. Architecture is carefully rendered, frequently with the walls of buildings opened up so that the viewer can look into the interior. International Gothic paintings often have elaborate frames that match the sumptuous painting style.

Regardless of whether artists worked in the International Gothic tradition, Northern European painters generally continued the practice of opening up wall spaces to see into rooms as in ***The Mérode Triptych*** (Figure 15.4). Typically, figures are encased in the rooms they occupy, rather than being proportional to their surroundings. Ground lines tilt up dramatically, as do table tops and virtually any flat surface. High horizons are the norm, as in ***The Portinari Altarpiece*** (Figure 15.11). Although symbolism can be seen in virtually any work of art in any art historical period, it seems to be particularly a part of the fabric of Northern European painting. Items that appear casually placed as a bit of naturalism can be construed as part of a symbolic network of interpretations existing on several important levels. Scholars have spilled a great deal of ink in decoding possible readings of important works.

Major Works of Fifteenth-century Painting in Northern Europe

Figure 15.3: Limbourg Brothers, *May* from *The Very Rich Hours of the Duke of Berry*, 1413–1416, ink on vellum, Musée Condé, Chantilly

Limbourg Brothers, *May* from *The Very Rich Hours of the Duke of Berry*, 1413–1416, ink on vellum, Musée Condé, Chantilly (Figure 15.3)

- International Gothic
- Full page illustrations contain the months of the year for a Book of Hours
- Top: astrological signs associated each month, Apollo riding a chariot bringing up the dawn
- Main scenes: labors of the month: i.e., February has peasants warming themselves by a cozy fire with the snow covering the landscape; May features nobles on horseback in a May Day parade; July has peasants harvesting wheat and shearing sheep; October has peasants planting winter wheat
- Naturalism of details; meticulously rendered castles; cast shadows
- Separation of the classes strictly emphasized by placement of serfs and nobility in different areas of the painting

Robert Campin (?) (The Master of Flémalle), *The Mérode Triptych*, 1425–1428, oil on wood, Metropolitan Museum of Art, New York (Figure 15.4)

- Left panel: donors, middle-class people kneeling before the holy scene
- Center panel: Annunciation taking place in an everyday Flemish interior
- Symbolism:
 o Towels and water are Mary's purity; water is a baptism symbol
 o Flowers have three buds symbolizing the Trinity; the unopened bud is the unborn Jesus; lilies also symbolize Mary's purity
 o Mary seated on the floor symbolizing her humility
 o Mary blocks the fireplace, or the entrance to hell
 o Candlestick: Mary holds Christ in the womb
 o Figure with a cross comes in through the window, the divine birth
- Humanization of traditional themes: no halos, domestic interiors, view into a Flemish cityscape
- Right panel: Joseph in his carpentry workshop; mousetrap symbolizes the capturing of the devil

- Meticulous handling of paint; intricate details
- Steeply rising ground line; figures too large for the architecture they sit in

Jan van Eyck, *The Ghent Altarpiece*, 1432, oil on wood, St. Bavo Cathedral, Ghent, Belgium (Figures 15.5 and 15.6)

- Polyptych placed on an altar of St. Bavo in Ghent, Belgium
- Great detail and extreme realism

Figure 15.4: Robert Campin (?) (The Master of Flémalle), *The Mérode Triptych*, 1425–1428, oil on wood, Metropolitan Museum of Art, New York

Figure 15.5: Jan van Eyck, exterior of *The Ghent Altarpiece*, 1432, oil on wood, St. Bavo Cathedral, Ghent, Belgium

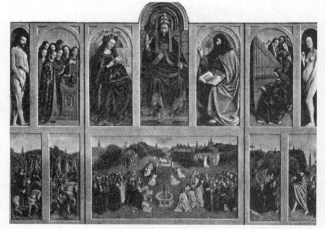

Figure 15.6: Jan van Eyck, exterior of *The Ghent Altarpiece*, 1432, oil on wood, St. Bavo Cathedral, Ghent, Belgium

- Interior top: God the Father in center sits in majesty wearing the pope's crown surrounded by Mary and John the Baptist; choirs of angels flank them; Adam and Eve appear in the corners
- Interior bottom: The Lamb of God in the center with a continuous landscape containing medieval knights and clergy
- Exterior top: Annunciation; prophets and sibyls who foretell Christ's coming
- Exterior bottom: two figures painted in grisaille in center (St. John the Baptist and John the Evangelist); two donors kneeling in outside niches

Jan van Eyck, *Arnolfini Wedding*, 1434, oil on wood, National Gallery, London (Figure 15.7)

- Traditionally assumed to be the wedding portrait of Giovanni Arnolfini and Giovanna Cenami; some scholars now say that this is not a wedding portrait, but actually a memorial to a deceased wife, or simply a betrothal
- Symbols of weddings abound: custom of burning a candle on the first night of a wedding; shoes cast off to indicate standing on holy ground; prayerful promising pose of groom
- Dog symbolizes fidelity or carnality
- Two witnesses in the convex mirror, perhaps Jan van Eyck himself, since the inscription reads "Jan van Eyck was here 1434"
- Wife pulls up dress to symbolize childbirth, although she is not pregnant
- Statue of St. Margaret, patron saint of childbirth, appears on the bedpost
- Man appears near the window symbolizing his role as someone who makes his way in the outside world; the woman appears farther in the room to emphasize her role as a homemaker
- Meticulous handling of paint; great concentration of minute details

Figure 15.7: Jan van Eyck, *Arnolfini Wedding*, 1434, oil on wood, National Gallery, London

Jan van Eyck, *Man in a Red Turban*, 1433, oil on wood, National Gallery, London (Figure 15.8)

- Perhaps a self-portrait
- Looks at the viewer with an unflinching stare
- Inscription on top frame: "As I can" and on bottom frame, "Jan van Eyck made me 1433, 21 October"

Figure 15.8: Jan van Eyck, *Man in a Red Turban*, 1433, oil on wood, National Gallery, London

- Naturalistic portrait with beard stubble and a dramatic turban draped over the head
- Acceptance of independent self-portraits implies an increased secular society

Figure 15.9: Rogier van der Weyden, *Deposition*, c. 1435, oil on wood, Prado, Madrid

Rogier van der Weyden, *Deposition*, c. 1435, oil on wood, Prado, Madrid (Figure 15.9)

- Shallow stage for figures jambed into a confining space
- Great attention to details
- Strong emotional impact of the scene
- Patrons of the archers' guild symbolized by the crossbows in the spandrels
- Figures in mirrored compositions: Christ and Mary; two end figures have similar poses; poses similar for Nicodemus (in printed drapery) and the figure holding Mary

Figure 15.10: Dirk Bouts, *Last Supper*, 1464–1468, oil on wood, St. Peter's, Louvain, Belgium

Dirk Bouts, *Last Supper*, 1464–1468, oil on wood, St. Peter's, Louvain, Belgium (Figure 15.10)

- Influence of Italian painting seen in the development of one-point perspective in Northern art
- Biblical drama of the Last Supper less important than the seriousness of the sacrament being created
- Four contemporaries appear as servants; perhaps they are the patrons of the painting
- Figures seem detached and impassive

Hugo van der Goes, central panel of the *Portinari Altarpiece*, c. 1476, tempera and oil on wood, Uffizi, Florence (Figure 15.11)

- Placed in the family chapel of Sant' Egidio in Florence, functioned as the chapel for Florence's largest hospital
- Placement in a maternity hospital chapel influences imagery
- Mary, as the mother of Christ, is central; St. Margaret, patron saint of childbirth, is in the right wing (not illustrated); Christ's thin appearance simulates a newborn
- Christ placed on a sheaf of wheat that symbolizes the sacredness of the Eucharist
- Plants in foreground have medicinal value and symbolic associations

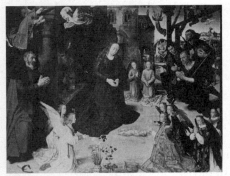

Figure 15.11: Hugo van der Goes, central panel of *The Portinari Altarpiece*, c. 1476, tempera and oil on wood, Uffizi, Florence

- Continuous landscape throughout the three panels
- Figures at different scales, some very large, some much smaller

Martin Schongauer, *Saint Anthony Tormented by Demons*, c. 1480–1490, engraving (Figure 15.12)

- Saint Anthony, a fourth-century saint, was a hermit who spent most of his life in solitude. When he was about twenty he went into the wilderness to spend

time in prayer, to study, and to do manual labor. There he underwent violent temptations, both spiritual and physical, but overcame them.

- Horrifying demons and spirits of all types beset Saint Anthony, torturing him almost beyond endurance
- Precise details; tight, vibrant forms; thin emaciated figures

CHARACTERISTICS OF EARLY NORTHERN RENAISSANCE SCULPTURE

Northern European sculpture continues the Gothic progression of having figures move away from the surrounding wall, although complete independence is not achieved as quickly as it is in Italy. However, classicizing drapery and nascent contrapposto emerges in the works of **Claus Sluter**.

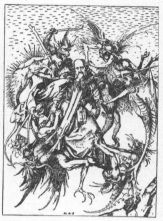

Figure 15.12: Martin Schongauer, *Saint Anthony Tormented by Demons*, c. 1480–1490, engraving, Metropolitan Museum of Art, New York

Major Work of Fifteenth-Century Sculpture in Northern Europe

Claus Sluter, *The Well of Moses***, 1395–1406, limestone, Dijon, France (Figure 15.13)**

- Large sculptural fountain with a Crucifixion (now destroyed) located over the well
- Six Old Testament figures surround the well
- Water symbolically represents the blood of Christ washing over and cleansing the figures around the well
- The well supplied water for a royally established monastery
- Drapery cascades in solid, heavy waves down the figures
- Rounded solid volumes
- Moses holds a copy of his writings; holds the position as intermediary between God and his people

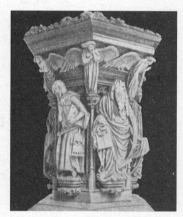

Figure 15.13: Claus Sluter, *The Well of Moses*, 1395–1406, limestone, Dijon, France

VOCABULARY

Altarpiece: a painted or sculpted panel set on an altar of a church (Figure 15.6)

Book of Hours: a book of prayers to be said at different times of day, days of the year (Figure 15.3)

Donor: a patron of a work of art, who is often seen in that work (Figure 15.4 left panel)

Engraving: a printmaking process in which a tool called a **burin** is used to carve into a metal plate, causing impressions to be made in the surface. Ink is passed into the crevices of the plate and paper is applied. The result is a print with remarkable details and finely shaded contours (Figure 15.12)

Etching: a printmaking process in which a metal plate is covered with a ground made of wax. The artist uses a tool to cut into the wax to leave the plate exposed. The plate is then submerged into an acid bath, which eats away at the exposed portions of the plate. The plate is removed from the acid, cleaned, and ink is filled into the crevices caused by the acid. Paper is applied and an impression is made. Etching produces the finest detail of the three types of early prints

Grisaille: (pronounced "gri-zahy") a painting done in neutral shades of gray to simulate the look of sculpture

Polyptych: a many-paneled altarpiece

Triptych: a three-paneled painting or sculpture (Figure 15.4)

Woodcut: a printmaking process by which a wooden tablet is carved into with a tool, leaving the design raised and the background cut away (very much as how a rubber stamp looks). Ink is rolled onto the raised portions, and an impression is made when paper is applied to the surface. Woodcuts have strong angular surfaces with sharply delineated lines.

Summary

Northern European art from the fifteenth century is dominated by monumental altarpieces prominently erected in great cathedrals. Flemish artists delight in symbolically rich compositions that evoke a visually enticing experience along with a religiously sincere and intellectually challenging interpretation. Flemish emphasis on minute details does not minimize the total effect. The introduction of oil paint provides a new luminous glow to Northern European works.

The invention of movable type brought about a revolution in the art world. Instead of producing individual items, artists could now make multiple images whose portability and affordability would ensure their widespread fame.

Practice Exercises

Questions 1–5 refer to Figure 15.14.

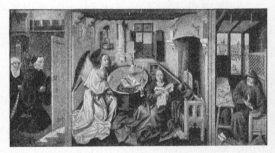

Figure 15.14

1. This work dates from

 (A) 1225
 (B) 1325
 (C) 1425
 (D) 1525

2. The work is

 (A) a manuscript illumination
 (B) a fresco in a city hall
 (C) an oil painting for private devotion
 (D) a tapestry for a chateau

3. Unlike Italian Renaissance painting, this Northern European work

 (A) has wings that fold closed over the main scene
 (B) has perspective used in both the central panel and the wings
 (C) is painted on vellum
 (D) is one continuous scene

4. The people kneeling on the left are

 (A) saints come to worship
 (B) the artist and his family
 (C) Biblical figures in contemporary dress
 (D) donors of the painting

5. This painting represents a humanization of Biblical subjects by having

 (A) the angel appear with multicolored wings
 (B) Mary sit on the floor
 (C) Joseph appear on the right, outside the main scene
 (D) the scene take place in a contemporary interior

6. An example of an artist(s) associated with the International Gothic style of painting would be

 (A) Hugo van der Goes
 (B) the Limbourg Brothers
 (C) Martin Schongauer
 (D) Rogier van der Weyden

7. An example of a polyptych would be

 (A) *The Ghent Altarpiece*
 (B) *The Very Rich Hours of the Duke of Berry*
 (C) *The Well of Moses*
 (D) *Saint Anthony Tormented by Demons*

8. A characteristic of oil paint is that it

 (A) is quick drying
 (B) is unable to be changed once painted
 (C) produces a shiny enamel-like surface
 (D) easily adapts to wall painting

Questions 9 refers to Figure 15.15.

9. This work was painted by

 (A) Jan van Eyck
 (B) Robert Campin
 (C) the Limbourg Brothers
 (D) Martin Schongauer

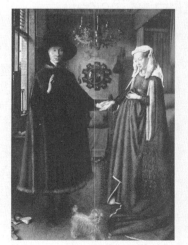

Figure 15.15

10. A painting done in grisaille looks

 (A) mass produced
 (B) like sculpture
 (C) open and airy
 (D) humanized

CHALLENGE | ## Short Essay

Critic Robert Hughes has said about Jan van Eyck,

> "Thus each object, each face and body in Jan van Eyck's work is spiritualized by its almost total detail: his scrutiny goes beyond the concrete and waits for our symbolic imagination to catch up with it. The objects themselves are charged with symbolism; Jan van Eyck's attitude to nature was medieval in that he seems to have regarded each created thing as a symbol of the workings of God's mind, and the universe as immense structure of metaphors."

Robert Hughes, *The Complete Paintings of The Van Eycks*, Harry Abrams: New York, 1968, p. 6.

Defend or reject Hughes's assertion by referring to at least one painting by van Eyck. Use one side of a sheet of lined paper to write your essay.

Answer Key

1. (**C**)	3. (**A**)	5. (**D**)	7. (**A**)	9. (**A**)
2. (**C**)	4. (**D**)	6. (**B**)	8. (**C**)	10. (**B**)

Answers Explained

Multiple-Choice

1. (**C**) *The Mérode Triptych* is from 1425.

2. (**C**) Like most Northern Renaissance paintings, this work is done in oil. It was meant for private devotion.

3. (**A**) Northern European altarpieces have wings that fold over the main scene.

4. (**D**) Generally, kneeling figures are donors in Renaissance paintings.

5. (**D**) Humanization of Renaissance themes includes placing Biblical subjects in contemporary settings.

6. (**B**) The Limbourg Brothers painted in the International Gothic style.

7. (**A**) *The Ghent Altarpiece* has many panels, therefore is a polyptych.

8. **(C)** Oil paintings have a high polished finish that is shiny and enamel-like.

9. **(A)** This painting is by Jan van Eyck; it is one of his signed works.

10. **(B)** Grisaille paintings look like sculpture.

Rubric for Short Essay
4: The student correctly identifies at least one painting by van Eyck and connects it appropriately with the quotation by Robert Hughes. At least three substantial examples of symbolism in van Eyck's painting are discussed. Discussion is full and without major errors.
3: The student correctly identifies at least one painting by van Eyck and connects it appropriately to the quotation. At least two substantial examples of symbolism in van Eyck's painting are discussed. Discussion may be less full, and may contain minor errors.
2: The student does not correctly identify a painting by van Eyck, although he or she chooses another work of Northern Renaissance art. At least two substantial examples of symbolism are explored, OR the student identifies a work by van Eyck but has a very limited discussion. There may be major errors.
1: The student does not correctly identify a painting by van Eyck, although another work of Northern Renaissance art is chosen, and at least one substantial example of symbolism is explored, OR the student identifies a work by van Eyck but has no discussion of merit. There may be major errors.
0: The student makes an attempt, but the response is without merit.

Short Essay Model Response

The works of Jan van Eyck are "charged with symbolism" as the critic Robert Hughes states in *The Complete Paintings of the van Eycks*. Such symbolism is shown in the paintings the *Ghent Altarpiece* and *Arnolfini Wedding*. In the *Ghent Altarpiece*, God is shown at the top of the open view, between Saint John the Baptist and the Virgin Mary. At the ends of either side of the open view are Adam and Eve, who cover their genitals with their hands, to symbolize how once they were kicked out of the Garden of Eden, they could no longer be uninhibited and realize their nakedness. At the bottom in the center of the altarpiece, a lamb is sacrificed, with its heart bleeding into a chalice. This symbolizes the crucifixion of Christ. On the outside of the altarpiece, in which the subjects are away from God, it is much darker than where the subjects are closer to him, which symbolizes how

closeness to God offers peace and light. The entire altarpiece symbolizes the salvation that can be found from God and Christ, as every piece of the altarpiece is shown to be a "symbol of the workings of God's mind," as Hughes stated.

Van Eyck's painting <u>Arnolfini Wedding</u> is charged with symbolism as well. The symbolism in this painting is centered around the theme of the sanctity of matrimony. The placement of the little dog in the painting symbolizes fidelity, a key element of marriage. Also in the painting, the bride holds her long dress around her stomach, almost giving the impression that she is pregnant. This serves as a symbol of fertility. Behind the bride, the curtains of the bed are pulled back, which symbolizes the marriage bed. Above the bed is a statue of Saint Margaret, the patron saint of childbirth, which further adds to the symbolism of fertility and children that accompany a marriage. Finally, the placement of a broom in the room in the painting symbolizes domesticity. All of these little details that account for so much symbolism explain how everything in van Eyck's work was done to symbolize the "workings of God's mind," as pointed out by Robert Hughes.

—Katherine S.

Analysis of Model Response

Katherine selects two van Eyck paintings—the minimum requirement is one. Her discussion of the *Ghent Altarpiece* and the *Arnolfini Wedding* proves that she has a firm understanding of these works, and is able to apply Robert Hughes's quotation directly to the paintings. She particularly emphasizes Hughes's apt phrase that each painting symbolizes the "workings of God's mind" when discussing van Eyck's approach to his subject. **This essay merits a 4.**

Early Renaissance in Italy: Fifteenth Century

TIME PERIOD: 1400–1500

The early Renaissance takes place in the courts of Italian city-states: Ferrara, Florence, Mantua, Naples, Rome, Venice, and so on.

KEY IDEAS

- The revitalization of classical ideals in literature, history, and philosophy had its impact on the fine arts.
- Renaissance courts were influenced by the spirit of humanism, which stressed the secular alongside the religious.
- Artists created realistic three-dimensional paintings based on the newly rationalized theories on linear perspective.
- Italian Renaissance sculpture is marked by a greater understanding of human anatomy; there is a revival of large-scale nude works.
- Architecture emphasizes open light spaces in a balanced and symmetrical environment.

HISTORICAL BACKGROUND

Italian city–states were controlled by ruling families who dominated politics throughout the fifteenth century. These princes were lavish spenders on the arts, and great connoisseurs of cutting-edge movements in painting and sculpture. Indeed, they embellished their palaces with the latest innovative paintings by artists such as **Uccello** and **Botticelli**. They commissioned architectural works from the most pioneering architects of the day. Competition among families and city–states encouraged a competition in the arts, each state and family seeking to outdo the other.

Princely courts gradually turned their attention away from religious subjects to more secular concerns, in a spirit today defined as **humanism**. It became acceptable, in fact encouraged, to explore Italy's pagan past as a way of shedding light on contemporary life. The exploration of new worlds, epitomized by the great European explorers, was mirrored in a new growth and appreciation of the sciences, as well as the arts.

Patronage and Artistic Life

It was customary for great families to have a private chapel in the local church dedicated to their use. Artists would often be asked to paint murals in these chapels to enhance the spirituality of the location. Thus, many paintings of this period are identified by the patron's chapels: Masaccio painted *Tribute Money* (Figure 16.10) and *Expulsion from the Garden of Eden* (Figure 16.11) on the walls of the Brancacci Chapel in Santa Maria del Carmine in Florence in 1425, and Ghirlandaio painted the *Birth of the Virgin* (Figure 16.21) in the Tornabuoni Chapel of Santa Maria Novella, also in Florence in 1485. The influence of the patrons can be seen in a number of ways, including such things as specifying the amount of gold lavished on an altarpiece or which family members the artist was required to prominently place in the foreground of the painting. In the Ghirlandaio work, members of the Tornabuoni family are noticeably featured, even placed more conspicuously than the holy figures on the right who are supposedly the focus of the work. In Nanni di Banco's *Four Crowned Saints* of 1409 (Figure 16.27) the artist places a tribute to his patrons, the guild of sculptors, in the relief panel below the main figures.

INNOVATIONS OF EARLY RENAISSANCE ARCHITECTURE

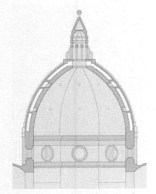

Figure 16.1: Diagram of the dome of Florence Cathedral showing two domes, an interior that supports the structure, and an exterior that achieves a soaring silhouette.

The great technological achievement of the age is expressed in the building of the dome for Florence Cathedral. When the building was originally conceived in the Gothic era, a future dome was planned at between 135 and 140 feet across. It did not seem to bother anyone that this type of dome would require an engineering prowess that did not currently exist. In order to finally complete the project, which had languished for a hundred years, a dome was designed by **Brunelleschi** using an entirely innovative technique, achieving very different results from prior dome designs. The low, flat hemispherical domes of the Romans or the Byzantines had the authority of the ancients associated with them, but they lacked the vertical thrust to dominate a city skyline. In response, Brunelleschi designed an ogival arch that soars into the sky. To complete the structure, Brunelleschi invented a technique of erecting two domes (Figure 16.1), one within the other, to maximize strength and stability. The exterior dome is a light shell that provides a graceful silhouette over the city. The interior dome does the work of supporting the exterior dome. A **lantern** is positioned atop the building to anchor the two domes in place.

Characteristics of Fifteenth-Century Italian Architecture

Renaissance architecture depends on order, clarity, and light. The darkness and mystery, indeed the sacred sense of Gothic cathedrals, was deemed barbaric. In its place were created buildings with wide window spaces, limited stained glass, and vivid wall paintings.

Although all buildings need mathematics to sustain the engineering principals inherent in their design, Renaissance buildings seem to stress geometric designs more demonstrably than most. Harmonies were achieved by a system of ideal proportions learned from an architectural treatise by the Roman Vitruvius. The ratios and proportions of various elements of the interior of Florentine Renaissance churches were interpreted as expressions of humanistic ideals. The Early Christian past was recalled in the use of unvaulted naves with coffered ceilings.

Thus, the crossing is twice the size of the nave bays, the nave twice the width of the side aisles, and the side aisles twice the size of side chapels. Arches and columns take up two-thirds of the height of the nave, and so on. This logical expression is often strongly delineated by the floor patterns in the nave, in which white and grey marble lines demarcate the spaces, as at Brunelleschi's **San Lorenzo** (Figure 16.3).

Florentine palaces, such as Michelozzo's **Palazzo Medici-Riccardi** (Figure 16.5), have austere dominating façades that rise three stories from street level. Usually the first floor is reserved as public areas; business is regularly transacted here. These floors are heavily **rusticated** or more fervently articulated. The second floor rises in lightness, with a strong stringcourse marking the ceiling of one story and the floor of another. Here is where the family gathered in their private quarters. The third floor expresses even greater lightness with less articulation of the stone. A heavy cornice caps off the roof, in the style of a number of Roman temples.

Major Works of Fifteenth-Century Italian Architecture

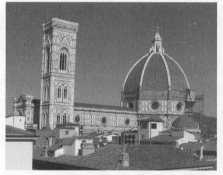

Figure 16.2: Filippo Brunelleschi, dome of Florence Cathedral, 1420–1436, Florence

Filippo Brunelleschi, dome of Florence Cathedral, 1420–1436, Florencre (Figure 16.2)

- Raised on a drum to increase height, meant to be experienced from the inside and the outside
- Built without centering devices, an architectural accomplishment of the time
- Double dome of two shells, a light exterior shell and a heavier interior dome; walkway circling between domes enables interior to be maintained from within the structure
- Surmounted by the lantern which anchors the ribs of the dome in place

Filippo Brunelleschi, San Lorenzo, 1421–1469, Florence (Figure 16.3)

Figure 16.3: Filippo Brunelleschi, San Lorenzo, 1421–1469, Florence

- Early Christian-type wooden ceiling
- Rectangular floor grids define the spaces: main aisle twice the width of the side aisles, which are twice the width of the side chapels
- Cool, harmonious interior with spare decorative touches
- Feeling is light, airy; minimal stained glass

Filippo Brunelleschi, Pazzi Chapel, designed 1423, built 1442–1465, Florence, Italy (Figure 16.4)

- Rectangular chapel attached to the church of Santa Croce, Florence
- Two barrel vaults on the interior, small dome over crossing
- Interior has a restrained sense of color, muted tones, punctuated by glazed terra-cotta tiles

Figure 16.4: Filippo Brunelleschi, Pazzi Chapel, 1442–1465, Florence

Michelozzo, Palazzo Medici-Riccardi, 1444, Florence (Figure 16.5)

- Rusticated ground floor; second floor strongly articulated blocks; third floor smooth surface—building seems to get lighter as it goes up
- Roman arches at bottom used as entries to shops and businesses
- Strong cornice placed on top
- Interior courtyard allows light and air into the interior rooms of the palace
- Built to express the civic pride and political power of the Medici family; rusticated bottom floor expressed fortitude of Medici family
- Symmetrical plan

Figure 16.5: Michelozzo, Palazzo Medici-Riccardi, 1444, Florence

Leon Battista Alberti, Palazzo Rucellai, 1452–1470, Florence (Figure 16.6)

- Three horizontal floors separated by a strongly articulated stringcourse
- Pilasters rise vertically and divide the spaces into squarish shapes
- Strong cornice caps the building
- Rejects rustication of Michelozzo, instead used beveled masonry joints
- First floor pilasters are Tuscan (derived from Doric); second are Alberti's own invention (derived from Ionic); third are Corinthian
- Friezes contain Rucellai family symbols: billowing sails

Figure 16.6: Leon Battista Alberti, Palazzo Rucellai, 1452–1470, Florence

Leon Battista Alberti, Sant' Andrea, 1470, Mantua, Italy (Figure 16.7)

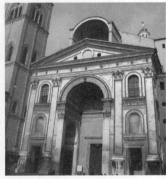

- Combination of a Roman triumphal arch and an ancient temple façade
- Giant pilasters flank arch and support pediment
- First Roman triumphal arch in Christian architecture
- Size of façade dictated by the small scale of piazza in front of the church, and Alberti's desire to have identical proportions of width and height on the façade
- Large barrel vault canopy hangs above the west façade and shields the west window of the nave from sunlight
- Interior possesses great barrel vault with no side aisles; coffered ceiling reminiscent of Pantheon and Early Christian churches

Figure16.7: Leon Battista Alberti, Sant'Andrea, 1470, Mantua, Italy

INNOVATIONS IN FIFTEENTH-CENTURY ITALIAN PAINTING AND SCULPTURE

The most characteristic development of Italian Renaissance painting is the use of linear perspective, a technique some scholars say was known to the Romans. Other scholars have attributed its revitalization, if not invention, to **Filippo Brunelleschi**, who developed perspective while drawing the Florence Cathedral Baptistery in the early fifteenth century. Some artists, like **Uccello**, were fascinated with perspective, showing objects and people in proportion with one another, unlike medieval art which has people dominating compositions. Artists who were trained prior to this tradition, like **Ghiberti**, were quick to see the advantages to linear perspective and incorporated it into their later works. Others, like **Masaccio**, seem to be trained with it from the beginning.

Later in the century, perspective becomes an instrument that some artists would use, or exploit, to create different artistic effects. The use of perspective to intentionally fool the eye, the **tromp l'oeil technique**, is an outgrowth of the ability of later fifteenth-century painters like **Mantegna** to employ it as one tool in an arsenal of techniques.

Perspective also affects the history of sculpture. Relief castings and carvings, with their flat planes, are incised to varying depths to create a sense of space, as in the panels in the *Gates of Paradise* (Figure 16.25).

Characteristics of Early Renaissance Painting

In the early part of the fifteenth century, religious paintings dominated, but by the end of the century, portraits and mythological scenes proliferated, reflecting humanist ideals and aspirations.

The willingness to explore the nude, particularly the male nude, increased during the century, so **Masaccio's** two nude figures from the *Expulsion from the Garden of Eden* (Figure 16.11), which seemed daring in 1425, become even more realistic, leading to those of the complicated allegorical paintings of **Signorelli** by the end of the century. Similarly, the use of perspective, approximated by the International Gothic painters like **Gentile da Fabriano**, became mathematically consistent in the works of **Masaccio** and **Perugino**.

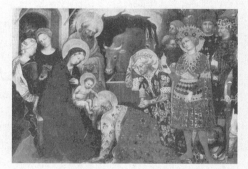

Figure 16.8: Gentile da Fabriano, detail of the *Adoration of the Magi*, 1423, tempera on panel, Uffizi, Florence

Major Works of Fifteenth-Century Italian Painting

Gentile da Fabriano, detail of the *Adoration of the Magi*, 1423, tempera on panel, Uffizi, Florence (Figure 16.8)

- International Gothic-style painting
- Fancifully dressed figures in a courtly outing to see the Christ child at the Epiphany—reflects the wealth of the patrons, the Strozzi family
- Exotic animals reflect the private menageries of Renaissance princes
- Gold leaf used on frame and on elements of the painting itself
- Kings are of various ages symbolizing the Three Ages of Man
- High horizon line filled with activity
- Naturalism seen in the various animals viewed from many angles

Masaccio, *Holy Trinity*, c. 1427, fresco, Santa Maria Novella, Florence (Figure 16.9)

- Created for the Lenzi family as a tombstone
- Triangular figural composition dominated by Brunelleschi-inspired architecture
- Christ appears in the dual role as the Crucified Christ and as the second person of the Trinity—God the Father supports him, the dove of the Holy Spirit is between the two
- Mary and Saint John flank Christ; these are the two traditional figures in crucifixion scenes

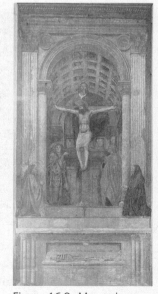

Figure 16.9: Masaccio, *Holy Trinity*, 1427, fresco, Santa Maria Novella, Florence

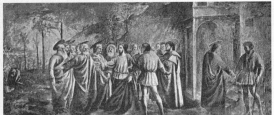

Figure 16.10: Masaccio, *Tribute Money*, 1425, fresco, Santa Maria del Carmine, Florence

- Patrons kneel outside the arch
- Realism of faces
- Vanishing point at the foot of the cross
- Skeleton below painting symbolizes death; inscription reads "I once was what you are; and what I am you will become."

Masaccio, *Tribute Money*, 1425, fresco, Santa Maria del Carmine, Florence (Figure 16.10)

- Illustrates a moment from the New Testament, Matthew 17: 24–27, when Jesus is asked if he should pay tribute to the civil authorities, the tax collectors; Jesus tells Peter that he should hook a fish from the sea and remove a coin from its mouth—this will more than pay the tax collectors
- Continuous narrative: at left Peter gets the money from the fish, at center Jesus confronts the brutish-looking tax collector, at right Peter pays the tax collector; narrative moves from center to left scene to the right scene
- Probably related to the contemporary debate over taxation to support a war against Milan
- Landscape contains elements of atmospheric perspective
- Monumentality of figures; figures cast shadows

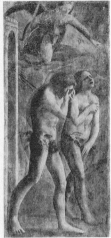

Figure 16.11: Masaccio, *Expulsion from the Garden of Eden*, 1425, fresco, Santa Maria del Carmine, Florence

Masaccio, *Expulsion from the Garden of Eden*, 1425, fresco, Santa Maria del Carmine, Florence (Figure 16.11)

- Bold use of nude forms
- Intense expressions; Adam hides his face in shame; Eve hides her body in shame
- Bleak background represents the desolation outside the Garden of Eden
- Angel is foreshortened

Paolo Uccello, *Battle of San Romano*, c. 1455, tempera on wood, National Gallery, London (Figure 16.12)

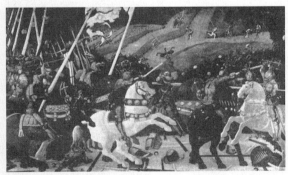

Figure 16.12: Paolo Uccello, *Battle of San Romano*, c. 1455, tempera on wood, National Gallery, London

- Depicts the battle between Florence and Siena in 1432
- One of three paintings placed in Lorenzo de' Medici's bedchamber
- Niccolò da Tolentino in center on white horse leads the charge
- Strong use of orthogonals in the figures of men and armaments lying on the ground; great interest in vanishing points
- More of a ceremonial scene than a battle scene; horses look like toys

Fra Angelico, *Annunciation*, 1438–1447, fresco, Museum of San Marco, Florence (Figure 16.13)

- Painted at the top of the stairs of the dormitory entrance; architecture of painting reflects the architecture of the monastary

- Humility of figures; serenely religious; solid Giotto-like quality
- Smoothly modeled figures of extreme delicacy
- Empty spare scene equivalent to the monastic cells; one of several scenes in the monastery
- Foliated capitals
- Brunelleschi-like arches

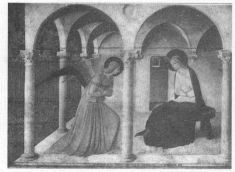

Figure 16.13: Fra Angelico, *Annunciation*, 1438–1447, fresco, Museum of San Marco, Florence

Andrea del Castagno, *The Last Supper*, 1447, fresco, Sant'Apollonia, Florence (Figure 16.14)

- Painted for cloistered nuns in a convent
- Placed in a dining hall; a religious scene of eating complements the activity in the room; red brick tiles on the floor complement the tiles in the convent
- Figures are individualized; precise edging; uniform sharp focus; little communication among figures
- Judas on our side of the table, apart from the others to symbolize his (and our) guilt; he is even eating before Christ has blessed the food; animated marble pattern of rear wall simulating lightning point to Judas's head
- Unusual spatial arrangement of room: six marble panels on left and back walls, four panels and two windows on right, implying that the room is a square, although it doesn't appear this way; twelve loops on the stringcourse on the back wall, only six on each side implying that the room is 2:1.

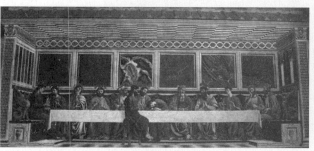

Figure 16.14: Andrea del Castagno, *Last Supper*, 1447, fresco. Sant'Apollonia, Florence

Figure 16.15: Antonio del Pollaiuolo, *Battle of Ten Naked Men*, 1465–1470, engraving, Private Collection

Antonio del Pollaiuolo, *Battle of Ten Naked Men*, 1465–1470, engraving (Figure 16.15)

- Unknown subject matter; may have been done as a study of the nude in action
- Dense vegetative forms push figures forward
- Imprecise anatomy, but expressive of flexed muscles and active poses
- Many figures seem to be in mirrored poses

Piero della Francesca, *Resurrection*, c. 1463, fresco, Palazzo Comunale, San Sepolcro, Italy (Figure 16.16)

- Pale colors, flat background
- Man as the center, the height of any drama
- Geometric shapes inspired by Uccello's work
- Christ as an enormous figure who conquers all; holds a labarum, which is the standard of victory over death
- Christ is either stepping out of his sarcophagus or has his foot on its lid

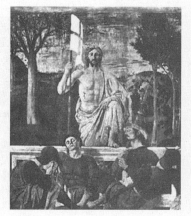

Figure 16.16: Piero della Francesca, *Resurrection*, c. 1463, fresco, Palazzo Comunale, San Sepolcro, Italy

- Moralized landscape: possible interpretation: at left is a large and bare area with trees that are strong and mature, the road uphill in life is difficult and steep, but ultimately rewarding; at right is the easy, beguiling way, a path leading to a country pleasure villa
- Landscape could also symbolize death and new life, live tree/dead tree contrast spoken by Christ himself: Tree of Knowledge vs. Tree of Life
- Painting's subject is the name of the town and so the location is in a city hall, not a church

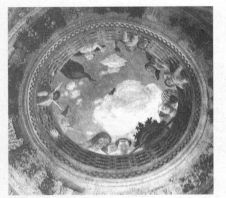

Figure 16.17: Andrea Mantegna, *Room of the Newlyweds*, 1465–1474, ceiling fresco, Ducal Palace, Mantua

Andrea Mantegna, *Room of the Newlyweds*, 1465–1474, fresco, Ducal Palace, Mantua (Figure 16.17)

- Painted in a room that was used as a bedroom and a reception room
- Room is a cube in shape, "domed" with an illusionistically painted central panel
- Oculus contains two groups of women leaning over a balustrade around an opening to the sky, many looking down at viewer
- Unsettling imagery in the bird posed overhead, the flower pot only supported by the round wooden stick
- Dramatically foreshortened angels seen from the front and back, resting their feet on the painted ledges

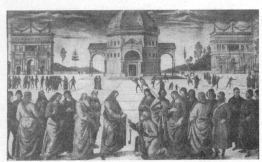

Figure 16.18: Pietro Perugino, *Christ Delivering the Keys of the Kingdom to Saint Peter*, 1482, fresco, Sistine Chapel, Rome

Pietro Perugino, *Christ Delivering the Keys of the Kingdom to Saint Peter*, 1482, fresco, Sistine Chapel, Rome (Figure 16.18)

- Christ delivers the keys of his earthly kingdom to Saint Peter, a theme treasured by the popes, who saw themselves as descendants of Saint Peter
- Left background: tribute money
- Right background: stoning of Christ
- Models of the Arch of Constantine in the background; central basilica seems to reflect Brunelleschi and Alberti ideas on architecture
- One-point perspective, vast piazza
- Open space provides dramatic emphasis on the keys
- Figures stand in a contrapposto, with heads tilted and knees bent
- Many contemporary faces in the crowd

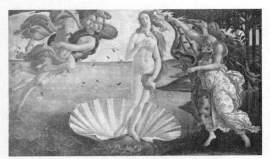

Figure 16.19: Sandro Botticelli, *Birth of Venus*, 1485, tempera on canvas, Uffizi, Florence

Sandro Botticelli, *Birth of Venus*, 1485, tempera on canvas, Uffizi, Florence (Figure 16.19)

- Venus emerges fully grown from the foam of the sea; faraway look in her eyes
- Roses scattered before her; roses created at the same time as Venus, symbolizing that love can be painful
- Left: zephyr (west wind) and chloris (nymph)

- Right: handmaiden rushes to clothe her
- Figures float, not anchored to the ground
- Crisply drawn figures; pale colors
- Landscape flat and unrealistic, simple V-shaped waves
- A Medici commission

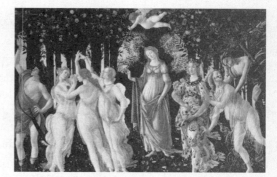

Figure 16.20: Sandro Botticelli, *Spring*, c. 1482, tempera on wood, Uffizi, Florence

Sandro Botticelli, *Spring*, c. 1482, tempera on wood, Uffizi, Florence (Figure 16.20)

- Narrow stage setting for figures arranged close to the picture plane
- Perhaps executed to celebrate a Medici wedding, which would account for the fertility symbols: the fruit, the flowers, spring, and Venus and Cupid
- At left: Mercury holding a caduceus up to the air to dispel storm clouds
- Next: the three Graces dance together. They are the embodiment of the beauty Venus creates. Virginity expressed in their loose long hair
- In center: Venus, the goddess of love as well as marriage, wearing a bridal wreath on her head with Cupid her son above her. He aims his bow and arrow at the three Graces
- At right: a Zephyr reaches for the nymph Chloris, who transforms into the richly garbed Flora, goddess of Spring
- Large orange balls may refer to the Medici coat-of-arms

Domenico Ghirlandaio, *Birth of the Virgin*, 1485–1490, fresco, Santa Maria Novella, Florence (Figure 16.21)

- Religious scene set in a Florentine home
- Saint Anne reclines at right in her palace room decorated with intarsia and sculpture
- Midwives to St. Anne following Mary's birth
- Daughter of patron, Giovanni Tornabuoni, shown in the center, a position she must have had in Florentine society
- Upper left corner: story of Mary's parents, Joachim and Anna, meeting

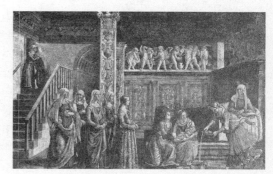

Figure 16.21: Domenico Ghirlandaio, *Birth of the Virgin*, 1485–1490, fresco, Santa Maria Novella, Florence

Luca Signorelli, *Damned Cast into Hell*, 1499–1504, fresco, Orvieto Cathedral, Orvieto, Italy (Figure 16.22)

- Struggling nudes in one of a colossal series of frescoed compositions articulating the end of the world, a common theme close to the end of the fifteenth century
- The murals executed to counter ideas proclaimed by a heretical sect of Christians who questioned the existence of purgatory and a distinct place called heaven and a distinct place called hell
- Heaven is guarded by armored angels in upper right; devils carry off the damned

Figure 16.22: Luca Signorelli, *Damned Cast into Hell*, 1499–1504, fresco, Orvieto Cathedral, Orvieto, Italy

- Bizarre and lurid coloration of devils symbolizes their evil
- Impenetrable mass of human bodies in a confused tangle of torment
- Many figures die by strangulation
- Largest Renaissance treatment of human nudes to date

Characteristics of Fifteenth-Century Italian Sculpture

Interest in humanism and the rebirth of Greco–Roman classics also spurs an interest in authentic Greek and Roman sculptures. The ancients gloried in the nude form in a way that was interpreted by medieval artists as pagan. The revival of nudity in life-size sculpture is begun in Florence with **Donatello's *David*** (Figure 16.28), and continued throughout the century.

Nudity is one manifestation of an increased study of human anatomy. Drawings of people with heroic bodies are sketched in the nude and transferred into stone and bronze. Some artists, like **Pollaiuolo**, show the intense physical interaction of forms in the twisting gestures and straining muscles of their works.

Figure 16.23: Lorenzo Ghiberti, *Sacrifice of Isaac*, 1401–1403, gilt bronze, National Museum, Bargello, Florence

Major Works of Fifteenth-Century Italian Sculpture

Works for Florence Cathedral Baptistery

Lorenzo Ghiberti, *Sacrifice of Isaac*, 1401–1403, gilt bronze, National Museum, Bargello, Florence (Figure 16.23)

- Executed, with Brunelleschi's *Sacrifice of Isaac*, as part of a competition to do a set of bronze doors for Florence Cathedral Baptistery; Ghiberti's is the winning panel design
- God asks Abraham to prove his love by sacrificing his son; Abraham is about to comply when an angel reveals this is only a test and a ram should be sacrificed instead
- Gothic quatrefoil pattern; matches panels of another set of Gothic doors already on Florence Baptistery
- Influence of the International Gothic style in the gracefulness of gestures and the Gothic sway to the body of Abraham—more in the Sienese style, may have looked more original to the competition judges
- Figures separated, greater clarity of vision
- Figure of Isaac a quotation from ancient sources

Figure 16.24: Filippo Brunelleschi, *Sacrifice of Isaac*, 1401–1403, bronze, National Museum, Bargello, Florence

Filippo Brunelleschi, *Sacrifice of Isaac*, 1401–1403, bronze, National Museum, Bargello, Florence (Figure 16.24)

- One dense group, great drama between the masses
- Figures of weight and substance; dramatic tension and rigor
- Immediacy of the action; angel makes it just in time
- Figures spill out over the borders of the quatrefoil

Lorenzo Ghiberti, *Gates of Paradise*, 1425–1452, gilt bronze, now in the Museum of Cathedral Works, Florence (Figures 16.25 and 16.26)

- Commision awarded to Ghiberti after the success of the second set of Baptistery doors
- Spatially more sophisticated than panels of his previous set of doors; figures have a more convincing volume
- Lean, elegant, elongated bodies
- Delicate lines
- Linear perspective used throughout

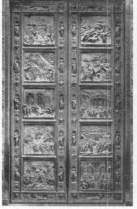

Figure 16.25: Lorenzo Ghiberti, *Gates of Paradise*, 1425–1452, gilt bronze, now in the Museum of Cathedral Works, Florence

Figure 16.26: Detail of *Gates of Paradise: Isaac with Jacob and Esau*, 1425–1452, gilt bronze, now in the Museum of Cathedral Works, Florence

Nanni di Banco, *Four Crowned Saints*, 1409–1416/7, marble, Or San Michele, Florence (Figure 16.27)

- Built for the guild of wood and stone carvers, of which Nanni was a member
- Depicts four Christian sculptors who refused to carve a statue of a pagan god for the Roman Emperor Diocletian and were martyred
- Saints wear Roman togas; heads are influenced by portraits of Roman emperors
- Saints seem to be discussing their fate; feet placed outside of arch, stepping into our space
- Pedestal carved in an arc following the positioning of the saints
- Figures are independent of the niche in which they stand
- Bottom scene contains a view of sculptors at work on their craft

Figure 16.27: Nanni di Banco, *Four Crowned Saints*, 1409–1416/7, marble, Or San Michele, Florence

Figure 16.28: Donatello, *David*, 1420s–1460s, bronze, National Museum, Bargello, Florence

Donatello, *David*, 1420s–1460s, bronze, National Museum, Bargello, Florence (Figure 16.28)

- First large bronze nude since antiquity
- Exaggerated contrapposto of the body
- Life-size work probably meant to be housed in the Medici Palace, not for public viewing
- Androgynous figure
- Stance: nonchalance, contemplating the victory over Goliath—Goliath's head at David's feet; David's head is lowered to suggest humility
- Laurel on hat indicates David was a poet; hat a foppish Renaissance design

Donatello, *Mary Magdalene*, c. 1430–1450, wood, Museum of Cathedral Works, Florence (Figure 16.29)

- Hair: covers her body, she wiped Christ's feet with her hair
- Gilded hair indicates her spirituality, and her former beauty

Figure 16.29: Donatello, *Mary Magdalene*, c. 1430–1450, wood, Museum of Cathedral Works, Florence

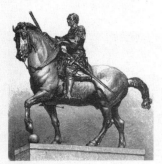

Figure 16.30: Donatello, *Gattamelata*, 1445–1450, bronze, Padua, Italy

- Emaciated from thirty years of penitence
- Face shows the torture of badly led life; ravages of time on her body
- Gesture of prayer expresses a world of spirituality
- Eyes focused on an inner reality and a higher form of beauty

Donatello, *Gattamelata*, 1445–1450, bronze, Padua, Italy (Figure 16.30)

- Nickname for warrior, "Honeyed Cat"
- Commemorative monument for a cemetery
- Face reflects stern expression of a military commander, cf. *Marcus Aurelius* (Figure 7.36)
- Horse is spirited, resting one leg on a ball; rider is in control

Luca della Robbia, *Madonna and Child*, 1455–1460, terra-cotta, Or San Michele, Florence (Figure 16.31)

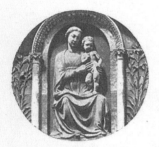

Figure 16.31: Luca della Robbia, *Madonna and Child*, 1455–1460, terra-cotta, Or San Michele, Florence

- White glazed terra-cotta of flesh areas simulates marble work
- Drapery consists of rich colored glazes on luminous ceramic forms
- Soft quality of the ceramic lends a gentility to the artistic expression
- Ceramic is an inexpensive medium that retains color and polish out of doors

Antonio del Pollaiuolo, *Hercules and Antaeus*, c. 1475, National Museum, Bargello, Florence (Figure 16.32)

- Ancient myth: Hercules must lift Antaeus off the ground to defeat him—Antaeus gets his strength from his mother, who is the earth goddess
- Active composition with limbs jutting out in various directions
- Strong angularity expressed
- Sinewy and strong figures

Andrea del Verrocchio, *Colleoni*, c. 1481–1496, bronze, Venice (Figure 16.33)

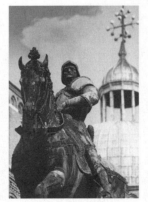

- Military leader fought for the Venetians
- Very powerful and spirited animal tamed by an animated and victorious leader
- Dramatically alive and forceful appearance with bulging, fiery eyes and erect position in saddle

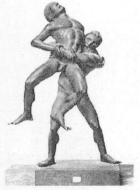

Figure 16.32: Antonio del Pollaiuolo, *Hercules and Antaeus*, c. 1475, National Museum, Bargello, Florence

Figure 16.33: Andrea del Verrocchio, *Colleoni*, c. 1481–1496, bronze, Venice

VOCABULARY

Bottega: the studio of an Italian artist

Humanism: an intellectual movement in the Renaissance that emphasized the secular alonside the religious. Humanists were greatly attracted to the achievements of the classical past, and stressed the study of classical literature, history, philosophy, and art

Lantern: a small structure with openings for light that crowns a dome (Figure 16.2)

Orthogonal: lines that appear to recede toward a vanishing point in a painting with linear perspective

Pilaster: a flattened column attached to a wall with a capital, a shaft, and a base (Figure 16.7)

Quattrocento: the 1400s, or fifteenth century, in Italian art

Rusticate: to deeply and roughly incise stones to give a rough and rustic texture to its appearance (Figure 16.5)

Stringcourse: a horizontal molding

Trompe l'oeil: (French, meaning "fools the eye") a form of painting that attempts to represent an object as existing in three dimensions, and therefore resembles the real thing (Figure 16.17)

Summary

Humanist courts of Renaissance Italy patronized artists who rendered both religious compositions and secular works. After 1450 it is common to see contemporary events, ancient mythology, or portraits of significant people take their place side by side with scenes of the Annunciation and Crucifixion.

Brunelleschi's discovery of one-point perspective revolutionized Italian painting. At first, artists like Masaccio faithfully used the formula in their compositions, creating realistic three-dimensional spaces on their surfaces. Later, painters like Castagno and Mantegna used perspective as a tool to manipulate the viewer's impression of a particular scene.

Sculptors competed with the glory of ancient artists by creating monumental figures and equestrian images, and revived antiquity's interest in nudity and correct human proportion.

Architecture was dominated by spatial harmony and light interiors that contrasted markedly with the mystical stained glass-filled Gothic buildings.

Practice Exercises

Questions 1 and 2 refer to Figure 16.34.

1. This painting depicts a scene from

 (A) The Old Testament
 (B) the New Testament
 (C) Greek mythology
 (D) a treatise by Vitruvius

Figure 16.34

2. This painting is by

 (A) Luca Signorelli
 (B) Domenico Ghirlandaio
 (C) Masaccio
 (D) Sandro Botticelli

Questions 3 and 4 refer to Figure 16.35.

3. This painting is an illustration of the painting technique called

 (A) a pilaster
 (B) tromp l'oeil
 (C) rustication
 (D) a lantern

Figure 16.35

4. This painting is placed

 (A) on a ceiling
 (B) on a wall
 (C) in a convent
 (D) in a dining hall

5. Ghiberti's *Gates of Paradise* was originally located on the doors of the

 (A) Florence Cathedral
 (B) Florence Baptistery
 (C) Pisa Cathedral
 (D) Palazzo Medici-Riccardi

6. Masaccio's *Expulsion from the Garden of Eden* and *Tribute Money* were placed in a private chapel owned by which of the following families?

 CHALLENGE

 (A) Medici
 (B) Brancacci
 (C) Lenzi
 (D) Tornabuoni

Questions 7–9 refer to Figure 16.36.

7. The scene in this painting depicts Christ handing keys to

 (A) Mary
 (B) David
 (C) Saint Peter
 (D) the Magi

Figure 16.36

8. These keys are significant because

 (A) they open the doors to the Sistine Chapel
 (B) they are symbolic of the relationship between people
 (C) they symbolize the pope's authority
 (D) few people owned keys, therefore making these most precious

9. The buildings on the extreme left and right are free copies of the

 (A) Arch of Titus
 (B) Ara Pacis
 (C) Parthenon
 (D) Arch of Constantine

10. Renaissance architecture can be characterized by

 (A) the use of Roman type domes
 (B) great sheets of stained glass windows
 (C) flying buttresses
 (D) open, light, and airy interiors

Short Essay

Identify the artist of Figure 16.37. Discuss how the innovations carried out in this work led to the development of Italian Renaissance painting. Use one side of a sheet of lined paper to write your essay.

Figure 16.37

Answer Key

1. **(C)**	3. **(B)**	5. **(B)**	7. **(C)**	9. **(D)**
2. **(D)**	4. **(A)**	6. **(B)**	8. **(C)**	10. **(D)**

Answers Explained

Multiple-Choice

1. **(C)** The subject of the painting, the birth of Venus, is an episode from Greek mythology.

2. **(D)** Sandro Botticelli is the painter.

3. **(B)** The technique is tromp l'oeil, in which the figures are represented as if in the actual spaces.

4. **(A)** This is a ceiling painting. The figures are looking down on those in the room.

5. **(B)** The *Gates of Paradise* are placed on the doors of the Florence Baptistery.

6. **(B)** The Brancacci family commissioned the Masaccio paintings.

7. (**C**) Christ is handing the Keys of the Kingdom of Heaven to Saint Peter.

8. (**C**) These keys symbolize the pope's authority, since Saint Peter was the first pope.

9. (**D**) The buildings on the extreme left and right are free copies of the Arch of Constantine.

10. (**D**) Renaissance buildings have open, light, and airy interiors. Gothic darkness is avoided.

Rubric for Short Essay

4: The student identifies the artist and articulates at least two characteristics seen in this painting that lead to the development of Italian Renaissance art. Discussion is full and without major errors.

3: The student identifies the artist and articulates one characteristic seen in this painting that leads to the development of Italian Renaissance art, OR the student does not identify the artist but articulates two characteristics seen in the painting that lead to the development of Italian Renaissance art. Discussion may be lacking and may contain minor errors.

2: The student identifies the artist and minimally sketches some of the characteristics seen in the painting that lead to the development of Italian Renaissance art. There may be major errors.

1: The student identifies only the artist and contributes nothing else, OR does not identify the artist but enumerates one characteristic of Italian Renaissance painting forecast in this work. There may be major errors.

0: The student makes an attempt, but the response is without merit.

Short Essay Model Response

The artist is Masaccio. The innovations he carried out in the <u>Holy Trinity</u> led to the development of Italian Renaissance painting in many ways.

One such way is the use of the Renaissance triangle, which will be characteristic of later paintings in the High Renaissance era. The triangle balances the painting by having the kneeling donors at the borders of the composition, the standing saints closer to the middle, and the trinity at the top of the composition.

Masaccio also uses linear perspective and foreshortening, two tools of fifteenth-century painters. Deep into the painting, God the Father seems to be standing on a ledge behind Jesus. There appears to be a barrel vault deeper behind God. The lines on the ceiling—the orthogonals—draw the eye back into deep space. The saints stand closer to our space between the columns, and the donors kneel in front. From our point of view this big room opens up to our view. Even at the bottom of the painting, in which a skeleton's casket is exposed, we see a ledge that expresses depth. These two details help express how Masaccio helped develop Italian Renaissance painting.

—Kerri M.

Analysis of Model Response

Kerri quickly identifies the artist as Masaccio, earning one point. However, she gains no points for correctly identifying the painting because it is not asked for in the question. Kerri then goes on to assess two characteristics seen in this painting that will become standard in Italian Renaissance art: linear perspective and a triangular format. Importantly, Kerri does not simply list the characteristics, which would have earned a 2, but correctly addresses the characteristics to the painting, pointing out where the triangular format is to be seen and where the linear perspective is most visible. She does, however, mention foreshortening, but does not elaborate where this can be found. **This essay merits a 4.**

High Renaissance

 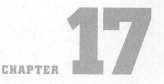

KEY IDEAS

- The revitalization of the city of Rome under the patronage of Pope Julius II led to one of the most creative outbursts in the history of art.
- High Renaissance artists seek to emulate Roman grandeur by undertaking awe-inspiring artistic projects.
- High Renaissance compositions are marked by balance, symmetry, and ideal proportions. Triangular compositions are also favored.
- Venetian painters stress sensuous forms with sophisticated color harmonies.
- Portraits reveal the likenesses of the sitters as well as their character and personality.

HISTORICAL BACKGROUND

Italian city–states with their large bankrolls and small populations were easy pickings for Spain and France, as they began their advances over the Italian peninsula. Venice alone remained an independent power, with its incomparable fleet bringing goods and profits around the Mediterranean.

The High Renaissance flourished in the cultivated courts of princes, doges, and popes—each wanting to make his city–state greater than his neighbor's. Unfortunately, most of this came to a temporary halt with the sack of Rome in 1527—a six-month rape of the city that did much to undo the achievements of one of the most creative moments in art history. What emerged from the ruins of Rome was a new period, Mannerism, which took art on a different path.

Patronage and Artistic Life

Most Renaissance artists came from humble origins, although some like **Titian** and **Michelangelo** came from families of limited influence. Every artist had to join a trade guild, which sometimes made them seem equivalent to house painters or carpenters. Even so, artists could achieve great fame, so great that monarchs competed to have them in their employ. Francis I of France is said to have held the dying **Leonardo da Vinci** in his arms, Charles V of the Holy Roman Empire lavished praise upon **Titian**, and **Michelangelo** was called "divino" by his biographers.

The dominant patron of the era was Pope Julius II, a powerful force in European religion and politics. It was Julius's ambition that transformed the rather ramshackle

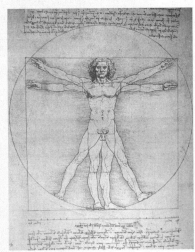

Figure 17.1: Leonardo da Vinci, *Vitruvian Man*, c. 1487, pen and ink, Academy, Venice

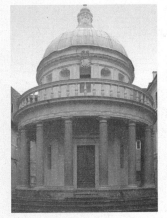

Figure 17.2: Bramante, The Tempietto, 1502, Rome

medieval town of Rome into an artistic center and capital of the Renaissance. It was Julius's devotion to the arts that inspired **Bramante**, **Raphael**, and **Michelangelo** to do their greatest work.

Women, like **Isabella d'Este**, became great patrons of the arts as well. Isabella commissioned portraits from **Leonardo da Vinci** and **Titian**, and even went so far as to sketch an allegory for Perugino, which she would have liked him to execute.

Even with fame, most artists lived modestly, working for local dukes or counts and getting paid when it was convenient for the master to do so.

INNOVATIONS OF HIGH RENAISSANCE ARCHITECTURE

The ancient Roman treatise on architecture by Vitruvius became widely known and discussed in the Renaissance. Leonardo rendered a famous drawing of a Vitruvian man—a figure who was ideally proportioned within the geometric shapes of a circle and a square (Figure 17.1). Important ideas of architectural composition based on Vitruvian ideals of perfect symmetry and composition became the guiding principles of **Bramante's** architectural work.

Characteristics of High Renaissance Architecture

The Tempietto of 1502 (Figure 17.2) illustrates Bramante's belief in the circle as the perfect form and in the dominance of classical architectural orders. Bramante builds on these ideas with the new plan to rebuild Saint Peter's, in which the Greek cross—a cross whose all four sides are of equal length—would be used with a dome over the crossing. Later, Bramante's plan was altered by succeeding architects.

Major Works of High Renaissance Architecture

Bramante, The Tempietto, 1502, Rome (Figure 17.2)

- A martyrium that commemorates the place where Saint Peter was crucified; commissioned by King Ferdinand and Queen Isabella of Spain
- Circular shrine reminiscent of a Greek tholos; no inscriptions, limited carving in the metopes
- Columns, called a peristyle, surround a cylindrical cella topped by a dome
 - Combination of pagan architecture and a Christian theme, common in Renaissance art
 - Circle represents divine perfection; proportions of width and height of ground floor repeated in upper floor
 - Light and shadow interplay in the projecting of columns before the main structure

Antonio da Sangallo, Farnese Palace, c. 1530–1546, Rome (Figure 17.3)

- High Renaissance palace
- Sweeping horizontal front, enlarged by Michelangelo

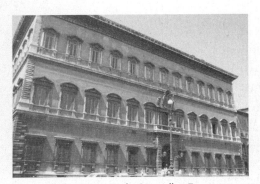

Figure 17.3: Antonio da Sangallo, Farnese Palace, c. 1530–1546, Rome

- Heavily rusticated entrance and quoins
- Each story has different window frames
- Heavy cornice crowns the work
- Built for Cardinal Alessandro Farnese, later elected Pope Paul III

Figure 17.4: Michelangelo, Campidoglio (Capitoline Hill), c. 1537, Rome

Michelangelo, Campidoglio (Capitoline Hill), c. 1537, Rome (Figure 17.4)

- Civic plaza in the center of Rome, built for Pope Paul III
- Huge pilasters dominate the structures, cutting vertically through the stories and towering over the viewer
- Worked around existing buildings on the site; created a trapezoid plan
- Oval plaza design unifies unusual building angles
- Ancient sculpture of *Marcus Aurelius* (Figure 7.36) placed at the center of the plaza; a copy has now replaced it

Figure 17.5: Michelangelo, Saint Peter's interior dome, 1546–1564, Rome

Michelangelo, Saint Peter's, 1546–1564, Rome (Figures 17.5, 17.6, 17.7)

- Michelangelo becomes the official architect well into construction
- Respected Bramante's plan of a Greek cross, and supported the idea of a hemispherical dome like the Pantheon (the shape of the dome was later changed by Giacomo della Porta after Michelangelo's death)
- Alternating window designs
- Double dome, cf. Brunelleschi's dome of Florence Cathedral (Figure 16.2)
- Massive pilasters rise dramatically from the ground and run through the two stories
- Characteristics of Venetian High Renaissance painting

INNOVATIONS OF HIGH RENAISSANCE PAINTING

Northern European artists discovered the durability and portability of canvas as a painting surface. This was immediately taken up in Venice, where the former backing of choice—wood—would often warp in damp climate. Since canvas is a material with a grainy texture, great care was made to prepare it in such a way as to minimize the effect the cloth would have on the paint. Canvas, therefore, had to be primed properly to make it resemble the enamel-like surface of wood. In modern art, the grainy texture is often maintained for the earthy feel it lends a painting.

Figure 17.6: Michelangelo, Saint Peter's, 1546–1564, Rome

Leonardo da Vinci used a painting technique known as **sfumato**, in which he rendered forms in a subtly soft way to create a misty effect across the painted surface. Sfumato has the effect of distancing the viewer from the subject by placing the subject in a hazy world removed from us.

Artists also employed **chiaroscuro**, which provides soft transitions between light and dark. Chiaroscuro often heightens modeling effects in a work by having the light define the forms.

Figure 17.7: Michelangelo, Saint Peter's, 1546–1564, Rome

Venetian artists, particularly **Titian**, increased the richness of oil-painted surfaces by applying **glazes**. Glazes had been used on pottery since ancient times, when they were applied to ceramics to give them a highly polished sheen. In painting, as in pottery, glazes are transparent so that the painted surface shows through. However, glazes subtly change colors by brightening them, much as varnish brightens wood.

In portrait painting, instead of profiles, which were popular in the quattrocento, three-quarter views became fashionable. This view obscures facial defects that profiles enhance. With **Leonardo da Vinci's** *Mona Lisa* (Figure 17.9), portraits become psychological paintings. It was not enough for artists to capture likenesses; artists were expected to express the character of the sitter.

Characteristics of High Renaissance Painting

The idealization that characterizes **Raphael's** work becomes the standard High Renaissance expression. Raphael specialized in balanced compositions, warm colors, and ideally proportioned figures. He favored a triangular composition: The heavy bottom anchors forms securely and then yields to a lighter touch as the viewer's eye ascends.

Works like **Leonardo da Vinci's** *The Last Supper* (Figure 17.8) show a High Renaissance composition, with the key figure, in this case Jesus, in the center of the work, alone and highlighted by the window behind. The twelve apostles are grouped in threes, symmetrically balanced around Jesus, who is the focal point of the orthogonals. Even so, the work's formal structure does not dominate because the Biblical drama is rendered so effectively on the faces of the individuals.

Major Works of High Renaissance Painting

Leonardo da Vinci, *The Last Supper*, 1495–1498, tempera and oil on plaster, Santa Maria delle Grazie, Milan (Figure 17.8)

- Commissioned by the Sforza of Milan for the refectory, or dining hall, of a Dominican abbey
- Relationship between the friars eating and a Biblical meal
- Only Leonardo work remaining in situ
- Linear perspective; orthogonals of ceiling and floor point to Jesus
- Apostles in groupings of three, Jesus is alone but before a group of three windows symbolizing the Trinity
- Leonardo used an experimental combination of paints to yield a greater chiaroscuro; however, the paints began to peel off the wall in Leonardo's lifetime. As a result, the painting has been restored many times.
- Great drama of the moment: Jesus says, "One of you will betray me." (Matthew 26:21)
- Various reactions on the faces of the apostles: surprise, fear, anger, denial, suspicion; anguish on the face of Jesus
- Judas falls back clutching his bag of coins, face in darkness

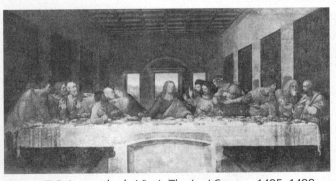

Figure 17.8: Leonardo da Vinci, *The Last Supper*, 1495–1498, tempera and oil on plaster, Santa Maria delle Grazie, Milan

Leonardo da Vinci, *Mona Lisa*, 1503–1505, oil on wood, Louvre, Paris (Figure 17.9)

- Sfumato and chiaroscuro; atmospheric perspective in the background
- A three-quarter turn toward the viewer, relaxed with a gentle contrapposto to the body
- Engages the viewer directly, seems to be— but is not—smiling
- Pyramidal composition
- Psychological intensity

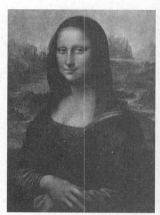

Figure 17.9: Leonardo da Vinci, *Mona Lisa*, 1503–1505, oil on wood, Louvre, Paris

Figure 17.10: Leonardo da Vinci, *Virgin and Child with Saint Anne and Saint John*, 1505–1507, charcoal sketch on brown paper, National Gallery, London

Leonardo da Vinci, *Virgin and Child with Saint Anne and Saint John*, 1505–1507, charcoal sketch on brown paper, National Gallery, London (Figure 17.10)

- Figures arranged in a spatially complex manner
- Charcoal drawing with sensitivity to shading and color tones
- Upraised finger a motif in Leonardo's art (cf. Leonardo's *The Last Supper* (Figure 17.8), Leonardo in Raphael's *The School of Athens*) (Figure 17.14)

Michelangelo, Sistine Chapel Ceiling, 1508–1512, fresco, Vatican, Rome (Figure 17.11)

- Sistine Chapel erected in 1472 and painted by quattrocento masters including Botticelli and Perugino, as well as Michelangelo's teacher Ghirlandaio
- Function of Sistine Chapel: the place where new popes are elected
- Michelangelo chose a complicated arrangement of figures for the ceiling, broadly illustrating the first few chapters of Genesis, with accompanying Old Testament figures and antique sibyls—many based on antique sculptures
- Three hundred figures on ceiling, no two in the same pose; Michelangelo's lifelong preoccupation with the male nude in motion
- Enormous variety of expression
- Painted cornices frame groupings of figures in a highly organized way
- Many figures, like the Ignudi, are done for artistic expression rather than to enhance the narrative
- Acorns are a motif on the ceiling, inspired by the crest of the patron, Pope Julius II

Figure 17.11: Michelangelo, Sistine Chapel Ceiling, 1508–1512, Vatican, Rome

Michelangelo, *Creation of Adam* fresco from the Sistine Chapel Ceiling, 1511–1512, Rome, Italy (Figure 17.12)

- God is flying through the sky; Adam is bound to the earth
- God makes Adam in his "image and likeness"

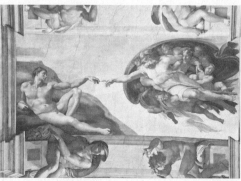

Figure 17.12: Michelangelo, *Creation of Adam* fresco from the Sistine Chapel Ceiling, 1511–1512, Rome, Italy

- Two extremely powerful figures possess a sculptural quality; Adam was influenced by the Greek Hellenistic sculpture of the *Belvedere Torso*
- Around God the Father's arms is Eve waiting to be born (some scholars suggest it is the Virgin Mary with the Christ child)

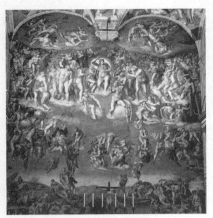

Figure 17.13: Michelangelo, *Last Judgment* fresco from the Sistine Chapel, 1534–1541, Rome

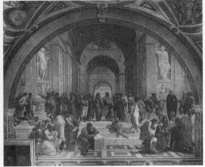

Figure 17.14: Raphael, *The School of Athens*, 1509–1511, fresco, Vatican, Rome

Michelangelo, *Last Judgment* fresco from the Sistine Chapel, 1534–1541, Rome (Figure 17.13)

- In contrast to the ceiling, there are no cornice divisions; it is one large space with figures more casually grouped
- Mannerism shown in the distortions of the body, elongations, crowded groups
- Four broad horizontal bands act as the unifying element:
 1. Bottom: left: dead rising, right: the mouth of hell
 2. Second level: ascending elect, descending sinners, trumpeting angels
 3. Third level: those rising to heaven gathered around Jesus
 4. Top lunettes: angels carrying the Cross and the Column, instruments used at Christ's death
- Christ in center and gestures defiantly with right hand; complex pose
- Justice is delivered: the good rise, the evil fall
- Lower right-hand corner has figures from Dante's Inferno: Minos and Charon
- Saint Bartholomew's face is modeled on a contemporary critic. Saint Bartholomew holds his skin, a symbol of his martyrdom, but the skin's face is Michelangelo's. An oblique remark about critics who skin him alive with their criticism
- Spiraling composition is a reaction against the High Renaissance harmony of the Sistine Chapel ceiling, and reflects the disunity of Christendom caused by the Reformation

Raphael, *The School of Athens*, 1509–1511, fresco, Vatican, Rome (Figure 17.14)

- Commissioned by Pope Julius II to decorate his library
- Painting originally called "Philosophy" because the pope's philosophy books were meant to be housed on shelving below
- One painting in a complex program of works that illustrates the vastness and variety of the papal library
- Open, clear light uniformly spread throughout composition
- Nobility and monumentality of forms parallel to the greatness of the figures represented; figures gesture to indicate their philosophical thought
- Building behind might reflect Bramante's plan for Saint Peter's
- In center are the two greatest figures in ancient Greek thought: Plato (with the features of Leonardo on left, pointing up) and Aristotle
- Bramante is the bald figure of Euclid on the lower right
- Raphael is in the corner at extreme right
- Michelangelo resting on the stone block writing a poem
- Raphael's overall composition influenced by Leonardo da Vinci's *The Last Supper* (Figure 17.8)

Raphael, *Madonna with the Goldfinch*, c. 1506, oil on panel, Uffizi, Florence (Figure 17.15)

- The Holy Family is a perennial theme in Raphael's work
- Figures sit in a triangular composition in a lush garden setting
- Sweetness of faces of Mary and the Christ child dominate
- Clarity of forms; atmospheric perspective; chiaroscuro renders modeling

Figure 17.15: Raphael, *Madonna with the Goldfinch*, c. 1506, oil on panel, Uffizi, Florence

Raphael, *Galatea*, c. 1513, fresco, Villa Farnesina, Rome (Figure 17.16)

- Story taken from Ovid's *Metamorphoses*
- Galatea escapes from the Cyclops Polyphemus by riding on a shell pulled by dolphins
- Galatea's complex figural pose has hair and head facing left, arms right, one leg raised, and one leg straight
- Composition rests on a series of triangles
- Lively vibrant bodies energetically and playfully arranged

Figure 17.16: Raphael, *Galatea*, c. 1513, fresco, Villa Farnesina, Rome

Characteristics of High Renaissance Sculpture

Classical ideas from Greece and Rome dominate High Renaissance sculpture. Heroic nudity was considered the height of idealization, as the deeds of the great figures of the Bible and ancient mythology loomed large in the imagination of Renaissance artists, patrons, and the public in general. Figures have little negative space and are sometimes meant to be seen from one point of view—usually the front.

Although important bronze sculpture was made during the Renaissance, marble was the medium of choice, and the one that evoked the power of ancient art. Additionally, sculpture was left unpainted because it was felt, wrongfully, that the ancients revered in the purity of white marble.

Major Works of High Renaissance Sculpture

Michelangelo, *Pietà*, c. 1498, marble, Saint Peter's, Rome (Figure 17.17)

- Commissioned for Old Saint Peter's and originally intended as a funerary monument; scenes of mourning over the dead Jesus appropriate for funerary monument
- Pyramidal composition; little negative space; compact; monumental; frontal viewpoint preferred, the work was meant to be placed against the wall of a chapel
- Heavy drapery masks Mary's size as she easily holds Jesus in her lap
- Christ is portrayed as serene
- Mary appears to be too young to have a 33-year-old son. Michelangelo claimed, "Don't you know that chaste women remain far fresher than those who are not chaste? So much more the Virgin…never has the least lascivious desire ever arisen that might alter her body…"
- Signed on the sash across Mary's chest, the only work Michelangelo ever signed

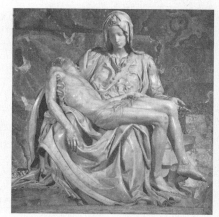

Figure 17.17: Michelangelo, *Pietà*, c. 1498, marble, Saint Peter's, Rome

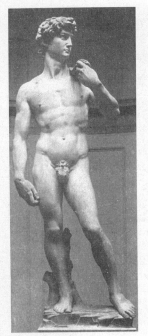

Figure 17.18:
Michelangelo, *David*,
1501–1504, marble,
Academy, Florence

Michelangelo, *David*, 1501–1504, marble, Academy, Florence (Figure 17.18)

- Figure of David represents Florence as she faced larger, more powerful and threatening states like France
- Michelangelo rendered this figure from a block of marble worked on by another artist who abandoned the project
- First colossal nude since the ancient world
- David anticipates the action of challenging Goliath; great concentration on the face
- Slight contrapposto; little negative space; compact pose; monumental forms

Michelangelo, *Moses*, 1513–1515, marble, Saint Peter in Chains, Rome (Figure 17.19)

- Commissioned by Pope Julius II as part of his immense tomb, which was never completed as planned
- Originally meant to be seen from below, oblique angle of the legs would have allowed viewing from this point of view
- Horns: mistranslation of Biblical text; Moses thought to have had "horns" coming out of his head after visiting Mount Sinai, an improper translation for "rays"
- Figure is in awe, but awesome to the view as well; heroic body, idealized forms
- Figure shows a pent-up energy, as if he is ready to stand up and act
- Inspired by Greek Hellenistic sculpture of *Laöcoon* (Figure 5.23)

CHARACTERISTICS OF VENETIAN HIGH RENAISSANCE PAINTING

In contrast to the Florentines and Romans, whose paintings valued line and contour, the Venetians bathed their figures in a soft atmospheric ambiance highlighted by a gently modulated use of light. Bodies are sensuously rendered. While Florentines and Venetians both paint religious scenes, Florentines choose to see them as heroic accomplishments, whereas Venetians imbue their saints with a more human touch, setting them in bucolic environments that show a genuine interest in the beauty of the natural world. This natural setting is often called **Arcadian**.

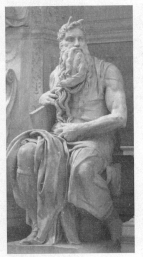

Figure 17.19:
Michelangelo, *Moses*,
1513–1515, marble,
Saint Peter in Chains,
Rome

The damp Venetian climate caused wooden paintings to warp and crack, frescoes to peel and flake. Artists opted for **canvas**, a more secure and lightweight surface that could maintain the integrity of a work for an indefinite period.

Major Works of The Venetian High Renaissance

Giovanni Bellini, *San Zaccaria Altarpiece*, 1505, originally oil on wood, now oil on canvas, San Zaccaria, Venice (Figure 17.20)

- Single cohesive grouping
- Serene coloring; glowing colors
- Subdued lines

- Parallel positions of saints
- Sacra conversazione
- Bellini was teacher to Giorgione and Titian; introduced them to oil painting

Giorgione (and Titian), *The Pastoral Concert,* **c. 1508, oil on canvas, Louvre, Paris (Figure 17.21)**

- Soft modeling of figures; rich application of glazes
- Shepherds are poets who are playing music in an Arcadian landscape
- Muses are inspiring the poets to play by lifting water out of the well of inspiration
- Deep chiaroscuro, no clear cut edges

Giorgione, *The Tempest,* **c. 1510, oil on canvas, Academy, Venice (Figure 17.22)**

- Intense scholarly debate over the meaning
- Soldier on left with halberd is staring at breast-feeding woman
- Incongruities in the lightning bolt, the broken columns, the arch that is only half completed
- Emerging use of oil paint in Venetian art allows artists to render softer color tonalities and harmonies
- Emerging landscape tradition

Titian, *Isabella d'Este,* **1534–1536, oil on canvas, Art History Museum, Vienna (Figure 17.23)**

- Powerful artistic patroness from Mantua
- Was actually sixty when portrait was painted, but she wanted to look twenty; earlier portrait was used as a model
- Self-assured
- Head and hands receive most attention
- Garment fades into the background

Titian, *Madonna of the Pesaro Family,* **1519–1526, oil on canvas, Santa Maria dei Frari, Venice (Figure 17.24)**

- Painted to commemorate the Venetian victory won by Jacopo Pesaro at the Battle of Santa Maura in 1502 against the Turks
- Jacopo kneels at left with Saint George (?) and a bowing Turk; members of the Pesaro family at right are presented by Saint Francis of Assisi
- Saint Peter in center with keys looking down to Pesaro

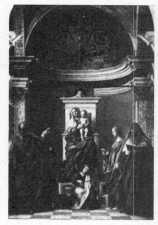

Figure 17.20: Giovanni Bellini, *San Zaccaria Altarpiece*, 1505, originally oil on wood, now oil on canvas, San Zaccaria, Venice

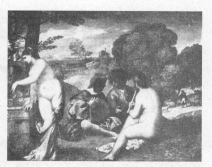

Figure 17.21: Giorgione (and Titian), *The Pastoral Concert*, c. 1508, oil on canvas, Louvre, Paris

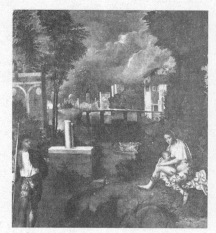

Figure 17.22: Giorgione, *The Tempest*, c. 1510, oil on canvas, Academy, Venice

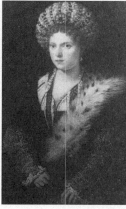

Figure 17.23: Titian, *Isabella d'Este*, 1534–1536, oil on canvas, Art History Museum, Vienna

Figure 17.24: Titian, *Madonna of the Pesaro Family*, 1519–1526, oil on canvas, Santa Maria dei Frari, Venice

- Strong diagonals and triangles in the work; Madonna and Child placed off center, but still at the focus of interest
- Novel approach of asymmetrical composition; visible brushwork in secondary passages
- Composition is balanced by color rather than by design
- Columns added later by another artist

Figure 17.25: Titian, *Venus of Urbino*, 1538, oil on canvas, Uffizi, Florence

Titian, *Venus of Urbino*, 1538, oil on canvas, Uffizi, Florence (Figure 17.25)

- May not have been a Venus, may have been a courtesan
- Sensuous delight in the skin tones
- Looks at us directly
- Complex spatial environment: figure placed forward on the picture plane, servants in middle space; open window with plants in background
- Roses contribute to the floral motif carried throughout the work
- Dog perhaps symbolizes faithfulness
- Cassoni: trunks intended for storage of clothing for a wife's trousseau
- Painting became a standard for future reclining female nudes, cf. Manet *Olympia* (Figure 24.6), Ingres, *The Grand Odalisque* (Figure 23.12)

VOCABULARY

Arcadian: a simple rural and rustic setting used especially in Venetian paintings of the High Renaissance. It is named after Arcadia, a district in Greece to which poets and painters have attributed a rural simplicity and an idyllically untroubled world (Figure 17.21).

Canvas: a heavy woven material used as the surface of a painting; first widely used in Venice (Figure 17.23)

Chiaroscuro: a gradual transition from light to dark in a painting. Forms are not determined by sharp outlines, but by the meeting of lighter and darker areas (Figure 17.20)

Cinquecento: the 1500s, or sixteenth century, in Italian art

Glazes: thin transparent layers put over a painting to alter the color and build up a rich sonorous effect

Ignudi: nude corner figures on the Sistine Chapel ceiling (Figure 17.11)

Martyrium (plural: **martyria**)**:** a shrine built over a place of martyrdom or a grave of a martyred Christian saint (Figure 17.2)

Quoins: an exterior angle on the façade of a building that has large dressed stones forming a decorative contrast with the wall (Figure 17.3)

Sacra conversazione: an altarpiece in which the Madonna and Child are accompanied by saints and engaged in a "holy conversation" (Figure 17.20)

Sfumato: a smoke-light or hazy effect that distances the viewer from the subject of a painting (Figure 17.9)

Summary

The Papal Court of Julius II commissioned some of the greatest works of Renaissance art to beautify the Vatican, including starting construction on the new Saint Peter's. Artists sought to rival the ancients with their accomplishments, often doing heroic feats like carving monumental sculptures from a single block of marble, or painting vast walls in fresco.

Women begin to emerge as powerful patrons of the arts as well, commissioning major works from celebrated artists like Titian and Leonardo da Vinci.

The Venetian School of painting was at its height during this period, realizing works that have a soft, sensuous surface texture layered with glazes. Sfumato and chiaroscuro are widely used to enhance this sensuous effect.

Practice Exercises

1. Pope Julius II was the patron of all of the following projects EXCEPT

 (A) Raphael's *The School of Athens*
 (B) Michelangelo's Sistine Chapel
 (C) Leonardo da Vinci's *The Last Supper*
 (D) Saint Peter's

2. Michelangelo's figure of *David* is different from other versions by Donatello and Verrocchio because it

 CHALLENGE

 (A) shows him nude
 (B) was made for patrons in Florence
 (C) takes place before the battle with Goliath
 (D) is three-dimensional rather than a relief sculpture

3. Ignudi are figures that appear in

 (A) Michelangelo's *Last Judgment*
 (B) Leonardo's *The Last Supper*
 (C) Raphael's *The School of Athens*
 (D) Michelangelo's Sistine Chapel ceiling

4. An example of a sacra conversazione is

 (A) Leonardo's *Mona Lisa*
 (B) Titian's *Venus of Urbino*
 (C) Bellini's *San Zaccaria Altarpiece*
 (D) Leonardo's *The Last Supper*

5. One of the characteristics of High Renaissance portraiture is the introduction of

(A) painterly brushstroke
(B) psychological intensity
(C) classical nudity
(D) patrons altering their age

6. The Sistine Chapel is used for

(A) ordinations of priests
(B) burials of the popes
(C) elections of popes
(D) weddings of kings and queens

7. Bramante's Tempietto was commissioned by

(A) Saint Peter
(B) Pope Julius II
(C) Ferdinand and Isabella of Spain
(D) Isabella d'Este

8. Titian's *Madonna of the Pesaro Family* is a painting commissioned

(A) to honor a naval victory
(B) in gratitude for all the Pesaro family has donated to the church over the years
(C) as a funerary monument
(D) to be placed over the pope's library books

9. Bramante's Tempietto marks the spot where

(A) Rome was founded
(B) Jesus built the first church
(C) Julius II began the new Saint Peter's
(D) Saint Peter was martyred

10. All of the following cities are known for their High Renaissance monuments except

(A) Siena
(B) Venice
(C) Florence
(D) Rome

Short Essay

Figure 17.26

Identify the artist and the name of the work in Figure 17.26. Tell how this work is typical of the sculpture this artist produced. Use one side of a sheet of lined paper to write your essay.

Answer Key

1. (C)	3. (D)	5. (B)	7. (C)	9. (D)
2. (C)	4. (C)	6. (C)	8. (A)	10. (A)

Answers Explained

Multiple-Choice

1. (C) Pope Julius II sponsored work by Raphael, Michelangelo, and Bramante—not by Leonardo da Vinci.

2. (C) Michelangelo's version takes place before the battle with Goliath. Donatello's and Verrocchio's versions have Goliath's head at their feet.

3. (D) Ignudi appear as corner figures to the main scenes of the Sistine Chapel ceiling.

4. (C) Bellini's *San Zaccaria Altarpiece* is an example of a sacra conversazione. The Madonna and Child are surrounded by thoughtful and introspective saints.

5. (B) Leonardo da Vinci's *Mona Lisa* begins a trend in portraiture to emphasize a sitter's psychology.

6. (C) The Sistine Chapel is still used today for the election of popes.

7. (C) The Tempietto was commissioned by Ferdinand and Isabella of Spain to mark the spot where tradition has it that Saint Peter was crucified.

8. (**A**) Titian's *Madonna of the Pesaro Family* was painted as a thank you to Jacopo Pesaro for his role in defeating the Turks.

9. (**D**) Bramante's Tempietto is on the spot where it is said Saint Peter was martyred.

10. (**A**) Siena was not a High Renaissance center.

Rubric for Short Essay

4: The student identifies this sculpture as a work by Michelangelo. The highest level response includes three reasons why this work could be considered a work by Michelangelo, and compares it to another Michelangelo sculpture. There are no major errors.

3: The student identifies this sculpture as a work by Michelangelo. This response includes two reasons why this work should be considered a work by Michelangelo. There may be minor errors.

2: This is the highest score one can earn if the student misidentifies the artist, but supplies the name of another Italian Renaissance sculptor (Donatello, Bologna, and so on). The student gives two reasons why this would be considered an Italian Renaissance work, OR the student identifies this work as by Michelangelo, but gives only one reason why. There may be major errors.

1: The student does not identify Michelangelo as the artist, and writes in a general way about Italian Renaissance sculpture, OR the student identifies only Michelangelo, and does not write about the reasons for the attribution. There may be major errors.

0: The student makes an attempt, but the response is without merit.

Short Essay Model Response

Michelangelo Buonarroti carved this piece, <u>The Moses</u>, for the tomb of Pope Julius II. The work is typical of Michelangelo's sculpture in its massive size and overpowering appearance. The sculptor had a preference for the colossi, and his work is normally larger than life. This enormous, aggressively masculine figure is similar to the tall, assertive <u>David</u>. Michelangelo used Classical Greek sculpture as his example, and both <u>David</u> and <u>Moses</u> present the heroic ideal of the Greek style. Both are smoothly modeled from marble, Michelangelo's stone of choice, and both were constructed from single, solid blocks. The practice of carving from one solid block of marble, like an ever-expanding relief, gives the sculptor more liberty to modify his creation as his figures develop.

Michelangelo's unfinished <u>Captives</u> reveal the subtleties of freeing the sculpture from its marble, and the process may be viewed as a microcosm for the artist's neo-platonic belief that the body is a prisoner of the soul. Michelangelo therefore emulated classical sculpture because, like the <u>David</u> and <u>Moses</u>, it represented the power of potential. Classical Greek style depicts the figure before the action, in graceful contrapposto, but full of simmering, withheld emotion waiting to break. The formal gestures of Michelangelo's sculpture, so beautifully restrained, hint at the perfectability of humans: Perhaps man has the capacity to be ideal when he can check his own emotions.

—Gabriel Sl.

Analysis of Model Response

Gabriel gains one point for identifying the artist as Michelangelo. However, the other facts about Moses and the tomb of Pope Julius II, while showing that the student has mastered the material, do not add to the score of the essay. Gabriel understands Michelangelo's sculptural oeuvre by making references to his *David* and his *Captives*. He correctly lists a number of salient characteristics: The single block of stone, the use of marble, the inspiration from classical Greece, and the understated use of gestures. The statements about neo-platonism, which are usually not covered in high school, prove to the reader that the student has gone beyond the classroom in his study of Michelangelo. **This essay merits a 4.**

Mannerism and Other Trends of Late Sixteenth-Century Italy

TIME PERIOD: 1520–1600, Italy

Mannerism comes from the Italian word *maniera*, meaning "mannered" or "style."

KEY IDEAS

- Mannerist art is deliberately intellectual, asking the viewer to respond in a sophisticated way to the spatial challenges presented in a painting or a sculpture.
- Mannerist painting and sculpture are characterized by complicated compositions, distorted figure styles, and complex allegorical interpretations.
- Mannerist architecture often employs classical elements in a new and unusual way that defies traditional formulas.

HISTORICAL BACKGROUND

When Martin Luther nailed his theses to the doors of a church in Wittenberg, Germany in 1517, he touched off a religious and political upheaval that had long-lasting repercussions throughout Europe. Even if this movement, called the Protestant Reformation, was treated as a heresy in Italy, it had a dramatic impact on Italian art. No longer was the High Renaissance sense of perfection a representation of the world as it is, or could ever be. Mannerist distortions were more appropriate in this highly contentious period. Indeed, the basic tenets of Mannerism concern the tension between the ideal, the natural, and the symmetrical against the real, the artificial, and the unbalanced.

The schism that the Reformation caused was met by a Catholic response, framed at the Council of Trent (1545–1563) and later termed the Counter-Reformation. At the Council a new order of priests was created, called the Jesuits, whose missionary

activity and commitment to education is still visible around the world today. The Jesuits quickly saw the power of art as a teaching tool and a religious statement, and became great patrons of the arts.

The religious and political upheaval that characterized the sixteenth century was exemplified by the sacking of the city of Rome in 1527. The unpaid army of the Holy Roman Empire, after defeating the French troops in Italy, sought restitution in looting and pillaging the holy city. The desecration of Rome shook all Christendom, especially since it proved that its chief holy place could so easily fall victim to the undisciplined and the greedy.

Patronage and Artistic Life

The first permanent painting academy was established by Cosimo I of Florence in 1563; its function was to train artists and improve their status in society. The best artists, however, did not need academies, nor did they need patrons. Although some preferred to work for a duke and stay in his graces, the reality was that a duke usually did not have enough commissions to keep a painter occupied. Famous artists did not need this security, and most achieved success by keeping their important patrons satisfied. Michelangelo's relationship with Pope Julius II was successful in part because Julius became his preferred, although by no means his only, customer. Mannerist painters saw nothing about this situation worth changing.

A number of important books were published during this period that showcased the increased status of artists. Benvenuto Cellini, a Mannerist sculptor whose works today number only a precious few, wrote an extensive *Autobiography* between 1558 and 1562 detailing his relationship with princes and kings. Simultaneously, Giorgio Vasari wrote a definitive series of biographies on the greatest painters from Cimabue to Michelangelo in 1550, and then updated it in 1568. Certainly this would not have been possible unless there was considerable interest in reading such a weighty set of tomes.

Andrea Palladio wrote what was to become the most influential books ever written on architecture called *The Four Books on Architecture* (begun 1570). They became the standard for the professional and the amateur, having an influence that has been deeply felt even into the twentieth century.

INNOVATIONS AND CHARACTERISTICS OF MANNERIST ARCHITECTURE

Mannerist architecture invites us to question the use of classical vocabulary on a sixteenth-century building. Drawing on a wealth of antique elements, the Mannerist architect playfully engages the viewer in the reuse of these elements independent of their original function. These are commonly seen in works like the **Palazzo del Tè** (Figure 18.1) in which a bold interlocking of classical forms is arranged in a way to make us ponder the significance of ancient architecture in the Renaissance.

Major Works of Mannerist Architecture

Giulio Romano, Palazzo del Tè, 1525–1535, Mantua, Italy (Figure 18.1)

Figure 18.1: Giulio Romano, Palazzo del Tè, 1525–1535, Mantua, Italy

- Horse farm and a villa
- Unsettling architectural setting
 o Triglyphs dip into the cornice, creating holes above
 o Pediment corners do not meet
 o Window openings at unconventional locations
 o Engaged columns divide façade into unequal bays
 o Massive columns carry almost no weight, just a narrow cornice
 o Keystone pops out of the arches
 o Oddly sized stones
 o Highly unusual placement of arch below a pediment

Giacomo della Porta, Il Gesù façade, 1575–1584, Rome (Figure 18.2)

Figure 18.2: Giacomo della Porta, Il Gesù façade, 1575–1584, Rome

- Principal church of the Jesuit order
- Column groupings emphasize central doorway
- Tympana and pediment over central door
- Slight crescendo of forms toward the center
- Two stories separated by cornice; united by scrolls
- Framing niche acts as a unifying device
- Interior has no aisles, meant for grand ceremonies

INNOVATIONS OF MANNERIST PAINTING

Typical High Renaissance paintings have a perspective grid on a plaza that leads the eye to a central point (cf. *The School of Athens*), (Figure 17.14). Mannerists chose to discard conventional theories of perspective by having the eye wander around a picture plane—as in **Pontormo** (Figure 18.3)—or use perspective to create an interesting illusion—as in **Parmigianino** (Figure 18.5). Although heavily indebted to High Renaissance forms, the Mannerist uses these as starting points to freely vary the ideals of the previous generation. It is the ability of the Mannerists to defy the conventional classical order and rationality that gives the style much of its appeal.

A new artistic subject, the **still life**, is born in the Mannerist period. Although understood as the lowest form of painting, it gradually becomes an accepted art form in seventeenth-century Holland. **Genre** paintings are introduced as scenes of everyday life become acceptable in finished works of art.

Characteristics of Mannerist Painting

For many years scholars saw the demanding compositions of Mannerist paintings as crude reflections of High Renaissance art—the aftermath of a great period. But scholars have slowly come to realize that the unusual complexities and ambiguous spaces—the artifice—of Mannerist art is its most endearing quality. This is an intensely intellectual art form that is deliberately complex, seeking refinement in unusual compositions and contrived settings. The irrational spatial effects rely on an

exaggeration of forms, obscure imagery, and symbolic enigmas whose consequence is puzzling, stimulating, and challenging. It is the calculated ambiguity of Mannerist painting that gives it its enduring value.

Major Works of Mannerist Painting

Jacopo da Pontormo, *Entombment*, 1525–1528, oil on wood, Santa Felicità, Florence (Figure 18.3)

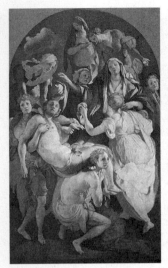

Figure 18.3: Jacopo da Pontormo, *Entombment*, 1525–1528, oil on wood, Santa Felicità, Florence

- Center of the circular composition is a grouping of hands
- Elongation of bodies
- High-keyed colors, perhaps taking into account the darkness of the chapel it is placed in
- No ground line for many figures; what is Mary sitting on?
- Hands seem disembodied
- Some androgynous figures
- No weeping, just yearning
- Linear bodies twisting around one another
- Anti-classical composition

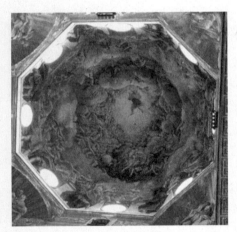

Figure 18.4: Antonio Correggio, detail of *Assumption of the Virgin*, 1526–1530, fresco, Parma Cathedral, Parma, Italy

Antonio Correggio, *Assumption of the Virgin*, 1526–1530, fresco, Parma Cathedral, Parma, Italy (Figure 18.4)

- View of the sky with hundreds of figures flying overhead in concentric rings
- Weightlessness of the bodies
- Clouds appear as soft and elusive masses
- Saints at lowest level; second level has the Virgin escorted to heaven with angels; celestial glory at top with Christ waiting to receive his mother
- Glowing colors set in a blazing setting that prefigures the Baroque

Parmigianino, *Madonna of the Long Neck*, 1535, oil on wood, Uffizi, Florence (Figure 18.5)

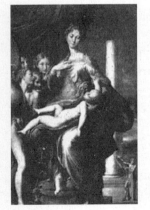

Figure 18.5: Parmigianino, *Madonna of the Long Neck*, 1535, oil on wood, Uffizi, Florence

- Mary's small head, long neck, delicate gesture, graceful hand
- Crowding of heads on left
- Elongated torsos and disembodied limbs
- Column appears to be singular at top but descends to a row of columns at bottom
- Small figure at base strangely out of proportion; role in the painting uncertain
- Pose of Mary and Jesus reminiscent of the Pietà

Agnolo Bronzino, *Venus, Cupid, Folly, and Time*, 1546, oil on panel, National Gallery, London (Figure 18.6)

- Commissioned by Cosimo de' Medici of Florence as a gift to Francis I of France
- Complicated allegorical structure that invites a multiplicity of meanings

- Cupid kisses his mother Venus, but has his eye on her golden apple; he rests on a pillow, indicating his idleness
- Venus responds to Cupid, but removes an arrow behind his back from his quiver
- Folly throws flowers at the couple
- Masks symbolize falseness; doves symbolize love
- Fraud or Vanity has a beautiful face and offers a honeycomb, but underneath she is an animal and has a poisonous lizard in her other hand; her hands seem to be reversed
- Envy, on left, is green; has recently been symbolically interpreted as syphilis
- Fury or Truth at top left; Time at top right, exposing all
- Has been interpreted as a morality piece about syphilis
- Complex imagery and poses
- Figures in a congested composition pushed to the front of the picture plane

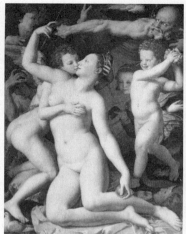

Figure 18.6: Agnolo Bronzino, *Venus, Cupid, Folly, and Time*, 1546, oil on panel, National Gallery, London

Jacopo Tintoretto, *The Last Supper*, 1594, oil on canvas, Santa Maria Maggiore, Rome (Figure 18.7)

- Christ in the center, yet powerful diagonals pull the eye into the distance
- Elongated figures
- Light reveals flying angels
- Light casts long shadows
- Many details of everyday life dominate painting
- No action, no announcement of betrayal, nameless apostles, insignificant Judas; divinity of Christ expressed in Holy Communion is stressed
- Christ gives the Eucharist to Saint Peter
- Original point of view was from an angle which would have given it more balance

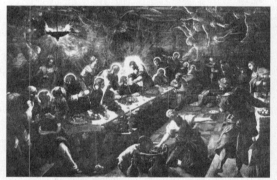

Figure 18.7: Jacopo Tintoretto, *The Last Supper*, 1594, oil on canvas, Santa Maria Maggiore, Rome

INNOVATIONS OF MANNERIST SCULPTURE

Mannerist sculptors freed the viewer from the frontal position that artists like Michelangelo and Donatello wanted us to stand in. Since medieval art, most works of sculpture had a primary viewpoint. Mannerists, like **Bologna**, questioned these assumptions and make us move around the work to appreciate it.

Characteristics of Mannerist Sculpture

The elongation of figures that dominate so much of Mannerist painting is reflected in sculpture as well. It is typical for intertwining figures to have their legs and arms inexplicably intermeshed. On occasion, disembodied hands appear, sometimes floating in space in a mix of bodies. Negative space, the anathema of High Renaissance sculpture, is the hallmark of Mannerism. Compositions are often crowded, inviting the viewer to examine the details to understand the whole.

Major Works of Mannerist Sculpture

Benvenuto Cellini, *Perseus with the Head of the Medusa*, **1545–1554, bronze, Florence (Figure 18.8)**

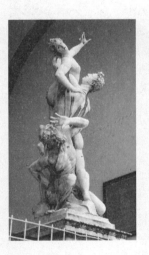

- Perseus decapitates the Medusa to prevent her from turning people into stone
- Commissioned to stand under the Loggia della Signoria in downtown Florence, across the plaza from Michelangelo's *David* among many other works
- Symbolizes the Medici taking off the head of tyrants for the benefit of Florentine citizens
- Elongated, lanky proportions, sensuously rendered body of Perseus
- No attempt to show the horror of decapitation, blood is fascinating rather than horrifying

Figure 18.8: Benvenuto Cellini, *Perseus with the Head of the Medusa*, 1545–1554, bronze, Florence

Giovanni da Bologna, *Abduction of the Sabine Women*, **1583, marble, Florence (Figures 18.9, 18.10, and 18.11)**

- Title of work given later
- Spiral movement; precursor of the Baroque
- Must be seen in the round
- Negative space
- References to *Laocoön* (Figure 5.23)

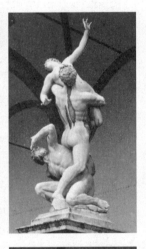

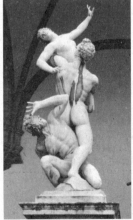

Figures 18.9, 18.10, and 18.11: Giovanni da Bologna, *Abduction of the Sabine Women*, 1583, marble, Florence

- It had been thought that the ancients sculpted monumental works from one block of stone; Renaissance artists discovered this was untrue; Bologna wanted to surpass the ancients by carving from one block
- Symbolism of the Medici (young man) taking Florence (the woman) from the preceding government (the old man)

Classicizing Trend in Late Fifteenth-Century Art and Architecture

The spirit of High Renaissance painting never faded in the sixteenth century, despite the dominance of Mannerist art. Artists like **Veronese** continued to work on grand compositions highlighted by majestic architectural elements of vast size. Courtly gestures and imposing theatrical elements dominate paintings that seem to be set as if the figures are partaking in a splendid pageant.

Although many Mannerist architects, like **Romano**, enjoy delighting the senses by breaking the academic code, just as many, like **Palladio**, revitalized classical forms. There is nothing more textbook than the **Villa Rotonda** (Figure 18.13), although it must be admitted

that this building is unique in Palladio's repertory. **San Giorgio Maggiore** (Figure 18.14) is more Mannerist in its intersection of pediments and columns.

Major Works of Late Fifteenth-Century Art and Architecture

Paolo Veronese, *Christ in the House of Levi*, 1573, oil on canvas, Academy, Venice (Figure 18.12)

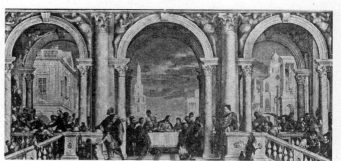

Figure 18.12: Paolo Veronese, *Christ in the House of Levi*, 1573, oil on canvas, Academy, Venice

- Originally titled *Last Supper* but name was changed because it was deemed inappropriate for a sacred scene
- Mary and Christ lost in a vast array of miscellaneous figures
- Sumptuous setting; architecture overwhelms; courtly gestures; brocaded costumes
- Mark 2:13–17; Jesus has dinner in a house filled with sinners, thus pointing out that it is his mission to save sinners

Andrea Palladio, Villa Rotonda, 1566–1570, Vicenza, Italy (Figure 18.13)

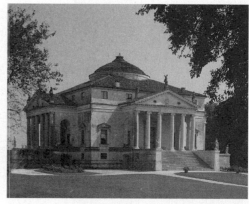

Figure 18.13: Andrea Palladio, Villa Rotonda, 1566–1570, Vicenza, Italy

- Building has four identical façades, from each porch there is a different view
- When the building is viewed from afar, no matter from what angle, it looks complete
- Used as a working farm, family estate, villa retreat
- Symmetrical ground plan
- Villa appears as a minitemple; perhaps a residence of the Muses; ideal nature of the central plan evokes the ancients
- Low round Roman-style dome, not the domes of the Renaissance
- Originally the dome had an oculus, like the Pantheon, but is now glazed
- Building set on a high podium; pediments dominate doors and windows
- Interior has rotunda; four larger rooms alternate with four smaller spaces; the latter allow for more intimate settings

Andrea Palladio, San Giorgio Maggiore, 1565, Venice (Figure 18.14)

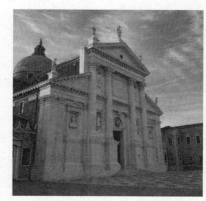

Figure 18.14: Andrea Palladio, San Giorgio Maggiore, 1565, Venice

- Interlocking pediments and columns
- High pedestals for columns
- More Mannerist than the Villa Rotonda, two temple façades intersect
- Clearly lit interior

VOCABULARY

Genre painting: painting in which scenes of everyday life are depicted
Still life: a painting of a grouping of inanimate objects, such as flowers or fruit
Villa (Italian) or **Chateau (French; plural: chateaux):** a large country estate, manor house (Figure 18.13).

Summary

Mannerist artists broke the conventional representations of Italian Renaissance art by introducing intentionally distorted figures, acidy colors, and unusual compositions to create evocative and highly intellectual works of art that challenge the viewer's perceptions and ideals. Perspective was used as a tool to manipulate a composition into intriguing arrangements of spatial forms.

The questioning of artistic values extends to the types of paintings as well. Still lifes and genre paintings, long considered too low for sophisticated artists, make their first appearance.

Mannerist architects seek to combine conventional architectural elements in a refined and challenging interplay of forms. It is this ambiguity that gives Mannerism a fascination today.

Alongside the dominance of Mannerist painting, classicism persists in Northern Italy in the works of Veronese and Palladio.

Practice Exercises

Questions 1–3 refer to Figure 18.15.

1. The artist of this work is

 (A) Jacapo Tintoretto
 (B) Giacomo della Porta
 (C) Paolo Veronese
 (D) Giovanni da Bologna

2. This work was carved from one piece of marble because

 (A) the artist wanted to challenge the ancients
 (B) there was only one piece of marble left in the quarry
 (C) marble was the approved medium of the ancients
 (D) the cost of marble had gone up

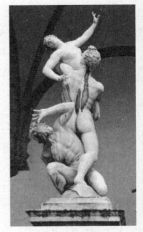

Figure 18.15

3. Which ancient work of sculpture inspired this composition?

 (A) *Venus de Milo*
 (B) *Laocoön*
 (C) *Discus Thrower*
 (D) *Nike of Samothrace*

4. Mannerist paintings can be characterized by

 (A) harmony
 (B) symmetry
 (C) pastel colors
 (D) artifice

5. A new type of painting introduced in the Mannerist period is the

 CHALLENGE

 (A) landscape
 (B) mythological painting
 (C) still life
 (D) abstract

6. Correggio's ceiling painting at Parma Cathedral is different than Michelangelo's Sistine Chapel ceiling in that Correggio's is

 CHALLENGE

 (A) not divided up by architectural features
 (B) not high overhead
 (C) of a secular subject matter
 (D) not three-dimensional

Questions 7–9 refer to Figure 18.16.

Figure 18.16

7. This building has a Mannerist influence in the

 (A) classical forms used in an irregular pattern
 (B) dome that is low and wide
 (C) pediment that should be placed higher on the façade
 (D) fact that there is no Greek temple behind the building

8. This building was built

 (A) for wedding receptions
 (B) for the pope's private apartments
 (C) to house horses in a stable
 (D) for religious services

9. This building is dramatically located in the

 (A) Mediterranean Sea
 (B) Grand Canal in Venice
 (C) Tiber River in Rome
 (D) Nile

10. Jacopo Tintoretto's *Last Supper* is different than previous renditions of this Biblical story in that

 (A) Christ is announcing that someone will betray him
 (B) Judas is at the far side of the table
 (C) the main drama is diffused by an elaborate grouping of subsidiary figures
 (D) Tintoretto painted it in a religious building

Short Essay

CHALLENGE

Andrea Palladio said in his *Four Books on Architecture*, "Guided by a natural inclination, I gave myself up in my most early years to the study of architecture: And as it was always my opinion, that the ancient Romans, as in many other things, so in building well, vastly excelled all those who have been since their time, I proposed to myself Vitruvius for my master and guide, who is the only ancient writer of this art, and set myself to search in to the relics of all the ancient edifices, that, in spite of time and cruelty of the Barbarians, yet remain; and finding them much more worthy of observation, than at first I had imagined, I began very minutely with the utmost diligence to measure every one of their parts...."

Choose and identify a building designed by Palladio. Discuss how this building illustrates the quotation. How is the work inspired by Roman architecture and how does it deviate from it? Use one side of a sheet of lined paper to write your essay.

Answer Key

1. **(D)**	3. **(B)**	5. **(C)**	7. **(A)**	9. **(B)**
2. **(A)**	4. **(D)**	6. **(A)**	8. **(D)**	10. **(C)**

Answers Explained

Multiple-Choice

1. **(D)** Giovanni da Bologna sculpted the *Abduction of the Sabine Women*.

2. **(A)** Bologna felt he was challenging the ancients by carving from a single block of marble.

3. **(B)** The *Laocoön* inspired both the figure on the bottom and the one at the top.

4. **(D)** Artifice is the hallmark of Mannerist painting.

5. **(C)** Still lives were new to the Mannerist period. Landscapes and abstract paintings came later. Mythological scenes appeared in the ancient world.

6. **(A)** One difference between Correggio's ceiling and Michelangelo's is that the former is not architecturally divided the way the scenes in Michelangelo's are.

7. (**A**) The classical forms are used in ways never intended by the ancients. For example, there are two pediments, one within the other, and columns cross in front of the lower pediment.

8. (**D**) This building was built as a church.

9. (**B**) Santa Maria Maggiore is on the Grand Canal in Venice.

10. (**C**) Tintoretto diffuses the drama by creating a huge wait staff for the banquet.

Rubric for Short Essay

4: The student explains the quotation, and uses an appropriate Palladio building to illustrate how the work is both Roman in inspiration and Renaissance in execution. There are no major errors.

3: The student explains the quotation, and uses an appropriate Palladio building; however, there are fewer examples and less detail in illustrating how the work is both Roman in inspiration and Renaissance in execution. There may be minor errors.

2: The student misinterprets or only partly explains the quotation and provides a Renaissance building that is not necessarily by Palladio to illustrate how the work is both Roman in inspiration and Renaissance in execution. There may be major errors.

1: The student has only a passing idea of how to apply the quotation to a Renaissance work. There may be major errors.

0: The student makes an attempt, but the response is without merit.

Short Essay Model Response

Palladio drew inspiration from Roman architecture in his work. He based his Four Books on Architecture on the study of ancient Rome. Buildings such as the Villa Rotonda in Vicenza, Italy, display strong Roman qualities and also those Greek characteristics that in turn inspired the Romans. However, Palladio was an architect of the Mannerist period, so this building also exhibits Renaissance qualities.

The façade of the country estate of the Villa Rotonda is strongly Roman. In that sense, it clearly illustrates the quotation in which Palladio says that it has "great diligence to measure every one of their parts." The building features a Greek temple front with a pediment and six Ionic columns and a low Roman dome. Like the Pantheon in Rome, Italy, this building has a rectangular shape behind the pediment and a dome with an oculus at the top. The symmetry and mathematical proportions favored by the Romans are

in evidence both in the ground plan and in the overall exterior design. There are also Greek-style statues above the pediment as well as pediments above the windows.

The Villa Rotonda deviates from Roman architecture, however, in several important ways. This building's façade is the same on all four sides, which is unusual in a rectangular building from the Renaissance and from the Roman world. This fits into the Renaissance notion that the home can become a temple of its own kind. To have a building look the same on all four sides allows it to be complete no matter from where you look at it.

While looking to Roman architecture "worthy of observation" Palladio displayed Mannerist qualities in his cutting edge use of uniformity on all sides of the villa. He was among the most influential architects of his time and perhaps the most important contributor to architecture in history.

—Katyann G.

Analysis of Model Response

Katyann's response is strong in connecting the quotation to the Roman qualities of the Villa Rotonda, and also addresses how Palladio's work deviates from ancient examples. **This essay merits a 4.**

Later Renaissance in Northern Europe and Spain: Sixteenth Century

TIME PERIOD: 1500–1600

KEY IDEAS

- The Reformation sparked a series of iconoclasms throughout Northern Europe, destroying much great art work and prohibiting new work from being created; nonetheless, in most places in Northern Europe, the sixteenth century was a creative and dynamic period.
- Artists, particularly sculptors, sought new ways to represent figures without appearing to create pagan idols.
- Northern European art is powerfully influenced by the achievements of the Italian Renaissance although most Northern painters retained their own artistic traditions.
- Albrecht Dürer represents the combination of Northern Renaissance realism and interest in detail with the Italian concern for size and monumentality.

HISTORICAL BACKGROUND

According to tradition, the Reformation began in 1517 when a German monk and scholar named Martin Luther nailed a list of his complaints to the doors of All Saints Church in Wittenberg, Germany. Perhaps unknowingly, he began one of the greatest upheavals in European history, causing a split in the Christian faith and political turmoil that would last for centuries. Those countries that were Christian the shortest period of time (Germany, Scandinavia, and the Netherlands) became Protestant. Those with longer Christian traditions (Spain, Italy, Portugal, and Poland) remained Catholic.

With a Protestant wave of anti-Catholic feeling came an iconoclastic movement attacking paintings and sculptures of holy figures, which only a short while before were considered sacred. Calvinists, in particular, were staunchly opposed to what they saw as blasphemous and idolatrous images; they spearheaded the iconoclastic movement.

Patronage and Artistic Life

The conflict between Protestant iconoclasm and Catholic images put artists squarely in the middle. On the one hand, the Church was an excellent source of employment; on the other, what if the contentions of the Protestants were true?

Many, like **Dürer**, tried to resolve the issue by either turning to other types of painting, like portraits, or by seeking a middle road by playing down religious ecstasies or the lives of the saints. Protestants thought that God could be reached directly through human intercession, so paintings of Jesus, when permitted, were direct and forceful. Catholics wanted intermediaries, such as Mary, the saints, or the priesthood to direct their thoughts, so these images were more permissible. However, Catholics always insisted that a sculpture of Mary was just a reminder of the figure one was praying to. Idolatry was not endorsed by either.

The Northern European economy can be characterized by a capitalist market system that flourished due to expansive trade across the Atlantic. This brought with it a parallel emphasis on buying and selling works of art as commodities. New technologies in printmaking made artists internationally popular, and more courted than ever before.

CHARACTERISTICS OF SIXTEENTH-CENTURY ARCHITECTURE

There was still a desire to reassert Gothic forms in sixteenth-century architecture, although that was eventually suppressed by patrons who felt that the Gothic style was old-fashioned. Instead, Italian High Renaissance columns, pilasters, and pediments made their way north and to Spain, as in **The Louvre** (Figure 19.1) and **The Escorial** (Figure 19.2). Still, some Gothic elements persisted in the verticality of northern architecture.

Major Works of Sixteenth-Century Architecture

Pierre Lescot, The Louvre, begun 1546, Paris, France (Figure 19.1)

- Royal palace for French kings
- Overall horizontal emphasis
- Roman arcading on the bottom floor
- Tympana over the projecting bays
 - French: pitched roof, large window spaces, double columns encase a niche that contains sculpture
 - Italian Renaissance: pediments, pilasters
 - Marriage of a French chateau and an Italian palazzo

Juan de Herrera and Juan Bautista de Toledo, The Escorial, c. 1563–1584, Escorial, Madrid (Figure 19.2)

- Palace, monastery, royal mausoleum, church
- Philip II's personality reflected in the structure: severe, restrained, massive yet understated
- Four towers dominate the corners

Figure 19.1: Pierre Lescot, The Louvre, begun 1546, Paris, France

- Dedicated to Saint Lawrence, on whose feast day in 1557 Philip II won the Battle of San Quintín; ground plan is the shape of a gridiron (Saint Lawrence was tied to a gridiron and burned to death)
- Entrance flanked by engaged Doric columns and surmounted by a pediment

CHARACTERISTICS OF SIXTEENTH-CENTURY PAINTING

Figure 19.2: Juan de Herrera and Juan Bautista de Toledo, The Escorial, c. 1563–1584, Escorial, Madrid

Northern European art during the sixteenth century is characterized by the assimilation of Italian Renaissance ideas into a Northern European context. Michelangelo was enormously popular in Northern Europe, even though he never went there, and only one of his works did. However, many other Italian artists made the journey, including the elderly Leonardo da Vinci, sculptor Benvenuto Cellini, and painter Rosso Fiorentino. Artists like Greek-born **El Greco** studied in Italy; northerners like **Dürer** and **Bruegel** made extended Italian visits.

The contemporary Mannerist movement, with its elongated and stylized figures, as well as the High Renaissance propensity to use massiveness and size, influenced some Northern European painters. Nevertheless, Northern European painters were not derivative. Instead, they are characterized by a clever mix of Italian art with their own artistic traditions, which include the rendering of minute details and painstaking realism. Most exemplary is **Dürer**, who artfully combines Italian monumentality with Northern European precision. Not everyone, however, was impressed with Italianate painting—for all the time **Bruegel** spent in Italy, his paintings still look thoroughly Northern.

Northern European painting had a fondness for nature unknown in Italian art—whether it is seen in sweeping Alpine landscape views or the study of a rabbit or even a clump of earth. Landscapes, no matter how purely represented, generally have a trace of human involvement, sometimes shown by the presence of buildings or farms, or the rendering of small people in an overwhelming setting.

Northern artists continued to use high horizon lines that enabled a large area of the canvas to be filled with earthbound details. In general, there is a reluctance to use linear perspective in paintings, although atmospheric perspective is featured in landscapes.

After the Reformation, religious imagery is downplayed in favor of portraits or scenes of everyday life. **El Greco**, however, was the exception. Born in Crete and trained in Venice, El Greco had a thorough understanding of Mannerist painting conventions and the religious fervor of the Council of Trent. His fiery and passionate works more closely represent Mannerist ideals rather than Northern European pictorial values.

The Reformation, with its powerful iconoclastic doctrine, proved to be a challenge for sculptors whose works were occasionally interpreted as pagan idols. Most sculptures were smashed or dismembered by rioting religious zealots. Thus, significant sculpture continued to be created in Catholic countries, like Italy, but not in the Protestant north.

Figure 19.3: Hieronymus Bosch, Left panel: *Garden of Eden* from *Garden of Earthly Delights*, 1505–1510, oil on wood, Prado, Madrid

Figure 19.5: Hieronymus Bosch, Right panel detail: *Garden of Earthly Delights*, 1505–1510, oil on wood, Prado, Madrid

Figure 19.4: Hieronymus Bosch, Central panel: *Garden of Earthly Delights*, 1505–1510, oil on wood, Prado, Madrid

Figure 19.6: Matthias Grünewald, central panel of first view of *Isenheim Altarpiece*, 1510–1515, oil on panel, Musée d'Unterlinden, Colmar

Major Works of Sixteenth-Century Painting

Hieronymus Bosch, *Garden of Earthly Delights*, 1505–1510, oil on wood, Prado, Madrid (Figures 19.3, 19.4, and 19.5)

- Left panel: Garden of Eden; the state of humans in an ideal world; however, even here there are signs of the evils to come—animals are violent, eating one another; Adam and Eve are thin, insubstantial nudes who lack backbone and resolve, and act only on impulses
- Central panel: the Garden of Earthly Delights—the result of Adam and Eve's sin; primitive humanity indulging in sexual play; eating sexually suggestive berries and fruits; idleness; sexually suggestive towers and wading pools; animals suggest sexual perversity
- Right panel: hell; the results of the activities in the central panel; souls are tormented by demons and made to pay for their excesses on earth; musical instruments, which can arouse passions, abound as symbols of torture
- Painting probably symbolizes the four stages of alchemy: the bringing together of opposite elements (left panel), their mixing (central panel), purification process by fire (right panel), cleansing of the elements (outside panel, not illustrated)
- Figures are light and nonsubstantial, lacking individuality and will, having no minds of their own
- High horizons pack many details in the paintings

Matthias Grünewald, central panel of first view of *Isenheim Altarpiece*, 1510–1515, oil on panel, Musée d'Unterlinden, Colmar (Figure 19.6)

- Placed in a monastery hospital where people were treated for "Saint Anthony's Fire," or ergotism—a disease caused by eating a fungus that grows on rye flour
- St. Anthony's Fire explains the presence of St. Anthony on the first and third views (not illustrated)
- Ergotism causes convulsions and gangrene

- *First view:* Crucifixion: dark background; dead, decomposing flesh; arms almost torn from sockets; lashed and whipped body; agony of the body unflinchingly shown; symbolizes the agony of ergotism; swooning Mary dressed like the nuns who worked in the hospital; when panels open to reveal next scene, Christ is amputated as patients suffering ergotism would be; same true in the predella: Christ's legs seem amputated below the kneecaps (not illustrated)
- *Second view:* Marian symbols: the enclosed garden, closed gate, rosebush, rosary; Christ rises from the dead on right—his rags changed to glorious robes, showing his wounds, which do not harm him now; message to patients is that earthly diseases will vanish in the next world
- *Third view:* symbols of ergotism: oozing boils, withered arm, distended stomach (not illustrated)

Figure 19.7: Albrecht Dürer, *Adam and Eve*, 1504, engraving, Museum of Fine Arts, Boston

Albrecht Dürer, *Adam and Eve*, 1504, engraving, Museum of Fine Arts, Boston (Figure 19.7

- Influenced by classical sculpture; Adam looks like the ancient Greek sculpture called *The Apollo Belvedere*; Eve like *Medici Venus*; Italian massing of forms
- Ideal image of humans before the Fall of Man
- Contrapposto of figures from the Italian Renaissance
- Four humors are represented in the animals below: cat (choleric or angry), rabbit (sanguine or energetic), elk (melancholic or sad), ox (phlegmatic or lethargic); four humors were kept in balance before the Fall of Man
- Mouse represents Satan
- Parrot a symbol of cleverness
- Adam tries to dissuade Eve; he grasps the mountain ash, a tree from which snakes recoil
- Northern European devotion to detailed paintings

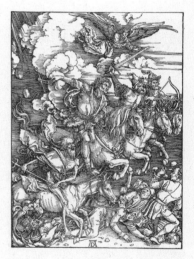

Figure 19.8: Albrecht Dürer, *Four Horsemen of the Apocalypse*, 1498, woodcut, Metropolitan Museum of Art, New York

Albrecht Dürer, *Four Horsemen of the Apocalypse*, 1498, woodcut, Metropolitan Museum of Art, New York (Figure 19.8)

- Four horsemen are described in the Book of Revelations as coming at the end of the world to destroy life. Their weapons include famine (scales), war (sword), death (pitchfork), and pestilence (bow)
- Gothic forms, inspired by Mantegna's prints
- No background, no dividing line between earth and heaven
- Crowded tumultuous forms riding over the dead

Albrecht Dürer, *Self-Portrait*, 1500, oil on wood panel, Alte Pinakothek, Munich (Figure 19.9)
- Christ-like pose, not blasphemous, human creativity as a reflection of God's creativity
- Frontality, symmetry directly facing and engaging spectator
- Solid High Renaissance triangular form

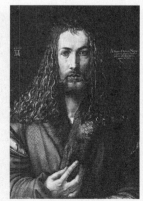

Figure 19.9: Albrecht Dürer, *Self-Portrait*, 1500, oil on wood panel, Alte Pinakothek, Munich

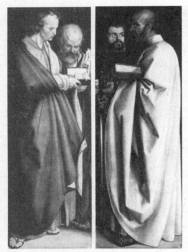

Figure 19.10: Albrecht Dürer, *Four Apostles*, 1526, oil on wood panel, Alte Pinakothek, Munich

Albrecht Dürer, *Four Apostles*, 1526, oil on wood panel, Alte Pinakothek, Munich (Figure 19.10)

- John and Peter on left; Peter represented the pope in Rome, Dürer, a Lutheran, places him behind
- Mark and Paul on right; Paul was a favorite of Protestants
- Four humors expressed in the apostles: John sanguine, Paul melancholic, Mark choleric, Peter phlegmatic
- Figures have Italian size; Northern European interest in detail
- Painted for a city hall, not a church

Albrecht Altdorfer, *Battle of Issus*, 1529, oil on wood panel, Alte Pinakothek, Munich (Figure 19.11)

- Depicts the victory of Alexander the Great over Persian King Darius in 333 B.C.E.; however, figures wear medieval armor in an Alpine landscape
- Allusion to the battle against the Turks fought by Altdorfer's patron, William IV of Bavaria
- Sun sets over the Greeks, moon rises over Persians
- References to the Nile delta in the background: Cyprus in the Mediterranean, the isthmus of Suez
- Microscopic detailing and rich coloring

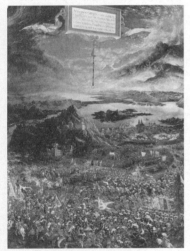

Figure 19.11: Albrecht Altdorfer, *Battle of Issus*, 1529, oil on wood panel, Alte Pinakothek, Munich

Hans Holbein, *The French Ambassadors*, 1533, oil and tempera on wood panel, National Gallery, London (Figure 19.12)

- Their educated backgrounds characterized by the implements on the table between them
- Anamorphic image of the skull at the bottom of the painting, said to be visible at an angle from a staircase or with a cylindrical mirror
- Left figure: massive, worldly, extroverted, gazing at spectator
- Right figure: introverted, ecclesiastical; in dark clothing with slightly averted eyes
- Concealed crucifix (upper left); Christ presiding over destinies; lute with a broken string (death symbol?)

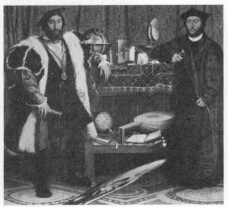

Figure 19.12: Hans Holbein, *The French Ambassadors*, 1533, oil and tempera on wood panel, National Gallery, London

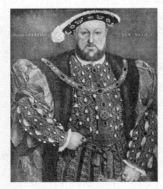

Figure 19.13: Hans Holbein, *Henry VIII*, 1540, oil on wood panel, Galleria Nazionale d'Arte Antica, Rome

Hans Holbein, *Henry VIII*, 1540, oil on wood panel, Galleria Nazionale d'Arte Antica, Rome (Figure 19.13)

- Confident, massive, confrontational; frontality
- Mannerist influence
- Blue background a Holbein trademark
- Dressed for his wedding to his fourth wife, Anne of Cleves

Pieter Bruegel, *Return of the Hunters,* **1565, oil on wood panel, Art History Museum, Vienna (Figure 19.14)**

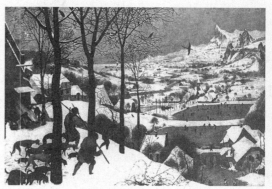

- One of a series of paintings representing the months—this is November/December
- Alpine landscape, winter scene
- Strong diagonals lead the eye deeper into the painting
- Figures are peasant types, not individuals
- Landscape has high horizon line, a Northern European tradition
- Endless details; nothing is static
- Hunters have had little success in the winter hunt; dogs are skinny and hang their heads

Figure 19.14: Pieter Bruegel, *Return of the Hunters*, 1565, oil on wood panel, Art History Museum, Vienna

El Greco, *The Burial of Count Orgaz,* **1586, oil on canvas, Santo Tomé, Toledo, Spain (Figure 19.15)**

- Count Orgaz died three centuries earlier before the painting was commissioned
- Tomb is directly below the painting; Orgaz is being placed directly into his tomb
- He was a great philanthropist; the saints descend from heaven to bury him; this painting is a recreation of that miracle
- Emphasizes Catholic belief that philanthropy and good works are necessary for leading a good Christian life
- Combination of Venetian color, Spanish mysticism, Mannerist elongation
- Mannerist use of space; twisting of figures; disembodied hands
- Priest on right conducts funeral, although crowd is unmoved
- Soul transported up to heaven by angels
- Painting divided in half: bottom is the somber earth, above the ecstatic heaven; only the cross bridges the gap
- Child is El Greco's son: Jorge Manuel. Is he pointing to Count Orgaz or the rose on the sleeve of the saint?
- Anachronistic scene: Christian saints from the earliest days of the Church bury a fourteenth-century man with sixteenth-century dignitaries in attendance

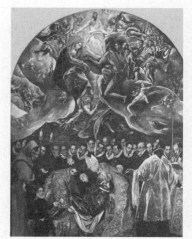

Figure 19.15: El Greco, *The Burial of Count Orgaz*, 1586, oil on canvas, Santo Tomé, Toledo, Spain

VOCABULARY

Anamorphic image: an image that must be viewed by a special means, such as a mirror, in order to be recognized (Figure 19.11)

Engraving: a printmaking process in which a tool called a **burin** is used to carve into a metal plate, causing impressions to be made in the surface. Ink is passed into the crevices of the plate, and paper is applied. The result is a print with remarkable details and finely shaded contours (Figure 19.7)

Polyptych: a many-paneled altarpiece

Woodcut: a printmaking process by which a wooden tablet is gouged into with a tool, leaving the design raised and the background cut away (very much as how a rubber stamp looks). Ink is rolled onto the raised portions, and an impression is made when paper is applied to the surface. Woodcuts have strong angular surfaces with sharply delineated lines (Figure 19.8)

Summary

The achievements of Italian Renaissance painters had a profound effect on their Northern European counterparts in the sixteenth century. The monumentality of forms, particularly in the works of Michelangelo, were of great interest to Northern European artists, who traveled to Italy in great numbers. Even so, most Northern painters continued their own tradition of meticulously painting details, high horizon lines, and colorful surfaces that characterize their art.

The civil unrest that was an outgrowth of the Reformation caused many churches to be violated as works of art were smashed and destroyed because they were thought to be pagan. Protestants in general sought more austere church interiors in reaction against the perceived lavishness of their Catholic counterparts.

Mannerism, with its elongated figures and complex poses influenced artists like El Greco, who visited Italy before establishing himself in Spain.

Practice Exercises

1. Hans Holbein worked at the court of

 (A) Francis I
 (B) William IV
 (C) Julius II
 (D) Henry VIII

CHALLENGE

2. Which of the following paintings is still in situ?

 (A) *French Ambassadors*
 (B) *Return of the Hunters*
 (C) *The Burial of Count Orgaz*
 (D) *Battle of Issus*

3. The marriage of Italian monumentality and Northern European detail can be seen in

 (A) *Return of the Hunters*
 (B) *The Four Apostles*
 (C) *The Burial of Count Orgaz*
 (D) *Battle of Issus*

4. *The Four Horsemen of the Apocalypse* are war, pestilence, death, and

 (A) famine
 (B) Satan
 (C) agony
 (D) natural disasters

5. The *Isenheim Altarpiece* was originally placed in a

 (A) museum
 (B) hospital
 (C) town hall
 (D) castle

6. The Protestant Reformation had its most damaging effect on

 (A) painting
 (B) sculpture
 (C) architecture
 (D) printmaking

Questions 7 and 8 refer to Figure 19.16.

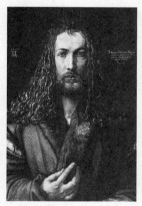

Figure 19.16

7. This work is a self-portrait of

 (A) Pieter Bruegel
 (B) Hans Holbein
 (C) Albrecht Dürer
 (D) Matthias Grünewald

8. However, this work is also a portrait of the artist as Christ. This would have been interpreted as

 (A) sacrilegious
 (B) blasphemy
 (C) an expression of God's creativity
 (D) a compliment to God

9. The Escorial functioned as a palace and as a

 (A) wedding chapel
 (B) stable
 (C) royal mausoleum
 (D) museum

10. The *Battle of Issus* is meant to parallel contemporary battles against

 CHALLENGE

 (A) Protestants
 (B) Catholics
 (C) both Protestants and Catholics
 (D) Turks

Short Essay

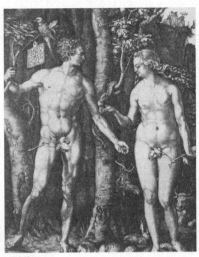

The work in Figure 19.17 is Dürer's *Adam and Eve*. In what ways does this print reflect a combination of Northern European and Italian ideals in Renaissance art? Use one side of a sheet of lined paper to write your essay.

Figure 19.17

Answer Key

1. (**D**)	3. (**B**)	5. (**B**)	7. (**C**)	9. (**C**)
2. (**C**)	4. (**A**)	6. (**B**)	8. (**C**)	10. (**D**)

Answers Explained

Multiple-Choice

1. (**D**) Hans Holbein worked for Henry VIII of England.

2. (**C**) *The Burial of Count Orgaz* is still in the church it was painted for in Toledo, Spain.

3. (**B**) Dürer's *The Four Apostles* shows the mix of Italian monumentality and Northern European detail.

4. (**A**) Famine is a horseman of the apocalypse.

5. (**B**) Originally, the *Isenheim Altarpiece* was placed in a hospital.

6. (**B**) Protestant iconoclasts smashed many sculptures in the Reformation.

7. (**C**) This work is Dürer's self-portrait.

8. (**C**) This would have been interpreted as expressing God's gift of creativity to Dürer.

9. (**C**) The Escorial was also a royal mausoleum. The kings of Spain are buried there.

10. (**D**) The *Battle of Issus* is an allegory for William IV's battles against the Turks.

Rubric for Short Essay

4: The student analyzes both the Italian and Northern European influences in this work. The student specifies where these influences exist and points out clear examples. There are no major errors.

3: The student analyzes both the Italian and Northern European influences in this work. The student is less specific in discussing where these influences occur and examples are less clearly explained. There may be minor errors.

2: The student gives either the Italian or Northern European influences in this work, and points to one example with some specificity. There may be major errors.

1: The student only generally mentions either one Italian or one Northern European influence in this work, but does not point to an example with any specificity. There may be major errors.

0: The student makes an attempt, but the response is without merit.

Short Essay Model Response

Adam and Eve, an engraving done by Albrecht Dürer in the early 16th century, is a superb example of the effect of Italian Renaissance ideas being introduced to Northern Europe. As a young man, Dürer studied in Italy and *Adam and Eve* is a unique blend of Italian and Northern European ideals.

The moment the viewer looks at the engraving, the subject is instantly recognized—Adam and Eve are standing in front of the Tree of Knowledge, about to taste the forbidden fruit. The selection of a religious scene is very typical of Renaissance art in general (both northern and southern), but choosing to portray this famous moment in the Old Testament also allows Dürer to depict a nude human body. The two figures, standing in contrapposto, look like classical Greek sculptures (especially Adam, who with his outstretched hand is very reminiscent of the *Apollo of Belvedere*) and are portrayed with careful attention to anatomical detail. This interest in human anatomy and Greek antiquity is a direct influence of the Italian Renaissance.

The engraving, however, retains some features typical of Northern Renaissance art. Keeping in the tradition of old Northern European masters such as van Eyck, Dürer pays incredibly close attention to surface detail—every square inch of the work, from Adam's curls to the bark of the tree, is done in a meticulous fashion. Furthermore, the engraving is crammed with objects—every single one of which is there for a reason. For example, four of the animals are thought to symbolize the medieval concept of the four temperaments: the rabbit sanguine, the cat choleric, the elk melancholic, and the ox phlegmatic.

It is almost as if <u>Adam and Eve</u> is a memento of the spread of the Italian Renaissance to the rest of Europe. The engraving's concern with the beauty and the proportions of the human body is typically Italian while its saturated symbolic setting is unmistakably Northern European.

—Alex U.

Analysis of Model Response

Alex explains that there are both Italian and Northern European influences in Dürer's famous print of *Adam and Eve*. He points to the artist's interest in idealized figural anatomy, which is derived from Italian sources that are ultimately expressions of ancient Greek models in works such as the *Apollo Belvedere*. He also explains how the print emphasizes Northern European devotion to detailed works, both in their minute rendering of forms (such as the bark of the tree) and in their many layers of intricate symbolism (providing an example of the animals in the foreground). However, students should avoid using the word "unique" in almost any circumstance, as it expresses an individuality that a work may not possess. **This essay merits a 4.**

Baroque Art

TIME PERIOD: 1600–1700

The term "Baroque" means "irregularly shaped" or "odd," a negative word that evolved in the eighteenth century to describe the Baroque's departure from the Italian Renaissance.

KEY IDEAS

- The Counter-Reformation, which symbolized the Catholic resurgence, finds an artistic parallel in Baroque art of Italy, Flanders, Spain, and France.
- Baroque art also flourishes in Protestant Holland, which becomes a counter-voice to Catholic art.
- Baroque painting is divided into two schools of thought: the classicists, inspired by the works of central Italian artists such as Raphael; and the naturalists, inspired by Venetian painters such as Titian.
- Baroque artists experiment with different art forms, such as genre paintings, landscapes, and still lifes, and bring them artistically to the same level as traditional subjects.
- Baroque architecture is associated with the majestic royal courts of Europe.

HISTORICAL BACKGROUND

In 1600, the artistic center of Europe was Rome, particularly at the court of the popes. The completion of Saint Peter's became a crusade for the Catholic Church, both as an evocation of faith and as a symbol of the Church on earth. By 1650, however, the increased power and influence of the French kings, first at Paris and then at their capital in Versailles, shifted the art world to France. While Rome still kept its allure as the keeper of the masterpieces for both the ancient world and the Renaissance, France became the center of modern art and innovation, a position it kept unchallenged until the beginning of World War II.

The most important political watershed of the seventeenth century was the Thirty Years' War, which ended in 1648. Ostensibly started over religion, and featuring a Catholic resurgence called the Counter-Reformation, the Thirty Years' War also had active political, economic, and social components as well. The war succeeded in devastating central Europe so effectively that economic activity and artistic production ground to a halt in this region for the balance of the seventeenth century.

The Counter-Reformation movement reaffirmed all the things the Protestant Reformation was against. Protestants were largely iconoclasts, breaking painted and sculpted images in churches; Catholics endorsed the place of images and were rein-spired to create new ones. Protestants derided saints; Catholics reaffirmed the com-munion of saints and glorified their images. Protestants played down miracles; Catholics made them visible and palpable as in the *Ecstasy of Saint Theresa* (Figure 20.14).

Patronage and Artistic Life

Even with all the religious conflict, the Catholic Church was still the greatest source of artistic commissions in the seventeenth century, closely followed by royalty and their autocratic governments. Huge churches and massive palaces had big spaces that needed to be filled with large paintings commanding high prices. However, artists were not just interested in monetary gain; many Baroque artists such as **Rubens** and **Bernini** were intensely religious people, who were acting out of a firm commitment to their faith as well as to their art. Credit must be given to the highly cultivated and farsighted patrons who allowed artists to flourish; Pope Urban VIII, for example, sponsored some of Bernini's best work.

The Special Case of Holland

While the Baroque is often associated with stately court art, it also flourished in mer-cantile Holland. Dutch paintings are harbingers of modern taste: landscapes, por-traits, and genre paintings flourished; religious ecstasies, great myths, and historical subjects were avoided. In contrast to the massive buildings in other countries, Dutch houses are small and wall space scarce, so painters designed their works to hang in more intimate settings. Even though commerce and trade boomed, the Dutch did not want industry portrayed in their works. Ships are sailboats, not merchant vessels, which courageously braved the weather, not unloaded cargo. Animals are shown qui-etly grazing rather than giving milk or being shorn for wool. A featureless flat Dutch landscape is animated by powerful and evocative skies.

Dutch painting, however, has several things in common with the rest of European art. Most significantly, Dutch art features many layers of symbolism that provokes the viewer to intellectual consideration. Still life paintings, for example, are not the mere arrangement of inanimate objects, but a cause to ponder the passing and fleetness of life. Stark church interiors often symbolized the triumph of Protestantism over Catholicism. Indeed, while Dutch art may seem outside the mainstream of the Baroque, it does have important parallels with contemporary art in the rest of Europe.

INNOVATIONS IN BAROQUE ARCHITECTURE

Landscape architecture becomes an important artistic expression in the Baroque. Starting at **Versailles** (Figure 20.7) and continuing throughout the eighteenth cen-tury, palaces are envisioned as the principal feature in an ensemble with gardens that are imaginatively arranged to enhance the buildings they framed. Long views are important. Key windows are viewing stations upon which gardens spread out before the viewer in an imaginatively orchestrated display that suggests man's control over his environment. Views look down extended avenues carpeted by lawns and

embraced by bordering trees, usually terminating in a statue or a fountain. The purpose is to impress the viewer with a sense of limitlessness.

Characteristics of Baroque Architecture

Baroque architecture relies on movement. Façades undulate, creating symmetrical cavities of shadow alternating with projecting pilasters that capture the sun. Emphasis is on the center of the façade with wavelike forms that accentuate the entrance. Usually entrances are topped by pediments or tympana to reinforce their importance. A careful interplay of concave and convex shapes marks the most experimental buildings by **Borromini** and **Guarini**. Interiors are richly designed to combine all the arts; painting and sculpture service the architectural members in a choreographed ensemble. The aim of Baroque buildings is a dramatically unified effect.

Baroque architecture is large; it seeks to impress with its size and its elaborate ornamentation. In this regard, the Baroque style represents the imperial or papal achievements of its patrons—proclaiming their power and wealth. Buildings are erected at high points accessible by elaborately carved staircases, ones that spill out toward the spectator and change direction—and view—as they rise.

Major Works of Italian Baroque Architecture

Carlo Maderno, façade of Saint Peter's, 1607–1612, Rome (Figure 20.1)

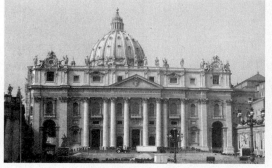

Figure 20.1: Carlo Maderno, façade of Saint Peter's, 1607–1612, Rome

- Façade and nave added to Michelangelo's design of Saint Peter's, making it a Latin cross plan
- Wide and low façade: originally conceived with flanking bell towers that were never completed above the façade level
- Emphasis on the center of the façade with pediment highlighting the main door
- Pilasters on each end gradually become rounded engaged columns around the central door (cf. Il Gesù, Figure 18.2)

Gianlorenzo Bernini, Colonnade of Saint Peter's, 1656–1657, Rome (Figure 20.2)

Figure 20.2: Gianlorenzo Bernini, Colonnade of Saint Peter's, 1656–1657, Rome

- Huge plaza that can hold half a million people
- Bernini wanted a surprising transition between the crowded streets of Rome and giant vista of Saint Peter's
- Colonnade acts as a dramatic gesture of embracing arms, symbolically brings the faithful into the building
- Shaped like a skeleton keyhole; Saint Peter holds the keys to the kingdom of heaven
- Oval centered around a previously erected Egyptian obelisk; preexisting buildings determined a trapezoid shape in front of church

Figures 20.3 and 20.4: Francesco Borromini, Saint Charles of the Four Fountains (San Carlo alle Quattro Fontane), 1638–1641, Rome

Francesco Borromini, Saint Charles of the Four Fountains (San Carlo alle Quattro Fontane), 1638–1641, Rome (Figures 20.3 and 20.4)

- So named because it is on a square in Rome with four fountains
- Unusually small site
- Alternating convex and concave patterns and undulating volumes in ground plan and façade
- Façade higher than the rest of the building
- Interior side chapels merge into central space
- Interior dome oval shaped and coffered
- Walls treated sculpturally
- Borromini worked in shades of white, avoided colors used in many Baroque buildings

Figure 20.5: Francesco Borromini, Sant'Agnese, 1653–1663, Rome

Francesco Borromini, Sant'Agnese, 1653–1663, Rome (Figure 20.5)

- Church dominates elliptical plaza
- Interplay of convex and concave forms on façade
- Dome framed by elaborate towers; dome rises dramatically above concave façade
- Centrally planned building with a wide rounded transept
- Interior spaces flow unobstructed into one another

Figure 20.6: Guarino Guarini, Chapel of the Holy Shroud, 1667–1694, Turin, Italy

Guarino Guarini, Chapel of the Holy Shroud, 1667–1694, Turin, Italy (Figure 20.6)

- Extremely complex Baroque space
- Diminishing hexagonal ribs cross one another creating an airy domed space of dazzling intricacy
- Illusion of endless spaces, almost kaleidoscopelike on the interior (not illustrated)
- Interior centered on a 12-pointed star with the Holy Spirit
- Chapel holds the controversial Shroud of Turin

Major Work of French Baroque Architecture

Jules Hardouin-Mansart among others, Versailles, begun 1669, Versailles, France (Figure 20.7 and 20.8)

- Reorganization and remodeling of a hunting lodge into an elaborate palace
- Center of the building was Louis XIVs bedroom, or audience chamber, from which all aspects of the design radiate like rays from the sun (hence Louis's sobriquet "the Sun King")
- Versailles corresponds to Louis XIV's political and economic ambitions

Figure 20.7: Jules Hardouin-Mansart among others, Versailles, begun 1669, Versailles, France

- Building was centered in a vast garden and town complex radiating from it
- Subdued exterior decoration on façade; undulation of projecting members is understated
- Hall of Mirrors: 240-feet long; barrel-vaulted painted ceiling; light comes in from one side and ricochets off the largest panes of glass that could be made at the time; flickering use of light in an architectural setting; ceiling paintings illustrate civil and military achievements of Louis XIV

Figure 20.8: Jules Hardouin-Mansart among others, Hall of Mirrors, Versailles, begun 1669, Versailles, France

Major Works of English Baroque Architecture

Inigo Jones, Banqueting House, 1619–1622, London, England (Figure 20.9)

- Inspired by Palladio, introduced the Palladian style to England
- Built for James I of England to replace a hall destroyed by fire
- Modest emphasis on the center of the façade
- Central bay of six windows framed by engaged columns
- Flat pilasters recessed around windows
- Rusticated basement level
- Two stories of windows disguise one large room on the interior
- Balustraded roof

Figure 20.9: Inigo Jones, Banqueting House, 1619–1622, London, England

Christopher Wren, Saint Paul's, 1675–1710, London, England (Figure 20.10)

- Designed after the Great Fire of London in 1666 destroyed the Gothic building on this site
- Façade: frontispiece projects in front of building creating dark/light contrast in the center; emphasis on center—sides recede
- Bell towers: Borromini inspired Baroque compositions of great complexity graceful volumes and rhythmic movement
- Dome: actually three domes:
 o inner wooden dome low and curved, painted
 o second dome is structural, holding up the lantern
 o exterior dome fills out the space graciously; influence of Bramante's Tempietto (Figure 17.2)

Figure 20.10: Christopher Wren, Saint Paul's, 1675–1710, London, England

John Vanbrugh, Blenheim Palace, begun 1705, Woodstock, England (Figure 20.11)

- Given by Britain as a thank you to the Duke of Marlborough for winning the Battle of Blenheim in 1704 in the War of Spanish Succession
- Emblems of might abound throughout the complex: trophies, cannonballs, flaming urns, statuary

Figure 20.11: John Vanbrugh, Blenheim Palace, begun 1705, Woodstock, England

- Italian Baroque complexity of design
- Projecting pavilions
- Accent on the central core of nine bays and the corner towers
- Façade echoes patterns of advance and retreat
- Basement has porthole windows, Vanbrugh's favorite motif
- Grand majestic palace structure; cf. Versailles, Bernini's colonnade at Saint Peter's

INNOVATIONS OF BAROQUE PAINTING AND SCULPTURE

Baroque artists explored subjects born in the Renaissance but previously considered too humble for serious painters to indulge in. These subjects, still life, genre, and landscape painting, flourished in the seventeenth-century as never before. While religious and historical paintings were still considered the highest form of expression, even great artists such as **Rembrandt** and **Rubens** painted landscapes, and classicists like **Carracci** painted genre scenes. Still lifes were a specialty of the Dutch school.

Landscapes and still lifes exist not in and of themselves, but to express a higher meaning. Still lifes frequently contain a **vanitas** theme, which stresses the brevity of life and the folly of human vanity. Broad open landscapes feature small figures in the foreground acting out a Biblical or mythological passage. Genre paintings often had an allegorical commentary on a contemporary or historical issue.

Landscapes were never actual views of a particular site; instead they were composed in a studio from sketches done in the field. The artist was free to select trees from one place and put them with buildings from another. Landscape painters, like **Carracci** and **Claude**, felt they had to reach beyond the visual into a world of creation that relies on the thoughtful combination of disparate elements to make an artistic statement.

Painters were fascinated by **Caravaggio's** use of **tenebrism**—even the greatest painters of the century experiment with it. The handling of light and shadow became a trademark of the Baroque, not only for painters, but for sculptors and architects as well. Northern artists like **Hals** and **Leyster** specialized in **impasto** brushwork, which created a feeling of spontaneity with a vibrant use of visible brushwork. Similarly, sculptors animated the texture of surfaces by variously polishing or abrading surfaces.

Characteristics of Baroque Painting

There are two trends that dominate Baroque painting: Naturalism and Classicism. Naturalist painters, like **Caravaggio** and **Gentileschi**, paint with an expressive sense of movement. Figures are dramatically rendered, even in what would appear to be a simple portrait. Light effects are key, as offstage sources illuminated parts of figures in a strong dark light contrast called **tenebroso**. Colors are descriptive and evocative. Inspiration for the naturalist school of painting comes from the Venetian Renaissance, and passes through **Caravaggio** and onto **Rubens** and his followers, who are called **Rubénistes.** Naturalists reject what they perceive as the contortions and artificiality of the Mannerists.

Classicist painters, taking their cue from **Carracci** and **Reni**, subdued the wilder emotions and colors of the Naturalists, and maintained inspiration from classicizing

painters like Raphael. The Classicists found fullest expression in the art of **Poussin** and his followers called **Poussinistes**. This type of painting dominated French art throughout the Baroque.

Characteristics of Baroque Sculpture

As in the other arts, Baroque sculpture stressed movement. Figures are caught in mid-motion, mouths open, with the flesh of one figure yielding to the touch of another. Large works, particularly those by **Bernini**, were often meant to be placed in the middle of the floor or at a slight distance from a wall and be seen in the round. Sculptors employ negative space, carving large openings in a work so that the viewer can contemplate a multiplicity of angles. Marble is treated with a tactile sense: Human skin given a high polish, angel wings shown with a feathery touch, animal skins reveal a coarser feel. Baroque sculptors found inspiration in the major works of the Greek Hellenistic period.

Major Works of Italian Baroque Art

Gianlorenzo Bernini, *David*, 1623, marble, Borghese Gallery, Rome (Figure 20.12)

* In mid-action, swinging the slingshot, a shepherd's weapon, at Goliath
* Harp at David's feet symbolizes his role as a psalmist
* Bernini's idealized self-portrait in the face of David; intensive gaze
* Meant to be seen from multiple views
* Use of negative space animates sculpture and surroundings

Figure 20.12: Gianlorenzo Bernini, *David*, 1623, marble, Borghese Gallery, Rome

Figure 20.13: Gianlorenzo Bernini, *Baldacchino*, 1624–1633, bronze, Saint Peter's, Rome

Gianlorenzo Bernini, *Baldacchino*, 1624–1633, bronze, Saint Peter's, Rome (Figure 20.13)

* Over the main altar of Saint Peter's, four twisting corkscrew columns that spiral upward
* Directs viewer's vision down the nave of Saint Peter's
* Acts as a shrine and canopy over the grave of Saint Peter, buried under the basilica
* Bees and suns appear prominently on top corners: symbols of the patrons, the Barberini family
* Symbol of the Counter-Reformation spirit in Rome
* Feat of bronze casting

Gianlorenzo Bernini, *Ecstasy of Saint Theresa*, 1645–1652, marble, Santa Maria della Vittoria, Rome (Figure 20.14)

* A sculptural interpretation of Saint Theresa's diary in which she tells of her visions of God, many involving an angel descending with an arrow and plunging it into her

Figure 20.14: Gianlorenzo Bernini, *Ecstasy of Saint Theresa*, 1645–1652, marble, Santa Maria della Vittoria, Rome

Figure 20.15: Caravaggio, *Calling of Saint Matthew*, 1597–1601, oil on canvas, San Luigi dei Francesi, Rome

- Natural light redirected onto the sculpture from a window hidden above the work
- Marble handled in a tactile way to reveal textures: skin is high gloss, feathers of angel are rougher, drapery is animated and fluid, clouds are roughly cut
- Figures seem to float in their space, with the rays of God's light symbolically illuminating the scene from behind
- Saint Theresa's pose suggests sexual exhaustion, a feeling that is consistent with her description of spiritual ecstasy described in her diary entries
- Stagelike setting with the patrons, members of the Cornaro family, sitting in theatre boxes looking on and commenting (not illustrated)

Caravaggio, *Calling of Saint Matthew*, 1597–1601, oil on canvas, San Luigi dei Francesi, Rome (Figure 20.15)

- Light comes in from two sources on right, creating a tenebroso effect on figures
- Diagonal shaft of light points directly to Saint Matthew, who points to himself as if unsure that Christ would select a tax collector, depicting a moment in time
- Christ's hand gesture similar to Adam's on the Sistine Chapel ceiling (Figure 17.12)
- Foppishly dressed figures are in the latest Baroque fashion
- Narrow stage for figures to sit and stand on
- Only slight suggestion of halo on Christ's head indicates sanctity of the scene
- Sensual figures, everyday characteristics
- Naturalist approach to the Baroque

Figure 20.16: Caravaggio, *Entombment*, 1603, oil on canvas, Vatican Museum, Rome

Caravaggio, *Entombment*, 1603, oil on canvas, Vatican Museum, Rome (Figure 20.16)

- Christ's body placed in a grave; painting placed over an altar so Christ is symbolically being placed on the altar
- A visualization of transubstantiation, that is, the effect of turning the Eucharistic meal into the body and blood of Jesus—a Counter-Reformation idea denied by Protestants
- Figures pushed forward toward the picture plane
- Stone slab seems to come forward into our space
- Nicodemus, the figure looking at us, is said to resemble Caravaggio himself; a common-looking figure drawn without an aura of holiness

Figure 20.17: Annibale Carracci, *Loves of the Gods*, 1597–1601, fresco, Farnese Palace ceiling, Rome

Annibale Carracci, *Loves of the Gods*, 1597–1601, fresco, Farnese Palace ceiling, Rome (Figure 20.17)

- Barrel vaulted ceiling combines *quadro riportato* with *di sotto in sù* painting
- Idealized bodies in a variety of poses

- Vigorous movements
- Rich color
- Figures overlap the painted and stucco frames, sitting on them, putting their hands over them
- Loves of the gods played out in bacchanalian abandon on the ceiling
- Rich colors inspired by the Venetians

Artemisia Gentileschi, *Judith and Her Maidservant with the Head of Holofernes*, 1614–1620, oil on canvas, Uffizi, Florence (Figure 20.18)

- Influence of Caravaggio in the tenebrism and gory details
- Dramatic lighting, emotional pathos
- Face of Judith a self-portrait, the artist identified with Old Testament heroines; Gentileschi was raped by a male patron—an event that went to trial
- Gentileschi specialized in painted images of women triumphing over men

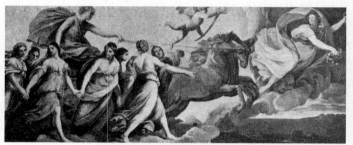

Figure 20.18: Artemisia Gentileschi, *Judith and Her Maidservant with the Head of Holofernes*, 1614–1620, oil on canvas, Uffizi, Florence

ROMAN CEILING PAINTINGS

Guido Reni, *Aurora*, 1613–1614, fresco, Casino Rospigliosi, Rome (Figure 20.19)

Pietro da Cortona, *Triumph of the Barberini* (also called *Triumph of the Divine Providence*) 1633–1639, fresco, Palazzo Barberini, Rome (Figure 20.20)

- Ceiling paintings in Rome
- Reni:
 - o Classicist trend in painting
 - o *Quadro riportato*
 - o Influenced by Raphael
 - o Aurora leads Apollo's chariot, Cupid and the Seasons dance about the heavenly car
 - o Soft modeling, sweet airy vision
- Da Cortona:
 - o Naturalist trend in painting
 - o *Di sotto in sù*
 - o Symbols of the Barberini family include the bees and laurel wreaths
 - o Figures move easily in an open space unified by extensive use of light and color
 - o Ceiling subdivided by a painted architectural framework that figures spill over

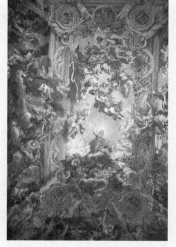

Figure 20.19: Guido Reni, *Aurora*, 1613–1614, fresco, Casino Rospigliosi, Rome

Figure 20.20: Pietro da Cortona, *Triumph of the Barberini*, 1633–1639, fresco, Palazzo Barberini, Rome

Major Works of Spanish Baroque Art

Diego Velázquez, *The Water Carrier of Seville*, c. 1619, oil on canvas, Wellington Museum, London (Figure 20.21)

- Early work of Velázquez shows intense interest in Caravaggio tenebrism
- Deceptively simple genre scene has a sacred quality about the expressions, the handing over of the glass, the clarity of the water
- Rounded volumes of the foreground figures, the water jug
- Water is sweetened by a fresh fig placed for flavor

Figure 20.21: Diego Velázquez, *The Water Carrier of Seville*, c. 1619, oil on canvas, Wellington Museum, London

Diego Velázquez, *The Surrender of Breda*, 1634–1635, oil on canvas, Prado, Madrid (Figure 20.22)

- Depicts the 1625 episode in which the Dutch were forced to yield the town of Breda to the Spanish
- Stresses the graciousness of the Spanish victors, militarily dignified, a uniform fighting force, magnanimous in victory
- Dutch on left: more scattered, less organized, youthful
- Spanish weapons arrayed to symbolize military might of victors; Dutch weapons appear less organized and inconsequential
 - Imaginary landscape of Breda tenderly rendered in the background; a cross is formed in a distant lake—symbolic of Catholic domination over Protestant forces
 - Soldiers' mutual respect in honoring the valor of the other side
 - Open space in center of painting emphasizes the keys and the symbolism of a city resigned
 - Velázquez never met the Dutch, nor had he been to Breda

Figure 20.22: Diego Velázquez, *The Surrender of Breda*, 1634–1635, oil on canvas, Prado, Madrid

Diego Velázquez, *Las Meninas*, 1656, oil on canvas, Prado, Madrid (Figure 20.23)

- Group portrait of the artist in his studio at work; he steps back from the canvas and looks at the viewer
- Velázquez wears the cross of the Royal Order of Santiago, elevating him to knighthood
- Central is the Infanta Margharita of Spain with her meninas, or attendants, a dog, a dwarf, and a midget. Behind are two chaperones in half-shadow. In the doorway is perhaps José Nieto, who was head of the queen's tapestry works (hence his hand on a curtain)
- King and queen appear in a mirror. But what is the mirror reflecting: Velázquez's canvas? The king and queen standing in our space (is this why people have turned around?). Or is it reflecting a painting of the king and queen on our wall of the room?
- Alternating darks and lights draw us deeper into the canvas; the mirror simultaneously reflects out into our space
- Dappled effect of light on shimmering surfaces
- Painting originally hung in Philip IV's study

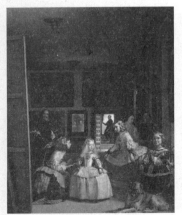

Figure 20.23: Diego Velázquez, *Las Meninas*, 1656, oil on canvas, Prado, Madrid

Major Works of Flemish Baroque Art

Peter Paul Rubens, central panel of *Raising of the Cross*, 1610–1611, oil on canvas, Cathedral, Antwerp (Figure 20.24)

- Triptych acts as one continuous space across the three panels
- Strong diagonals direct viewer's attention to Christ
- Heroic musculature of figures
- Spontaneity of expression
- Dramatic use of lighting
- Intensely religious, yet possessing exuberance and passion

Figure 20.24: Peter Paul Rubens, central panel of *Raising of the Cross*, 1610–1611, oil on canvas, Cathedral, Antwerp

Peter Paul Rubens, *Marie de' Medici Cycle*, 1622–1625, oil on canvas, Louvre, Paris (Figure 20.25)

- Heroic gestures, demonstrative spiraling figures
- Mellow intensity of color, inspired by Titian and Caravaggio
- Sumptuous full-fleshed women
- Twenty-one huge historical paintings allegorically retelling the life of Marie de' Medici, Queen of France, wife of Henry IV
- Splendid costumes suggest opulent theatrical production
- Allegories assist in telling the story and mix freely with historical people
- Marie arrives in France after a sea voyage guarded by Neptune and sea nymphs; France falls to her feet to greet her; angel with two trumpets heralds her arrival; Marie dressed in silver is almost lost in the crowd of welcoming figures

Anthony Van Dyck, *Charles I Dismounted*, c. 1635, oil on canvas, Louvre, Paris (Figure 20.26)

- Charles I of England walking before his bowing horse
- Image of royalty at ease in a natural setting
- Engages the viewer with a direct look, haughty pose
- Hat frames the head
- Charles's shortness minimized by his relationship to the figures around him
- Venetian landscape

Figure 20.25: Peter Paul Rubens, *Arrival of Marie de'Medici in Marseilles*, 1622–1625, oil on canvas, Louvre, Paris

Figure 20.26: Anthony Van Dyck, *Charles I Dismounted*, c. 1635, oil on canvas, Louvre, Paris

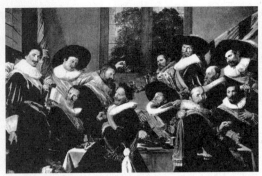

Figure 20.27: Frans Hals, *Officers of the Haarlem Militia Company of Saint Adrian*, c. 1627, oil on canvas, Frans Hals Museum, Haarlem

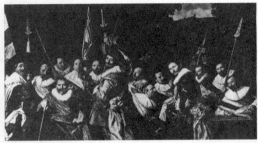

Figure 20.28: Frans Hals, *Archers of the Saint Hadrian*, c. 1633, oil on canvas, Frans Hals Museum, Haarlem

Figure 20.29: Judith Leyster, *Self-Portrait*, c. 1633, oil on canvas, National Gallery, Washington

Figure 20.30: Rembrandt van Rijn, *Self-Portrait* , c. 1659–1660, oil on canvas, Kenwood House, London

Major Works of Dutch Baroque Art

Frans Hals, *Officers of the Haarlem Militia Company of Saint Adrian*, c. 1627, oil on canvas, Frans Hals Museum, Haarlem (Figure 20.27) and *Archers of the Saint Hadrian*, c. 1633, oil on canvas, Frans Hals Museum, Haarlem (Figure 20.28)

- Specialist in single portraits, marriage portraits, and group portraits
- Achieved fame by painting complex groupings of Dutch fraternal organizations
- Although ostensibly military, the groupings reveal the relative social positions of the people in the works
- Creative arrangement of figures: some standing, some seated, according to their position in society
- Impasto technique
- Lively, quick, and amiable expressions on the figures
- Uniformity of dress not a deterrent to a lively composition, dramatic colors
- *1627 painting:* sharp use of compositional diagonals form a focus at the center of the painting; two distinct groups; lively exchange of conversation, food, and drink; animated faces, some engaging us, others turn to one another
- *1633 painting:* two distinct groups showing a split in the political and social structure of the company; group on right more relaxed; group on left surrounds Colonel Loo, who is authoritarian and commanding; shows Hals's ability to assess personalities and characters

Judith Leyster, *Self-Portrait*, c. 1633, oil on canvas, National Gallery, Washington (Figure 20.29)

- Self-portrait shows a self-consciously secure artist at work at her craft
- Turns affably around to chat, while engaged in her work
- Painting a fiddler who also turns and smiles at us
- Impasto brushwork reminiscent of Hals, whom Leyster knew and was inspired by
- Image of the successful capable artist

Rembrandt van Rijn, *Self-Portrait*, oil on canvas, c. 1659–1660, Kenwood House, London (Figure 20.30)

- Rembrandt did many self-portraits revealing great psychological tension
- They capture his various states of mind: suffering, dignified, weariness, satisfaction
- Penetrating gazes
- Soft chiaroscuro lighting

Rembrandt van Rijn, *Anatomy Lesson of Dr. Tulp*, 1632, oil on canvas, Mauritshuis, The Hague, Netherlands (Figure 20.31)

- Rembrandt's first group portrait
- Specific anatomy lesson of January 1632; public anatomy lessons lasted four to five days and were held indoors in the winter
- Dr. Tulp is seated in a place of honor; wears a rimmed hat that is an academic badge of a chairman; his hands are prominently displayed
- Compares the corpse with the drawing in a great book on the right, and the positioning of his own arm
- Influenced by Caravaggio and Tenebroso

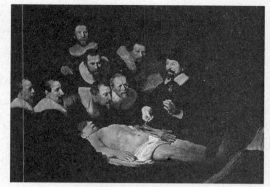

Figure 20.31: Rembrandt van Rijn, *Anatomy Lesson of Dr. Tulp*, 1632, oil on canvas, Mauritshuis, The Hague, Netherlands

Rembrandt van Rijn, *Night Watch*, 1642, oil on canvas, Rijksmuseum, Amsterdam (Figure 20.32)

- Eighteen men portrayed in the commission, represented according to how much each paid; individual sitters knew beforehand whether they would be partially or fully represented
- Militia marching out on patrol, or on parade
- Captain Cocq holds a baton and wears a red sash; speaking as he comes forward, perhaps ordering Lt. Ruytenburgh to make the men march
- Emphasis on the glove, a challenge or a victory, highlighted by the gold background
- Lt. Ruytenburgh holds a partisan, is dressed in yellow, and accompanies the captain
- Central group comes forward, subordinate lateral groups move behind
- Allegorical figure of girl in gold carrying a large white chicken dangling from her waist; girl is a kind of mascot; the claws of the chicken symbolize the militia called the Arquebusiers after the gun featured in the painting
- Painted for an assembly hall as part of a group of paintings of various militias
- Painting later cut down on all sides when it was moved from its original position
- Misnamed painting; thought to have been a nocturnal scene because of the grime accumulated over the years

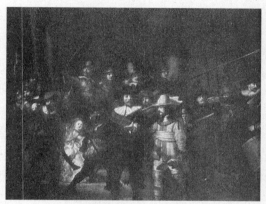

Figure 20.32: Rembrandt van Rijn, *Night Watch*, 1642, oil on canvas, Rijksmuseum, Amsterdam

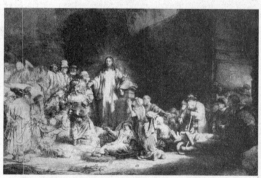

Figure 20.33: Rembrandt van Rijn, *Christ with the Sick, Receiving Children "The Hundred Guilder Print,"* c. 1649, etching, Morgan Library, New York

Rembrandt van Rijn, *Christ with the Sick, Receiving Children "The Hundred Guilder Print,"* c. 1649, etching, Morgan Library, New York (Figure 20.33)

- Jesus feels the pain of the infirm and the handicapped, touching and preaching (Matthew 19); intense and emotional rendering of poignant scene in the New Testament
- Great contrasts of dark recession on right with lightly sketched left side
- So-called 100 Guilder Print, because of the high price the print earned when sold

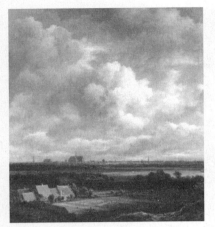

Figure 20.34: Jacob van Ruisdael, *View of Haarlem from the Dunes at Overveen*, c. 1670, oil on canvas, Maurithuis, The Hague, Netherlands

Jacob van Ruisdael, *View of Haarlem from the Dunes at Overveen*, **c. 1670, oil on canvas, Maurithuis, The Hague, Netherlands (Figure 20.34)**

* Landscape portrays a landfill project of 1650–1670 that reclaimed huge tracts of land from the sea
* Flat land animated by alternating dark and light effects that deepen the perspective and draw the eye into the composition
* Bleached linen, a local industry, dries in the sunlight, and adds diagonal lines of depth to the composition
* Animated and boldly rendered sky

Jan Vermeer, *The Music Lesson*, **1662, oil on canvas, Buckingham Palace, London (Figure 20.35)**

* Small number of Vermeer works in existence
* Except for two landscapes, Vermeer's works portray intimate scenes in the interior of Dutch homes
* Viewer looks into a private world in which seemingly small gestures take on a significance greater than what first appears
* Figures seem unaware of our presence
* Light enters from the left and warmly highlights textures and surfaces: woven table covering, marble checkerboard floor, ceramic jug, wooden cello, upholstered chair, woman's reflection in the mirror, etc.

Figure 20.35: Jan Vermeer, *The Music Lesson*, 1662, oil on canvas, Buckingham Palace, London

Major Works of French Baroque Art

Claude Lorrain, *Embarkation of the Queen of Sheba*, **1648, National Gallery, London (Figure 20.36)**

* Episode taken from 1 Kings 10
* Queen at left leaves a palace to enter a small boat to transition to the large boat in the distance
 * Framing elements on left and right of canvas's center relatively empty with a shimmering rising sun
 * Composition is backlit with waves picking up sunlight
 * Anachronistic combination of images: Roman ruins, medieval tower, and Baroque palace
 * Landscape dominates; people are relatively insignificant
 * Proportions in fifths: horizon two-fifths of height of painting; columns at left and palace at right occupy one-fifth of the composition each

Nicolas Poussin, *Et in Arcadia Ego*, **c. 1655, oil on canvas, Louvre, Paris (Figure 20.37)**

* Poussin believed paintings should edify, show moral meanings, be didactic
* Inscription on memorial: "I too am in Arcadia"

Figure 20.36: Claude Lorrain, *Embarkation of the Queen of Sheba*, 1648, National Gallery, London

- Ill-educated shepherds, who live an idyllic life, find it difficult to read the inscription on the tombstone
- Allegorical female figure of Arcadia gently places her hand on the back of one of the shepherds
- Shepherd reading inscription has a shadow that forms the figure of the Grim Reaper
- Background suggests youthful trees, mature trees, and dead trunks

Figure 20.37: Nicolas Poussin, *Et in Arcadia Ego*, c. 1655, oil on canvas, Louvre, Paris

Hyacinthe Rigaud, *Louis XIV*, 1701, oil on canvas, Louvre, Paris (Figure 20.38)

- Louis XIV is every inch the Baroque absolute ruler in a Baroque setting wearing Baroque costuming; he is 63 yet appears in his coronation robes
- A slow, stately procession through Versailles
- Wigged, bedecked with elaborate velvet robes, scepter in hand, crown at his side, sword noticeably placed as a military weapon and a phallic symbol
- Proud of his legs, Louis exposes them for us to admire
- Looks down on us

VOCABULARY

Baldacchino: a canopy placed over an altar or a shrine (Figure 20.13)

Genre painting: painting in which scenes of everyday life are depicted (Figure 20.21)

Impasto: a thick and very visible application of paint on a painting surface

Poussinistes and **Rubénistes:** admirers and imitators of Poussin and Rubens, respectively. The former felt that Poussin's mastery of drawing, composition, and emotional restraint were superior. The latter found greater value in Rubens's use of color, rich textures, and highly charged emotions

Figure 20.38: Hyacinthe Rigaud, *Louis XIV*, 1701, oil on canvas, Louvre, Paris

Quadro riportato and **Di sotto in sù:** both are types of ceiling paintings. Quadro riportato is a wall mural that is executed on a curved ceiling vault (Figure 20.19). To view a quadro riportato work, one must stand in a particular spot in order for it to appear right side up. The Sistine Chapel ceiling is done in quadro riportato. In contrast, di sotto in sù ("from the bottom up") works are ceiling paintings in which the figures seem to be hovering above the viewers, often looking down at us (Figure 20.20). Mantegna's *Room of the Newlyweds* (Figure 16.17) is painted in di sotto in sù

Tenebroso/Tenebrism: a dramatic dark and light contrast in a painting (Figure 20.16)

Vanitas: a theme in still life painting that stresses the brevity of life and the folly of human vanity

Summary

The Baroque has always symbolized the grand, the majestic, the colorful, and the sumptuous in European art. While the work of Rubens and Bernini and the architecture of Versailles certainly qualify as this view of the Baroque, the period is equally famous for small Dutch paintings of penetrating psychological intensity and masterful interplays of light and shadow.

Illusion is a key element of the Baroque aesthetic. Whether it be the floating of Saint Theresa on a cloud or the tromp l'oeil ceilings of Roman palaces, the Baroque teases our imagination by stretching the limits of the space deep into the picture plane. The same complexity of thought is applied to intriguing and symbolic still lifes, known as vanitas paintings, or intricate groupings of figures such as the *Night Watch* (Figure 20.32) or *Las Meninas* (Figure 20.23).

The Baroque is characterized by a sense of ceaseless movement. Building façades undulate, sculptures are seen in the round, and portraits show sitters ready to speak or interact with the viewer. Even the most classicist painters of the age, like Poussin or Claude, revel in figures that move with elegance and grace across a picture plane. More naturalist painters, like Caravaggio and Gentileschi, use dramatic contrasts of light and dark to highlight the movement of the figures.

The Baroque achieves a splendor through an energetic interaction reminiscent of Hellenistic Greek art, which serves as its original role model.

Practice Exercises

CHALLENGE

1. St. Charles of the Four Fountains is an unusual Baroque building because of its

 (A) rich decorative textures of various colors
 (B) large staircase preceding the entrance
 (C) undulating forms
 (D) small size

2. Vanitas paintings deal with

 (A) human folly
 (B) corruption in high places
 (C) ceiling paintings
 (D) imitating sculpture

3. An artist known for his impasto technique is

 (A) Guido Reni
 (B) Nicolas Poussin
 (C) Claude Lorrain
 (D) Frans Hals

4. The direct influence of Caravaggio can be seen in works by other painters, especially

 (A) Diego Velázquez's *Water Carrier of Seville*
 (B) Anthony Van Dyck's *Charles I Dismounted*
 (C) Jacob van Ruisdael's *View of Haarlem*
 (D) Hyacinthe Rigaud's *Louis XIV*

5. Patronage in the Baroque period comes principally from the aristocracy or the Church except in

 (A) Flanders
 (B) Spain
 (C) Holland
 (D) France

6. Portrait painters, such as Rembrandt van Rijn, were noted for their

 (A) fidelity to the likenesses of their subjects
 (B) psychological penetration
 (C) equity in arranging individuals in groups
 (D) reliance on classical subject matter

7. The difference between *quadro riportato* and *di sotto in sù* paintings is that di sotto in sù paintings

 (A) have figures that are placed as if they were over your head
 (B) rely on viewing from a single angle
 (C) prefer the classicist trend in the Baroque over the naturalist
 (D) have trees or buildings that frame the composition

8. Saint Paul's Cathedral by Christopher Wren was built

 (A) after the Thirty Years' War
 (B) as a Counter-Reformation statement
 (C) after the War of Spanish Succession
 (D) after the Great Fire of London

9. An important development in the Baroque is interest in landscape architecture. Usually Baroque landscape architects

 CHALLENGE

 (A) try to dominate the building with landscape
 (B) create long avenues for dramatic views
 (C) rely on the circle as the most perfect shape
 (D) imitate great landscape paintings in their work

10. Genre paintings are the specialty of

 (A) Frans Hals
 (B) Hyacinthe Rigaud
 (C) Nicolas Poussin
 (D) Jan Vermeer

Short Essay

Biographer Giovanni Bellori said about Caravaggio in 1672:

> There is no question that Caravaggio advanced the art of painting because he came upon the scene at a time when realism was not much in fashion and when figures were made according to convention and manner and satisfied more the taste for gracefulness than for truth. Thus by avoiding all prettiness and vanity in his color, Caravaggio strengthened his tones and gave them flesh and blood.
>
> —Bellori, *The Lives of Modern Painters, Sculptors and Architects*

Choose and identify a work by Caravaggio. Discuss the validity of Bellori's statement about Caravaggio's work in view of art works that have preceded it. Use one side of a sheet of lined paper to write your essay.

Answer Key

1. (D)	3. (D)	5. (C)	7. (A)	9. (B)
2. (A)	4. (A)	6. (B)	8. (D)	10. (D)

Answers Explained

Multiple-Choice

1. (**D**) Usually Baroque buildings are large, but this building is comparatively small. It has the undulating walls that characterize Baroque buildings, but does not have a large staircase, nor a variously colored interior. White is dominant.

2. (**A**) Vanitas paintings moralize against the folly of human endeavor.

3. (**D**) Many painters used impasto; however, Hals is the only one in this group. The others had a nearly brushless and flat approach to painting.

4. (**A**) The sharp tenebroso of Caravaggio's work can be seen in Velázquez's *Water Carrier of Seville.*

5. (**C**) Holland was unusual in its more middle-class approach to commissioning and creating art. The other countries mentioned were dominated by church and state.

6. (**B**) Above all, Rembrandt van Rijn is remembered for penetrating beneath appearances to reveal a deeper psychological state.

7. (**A**) *Di sotto in sù* paintings appear as though the figures are actually standing above the viewer. Therefore, feet are more prominently displayed than heads, which are further away.

8. (**D**) The Great Fire of London ruined the previous Saint Paul's, a Gothic church, which was on this site. Wren replaced it with a Baroque church.

9. (**B**) Landscape architects liked the limitless view that long avenues would create. They worked their gardens around enhancing such views.

10. (**D**) Vermeer painted genre scenes. Hals and Rigaud painted portraits; Poussin religious and historical scenes.

Rubric for Short Essay

4: The student identifies an appropriate work by Caravaggio and discusses Bellori's assertion that Caravaggio's work is different from paintings from the preceding Mannerist period. There are no major errors.

3: The student identifies an appropriate work by Caravaggio and discusses what Bellori says separates Caravaggio's work from artwork of the preceding Mannerist period. Discussion is less full, and there may be minor errors.

2: The student does not identify a work by Caravaggio, but explains generally how his work is different from the preceding Mannerist period, OR the student identifies an appropriate work by Caravaggio, but offers limited discussion on the contrasts with the prior Mannerist period. There may be major errors.

1: The student identifies only a work by Caravaggio and offers little else of merit, OR the student gives a limited understanding of how Caravaggio's work contrasts with the prior Mannerist period. There may be major errors.

0: The student makes an attempt, but the response is without merit.

Short Essay Model Response

Italian painter Caravaggio exercised a significant influence on the style and techniques of painting toward the end of the 16th century and into the 17th. As biographer Giovanni Bellori described in 1672, Caravaggio veered away from the "manner" and "convention" that marked most of the paintings being produced and opted instead for a more natural style that, as Bellori said, gave his figures "flesh and blood." In particular, Caravaggio's The Calling of St. Matthew from 1599–1602, demonstrates some of these qualities that distinguished the artist's work from that of the Mannerist artists that preceded him.

Like most Mannerist artists, including Pontormo and Tintoretto, Caravaggio often painted religious compositions, such as <u>The Calling of St. Matthew</u>. However, he rids his work of the acidic colors and spiraled arrangements popular among the Mannerists and instead achieves a sense of divinity and spirituality through naturalism. Matthew and the accompanying figures are spread horizontally across the canvas, rather than in the awkward poses of Mannerist work. The figures are shown in contemporary clothing and in a tavern setting that would have been easily identifiable for the viewer. Bringing his religious portrayals closer to the viewer's everyday reality without losing the dignity and spirituality of a religious scene contributed to the "gracefulness for truth" that Bellori finds in Caravaggio's work. He uses careful lighting to sharply highlight specific fragments of his figures against the dark shadows. This creates a heightened drama and tension within the composition but also guides the narrative elements of the scene. Jesus enters at the right edge of the canvas and, despite the slight halo, might be easily overlooked were it not for Caravaggio's authoritative lighting that shines against the side of his face and along his outstretched finger pointing toward Matthew, who, also lit by this supernatural light, echoes the pose. The lighting and composition externalize the importance of this divine event. An otherwise common tavern scene is transformed into <u>The Calling of St. Matthew</u> through the stark lighting, to be known as tenebrism, that Caravaggio uses to both conceal unimportant details and emphasize the identity and holiness of characters like Matthew and Christ.

As Bellori said in 1672, Caravaggio painted with an eye toward realism when Mannerist painting mostly dominated the art scene. In avoiding the tendencies of the Mannerist style and immersing his painting in naturalism of colors, light, and composition, Caravaggio's work, like <u>The Calling of St. Matthew</u>, achieves a spirituality and strength until then unseen. It's these qualities, further described above, that support Bellori's claim that Caravaggio "advanced the art of painting."

—Evan S.

Analysis of Model Response

Evan's excellent response has much to recommend it. He focuses on the quotation and makes it the crux of his answer, making sure that the reader knows that he fully understands the context of the question. Further, he identifies a suitable Caravaggio painting and analyzes the compositional quality of the work in light of prior religious paintings by Mannerists such as Pontormo or Tintoretto. Evan's intimate grasp of the subtleties of the differences between the Mannerists and Caravaggio creates a firm foundation. **This essay merits a 4.**

The Rococo in Europe and Eighteenth-Century English Painting

The Rococo derives its name from a combination of the French *rocaille*, meaning "pebble" or "shell," and the Italian *barocco*, meaning "baroque." Thus, motifs in the Rococo were thought to resemble ornate shell or pebble work.

KEY IDEAS

- The shift of power from the royal court to the aristocrats is paralleled in the shift in taste from the Baroque to the Rococo.
- The French Royal Academy dictated artistic taste in eighteenth-century Paris.
- Rococo architecture seeks to unite the arts in a coherent artistic experience.
- A quintessential Rococo painting is the *fête galante*, which portrays the aristocracy in their leisurely pursuits.
- The Rococo also developed a strong school of satirical painting.

HISTORICAL BACKGROUND

Center stage in early-eighteenth-century politics was the European conquest of the rest of the world. The great struggles of the time took place among the colonial powers, who at first merely established trading stations in the lands they encountered, but later occupied distant places by layering new settlers, new languages, new religions, and new governments onto an indigenous population. At first, Europeans hoped to become wealthy by exploiting these new territories, but the cost of maintaining foreign armies soon began to outweigh the commercial benefits.

As European settlers grew wistful for home, they built Baroque- and Rococo-inspired buildings, imported Rococo fashions and garments, and made the New World seem as much like the Old World as they could.

In France, the court at Versailles began to diminish after the death of Louis XIV, leaving less power in the hands of the king and more in the nobility. Therefore, the

Rococo departs from the Baroque interest in royalty, and takes on a more aristocratic flavor, particularly in the decoration of lavish townhouses that the upper class kept in Paris—not in Versailles.

Patronage and Artistic Life

It was impossible for a Frenchman to make a career in painting without the blessing of the **French Royal Academy**, which insisted on a very traditional style of representation in the fine arts. Artists were trained by studying anatomy and drawing from live models. No artist could succeed without demonstrating his mastery of perspective; this was key to the eighteenth-century understanding of spatial relationships. Women need not apply, because extremely few were admitted, regardless of ability.

The French Academy's training had far-reaching effects. When other countries established their own academies, they took the French as their model. In this way, artists promoted themselves through a distinguished organization that was both elevating and limiting at the same time.

Figure 21.1: Johann Bathasar Neumann, Vierzehnheiligen (Church of the Fourteen Saints), 1743–1772, Staffelstein, Germany

Figure 21.2: Interior of Vierzehnheiligen (Church of the Fourteen Saints), 1743–1772, Staffelstein, Germany

INNOVATIONS OF ROCOCO ARCHITECTURE

There are no straight lines in the Rococo—everything is sophisticated elegance and stylish grace, the height of refinement. Taking the Baroque one step further, Rococo architects made walls pliable surfaces in which forms undulated and curved in such a manner that it is sometimes difficult to determine exactly what shape a building is. Further, Rococo buildings unite the arts of painting, architecture, and sculpture in a complete artistic unity.

Characteristics of Rococo Architecture

Architecture is where Rococo artists best expressed their artistic unity with the other arts. The architect conceives of his building as a work of sculpture, whose walls bend and undulate at his will, creating dynamic and moving spatial environments. Churches avoid stained glass because clear light is needed to shine on the painted walls revealing the delicate interplay of pastel colors. Sculptures are placed everywhere—on altars, on capitals, on cornices—there were no empty spaces. Figures on ceilings often have their legs overlap painted frames that seem to come out into our own space. Rococo art is a living organism of forms that is generated by a single artistic principle: More is more.

Major Work of Rococo Architecture

Johann Bathasar Neumann, Vierzehnheiligen (Church of the Fourteen Saints), 1743–1772, Staffelstein, Germany (Figures 21.1 and 21.2)

- Exterior: undulating forms in a complex arrangement of curved shapes; towers of complicated curvilinear design
- Interior: no straight lines; curves and oval shapes interlock and intertwine; light pastel colors abound; combination of painting sculpture and architecture; Altar of Mercy placed conspicuously in the center

INNOVATIONS OF ROCOCO PAINTING

Just as in architecture, Rococo painting shuns straight lines, even in the frames of paintings. It is typical of **Tiepolo** to have curved frames with delicate rounded forms in which the limbs of several of the figures spill over the sides so that the viewer is hard-pressed to determine what is painted and what is sculpted.

Rococo art is flagrantly erotic, sensual in its appeal to the viewer. The curvilinear characteristics of Rococo paintings enhance their seductiveness. Unlike the sensual paintings of the Venetian Renaissance, these paintings tease the imagination by presenting playful scenes of love and romance with overt sexual overtones.

Although the French are most noted for the Rococo, there were also active centers in England, central Europe, and Venice.

Characteristics of Rococo Painting

Rococo painting is the triumph of the Rubénistes over the Poussinistes. Artists, particularly those of Flemish descent like **Watteau**, were captivated by Rubens's use of color to create form and modeling.

Figures in Rococo painting are slender, often seen from the back. Their light frames are clothed in shimmering fabrics worn in bucolic settings like park benches or downy meadows. Gardens are rich with plant life and flowers dominate. Figures walk easily through forested glens and flowery copses, contributing to a feeling of oneness with nature reminiscent of the Arcadian paintings of the Venetian Renaissance.

Colors are never thick or richly painted; instead, **pastel** hues dominate. Some artists, like Rosalba Carriera, specialized in pastel paintings that possessed an extraordinary lifelike quality. Others transferred the spontaneous brushwork and light palette of pastels to oils.

By and large, Rococo art is more domestic than Baroque, meaning it is more for private rather than public display. **Fête galante** painting, a term typified by Watteau, featured the aristocracy taking long walks or listening to sentimental love songs in garden settings.

Major Works of French Rococo Painting

Jean-Antoine Watteau, *The Return from Cythera*, 1717–1719, oil on canvas, Louvre, Paris (Figure 21.3)

- Submitted painting to the Royal Academy as a presentation piece
- Light and dreamy atmospheric perspective
- Iridescent colors
- Slender, delicate figures
- Arcadian elements
- Asymmetry
- Fête galante
- Venus overlooks the scene, bedecked with flowers
- On right: lady listens to a proposition by a pilgrim carrying a handbook on love, a stick, and a flask
- Gilded boat topped by flying cupids
- Bacchus allusion in the panther hide

Figure 21.3: Jean-Antoine Watteau, *The Return from Cythera*, 1717–1719, oil on canvas, Louvre, Paris

Figure 21.4: Jean-Honoré Fragonard, *The Swing*, 1766, oil on canvas, Wallace Collection, London

- Inspired by a 1700 play
- Indebted to Rubens, Titian, Veronese; *Mona Lisa*–like background

Jean-Honoré Fragonard, *The Swing*, 1766, oil on canvas, Wallace Collection, London (Figure 21.4)

- Figures are small in a dominant gardenlike setting
- Atmospheric perspective
- Puffy clouds; rich vegetation; abundant flowers; sinuous curves
- Patron in lower left looking up the skirt of a young lady who swings flirtatiously, boldly kicking off her shoe at a Cupid sculpture
- Unsuspecting bishop swings her from behind
- An intrigue painting; patron hides in a bower; Cupid asks the young lady to be discreet and/or may be a symbol for the secret hiding of the patron

Marie-Louise-Élisabeth Vigée-Lebrun, *Self-Portrait*, 1790, oil on canvas, Uffizi, Florence (Figure 21.5)

- Forty self-portraits exist, all highly idealized
- Looks at the viewer as she paints a portrait of Marie Antoinette, who is rendered from memory since she was killed during the French Revolution; subject in painting looks admiringly upon the painter
- Light Rococo touch to the coloring
- Inspired by the portraits of Rubens

Figure 21.5 : Marie-Louise-Élisabeth Vigée-Lebrun, *Self-Portrait*, 1790, oil on canvas, Uffizi, Florence

Marie-Louise-Élisabeth Vigée-Lebrun, *Marie Antoinette and Her Children*, 1787, oil on canvas, Versailles, France (Figure 21.6)

- Marie Antoinette, queen of France, had the reputation for being an immoral woman; this painting is done to counteract that image
- Queen as the Mother of France, has known hardship that is expressed in the empty cradle representing her recently deceased child
- Other children gather around her; the future king of France—the dauphin—stands apart on the right
- A modern, secular version of the Holy Family by Raphael; a High Renaissance triangular composition
- Setting in Versailles; the Hall of Mirrors is behind her

Major Work of Italian Rococo Painting

Giambattista Tiepolo, *Apotheosis of the Pisani Family*, 1761–1762, fresco, Villa Pisani, Strà, Italy (Figure 21.7)

- Feeling of limitless space, dazzling light, pastel colors
- Debt to Veronese in drapery
- Di sotto in sù
- Spiraling forms
- Historical and allegorical imagery mixed

Figure 21.6: Marie-Louise-Élisabeth Vigée-Lebrun, *Marie Antoinette and Her Children*, 1787, oil on canvas, Versailles, France

- Painted figures intermix with sculpted figures
- Elaborate frames with curved moldings; legs hang over frame
- Combines real figures with allegories and personifications
- Members of the Pisani family float heavenward among a legion of heavenly attributes

INNOVATIONS OF EIGHTEENTH-CENTURY ENGLISH PAINTING

Freedom of expression swept through France and England at the beginning of the eighteenth century and found its fullest expression in the satires of Jonathan Swift's *Gulliver's Travels* and Voltaire's *Candide*. The visual arts responded by painting the first overt satires, the most famous of which are by the English painter **Hogarth**. Satirical paintings usually were done in a series to help spell out a story as in *Marriage à la Mode* (Figure 21.8). Afterward the paintings were transferred to prints, so that the message could be mass-produced. Themes stem from exposing political corruption to spoofs on contemporary lifestyles. Hogarth knew that the pictorial would reach more people than the written, and he hoped to use his prints to didactically expose his audience to abuses in the upper class. Society had changed so much that by now those in power grew more tolerant of criticism so as to allow satirical painting to flourish, at least in England. Today, the political cartoon is the descendant of these satirical prints.

Figure 21.7: Giambattista Tiepolo, *Apotheosis of the Pisani Family*, 1761-2, fresco, Villa Pisani, Strà, Italy

Characteristics of Eighteenth-Century English Painting

Inspired by the Rococo, English portrait painters of the period derived a style that combined French elitism with grand classical allusions. This elevated style of painting in which figures often adopt the poses of ancient statuary and stand before columns or arches is called **The Grand Manner**. Paintings are marked by full-length life-size figures in cutting-edge fashion. **Reynolds** tended to favor allegorical settings and references; **Gainsborough** was more interested in representing the pastoral glory of the English countryside behind his figures.

Major Works of Eighteenth-Century English Painting

William Hogarth, *The Breakfast Scene* from *Marriage à la Mode*, 1745, oil on canvas, National Gallery, London (Figure 21.8)

- One of six scenes in a suite of paintings called *Marriage à la Mode*
- Narrative paintings; later turned into a series of prints
- Highly satiric paintings about aristocratic English society and those who would like to buy their way into it

Figure 21.8: William Hogarth, *The Breakfast Scene* from *Marriage à la Mode*, 1745, oil on canvas, National Gallery, London

- *Breakfast Scene*: shortly after the marriage, each partner has been pursuing pleasures without the other
 - o Husband has been out all night with another woman (the dog sniffs suspiciously at another bonnet); the broken sword means he has been in a fight and probably lost (and may also be a symbol for sexual inadequacy)
 - o The wife has been playing cards all night, the steward (at left) indicating by his expression that she has lost a fortune at whist; he holds nine unpaid bills in his hand, one was paid by mistake
 - o Turned-over chair indicates that the violin player made a hasty retreat when the husband came home

Thomas Gainsborough, *Blue Boy*, 1770, oil on canvas, Huntington Library, San Marino, California, and *Sarah Siddons*, 1785, oil on canvas, National Gallery, London (Figures 21.9 and 21.10)

- Portrait painter, over seven hundred exist
- Influenced by Watteau in the feathery light-hued landscapes

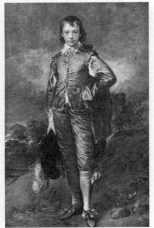

Figure 21.9: Thomas Gainsborough, *Blue Boy*, 1770, oil on canvas, Huntington Library, San Marino, California

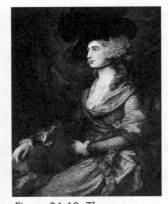

Figure 21.10: Thomas Gainsborough, *Sarah Siddons*, 1785, oil on canvas, National Gallery, London

- Influenced by van Dyck in large formal standing portraits as in *Blue Boy*
- *Blue Boy*: debt to van Dyck in pose and coloring; firmly modeled figure; aristocratic elegance; tasteful color-coordinated drapery; sitter said to be Gainsborough's friend's son, not an aristocrat but an ironmonger; cool blues set off against stormy sky; legend around the work alleges that Gainsborough painted the portrait in blue to prove Reynolds wrong about the viability of blue as a central color in a portrait
- *Sarah Siddons*: aristocratic portrait of actress painted in fashionable dress of the time, not weighed down by allegories and symbols; bold profile even though sitter had a long nose; sitting in a modern chair not a throne; simple curtain symbolizes a theater box; various forms of drapery painted to reflect the texture of each fabric

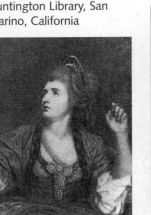

Figure 21.11: Joshua Reynolds, detail of *Sarah Siddons as a Tragic Muse*, 1783–1784, oil on canvas, Huntington Art Gallery, San Marino, California

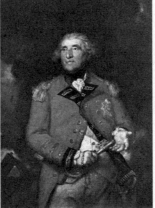

Figure 21.12: Joshua Reynolds, *Lord Heathfield Governor of Gibraltar during the Siege of 1779–83*, 1787, oil on canvas, National Gallery, London

Joshua Reynolds, *Sarah Siddons as a Tragic Muse*, 1783–1784, oil on canvas, Huntington Art Gallery, San Marino, California, and *Lord Heathfield Govenor of Gibraltar during the Siege of 1779–83*, 1787, oil on canvas, National Gallery, London (Figures 21.11 and 21.12)

- Women are flattered; idiosyncratic features are reduced
- Women often have allegories or mythological attributes

- Women are unaffected by relationships, obligations, domestic responsibilities
- Men posed with allegories
- Backgrounds are often perfunctory
- Discrete reference to rank; figures are rarely ostentatious
- Hands have simple gestures
- *Sarah Siddons:* sits enthroned between elements of catharsis: pity and terror; melancholy look on face; Rembrandt-like chiaroscuro and coloring; cf. Michelangelo's *Isaiah* on Sistine Chapel ceiling
- *Lord Heathfield:* English officer holding keys to the fortress of Gibraltar; heroic themes of battle; pensive contemplation of the victory and its costs.

VOCABULARY

Academy: an institution whose main objectives include training artists in an academic tradition, ennobling the profession, and holding exhibitions

Apotheosis: a type of painting in which the figures are rising heavenward (Figure 21.7)

Fête galante: an eighteenth-century French style of painting that depicts the aristocracy walking through a forested landscape (Figure 21.3)

Grand Manner: a style of eighteenth-century painting that features large works with figures posed as ancient statuary or before classical elements such as columns or arches (Figure 21.11)

Pastel: a colored chalk that when mixed with other ingredients produces a medium that has a soft and delicate hue

Summary

The early eighteenth century saw the shift of power turn away from the king and his court at Versailles to the nobles in Paris. The royal imagery and rich coloring of Baroque painting was correspondingly replaced by lighter pastels and a theatrical flair. Watteau's lighthearted compositions, called *fête galantes*, were symbolic of the aristocratic taste of the period.

Partly inspired by the French Rococo, a strong school of portrait painting under the leadership of Gainsborough and Reynolds emerged in England. In addition, English painters and patrons delighted in satirical painting, reflecting a more relaxed attitude in the eighteenth century toward criticism and censorship.

The aristocratic associations of the Rococo caused the style to be reviled by the Neoclassicists of the next generation, who thought that the style was decadent and amoral. Even so, the Rococo continued to be the dominant style in territories occupied by Europeans in other parts of the world—there it symbolized a cultured and refined view of the world in the midst of perceived pagans.

Practice Exercises

1. *Fête Galante* paintings were the specialty of

 (A) William Hogarth
 (B) Joshua Reynolds
 (C) Giambattista Tiepolo
 (D) Jean-Antoine Watteau

2. The satirical works of Swift and Voltaire found visual expression in the paintings of

 (A) Giambattista Tiepolo
 (B) William Hogarth
 (C) Thomas Gainsborough
 (D) Jean-Antoine Watteau

3. Ceiling paintings continued to be painted in the Rococo period by

 (A) Giambattista Tiepolo
 (B) Joshua Reynolds
 (C) Jean-Antoine Watteau
 (D) William Hogarth

CHALLENGE
4. A characteristic of Rococo architecture is its

 (A) adherence to the rules of the French Academy
 (B) influence of the work of Renaissance architects
 (C) union of the various arts
 (D) interest in geometric precision

5. In paintings, Rococo figures are

 (A) heroic
 (B) muscular
 (C) slender
 (D) twisted

6. English eighteenth-century portraits show people

 (A) at home
 (B) at work
 (C) living the high life
 (D) in the countryside

7. Hogarth's narrative suite *Marriage à la Mode* is about how

 (A) society demeans the institution of marriage
 (B) the marriage of two people of widely different ages is unsuitable
 (C) marriage as an institution should be abolished
 (D) peasants do not understand the sacredness of marriage

Question 8 refers to Figure 21.13.

8. Élisabeth Vigée-Lebrun's self-portrait shows her painting the likeness of

 (A) Maria Theresa
 (B) Louis XIV
 (C) Sarah Siddons
 (D) Marie Antoinette

Figure 21.13

9. Pastel paintings were praised for their

 (A) satiric quality
 (B) lifelike realism
 (C) dynamic colors
 (D) linear perspective

10. A common subject of Rococo paintings is

 (A) religious conviction
 (B) historical events
 (C) power and glory
 (D) the pursuit of love

Short Essay

Figure 21.14

Figure 21.15

Self-portraits often reveal as much about the appearance of the artist as well as his or her role as a professional. Identify the artists of these self-portraits and discuss what is being said about the sitter and his or her role as an artist.

Answer Key

1. **(D)**	3. **(A)**	5. **(C)**	7. **(A)**	9. **(B)**
2. **(B)**	4. **(C)**	6. **(D)**	8. **(D)**	10. **(D)**

Answers Explained

Multiple-Choice

1. **(D)** Jean-Antoine Watteau painted fête galante paintings such as *The Return from Cythera*.

2. **(B)** William Hogarth is the only one of this group who is a satirical painter.

3. **(A)** Giambattista Tiepolo is the only one of this group who painted ceilings.

4. **(C)** Rococo architecture joins the various arts together as a united visual experience.

5. **(C)** Rococo figures are slender as in *The Return from Cythera* or *The Swing*.

6. **(D)** English subjects prefer being seen in country settings in their portraits.

7. **(A)** William Hogarth's paintings depict the unfit marriage between the son of a nobleman and the daughter of an alderman.

8. **(D)** Élisabeth Vigée-Lebrun's self-portrait shows her painting a likeness of Marie Antoinette from memory.

9. **(B)** Artists and subjects enjoyed the lifelike qualities pastels brought to portraiture.

10. **(D)** Works by Jean-Antoine Watteau and Jean-Honoré Fragonard attest to love as a principal theme in Rococo paintings.

Rubric for Short Essay	
4:	The student identifies the artists and understands the professional relationship expressed in each painting. Discussion is full and there are no major errors.
3:	The student identifies one artist and provides a full discussion, or identifies both artists and provides an unbalanced discussion. There may be some errors.
2:	The student can provide only the identifications OR one identification and one full discussion OR two full discussions without identifications.
1:	Student provides only one identification OR one discussion. There may be major errors.
0:	The student makes an attempt, but the response is without merit.

Short Essay Model Response

The artists that created these two self portraits are Judith Leyster of the Baroque period and Elisabeth Vigée-Leburn from the Rococo period. Though both are female artists, the two women have different styles of painting and focused on different subjects. Judith Leyster shows through herself portraits a certain confidence about her, she is faced to the viewer, giving the idea that she is talking and very friendly, animated feeling. Leburn, in her self portrait, is also looking at the viewer with a slight smile. Though she is engaged with the viewer, she doesn't seem as confident as Leyster. Both artists also are different in what they are painting in their self portraits. Leyster is painting a fiddler with a large smile while Leburn is painting a portrait of Marie Antoinette showing her admiration for the woman, and as a reminder that she achieved success by working for the queen. Both women show different styles, but in the end it's still an accomplishment that both Leyster and Leburn were known women that were quite successful in their artwork.

—Marsha G.

Analysis of Model Response

Marsha correctly identifies the two artists as Judith Leyster and Vigée-Lebrun (the spelling error is not counted against the student). Both artists are placed properly in their periods (Baroque and Rococo, respectively) although this is not asked for in the question. Marsha points out Leyster's self-conscious "confidence" and "friendly animated feeling," but does not identify this as a sign that the artist has achieved a certain level of recognition and accomplishment. The discussion of Vigée-Lebrun is stronger because it relates the creation of a portrait of Marie Antoinette as a reflection on herself. **This essay merits a 3.**

Neoclassicism

 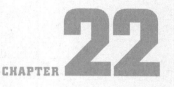

TIME PERIOD: 1750–1815

KEY IDEAS

- The Enlightenment brought about a rejection of royal and aristocratic authority. The Rococo style was replaced by the Neoclassical, which was perceived as more democratic.
- Neoclassicism was inspired by the unearthing of the ruins at Pompeii and the books of art theorist Johann Winckelmann.
- Even if works of art depict current events or contemporary portraits, there are frequent classical allusions.
- The late eighteenth century was the age of the Industrial Revolution: new technologies such as cast iron were introduced into architecture, and for the first time it became more economical to carve from bronze than marble.

HISTORICAL BACKGROUND

The late eighteenth century was the age of the Industrial Revolution. Populations boomed as mass-production, technological innovation, and medical science marched relentlessly forward. The improvements in the quality of life that the Industrial Revolution yielded were often offset by a new slavery to mechanized work and inhumane working conditions.

At the same time, Europe was being swept by a new intellectual transformation called The Enlightenment, in which philosophers and scientists based their ideas on logic and observation, rather than tradition and folk wisdom. Knowledge began to be structured in a deliberate way: Denis Diderot (1713–1784) organized and edited a massive 52-volume French encyclopedia in 1764, Samuel Johnson (1709–1784) composed the first English dictionary singlehandedly in 1755, and Jean-Jacques Rousseau discussed how a legitimate government was an expression of the general will in his 1762 *Social Contract*.

With all this change came political ferment—the late eighteenth century being a particularly transformational moment in European politics. Some artists, like David, were caught up in the turbulent politics of the time and advocated the sweeping societal changes that they thought the French Revolution espoused.

Patronage and Artistic Life

Rome was the place to be—to see the past. New artistic life was springing up all over Europe, leaving Rome as the custodian of inspiration and tradition, but not of

progress. Italy's seminal position as a cultural cornucopia was magnified in 1748 by the discovery of the buried city of Pompeii. Suddenly genuine Roman works were being dug up daily, and the world could admire an entire ancient city.

The discovery of Pompeii inspired art theorist Johann Winckelmann (1717–1768) to publish *The History of Ancient Art* in 1764, which many consider the first art history book. Winckelmann heavily criticized the waning Rococo as decadent, and celebrated the ancients for their purity of form and crispness of execution.

Because of renewed interest in studying the ancients, art academies began to spring up around Europe and in the United States. Artists were trained in what the Academy viewed as the proper classical tradition—part of that training sent many artists to Rome to study works firsthand.

The French Academy showcased selected works by its members in an annual or biannual event called the **Salon**, so-called because it was held in a large room, the Salon Carrè, in the Louvre. Art critics and judges would scout out the best of the current art scene, and accept a limited number of paintings for public view at the Salon. If an artist received this critical endorsement, it meant his or her prestige greatly increased, as well as the value of his paintings.

The Salons had very traditional standards, insisting on artists employing a flawless technique with emphasis on established subjects executed with conventional perspective and drawing. History paintings, that is, those paintings dealing with historical, religious, or mythological subjects, were most prized. Portraits were next in importance, followed by landscapes, genre paintings, and then still lifes.

No education was complete without a **Grand Tour** of Italy. Usually under the guidance of a connoisseur, the tour visited cities like Naples, Florence, Venice, and Rome. It was here that people could immerse themselves in the lessons of the ancient world and perhaps collect an antiquity or two, or buy a work from a contemporary artist under the guidance of the connoisseur. The blessings of the Neoclassical period were firmly entrenched in the mind of art professionals and educated amateurs.

INNOVATIONS OF NEOCLASSICAL ARCHITECTURE

The great technological advance in eighteenth-century architecture was the introduction of cast iron. Classicists saw the daring use of exposed iron as an anathema because ancient buildings with their massive stone walls were to them the only acceptable building medium. Gradually, however, even the most conservative architects recognized the strength and economy of metal construction and used these materials in the substructure or behind the walls of stone or wood buildings.

In Coalbrookdale, England, a family of ironmongers who established a village industry needed to get their products across the river to market. They constructed the first structure made of iron, a bridge (Figure 22.4), and proved that this new material could be both a structural and aesthetic success. In the nineteenth century, iron transformed the history of architecture.

Characteristics of Neoclassical Architecture

The best Neoclassical buildings were not dry adaptations of the rules of ancient architecture, but a clever revision of classical principles onto a modern framework. While many buildings had the outward trappings of Roman works, they were also efficiently tailored to living in the eighteenth century.

Ancient architecture came to Europe distilled through the books written by the Renaissance architect Andrea Palladio, and reemphasized by the classicizing works of Inigo Jones. From these sources Neoclassicists learned about symmetry, balance, composition, and order. Greek and Roman columns, with their appropriate capitals, appeared on the façades of most great houses of the period, even in the remote hills of Virginia. Pediments crown entrances and top windows. Domes grace the center of homes, often setting off gallery space. The interior layout is nearly or completely symmetrical, with rectangular rooms mirroring one another on either side of the building. Each room is decorated with a different theme, some inspired by the ancient world, others with a dominant color in wallpaper or paint. It is common for an eighteenth-century home, like the White House or **Chiswick House** (Figure 22.1), to have a green room or a red room. Others, like those designed by Robert Adam, had an Etruscan room or a classical entrance gallery.

Major Works of Neoclassical Architecture

Richard Boyle and William Kent, Chiswick House, 1725, London, England (Figure 22.1)

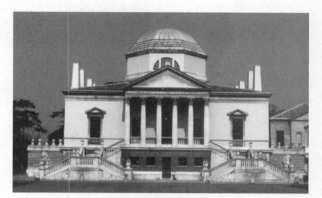

Figure 22.1: Richard Boyle and William Kent, Chiswick House, 1725, London, England

- Boyle: amateur architect
- Kent: interior and garden designer
- Influence of Palladio's Villa Rotunda (Figure 18.13); Palladio's statue is placed at far left; Palladian motif of the decorated balls on the balustrade of the main floor; Palladian low dome; main floor raised over exposed basement level; pediments over windows and doors
- Jones statue at far right (father of English classicism)
- Symmetrical balance of façade, even chimneys are balanced
- Un-Italian are the large semicircular dome windows and obelisk-like chimneys
- Rusticated bottom floor influenced by Italian Renaissance buildings
- Clear, open, white stone surface above, with no ornamentation
- Baroque tradition lingers in the double staircase that changes view as it ascends

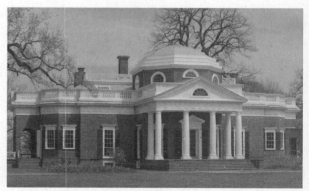

Figure 22.2: Thomas Jefferson, Monticello, 1770–1806, Charlottesville, Virginia

- Domed central room is an art gallery containing busts and paintings
- Not a residence, but a pavilion where Boyle would entertain guests and show his art collection
- Richly decorated rooms of brilliant color

Thomas Jefferson, Monticello, 1770–1806, Charlottesville, Virginia (Figure 22.2)

- "Little mountain" in Italian
- Chief building on Jefferson's plantation

- Symmetrical interior design
- Brick building, stucco applied to trim to give the effect of marble
- Tall French doors and windows to allow circulation in hot Virginia summers
- Appears to be a one-story building with a dome, but the balustrade hides the second floor
- Inspired by Palladian villas in Italy and Roman ruins in France
- Octagonal dome
- Jefferson obsessed with saving space in his home: very narrow spiral staircases, beds in alcoves or in walls between rooms

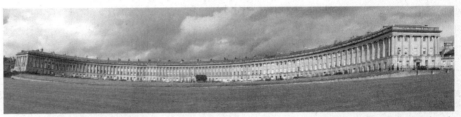

Figure 22.3: John Wood the Younger, The Royal Crescent, 1769–1775, Bath, England

John Wood the Younger, The Royal Crescent, 1769–1775, Bath, England (Figure 22.3)

- Bath is a summer resort where the wealthy can take in the health benefits of the naturally warmed waters
- Wood's Roman design is in keeping with Bath being an ancient Roman city
- Thirty residences in an elliptical sweep
- 114 grand Ionic columns rhythmically framing windows; central house marked by two pairs of double columns and a lunette over the main window
- Balustraded cornice unifies composition
- Typical English chimney pots placed at rhythmically spaced points along the roofline
- English characteristic of great length of the crescent
- Façade is Wood's design, back of houses constructed to the buyer's tastes; no two houses are identical

- Public rooms on the second floor of the houses to provide a majestic view down the hill below; parlor (on the *piano nobile*, or main floor, always raised above street level) is 36′ long and 20–25′ deep

Abraham Darby and Thomas Pritchard, Coalbrookdale Bridge, 1776–1779, England (Figure 22.4)

- First substantial structure made of iron
- Five parallel metal Roman arches
- Cast iron is brittle, but the clever design has made the bridge stand effectively

Figure 22.4: Abraham Darby and Thomas Pritchard, Coalbrookdale Bridge, 1776–1779, England

INNOVATIONS OF NEOCLASSICAL PAINTING

The Neoclassical spirit encouraged artists to cloak their modern sitters in ancient garb, and to ennoble their faces to make their appearance seem more antique. For example, Canova's now destroyed sculpture of George Washington had him dressed as a Roman general. However, Benjamin West was the first (in 1771) to take epic contemporary events and wrap the figures in modern rather than ancient drapery in *The Death of General Wolfe* (Figure 22.6).

Characteristics of Neoclassical Painting

Stories from the great epics of antiquity spoke meaningfully to eighteenth-century painters. Mythological or Biblical scenes were painted with a modern context in mind. The retelling of the story of the Horatii would be a dry academic exercise if it did not have the added implication of self-sacrifice for the greater good. A painting like this was called an **exemplum virtutis**.

Even paintings that did not have mythological references had sub-texts inviting the viewer to take measure of a person, a situation, and a state of affairs. Copley's portrait of **Samuel Adams** (Figure 22.5) is as much an understanding of Adams' likeness and character as it is a statement about the Boston Massacre.

Compositions in Neoclassical paintings were symmetrical, with linear perspective leading the eye into a carefully constructed background. The most exemplary works were marked by invisible brushwork and clarity of detail.

Figure 22.5: John Singleton Copley, *Samuel Adams*, c. 1770–1772, oil on canvas, Museum of Fine Arts, Boston

Major Works of Neoclassical Painting

John Singleton Copley, *Samuel Adams*, c. 1770–1772, oil on canvas, Museum of Fine Arts, Boston (Figure 22.5)

- Portrait contains a forceful and direct gaze, engaging the spectator in a confrontation; focus on the head
- Figure up close to the picture plane
- Rich colors, concentration on reflective surfaces
- Meticulous handling of paint
- Adams pointing in an animated way at the Massachusetts charter; confronting the Massachusetts governor over the Boston Massacre; powerful gesture

Benjamin West, *Death of General Wolfe*, 1771, oil on canvas, National Gallery, Ottawa (Figure 22.6)

Figure 22.6: Benjamin West, *Death of General Wolfe*, 1771, oil on canvas, National Gallery, Ottawa

- Scene depicting the Battle of Quebec in 1759
- West shows the entire battle in the background of the painting: English boats unloading their cannon in early morning at extreme right; cannon put in place in center distance at mid-morning; battle at left with Quebec cathedral breaking through the smoke
- Very short battle, French in disarray and running from the battle scene

Figure 22.7: Angelica Kauffmann, *Cornelia Pointing to Her Children as Treasures*, 1785, oil on canvas, Virginia Museum of Fine Arts, Richmond

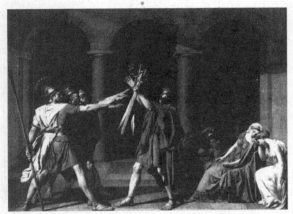

Figure 22.8: Jacques-Louis David, *Oath of the Horatii*, 1784, oil on canvas, Louvre, Paris

- French colors captured at left and brought to General Wolfe before his death
- Wolfe died of sniper shots to the wrist, groin (not painted), and side
- Wolfe died nearly alone, but in the painting he is surrounded by friends and admirers
- Wolfe's unflattering looks, his cleft chin, his large protruding eyes, his small mouth, and his upturned nose are minimized in his upturned heavenward glance
- Compositional arrangement in thirds reflects triptych-like compositions of the Renaissance; triangular units reflect High Renaissance paintings
- Religious associations of the victory: Protestantism over Catholicism
- Wolfe bathed in the pool of light; he is in the pose of Christ being taken down from the cross
- Wolfe's pose also cf. *Dying Gaul* (Figure 5.18) and Michelangelo's *Pietà* (Figure 17.17)
- Native American sets the scene as the Americas and contemplates the consequences of Wolfe's victory
- Great innovation in portraying Wolfe in contemporary costume rather than Roman robes

Angelica Kauffmann, *Cornelia Pointing to Her Children as Treasures*, 1785, oil on canvas, Virginia Museum of Fine Arts, Richmond (Figure 22.7)

- Exemplum virtutis
- Story and setting is Roman, with figures before an Italianate background
- Cornelia, a noble woman, is shown jewelry by a visitor who asks to see Cornelia's jewels
- Cornelia responds that her children are her jewels and presents her sons; interestingly, her daughter who is fascinated by the jewel box, is not presented in this light
- A truly noble woman places her children above material possessions

Jacques-Louis David, *Oath of the Horatii*, 1784, oil on canvas, Louvre, Paris (Figure 22.8)

- Exemplum virtutis
- Story of three Roman brothers (the Horatii) who do battle with three other brothers (the Curiatii—not painted) from a nearby city; they pledge their fidelity to their father and to Rome
- One of the three women on right is a Horatii engaged to one of the Curiatii brothers; another woman is the sister of the Curiatii brothers
- Forms are vigorous, powerful, animated, emphatic
- Gestures are sweeping and unified

- Figures pushed to the foreground
- Neoclassical drapery and tripartite composition
- Not Neoclassical in its Caravaggio-like lighting and un-Roman architectural capitals
- Painted under royal patronage

Jacques-Louis David, *Death of Marat*, 1793, oil on canvas, Museum of Ancient Art, Brussels (Figure 22.9)

- Marat was a leader of the French Revolution, who was stabbed in his bathtub by Charlotte Corday, a more moderate revolutionary who denounced the killing of the king
- Suffering from skin cancer, Marat took baths for hours to relieve the itch; he is not shown with the effects of cancer except for his turban soaked in vinegar, thought to have been a cure
- His desk is set up in the tub so he can do work; killed at the moment of issuing a letter of condolences
- Killed with a butcher knife with blood still on the handle
- Pose is the Descent from the Cross, or Michelangelo's *Pietà* (Figure 17.17)
- Tombstonelike desk inscribed "To Marat, David, Year 2" reflecting the French Revolution's reordering of the calendar
- Caravaggio-like lighting

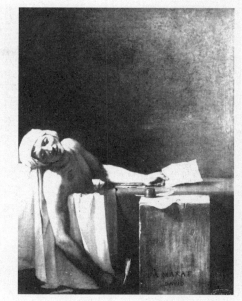

Figure 22.9: Jacques-Louis David, *Death of Marat*, 1793, oil on canvas, Museum of Ancient Art, Brussels

INNOVATIONS OF NEOCLASSICAL SCULPTURE

Prior to the Industrial Revolution, bronze was the most expensive and most highly prized sculptural medium. Mass production of metal made possible by factories in England and Germany caused the price of bronze to fall, while simultaneously causing the price of marble to rise. Stonework relied on manual labor, a cost that was now going up. However, because it was felt that the ancients preferred marble, it still seemed more authentic, possessing an authoritative appeal. It was also assumed that the ancients preferred an unpainted sculpture, because the majority of marbles that have come down to us have lost their color.

The recovery of artifacts from Pompeii increasingly inspired sculptors to work in the classical medium. This reached a fever pitch with the importation of the Parthenon sculptures, the Elgin Marbles, to London, where they were eventually purchased by the state and ensconced in the Neoclassical British Museum. Sculptors like **Canova** saw the Neoclassical style as a continuance of an ancient tradition.

Characteristics of Neoclassical Sculpture

Sculpture, while deeply affected by classicism, also was mindful of the realistic likeness of the sitter. Sculptors moved away from figures wrapped in ancient robes to more realistic figural poses in contemporary drapery. Classical allusions were kept to a secondary influence. Still, Neoclassical sculpture was carved from white marble with no paint added, the way it was felt the ancients worked.

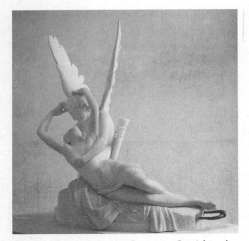

Figure 22.10: Antonio Canova, *Cupid and Psyche*, 1787–1793, marble, Louvre, Paris

Major Works of Neoclassical Sculpture

Antonio Canova, *Cupid and Psyche*, 1787–1793, marble, Louvre, Paris (Figure 22.10)

- Smooth, polished surfaces
- Classical nudes preferred, sensuality of the flesh
- Exploited marble's sensitivity to chiaroscuro
- Said to have been inspired by a painting found at the Roman ruins of Herculaneum
- Psyche has fainted after opening a vase that Venus commanded her not to open; revived by Cupid's kiss
- Adept handling of multiple views and negative space

Antonio Canova, *Pauline Borghese as Venus*, 1808, marble, Galleria Borghese, Rome (Figure 22.11)

- Napoleon's sister posed as Venus, possessing an apple, Venus's attribute
- Pauline noted for her licentiousness
- Work does not intend to seduce; pose not realistic
 - Very few people allowed to see the sculpture
 - Very risqué for the wife of the ruler of Rome

VOCABULARY

Exemplum virtutis: a painting that tells a moral tale for the viewer (Figure 22.8)

Grand Tour: In order to complete their education young Englishmen and Americans in the eighteenth century undertook a journey to Italy to absorb ancient and Renaissance sites

Salon: a government-sponsored exhibition of artworks held in Paris

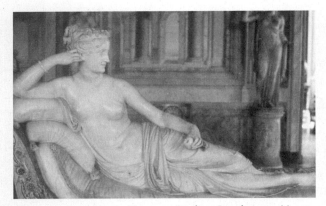

Figure 22.11: Antonio Canova, *Pauline Borghese as Venus*, 1808, marble, Galleria Borghese, Rome

Summary

Intellectuals influenced by the Enlightenment were quick to reject the Rococo as decadent, and espoused Neoclassicism as a movement that expressed the "Liberty, Equality, and Fraternity" of the French Revolution. Moreover, the discovery of Pompeii and the writings of Johann Winckelmann, the first art historian, did much to revive interest in the classics and use them as models for the modern experience.

Neoclassical painting and sculpture was so dominated by the spirit of Greece and Rome that contemporaries were often clothed in antique robes to indicate an affinity with the deeds and events of the ancient world. One of the reasons why West's *Death of General Wolfe* broke new ground is because of its daring rejection of ancient dress. Other artists, like David, Kauffmann, and Canova, unashamedly drew inspiration from the ancients and used these ideas as commentaries on the modern world.

Practice Exercises

1. The *Death of General Wolfe* was a groundbreaking work because

 (A) it was painted about a contemporary event
 (B) the figures were dressed in modern clothes
 (C) the figures were grouped symmetrically
 (D) the scene is historically accurate

2. The Coalbrookdale Bridge is important in the history of architecture because it

 (A) is made of iron
 (B) uses a suspension system
 (C) is based on Roman models
 (D) spans a wide river

3. Even though Jacques-Louis David is considered a Neoclassical artist, his artwork appears to be at least partly inspired by nonclassical artists like

 (A) Titian
 (B) El Greco
 (C) Caravaggio
 (D) Jean-Antoine Watteau

4. Neoclassical architects were strongly influenced by the work of

 (A) Christopher Wren
 (B) Andrea Palladio
 (C) Francesco Borromini
 (D) Antonio Canova

5. The Royal Crescent was built so that its residents could take advantage of

 (A) a nearby villa
 (B) a spa
 (C) a palace
 (D) living in a suburban environment

6. Neoclassicists assumed that

 (A) the ancients preferred to work in bronze
 (B) that ancient sculpture was painted
 (C) Pompeii was the center of ancient art
 (D) sculpting in marble was continuing the tradition set in the ancient world

7. Neoclassical paintings are characterized by

 (A) visible brushwork
 (B) references to medieval art
 (C) meticulous handling of paint
 (D) Baroque grandeur

CHALLENGE

8. Johann Winckelmann is important to art history because he

 (A) unearthed the ruins at Pompeii
 (B) assisted in the making of cast iron
 (C) instructed Jefferson on how to build Monticello
 (D) wrote the first art history book

9. Antonio Canova's sculptures

 (A) are rough to the touch
 (B) exploit the sensuality of the flesh
 (C) were never exhibited in his lifetime
 (D) were carved by assistants

10. In Jacques-Louis David's *Death of Marat* it is assumed that the viewer is aware of Michelangelo's

 (A) *David*
 (B) *Creation of Adam*
 (C) *Moses*
 (D) *Pietà*

Short Essay

Figure 22.12

This painting was painted by Jacques-Louis David in the eighteenth century. Who is the subject of the work? How and why does David modify the historical reality behind the work of art?

Answer Key

1. **(B)** 3. **(C)** 5. **(B)** 7. **(C)** 9. **(B)**
2. **(A)** 4. **(B)** 6. **(D)** 8. **(D)** 10. **(D)**

Answers Explained

Multiple-Choice

1. **(B)** It was the custom to paint contemporary scenes, even some portraits, in antique garb. West's painting breaks new ground by using modern dress.

2. **(A)** The Coalbrookdale Bridge is the first major building designed with iron.

3. **(C)** Caravaggio's nonclassical and often lurid lighting is used by David in *The Death of Marat* and *Oath of the Horatii.*

4. **(B)** Andrea Palladio formed the inspiration for the work of Boyle and Jefferson.

5. **(B)** The Royal Crescent was built near the hot springs of Bath, England.

6. **(D)** Neoclassicists assumed that the ancients preferred marble carving, because much more of it survives than their bronze counterparts.

7. **(C)** Smooth enamel-like paint application is a characteristic of Neoclassicism.

8. **(D)** Johann Winckelmann's art books were extremely influential and widely read.

9. **(B)** Antonio Canova's sculptures have a sensual feel about the treatment of the marble, as in *Cupid and Psyche* and *Pauline Borghese as Venus.*

10. **(D)** Michelangelo's *Pietà* is one of the inspirations for the pose of Marat.

Rubric for Short Essay

4: Student identifies Jean-Paul Marat or Marat as the subject and discusses the circumstances of his death. Student understands that the body of Marat was arranged to suit artistic aims. For example, Marat is arranged in a *pietà* position and his skin condition has been modified for presentation. Student must discuss how and why David modified historical reality. Discussion is full and without significant errors.

3: Student identifies Marat as the subject and discusses the circumstances of his death. Student explains some of the artistic responses in this work, but the discussion is less full, perhaps addressing either how or why but not both. It may contain errors.

2: This is the highest grade a student can earn if he or she does not know the subject is Marat. If the student identifies the subject and knows something about the historical context, the grade of 2 is earned.

1: If the student only identifies the subject or the historical context, a grade of 1 is earned.

0: Student makes an attempt, but the response is without merit.

Short Essay Model Response

Marat is the subject of this work. He was a leader in the French Revolution and a blood thirsty one at that. He was killed while writing a letter apologizing for the death of the husband of the woman that killed him. His placement in the bath tub was to soothe the constant itching of his skin cancer this can be told from the vinegar soaked turban on his head, which was considered a possible cure at the time. The skin cancer would have taken away from beauty of the work, so the skin is portrayed in a more attractive fashion. Also, to enhance the visual effect of the work and the impact it makes, Marat is placed in Pietá position.

—Zach B.

Analysis of Model Response

Zach correctly identifies the subject as Marat, and as a leader of the French Revolution. He understands that the reality of his murder has been changed, first by understanding that skin cancer has been eliminated, and then by the pietà position that the figure is lying in. Zach needs to explain why David makes these alterations, and is a point missed in this essay. **This essay merits a 3.**

Romanticism

The French Revolution of 1789 and the European revolts of 1848 form a neat, although not completely accurate, boundary for Romanticism.

KEY IDEAS

- Romanticism is heavily influenced by a spirit of individuality and a freedom of expression unique up until this time.
- Romantics enjoy the sublime in nature and the revolutionary in politics.
- Romantic painters explore the unconscious world of dreams and fantasies.
- A new art form called photography is invented; its immediacy makes it an overnight sensation.
- Architecture revives historical forms, especially from the Middle Ages.

HISTORICAL BACKGROUND

In *A Tale of Two Cities*, Charles Dickens describes the Romantic period of the French Revolution: "It was the best of times, it was the worst of times." Indeed this was true. The revolutionary spirit of casting off oppressors and installing "Liberty, Equality, and Fraternity" created a dynamic for freedom not just in France, but throughout Europe, and in North and South America as well. However, the French Revolution itself, even though well-intentioned, devolved into the chaos of the Reign of Terror and eventually the Napoleonic Wars.

Nonetheless, the philosophical powers that were unleashed by these revolutionary impulses had long-term positive effects on European life, which are embodied in the Romantic spirit. Romantics espoused social independence, freedom of individual thought, and the ability to express oneself openly. This was manifest not only in the political battles of the day, but also in the societal changes in general education, social welfare, and a newfound expression in the arts. As a reaction against the Enlightenment, the Romantics would argue that you should trust your heart, not your head.

Patronage and Artistic Life

The Romantic artist was a troubled genius, deeply affected by all around him or her—temperamental, critical, and always exhausted. Seeking pleasure in things of greatest refinement, or adventures of audacious daring, the Romantic was a product of the extremes of human endeavor. **Turner** liked to be tied to the deck of a ship in a storm so that he could bring a greater sense of the **sublime** to his paintings. **Fuseli**

drew so many haunted visions in his notebooks that his wife burned them in an oven after his death, feeling that she saved the world from his apparitions.

Stereotypically, Romantic artists were loners who fought for important causes. **Delacroix** and **Gros** painted a number of great political paintings, **Rude** lionized the French Revolution, and **Goya** understood that human folly exists on the side of the villain and the hero alike.

Romantics enjoyed a state of melancholy, that is, a gloomy, depressed, and pensive mindset that is soberly thoughtful. This can be seen in a series of nineteenth century portraits. Romantics also championed the antihero, a protagonist who does not have the typical characteristics of a hero, often shunning society and rarely speaking, but capable of great heroic deeds.

The greatest artistic invention of the period was the development of photography. Since this was a new art form, there were no academies, no salons, and no schools from which to learn the craft. Even so, the mechanical nature of the camera prejudiced the public against viewing photographs as works of art. Anyone with a camera and a how-to book could open a photo shop. Because of photography's universality, and because there were no preconceived notions about photographers creating great art, marginalized populations, including women, easily entered the field. Some of the most important advances in the history of photography were made by these groups; it was the first instance of equal opportunity in the arts.

INNOVATIONS OF ROMANTIC ARCHITECTURE

The use of iron in architecture, which started in the Neoclassical period, became more important in the Romantic. Architects concerned with reviving past architectural styles like Gothic or Romanesque used ironwork, but hid it under the skin of the building. More adventuresome architects, like **Henri Labrouste**, used stone on the exterior, but were unafraid of iron as an exposed structural element on the interior. Progressive architects found the elegance and malleability of ironwork irresistible, especially when combined with walls of glass.

In 1850, **Sir Joseph Paxton** designed the first grand scale use of iron and glass in the construction of The Crystal Palace (Figure 23.5). While contemporaries did not view this building as architecture, those who understood engineering knew that this was the face of the future.

Characteristics of Romantic Architecture

Nineteenth-century architecture is characterized by a revival of nearly every style of the past. Historicism and yearning for past ideals fueled a reliance on the old, the tried, and the familiar.

There was symbolism in this. The Middle Ages represented a time when religion was more devout and sincere, and life was more centered around faith. Modern living, it was felt, was corrupted by the Industrial Revolution. People were so nostalgic for medieval ruins that when there were none handy, they had ruins built so that Romantic souls could ponder the loss of civilization.

Medieval art may have been the favorite theme to revive, but it was by no means the only one. Egyptian, Islamic, and even Baroque architecture was updated and grafted onto structures that had no connection with their original inspiration. Bath houses in England are done in the Islamic style; opera houses in Paris are Baroque;

office buildings in the United States are Gothic; a monument to George Washington in Washington, D.C., is an Egyptian obelisk.

Major Works of Romantic Architecture

Neo-Gothic Architecture

Charles Barry and Augustus Pugin, The Houses of Parliament, 1836–1860, London (Figure 23.1)

Figure 23.1: Charles Barry and Augustus Pugin, 1836–1860, The Houses of Parliament, London

- Competition held in 1835 for a new Houses of Parliament after the old one burned down
- 97 entrants in the contest; 91 in the Perpendicular Gothic, 6 in the Elizabethan style; thought to be native English styles
- Enormous structure of 1,100 rooms, 100 staircases, 2 miles of corridors
- Modern office building cloaked in medieval clothes
- Barry a classical architect, accounts for regularity of plan
- Pugin a Gothic architect, added Gothic architectural touches to the structure
- Profusion of Gothic ornament is greater than would appear in an original Gothic building
- Big Ben is a clock tower, in a sense a village clock for all of England

Neo-Baroque Architecture

Charles Garnier, The Opéra, 1861–1874, Paris (Figures 23.2 and 23.3)

- Baroque revival architecture
- Rich profusion of ornament on interior and exterior
- Elaborate entrances
- Opera as a place where people go to be seen, rather than a place where people go to see the opera
- Huge spiraling staircase with alcoves and balconies for the ladies to show their latest fashions during intermission; Garnier commented that the staircase *is* the opera
- Mirrors on columns reflect the flicker of gas light and allow ladies to check their hair
- Iron extensively used, but not where it would show
- Auditorium as anticlimax to the foyers and staircases

Figure 23.2: Charles Garnier, The Opéra, 1861–1874, Paris

Figure 23.3: Charles Garnier, The Opéra, 1861–1874, Paris

Iron Buildings

Henri Labrouste, Bibliothèque Saint-Genevieve, 1843–1850, Paris (Figure 23.4)

- First library in Paris to be open at night. Used gas lighting and therefore needed to be fireproof, have great window spaces, and be centrally heated

Figure 23.4: Henri Labrouste, Bibliothèque Saint-Genevieve, 1843–1850, Paris

 - First consistently exposed use of iron in a monumental building
 - Main door: two flat Tuscan columns surmounted by lamps that symbolize the nighttime opening hours; lamps look like bookmarks; name of building over door as if a title page of a book
 - Façade: a table of contents of 810 authors in chronological order starting with Moses; central name is the Byzantine author Psellus—the meeting of East and West; last name is Swedish chemist Berzelous; letters originally in red to look like printing on paper
 - Parallel relationship of inside and outside arches
 - Interior: iron arches symbolize mechanically set lines of print; continuity of arch spaces; two large barrel vaults represent two columns on a printed page; represent two pages of an open book with the columns acting as a book spine

Joseph Paxton, The Crystal Palace, 1850–1851, London (Figure 23.5)

Figure 23.5: Joseph Paxton, The Crystal Palace, 1850–1851, London

- First World's Fair held here
- Huge building: 19 acres, 1,851 feet long—symbolic of the year it was built
- Built in only 39 weeks, under budget and ahead of schedule
- Barrel-vaulted nave high enough to cover trees already existing on property
- Building meant to be temporary, economical, simple, capable of rapid erection and dismantling, built of fire-resistant materials and possessing great window space
- Huge open interior space for display of products
- First large freestanding iron frame building in England
- Glass curtain walls; Paxton received his training in building greenhouses
- First monumental building built out of factory-produced parts

INNOVATIONS OF ROMANTIC PAINTING AND SCULPTURE

Artists were impressed by the **sublime** in art. What the Enlightenment saw as ordered, symmetrical, logical, and scientific—and therefore beautiful—the Romantics viewed with disdain. **William Blake** says in his poem "The Tyger":

> Tyger! Tyger! burning bright,
> In the forests of the night:
> What immortal hand or eye,
> Could frame thy fearful symmetry?

The word "symmetry" does not rhyme with "eye," although the rhythm of the poem seems to want it to. Blake points out that there is a "fearful symmetry," in works that express the Neoclassical ideal. One of his greatest enemies was the thinker Sir Isaac Newton, whom he depicted as calculating the universe at the bottom of the ocean.

Artists wanted to create the fantastic, the unconscious, the haunted, and the insane. **Géricault** and **Goya** visited asylums and depicted their residents. **Fuseli** painted the underside of the subconscious state in *The Nightmare* (Figure 23.15) a hundred years before Freud.

Photography had an enormous impact on painters. Some fled painting, feeling that their efforts could not match the precision and speed of a photograph. Others more wisely saw that pictures could be a great aid in a painter's work, from hiring a model to capturing a landscape. Painters eventually learned that photography was a new art form that was not in competition with the long-standing tradition of painting.

Characteristics of Romantic Painting and Sculpture

Artists, like everyone else, were caught up in European and American revolutions. The fight for Greek independence was particularly galvanizing for European intellectuals. Political paintings became important, expressing the artist's solidarity with a social movement or a political position. **Gros**, **Delacroix**, and **Goya** are among many who create memorable political compositions.

Even landscape painting had a political agenda. No longer content to paint scenes for their physical beauty or artistic arrangement, landscape painters needed to make a contemporary statement. Perhaps, like **Constable**, the paintings were expressions against the Industrial Revolution, or as in the case of **Cole**, an answer to criticism on how Americans had polluted their land.

Major Works of Spanish Romantic Painting

Francisco de Goya, *The Sleep of Reason Produces Monsters*, 1799, etching and aquatint, Prado, Madrid (Figure 23.6)

- Reason falls asleep while at work; haunted by dreams of bats and owls, nocturnal creatures
- Monsters haunt even the most rational mind

Francisco de Goya, *Family of Charles IV*, 1800, oil on canvas, Prado, Madrid (Figure 23.7)

- Accentuated dazzling costumes and royal trappings
- Some scholars feel that Goya was mocking Spanish royalty; however, he used a mirror to have sitters compare their likenesses to his painted images

Figure 23.6: Francisco de Goya, *The Sleep of Reason Produces Monsters*, 1799, etching and aquatint, Prado, Madrid

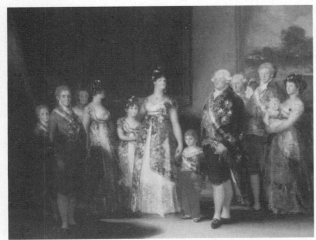

Figure 23.7: Francisco de Goya, *Family of Charles IV*, 1800, oil on canvas, Prado, Madrid

- Cf. Velázquez's *Las Meninas* (Figure 20.23)
- Triptychlike arrangement of figures
- Goya in shadow in background—not to be confused with royalty
- Queen in center with youngest children
- Two great canvases hanging in rear draw a parallel with *Las Meninas*

Francisco de Goya, *Third of May 1808*, oil on canvas, 1814–1815, Prado, Madrid (Figure 23.8)

- Execution of Spanish rebels after the failed uprising against the occupying French of 2 May 1808
- Robotic repetitive movements of the faceless French
- Central Spanish figure is in Christ-like sacrificial pose with hand marks of the nailed crucifixion
- Church is silent, powerless in the background
- Brutal inhumanity displayed in blood-soaked foreground

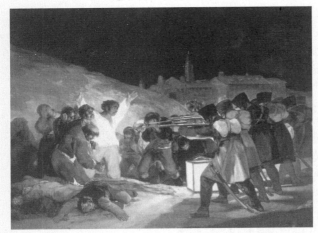

Figure 23.8: Francisco de Goya, *Third of May 1808*, oil on canvas, 1814–1815, Prado, Madrid

Francisco de Goya, *Saturn Devouring One of His Children*, 1819–1823, oil on canvas, Prado, Madrid (Figure 23.9)

- One of his black paintings
- Illustrates the myth of Saturn eating each of his children because of a prophecy that one of them would grow up to be greater than he; nothing in the painting suggests the myth stated in the title
- Sinister blackness, panic-stricken eyes; ragged edges of ripped sacrificial child's body
- Voracious mouth
- Symbolism:
 o human self-destruction
 o time destroys all its creations
 o a country eating its young in pointless wars

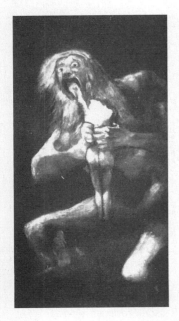

Figure 23.9: Francisco de Goya, *Saturn Devouring One of His Children*, 1819–1823, oil on canvas, Prado, Madrid

Major Works of French Romantic Painting

Antoine-Jean Gros, *Napoleon in the Pesthouse of Jaffa*, 1804, oil on canvas, Louvre, Paris (Figure 23.10)

- Plague broke out among Napoleon's troops during a campaign in Jaffa, Israel; the sick were housed in a converted mosque

- Napoleon touches the open sore of a soldier without his glove to prove that the disease is not contagious; comforts them; unafraid; enters the pesthouse to calm fears
- Cf. Christ healing the sick; doubting Thomas
- Many doctors died, including the prominently placed one in lower right
- Not shown is the fact that Napoleon ordered the sick to be poisoned so that he would not have to take them back to France
- Composition influenced by *Oath of the Horatii* (Figure 22.8), but columns do not frame the space; figures overlap the arches
- Figures in various states of disarray scattered around the front of canvas in semidarkness

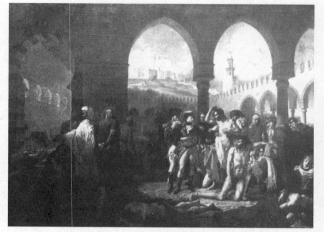

Figure 23.10: Antoine-Jean Gros, *Napoleon in the Pesthouse of Jaffa*, 1804, oil on canvas, Louvre, Paris

Théodore Géricault, *The Raft of the Medusa,* 1818–1819, oil on canvas, Louvre, Paris (Figure 23.11)

- Illustrates the story of a shipwrecked vessel off the African coast in 1816; not enough room for passengers on lifeboats, so captain made rafts from the timbers of the *Medusa* and put 150 people aboard; it was set adrift in the Atlantic
- Fifteen people survived the two-week ordeal by eating one another
- Géricault depicts the moment when the raft is spotted by a rescue vessel, the *Argus*, viewable on horizon at right
- Ocean tilts the raft closer to our view
- Breakup of raft suggested by drifting timbers
- Heroic musculature of figures
- Body on extreme left has no torso—suggestion of cannibalism
- A political painting that was hostile to France's Bourbon government
- Composition centered around an "X"; triangular forms dominate

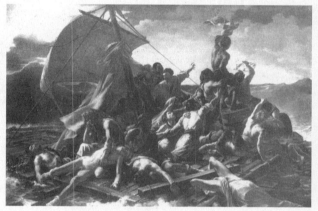

Figure 23.11: Théodore Géricault, *The Raft of the Medusa*, 1818–1819, oil on canvas, Louvre, Paris

Jean-Auguste Ingres, *The Grand Odalisque,* 1814, oil on canvas, Louvre, Paris (Figure 23.12)

- Raphael-like face
- Turkish elements: incense burner, peacock fan, tapestrylike turban, hashish pipe
- Inconsistent arrangement of limbs: rubbery arm, elongated back, placement of leg, one arm is longer than the other
- Heavily influenced by Italian Mannerism

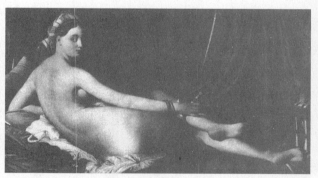

Figure 23.12: Jean-Auguste Ingres, *The Grand Odalisque*, 1814, oil on canvas, Louvre, Paris

Eugène Delacroix, *Liberty Leading the People,* **1830, oil on canvas, Louvre, Paris (Figure 23.13)**

- July Revolution of 1830; Liberty with French tricolor marches over the barricades to overthrow government soldiers
- Red/white/blue echo throughout the painting
- Strong pyramidical structure

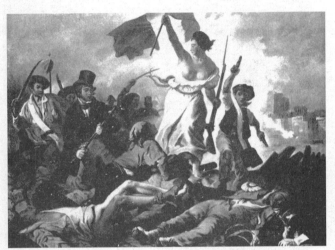

- Child with pistols symbolizes the role of students in the revolt; middle class by man in top hat and carrying rifle; lower class represented by man at extreme left with sword in hand and pistol in belt
- Acquired by the French state in 1931, but not exhibited publicly for 25 years because of its subversive message

Figure 23.13: Eugène Delacroix, *Liberty Leading the People,* 1830, oil on canvas, Louvre, Paris

Major Works of British and American Romantic Painting

William Blake, *Ancient of Days,* **1794, etching, Whitworth Art Gallery, Manchester, England (Figure 23.14)**

- Wrote and illustrated his own work, and illustrated works by Dante, among others
- Rejected rationalism of the Enlightenment
- Acknowledgment of the beastliness of humans
- From a book of Blake's poems
- Figure covers the sun with his body, opens his fingers in an impossible way to measure the earth with calipers

- Strong lateral wind
- Figure is Urizen, a pun on "your reason"—an evil Enlightenment figure of rational thinking

Henry Fuseli, *The Nightmare,* **1790, oil on canvas, Frankfurter Goethe-Museum, Frankfurt, Germany (Figure 23.15)**

- Erotic theme; horse as a male symbol coming through parted red theatrical curtains; woman lying on bed in a tortured sexual sleep
- Incubus sits on her chest suffocating her
- Mara is a spirit in Norse mythology who suffocates sleepers
- Woman is thrown off the back of the bed in a submissive pose
- Not an illustration of a nightmare, but the sensation of terror it produces

Figure 23.14: William Blake, *Ancient of Days,* 1794, etching, Whitworth Art Gallery, Manchester, England

Figure 23.15: Henry Fuseli, *The Nightmare,* 1790, oil on canvas, Frankfurter Goethe-Museum, Frankfurt, Germany

- Painting may have been done as a reaction to a jilted romance during which Fuseli claimed to have had sex with a woman in his dreams
- Figural style from Italian Mannerism

John Constable, *The Hay Wain*, 1821, oil on canvas, National Gallery, London (Figure 23.16)

- Vibrant, shimmering paint application with a careful rendering of atmospheric effects
- Painted English countryside as a reaction against the Industrial Revolution, which was removing most of the well-appointed hedge rows on the landscape
- Oneness with nature; man is an active participant but does not disturb
- Clouds fill the sky; sense of the momentary
- Cottage is one with the countryside, grows in among the trees
- Boat easily fords the river
- Dappled reflections on water surface
- Everything and everyone in harmony with nature, an ideal state

Figure 23.16: John Constable, *The Hay Wain*, 1821, oil on canvas, National Gallery, London

Joseph M.W. Turner, *The Fighting Téméraire*, 1838, oil on canvas, National Gallery, London (Figure 23.17)

- Turner liked extremes in nature: avalanches, seastorms, whirlwinds, and so on
- Color is the dominant motif
- Concept of vortex in his work, play on Turner's name
- Admiral Nelson's flagship at the Battle of Trafalgar in 1805 being brought to a berth to be dismantled
- Contrasts: warm and cool colors; tall, white, glowing, pale glorious sail-powered ship of the past contrasted with small, black, modern tugboat of the future
- Symbolic sunset; elegy of the last days of sailboats; historical changes

Figure 23.17: Joseph M.W. Turner, *The Fighting Téméraire*, 1838, oil on canvas, National Gallery, London

Thomas Cole, *The Oxbow*, 1836, oil on canvas, Metropolitan Museum of Art, New York (Figure 23.18)

- Founder of the Hudson River School
- Actual view in Massachusetts
- Cole's division of landscape into two clearly contrasting areas: the Romantic on the left and the Claude-like landscape on the right

Figure 23.18: Thomas Cole, *The Oxbow*, 1836, oil on canvas, Metropolitan Museum of Art, New York

- Cole's self-portrait in the foreground amid a dense forest that is impenetrably thick, with broken trees, and a wild landscape with storms; the sublime
- On the right, man's touch is seen in light, cultivated fields, boats drifting down the river
- Painted as reply to a British book that alleged that Americans had destroyed a wilderness with industry

Figure 23.19: Caspar David Friedrich, *Two Men Gazing at the Moon*, 1819, oil on canvas, State Art Museum, Dresden

Major Work of German Romantic Painting

Caspar David Friedrich, *Two Men Gazing at the Moon*, 1819, oil on canvas, State Art Museum, Dresden (Figure 23.19)

- The sublime
- Moon held a special symbolism in the Romantic age: the nocturnal, the ghostly, the unknowable, romance, etc.
- For Friedrich, landscapes and panoramas were windows through which one could experience God
- Sentimental longing; melancholic mood
- Friedrich appears in cap and cloak walking with a cane, admiring the sunset
- Friedrich is accompanied by August Heinrich, his student, who prematurely dies; this painting is a memorial to their friendship
- Old oak tree with moss symbolizes Friedrich; young cut-down tree in foreground symbolizes Heinrich
- *Rückenfigur*: in Romantic painting, a figure seen from the back, often in the contemplation of nature

Figure 23.20: François Rude, *Departure of the Volunteers of 1792*, or *La Marseillaise*, 1833–1836, Arc de Triomphe, Paris

Major Works of French Romantic Sculpture

François Rude, *Departure of the Volunteers of 1792*, or *La Marseillaise*, 1833–1836, Arc de Triomphe, Paris (Figure 23.20)

- 1833 commission to place a sculpture on the Arc de Triomphe, Paris
- Represents the volunteers who protected France during the Austrian–Prussian invasion of 1792
- Winged figure: France or Victory or Bellona (god of war) helmeted, giving a war cry
- Volunteers surge forward in a tangle
- None really looks ready for war: some are too old, others too young
- Leader wears Roman armor and is encouraging a nude boy
- Raises scene to mythic proportions

Antoine-Louis Barye, *Jaguar Devouring a Hare*, 1850, bronze, Godwin-Ternbach Museum, Queens College, Flushing, New York (Figure 23.21)

Figure 23.21: Antoine-Louis Barye, *Jaguar Devouring a Hare*, 1850, bronze, Godwin-Ternbach Museum, Queens College, Flushing, New York

- Barye's work concentrates on isolated incidents of a single group of combating animals
- "Survival of the fittest," a term used in 1864 and then most famously in the 1869 edition of Darwin's *Origin of Species*; however, it represents an idea widely held in the beginning of the nineteenth century
- Jaguar feeds mercilessly on the living entrails of the hare, depicted just at the moment of its death
- Study in animal anatomy

THE DEVELOPMENT OF PHOTOGRAPHY

Experiments in photography go back to the seventeenth century, when artists used a device called a **camera obscura** (Figure 23.22) to focus images in a box so that artists could render accurate copies of the scene before them. Gradually, photosensitive paper was introduced that could replicate the silhouette of an object when exposed to light. These objects were called **photograms**, which yielded a primitive type of photography that captured outlines of objects and little else.

Figure 23.22: Camera obscura

Modern photography was invented in two different places at the same time: France and England. The French version, called the **daguerreotype** after its inventor Louis Daguerre, was a single image that is characterized by a sharp focus and great clarity of detail. Englishman William Talbot invented the **calotype**, which, though at first inferior in quality to the French version, was less costly to make and had an accompanying negative that could generate an unlimited number of copies from the original. Both men showed their inventions to scientific conventions in January 1839.

Photography spread quickly, and technological advances followed almost as fast. For example, shutter speeds were made faster so that sitters could pose for pictures without blurring, and the cameras themselves became increasingly portable and user-friendly. The advantages to photography were obvious to everyone: It went everywhere a person could go, capturing and illustrating everything from the exotic to the commonplace.

Figure 23.23: Louis Daguerre, *Artist's Studio*, 1837, daguerreotype, French Photographic Society, Paris

Major Works of Photography

Louis Daguerre, *Artist's Studio*, 1837, daguerreotype, French Photographic Society, Paris (Figure 23.23)

- Still life inspired by painted still lives, like vanitas paintings
- Variety of textures: fabric, wicker, plaster, framed print, and so on
- New art form inspired by older art forms
- Daguerreotypes have a shiny surface with great detail

Figure 23.24: Nadar, *Nadar in a Balloon*, Private Collection

Figure 23.25: Nadar, *Portrait of Théophile Gautier*, 1856, Private Collection

Nadar, *Nadar in a Balloon*, and *Portrait of Théophile Gautier*, 1856 (Figures 23.24 and 23.25)

- Nadar floated over Paris in a hot air balloon to take the first aerial photographs in history
- Controlled camera angles
- Eyes often left in shadow: deep penetration, more piercing and mysterious
- Forehead usually highlighted
- Concentration on figure without props or settings
- Sitters determined their pose

VOCABULARY

Calotype: a type of early photograph, developed by William H. F. Talbot that is characterized by its grainy quality. A calotype is considered the forefather of all photography because it produces both a positive and a negative image

Camera obscura: (Latin, meaning "dark room") a box with a lens which captures light and casts an image on the opposite side (Figure 23.22)

Daguerreotype: a type of early photograph, developed by Louis Daguerre that is characterized by a shiny surface, meticulous finish, and clarity of detail. Daguerreotypes are unique photographs; they have no negative (Figure 23.23)

Photogram: an image made by placing objects on photosensitive paper and exposing them to light to produce a silhouette

Rückenfigur: in Romantic painting, a figure seen from the back, often in the contemplation of nature (Figure 23.19)

School: a group of artists who share the same philosophy, work around the same time, but not necessarily together

The sublime: any cathartic experience from the catastrophic to the intellectual that causes the viewer to marvel in awe, wonder, and passion (Figure 23.19)

Summary

A spirited cultural movement called Romanticism inspired artists to move beyond former boundaries and express themselves as individuals. Romantic artists introduce new subjects such as grand political canvases, the world of the unconscious, and the awesome grandeur of nature.

Romantics were influenced by the invention of photography, which was used by some artists as a tool for preserving such things as a model's pose or a mountain landscape. Photography's immediacy and realistic impact made it a sensation from its inception, causing the art form to spread quickly among all classes of people.

Early nineteenth-century architects sought to revive former artistic styles and graft them onto modern buildings. It is common to see an office building, like the Houses of Parliament, wrapped in Gothic clothes. This yearning for the past is a reaction against the mechanization of the Industrial Revolution and a way of life that seemed to have permanently passed from the scene.

Practice Exercises

1. Romantic artists

 (A) embraced the spirit of the Enlightenment
 (B) favored harmonious and balanced compositions
 (C) rejected reason in favor of emotion
 (D) used color in the manner of Raphael

2. A painting that captures the sublime

 (A) has a political overtone
 (B) makes the viewer pause in wonder
 (C) rejects the precision of photography
 (D) has a medieval theme

3. A calotype is different from a daguerreotype in that a calotype

 (A) uses a camera obscura to make the image
 (B) has a painterly effect
 (C) was used to pose models for painters
 (D) has a negative

 CHALLENGE

Questions 4–6 refer to Figure 23.26.

4. This sculpture symbolically represents an episode from

 (A) the Bible
 (B) mythology
 (C) around the artist's own times
 (D) the future

5. This sculpture is located on

 (A) the Crystal Palace, London
 (B) Sainte-Genevieve Library, Paris
 (C) the Opera, Paris
 (D) the Arc de Triomphe, Paris

6. The figure at the top of this composition represents

 (A) Venus
 (B) Angel Gabriel
 (C) Bellona
 (D) Saturn

Figure 23.26

7. Nadar was a photographer who specialized in

 (A) news photography
 (B) portraits
 (C) still lifes
 (D) exposing social evil

8. Eugène Delacroix's *Liberty Leading the People* concerns

 (A) the French Revolution
 (B) American independence
 (C) the Napoleonic Wars
 (D) the July Revolution of 1830

9. An artist known for reacting against the Industrial Revolution in his works is

 (A) Henry Fuseli
 (B) John Constable
 (C) Jean Ingres
 (D) Eugène Delacroix

10. Goya assumes the audience for his painting of *Family of Charles IV* would be familiar with

 (A) Peter Paul Rubens's *Saturn Devouring His Children*
 (B) Diego Velázquez's *Las Meninas*
 (C) Raphael's *School of Athens*
 (D) Jacques-Louis David's *Oath of the Horatii*

Short Essay

Eugène Delacroix said: "What makes men of genius, or rather, what they make, is not new ideas, it is that idea—possessing them—that what has been said has still not been said enough."

Choose a Romantic work that you feel illustrates this quotation and explain why. Use one side of a sheet of lined paper to write your essay.

Answer Key

1. **(C)**	3. **(D)**	5. **(D)**	7. **(B)**	9. **(B)**
2. **(B)**	4. **(C)**	6. **(C)**	8. **(D)**	10. **(B)**

Answers Explained

Multiple-Choice

1. **(C)** Romantic artists rejected what they saw as the rigidity of the Enlightenment and artists like Raphael, which they saw as classically inspired. Instead they embraced emotion.

2. (**B**) The sublime makes the viewer pause in wonder. Although political overtones and medieval themes are characteristic of Romantic painting, they do not necessarily contribute to the sublime.

3. (**D**) A calotype has a negative; a daguerreotype does not.

4. (**C**) This sculpture represents an episode from the French Revolution, when Rude was young.

5. (**D**) This sculpture is located on the Arc de Triomphe in Paris.

6. (**C**) The figure at the top of this sculpture is Bellona, goddess of war. She also could be interpreted as France or Victory.

7. (**B**) Nadar did portraits. He also was famous for photographing Paris from a balloon, but he did no still lives, nor tackled social evils. News photography was in its infancy at the time.

8. (**D**) Delacroix's painting *Liberty Leading the People* celebrates the victors of the July Revolution of 1830.

9. (**B**) Constable's paintings of bucolic England are a reaction against the despoilment of the English countryside by the Industrial Revolution.

10. (**B**) Goya's painting makes a number of references to the Velázquez painting, including the large paintings in shadow in the background, which shows the artist working on the canvas and the presence of royalty.

Rubric for Short Essay

4: The student explains the quotation, takes a common theme in painting, and explores how a talented artist can find new expression in that theme. The student addresses a particular work that is immersed in this new expression. There are no major errors.

3: The student explains the quotation, takes a common theme in painting, and explores how a talented artist can find new expression in that theme. The student may not address a painting with great specificity, and may speak in only general terms about the Romantic era. There may be minor errors.

2: The student creates errors in either the explaining of the quotation, the choice of artists and paintings, OR the student chooses a work that is not Romantic. There may be major errors.

1: The student gives a marginal explanation of the quotation and discusses it only in general terms. There may be major errors.

0: The student makes an attempt, but the response is without merit.

Short Essay Model Response

Thomas Cole painted the Oxbow during the Romanticism period. Delacroix states that artists don't make new ideas, but just give them a different meaning. This is exactly what Cole did. Like other previous artists, Cole painted a landscape. But what made his different from older ones is that he had a new meaning for the viewer. In the painting, Cole displays two different aspects, the stormy side of nature and the serene side. Cole himself is in the painting but is well hidden in the foliage. This showed that man should be at peace with nature. On the left, he painted trees and plants that were destroyed by a storm.

This painting was painted during the Industrial Revolution so it shows that Cole believes that nature should be left alone and not be destroyed. He uses two different ideas derived from Constable (the peaceful nature) and Turner (the turbulent nature) to show his belief on the subject. This is different from previous landscapes because he shows that nature is beautiful but will be destroyed due to advancements in society. The meaning in the landscape is different from previous ones. It is not just to look at but to grasp a meaning.

—Mehak I.

Analysis of Model Response

Mehak proves that she understands the quotation by giving a good example, *The Oxbow*. She recounts how landscapes have been painted before, but this one has a different meaning. She goes on to explain how a traditional landscape has been transformed to make a statement about the Industrial Revolution. She also points to exact passages in this painting. **This essay merits a 4.**

Late Nineteenth–Century Art

 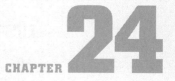

Movement	Dates
TIME PERIOD: 1848–1900	
Realism	1848–1860s
Pre-Raphaelite Brotherhood	1848–1860
Impressionism	1872–1880s
Post-Impressionism	1880s–1890s
Symbolism	1890s
Art Nouveau	1890s–1914

KEY IDEAS

- The Realist art movement was philosophically based on the theory of positivism.
- Japanese art had a profound impact on late nineteenth-century painting.
- Plein-air painting dominates much of Impressionist art.
- Post-Impressionists reacted against what they saw as the ephemeral quality of Impressionist painting.
- Symbolist painters seek to portray mystical personal visions.
- In the late nineteenth century the skyscraper was born as a result of new technological advances, the invention of the elevator, and the rise of land values.
- Art Nouveau seeks to create a unified artistic experience combining painting, sculpture, and architecture; it relies on organic forms and motifs

HISTORICAL BACKGROUND

The year 1848 was busy. Europe was shaken by revolutions in Sicily, Venice, Germany, Austria, and Lombardy—each challenging the old order and seeking to replace aristocracies with democracies. In France, Louis-Philippe, the great victor of the Revolution of 1830 and self-styled "Citizen King," faced internal pressure and deposed himself. He was soon replaced by Napoleon III, who led France down a path of belligerency culminating in the Franco-Prussian War of 1870. When the dust cleared, the Germans were masters of continental Europe, but by that time everyone had had enough of turmoil, and settled down for a generation of peace.

Social reformers were influenced by a concept called **positivism** promulgated by Auguste Comte (1798–1857). This theory allowed that all knowledge must come from proven ideas based on science or scientific theory. Comte said that only tested concepts can be accepted as truths. Key nineteenth-century thinkers like Charles Darwin (1809–1882) and Karl Marx (1818–1883) added to the spirit of positivism by exploring theories about human evolution and social equality. These efforts shook traditional thinking and created a clamor in intellectual circles. New inventions such as telephones, motion pictures, bicycles, and automobiles shrunk the world by opening communication to a wider audience.

Artists understood these powerful changes by exchanging traditional beliefs for the "**avant-garde**," a word coined at this time. The academies, so carefully set up in the eighteenth century, were abandoned in the late nineteenth century. Artists used the past for inspiration, but rejected traditional subject matter. Gone are religious subjects, aristocratic portraits, history paintings, and scenes from the great myths of Greece and Rome. Instead the spirit of **modernism** prevailed, artists choose to represent peasant scenes, landscapes, and still lives. Systematic and scientific archaeology began during this period as well, with excavations in Greece, Turkey, and Egypt.

Patronage and Artistic Life

Even though most artists wanted to exhibit at the Salon of Paris, many found the conservative nature of the jury to be stifling, and began to look elsewhere for recognition. Artists whose works were rejected by the Salon, such as **Courbet** or **Manet**, set up oppositional showcases, achieving fame by being antiestablishment. The Impressionist exhibitions of the 1870s and 1880s fall into this category.

One of the greatest changes in the marketing of art came about with the emergence of the art gallery. Here was a more comfortable viewing experience than the Salon: No great crowds, no idly curious—just the art lover with a dealer in tastefully appointed surroundings. Galleries featured carefully selected works of art from a limited number of artists, and were not the artistic impluvia that the Salon had become.

Paul Cézanne cultivated the persona of the struggling and misunderstood artist. He fought the conventional aspirations of his family, escaped to a bohemian lifestyle, and worked for years without success or recognition. The more he suffered, and the cruder he grew, the more people were attracted to him and found his artwork intriguing. He was one of the first to exploit the stereotype of the artist as rebel. Other artists follow suit: Gauguin escaped to Tahiti, van Gogh to the south of France.

INNOVATIONS OF LATE NINETEENTH-CENTURY ART

European artists were greatly influenced by an influx of Japanese art, particularly their highly sophisticated prints of genre scenes or landscapes. These broke European conventional methods of representation, but were still sophisticated and elegant. Japanese art relies on a different sense of depth, enhancing a flatness that dominates the background. Subjects appear at odd angles or on a tilt. This interest in all things Japanese was called **Japonisme**.

Painters felt that the artificial atmosphere of the studio inhibited artistic expression. In a movement that characterizes Impressionism, called **plein-air**, artists moved their studio outdoors seeking to capture the effects of atmosphere and light on a given subject. Often, as in the case of **Monet**, artists painted series of paintings on a similar theme, like *Haystack at the Sunset at Giverny* (Figure 24.14), *Rouen Cathedral* (Figure 24.15), or *Four Poplar Trees* (Figure 24.16), and hung each thematic sequence in a single gallery.

Analogously, photographers like **Muybridge** took photographs in a series and projected them with a device called a **zoopraxiscope** (Figure 24.12). This gave the illusion of movement, thereby becoming the precursor to motion pictures.

A new creative outlet for printmakers was the invention of **lithography** in 1798. Great Romantic artists such as Delacroix and Goya saw the medium's potential and made effective prints. By the late nineteenth century, those politically inclined, such as **Daumier**, used the lithography to critique society's ills. Others, like **Toulouse-Lautrec**, used the medium to mass-produce posters of the latest Parisian shows.

Characteristics of Realism

Courbet's aphorism "Show me an angel, and I'll paint one" sums up the Realist philosophy. Inspired by the **positivism** movement, Realist painters believe in painting things that one could experience with the five senses, which often translated into painting the lower classes in their environment. Usually peasants are depicted with reverence, their daily lives touched with a basic honesty and sincerity thought to be missing among the middle and upper classes. They are shown at one with the earth and the landscape; brown and ochre are the dominant hues.

Major Works of Realism

Gustave Courbet, *Burial at Ornans*, 1849, oil on canvas, Musée d'Orsay, Paris (Figure 24.1)

- Funeral in a drab country setting
- Huge scale suggests monumentality, but painting does not glorify any aspect of life
- S-curve of composition
- Only the cross rises above the group into the sky
- Unflattering characterizations of provincial officials
- Transcendent meaning of funerals and death missing
- Dog is as distracted as many of the people

Figure 24.1: Gustave Courbet, *Burial at Ornans*, 1849, oil on canvas. Musée d'Orsay, Paris

Figure 24.2: Honoré Daumier, *Rue Transnonain*, 1834, lithograph, Daumier Register

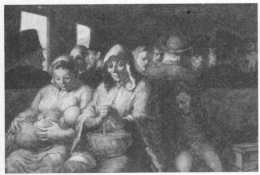

Figure 24.3: Honoré Daumier, *Third Class Carriage*, c. 1862, oil on canvas, National Gallery, Ottawa, Canada

Figure 24.4: Jean-François Millet, *The Gleaners*, 1857, oil on canvas, Louvre, Paris

Figure 24.5: Édouard Manet, *Luncheon on the Grass*, 1863, oil on canvas, Musée d'Orsay, Paris

Honoré Daumier, *Rue Transnonain*, 1834, lithograph, Daumier Register (Figure 24.2)

- Worker unrest in Lyon, France was suppressed by government troops
- When a soldier was shot from a workers' apartment complex, the troops came in and killed everyone indiscriminately for revenge
- Three generations shown: middle-aged man lying atop a child; elderly on extreme right
- Room in disorder symbolizes the surprise attack
- Critical print meant to stir the emotions of the viewer against the establishment
- Lithography used to mass-produce image and circulate to as many people as possible; French government tried to suppress distribution

Honoré Daumier, *Third Class Carriage*, c. 1862, oil on canvas, National Gallery, Ottawa, Canada (Figure 24.3)

- Poor huddled in the third-class compartment of a railroad car; lower-class section isolated from middle-class passengers emotionally and physically
- Anonymous people going about their way
- Figures in front represent a modern take on the Holy Family theme: Grandmother sits serenely, mother breastfeeds, grandchild sleeps

Jean-François Millet, *The Gleaners*, 1857, oil on canvas, Musée d'Orsay, Paris (Figure 24.4)

- Millet a member of the Barbizon School of painting, named after a rural town that painters settled in
- Gleaners were the poorest of the poor, picking up scraps left over after the general harvest
- Nobility of the poor, nobility of hard work
- Bent-backed figures become part of the landscape, do not interfere with the horizon
- Haystacks and wagon reflect compositional pattern of the gleaners
- Seen by the public as a socialist painting, some were suspicious of rising lower classes after the revolutions of 1848

Édouard Manet, *Luncheon on the Grass*, 1863, oil on canvas, Musée d'Orsay, Paris (Figure 24.5)

- Manet tried to enter the Salon with this painting; it was rejected. It became a "success de scandal" in the Salon des Refusés

- Figures obviously posing, no unity with the landscape
- Influenced by a Raphael composition and Giorgione's *The Pastoral Concert* (Figure 17.21)
- Jarring juxtaposition of nude woman with contemporarily dressed men
- Distortion of perspective

Édouard Manet, *Olympia*, 1863, oil on canvas, Musée d'Orsay, Paris (Figure 24.6)

- Created a scandal at the Salon of 1865
- Inspired by Titian's *Venus of Urbino* (Figure 17.245) and similar nudes by Goya and Giorgione
- Figure is cold and uninviting, no mystery, no joy
- Maid delivers flowers from an admirer
- Olympia is a common name for prostitutes of the time
- Olympia's frank, direct, uncaring, and unnerving look startled viewers
- Simplified modeling
- Stark contrast of colors

Rosa Bonheur, *Plowing in the Nivernais*, 1849, oil on canvas, Musée d'Orsay, Paris and *The Horse Fair*, 1853–1855, oil on canvas, Metropolitan Museum of Art, New York (Figures 24.7 and 24.8)

- Bonheur concentrated on painting animals, usually domesticated or farm animals, in natural settings
- Influenced by modern ideals expressed in positivism
- Large canvases, bringing a grandeur to the animal form
- Broke conventions of female painters who dabbled in miniatures of still lifes and landscapes; instead she dressed in men's clothes, smoked cigars, and painted on a large scale
- Virtues of simple country living
- Sweeping panoramas of figures from left to right

Winslow Homer, *Snap the Whip*, 1872, Butler Institute, Youngstown, Ohio (Figure 24.9)

- Ideal vision of life in rural America
- Seemingly simple scene that evokes thought and concentration
- Monumentality of the forms
- Echoes of the American Civil War throughout his early works, that is, the chain of boys is a broken union
- Reactions against industrialization of America

Figure 24.6: Édouard Manet, *Olympia*, 1863, oil on canvas, Musée d'Orsay, Paris

Figure 24.7: Rosa Bonheur, *Plowing in the Nivernais*, 1849, oil on canvas, Musée d'Orsay, Paris

Figure 24.8: Rosa Bonheur, *The Horse Fair*, 1853–1855, oil on canvas, Metropolitan Museum of Art, New York

Figure 24.9: Winslow Homer, *Snap the Whip*, 1872, Butler Institute, Youngstown, Ohio

Figure 24.10: Thomas Eakins, *The Gross Clinic*, 1875, oil on canvas, Philadelphia Museum of Art and Pennsylvania Academy of Art.

Thomas Eakins, *The Gross Clinic*, 1875, oil on canvas, Philadelphia Museum of Art and Pennsylvania Academy of Art (Figure 24.10)

- Dr. Samuel Gross, lecturing, while performing an operation on a patient with osteomyelitis
- Anesthesiologist applying chloroform in a gauze to the patient's unseen head
- Operation takes place in a glass-domed amphitheater, with students gathered around taking notes on Dr. Gross's procedures
- Antiseptic garb unknown at this time; Gross dressed in a business suit
- Gross, patient, and the operation form a triangle
- Patient's mother at extreme left covering her face
- Gross rendered with Rembrandt-like use of light, heightens intensity of gaze, focal point is his brain
- Sharpest focus: blood-stained hands
- Painting celebrates the advances in medical science
- Eakins took photographs of Gross, who had no time to pose for paintings

Henry O. Tanner, *The Banjo Lesson*, 1893, oil on canvas, Hampton University Museum, Hampton, Virginia (Figure 24.11)

- Tanner was a student of Eakins
- Painterly brushwork; monumentality of forms
- Exchange of values from one generation to another; poverty no impediment to life with dignity; majesty of simple everyday events
- Sense of a deep emotional experience; unsentimental yet affectionate image; shared intimacy
- Painted to answer stereotypes of African-Americans as people who boisterously played on folk instruments; this is a serious exchange

Figure 24.11: Henry O. Tanner, *The Banjo Lesson*, 1893, oil on canvas, Hampton University Museum, Hampton, Virginia

Eadweard Muybridge, *Horse Jumping*, 1878, photograph (Figure 24.12)

- Photography now advanced enough that it can capture moments the human eye cannot
- Cameras snap photos at evenly spaced points along a track, giving the effect of things happening in sequence
- These motion studies bridge the gap between still photography and movies
- Used a device called a zoopraxiscope
- Great influence on painters like Degas, Eakins, Duchamp, and Boccioni

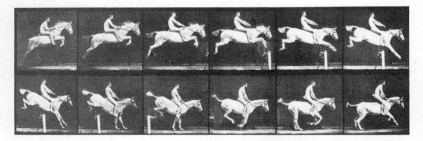

Figure 24.12: Eadweard Muybridge, *Horse Jumping*, 1878, photograph, from *Animal Locomation*

The Pre-Raphaelite Brotherhood

The Pre-Raphaelite Brotherhood (founded 1848—active until about 1860) was a tightly knit group of English artists who believed that Raphael, though a great painter, caused the death of art history by introducing a dramatic form of chiaroscuro into his paintings. This technique, it was felt, gradually diminished a work's impact. Instead the PRB (as they signed their works) found inspiration in both Northern European and Italian works of the fifteenth century, and proclaimed artists like Fra Angelico and Jan van Eyck as their models. Many PRB paintings lavished attention on precise details. Some artists enshrined their works in frames that look more like settings for religious altarpieces.

Pre-Raphaelite paintings rely on literary texts for inspiration, and in the case of Rossetti, these works were sometimes written by the artist. Both the paintings and poetry can be characterized by a strong attachment to symbolism and affection for medieval themes. Dante was particularly influential. The principal members of the Pre-Raphaelite movement are William Holman Hunt, Dante Gabriel Rossetti, and Sir John Everett Millais.

Major Work of the Pre-Raphaelite Brotherhood

Dante Gabriel Rossetti, *Beata Beatrix*, c. 1863, oil on canvas, Tate Gallery, London (Figure 24.13)

Figure 24.13: Dante Gabriel Rossetti, *Beata Beatrix*, c. 1863, oil on canvas, Tate Gallery, London

- Main figure is Elizabeth Siddal, the artist's wife, who overdosed on laudanum; theories exist that she may have committed suicide
- The sitter's eyes are closed to suggest death; laudanum is symbolically present in the poppy plant held by the red dove
- Sundial symbolizes time
- In the background Dante (right) looks across the Arno River in Florence at Beatrice (left) in a scene from Dante's poem *La Vita Nuova (The New Life)*; symbolism of Rossetti (as Dante) yearning for missing love Elizabeth (Beatrice)
- Sensual and erotic overtones

Characteristics of Impressionism

Impressionism is a true modernist movement symbolized by the **avant-garde** artists who spearheaded it. Relying on the transient, the quick and the fleeting, Impressionist brushstrokes seek to capture the dappling effects of light across a given surface. The knowledge that shadows contain color, that times of day and seasons of the year affect the appearance of objects—these are the basic tenets of Impressionism. Often working in **plein-air**, Impressionists use a spectacular color range, varying from subtle harmonies to stark contrasts of brilliant hues.

Impressionists concentrate on landscape and still-life painting, imbuing them with an urban viewpoint, even when depicting a country scene. Some, like **Degas** and **Renoir**, make the human figure in movement a specialty, others, like **Monet**, eventually abandon figure painting altogether.

The influence of Japanese art cannot be underestimated. Artists like **Cassatt** were struck by the freedom that Japanese artists used to show figures from the back, or solid blocks of color without gradations of hues. Others, like **Whistler**, signed their

Figure 24.14: Claude Monet. *Haystack at the Sunset near Giverny*. 1891, oil on canvas. Museum of Fine Arts, Boston

names in a Japanese anagram and imitated the flatness and off-center compositional qualities Japanese prints typically have.

Impressionism originally prided itself on being both antiacademic and antibourgeois; ironically, today it is the hallmark of bourgeois taste.

Major Works of Impressionism

Claude Monet, paintings in a series: *Haystack at the Sunset near Giverny*, **1891, Museum of Fine Arts, Boston,** *Rouen Cathedral*, **1894, and** *Four Poplar Trees*, **1891, Metropolitan Museum of Art, New York (Figures 24.14, 24.15, and 24.16)**

Figure 24.15: Claude Monet, *Rouen Cathedral*, 1894, oil on canvas, Metropolitan Museum of Art, New York

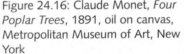

Figure 24.16: Claude Monet, *Four Poplar Trees*, 1891, oil on canvas, Metropolitan Museum of Art, New York

- Series of paintings of the same subject done at different times of day/days of the year
- Subtle gradations of light on the surface
- Forms dissolve and dematerialize, color overwhelms the forms
- Meant to hang together for effect
- Haystacks were the first series paintings to hang as a group; some thirty were painted, fifteen hung in the original exhibition

Pierre Auguste Renoir, *Le Moulin de la Galette*, **1876, oil on canvas, Musée d'Orsay, Paris (Figure 24.17)**

- Dappling effect of fleeting light on a given subject
- People go about their business, they do not pose
- Outdoor leisure activities of the middle class
- Clipped figures on extremes of painting suggest a photographic randomness
- Child in lower left suggests a relaxed and innocent atmosphere

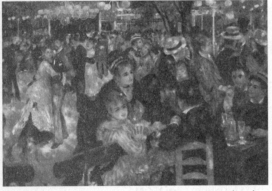

Figure 24.17: Pierre Auguste Renoir, *Le Moulin de la Galette*, 1876, oil on canvas, Musée d'Orsay, Paris

Edgar Degas, *The Rehearsal on Stage*, **1874, oil on canvas, Metropolitan Museum of Art, New York (Figure 24.18)**

- Worked mostly indoors on subjects that suggest movement, such as ballet dancers
- Asymmetrical compositions

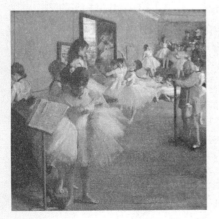

Figure 24.18: Edgar Degas, *The Rehearsal on Stage*, 1874, oil on canvas, Metropolitan Museum of Art, New York

- Firmly drawn bodies contrast with feathery brushstrokes of costuming, setting
- Influence of Japanese prints in compositional elements
- Figures often seen from the back, cut off at the edges of the composition, or marginalized

Édouard Manet, *Bar at the Folies Bergère*, 1881–1882, oil on canvas, Courtauld Gallery, London (Figure 24.19)

- Faraway look in the eyes of the barmaid who seems bored by her customer
- Mirror reflects into our world
- Uncertainty as to what the mirror is reflecting: is it her back listening to a customer, or is this another barmaid?
- Trapeze act in far upper left corner, largely ignored by customers
- Composition pushes goods up close to the customer
- Modern sales technique of placing the products next to a pretty salesgirl

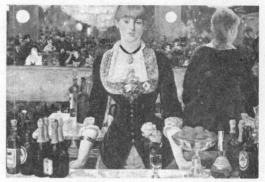

Figure 24.19: Édouard Manet, *Bar at the Folies Bergère*, 1881–1882, oil on canvas, Courtauld Gallery, London

Berthe Morisot, *Villa at the Seaside*, 1874, oil on canvas, Norton Simon, Los Angeles (Figure 24.20)

- Morisot was the sister-in-law of Manet and granddaughter of Fragonard
- Figures are informally placed
- Sketchy, painterly brushwork
- Instantaneous moment caught with spontaneity of expression
- Reveals the habits of middle-class women of the time, carefully wrapping themselves up when going out in the sun
- Even though outdoors, sharing a private intimate moment
- Asymmetrical composition

Figure 24.20: Berthe Morisot, *Villa at the Seaside*, 1874, oil on canvas, Norton Simon, Los Angeles

Mary Cassatt, *Mother and Child with a Rose Scarf*, 1908, oil on canvas, Metropolitan Museum of Art, New York (Figure 24.21)

- Mother-and-child theme a specialty of Cassatt
- Tenderness foreign to other Impressionists
- Figures from everyday life
- Cassatt's world is filled with women; women as independent and not needing men to complete themselves; women who enjoy the company of other women
- No posing or acting, figures possess a natural charm
- Decorative charm influenced by Japanese art

Figure 24.21: Mary Cassatt, *Mother and Child with a Rose Scarf*, 1908, oil on canvas, Metropolitan Museum of Art, New York

Figure 24.22 James Whistler, *Nocturne in Black and Gold: The Falling Rocket*, 1875, oil on wood, Detroit Institute of Art, Michigan

James Whistler, *Nocturne in Black and Gold: The Falling Rocket*, 1875, oil on wood, Detroit Institute of Art Michigan (Figure 24.22)

- Subtle harmonies of painting comparable to subtle harmonies of music
- Japanese signature in lower right corner
- Atmospheric effects of fireworks over a riverbank; not a realistic depiction but a study in the harmonies of colors, shapes, and light
- Famous lawsuit over this painting in which Whistler sued an art critic over his opinions of his painting, which he claimed damaged his reputation; Whistler won the trial, but was forced into bankruptcy in paying the court costs

Characteristics of Post-Impressionism

While the Impressionists stressed light, shading, and color, the Post-Impressionists—that is, those painters of the next generation—moved beyond these ideals to combine them with an analysis of the structure of a given subject. **Paul Cézanne**, the quintessential Post-Impressionist, said that he wished to "make Impressionism something solid and durable, like the art of the museums." It is common for Post-Impressionists to move toward abstraction in their work, and yet seemingly paradoxically retaining solid forms, exploring underlying structure, and preserving traditional elements such as perspective.

Major Works of Post-Impressionism

Figure 24.23: Henri de Toulouse-Lautrec, *At the Moulin Rouge*, 1892–1895, oil on canvas, Art Institute of Chicago

Henri de Toulouse-Lautrec, *At the Moulin Rouge*, 1892–1895, oil on canvas, Art Institute of Chicago (Figure 24.23)

- Specializes in scenes of Parisian nightlife
- Tilted perspective of Japanese prints
- Zigzag compositions
- Large areas of flat color
- Figures are out to have a good time, but everything appears to be joyless
- Tiny bearded man in back is a self-portrait, he is standing with his very tall cousin
- Fanciful use of line, sometimes disguising anatomy beneath

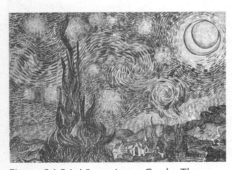

Figure 24.24: Vincent van Gogh, *The Starry Night*, 1889, reed brush drawing, Museum of Architecture, Bremen, Germany

Vincent van Gogh, *The Starry Night*, 1889, reed brush drawing, Museum of Architecture, Bremen, Germany (Figure 24.24)

- Thick short brushstrokes
- Mountains in the distance that Van Gogh could see at his hospital room in St.-Rémy, steepness exaggerated
- Composite landscape: Dutch church, cresent moon, Mediterranean cypress tree
- At one with the forces of nature
- Parts of the canvas can be seen through the brushwork; artist need not fill in every space of the composition

- Strong left-to-right wavelike impulse in the work, broken only by tree and church steeple
- Tree looks like green flames reaching into the sky exploding with stars over a placid village; cypress tree a traditional symbol of death and eternal life

Paul Gauguin, *Vision after the Sermon*, 1888, oil on canvas, National Galleries of Scotland, Edinburgh (Figure 24.25)

- After a sermon on Jacob wrestling an angel, the worshippers exit the church and envision the scene
- Tree trunk separates the real from the miracle
- Red heat of the sermon matches the red earth
- Tilted perspective
- Priest at lower right looks like Gauguin
- Apple tree, tree of knowledge, not in story, Gauguin addition
- Cow symbolizes man's redemption, Ezekiel's sacrifice
- Broad areas of relatively flat color, subtle variations of hue within color planes

Figure 24.25: Paul Gauguin, *Vision after the Sermon*, 1888, oil on canvas, National Galleries of Scotland, Edinburgh

Georges Seurat, *Sunday Afternoon on the Grand Jatte*, 1884–1886, oil on canvas, Art Institute of Chicago (Figure 24.26)

- Pointillist technique
- Analysis of color relationships
- Traditional perspective, alternate patterns of light and dark increase sense of depth
- Figures are statuesque, uncommunicative, almost all are faceless, as if expressing the anonymity of modern society
- Frozen quality
- Afternoon activity of the middle class on a Sunday

Figure 24.26: Georges Seurat, *Sunday Afternoon on the Grand Jatte*, 1884–1886, oil on canvas, Art Institute of Chicago

Paul Cézanne, *Mount Saint-Victoire* (Figure 24.27) 1902–1904, oil on canvas, Philadelphia Museum of Art, Philadelphia

- One of eleven canvases of this view, series dominates Cézanne's mature period
- Had contempt for flat painting, wanted rounded and firm objects, but ones that were geometric constructions made from splashes of undiluted color
- Used perspective through juxtaposing forward warm colors with receding cool colors
- Landscape rarely contains humans
- Not the countryside of Impressionism, more interested in geometric forms rather than dappled effects of light

Figure 24.27: Paul Cézanne, *Mount Saint-Victoire*, 1902–1904, oil on canvas, Philadelphia Museum of Art, Philadelphia

Figure 24.28: Paul Cézanne, *A Basket of Apples*, c. 1893, oil on canvas, Art Institute of Chicago

- Not a momentary glimpse of atmosphere as in the Impressionists, but a solid and firmly constructed mountain and foreground
- Landscape seen from an elevation
- Invited to look at space, but not enter

Paul Cézanne, *A Basket of Apples*, c. 1893, oil on canvas, Art Institute of Chicago (Figure 24.28)

- An exercise in the solidity of forms; the contrasting nature of round objects, flat objects, and the drapery falling into our own space
- Strong painterly brushstrokes
- Contrasts between two-dimensionality of the painting surface and three-dimensionality of objects; objects tilt toward us yet remain fixed on the tabletop

Characteristics of Symbolism

As a reaction against the literal world of Realism, Symbolist artists felt that the unseen forces of life, the things that are deeply felt rather than merely seen, were the guiding influences in painting. Symbolists embraced a mystical philosophy in which the dreams and inner experiences of an artist's life became the source of inspiration. Hence, Symbolists vary greatly in their painting styles from the very flat primitive quality of **Rousseau's** painting to the expressionistic swirls of **Munch's** art.

Major Works of Symbolism

Figure 24.29: Henri Rousseau, *The Sleeping Gypsy*, 1897, oil on canvas, Museum of Modern Art, New York

Henri Rousseau, *The Sleeping Gypsy*, 1897, oil on canvas, Museum of Modern Art, New York (Figure 24.29)

- Rousseau had no formal artistic training; called a "primitive" artist
- Strange ambiguities and juxtapositions
- Sterile and desertlike environment with lion, a jungle animal, sniffing at a gypsy like a curious cat
- Tilted perspective of gypsy pose
- Recurrent use of stripes in composition
- Is the lion a dream? Is the gypsy really sleeping as she holds onto a walking stick?
- Inscription: "The feline, though ferocious, is loathe to leap upon its prey, who, overcome by fatigue, lies in a deep sleep."

Figure 24.30: Edvard Munch, *The Scream*, 1893, tempera and casein on cardboard, National Gallery, Oslo

Edvard Munch, *The Scream*, 1893, tempera and casein on cardboard, National Gallery, Oslo (Figure 24.30)

- Figure walking along a wharf, boats are at sea in the distance
- Long thick brushstrokes swirl around composition
- Figure cries out in a horrifying scream, the landscape echoes his emotions

- Discordant colors symbolize anguish
- Emaciated twisting stick figure with skull-like head
- Prefigures Expressionist art
- Painted as part of a series called *The Frieze of Life*
- Art Nouveau swirling patterns

Characteristics of Art Nouveau

Art Nouveau developed in a few artistic centers in Europe—Brussels, Barcelona, Paris, and Vienna—and lasted from about 1890 to the outbreak of World War I in 1914. Art Nouveau seeks to eliminate the separation among various artistic media and combine them into one unified experience. Thus, an Art Nouveau building was designed, furnished, and decorated by the same artist or artistic team as an integrated whole.

Stylistically, Art Nouveau relies on vegetal and floral patterns, complexity of design, and undulating surfaces. Straight lines are assiduously avoided; the accent is on the curvilinear. Designers particularly enjoy using elaborately conceived wrought ironwork for balconies, fences, railings, and structural elements.

Figure 24.31: Antonio Gaudí, Casa Mila, 1907, Barcelona, Spain

Major Works of Art Nouveau

Antonio Gaudí, Casa Mila, 1907, Barcelona, Spain (Figure 24.31)

- Undulating twisting forms of hand-cut stone
- Embellishments of wrought iron, a Catalan specialty
- Conservative in its use of cut stone, modern in its design
- Interior spaces marked by elastic walls of indefinite shape
- Modern apartment building for its time: garage for carriages below, elevators to take people up to their apartments

Gustav Klimt, *The Kiss*, 1907–1908, oil on canvas, Austrian Gallery, Vienna (Figure 24.32)

- Little of the human form is actually seen: two heads, four hands, two feet
- The bodies are suggested under a sea of richly designed patterning
- Male figure has large rectangular boxes; female figure has circular forms
- Suggests all-consuming love; passion; eroticism
- Spaced in an indeterminate location against a flattened background

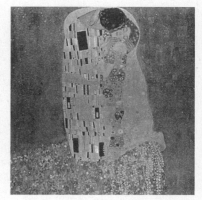

Figure 24.32: Gustav Klimt, *The Kiss*, 1907–1908, oil on canvas, Austrian Gallery, Vienna

Characteristics of Late Nineteenth-Century Architecture

The movement toward skeletal architecture increased in the late nineteenth century. Architects and engineers worked in the direction of a curtain wall, that is, a building that is held up by an interior framework, called a **skeleton**, the exterior wall being a mere curtain made of glass or steel that keeps out the weather.

The emphasis is on the vertical. Land values soar in modern cities, and architects respond by building up. Buildings emphasized their verticality by placing tall

pilasters and setting back windows behind them, such as at **The Guaranty Building** (Figure 24.37). Still, architects conceived their buildings as works of art, and covered them in traditional terra-cotta or ironwork.

During this period, the greatest advances in architecture were made by the Chicago School, formed shortly after the Great Fire burned much of the city to the ground in 1871. This disaster exposed not only the faults of building downtown structures out of wood, but also demonstrated the weaknesses of iron, which melts and bends under high temperatures. What survived quite nicely is building ceramic, especially when steel or iron is wrapped in terra-cotta casings. This became the mainstay of Chicago buildings built in the late nineteenth century, such as **Carson Pirie Scott** (Figure 24.36). These buildings demanded open and wide window spaces for light and air, as well as allowing passersby to admire window displays. Thus, the Chicago window was developed with a central immobile windowpane flanked by two smaller double-hung windows that opened for ventilation (Figure 24.33).

The single most important development in the history of early modern architecture is the invention of the elevator by Elisha Otis. This made buildings of indefinite height a reality.

Figure 24.33: Chicago windows on Daniel Burnham's Reliance Building, 1890–1894, Chicago

Major Works of Late Nineteenth-Century Architecture

Henry H. Richardson, Marshall Field Warehouse, 1885–1887, Chicago, demolished (Figure 24.34)

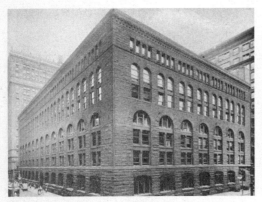

Figure 24.34: Henry H. Richardson, Marshall Field Warehouse, 1885–1887, Chicago, demolished

- Cf. Florentine Renaissance palaces, Micholozzo's Medici Palace (Figure 16.5)
- Heavy round arches resemble Romanesque architecture
- Rusticated masonry
- Self-bearing masonry exterior walls
- Slow gradation of masonry from heavy at bottom floor to flat and light on top floor
- Iron columns used for interior supports
- Interior arranged around a central court
- Few historical allusions: no capitals, columns, pediments, main entrance unaccented
- Subtle grouping of windows as building gets taller
- Solid massive appearance topped by a flat cornice
- Masculine image of a warehouse to counter the feminine image of a department store

Gustave Eiffel, The Eiffel Tower, 1887–1889, Paris (Figure 24.35)

- Eiffel specialized in building metal structures, particularly railway bridges; bottom story looks like a railroad bridge
- Eiffel helped in the construction of the Statue of Liberty, the Panama Canal
- Innovative elevator swings diagonally up ramplike sides of tower
- Centerpiece of the 1889 Paris Universal Exposition

- Assembled from a limited number of shapes, symbolizing the interlocking members of a democratic society
- Triumph of wrought-iron design

Louis Sullivan, Carson Pirie Scott, 1899–1904, Chicago (Figure 24.36)

- Horizontal emphasis symbolizes continuous flow of floor space
- Maximum window areas to admit light, also to display store wares
- Nonsupportive role of exterior
- Cast iron decorative elements transformed the store into a beautiful place to buy beautiful things
- Influence of Art Nouveau in decorative touches
- Sullivan motto: "Form follows function"

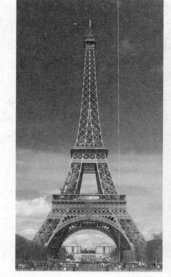

Figure 24.35: Gustave Eiffel, The Eiffel Tower, 1887–1889, Paris

Figure 24.36: Louis Sullivan, Carson Pirie Scott, 1899–1904, Chicago

Louis Sullivan, The Guaranty Building, 1894–1896, Buffalo, New York (Figure 24.37)

- Prototype of modern office building
- Accent on vertical thrust, windows placed back in space so that pilasters stretch through body of buildings unimpeded
- Exterior coated in decorative terra-cotta tiles; interior ornament elaborately arranged around lobby areas, hallways, elevator, even exposed areas under staircases
- Some historical touches in the round entrance arches and the heavy cornice at the top of the building; columns on ground floor have fanciful capitals

Characteristics of Late Nineteenth-Century Sculpture

Figure 24.37: Louis Sullivan, The Guaranty Building, 1894–1896, Buffalo, New York

Late nineteenth-century sculpture, symbolized by **Rodin**, visibly represented the imprint of the artist's hand on a given work. Most works were hand molded first in clay, and then later cast in bronze or cut in marble, usually by a workshop. The sculptor then put finishing touches on a work he or she conceived, but never executed. The physical imprint of the hand is analogous to the visible brushstroke in Impressionist painting.

Major Works of Late Nineteenth-Century Sculpture

Augustus Saint-Gaudens, *Adams Memorial*, 1891, bronze, Rock Creek Cemetery, Washington, D.C. (Figure 24.38)

- Memorial not marked, dedicated to wife of Henry Adams, who committed suicide
- No dates, no artist signature, figure unnamed

Figure 24.38: Augustus Saint-Gaudens, *Adams Memorial*, 1891, bronze, Rock Creek Cemetery, Washington, D.C.

- Solitary; serene; contemplating the mystery of the ages; eyes barely open; hooded like an Eastern mystical figure
- Arm brings attention to the shrouded face
- Placed outdoors in a cemetery, yet surrounded by high bushes and largely hidden, for private contemplation

Augustus Saint-Gaudens, *Shaw Memorial*, 1897, bronze, Boston Common (Figure 24.39)

- One of many memorials commemorating the U.S. Civil War
- Very high relief sculpture of Colonel Shaw leading first regiment of African-American soldiers into battle
- Great range of soldiers' ages represented
- Great emphasis on military details; figures march in unison; patterning of rifles
- Realism of military march contrasted with allegorical figure of Peace above

Figure 24.39: Augustus Saint-Gaudens, *Shaw Memorial*, 1897, bronze, Boston Common

Auguste Rodin, *Burghers of Calais*, 1884–1886, bronze, Metropolitan Museum of Art, New York (Figure 24.40)

- Six burghers offer their lives to the English king in return for saving their besieged city during the Hundred Years' War
- English king insisted burghers wear sackcloths and carry the key to the city
- Parallels between Paris besieged during the Franco-Prussian War of 1870 and Calais besieged by the English in 1347
- Figures sculpted individually, then arranged as the artist thought best
- Figures suffer from privation, are weak and emaciated
- Each figure has a different emotion: some fearful, resigned, or forlorn
- Central figure is Eustache de Saint-Pierre, who has large swollen hands and a noose around his neck, ready for his execution
- Details reduced to emphasize overall impression
- Meant to be placed at ground level so that people could see it close up
- Rejected by town council of Calais as being inglorious; they wanted a single allegorical figure

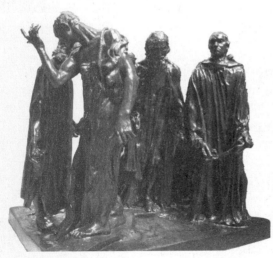

Figure 24.40: Auguste Rodin, *Burghers of Calais*, 1884–1886, bronze, Metropolitan Museum of Art, New York

VOCABULARY

Avant-garde: an innovative group of artists who generally reject traditional approaches in favor of a more experimental technique

Japonisme: an attraction for Japanese art and artifacts that were imported into Europe in the late nineteenth century

Lithography: a printmaking technique that uses a flat stone surface as a base. The artist draws an image with a special crayon that attracts ink. Paper, which absorbs the ink, is applied to the surface and a print emerges (Figure 24.2)

Modernism: a movement begun in the late nineteenth century in which artists embraced the current at the expense of the traditional in both subject matter and in media. Modernist artists often seek to question the very nature of art itself.

Plein-air: painting in the outdoors to directly capture the effects of light and atmosphere on a given object (Figures 24.14, 24.15, and 24.16)

Pointillism: a painting technique that uses small dots of color that are combined by the eye at a given distance (Figure 24.26)

Positivism: a theory that expresses that all knowledge must come from proven ideas based on science or scientific theory; a philosophy promoted by French philosopher Auguste Comte (1798–1857)

Primitive or **naïve artist:** an artist without formal training; a folk artist. Henri Rousseau is a primitive artist

Skeleton: the supporting interior framework of a building

Zoopraxiscope: a device that projects sequences of photographs to give the illusion of movement (Figure 24.12)

Summary

The late nineteenth century is known for a series of art movements, one following quickly upon another: Realism, Pre-Raphaelite, Impressionism, Post-Impressionism, Symbolism, and Art Nouveau. Each movement expresses a different philosophy demonstrating the richness and diversity of artistic expression in this period.

Realism relied on the philosophy of positivism, which made paintings of mythological and religious scenes seem not only outdated but archaic. Pre-Raphaelites, by contrast, enshrined the past as a source of inspiration for their work. Many Impressionist artists painted in the outdoors, seeking to draw inspiration from nature. Post-Impressionists explored the underlying structural foundation of images, and laid the groundwork for much of modern art. Symbolists drew upon personal visions to create works resembling a dreamworld. Lastly, Art Nouveau was a stylish and creative art form that put emphasis on sinuous shapes and curvilinear forms.

The late nineteenth century saw a revival of sculpture under the command of Auguste Rodin, who molded works in clay giving a very tactile quality to his works.

The direction of late nineteenth-century architecture was vertical. Architects responded to increased land values and advances in engineering by designing taller and thinner. For the first time in history, cities began to be defined by their skylines, which rose dramatically in downtown areas.

Practice Exercises

1. The widespread influence of Japanese art in nineteenth-century Europe is called

 (A) Japonisme
 (B) ukiyo-e
 (C) Kyoto
 (D) pointillism

2. Henry Ossawa Tanner's paintings are characterized by

 (A) an effort to fit into the Impressionist mold
 (B) allusions to the African-American experience
 (C) extensive use of photography as a medium
 (D) painting in plein-air

3. The single most important invention in the development of the modern skyscraper is

 (A) wrought iron
 (B) cast iron
 (C) terra-cotta tiles
 (D) the elevator

Questions 4–6 refer to Figure 24.41.

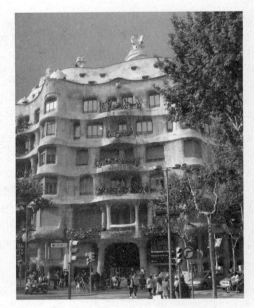

Figure 24.41

4. The designer of this building is

 (A) Louis Sullivan
 (B) Henry H. Richardson
 (C) Gustave Eiffel
 (D) Antonio Gaudí

5. The style associated with this building is

 (A) Impressionism
 (B) Post-Impressionism
 (C) Art Nouveau
 (D) Symbolism

6. The purpose of this building is

 (A) an apartment house
 (B) an office building
 (C) a parking garage
 (D) a factory

7. Nineteenth-century Realist painters felt an affinity for

 (A) religious subjects
 (B) historical paintings that show the effect of labor movements
 (C) peasants working with dignity
 (D) showing peasants in desperate situations

8. Although Paris was the center of the art world in the nineteenth century, artists sometimes defined themselves by their escape from the Paris art establishment. All of the following artists left Paris EXCEPT:

 `CHALLENGE`

 (A) Henri de Toulouse-Lautrec
 (B) Paul Gauguin
 (C) Paul Cézanne
 (D) Vincent Van Gogh

9. One of the basic concepts Impressionism embraces is that

 (A) color is controlled by mass and form
 (B) light transforms color
 (C) perspective is important to rendering shapes
 (D) brushstrokes should be fine and invisible

10. Mary Cassatt used women as a subject because

 `CHALLENGE`

 (A) no men would pose for her
 (B) she wanted to create a world in which women do not need men to complete them
 (C) men wanted to pay her less than women did
 (D) she objected to the exclusionary nature of the Salon and the Academy

Short Essay

Paul Cézanne, the great Post-Impressionist painter, said that he wished to "make Impressionism something solid and durable, like the art of the museums." What was Cézanne saying about the nature of Impressionism? Use an example of his work to explain how he formed a reaction against Impressionism. Use one side of a sheet of lined paper to write your essay.

Answer Key

1. **(A)**	3. **(D)**	5. **(C)**	7. **(C)**	9. **(B)**
2. **(B)**	4. **(D)**	6. **(A)**	8. **(A)**	10. **(B)**

Answers Explained

Multiple-Choice

1. **(A)** Japonisme is the term used to describe the Japanese influence on European art. Ukiyo-e is a style of Japanese prints. Kyoto is a city in Japan.

2. **(B)** Tanner used the African-American experience as the centerpiece of his oeuvre.

3. **(D)** Without the elevator, buildings would be nearly impossible beyond the sixth floor.

4. **(D)** Antonio Gaudí is the designer of the Casa Mila.

5. **(C)** The Casa Mila is from the Art Nouveau period.

6. **(A)** The Casa Mila is an apartment house.

7. **(C)** Realists glorified and dignified peasant labor. Works by Daumier, Millet, and Courbet are in agreement with this approach.

8. **(A)** Henri de Toulouse-Lautrec thrived on the Paris lifestyle, using its people and places as the fertile center of his work. Vincent Van Gogh and Paul Cézanne went to the south of France, and Paul Gauguin went to Tahiti and Martinique.

9. **(B)** Basic tenets of Impressionism include the following ideas: light transforms color, colors contain varying hues, and colors contain shadows of color.

10. **(B)** Mary Cassatt developed themes of women and children throughout her life. She enjoyed exploring women's relationships.

Rubric for Short Essay

4: The student explains the quotation and recognizes a particular work by Cézanne as a contrast with Impressionism. The student explains the characteristics of Impressionism that Cézanne was addressing. There are no major errors.

3: The student explains the quotation and recognizes a particular work by Cézanne as a contrast with Impressionism. There may be minor errors.

2: The student gives a limited explanation of the quotation and only passing knowledge of how Cézanne's work differs from Impressionism. There may be major errors.

1: The student gives almost no explanation of the quotation and makes only a passing attempt at answering the question correctly. There may be major errors.

0: The student makes an attempt, but the response is without merit.

Short Essay Model Response

The great Post-Impressionist painter, Paul Cézanne, once said that he wished to "make Impressionism something solid and durable, like the art of the museums." Cézanne believed there was no truth to Impressionism. Like many artists of his era, Cézanne experimented with colors, planes, and lines that are found in nature. His reaction against Impressionism is undeniable in one of his most-known works, <u>Mont Sainte-Victoire</u>. By viewing nature in terms of objects, Cézanne was able to create a central point in his paintings that gave them a depth completely opposite to traditional artists like Poussin.

Cézanne felt that the Impressionists aimed at dissolving nature into a blur of atmospheric effects. In response, he sought to solidify nature and translate it into an underlying structure of solid objects. In effect, the aims of each of these movements and artists are different, and the results vary tremendously.

Cézanne was ahead of his time and took a modern approach to creating the effects of depth, distance, structure, and solidity. His comprehension of visual properties and selection of color patterns created illusions of three-dimensionality for which he was, and continues to be, highly recognized for.

—Pamela P.

Analysis of Model Response

Pamela confidently expresses how Cézanne's art marks a departure from Impressionism into a world that is both abstract in its reliance on solids and shapes and realistic in its depiction of Mont St.-Victoire. She understands the quotation and draws upon a solid example to illustrate her point. **This essay merits a 4.**

Early Twentieth-Century Art

TIME PERIOD: 1900–1945

Movement	Dates	Major Artists
Prairie Style	1900–1917	Wright
Fauvism	c. 1905	Matisse
Expressionism	1905–1930s	Modersohn-Becker
• The Bridge	1905	Kirchner
• The Blue Rider	1911	Kandinsky, Marc
Cubism	1907–1930s	Picasso
Futurism	1909–1914	Boccioni
Metaphysical Painting	1910–1920s	DeChirico
Suprematism	1913–1920s	Malevich
Constructivism	1914–1920s	Tatlin
Dada	1916–1925	Duchamp
DeStijl	1917–1930s	Mondrian, Rietveld
Bauhaus	1919–1933	Gropius
Precisionism	1920s	O'Keeffe
Mexican Muralists	1920s–1930s	Rivera
International Style	1920s–1930s	Le Corbusier
Surrealism	1924–1930s	Dalí, Kahlo, Miró, Oppenheim
Art Deco	1920–1930s	Van Alen
Organic Art	Late 1920s–1930s	Brancusi, Moore
Depression Era Art	1930s	Hopper, Lange, Lawrence, Wood

KEY IDEAS

- Early modern art flourished at a time of immense political unrest and social upheaval.
- Modern artists and architects were quick to embrace new technologies in the creation of their works.
- Avant-garde patrons cultivated cutting-edge artist, allowing them to flourish.
- The Armory Show introduced modern art to America, and Gallery 291 exhibited photographs beside paintings as works of art.
- Modern art takes on a more international flavor than ever—great movements take place in locations hitherto thought of as cultural backwaters like Mexico and Russia.
- The period is characterized by artists who were also theoreticians and published manifestos on their artistic beliefs.

HISTORICAL BACKGROUND

With the cataclysmic events of World War I and World War II, as well as the Great Depression, one would never suspect that the early twentieth century was an intensely creative period in the arts. But in nearly every artistic venue—literature, music, dance, and the fine arts—artistic expression flourished. Some movements fed on these very cataclysms for inspiration, others sought to escape the visceral world. Whatever the reason, the early twentieth century is one of the most creative periods in art history.

Patronage and Artistic Life

Early twentieth-century art was sponsored by extremely cultivated and intellectual patrons who were members of the avant-garde. They saw art as a way to embrace the modern spirit in a cultured way. These influential patrons, like Gertrude Stein, promoted great artists through their sponsorship and connections.

New to the art world is the patronage of museums. It has become standard for a great museum to hire the finest architectural firms to handle expansion projects and turn the museum into a work of art in its own right. Museums also commission works of sculpture and painting from contemporary artists to be showcased in their public spaces.

Not all modern art, however, was greeted with enthusiasm. The **Armory Show** of 1913, which introduced modern art to American audiences, was generally reviled by American audiences. **Picasso's** *Les Demoiselles d'Avignon* (Figure 25.6) horrified the public. **Duchamp's** *Fountain* (Figure 25.12) even upset the promoters of the gallery who were supposed to allow anyone to be able to exhibit, provided he or she paid the six-dollar admission fee.

INNOVATIONS OF EARLY TWENTIETH-CENTURY ARCHITECTURE

Early twentieth-century architecture is marked by a complete embrace of technological advances. **Ferroconcrete** construction, particularly in Europe, allowed for new

designs employing skeleton frameworks and glass walls. The **cantilever** (Figure 25.27) helped push building elements beyond the solid structure of the skeletal framework.

In general, architects avoided historical associations: There are few columns and fewer flying buttresses. Architects prefer clean sleek lines that stress the building's underlying structure and emphasize the impact of the machine and technology.

INNOVATIONS OF EARLY TWENTIETH-CENTURY PAINTING

All of the characteristic painter's tools of expression were under question in the early twentieth century. Color was not only used to describe a setting or an artist's impression, but also to evoke a feeling and challenge the viewer. Perspective was generally discarded, or violently tilted for dramatic impact. Compositions were forcefully altered in a new and dynamic way.

Most radically, the introduction of pure form, **abstraction**, became the feature of modern art. Actually, abstract art has always existed, usually in marginal areas of works of art, sometimes in frames or as decorative designs. New is the placement of the abstract form directly in the center of the composition—a statement averring that abstraction has a meaning independent of realistically conveyed representations.

Artists moved beyond the traditional oil-on-canvas approach to great art, and were inspired by **frottage** and **collage**, techniques formerly relegated to children's art. Such fervent experimentation led Europeans to draw inspiration from African cultures, hitherto ignored or labeled as primitive. Europeans were stimulated by African artists' ability to create works in geometric, even abstract, terms, unafraid of a lack of conventional reality. This freedom of expression inspired Europeans to rethink traditional representations, sometimes by writing their thoughts down in artistic manifestos, which served as a call to arms for their movement.

INNOVATIONS OF EARLY TWENTIETH-CENTURY SCULPTURE

The adventurous spirit that epitomizes modern painting and architecture also characterizes modern sculpture. Artists used new materials, such as plastic, and new formats, such as collages, to create dynamic compositions. Artists also dangled metal shapes from a ceiling and called them **mobiles**.

In the Dada movement, artists saw a found object and turn it into a work of art. These **ready-mades** became works of art simply because the artist said they were.

Characteristics of Fauvism

Fauvism is an art movement that debuted in 1905 at Salon d'Automne in Paris. It was so named because a critic, Louis Vauxcelles, thought that the paintings looked as if they were created by "Wild Beasts." Fauvism was inspired by Post-Impressionist painters like Gauguin and Van Gogh, whose work was exhibited in Paris around this time. Fauves stressed a painterly surface with broad flat areas of violently contrasting color. Figure modeling and color harmonies were suppressed so that expressive effects could be maximized. Fauvism all but died out by 1908.

Figure 25.1: Henri
Matisse, *Woman with a
Hat*, 1905, oil on canvas,
San Francisco Museum
of Modern Art,
California

Major Work of Fauvism

Henri Matisse, *Woman with a Hat*, 1905, oil on canvas, San Francisco Museum of Modern Art, California (Figure 25.1)

- Conventional composition
- Violent contrasts of color
- Energetic painterly brushwork
- Exhibited at the 1905 Salon d'Automne in Paris
- Matisse's wife

Characteristics of Expressionism

Inspired by the Fauve movement in Paris, a group of German artists in Dresden gathered around **Kirchner** and formed Die Brüke, **The Bridge**, in 1905, so named because they saw themselves as a bridge from traditional to modern painting. They emphasized the same Fauve ideals expressed in violent juxtapositions of color, which so purposely roused the ire of critics and the public.

A second Expressionist group, called **Der Blaue Reiter**, **The Blue Rider**, formed in Munich, Germany, in 1911. This group (so named because of an affection the founders had for horses and the color blue) began to forsake representational art and move toward abstraction. Highly intellectual, and filled with theories of artistic representation, artists like **Kandinsky** and **Marc** saw abstraction as a way of conceiving the natural world in terms that went beyond representation. Kandinsky's theories were best expressed in his influential essay, *Concerning the Spiritual in Art*, which outlined his theories on color and form for the modern movement.

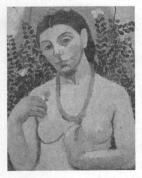

Figure 25.2:Paula
Modersohn-Becker,
*Self-Portrait with an
Amber Necklace*, 1906,
oil on canvas, Art
Museum, Basel,
Switzerland

Major Works of Expressionism

Paula Modersohn-Becker, *Self-Portrait with an Amber Necklace*, 1906, oil on canvas, Art Museum, Basel, Switzerland (Figure 25.2)

- Unusual self-portrait, artist portrays herself as nude
- She presents two flowers, has three more in her hair, symbolic of fertility and beauty
- She looks out at viewer with a mixture of confidence, tenderness, humanity, and femininity
 - Thick paint application creates an intentionally primitive feeling
 - Interlocking surfaces of color

Vassily Kandinsky, *Improvisation 28*, 1912, oil on canvas, Guggenheim Museum, New York (Figure 25.3)

- Movement toward abstraction; representational objects suggested rather than depicted
- Title derived from musical compositions
- Strongly articulated use of black lines
- Colors seem to shade around line forms

Figure 25.3: Vassily Kandinsky,
Improvisation 28, 1912, oil on canvas,
Guggenheim Museum, New York

Franz Marc, *Large Blue Horses*, 1911, oil on canvas, Walker Art Center, Minneapolis (Figure 25.4)

- Marc was a cofounder of Der Blaue Reiter
- Swirling shapes and dynamic composition; suggests sweeping movement; shape of horses harmonizes with landscape
- Emotional impact of blue color for horses; color draws horses together as if in a common experience

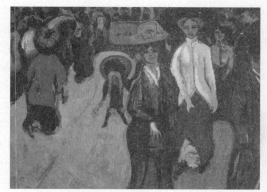

Figure 25.4: Franz Marc, *Large Blue Horses*, 1911, oil on canvas, Walker Art Center, Minneapolis

Ernst Kirchner, *Street, Dresden*, 1908, oil on canvas, Museum of Modern Art, New York (Figure 25.5)

- Uncomfortably close encounter with women on a Dresden Street
- Colors are nonrepresentational, but symbolic and chosen to provide a jarring impact
- Expressive quality of horrified facial features and grim surroundings
- Titled perspective moves things closer to the picture plane

Characteristics of Cubism

Cubism was born in the studio of **Pablo Picasso**, who in 1907 revealed the first cubist painting, *Les Demoiselles d'Avignon* (Figure 25.6). Perhaps influenced by the simple geometries of African masks, then the rage in Paris, Picasso was inspired to break down the human form into angles and shapes, achieving a new way of looking at the human figure from many sides at once. This use of multiple views shows parts of a face, for example, from a number of angles. Cubism is dominated by wedges and facets that are sometimes shaded to simulate depth.

Figure 25.5: Ernst Kirchner, *Street, Dresden*, 1908, oil on canvas, Museum of Modern Art, New York

The first phase of Cubism, from 1907–1912, called **Analytical**, was highly experimental, showing jagged edges and sharp multifaceted lines. The second phase, after 1912, called **Synthetic Cubism**, was initially inspired by collages and found objects and featured flattened forms. The last phase, **Curvilinear Cubism**, in the 1930s, was a more flowing rounded response to the flattened and firm edges of Synthetic.

Major Works of Cubism

Pablo Picasso, *Les Demoiselles d'Avignon*, 1907, oil on canvas, Museum of Modern Art, New York (Figure 25.6)

- First Cubist work, influenced by late Cézanne, and perhaps African masks
- Represents five prostitutes in a bordello on Avignon Street in Barcelona, each posing for a customer
- Poses are not traditionally alluring but awkward, expressionless, and uninviting

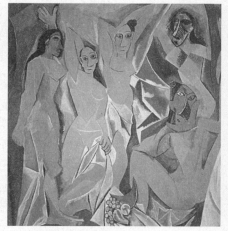

Figure 25.6: Pablo Picasso, *Les Demoiselles d'Avignon*, 1907, oil on canvas, Museum of Modern Art, New York

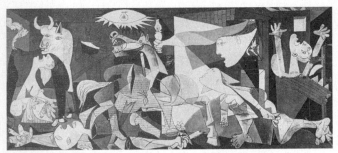

Figure 25.7: Pablo Picasso, *Guernica*, 1937, oil on canvas, Reina Sofia, Madrid

- Three on left more conservatively painted, two on right more radical; reflects a dichotomy in Picasso
- Multiple views expressed at the same time
- No real depth

Pablo Picasso, *Guernica*, 1937, oil on canvas, Reina Sofia, Madrid (Figure 25.7)

- Painted for the Spanish pavilion of the 1937 Parisian World's Fair
- A reaction to the Fascist bombing of the militarily insignificant town of Guernica in northern Spain during the Spanish Civil War
- Done in black and white to imitate news photos
- Picasso usually not a symbolic painter, but here symbols abound
 - Pietà on left with stigmata on child's hands
 - Bull symbolizes brutality and darkness; but could also symbolize Spain herself
 - Fallen warrior at bottom left holds a broken sword, perhaps meant to evoke a fallen war memorial
 - Woman with torch is an allegory of Liberty
- Horse in panic tramples on everything and everyone
- Wounded figures on right rush in, seeking shelter
- Figures in perspective on bottom recall the dead figures in Ucello's *Battle of San Romano* (cf. Figure 16.12)

Characteristics of Futurism

Just before World War I, a group of Italian artists came together to celebrate the scientific and technological progress of the modern world. The glory of the machine and a fascination with speed were the chief subjects of Futurist art. Influenced by Cubism, the Futurists enjoyed the prismatic effects of representation, rendering an almost shattered look to their work. Futurist theories were given formal expression by Filippo Tommaso Marinetti, who published manifestos that advocated an artistic revolution. The Futurists were at their height between 1909 and 1914.

Figure 25.8: Umberto Boccioni, *Unique Forms of Continuity in Space*, 1913, bronze, Museum of Modern Art, New York

Major Work of Futurism

Umberto Boccioni, *Unique Forms of Continuity in Space*, 1913, bronze, Museum of Modern Art, New York (Figure 25.8)

- Cf. *Nike of Samothrace* (Figure 5.20)
- Affected by the atmosphere around it as it strides pridefully forward
- Provides the illusion of movement
- Abstract forms fly around the armless figure

The Armory Show

The Armory Show, named after the building in New York where it was held, was mounted in 1913 to introduce Americans to the current trends in European art. Many contemporary artists, such as Duchamp and Picasso, were showcased in America for the first time. The show also exhibited prominent American artists.

Marcel Duchamp, *Nude Descending a Staircase, No. 2*, 1912, oil on canvas, Philadelphia Museum of Art, Pennsylvania (Figure 25.9)

- The Succès de Scandale of the Armory Show
- A Cubist and/or Futurist painting depicting an assumed nude going down a flight of stairs
- Influenced by motion pictures, multiple-exposure photography
- Limited color range

Photo-Secession

From 1902 through 1917 Alfred Stieglitz's gallery, called Gallery 291, was the most progressive gallery in the United States, showcasing photographs as works of art beside avant-garde European paintings and modern American works.

Alfred Stieglitz, *The Steerage*, 1907, photograph, Private Collection (Figure 25.10)

- Stieglitz photographed the world as he saw it, arranged little and allowed people and events to make their own compositions
- Interested in compositional possibilities of diagonals and lines acting as framing elements
- Diagonals and framing effects of ladders, sails, steam pipes, and so on
- Depicts the poorest passengers on a ship traveling from the United States to Europe in 1907; these were mostly rejected immigrants to the United States on the return journey; they were allowed out for air for a limited time

Characteristics of Precisionism

Precisionism was a loosely organized 1920s movement that stressed the flat precision of synthetic Cubism and interest in the sharp edges of machinery.

Major Work of Precisionism

Georgia O'Keeffe, *Light Iris*, 1924, oil on canvas, Virginia Museum of Fine-Arts, Richmond (Figure 25.11)

- Simplified monumental shapes, organic forms
- Minimal details; monumentality of a delicate flower
- Broad planes of unmodulated color
- Tilted perspective
- Erotic overtones; female sexuality; naturally beautiful flower blossoming

Characteristics of Dada

Dada, a nonsense word that literally means "hobby horse," is a term directed at a movement in Zurich, Cologne, Berlin, Paris, and New York from 1916 to 1925. Disillusioned by the useless slaughter of World War I, the Dadaists rejected conventional methods of representation and the conventional man-

Figure 25.9: Marcel Duchamp, *Nude Descending a Staircase, No. 2*, 1912, oil on canvas, Philadelphia Museum of Art, Pennsylvania

Figure 25.10: Alfred Stieglitz, *The Steerage*, 1907, photograph, Private Collection

Figure 25.11: Georgia O'Keeffe, *Light Iris*, 1924, oil on canvas, Virginia Museum of Fine-Arts, Richmond

ner in which they were exhibited. Oil and canvas were abandoned. Instead, Dadaists accepted **ready-mades** as an art form, and often did their work on glass. Dadaists challenged the relationship between words and images, often incorporating words prominently in their works. The meaning of Dada works is frequently contingent on location or accident. If a glass should shatter, as a few did, it was hailed as an enhancement, acknowledging the hand of chance in this achievement. In sum, Dada accepts the dominance of the artistic concept over the execution.

Major Work of Dada

Figure 25.12: Marcel Duchamp, *Fountain*, original 1917, china, Philadelphia Museum of Art, Pennsylvania

Marcel Duchamp, *Fountain*, original 1917, china, Philadelphia Museum of Art, Pennsylvania (Figure 25.12)

- Ready-made sculpture, actually a found object that Duchamp deemed to be a work of art
- Entered in an unjuried show, but the work was refused
- Signed by the "artist" R. Mutt, a pun on the *Mutt and Jeff* comic strip and Mott Iron Works
- Title *Fountain* a pun; fountains spout liquid, a urinal is meant to collect it

Characteristics of Metaphysical Painting

Metaphysical painting was an Italian movement that flourished from 1910 through the 1920s. Human beings, often shadows or tailor's dummies, were cast in open and mysterious plazas of infinite space. The introduction of alien elements created enigmas that foreshadowed Surrealist painting. Influenced by the work of late nineteenth-century German philosophers, metaphysical painting asks the viewer to interpret a meaning based on symbols, suggestions, and impressions.

Major Work of Metaphysical Painting

Figure 25.13: Giorgio DeChirico, *Melancholy and Mystery of a Street*, 1914, oil on canvas, Private Collection

Giorgio DeChirico, *Melancholy and Mystery of a Street*, 1914, oil on canvas, Private Collection (Figure 25.13)

- Deep pull into space
- Shadowy, eerie forms that create mystery and foreboding
- Juxtaposition of large dark spaces and open light vistas
- Empty van with nothing in it

Characteristics of Surrealism

Inspired by the psychological studies of Freud and Jung, Surrealists sought to represent an unseen world of dreams, subconscious thoughts, and unspoken communication. Starting with the theories of Andre Breton in 1924, the movement went in two directions: The abstract tradition of **biomorphic** and suggestive forms, and the veristic tradition of using reality-based subjects put together in unusual ways. Those who seek to understand the inscrutable world of

Surrealism by looking at a painting's title will find themselves even more confused than when they started. Surrealism is meant to puzzle, challenge, and fascinate; its sources are in mysticism, psychology, and the symbolic. It is not meant to be clearly understood and didactic.

Major Works of Surrealism

Max Ernst, *Two Children Are Threatened by a Nightingale*, 1924, oil on wood, Museum of Modern Art, New York (Figure 25.14)

- Contraries abound:
 - Why is a nightingale out in the daytime?
 - How could such a bird frighten children, one of whom has collapsed?
 - What is the relative size between the fence and the children?
 - Who is the shadowy figure on the house, and what is it holding?
 - What will happen when the figure presses the button?
 - What does the lever on the house do?

Salvador Dalí, *The Persistence of Memory*, 1931, oil on canvas, Museum of Modern Art, New York (Figure 25.15)

- Huge empty spaces suggested by vast landscape
- Drooping watches all tell different times
- Only life is the fly on the watch and the ants on the closed watch fob
- Hallucinatory
- Barren and uninhabited landscape
- Bonelike hand seems to caricature Dalí's face
- Visual ironies: tree grows from a firm block, clock hangs from a dead tree branch

Joan Miró, *Painting*, 1933, oil on canvas, Museum of Modern Art, New York (Figure 25.16)

- Biomorphic shapes set on a series of simple background colors; color harmonies are softly modeled
- Shapes suggest realistic objects
- Shapes are delineated by solid black outlines; some objects filled in with black
- Amoeba-like shapes
- Playful forms interact in a free-flowing pattern

Figure 25.14: Max Ernst, *Two Children Are Threatened by a Nightingale*, 1924, oil on wood, Museum of Modern Art, New York

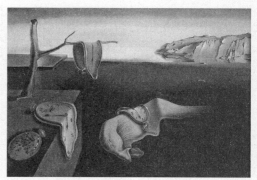

Figure 25.15: Salvador Dalí, *The Persistence of Memory*, 1931, oil on canvas, Museum of Modern Art, New York

Figure 25.16: Joan Miró, *Painting*, 1933, oil on canvas, Museum of Modern Art, New York

Figure 25.17: Alexander Calder, *Lobster Tail and Fish Trap*, 1939, steel wire and aluminum, Museum of Modern Art, New York

Figure 25.18: Meret Oppenheim, *Object*, 1936, fur-covered cup, Museum of Modern Art, New York

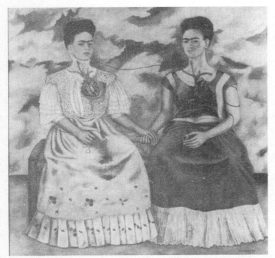

Figure 25.19: Frida Kahlo, *The Two Fridas*, 1939, oil on canvas, Museum of Modern Art, Mexico City

Alexander Calder, *Lobster Tail and Fish Trap*, 1939, steel wire and aluminum, Museum of Modern Art, New York (Figure 25.17)

- A mobile, hung from a ceiling, perfectly balanced and changing shape at each breeze
- Primary and neutral colors
- Biomorphic flat forms suggest but do not depict reality
- Commissioned by the Museum of Modern Art

Meret Oppenheim, *Object*, 1936, fur-covered cup, Museum of Modern Art, New York (Figure 25.18)

- Said to have been done in response to Picasso's claim that anything looks good in fur
- Combination of unlike objects: fur-covered teacup, saucer, and spoon
- Erotic overtones

Frida Kahlo, *The Two Fridas*, 1939, oil on canvas, Museum of Modern Art, Mexico City (Figure 25.19)

- Juxtaposition of two self-portraits
- Left: Kahlo dressed as a Spanish lady in white lace
- Right: Kahlo dressed as a Mexican peasant—the stiffness and provincial quality of Mexican folk art serves as a direct inspiration for the artist
- Her two hearts are twined together by veins that are cut by scissors at one end and lead to a portrait of her husband, artist Rivera, at the other; painted at the time of their divorce
- Barren landscape, two figures sit against a wildly active sky
- Kahlo rejected the label of Surrealism to her artwork

Characteristics of Suprematism

Right before the Russian 1917 Revolution and continuing for a short time thereafter, artists like **Malevich** began a powerful independent movement in the arts. The Suprematists so named their movement because they thought nonobjective reality was greater than anything that could be achieved by representation. From 1913 to the early 1920s, artists like Malevich produced a series of canvases he called "the supremacy of pure feeling." Forms float on a white background, usually suspended in thoughtful arrangements. Limited use of color, as well as geometric shapes placed at diagonals, are the hallmarks of Suprematism. However, the communist government in Russia turned its back on abstract art, as many totalitarian governments do, and the Suprematists passed into history.

Major Work of Suprematism

Kazimir Malevich, *Suprematist Composition: Airplane Flying*, 1915, oil on canvas, Museum of Modern Art, New York (Figure 25.20)

- Simple rectangular forms placed the white background
- Composition asks us to contemplate relationship of forms
- Pure idealism of forms
- Artist said he wanted to "free art from the burden of the object"

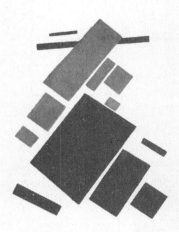

Figure 25.20: Kazimir Malevich, *Suprematist Composition: Airplane Flying*, 1915, oil on canvas, Museum of Modern Art, New York

Characteristics of Constructivism

Constructivists experimented with new architectural materials and assembled them in a way devoid of historical reference. Beginning in 1914, Tatlin and others saw the new Russia as an idealistic center removed from historical reference and decoration. Influenced by the Cubists and the Futurists, Constructivism designed buildings with no precise façades. Emphasis was placed on the dramatic use of the materials used to create the project.

Major Work of Constructivism

Vladimir Tatlin, *Monument to the Third International*, 1919–1920, wood, iron, glass, model now destroyed (Figure 25.21)

- Commemorates the 1917 Russian Revolution
- Tatlin believed that abstract art represented a new society built free of past associations
- To have been made of iron and glass, existed as a model, now lost or destroyed
- Axis pointed to star Polaris: symbol of universal humanity
- Three chambers were to rotate around a central axis inside a tilted spiral cage; each chamber housed a facility for a different kind of government activity and rotated at a different speed
- Bottom: glass structure for lectures and meetings, rotated once a year
- Middle: intended for administration, rotated monthly
- Top: information center, rotated daily
- Lacks a main façade; seems to burrow into the earth
- Was to have been built in Moscow as the headquarters for propaganda for the Soviet Union
- Never built; would have been the world's tallest building

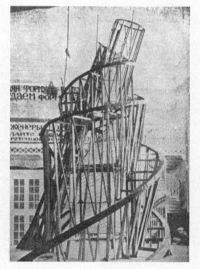

Figure 25.21: Vladimir Tatlin, *Monument to the Third International*, 1919–1920, wood, iron, glass, model now destroyed

Characteristics of DeStijl

DeStijl was a movement symbolized by the Dutch painter **Mondrian**, and reached its height between 1917 and the 1930s. At its purest, DeStijl paintings are completely abstract; even the titles make no reference to nature. They are painted on a white background and use black lines to shape the rectangular spaces. Only the three primary colors are used: red, yellow, and blue, and they are painted without modulation. Lines can only be placed perpendicularly—diagonals are forbidden.

Figure 25.22: Piet Mondrian, *Composition in Black and White and Red*, oil on canvas, 1936, Museum of Modern Art, New York

Major Works of DeStijl

Piet Mondrian, *Composition in Black and White and Red*, 1936, oil on canvas, Museum of Modern Art, New York (Figure 25.22)

- Only primary colors used: red, yellow, blue and the neutrals white and black
- Severe geometry of form, only right angles; gridlike forms
- No shading of colors

Gerrit Rietveld, Schröder House, 1924, Utrecht, Netherlands (Figure 25.23)

- An arrangement that suggests DeStijl paintings; geometric grid-like façade; asymmetrical interlocking planes
- Private rooms of house on bottom floor; public rooms on top floor
- Free-flowing interior has partitions that can open and close at will creating new spaces

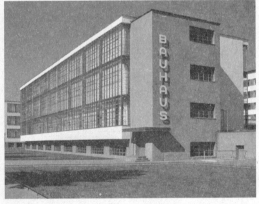

Figure 25.23: Gerrit Rietveld, Schröder House, 1924, Utrecht, Netherlands

Characteristics of the Bauhaus

The Bauhaus was a school of architecture and interior design that was open from 1919 to 1933, first in Weimar and then in Dessau, Germany. The Bauhaus taught that all art forms, from simply crafted objects to large architectural complexes, should be designed as a unit. Technology was embraced. Students were encouraged to understand all aspects of artistic endeavor, and how they could be woven together into a coherent whole.

Influenced by DeStijl and Constructivism, the Bauhaus had simple, but elegant, designs that were based on a harmonious geometry and a brevity of expressive forms. The Bauhaus represents a marriage of art and technology, a free combining of science and fine arts in a creative and experimental way.

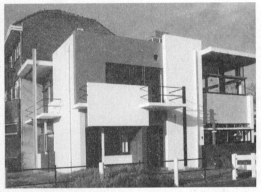

Figure 25.24: Walter Gropius, The Bauhaus, 1925–1926, Dessau, Germany

Major Work of the Bauhaus

Walter Gropius, The Bauhaus, 1925–1926, Dessau, Germany (Figures 25.24 and 25.25)

- Building lifted off the ground; seems to float
- Framing white horizontal stringcourses embrace building
- Glass walls reveal classrooms beyond
- Devoid of embellishments or architectural motifs
- Bauhaus means "house of building"

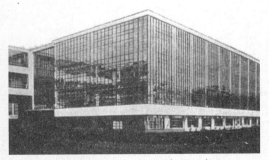

Figure 25.25: Walter Gropius, The Bauhaus, 1925–1926, Dessau, Germany

Characteristics of the International Style

Le Corbusier's dictum that a house should be a "machine for living" sums up the International Style from the 1920s to the 1950s. Greatly influenced by the stream-lined qualities of the Bauhaus, the International Style celebrates the clean spacious white lines of a building's façade. The internal structure is a skeleton system which holds the building up from within and allows great planes of glass to wrap around the walls using **ferroconcrete** construction. A key characteristic is the lack of architectural ornament and an avoidance of sculpture and painting applied to exterior surfaces.

Major Work of the International Style

Le Corbusier, Villa Savoye, 1929, Poissy-sur-Seine, France (Figure 25.26)

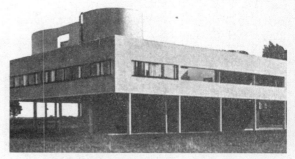

Figure 25.26: Le Corbusier, Villa Savoye, 1929, Poissy-sur-Seine, France

- Three-bedroom villa with servant's quarters
- Boxlike horizontal quality; an abstraction of a house
- Main part of house lifted off the ground by narrow pilotis—thin freestanding posts
- Turning circle on bottom floor is a carport, so that family members can enter the house directly from their car
- All space is utilized, including the roof which acts as a patio

Characteristics of the Prairie Style

The Prairie School of architecture concerns a group of architects working in Chicago from 1900 to 1917, of which **Frank Lloyd Wright** is the most famous. They rejected the idea that buildings should be done in historic styles of architecture; however, they insisted that they should be in harmony with their site. Wright employed complex irregular plans and forms that seemed to reflect the abstract shapes of contemporary painting: Rectangles, triangles, squares, and circles.

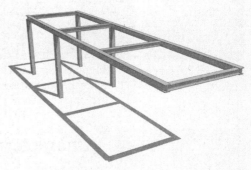

Figure 25.27: Cantilever

Stylized botanical shapes were particularly prized. Wright used **cantilever** construction to have porches and terraces extend out from the main section of a structure (Figure 25.27). Cantilevers give the impression of forms hovering over open space, held up by seemingly weightless anchors.

The organic qualities of the materials—concrete with pebble aggregate, sand-finished stucco, rough-hewn lumber, and natural woods—were believed to be the most beautiful. The horizontal nature of the prairie is stressed in the alignment of these houses. Although **Falling Water** was designed well after The Prairie School peaked, it still reflects many of the same characteristics.

Major Work of the Prairie Style and Wright's Later Work

Frank Lloyd Wright, The Robie House, 1907–1909, Chicago (Figure 25.28)

- Accent on the horizontal nature of the prairie reflected in the long ground-hugging lines of the buildings

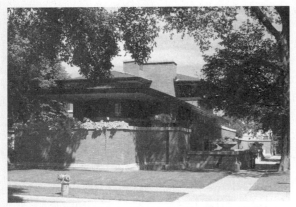

Figure 25.28: Frank Lloyd Wright, The Robie House, 1907–1909, Chicago

- Cantilever construction
- Porches covered by long balconies
- Corners were turned with windows, not piers; panes are placed edge to edge with no support
- Roof is angled to allow low winter sun to enter; keep out hot summer sun
- Built without blinds or curtains in mind; little closet space
- Entrance hidden from view, not on or near the sidewalk

Frank Lloyd Wright, Kaufmann House "Falling Water," 1936–1939, Bear Run, Pennsylvania (Figure 25.29)

- Cantilevered porches extend over waterfall; accent on horizontal lines; architecture in harmony with site
- Living room contains glass curtain wall around three of the four sides; embraces the woods around it
- Floor of living room and walls of building are made from stone of the area
- Hearth is the center of the house, an outcropping of natural stones surrounds it
- Suppression of space devoted to hanging a painting; Wright wanted architecture to dominate
- Irregularity and complexity of ground plan and design

Figure 25.29: Frank Lloyd Wright, Kaufmann House "Falling Water," 1936–1939, Bear Run, Pennsylvania

Characteristics of Art Deco

As a reaction against the simplified forms of the International Style, Art Deco expresses a refined taste in streamlined art whose focus is on industry, the machine, and aerodynamics. The name comes from the 1925 Exposition Internationale des Arts Decoratifs Industriels et Modernes, held in Paris, which celebrated living in the modern world. Sometimes seen as a descendant of Art Nouveau, Art Deco replaces the vegetal forms of its parent with machine stylization. Favorite themes include stylized automobile wheels and grills, cruise-ship portholes and railings, and parallel lines contrasting with zigzags. The style was popular in the 1920s and 1930s.

Major Work of Art Deco

William Van Alen, The Chrysler Building, 1928–1930, New York (Figure 25.30)

Figure 25.30: William Van Alen, The Chrysler Building, 1928–1930, New York

- Was the tallest building in the world when built, surpassing the Eiffel Tower
- Lobby: clad in a rich mix of marble, onyx, and amber
- Extensive use of streamlined metalwork on the façade

- Car motifs dominate: symbols of metal hubcaps on the shafts, gargoyles in the form of radiator caps, car fenders, and hood ornaments
- Stainless steel used at the top both for the beauty of the metal and easy maintenance

Characteristics of Organic Art

More symbolic than depictive, Organic art uses a few basic shapes and builds upon these. The belief in the honesty of simple shapes, and the sleekness and roundness of forms, makes the sculptures seem deceptively simple. In truth, they show a great understanding of the nature of the materials used.

Major Works of Organic Art

Constantin Brancusi, *Bird in Space,* **1928, bronze, Museum of Modern Art, New York (Figure 25.31)**

- Anchored onto a marble base, the figure then soars up directly before us
- Not the image of a bird, but the impression of a bird sweeping into the sky
- Shiny bronze surface reflects the essence of flight
- Famous trial over the importation of this object; customs maintained it was a tool and subject to an import duty; defendants said it was a work of art and exempt; judge had to determine whether it was a work of art

Henry Moore, *Reclining Figure,* **1947, bronze (Figure 25.32)**

- Moore did many on this theme
- Simplified forms with great areas of negative space
- Made of highly polished bronze
- Negative space emphasized
- Biomorphic forms
- Influenced by ancient Mayan chacmool figures (Figure 30.7)

Figure 25.31: Constantin Brancusi, *Bird in Space*, 1928, bronze, Museum of Modern Art, New York

Figure 25.32: Henry Moore, *Reclining Figure*, 1947, bronze

Characteristics of Depression Era Art

American art in the Great Depression, from 1929 to 1939, recognized the plight of the destitute, and raised social issues and concerns. Sometimes, in the case of **Lange's** photographs, the desperation of the Depression was made visible to the general public in the form of **documentary photography.** Social injustices were exposed in **Lawrence's** Migration series. City life, as in **Hopper's** work, and country life, as in **Wood's**, were explored unconventionally. All of these artists rejected European abstract art.

Lawrence's work was part of a particularly fertile period called the **Harlem Renaissance**, named after the New York neighborhood that African-Americans moved to in great numbers in the early twentieth century. The movement reached its fullest expression in painting, music, writing, and photography.

Figure 25.33: Dorothea Lange, *Migrant Mother*, 1935, photograph, Library of Congress, Washington, D.C.

Major Works of Depression Era Art

Dorothea Lange, *Migrant Mother*, 1935, photograph, Library of Congress, Washington, D.C. (Figure 25.33)

- Photographed migrant workers in a deserted pea-pickers camp in California
- Children turn away, framing their mother's face
- Mother is a symbol of despair and anxiety, yet has strength and determination
- Poverty expressed in the rags the infant is wrapped in
- Documentary photography

Edward Hopper, *Nighthawks*, 1942, oil on canvas, Art Institute of Chicago (Figure 25.34)

- Simple, quiet composition, but one that denotes tension
- City location that seems empty and deserted; loneliness of modern life

Figure 25.34: Edward Hopper, *Nighthawks*, 1942, oil on canvas, Art Institute of Chicago

- We see through a huge plate glass window of a luncheonette with no exterior door
- Three customers have no interaction, one counterman seems to listen to unspoken words
- Clarity of forms

Jacob Lawrence, *Migration of the Negro #58*, tempera on masonite, 1940–1941, Museum of Modern Art, New York (Figure 25.35)

- A series of sixty paintings that depicts the migration of African-Americans from the rural South to the urban North after World War I.
- Overall color unity in the series unites each painting
- Forms hover in large spaces
- Flat simple shapes
- Unmodulated colors
- Collective African-American experience, little individuality to the figures

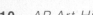

Figure 25.35: Jacob Lawrence, *Migration of the Negro #58*, tempera on masonite, 1940–1941, Museum of Modern Art, New York

Grant Wood, *American Gothic*, 1930, oil on beaverboard, Art Institute of Chicago (Figure 25.36)

- Grant Wood, considered a regionalist painter, emphasized Midwestern subjects in rural Iowa
- Artist's sister and his dentist posed in conventional Midwestern costumes before a carpenter Gothic house; meant to represent a father and a daughter
- Long oval heads; narrow chins; sloping shoulders. Cf. Royal Portals at Chartres (Figure 13.17)

- Seem to have an expression of disapproval or hostility
- Pitchfork design reflected in farmer's shirt
- Artist resisted interpreting the painting; some see it as an expression of pioneer hardihood; others as a satire

Characteristics of Mexican Muralists

A major revival of Mexican art took place in the 1920s and 1930s by artists whose training was in the age-old tradition of fresco painting. Using large murals that all could see and appreciate, the Mexican Muralists usually promoted a political or a social message. These didactic paintings have an unmistakable meaning rendered in an easy-to-read format. The themes generally promote the labor and struggle of the working classes, and usually have a socialist agenda.

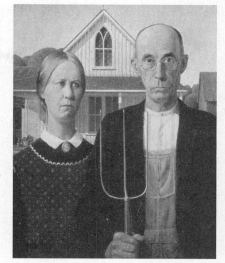
Figure 25.36: Grant Wood, *American Gothic*, 1930, oil on beaverboard, Art Institute of Chicago

Major Work of Mexican Muralism

Diego Rivera, *Detroit Industry*, 1932–1933, fresco, Detroit Institute of Fine Arts, Michigan (Figure 25.37)

- Automobile industry glorified with workers at the Ford River Rouge plant going through their daily activities
- Honors the worker and laborer
- Highly decorative and colorful
- Large, grand figures dominate
- Filled with anecdotal incidents
- Horror vacui
- Didactic painting
- Revival of fresco painting, a Mexican specialty

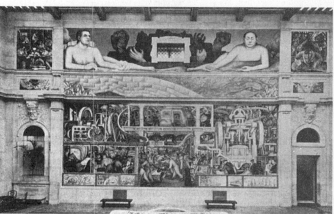
Figure 25.37: Diego Rivera, *Detroit Industry*, 1932–1933, fresco, Detroit Institute of Fine Arts, Michigan

VOCABULARY

Abstract: works of art that may have form, but have little or no attempt at pictorial representation (Figure 25.22)

Biomorphism: a movement stressing organic shapes that hint at natural forms (Figure 25.16)

Cantilever: a projecting beam that is attached to a building at one end, but suspended in the air at the other (Figure 25.27)

Collage: a composition made by pasting together different items onto a flat surface

Documentary photography: a type of photography that seeks social and political redress for current issues by using photographs as a way of exposing society's faults (Figure 25.33)

Ferroconcrete: steel reinforced concrete. The two materials act together to resist building stresses

Frottage: a composition made by rubbing a crayon or a pencil over paper placed over a surface with a raised design

Harlem Renaissance: a particularly rich artistic period in the 1920s and 1930s that is named after the African-American neighborhood in New York City where it emerged. It is marked by a cultural resurgence by African-Americans in the fields of painting, writing, music, and photography

Mobile: a sculpture made of several different items that dangle from a ceiling and can be set into motion by air currents

Ready-made: a commonplace object selected and exhibited as a work of art

Regionalism: an American art movement from the early twentieth century that emphasized Midwestern rural life in a direct style (Figure 25.36)

Summary

Early modern art is characterized by the birth of radical art movements. Avant-garde artists, with the help of their progressive patrons, broke new ground in rethinking the traditional figure, and in the use of color as a vehicle of expression rather than description.

Artists moved in many directions; for example, abstract art was approached in entirely different ways by artists as diverse as Kandinsky, Mondrian, and Malevich. Other artists, such as Brancusi, come close to the abstract form, using representational ideas as a starting point. Still others, such as Surrealists and Metaphysical painters, see conventional painting as a beginning, but expanded their horizons immediately after that.

Modern architects embrace new technology, using it to cantilever forms over open space, imitate the machine aesthetic of Art Deco, or espouse the complete artistic concept of the Bauhaus. Whatever the motivations, modern architecture is dominated by clear, clean, simple lines, paralleling some of the advances made in painting and sculpture.

Practice Exercises

CHALLENGE

1. Psychological studies about the subconscious and dream-states are key to the understanding of all of the following art movements EXCEPT

 (A) DeStijl
 (B) Surrealism
 (C) Dada
 (D) Metaphysical Painting

2. Mexican Muralists depicted

 (A) scenes of everyday life
 (B) satire on religion
 (C) socialist and political agendas
 (D) the artist and his struggle to be free

3. A ready-made is most likely found in which of the following movements?

 (A) Constructivism
 (B) Suprematism
 (C) Dada
 (D) The Prairie School

4. Gallery 291 is important in art history because

 CHALLENGE

 (A) it helped make photography an accepted art form
 (B) Picasso first exhibited *Guernica* here
 (C) it was where the Armory Show was held
 (D) it was the first display of Art Deco

5. Depression-era documentary photography involved photographing

 (A) documents
 (B) ships at sea
 (C) social injustices
 (D) socialism and Marxist movements

6. Mondrian's mature paintings did not allow

 (A) primary colors
 (B) black and white
 (C) gridlike patterns
 (D) diagonals

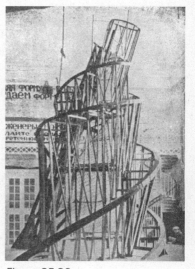

Figure 25.38

Questions 7–9 refer to Figure 25.38.

7. This picture shows a monument that was never built. It was supposed to have been located in

 (A) Paris
 (B) London
 (C) New York
 (D) Moscow

8. This building was designed by

 (A) Frank Lloyd Wright
 (B) Kasimir Malevich
 (C) Walter Gropius
 (D) Vladimir Tatlin

9. This building's function was a

 (A) government building
 (B) school
 (C) cathedral
 (D) warehouse

10. An inspiration for Cubist painters like Pablo Picasso was said to be works of art from

 (A) Africa
 (B) Japan
 (C) America
 (D) Tahiti

Short Essay

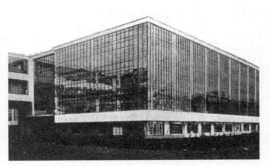

Figure 25.39

Figure 25.39 is the Bauhaus building in Germany. Who was the architect? In what way does the teachings of the Bauhaus School reflect the design of the building? Use one side of a sheet of lined paper to write your essay.

Answer Key

1. **(A)**	3. **(C)**	5. **(C)**	7. **(D)**	9. **(A)**
2. **(C)**	4. **(A)**	6. **(D)**	8. **(D)**	10. **(A)**

Answers Explained

Multiple-Choice

1. **(A)** The gridlike patterns of DeStijl painting were pure abstraction, and did not need the stimulus of philosophers and psychologists from the early part of the twentieth century.

2. **(C)** Mexican Muralists had a socialist agenda that they were not afraid to promote.

3. **(C)** Dadaists particularly enjoyed the ready-made, a found object that they decreed was a work of art.

4. (**A**) Stieglitz's Gallery 291 helped to establish photographs as works of art on a level with paintings.

5. (**C**) Documentary photographers worked to correct social injustices.

6. (**D**) There are no diagonals in Mondrian's mature work.

7. (**D**) The Monument to the Third International was designed to be built in Moscow.

8. (**D**) The Monument to the Third International was designed by Tatlin.

9. (**A**) The Monument to the Third International was to be a government building housing various administrative offices and public spaces.

10. (**A**) African art is said to have inspired Cubist painters like Picasso.

Rubric for Short Essay

4: The student identifies the architect as Gropius, one of the founders of the Bauhaus School. The student recognizes the integration of Bauhaus principles with the design of the building by pointing out instances of the design concepts in the accompanying photograph. There are no major errors.

3: The student identifies the work as Gropius, and explains some of the Bauhaus principles as seen in this photograph. Discussion is less specific and may have minor errors.

2: This is the highest score a student can earn without knowing the name of the architect of the Bauhaus School. The student addresses some of the design principles of the building. There may be major errors.

1: The student gives a passing explanation of the Bauhaus School and contributes a response only in a general way, OR the student gives only the name of the architect. There may be major errors.

0: The student makes an attempt, but the response is without merit.

Short Essay Model Response

The famous Bauhaus building in Germany was designed by Walter Gropius. Gropius was a founder of the Bauhaus School of Architecture, centered in this building. Every aspect of the building, as the school taught, stressed simplicity of design and functionality and as a result, the building has clean, clear lines. The building looks very horizontal due to the white concrete lines on the top and bottom. It also appears to be raised off the ground and the entire lower level is covered in windows.

New technological advances were important, for example, the inside is exposed through the use of glass walls. This was made possible by the innovative use of steel. The school taught that all parts of the design should be interrelated, so the design of the building is one unified piece, all parts harmonizing.

This building is a model of the twentieth-century Bauhaus style of architecture.

—Kari M.

Analysis of Model Response

Kari's response immediately addresses the name of the architect, and places the design principles of the Bauhaus style of architecture directly onto the photograph of the building. Although this essay could use some shaping, Kari enumerates many of the relevant characteristics of the Bauhaus style; that is "the design shall be interrelated" and "simplicity of design and functionality." **This essay merits a 4.**

Late Twentieth-Century Art and the Contemporary World

CHAPTER **26**

TIME PERIOD: 1945–TODAY		

Movement	Date	Artist
Abstract Expressionism	Late 1940s–1950s	DeKooning, Pollock
Pop Art	1955–1960s	Hamilton, Lichtenstein, Warhol
Color Field Painting	1960s	Rothko
Conceptual Art	1960s	Kosuth
Performance Art	1960s	
Op Art	1960s	
Minimalism	1960s–1970s	Judd
Site Art	1970s–1990s	Lin, Smithson
Feminist Art	1970s and beyond	Kruger, Sherman
Postmodern	1975–today	Johnson
Video, Computer, and Digital Art	contemporary	

KEY IDEAS

- Late modern art is a restless era of great experimentation, beginning with the achievements of The New York School.
- Contemporary art is characterized by short-lived movements of intense activity.
- Technological developments have brought about a flood of new products that the artist can use to express him- or herself.
- Most artists work in a variety of media.
- Modern architecture has been radically altered by the introduction of the computer, which makes drawing ground plans and sections easier and more efficient than ever before; the computer also checks automatically for structural errors.
- The number of important female artists, gallery owners, patrons, and customers has grown significantly in the late modern era, bringing about a closer equality of the sexes.

HISTORICAL BACKGROUND

The devastation of World War II formed the backdrop for much of the rest of the twentieth century. Far from solving the world's problems, it just replaced the Fascist menace with smaller conflicts no less deadly in the world's traditional hot spots. With the invention of television, global issues were brought into the living rooms of millions as never before. One disillusioning world problem after another—racism, the environment, weapons of mass destruction—has contributed to a tense atmosphere, even in parts of the world not physically touched by conflict. Artists are quick to pick up on social and political issues, using them as springboards to create artwork.

But not all is bleak in the contemporary world. The rapid growth of technology has brought great advances in medical science and everyday living. Inventions formerly beyond the realm of possibility, like home computers or cell phones, have turned into the necessities of modern life. New media has become fertile ground for artistic exploration. Artists exploit materials, like plastics, for their elastic properties. Video projections, computer graphics, sound installations, fiberglass products, and lasers are new technologies for artists to investigate. One challenge posed to the artist concerns how these media will be used in a way that will thoughtfully provoke the audience. Certainly the modern world has much to offer the artist.

Patronage and Artistic Life

One of the results of World War II was the abandonment of Paris as the art capital of the world, a position it had retained since about 1650. New York, the financial and cultural capital of the United States, took over that position, in part because that is where so many fleeing Europeans settled, and in part because it had an active artistic community that was unafraid of experimentation. Mondrian, Duchamp, and Kandinsky moved to New York, not so much to continue their work, most of which was well behind them, but to galvanize modern American artists in what has been

called The New York School. **Pollock**, **De Kooning**, and Frankenthaler, only the last of whom was a native New Yorker, settled here to do their most impressive works.

INNOVATIONS OF MODERN ARCHITECTURE

Everything about architecture has changed since 1945, and most of the changes have been brought about by the computer. No longer are blueprints painstakingly drawn by hand to exacting specifications. Programs like AutoCAD and MicroStation not only assist in drawing ground plans, but also automatically check for errors. They also make feasible designs that heretofore existed only in the mind. Frank Gehry's **Guggenheim Bilboa Museo** (Figure 26.6) is a good example of how computers can help architects render shapes and meaningful designs in an imaginative way.

New age technology has produced an array of products that make buildings lighter, cheaper, and more energy efficient than before. All these developments, however, come aligned with new challenges for architects. How can cost efficiency and expensive new technology be brought into a meaningful architectural plan? The resources are there for the future to explore.

Characteristics of Modern Architecture

One would be hard-pressed to find a modern building with pediments, Doric columns, or flying buttresses; historical associations have been banned from modern architecture. What exists is a proud display of technology: Innovative materials like titanium in **Gehry's** work, or unusual shapes like the late buildings of **Le Corbusier** or **Wright**.

Dark interiors, as in Gothic or Romanesque buildings, are out. Natural light supplemented by artificial light is in. Domes, such as Wright's **Guggenheim**, presage a modern fascination, almost obsession, with glass and its properties.

Modern buildings are polarized into either harmonizing with their surroundings or standing out and being completely different. In a strange way, the curvilinear patterns of Wright's **Guggenheim Museum** (Figure 26.2) both stand out from the rectangular grid of the buildings around it, yet harmonize with the Manhattan landscape. The **Georges Pompidou Center** in Paris (Figure 26.5), with its outdoor piping, is very different from the working-class community where it was placed, but has become a center of community attraction nonetheless.

Major Works of Modern Architecture

Le Corbusier, Notre Dame-du-Haut, 1950–1955, Ronchamp, France (Figure 26.1)

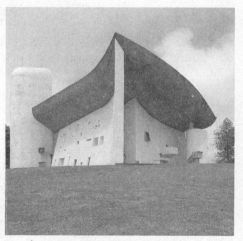

Figure 26.1: Le Corbusier, Notre Dame-du-Haut, 1950–1955, Ronchamp, France

- Exterior resembles a ship, a nun's habit, a dove (the Holy Spirit), and or praying hands
- Spaces for outdoor services
- Roof seems to float over the body of the building
- Random placement of windows has a deeply religious effect of scattered light on the interior; thick walls are punctured by stained glass windows
- Undressed concrete has a primitive feeling
- Sweeping roof bends downward over the nave

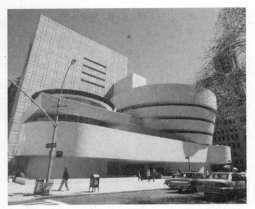

Figure 26.2: Frank Lloyd Wright, Guggenheim Museum, 1943–1959, New York

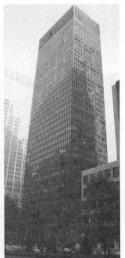

Figure 26.3: Ludwig Mies van der Rohe, Seagram Building, 1956–1958, New York

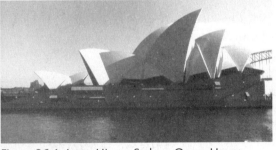

Figure 26.4: Joern Utzon, Sydney Opera House, 1959–1972, Sydney, Australia

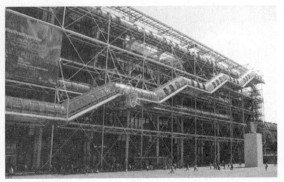

Figure 26.5: Richard Rogers and Renzo Piano, Georges Pompidou Center, 1977, Paris

Frank Lloyd Wright, Guggenheim Museum, 1943–1959, New York (Figure 26.2)

- Curvilinear patterns of the outside reveal a circular domed walkway on the inside
- Glass dome dominates an interior well of space
- Exhibits placed on the walls around the spiraling ramps
- Poured concrete
- Circular motif dominant throughout the building

Ludwig Mies van der Rohe, Seagram Building, 1956–1958, New York (Figure 26.3)

- A reflection of the Minimalist movement in painting
- Mies's saying "Less is more" can be see in this building with its great simplicity, geometry of design, and elegance of construction
- Set back from the street on a wide plaza balanced by reflecting pools
- Bronze veneer gives the skyscraper a monolithic look
- Interplay of vertical and horizontal accents
- Steel-and-glass skyscraper became the model after World War II
- A triumph of the International Style of architecture

Joern Utzon, Sydney Opera House, 1959–1972, Sydney, Australia (Figure 26.4)

- Actually three buildings: the largest is the concert hall, the second the opera house, the third the restaurant
- Groupings of fanlike vaults that resemble ship's sails; Sydney Opera House is in Sydney Harbor, surrounded by water on three sides
- Vaults grow upward from their bases, are independent structures, glass connects them

Richard Rogers and Renzo Piano, Georges Pompidou Center, 1977, Paris (Figure 26.5)

- Functions as an art museum and a cultural complex
- Interior framework of the building is exposed
- Color-coded system:
 - Red: escalators, elevators, stairs
 - Green: plumbing
 - Blue: air ducts, air conditioning
 - Yellow: electricity
- Interior has interchanging walls, flexible viewing spaces
- Predominance of metal and glass

- Use of gerberettes on the façade. Gerberettes are steel vertebrae that allude to ship building and symbolize the center as a cultural ship

Frank Gehry, Guggenheim Bilboa Museo, 1997, Bilboa, Spain (Figure 26.6)

- Appearance of asymmetrical exterior with outside walls giving no hint to interior spaces
- Irregular masses of titanium walls
- Sweeping curved lines
- Called Deconstructionist architecture—architecture that seeks to create a seemingly unstable environment with unusual spatial arrangements

Figure 26.6: Frank Gehry, Guggenheim Bilboa Museo, 1997, Bilboa, Spain

CHARACTERISTICS OF POSTMODERN ARCHITECTURE

Postmodern architecture, generally thought to emerge in the late 1970s and early 1980s sees the achievements of the International Style as cold and removed from the needs of modern cities with their cosmopolitan populations. Postmodernists see nothing wrong with incorporating ornament, traditional architectural expressions, and references to past styles in a modern context. Philip Johnson, himself a contributor to the International Style, as well as someone who worked on the Seagram Building (Figure 26.3), began the shift away to a Postmodern ideal with the AT&T building.

Philip Johnson, AT&T Building, now the Sony Building, 1978–1983, New York (Figure 26.7)

- 36-story building with floors of exceptionally tall ceilings so that the building could be 66 stories
- Pedimented top frame in the style of eighteenth-century English Chippendale furniture
- Strong vertical emphasis
- Looks like a pun on old-fashioned phones that had coin slots at the top and coin returns at the bottom
- Moved away from glass and steel box of the International Style to a reintroduction of stone on the exterior
- Base modeled on New York City's Municipal Building designed in 1908 by McKim, Mead and White; oculus at base resembles Romanesque or Renaissance church façades; cf. Sant'Andrea in Mantua (Figure 16.7)

Figure 26.7: Philip Johnson, AT&T Building, now the Sony Building, 1978–1983, New York

INNOVATIONS OF MODERN PAINTING

Oil on canvas is still the preferred medium. In the 1950s, however, a new type of paint—**acrylic**—was developed to wide popular appeal. Acrylics take very little time to dry, unlike oils, which can take weeks or even months, and unlike watercolor, acrylics do not change color when they dry. However, acrylics crack with time much faster than other paints do. Contemporary artists who are working "for the ages" still prefer oils, although commercially available extenders can prolong the life of acrylics.

While traditional painting techniques are still popular, many modern artists have abandoned the canvas for the computer screen and have reached into cyberspace to create new forms and modes of representation. Computer programs make the process easier, bringing with them a dizzy array of applications and alternatives. The computer has revolutionized the creative spirit of fine art.

INNOVATIONS OF MODERN SCULPTURE

Marble carving is dead. All the great advantages to marble—its permanence, durability, and lustrous shine—have been cast into the dustbin of history. Few artists want to spend years studying marble carving in a world that will offer no commissions for laboring over an art form that is associated with the ancients and has seemingly nothing to offer beyond that. Marble is also unforgiving; once chipped, it cannot be repaired without showing the damage.

Modern forms of sculpture are faster to produce and even easier to reproduce. Unlike marble or bronze they come in a variety of textures, from the high-polish porcelains by Jeff Koons to the knotty fabrics of Magdalena Abakanowicz. Anything that can be molded, like beeswax, is experimented with to make a visceral impact.

Figure 26.8: Jackson Pollock, *Number 1, 1950 (Lavender Mist)*, 1950, oil, enamel, and aluminum paint on canvas, National Gallery of Art, Washington, D.C.

On occasion, sculptors will combine objects into works of art, called **assemblages**. If the assemblages are large enough, they are called **installations** and can take up a whole room in a museum or gallery.

Characteristics of Abstract Expressionism

Sometimes called **The New York School**, Abstract Expressionism of the 1950s is the first American avant-garde art movement. It developed as a reaction against artists like **Mondrian** and **Malevich**, who took the Minimalist approach to abstraction. Abstract Expressionists seek a more active representation of the hand of the artist on a given work. Hence, **action painting** is a big component of Abstract Expressionism.

Major Works of Abstract Expressionism

Jackson Pollock, *Number 1, 1950 (Lavender Mist)*, 1950, oil, enamel, and aluminum paint on canvas, National Gallery of Art, Washington, D.C. (Figure 26.8)

Figure 26.9: Willem de Kooning, *Woman II*, 1952, oil on canvas, Museum of Modern Art, New York

- Action painting; the artist places a canvas on the floor and drips and splatters paint onto the surface
- Immense paintings engulf viewer
- Spontaneous and improvisational execution
- Limited color palette

Willem de Kooning, *Woman II*, 1952, oil on canvas, Museum of Modern Art, New York (Figure 26.9)

- Ferocious woman with great fierce teeth and huge eyes
- Large bulbous breasts are a satire on women who appear in magazine advertising; smile said to be influenced by an ad of a woman selling Camel cigarettes

- Slashing of paint onto canvas
- Jagged lines create an overpowering image

Major Work of The New York School Sculpture

Louise Nevelson, *Sky Cathedral*, 1958, wood, Museum of Modern Art, New York (Figure 26.10)

- Huge wooden constructions made of miscellaneous wooden parts: furniture, dowels, moldings, and so on, but painted black, unifying the composition
- Shallow boxes with wooden contents
- Complex interplay of recession and projection
- Cubist influence in the arrangement of forms

Figure 26.10: Louise Nelson, *Sky Cathedral*, 1958, wood, Museum of Modern Art, New York

Characteristics of Color Field Painting

Color Field Painting lacks the aggression of Abstract Expressionism. It relies on subtle tonal values that are often variations of a monochromatic hue. With **Rothko** the images are mysteriously hovering in an ambiguous space. With artists like Barnett Newman, there is a more clear-cut definition of forms with lines descending through the composition. Color Field Painting was popular in the 1960s.

Major Work of Color Field Painting

Mark Rothko, *Four Darks in Red*, 1958, oil on canvas, Whitney Museum, New York (Figure 26.11)

- Rectangular paintings with two, three, or four blocks of color
- Rich color stretches across the picture plane
- Radically simple compositions
- Tension exists in the harmony of the color relationships, by extension a tension exists in harmonious relationships in life, in one's self
- Luminous colors seem to recede and emerge
- Hazy edges
- Paintings have no titles, just the names of the colors used

Figure 26.11: Mark Rothko, *Four Darks in Red*, 1958, oil on canvas, Whitney Museum, New York

Characteristics of Pop Art

Pop, or Popular, Art is a term coined by an English critic in 1955 about a movement that gathered momentum in the 1950s and then reached its climax in the 1960s. It draws on materials of the everyday world, items of mass popular culture like consumer goods or famous singers—the Pop artist saw no distinction between "high" art or the design of mass-produced items. It glorifies, indeed magnifies, the commonplace, bringing the viewer face to face with everyday reality. Most Pop Artists proclaim that their art is not satirical, although sometimes this is hard to believe given the images they used and the scale used to dislpay them. It is generally thought that Pop Art is a reaction against Abstract Expressionism.

Major Works of Pop Art

Richard Hamilton, *Just What Is It That Makes Today's Homes So Different, So Appealing?,* **1956, collage, Kunsthalle Tübingen, Tübingen, Germany (Figure 26.12)**

Figure 26.12: Richard Hamilton, *Just What Is It That Makes Today's Homes So Different, So Appealing?,* 1956, collage, Kunsthalle Tübingen, Tübingen, Germany

- Mass marketing of products put together in a collage: Armor ham, Ford insignia, Tootsie Pop, and so on
- Mass-marketed items placed in almost a Surrealist arrangement: a woman with headlights for breasts wearing a lampshade, a romance comic book as a framed painting
- An Abstract Expressionist painting is a rug; a photograph of the moon is ceiling art
- Myriad of contemporary details
- Highlights aspects of a consumer society that is obsessed with the human body and advertising

Roy Lichtenstein, *Hopeless,* **1963, oil on canvas, Wallraf-Richartz Museum, Cologne (Figure 26.13)**

Figure 26.13: Roy Lichtenstein, *Hopeless,* 1963, oil on canvas, Wallraf-Richartz Museum, Cologne

- Heavy black outlines frame areas of unmodulated flat color
- Frames inspired by cartoons and comic books
- Hard, precise drawing
- Artist chooses a moment of transition or crisis
- Benday dots

Andy Warhol, *Marilyn Monroe,* **1964, silkscreen and oil on canvas, Leo Castelli Gallery, New York (Figure 26.14)**

Figure 26.14: Andy Warhol, *Marilyn Monroe,* 1964, silkscreen and oil on canvas, Leo Castelli Gallery, New York

- Marilyn's public face appears highlighted by bold, artificial colors
- Private persona of Marilyn submerged beneath the public face
- Social characteristics magnified: brilliance of blonde hair, heavily applied lipstick, seductive expression

Characteristics of Minimalism

Minimalism is a form of abstract art that denies representation of any kind, whether it exists on the objects themselves or in their titles. It embraces a complete abstract aesthetic, lacking all narrative, gestures, and impulses. Early twentieth-century artists like **Piet Mondrian** and **Kasimir Malevich** were precursors to the Minimalist movement that dominated the art world in the 1960s and continued into the 1970s.

Major Work of Minimalism

Donald Judd, *Untitled,* **1974, stainless steel and plexiglass, Paula Cooper Gallery, New York (Figure 26.15)**

- Geometric boxlike shapes aligned in a row or on a wall
- Highly polished surfaces

- Personality of the artist completely suppressed
- Objects have spaces between the boxes which create a dynamic interplay of solids, voids, and shadows

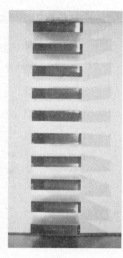

Figure 26.15: Donald Judd, *Untitled*. 1974, stainless steel and plexiglass, Paula Cooper Gallery, New York

Characteristics of Site Art

Sometimes called Earth Art, Site Art is dependent on its location to render full meaning. Often works of Site art are temporary, as in the works of **Christo** and **Jeanne-Claude**. Other times the works remain, but need the original environment intact in order for it to be fully understood. Such items are often called **earthworks**. Site Art dates from the 1970s and is still being done today.

Major Works of Site Art

Robert Smithson, *Spiral Jetty*, 1970, Great Salt Lake, Utah (Figure 26.16)
- Coil of rock in a part of the Great Salt Lake; located in an extremely remote and inaccessible area that features abandoned mines and mining equipment
- Upon walking on the jetty, the twisting and curling path changes the participant's view from every angle
- Artist used a tractor with native stone to create the jetty
- A jetty is supposed to be a pier in the water; here it is transformed into a curl of rocks sitting silently in a vast empty wilderness
- Coil is an image seen in North American earthworks, cf. Serpent Mound, Ohio (Figures 30.12 and 30.13)

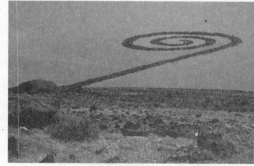

Figure 26.16: Robert Smithson, *Spiral Jetty*, 1970, Great Salt Lake, Utah

Maya Lin, Vietnam Veterans Memorial, 1981–1983, black granite, Washington, D.C. (Figure 26.17)

- V-shaped monument cut into the earth with 60,000 casualties of the Vietnam War listed in the order they were killed or reported missing
- One arm of the monument points to the Lincoln Memorial, the other to the Washington Monument
- Black granite as a highly reflective surface so that viewers can see themselves in the names of the veterans; black is an appropriate somber color for the memorial
- Strongly influenced by the Minimalist movement

Characteristics of Conceptual Art

The Conceptual artist sees a work of art in its purest form, as a thought or the thought process in his or her mind. Conceptual art sometimes realizes a work in a representational format, but more often looks down on an artistic product as a reduction of the original thought. This movement reached its height in the 1960s.

Figure 26.17: Maya Lin, Vietnam Veterans Memorial, 1981–1983, black granite, Washington, D.C.

Major Work of Conceptual Art

Joseph Kosuth, *One and Three Hammers*, 1965, Hammer, Photo of Hammer, etc., Leo Castelli Gallery, New York (Figure 26.18)

- Three types of hammers are suggested: a real hammer, a photo of a hammer, and a dictionary definition of a "hammer"

Figure 26.18: Joseph Kosuth, *One and Three Hammers*, 1965, Hammer, Photo of Hammer, etc., Leo Castelli Gallery, New York

- A study in the relationship of the three items; comparison and contrast offered among the three items
- A study in semiotics—a philosophical theory that discusses the relationship and function of signs and symbols in language
- Examination of the three objects asks viewer which is the real hammer and which expresses the greatest concept of the hammer

Characteristics of Performance Art

Performance art sees the act of making a work of art as the ultimate goal of the artist. The finished product is the result of an action, but not the principal intention of the artist. Performance artists may incorporate dance, music, film, and other activities into their creation. Performance art dates from the 1960s.

Characteristics of Op Art

Op, short for Optical, Art is a strictly abstract work that relies on optical illusions. Artists use fine lines in receding and emerging patterns to create a three-dimensional effect over the canvas. Often Op Artists will vary the length and waviness of the line to make a mind-boggling illusion. Op Art was popular in the 1960s.

Characteristics of Feminist Art

Figure 26.19: Barbara Kruger, *You Are a Captive Audience*, 1983, photograph, Annini Nosei Gallery, New York

Because of increasing awareness and acceptance of feminist issues in society, it has become easier for female artists to express themselves in a way that would bring interest in their art to a greater public. Not all Feminist artists, however, work with a social agenda. Some feel free within a female framework, others use their art to promote social issues they favor, and still others seek recognition as significant artists without the label of "Feminist," which they see as categorizing and demeaning. Feminist Art began in the 1970s and is still active today.

Major Works of Feminist Art

Barbara Kruger, *You Are a Captive Audience*, 1983, photograph, Annini Nosei Gallery, New York (Figure 26.19)

- Artist began as a graphic designer for *Mademoiselle* magazine
- Works have a mass-media influence

- Words placed in large photos as design elements, and to highlight a message
- Large single image with a short catchy phrase, much like magazine ad layouts
- Artistic message often relies on irony

Cindy Sherman, *Untitled Film Still*, #14, 1978, photograph, Metro Pictures Gallery, New York (Figure 26.20)

- Sixty-nine in the collection of the Museum of Modern Art, New York
- Artist uses herself as the primary figure in the series
- Imitates the way that images of women have been stereotypically depicted in the movies
- Criticizes the concept of women as objects to be merely gazed at

CHARACTERISTICS OF VIDEO ART, COMPUTER ART, AND DIGITAL ART

The increase in technology has brought with it alternative ways to express an artist's soul. Video, computer, and digital technology allows the artist to take or create an original subject and alter the size, color, background, shape, and continuity of the object almost infinitely. The freedom to change everything about the original object gives the artist complete license to maneuver the work in such a way that the original idea becomes subservient to the process that can be used to recreate it.

Figure 26.20: Cindy Sherman, *Untitled Film Still #14*, 1978, photograph, Metro Pictures Gallery, New York

VOCABULARY

Action Painting: an abstract painting in which the artist drips or splatters paint onto a surface like a canvas in order to create his or her work (Figure 26.8)

Assemblage: a three-dimensional work made of various materials such as wood, cloth, paper, and miscellaneous objects

Benday Dots: named for inventor Benjamin Day. This printing process uses the pointillist technique of colored dots from a limited palette placed closely together to achieve more colors and subtle shadings (Figure 26.13)

Color Field: a style of abstract painting characterized by simple shapes and monochromatic color (Figure 26.11)

Earthwork: a large outdoor work in which the earth itself is the medium (Figure 26.16)

Installation: a temporary work of art made up of assemblages created for a particular space, like an art gallery or a museum

Summary

Contemporary art defies categorization because artists easily adapt to new styles and artistic impulses. Therefore, movements are intense but fleeting, and influenced by current politics and culture. For example, the carnage of World War II influenced the dynamic experimentalism of the Abstract Expressionist movement of the 1950s. Pop Art reacted to the consumer culture and the growth of the middle class. Minimalists designed works that show a modern predilection for clean, open, and simple forms. Site Art expresses an awareness of the surroundings a work of art may have, and

insists on a mutual coexistence of the object and its environment. Awareness of feminist issues influenced not only the production of Feminist Art, but also spurred the growth of female collectors, artists, and gallery owners.

Contemporary artists have a great range of materials and venues to express themselves—perhaps more than any other time in history. Artists experiment both with new art forms and with new ideas to create a dynamic range of effects. Architecture has been particularly affected by the growth of technology, both in the planning stages by using a computer, and in the construction phases by using new types of metal and glass.

Modern art is sensitive to all contemporary issues—setting, world politics, technological advances, new techniques, and to the dynamics of the art market itself.

Practice Exercises

1. Action painting is a characteristic of

 (A) Abstract Expressionism
 (B) Pop Art
 (C) Color Field Painting
 (D) Conceptual Art

2. Cindy Sherman and Barbara Kruger create works that

 (A) express satisfaction with the status quo
 (B) question racial relationships in the United States
 (C) foresee environmental problems if Americans are not watchful today
 (D) criticize the media's perception of women

3. The *Spiral Jetty* is located in

 (A) Lake Superior
 (B) Long Island Sound
 (C) Great Salt Lake
 (D) San Francisco Bay

CHALLENGE

4. Minimalist artists of the 1960s and 1970s were inspired by earlier twentieth-century artists such as

 (A) Pablo Picasso
 (B) Salvator Dalí
 (C) Piet Mondrian
 (D) Frida Kahlo

5. "Less is more" is the artistic philosophy of

 (A) Ludwig van Mies van der Rohe
 (B) Judy Chicago
 (C) Andy Warhol
 (D) Roy Lichtenstein

6. Pop Art bases its philosophy on

 (A) Abstract Art
 (B) architectural forms
 (C) mass marketing
 (D) Classical Art

7. Benday dots are important in the work of

 (A) Richard Hamilton
 (B) Roy Lichtenstein
 (C) Maya Lin
 (D) Helen Frankenthaler

8. Christo's and Jeanne-Claude's work depends on

 (A) federal funding
 (B) site considerations
 (C) a feminist message
 (D) permanent structures

9. Op Art is a form of

 (A) abstraction
 (B) surrealism
 (C) Pop Art
 (D) feminism

10. Mark Rothko's work can be described as **CHALLENGE**

 (A) essentially narrative in quality
 (B) needing a title for an explanation of the meaning
 (C) colors rectangularly placed on a canvas
 (D) Conceptual Art

Short Essay

Maya Lin's quote about her Vietnam Veterans Memorial was "I wanted to work with the land and not dominate it." Choose a work of Site art, or a work that is heavily reliant on its site and discuss its relationship to the environment around it. Refer to the quotation in your remarks. Use one side of a sheet of lined paper to write your essay.

Answer Key

1. **(A)**	3. **(C)**	5. **(A)**	7. **(B)**	9. **(A)**
2. **(D)**	4. **(C)**	6. **(C)**	8. **(B)**	10. **(C)**

Answers Explained

Multiple-Choice

1. **(A)** Abstract expressionists use action painting to drip and splatter across canvases.

2. **(D)** Cindy Sherman and Barbara Kruger are Feminist artists.

3. **(C)** The *Spiral Jetty* is located in a remote corner of the Great Salt Lake.

4. **(C)** Piet Mondrian's geometric grids were the inspiration for much Minimalist art.

5. **(A)** Ludwig van Mies van der Rohe's simplicity of style expresses the "Less is more" philosophy in such works as the Seagram Building.

6. **(C)** Pop Art glorifies mass-marketed ideas.

7. **(B)** Benday dots are the trademark of Roy Lichtenstein's works.

8. **(B)** Christo and Jeanne-Claude carefully consider the site before any project gets underway.

9. **(A)** With its optical illusions and mass of lines Op Art is a definite form of abstract art.

10. **(C)** Mark Rothko painted soft-edged rectangles of color juxtaposed to one another.

Rubric for Short Essay

4: The student fully identifies a work of Site Art, examines how it harmonizes with its site, and does not dominate it. The student emphasizes the materials used to create the work and how this has an impact on its surroundings. The student must refer to the quotation to achieve the highest score. There are no major errors.

3: The student fully identifies a work of Site Art, examines how it harmonizes with its site, and does not dominate it. The student uses few specifics in discussing the work, and speaks in general terms about the surroundings. There may be minor errors.

2: The student partly identifies or misidentifies a work of Site Art, OR the student identifies a work correctly, but provides little else of substance. There may be major errors.

1: The student identifies only a work and provides nothing else of merit, OR the student speaks in generalities about Site Art and does not name a particular work. There may be major errors.

0: The student makes an attempt, but the response is without merit.

Short Essay Model Response

One work of Site art, the <u>Spiral Jetty</u>, is located in the Great Salt Lake in Utah. It is composed of the earth and rock, the same earth and rock of the natural landscape in the area. In this way, <u>Spiral Jetty</u> harmonizes with its surrounding environment, instead of just being obtrusive to the natural surroundings. The rocks used to create <u>Spiral Jetty</u> were planned out so that the colors would blend well together with the landscape; a man-made structure of artificial materials would stick out. <u>Spiral Jetty</u> works with the landscape and does not "dominate it."

Another fact about <u>Spiral Jetty</u> is that it is not always there, but shrinks or rises depending upon the water level. Robert Smithson wanted this, so that it could be in further harmony with the powers of nature.

—Nicole L.

Analysis of Model Response

Nicole correctly identifies a work of Site art and provides some background on how the work was created. However, she fails to mention how the work interacts with the environment when one walks on the jetty and sees the lake and mountains from many angles. Indeed, as Nicole points out, the *Spiral Jetty* does not dominate the environment, but adds a new dimension to it. She justly comments on the colors blending with the surroundings, and the use of natural materials of the area to harmonize with the environment. **This essay merits a 3.**

Indian and Southeast Asian Art

KEY IDEAS

- Indian art stresses the interconnectiveness of all the arts: architecture, painting, and sculpture.
- Buddhist and Hindu philosophies form a background to Indian artistic thought.
- A vibrant school of manuscript painting using brilliantly applied watercolors flourishes in India.

HISTORICAL BACKGROUND

The fertile Indus and Ganges valleys were too great a temptation for outsiders, and thus the history of India has become a history of invasions and assimilations. But those who invaded came to stay, and so Indian life today is a layering of disparate populations to create a cosmopolitan culture. There are eighteen official languages in India—Hindi, the one foreigners think of as the national language, is spoken natively by only 20 percent of the population. Along with Hindus and Muslims, there are many concentrations of Jains, Buddhists, Christians, and Sikhs, as well as myriad tribal religions. Geographically, India has enormous range as well, from the world's tallest mountains to vast deserts and tropical forests. This is one of the most diverse countries on earth.

Patronage and Artistic Life

The arts play a critical role in Indian life. Most rulers have been extremely generous patrons, commissioning great buildings, sculptures, and murals to enhance civic and religious life, as well as their own glory. The interconnectiveness of the arts in India is crucial to understanding Indian artistic life. Monuments are conceived as a combination of the arts; the artists who work on them carry out their work at the behest of an artist who acts as a team leader with a single artistic vision. Thus, Indian monuments have a surprising uniformity of style. The design of religious art and architecture may have also been determined by a priest or other religious advisor, who

ensured that proportions and iconography of monuments agreed with descriptions supplied in canonical texts and diagrams.

Much as in the European tradition, artists were trained as apprentices in workshops. The process was comprehensive; the artist learned everything from how to make a brush to how to create intricate miniatures or vast murals. Indians are highly organized in their approach to artistic training.

CHARACTERISTICS OF BUDDHIST PHILOSOPHY AND ART

Still practiced today as the dominant religion of Southeast Asia, Buddhism is a spiritual force that teaches individuals how to cope in a world full of misery. The central figure, Buddha (563–483 B.C.E.), who is not a god, rejected the worldly concerns of life at a royal court, and sought fulfillment traveling the countryside and living as an ascetic.

In Buddhism, life is believed to be full of suffering that is compounded by an endless cycle of birth and rebirth. The aim of every Buddhist is to end this cycle and achieve oneness with the supreme spirit, which involves a final release or extinguishing of the soul. This can only happen by accumulating spiritual merit through devotion to good works, charity, love of all beings, and religious fervor.

Buddhist art has a rich cultural iconography. Some of the most common symbols include:

- The Lion: a symbol of Buddha's royalty
- The Wheel: Buddha's law
- Lotus: a symbol of Buddha's pure nature. The lotus grows in swamps, but mud slides off its surface.
- Columns surrounded by a wheel: Buddha's teaching
- Empty Throne: Buddha, or a reminder of a Buddha's presence.

CHARACTERISTICS OF BUDDHIST ARCHITECTURE

The principal place of early Buddhist worship is the **stupa**, a mound-shaped shrine that has no interior. A stupa is a reliquary; worshippers gain spiritual merit through being in close proximity to its contents. A staircase leads the worshipper from the base to the drum. Buddhists pray while walking in a clockwise or easterly direction, that is, the direction of the sun's course. Because of the its distinctive shape, that of a giant hemisphere, and because one walks and prays with the sun, the stupa has cosmic symbolism. It is also conceived as being a symbol of Mt. Meru, the mountain that lies at the center of the world in Buddhist cosmology and serves as an axis connecting the earth and the heavens.

Stupas, like one at **Sanchi** (Figure 27.3), have a central mast of three umbrellas at the top of the monument, each umbrella symbolizing the three jewels of Buddhism: The Buddha, the Law, and the Community of Monks. The square enclosure around the umbrellas symbolizes a sacred tree surrounded by a fence.

Four **toranas**, at the cardinal points of the compass, act as elaborate gateways to the structure.

CHARACTERISTICS OF BUDDHIST PAINTING AND SCULPTURE

There is a surprising uniformity in the way in which Buddhas are depicted, given that they were produced over thousands of years and across thousands of miles. Typically Buddhas have a compact pose with little negative space (Figure 27.1). They are often seated, although standing and lying down are occasional variations. When seated, a Buddha is usually posed in a lotus position with the balls of his feet turned straight up, and a wheel marking on the souls of the feet is prominently displayed.

The treatment of drapery varies from region to region. In Central India, Buddhist drapery is extremely tight-fitting, and resting on one shoulder with folds slanting diagonally down the chest. In Gandhara, a region that spreads across northwest India, Pakistan, and Afghanistan, Buddhist figures wear heavy robes that cover both shoulders, similar to a Roman toga, showing a Hellenistic influence.

Buddhas are generally frontal, symmetrical, and have a nimbus, or halo, around their heads. Helpers, called **bodhisattvas**, are usually near the Buddha, sometimes attached to the nimbus.

Buddhas' moods are many, but most have a detached, removed quality that suggests meditation. Buddhas' actions and feelings are revealed by hand gestures called **mudras**.

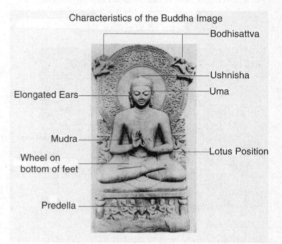

Figure 27.1: Principal characteristics of the Buddha

The head has a top knot, or **ushnisha**, and the hair has a series of tight-fitting curls. Extremely long ears dangle almost to his shoulders. A curl of hair called an **urna** appears between his brows. His rejection of courtly life explains his disdain for personal jewelry.

Beneath statues of Buddha there usually is a base or a **predella**, which can include donor figures and may have an illustration of one of his teachings or a story from his life.

Buddhist art also depicts distinctive figures called **yakshas** (males) and **yakshis** (females) (Figure 27.4), which are nature spirits that appear frequently in Indian popular religion. Their appearance in Buddhist art indicates their incorporation into the Buddhist pantheon. The females often stand in an elaborate dancelike poses, almost nude, with their breasts prominently displayed. The depiction of yakshas accentuates male characteristics such as powerful shoulders and arms.

Major Works of Buddhist Art

Lion Capital from Sarnath, c. 250 B.C.E., sandstone, Archaeological Museum, Sarnath, India (Figure 27.2)

Figure 27.2: Lion Capital from Sarnath, c. 250 B.C.E., sandstone, Archaeological Museum, Sarnath, India

- A seven-foot capital from a column erected along a pilgrimage route to see the holy sites connected with the life of Buddha
- Bell-shaped bottom of capital is an inverted lotus blossom
- Above petals is a frieze of four wheels and four symbolic animals: lion, horse, elephant, and bull; wheels symbolize Buddha's Law

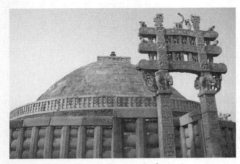

Figure 27.3: Great Stupa, 3rd century B.C.E.–1st century C.E., Sanchi, India

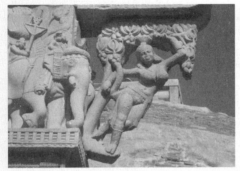

Figure 27.4: Yakshi from the Great Stupa, 3rd century B.C.E.—1st century C.E., Sanchi, India

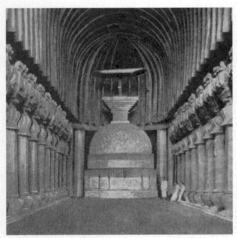

Figure 27.5: Chaitya Hall. c. 100 C.E., Karla, India

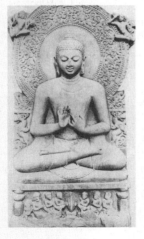

Figure 27.6: *Buddha Preaching the First Sermon*, 5th century, sandstone, Archaeological Museum, Sarnath, India

- Four lions, slightly hunched over, with stylized faces, noses, and whiskers
- Repetitive patterns of the manes
- Influence of animal capitals from Persepolis, Persia (Figure 2.17)

Great Stupa, third century B.C.E.–first century C.E., Sanchi, India (Figure 27.3 and Figure 27.4)

- A Buddhist shrine, mound shaped, and faced with dressed stone
- Three umbrellas at the top representing Buddha, Buddha's Law, and Monastic Orders
- Railing at crest of mound surrounds the umbrellas, symbolically a sacred tree
- Double stairway at south end leads from base to drum where there is a walkway for circumambulation
- Originally painted white
- Hemispherical dome is a replication of the dome of heaven
- Four toranas grace entrances, at cardinal points of the compass
- Torana: richly carved scenes on architraves; Buddha does not appear himself, but is symbolized by an empty throne or a tree under which he meditated; some of these reliefs may also represent the sacred sites where Shakyamuni Buddha visited or taught; horror vacui of composition; high-relief sculptures

Chaitya Hall, c. 100 C.E., Karla, India (Figure 27.5)

- Indian characteristic to carve into a mountain
- Has sexual connotations, penetrating the womb of a mountain
- Stupa is placed at the end with an ambulatory allowing for ritual circumambulation
- Basilican form with long nave defined by colonnade
- Bell-shaped capitals on columns
- Columns are vase-shaped at the base because they were originally made of wood and the bases were placed in vases to prevent insects from destroying the wood

Buddha Preaching the First Sermon, fifth century, sandstone, Archaeological Museum, Sarnath, India (Figure 27.6)

- Sitting in a yoga position, hands in a preaching mudra
- On predella: important narrative moment in Buddha's life—figures of Sakyamuni's followers who returned to him at the sermon in Deer Park; between the two groups of kneeling monks is the symbol of preaching, the Wheel
- Compact pose; epicene quality; tight-fitting garb
- Bodhisattvas in nimbus above him

Bodhisattva Padmapani, **from Cave 1, c. 475** B.C.E., **fresco, Ajanta, India (Figure 27.7)**

- Padmapani is holding a blue lotus
- Noble countenance and downcast eyes indicate humility
- Graceful curves simulate dance rhythms
- Wears a pointed crown showing his high caste, royal attributes also symbolize his great spiritual attainment
- Padmapani is equated with Avalokiteshvara, the Bodhisattva of Compassion

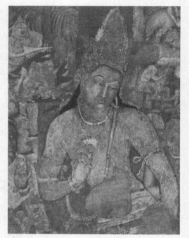

Figure 27.7: Bodhisattva Padmapani, from Cave 1, c. 475 B.C.E., fresco, Ajanta, India

Borobudur, 800, Java, Indonesia (Figure 27.8)

- Massive Buddhist monument contains 504 life-size Buddhas, 1,460 narrative relief sculptures on 1,300 panels 8,200 feet long; there are 1,500 stupas and one million carved blocks of stone
- Iconographically complex and intricate; many levels of meaning; may reflect Buddhist cosmology
- Meant to be walked around (circumambulated) on each terrace; six concentric square terraces topped by three circular tiers with a great stupa at the summit
- Pyramidal in form, aligned with the four cardinal points of the compass
- Lower stories represent the world of desire and negative impulses; middle areas represent the world of forms, people have to control these negative impulses; the top story is the world of formulas, where the physical world and worldly desire are expunged
- A place of pilgrimage

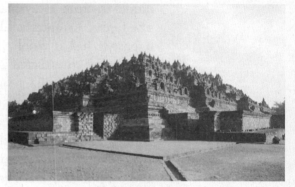

Figure 27.8: Borobudur, 800, Java, Indonesia

Death of the Buddha, **eleventh–twelfth century, granulite, Gal Vihara, Sri Lanka (Figure 27.9)**

- Tight-fitting clothes reveal Buddha's epicene body
- Peacefulness and serenity even in death
- Inspired by models from Indian Art

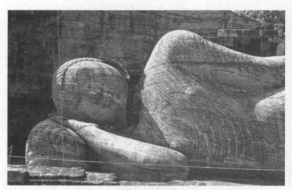

Figure 27.9: *Death of the Buddha*, 11th–12th century, granulite, Gal Vihara, Sri Lanka

CHARACTERISTICS OF HINDU ART AND PHILOSOPHY

To outsiders, Hinduism is a bewildering religion with myriad sects, each devoted to the worship of one of its many gods. The complexity and multiplicity of the practices and beliefs associated with Hinduism are evident in the name of the religion, which is an umbrella term meaning, "the religions of Hindustan (India)." Folk beliefs exist side by side with sophisticated philosophical schools. But all forms of Hinduism concentrate on the infinite variety of the divine, whether it is expressed in the gods, in nature, or in other human beings. Those who proclaim to be orthodox Hindus accept the Vedic texts as divine in origin, and many maintain aspects of the Vedic

social hierarchy, which assigns a caste of ritual specialists, known as Brahmins, to officiate between the gods and humankind.

As in the case of Buddhism, every Hindu is to lead a good life through prayer, good deeds, and religious devotion, because only in that way can he or she break the cycle of reincarnation. **Shiva** is one of the principal Hindu deities, who periodically dances the world to destruction and rebirth. Other important deities include Brahma, the creator god; Vishnu, the preserver god; and the great goddesses who are manifest as peaceful consorts, like Laksmi and Parvati.

CHARACTERISTICS OF HINDU ARCHITECTURE

The Hindu temple is not a hall for congregational worship; instead it is the residence of a god. The temples are solidly built with small interior rooms, just enough space for a few priests and individual worshippers. At the center is a tiny interior cella that is called the "Womb of the World" where the sacred statue invoked with the main deity is placed. Although Indians knew the arch, they preferred corbelled-vaulting techniques to create a cavelike look on the inside. Thick walls protect the deity from outside forces. An antechamber, where ceremonies are prepared, precedes the cella, and a hypostyle hall is visible from the outside where congregants can participate. Hindu temples are constructed amid a temple complex that includes subsidiary buildings.

In northern India, temples have a more vertical character, with large towers setting the decorative scheme, and other subsidiary towers imitating the shape but at various scales. Placed on high pedestals, temples have a sense of grandeur as they command the countryside. Major temples form "temple cities" in south India, where layers of concentric gated walls surround a network of temples, shrines, pillared halls, and colonnades. The Hindu temples found in Cambodia are based upon a pyramidal plan with a central shrine surrounded by subshrines and enclosed walls.

Temple exteriors are covered with sculpture, almost in a feverish frenzy to crowd every blank spot on the surface.

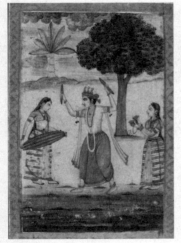

Figure 27.10: Miniature Painting of Krishna Doing Rain Dance, Rajasthan School, 19th century

CHARACTERISTICS OF HINDU PAINTING

Indians excel at painting miniatures, illustrations done with watercolor on paper, used either to illuminate books or as individual leaves kept in an album. One of the most famous schools of Indian painting is the Rajput School, which enjoyed illustrating Hindu myths and legends, especially the life of Krishna. Care is also lavished on individual portraits, which were done with immediacy and freshness.

As in most Indian art, compositions tend to be both crowded and colorful. Perspective is tilted upward so that the surface of objects, like tables or rugs, can be seen in their entirety. Floral patterns contribute to the richness of expression. Figures are painted with great delicacy and generally seem small compared to the landscape around them. They have a doll-like character that adds to the fairy-tale–like nature of the stories being illustrated.

Characteristics of Indian painting include a heightened and intense use of color, with black lines outlining figures. Humans have a wide range of emotion; figures often gesticulate wildly. Nature is seen as friendly and restorative. Few names of Indian artists have come down to us; the works are generally anonymous, even among the greatest masters.

CHARACTERISTICS OF HINDU SCULPTURE

Temple sculpture is a complete integration with the architecture to which it is attached—sometimes the buildings are thought of as a giant work of sculpture. Pairs of divine couples, known as **mithuna**, appear upon the exterior and doorways of some temples. Sexual allusions dominate and are expressed with candor, but not obscenity. Hindu sculptures accentuate sinuous curves and the lines of the body. Dance poses are common. Temple surfaces are also ornamented with organic and geometric designs, including lateral bands that depict subjects such as lotus flowers, temple bells, and strings of pearls.

Images placed in the "womb" of the temple are idols in that they are invoked with the essence of divinity that the figure represents. To touch the image is to touch the god himself or herself; few can do this. Instead the image is treated with the utmost respect and deference, and is occasionally exposed to public viewing. Worshippers experience the divine through actively seeing the invoked image, an experience known as **darshan** and performing **puja**, a ritual offering to the deity, which is mediated by temple priests.

Major Works of Hindu Art

Vishvanatha Temple, c. 1000, Khajuraho, North India (Figure 27.11)

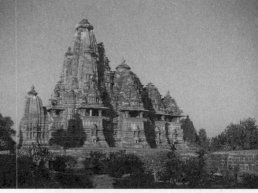

Figure 27.11: Vishvanatha Temple, c. 1000, Khajuraho, North India

- Placed on a high pedestal
- A series of shapes that build to become a large tower; complicated intertwining of similar forms
- In the center is the "embryo" room containing the shrine, very small, only space enough for the priest
- An ambulatory circles around the inner chamber
- Corbelled roofs have a beehive quality

Shiva Nataraja with a Nimbus, c. 1000 C.E., bronze (Figure 27.12)

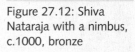

Figure 27.12: Shiva Nataraja with a nimbus, c.1000, bronze

- Vigorously dancing with one foot on a dwarf, the Demon of Ignorance; often depicted in a flaming nimbus
- Flying locks of hair terminate in rearing cobra heads
- One hand sounds the drum that he dances to, another has a flame
- Shiva has four hands
- Epicene quality
- Periodically destroys the universe so it can be reborn again
- He unfolds the universe out of the drum held in one of his right hands; he preserves it by uplifting his other right hand in a gesture indicating "do not be afraid"
- Shiva has a third vertical eye barely suggested between his other two eyes. He once burned the god Kama with this eye.

Angkor Wat, early twelfth century, Cambodia (Figure 27.13)

- Capital of medieval Cambodia built by Suryavarman II
- Main pyramid is surrounded by four corner towers; temple–mountain
- Corbelled gallery roofs

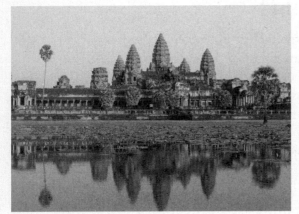

Figure 27.13: Angkor Wat, early 12th century, Cambodia

- Dedicated to Vishnu, most sculptures represent Vishnu's incarnations
- Horror vacui of sculptural reliefs
- Sculpture in rhythmic dance poses; repetition of shapes

Outer Gopura of the Great Temple of Madurai, thirteenth–seventeenth century, Madurai, India (Figure 27.14)

- Dedicated to Parvati, the wife of Shiva who is locally known as Minakshi
- A gopura or monumental entrance or gateway to a temple complex
- As temple cities expanded the gopuras were added to enclose greater spaces
- Sloping façade contains thousands of sculptures of gods and goddesses
- Interior staircases lead worshipper to the top

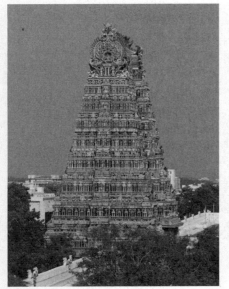

Figure 27.14: Outer Gopura of the Great Temple of Madurai, from the thirteenth–seventeenth century, Madurai, India

Major Work of Islamic India

Taj Mahal, c. 1632–1648, Agra, India (Figure 27.15)

- Translated to mean "Crown Palace"
- Named for Mumtaz Mahal, deceased wife of Shah Jahan; she died while giving birth to her fourteenth child
- Built to serve as Mumtaz Mahal's tomb. Shah Jahan was interred next to her after his death
- Symmetrical harmony of design
- Typical Islamic feature of one large arch flanked by two smaller arches
- Square plan with chamfered corners
 - Onion-shaped dome rises gracefully from the square façade
 - Small kiosks around dome lessen severity
 - Intricate floral and geometric inlays
 - Grounds represent a vast funerary garden, the gardens found in heaven in the Islamic tradition
 - Minarets act like a picture frame, directing our view and sheltering the monument

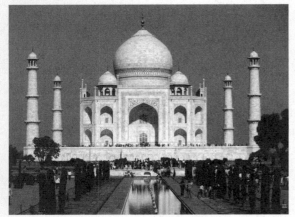

Figure 27.15: Taj Mahal, c. 1632–1648, Agra, India

VOCABULARY

Bodhisattva: a deity who refrains from entering nirvana to help others (Figure 27.7)

Buddha: a fully enlightened being. There are many Buddhas, the most famous of whom is Shakyamuni, also known as Gautama or Siddhartha (Figure 27.1)

Chaitya: a rock-cut shrine in basilican form with a stupa at the endpoint (Figure 27.5)

Darshan: in Hinduism, the ability of a worshipper to see a deity and the deity to see the worshipper

Gopura: a monumental entrance or gateway to an Indian temple complex (Figure 27.14)

Mithuna: in India, the mating of males and females in a ritualistic, symbolic, or physical sense

Mudra: a symbolic hand gesture in Hindu and Buddhist art (Figure 27.1)

Nirvana: an afterlife in which reincarnation ends and the soul becomes one with the supreme spirit

Puja: a Hindu prayer ritual

Shiva: the Hindu god of creation and destruction (Figure 27.12)

Stupa: a dome-shaped Buddhist shrine (Figure 27.3)

Torana: a gateway near a stupa that has two upright posts and three horizontal lintels. They are usually elaborately carved (Figure 27.3)

Urna: a circle of hair on the brows of a deity, sometimes represented as focal point (Figure 27.1)

Ushnisha: a protrusion at the top of the head, or the top knot of a Buddha (Figure 27.1)

Wat: a Buddhist monastery or temple in Cambodia (Figure 27.13)

Yakshi (masculine: **yaksha**): female and male figures of fertility in Buddhist and Hindu art (Figure 27.4)

Summary

The diversity of the Indian subcontinent is reflected in the wide range of artistic expression one finds there. Indians typically unify the arts, so that one large monument is realized as a single creative expression involving painting, sculpture, and architecture.

Buddhist images dominate early Indian art. Buddha himself is often depicted in a meditative state, with his various mudras revealing his inner thoughts. Hindu sculptures feature a myriad of gods, with Shiva as the most dominant. Both Buddhist and Hindu temples are mound-shaped, the Buddhist works being a large, solid hemisphere, and the Hindu a sculpted mountain with a small interior.

Both Hindu and Buddhist art are marked by horror vacui, forms piled one atop the other in crowded compositions.

Practice Exercises

1. Buddhas are usually attended by

 (A) Shivas
 (B) Bodhisattvas
 (C) Nirvana
 (D) a Wat

2. Sculptural decoration on the Great Stupa

 (A) is in horror vacui
 (B) has dancelike rhythms
 (C) shows a repetition of the same shape
 (D) is confined to the torana and is not on the stupa

CHALLENGE 3. Wheels are symbols in Buddhism because

 (A) carts are used to take people on pilgrimages
 (B) wheels are circles
 (C) they symbolize Buddha's Law
 (D) they connect far-flung countries and cultures

4. Hindu temples house

 (A) a congregational hall
 (B) an image that possesses the spirit of a god
 (C) a stupa
 (D) a rock-cut tomb

5. Shiva's image is characterized by all of the following EXCEPT

 (A) four hands
 (B) snakes
 (C) dancing on a dwarf
 (D) sitting in a lotus position

6. The Taj Mahal is a

 (A) monastery
 (B) tomb
 (C) stupa
 (D) Hindu temple

7. Hindu architecture uses corbelling, which means

 (A) a barrel vault spans the interior
 (B) stones are stacked closer together as they rise
 (C) architectural shapes are put in a mold and reproduced
 (D) one tower dominates the architectural composition

8. A favorite theme of the Rajput School of Painting is the story of [CHALLENGE]

 (A) Bodhisattva
 (B) Krishna
 (C) Mumtaz Mahal
 (D) Buddha

9. Images of lions on capitals of Buddhist buildings probably stem from earlier examples from

 (A) Persia
 (B) Pakistan
 (C) China
 (D) Islam

10. In Buddhism, lions are a symbol of

 (A) strength
 (B) loyalty
 (C) hardship
 (D) royalty

Short Essay

The concept of idealism is different in each culture around the world. Choose two figures from Indian art and discuss how they were created to reflect a sense of idealism. Use one side of a sheet of lined paper to write your essay.

Answer Key

1. **(B)**	3. **(C)**	5. **(D)**	7. **(B)**	9. **(A)**
2. **(D)**	4. **(B)**	6. **(B)**	8. **(B)**	10. **(D)**

Answers Explained

Multiple-Choice

1. **(B)** Buddhas are attended by Bodhisattvas, deities who refrain from entering nirvana to help guide others on the path.

2. **(D)** The Great Stupa has no decoration on the exterior; it is a plain dome. Sculpture appears in profusion on the torana.

3. **(C)** Wheels symbolize Buddha's Law.

4. (**B**) Hindu temples contain idols, images of a god that the spirit enters and inhabits. Worshippers are not allowed near the image, so there is no congregational space in a Hindu temple. A stupa is associated with Buddhism. Rock-cut tombs are Egyptian.

5. (**D**) Buddha sits in a lotus position, not Shiva.

6. (**B**) The Taj Mahal is an Islamic tomb for Mumtaz Mahal.

7. (**B**) Corbeled galleries have stones that slowly edge together as they rise, forming an archlike interior, without being a true arch.

8. (**B**) A favorite theme of Rajput painting is the colorful adventures of Krishna.

9. (**A**) Persian capitals, like those at Persepolis, inspired Indian sculpture.

10. (**D**) Lions symbolize royalty in India, as well as in many countries around the world.

Rubric for Short Essay

4: The student goes beyond a mere figural analysis of what a Buddha, Shiva, or a similar Indian figure looks like to an understanding of the roles the two figures occupy and how those roles reflect a concept of idealism. There are no major errors.

3: The student presents a figural analysis of two Indian figures and gives some explanation of how the two represent a concept of idealism. There may be minor errors.

2: The student gives some idea of the general characteristics of Indian idealism, but lacks specificity. There may be major errors.

1: The student's explanation is superficial, discussing Indian figures in the most general of terms. There may be major errors.

0: The student makes an attempt, but the response is without merit.

Short Essay Model Response

Both the <u>Sarnath Buddha</u> and the <u>Shiva Nataraja</u> are religious figures who appear deeply concentrated and self-absorbed. Both display contemplative downward gazes, and their serene faces are immersed in tranquility. In addition, both have elongated ears, specific <u>mudras</u>, or hand positions, and soft, feminine features. These androgynous bodies—with thin waists and supple limbs—provide a universal appeal; the religious icons are presenting an inner perspective that transcends gender boundaries, showing that religiosity is more important than sexuality. The idealism of the pieces is enhanced by the larger circular background of each, which may symbolize otherworldly influence or function like halos for the figures.

Of course, the manner in which each figure occupies his circular space varies tremendously. The <u>Sarnath Buddha,</u> a motionless, composed figural unit, forms a triangle with his body, suggesting a geometric idealization. The triangle overlaps the circular, celestial parameters, while the Buddha's head occupies the center, a sure indication that the mind is the key to reaching Enlightenment. In contrast, Shiva's solar plexus occupies the center of a flaming circle, a reflection of the importance of this spot as a center of energy and dance. Indeed, Shiva's body does not sit still like the Buddha's; instead it engages in wild, frenzied movement. The arms in all directions suggest motion and contrast to the contained, bilaterally symmetric arms of the Buddha. These multiple arms also give Shiva a divine nature, while Buddha is a mere mortal attempting to reach a sublime state.

—Gabriel Sl.

Analysis of Model Response

The composition is neatly organized in a way that reflects two figures, a Buddha and a Shiva, that both have elements of idealism. Gabriel is quick to see idealist characteristics in the "deeply concentrated and self-absorbed" look of each work. Particularly noteworthy are sentences like "the Buddha's head occupies the center, a sure indication that the mind is the key to reaching Enlightenment." Here Gabriel demonstrates how the composition of the sculpture reinforces the function of the person it represents.

The second paragraph contrasts the solitude of the Buddha with Shiva's intense activity, and what both positions imply. Gabriel identifies the individual Buddha and Shiva he has in mind; failure to identify an individual work may have the reader think of a different image.

One could quibble with Buddha being a "mere mortal," but this is an example of an insignificant error. A significant error would be identifying Buddha as a god in the Hindu pantheon, or as a Christian saint—this would indicate to the reader that the writer has no understanding of where Buddha belongs in the history of world culture. **This essay merits a 4.**

Chinese Art

TIME PERIOD: From prehistoric times to the present

KEY IDEAS

- The philosophies of Laozi and Confucius permeate Chinese thought, including the fine arts.
- Calligraphy is the most respected Chinese art form.
- Chinese painting formats include handscrolls, hanging scrolls, fans, and album leaves.
- Chinese architecture is based on courtyard style houses that express the Chinese philosophy about family and social position.
- Chinese art has a fondness for the monumental and the grand.

HISTORICAL BACKGROUND

Although Chinese culture seems monolithic to those in the West, China has the size and population of Europe, with the same ethnic diversity and the same number of languages. To speak in general terms of Chinese art, therefore, has the same validity as speaking in general terms about European art.

To make such a diverse subject more manageable, Chinese art is divided into historical periods named after the families who ruled China for vast stretches of time. These families, united by blood and tradition, formed dynasties, and their impact on Chinese culture has been enormous.

The first ruler of a united China was Emperor **Shih Huangdi**, who reigned in the third century B.C.E. He not only unified China politically, but was also responsible for codifying written Chinese, standardizing weights and measures, and establishing a uniform currency. Moreover, he started the famous Great Wall and began his majestic tomb. While historians have taken a more critical look at Shi Huangdi's accomplishments, his insistence on government promotion based on achievement rather than family connections, had far-reaching effects on Chinese society.

Dynastic fortunes reached their greatest height during the Tang Dynasty (618–906 C.E.). Brilliant periods were also achieved under the Yuan of Kublai Khan (1215–1294) and the Ming Dynasty (1368–1644), which built the **Forbidden City** (Figure 28.3).

Patronage and Artistic Life

Calligraphy is the central artistic expression in traditional China, standing as it does at a midpoint between poetry and painting. Those who wanted important state positions had to pass a battery of exams that included calligraphy. Even emperors were known to have been accomplished calligraphers, painters, and poets. Standard written Chinese is often at variance with the more cursive or running script used in paintings, some of which is so artistically rendered that modern Chinese readers cannot decipher it. Rather than letters, which are used in European languages, Chinese employs characters, each of which represents a word or an idea. Therefore, the artistic representation of a word inherently carries more meaning than a creatively written individual letter in English.

Artists worked under the patronage of religion or the state, although a counterculture was developed by a group called the **literati** who painted for themselves, eschewing public commissions and personal fame. These artists produced paintings of a highly individualized nature, not caring what the world at large would think.

CHARACTERISTICS OF CHINESE PHILOSOPHIES

Daoism and **Confucianism**, the two great philosophies of ancient China, dominate all aspects of Chinese art, from the original artistic thought to the final execution. Dao, meaning "the Way," can be characterized as a religious journey that allows the pilgrim to wander meaningfully in search of self-expression. It was begun by **Laozi** (604–531 B.C.E.), a philosopher who believed in escaping society's pressures, achieving serenity, and working toward a oneness with nature. Daoists emphasize individual expression and strongly embrace the philosophy of doing unto others. The yin and the yang are well-known Daoists symbols (Figure 28.6).

The great Chinese philosopher **Confucius** (551–479 B.C.E.) wrote about behavior, relationships, and duty in a series of precepts called *The Analects*. Built on a system of mutual respect, the Confucian model presents an ideal man whose attributes include loyalty, morality, generosity, and humanity. An important ingredient in Confucianism is respect for traditional values.

INNOVATIONS IN CHINESE ARCHITECTURE

The design of the stupa, a Buddhist building associated with India, moved eastward with missionaries along the Great Silk Road, transforming itself into the **pagoda** (Figure 28.2) when it reached China. Built for a sacred purpose, the pagoda characteristically has one design that is repeated vertically on each level, each smaller than the design below it. In this way, pagodas achieve substantial height through a repetition of forms.

Characteristics of Chinese Architecture

The exterior walls of a courtyard style residence (Figure 28.1) kept the crowded outside world away and framed an atrium in which family members resided in comparative tranquility. In harmony with Confucian thought, elders were to be honored and so were to live in a suite of rooms on the warmer north end of the courtyard. Children lived in the wings, servants in the south end. The southeast corner usually functioned as an entrance, the southwest as a lavatory.

This courtyard-style arrangement is reflected on a massive scale in the **Forbidden City**. The emperor's seat is in the Hall of Supreme Harmony, itself on the north end of a courtyard; the throne faces south. The entire Forbidden City is a rectangular grid with its southern entrance and its high walls keeping the concerns of the multitude at a safe distance.

The Chinese, both in the Forbidden City and in less lavish projects, used wood for their principal building material. Tiled roofs seem to float over structures with eaves that hang away from the wall space and curve up to allow light in and keep rain out. Walls protect the interior from the weather, but do not support the building. Instead, support comes from an interior fabric of wooden columns that are grooved together rather than nailed. Corbeled brackets are used to transition the tops of columns to the swinging eaves. Wooden architecture is painted both to preserve the wood and enhance artistic effect.

Figure 28.1: Chinese courtyard-style residence with the principal structure on the north side facing south.

Major Works of Chinese Architecture

Temple of Heaven, 1406–1420, rebuilt 1889, Beijing, China (Figure 28.2)

- Emperors performed rituals here twice a year to ensure a good harvest, rituals that only the Chinese elite could attend, no common folk allowed
- Foundation set on three levels of white marble with repeated designs
- Pagoda made of wood with three levels of roofs covered in ceramic blue tiles; tiles symbolize the heavens; no nails used in construction
- Interior has 12 columns symbolizing the hours of the day, 12 columns symbolizing the months of the year, then 4 columns symbolizing the seasons

Forbidden City, fifteenth century, Ming Dynasty, Beijing, China (Figure 28.3)

- Largest and most complete Chinese architectural ensemble in existence
- 9,000 rooms
- Walls 30 feet high to keep people out and those inside in
- Forbidden City so named because only the royal court could enter
- Each corner of the rectangular plan has a tower representing the four corners of the world

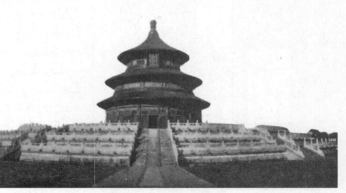

Figure 28.2: Pagoda, Temple of Heaven, 15th century, Beijing, China

Figure 28.3: Forbidden City, 15th Century, Ming Dynasty, Beijing, China

- Focus is the Hall of Supreme Harmony, the throne room and seat of power; wood structure made with elaborately painted beams; meant for grand ceremonies
- Yellow tile roofs and red painted wooden beams placed on marble foundations unify the structures in the Forbidden City into an artistic whole

CHARACTERISTICS OF CHINESE PAINTING

Chinese painting appears in many formats, including album leaves, fans, murals, and scrolls. Scrolls come in two formats: The handscroll (Figure 28.4), which is horizontal and can be read on a desk or table, and the hanging scroll (Figure 28.5), which is supported by a pole or hung for a time on a wall and unraveled vertically. No scrolls were allowed on permanent view in a home—they were something to be admired, studied, and analyzed, not hung for mere decorative qualities. Scrolls were stored away in cabinets specifically designed to hold them.

Figure 28.4: A Chinese handscroll read right to left. It starts with the title panel, moves to the main scene, and ends with a colophon.

Handscrolls are read right to left. Although paper is sometimes used as a painting surface, silks are preferred and specially chosen by the artist for their color and texture to evoke a mood. The silk is then attached to dowels and secured at the ends. When the scrolls are unwound, a title panel first appears, much like the title page in a book. As the scroll is carefully unrolled a section at a time, the viewer encounters both text and painting intertwined. Square red markings, made by artistically rendered seals, identify either the artist or the owners of the painting. In Chinese art, it is considered acceptable to comment on a work by writing poetry in praise of what has been read or seen. The commentaries are written on the last panel, called the **colophon**.

Figure 28.5: A Chinese hanging scroll with the main scene on the front and the title on the top back.

Landscape paintings are highly prized in Chinese art. Like European paintings of the same date, they do not seek to represent a particular forest or mountain, but reflect an artistic construct yielding a philosophical idea. Typically, some parts of a painting are empty and barren, suggesting openness and space. Other parts are crowded, almost impenetrable. This intertwining of crowded and empty spaces is a reflection of the Daoist theory of **yin** and **yang** (Figure 28.6), in which opposites flow into one another.

Another specialty in Chinese art is **porcelain**. Subtle and refined vase shapes are combined with imaginative designs to create works of art that appear to be utilitarian, but are actually objects that stand alone. To achieve maximum gloss and finish, sophisticated glazing techniques are applied to the surface. Glazing has the added benefit of protecting the vase from wear.

Figure 28.6: Yin and yang

The Literati

Some artists rejected the restrictive nature of court art and developed a highly individualized style. These artists, called **literati**, worked as painters, furniture makers, and landscape architects, as well as in other fields (Figure 28.9). The literati were often scholars rather than professional artists, and by tradition did not sell their works, but gave them to friends and connoisseurs.

Major Works of Chinese Painting

Ma Yuan, *Bare Willows and Distant Mountains,* late twelfth century, album leaf, ink on silk, Museum of Fine Arts, Boston (Figure 28.7)

- Intimate work with a poetic, sensitive, and lyrical mood
- Empty space contrasted with precise drawing
- Axe-cut strokes on rock surfaces
- Weeping trees silhouetted in black ink
- Subtly graded ink tones
- Diagonal organization

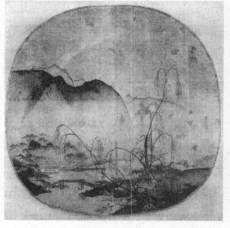

Figure 28.7: Ma Yuan, *Bare Willows and Distant Mountains*, late 12th century, album leaf, ink on silk, Museum of Fine Arts, Boston

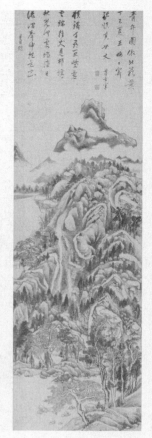

Figure 28.8: Dong QiChang, *Dwelling in the Qingbian Mountains*, 1617, ink on paper, Ming Dynasty, Cleveland Museum of Art

Dong QiChang, *Dwelling in the Qingbian Mountains,* 1617, ink on paper, Ming Dynasty, Cleveland Museum of Art (Figure 28.8)

- Dong QiChang as a literati painter, influenced by Daoism
- Thick impenetrable spaces alternating with open areas
- Mountain forms are strongly presented, yet negative space used to imply presence of clouds
- Piling up of forms in a radical arrangement composed of interlocking diagonals and curves

Shitao, *Man in a House Beneath a Cliff,* late seventeenth century, ink and color on paper, Qing Dynasty, Private Collection (Figure 28.9)

- Monk isolated in a forbidding landscape
- Inaccessible terrain
- Dots of color seem to be arbitrarily placed
- Literati painter influenced by QiChang

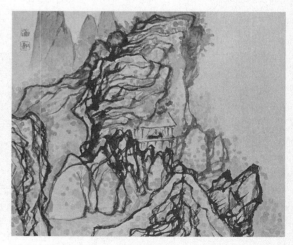

Figure 28.9: Shitao, *Man in a House Beneath a Cliff*, late 17th century, ink and color on paper, Qing Dynasty, Private Collection

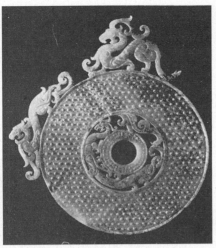

Figure 28.10: *Bi with Dragons*, 4th–3rd century B.C.E., nephrite, Eastern Zhou Dynasty, Nelson-Atkins Museum of Art, Kansas City

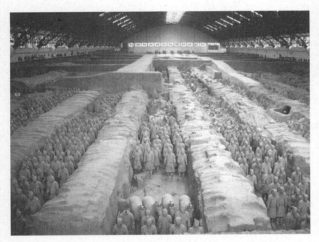

Figure 28.11: Army of Emperor Shi Huangdi, terra-cotta, c. 210 B.C.E., Qin Dynasty, Lintong, China

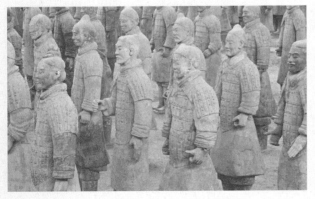

Figure 28.12: Army of Emperor Shi Huangdi, terra-cotta, c. 210 B.C.E., Qin Dynasty, Lintong, China

CHARACTERISTICS OF CHINESE SCULPTURE

China is a monumental civilization that has produced large-scale sculpture as a sign of grandeur. Enormous scale, without sacrificing artistic integrity, is a typical Chinese characteristic epitomized by the terra-cotta army of **Shi Huangdi** (Figures 28.11 and 28.12) and the huge **seated Buddha at Shanxi** (Figure 28.13). The Chinese have created a dazzling number of sculptures cut from the rock in situ, a technique probably imported from India.

At the same time, Chinese sculpture is known for intricately designed miniature objects. Those made of jade are especially prized for their beauty; they are durable and polish to a high shine in a matte green-gray color.

Major Works of Chinese Sculpture

***Bi with Dragons*, fourth–third century B.C.E., nephrite, Eastern Zhou Dynasty, Nelson-Atkins Museum of Art, Kansas City (Figure 28.10)**

- Circular jade disk with round center perhaps symbolizing heaven
- Dragons are a Chinese symbol of good luck and a bringer of weather in general and rain in particular
- Hard jade surface is expertly carved with finely modulated raised spirals and delicately penetrated surfaces

Army of Emperor Shi Huangdi, terra-cotta, c. 210 B.C.E., Qin Dynasty, Lintong, China (Figures 28.11 and 28.12)

- About 8,000 terra-cotta warriors, 100 wooden chariots, 2 bronze chariots, 30,000 weapons buried as part of the tomb of Emperor Shi Huangdi
- Soldiers are 6-feet tall, some fierce, some proud, some confident; taller than the average person of the time
- A representation of a Chinese army marching into the next world
- Daoism seen in the individualization of each soldier despite their numbers
- Originally colorfully painted
- Discovered in 1974

Seated Buddha, c. 460, stone, Shanxi, China (Figure 28.13)

- In situ rock carving of a 45-foot Buddha
- Buddha iconography: top knot on head, long ears, sits in a lotus position, tightly fitted garments
- Central Asian influence in his huge shoulders and pleated drapery
- Indian influence in face
- Gentle smile

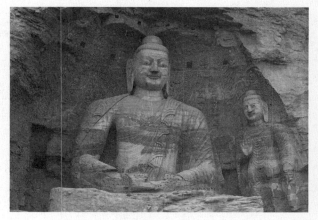

Figure 28.13: Seated Buddha, c. 460, stone, Shanxi, China

VOCABULARY

Bi: a round ceremonial disk found in ancient Chinese tombs. They are characterized by having a circular hole in the center, which may have symbolized heaven (Figure 28.10)

Colophon: a commentary on the end panel of a Chinese handscroll; an inscription at the end of a manuscript containing relevant information on its publication (Figure 28.4)

Confucianism: a philosophical belief begun by Confucius that stresses education, devotion to family, mutual respect, and traditional culture

Daoism: a philosophical belief begun by Laozi that stresses individual expression and a striving to find balance in one's life

Literati: a sophisticated and scholarly group of Chinese artists who painted for themselves rather than for fame and mass-acceptance. Their work is highly individualized (Figure 28.9)

Pagoda: a tower built of many stories. Each succeeding story is identical in style to the one beneath it, only smaller. Pagodas typically have dramatically projecting eaves that curl up at the ends (Figure 28.2)

Porcelain: a ceramic made from clay that when fired in a kiln produces a product that is hard, white, brittle, and shiny

Yin and yang: complementary polarities. The yin is a feminine symbol that has dark, soft, moist, and weak characteristics. The yang is the male symbol that has bright, hard, dry, and strong characteristics (Figure 28.6)

Summary

The great Chinese philosophies of Daoism and Confucianism dominate the fine arts, as well as all intellectual thought in China. They express the relationship of buildings to one another in courtyard-style residences from the most humble to the Forbidden City. They also articulate a relationship of the forms in Chinese painting.

Chinese artists apprenticed under a master and worked under a system of patronage controlled by religion or government. A powerful minority, the literati, deliberately chose to walk away from traditional artistic venues and cultivate a more individualized type of art.

Chinese art has a penchant for the monumental and the grand, epitomized by the Great Wall, the Colossal Buddhas, and the Tomb of Shi Huangdi. Considerable attention, however, is paid to smaller items such as delicate porcelains, finely cut jade figures, and laquered wooden objects.

Practice Exercises

1. Chinese scrolls can use all of the following material EXCEPT

 (A) silk
 (B) dowels
 (C) paper
 (D) cotton

2. The literati were a group of artists who

 (A) worked at court
 (B) believed in mass popularity
 (C) sought an individualized style
 (D) worked for foreign export

CHALLENGE 3. Confucianism is a philosophical belief that stresses

 (A) unity with nature
 (B) a oneness with god
 (C) a submission to Buddha
 (D) a respect for tradition

4. A colophon appears on a

 (A) scroll
 (B) fan
 (C) mural
 (D) sculpture

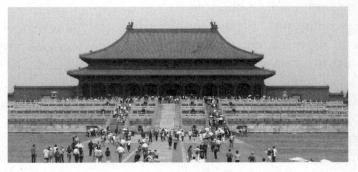

Figure 28.14

Questions 5–7 refer to Figure 28.14.

5. Like most Chinese architecture, the Forbidden City, above the foundations, is mostly built of

 (A) marble
 (B) granite
 (C) limestone
 (D) wood

6. In its plan, the Forbidden City represents

 (A) a giant pagoda
 (B) the culmination of Buddhist architecture in China
 (C) an influence from European palace architecture
 (D) a courtyard-style residence

7. The Forbidden City is located in

 (A) Hong Kong
 (B) Shanghai
 (C) Beijing
 (D) Xian

8. The most prominent feature of Chinese architecture is its

 (A) roof
 (B) interior
 (C) courtyard
 (D) crowded proportions

9. Chinese pagodas and statues of Buddha were inspired by works from

 (A) Japan
 (B) Rome
 (C) Cambodia
 (D) India

10. Chinese landscapes are known for their

 (A) faithfulness in recording a site
 (B) freedom to combine many disparate elements
 (C) empty compositions with only one or two objects in the scene
 (D) portrayal of large structures such as the Forbidden City

Short Essay

The landscape painting in Figure 28.15 is Chinese. How does it differ from a European landscape painting? Use one side of a sheet of lined paper to write your essay.

CHALLENGE

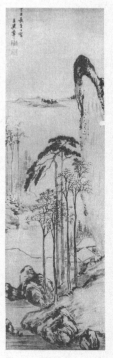

Figure 28.15

Answer Key

1. **(D)**	3. **(D)**	5. **(D)**	7. **(C)**	9. **(D)**
2. **(C)**	4. **(A)**	6. **(D)**	8. **(A)**	10. **(B)**

Answers Explained

Multiple-Choice

1. **(D)** Chinese scrolls can be painted on silk or paper. They are attached by dowels on either end. The Chinese did not make cotton scrolls.

2. **(C)** The literati eschewed court rituals and the popular appeal of artwork. They sought an individual style that they felt was deeply within them.

3. **(D)** Adherents to Confucianism are expected to respect traditional values greatly.

4. **(A)** A colophon appears as the last panel of a scroll.

5. **(D)** Chinese architecture has stone foundations and wooden walls and roofs.

6. **(D)** The Forbidden City is the realization of the courtyard style of Chinese architecture on a massive scale. This style has buildings around a rectangular perimeter, all facing inward, with the favored rooms having a southern exposure.

7. **(C)** The Forbidden City is located in downtown Beijing.

8. **(A)** The roof is the most prominent feature of a Chinese building with its sweeping eaves overhanging the walls.

9. **(D)** Chinese pagodas and statues of Buddha were inspired by works from India.

10. **(B)** Chinese landscapes allow the artist to think freely over a broad spectrum of representation.

Rubric for Short Essay

4: The student writes a cogent essay about how this painting has at least four distinct differences from a European painting. There are no major errors.

3: The student writes an essay about how this painting has at least three distinct differences from a European painting. There may be minor errors.

2: The student writes an essay about how this painting has two differences from a European painting. There may be major errors.

1: The student writes an essay about how this painting has only one difference from a European painting. There may be major errors.

0: The student makes an attempt, but the response is without merit.

Short Essay Model Response

As evidenced through the course of history, the rendering of the landscape in painting has tended to reflect the various aesthetic traditions of the culture that produced it. In the Chinese landscape painting seen in Figure 28.15, the various techniques employed by the artist reflect the certain aesthetic ideals seen in Chinese painting, which is in stark contrast to its European counterpart. The landscape is depicted in a vertical format, as opposed to the traditional horizontal landscape seen in European painting. All of the elements in the Chinese landscape painting seem to be pushed forward to the foreground of the composition due to the presence of a void space in the background. The technique of structuring the format of the composition in primarily the foreground and middleground of the painting is characteristically seen in Chinese landscapes, leaving the background relatively empty. In European landscapes, however, the format is more balanced with a certain structure created between the incorporation of the three planes of the composition. The forms of the landscape in Figure 28.15, such as the mountains and trees, are rendered through the use of contours instead of employing the techniques of shading and tonality. The swift strokes used by the artist merely hint at the forms in the landscape instead of being meticulously defined, as displayed in European landscapes.

There is also an uninhabited aspect visible in the Chinese landscape, where there is a lack of focus on the presence of man within the environment. Everything appears to be more untamed and wild, demonstrating the power of nature, which reflects the aesthetic ideals of the Chinese culture. This notion is communicated in the portrayal of depicting the houses and other elements that suggest the presence of man, in a diminutive way, thereby displaying the power of nature and its predominance in the landscape. However, in European landscape painting, there is usually a focus on including the human form in the composition, which demonstrates the importance of the attention in displaying the presence of man within the environment. The stark contrast is depicted between both the Chinese and European compositional devices in the use of rendering the format and techniques of a landscape painting.

—Jessica E.

Analysis of Model Response

This is an excellent essay. Jessica studies the painting in question and carefully notes characteristics that differentiate Chinese landscape from European. Among the important points made here are the "vertical format," "the elements…seem to be pushed forward to the foreground," "the swift strokes used by the artist merely hint at the forms in the landscape instead of being meticulously defined," and "the uninhabited aspect." **This essay merits a 4.**

Japanese Art

KEY IDEAS

- The Japanese have one of the best preserved continuous artistic traditions in the world.
- Zen Buddhist thought dominates much Japanese artistic production.
- The tea ceremony is a unique feature of Japanese culture.
- Ukiyo-e prints were originally sold as a middle-class art form in Japan, and became incredibly influential among the avant-garde in Europe.

HISTORICAL BACKGROUND

Japan is one of the few countries in the world that has never been successfully invaded by an outside army. There are those who have tried, like the Mongols in 1281, whose fleet was destroyed by a typhoon called a kamikaze, or divine wind, and there are those who have defeated the Japanese without invading, like the Allies in World War II, who never landed a force on the four principal islands, until the war was over.

Because of the relatively sheltered nature of the Japanese archipelago, and the infrequency of foreign interference, Japan has a greater proportion of its traditional artistic patrimony than almost any other country in the world. It was Commodore Perry who opened Japan, begrudgingly, to outside influence in 1854. One by-product of Perry's intervention was the shipment of **ukiyo-e** prints to European markets, first as packing material and then in their own right. They achieved enduring fame in nineteenth-century Europe and America, but were looked down upon by the upper classes in Japan, who were more than willing to send them off for export.

Patronage and Artistic Life

Japanese artists worked on commission, some for the royal court, others in the service of religion. Masters ran workshops with a range of assistants—the tradition in Japan usually marking this as a family-run business with the eldest son inheriting the trade. Assistants learned from the ground up, making paper and ink, for example. The master created the composition by brushing in key outlines and his assistants worked on the colors and details.

Painting is highly esteemed in Japan. Aristocrats of both sexes not only learned to paint, but became distinguished in the art form.

CHARACTERISTICS OF ZEN BUDDHISM

Zen is a school of Buddhism that is deeply rooted in all East Asian societies, and was imported from China in the late twelfth century. It had a particularly great impact on the art of Japan, where the Zen philosophy was warmly embraced.

Zen adherents reject worldliness, the collection of goods for their own sake, and physical adornment. Instead, the Zen world is centered on austerity, self-control, courage, and loyalty. Meditation is key to enlightenment; for example, samurai warriors reach deeply into themselves to perform acts of bravery and great physical endurance.

Zen teaches through intuition and introspection, rather than through books and scripture. Warriors as well as artists were quick to adopt a Zen philosophy.

CHARACTERISTICS OF JAPANESE TEA CEREMONY

The tea ceremony is a ritual of greater importance than it at first seems to the Westerner. The simple details, the crude vessels, the refined tea, the uncomplicated gestures—these alluring items are all part of a seemingly casual, but in fact, highly sophisticated tea ceremony that endures because of its minimalism. Teahouses have bamboo and wooden walls with floor mats of woven straw. Everything is carefully arranged to give the sense of straightforwardness and delicacy.

Visitors enter through a low doorway—symbolizing their humbleness—into a private setting. Rectangular spaces are broken by an unadorned alcove that houses a Zen painting done in a free and monochromatic style, selected to enhance an intimate atmosphere of warm and dark spaces.

Participants sit on the floor in a small space usually designed for about five people, and drink tea. The ceremony requires four principles: Purity, harmony, respect, and tranquility. All elements of the ceremony are proscribed, even the purification ritual of hand washing and the types of conversation allowed.

CHARACTERISTICS OF JAPANESE ARCHITECTURE

The austerity of **Zen** philosophy can be most readily seen in the simplicity of architectural design that dominates Japanese buildings. A traditional structure is usually a single story, made of wood, and meant to harmonize with its natural environment. The wood is typically undressed—the fine grains appreciated by the Japanese. Because wood is relatively light, the pillars could be placed at wide intervals to support the roof, opening the interior most dramatically to the outdoors.

Floors are raised above the ground to reduce humidity by allowing the air to circulate under the building. Eaves are long to generate shady interiors in the summer, and steeply pitched to allow the quick runoff of rain and snow.

Interiors have mobile spaces created by sliding screens, which act as room dividers, by changing its dimensions at will. Particularly lavish homes may have gilded screens, but most are of wooden materials. The floors are overlaid with removable straw mats.

A principal innovation in Japanese design is the Zen garden, which features meticulous arrangements of raked sand circling around prominently placed stones and plants (Figure 29.1). Each garden suggests wider vistas and elaborate landscapes. Zen gardens contain no water, but the careful placement of rocks often suggests a cascade or a rushing stream. Ultimately these gardens serve for spiritual refreshment, a place of contemplation and rejuvenation.

There is a deep respect for the natural world in Japanese thought. The native religion, Shintoism, believes in the sacredness of spirits inherent in nature. In a heavily forested and rocky terrained country like Japan, wood becomes the natural choice for building, and stone for Zen gardens.

Major Works of Japanese Architecture

Ise Shrine, first century, rebuilt every twenty years, Ise, Japan (Figure 29.2)

- Raised off the ground by wooden piles
- Thatched roof, held in place by thick heavy logs
- Unpainted cypress wood
- Much prized simplicity of design
- Few people allowed inside, just priests or royalty
- Building meant to complement, not intrude upon, the Ise forest
- Dedicated to the sun goddess Amaterasu-o-mi-kami, the presumed original ancestor of the Japanese royal family

Phoenix Hall, c. 1053, rebuilt, Uji, Japan (Figure 29.3)

- Two gilt bronze birds on roof are in the phoenix shape; phoenix is a symbol of the protection of the Buddha; roof itself suggest the wings of a phoenix in flight
- All the arts combine to create this work: architecture, landscape, sculpture, painting, crafts; reflection in water is a key element in the design
- Used as a kondo, a hall for spreading Buddhist teachings
- Airiness, lightness, raised off the ground
- Open nonwalled wings
- Complicated roof structure; sham second story; horizontal lines do not run through the building
- Chinese influence in the tile roofs and the stone base

Himeji Castle, 1601–1609, near Osaka, Japan (Figure 29.4)

- Called White Heron Castle because the white plaster used in construction gives the upper floors of the building an overall appearance of a large white bird with huge fluttering wings
- Castle built to control traffic between Kyoto and western Japan

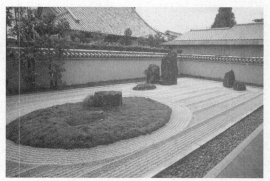

Figure 29.1: A detail from a Zen garden showing raked sand, carefully placed stones, and adjoining shrubs.

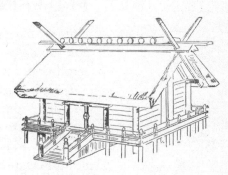

Figure 29.2: Ise Shrine, first century, rebuilt every 20 years, Ise, Japan

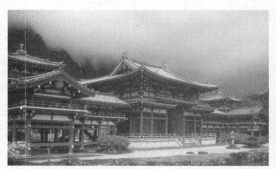

Figure 29.3: Phoenix Hall, c. 1053, rebuilt, Uji, Japan (copy in Hawaii)

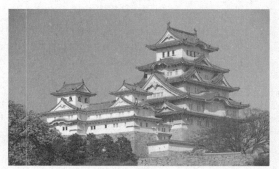

Figure 29.4: Himeji Castle, 1601–1609, near Osaka, Japan

- Castle was ringed by three sets of walls separated by moats, some of which have been destroyed
- Complex of 83 structures including donjons, gates, turrets, and breastworks
- Approach to castle was made through an elaborate series of paths that grow ever more narrow and twisted as they spiral uphill; enemies would have faced high walls and narrow gates
- Irregular and varied roof line with 15 gables
- Outer roof lines do not parallel inner floor levels; interior extremely dark owing to small size of windows
- Curved Chinese gables give composition a soaring quality

CHARACTERISTICS OF JAPANESE PAINTING AND PRINTMAKING

Chinese painting techniques and formats were popular in Japan as well, so it is common to see the Japanese as masters of the handscroll (Fig. 29.5), the hanging scroll (Fig. 29.7), and the decorative screen.

Characteristics of the Japanese style include elevated viewpoints, diagonal lines, and depersonalized faces.

A Japanese specialty is **haboku** or **ink-splashed** painting that involved applying in a free and open style that gives the illusion of being splashed on the surface. Sesshu (Figures 29.6 and 29.7) was a haboku specialist.

Genre painting from the seventeenth to the nineteenth centuries was dominated by **ukiyo-e**, a term that means "pictures of the floating world." The word "floating" is meant in the Buddhist sense of the passing or transient nature of life; therefore ukiyo-e works depict scenes of everyday life or pleasure: festivals, theatre (i.e., the kabuki), domestic life, geishas, brothels, and so on. Ukiyo-e is most famously represented in woodblock prints, although it can be found on scrolls and painted screens.

Ukiyo-e was immensely popular; millions of prints were sold to the middle class during its heyday, usually put between 1658 and 1858. Although disdained by the Japanese upper classes for being popular, they won particular affection in Europe and in the Americas as an example of innovative Japanese art.

Printmaking was a collaborative process between the artist and the publisher. The publisher determined the market, dictated the subject matter and style, and employed the woodblock carver and the printer. At first, all prints were in black and white, but the popularity encouraged experimentation, and a two-color system was introduced in 1741.

By 1765, a polychrome print was created, and while this made the product more expensive than before and more time-consuming to create, it was wildly popular and sold enthusiastically. Colors are subtle and delicate, and separated by black lines. Each color was applied one at a time, requiring a separate step in the printmaking process. This made the steps complicated with precise alignments critical to a successful print. Suzuki Harunobu was the first successful ukiyo-e artist in the polychrome tradition. **Hokusai** explored the relationship of ukiyo-e and landscape painting.

Western artists were taken with ukiyo-e prints. They particularly enjoyed the flat areas of color, the largely unmodulated tones, the lack of shadows, and the odd compositional angles, with figures occasionally seen from behind. Forms are often unex-

pectedly cut off and cropped by the frame of the work. The Western interest in realistic subject matter found agreement in ukiyo-e prints.

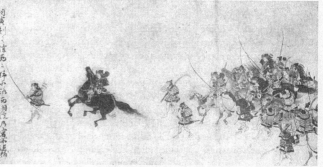

Figure 29.5: *The Burning of the Sanjo Palace*, late 13th century, handscroll on paper, Museum of Fine Arts, Boston

Major Works of Japanese Painting and Printmaking

The Burning of the Sanjo Palace, late thirteenth century, handscroll on paper, Museum of Fine Arts, Boston (Figure 29.5)

- Painted 100 years after the civil war depicted in the scene
- Elevated viewpoint
- Strong diagonals emphasizing movement and action
- Swift active brushstrokes
- Narrative read from right to left as the scroll is unrolled
- Depersonalized figures, many with only one stroke for the eyes, ears, and mouth
- Tangled mass of forms accentuated by Japanese armor
- Lone archer leads the escape from the burning palace with equestrian Japanese commander behind him

Sesshū Tōyō, *Winter Landscape*, c. 1470s, ink on paper, Tokyo National Museum (Figure 29.6)

- Highly individualized master of ink painting
- Artist inspired by Chinese paintings on his trip to China in 1467
- Abrupt transitions from near to far
- Jagged angular lines cut through the composition ("axe-cut" strokes) suggesting cragged mountains and forbidding landscape; sharp outlines define the space
- Zen monastery in middle distance bids a lone monk to travel there, a center of learning and quiet in an inhospitable and cold world
- Diagonal lines lead viewer deeper into composition
- Sesshū was a master of Zen, and his paintings have a spiritual calm that Zen adherents seek

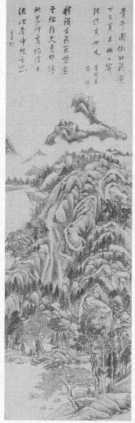

Figure 29.6: Sesshū Tōyō , *Winter Landscape*, c. 1470's, ink on paper, Tokyo National Museum

Sesshū Tōyō, *Summer*, 1495, ink on paper, Tokyo National Museum (Figure 29.7)

- Haboku or splashed-ink style of painting
- Foreground elements are emphasized, background elements are suggested through light application of ink washes
- Forms contain an element of abstraction, but are rooted in reality
- Horizontal strokes define ground lines, vertical strokes behind suggest the landscape
- Very few strokes form entire composition: great economy of means

Figure 29.7: Sesshū Tōyō , *Summer*, 1495, ink on paper, Tokyo National Museum

Figure 29.8 Hokusai, *The Great Wave*, 1826–1833, woodblock print, Metropolitan Museum of Art, New York

Hokusai, *The Great Wave*, **1826–1833, woodblock print, Metropolitan Museum of Art, New York (Figure 29.8)**

- First time landscape is a major theme in Japanese prints
- Last of a series of prints called *Thirty-Six Views of Mount Fuji*
- Personification of nature, it seems intent on drowning the figures in boats
- Mount Fuji, sacred mountain to the Japanese, seems to be one of the waves
- Striking design contrasts water and sky with large areas of negative space

CHARACTERISTICS OF JAPANESE SCULPTURE

Japanese sculpture runs the gamut from abstract forms seen in the **haniwa** figures to the intensely realistic sculptures of samurais or Buddhist priests. Masks are highly acclaimed in Japan, especially those used in religious rituals and in dramas, called **Noh** plays. Noh masks are small, delicately carved wooden masks that reveal to the audience the emotions of a character. Indeed, Noh masks are particular to a type of emotion, not to a character in a play, and can be used throughout a repertoire of plays provided that one emotion is inherent (Figure 29.9).

Figure 29.9: Noh mask

Figure 29.10: Haniwa Figure, 6th century, earthenware, Tokyo National Museum

Major Works of Japanese Sculpture

Haniwa Figure, sixth century, earthenware, Tokyo National Museum (Figure 29.10)

- Earthenware; the material is emphasized, not painted over
- Geometric, simplified shapes; unglazed figures
- Found in tomb sites made of artificial hills, these figures placed on top, close together, surrounding the grave mound
- Many shapes, sizes, animals, people, professions, houses, boats
- Never symmetrical: off-center eyes, unequal arms
- Tomb guardians? Spirit guardians?

Tori Busshi, *Shaka Triad*, **623, bronze, Nara, Japan (Figure 29.11)**

- Shaka, the Japanese name for Shakyamuni, the historical Buddha
- Frontal, long face and hands; wide nose; heavy jaw; face is fierce yet merciful
- Large hands express the promise of tranquility and the path to salvation

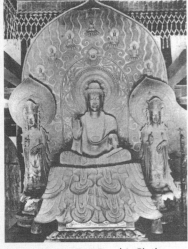

Figure 29.11: Tori Busshi, *Shaka Triad*, 623, bronze, Nara, Japan

- Influence of Chinese art in the elongated style, Tori was of Chinese descent
- Heads, hands, legs in high relief
- Bodies barely revealed, hidden under garments; figures lack volume
- Above Buddha is a flaming jewel of Buddhist wisdom in an inverted lotus blossom
- Originally placed in the center of a kondo
- Attendant bodhisattvas
- Originally placed in the center of a kondo
- Long inscription on back of halo says that a prince was ill, and this sculpture grouping was a supplication for his recovery. He died and the statue was completed for the repose of his soul in paradise.

VOCABULARY

Donjon: an inner stronghold of a castle complex (Figure 29.4)

Genre painting: painting in which scenes of everyday life are depicted

Haboku (splashed ink): a monochrome Japanese ink painting done in a free style in which ink seems to be splashed on a surface (Figure 29.7)

Haniwa: (from the Japanese for "circle of clay") Japanese ceramic figures that were placed on top of burial mounds (Figure 29.10)

Kondo: a hall used for Buddhist teachings (Figure 29.3)

Mandorla (Italian, meaning "almond"): a term that describes a large almond-shaped orb around holy figures like Christ and Buddha (Figure 29.11)

Ukiyo-e: translated as "pictures of the floating world," a Japanese genre painting popular from the seventeenth to the nineteenth century (Figure 29.8)

Zen: a metaphysical branch of Buddhism that teaches fulfillment through self-discipline and intuition

Summary

With much of its tradition intact, a firm history of Japanese artistic production can be studied from its earliest roots. Works of haniwa earthenware, among the oldest sculptures in Japan, show a sincere devotion to the honesty of the materials being used, a tradition that never ebbs in Japanese art.

Japanese architecture is particularly sensitive to the properties of wood construction. The earliest buildings maintain the beauty of untreated wood and show a great emphasis on harmonizing with the natural surrounding environment. Japanese buildings are meant to be viewed as part of an overall balance in nature. Japanese buildings never intrude upon a setting, but complement it fully.

Traditional Chinese forms of painting, such as scrolls, were admired in Japan. Nevertheless, uniquely Japanese artistic styles, such as ukiyo-e prints, were popular as well, particularly with the middle classes. The impact of ukiyo-e prints on nineteenth-century European art cannot be overstated.

Practice Exercises

1. Japanese haniwa figures are found in

 (A) temples
 (B) burial mounds
 (C) kondos
 (D) Zen monasteries

Questions 2 and 3 refer to Figure 29.12.

2. This print is typical of ukiyo-e art in that it

 (A) shows the Zen philosophy of rejecting the attractions of the material world
 (B) reflects the values of middle-class society
 (C) presents women on an equal footing with men
 (D) shows the influence of Western art

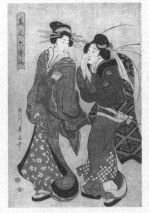

Figure 29.12

CHALLENGE

3. Women are typically shown in ukiyo-e prints with all of the following characteristics EXCEPT they

 (A) wear fanciful costumes
 (B) have small hands and feet
 (C) have small facial features
 (D) are always accompanied by men

4. The favorite material for Japanese architects is

 (A) wood
 (B) metal
 (C) stone
 (D) terra cotta

Questions 5–7 refer to Figure 29.13.

5. This building is called the

 (A) Forbidden City
 (B) Ise Shrine
 (C) Great Stupa
 (D) Phoenix Hall

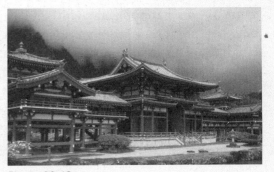

Figure 29.13

6. This building was probably used as a

 (A) tomb
 (B) kondo
 (C) Zen monastery
 (D) pagoda

7. Characteristic of Japanese architecture is the way in which this building

 (A) integrates various types of stone into its structure
 (B) has parallel horizontal lines that run across the structure
 (C) is integrated into the landscape setting
 (D) is influenced by Zen philosophy

8. Great simplicity of design is a Japanese characteristic that can be found in all of the following EXCEPT

 (A) the tea ceremony
 (B) ukiyo-e prints
 (C) Zen architecture
 (D) Japanese sculpture

9. The *Shaka Triad* was commissioned

 | CHALLENGE |

 (A) to assist in the recovery of an ailing prince
 (B) as a diplomatic gift
 (C) to be used as a model for haniwa sculptures
 (D) to decorate a royal palace

10. Japanese painting can be characterized by

 (A) strong shadows
 (B) triangular composition
 (C) devotion to Shiva
 (D) depersonalized people

Short Essay

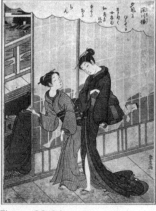

What aspects of Japanese art, visible in Figure 29.14, inspired nineteenth-century European painters? Use one side of a sheet of lined paper to write your essay.

| CHALLENGE |

Figure 29.14

Answer Key

1. (B)	3. (D)	5. (D)	7. (C)	9. (A)
2. (B)	4. (A)	6. (B)	8. (B)	10. (D)

Answers Explained

Multiple-Choice

1. **(B)** Haniwa figures have been found in ancient Japanese burial mounds.

2. **(B)** Ukiyo-e art shows the values of middle-class society. Men and women were not on an equal footing in traditional Japan, nor did the Zen approach to austerity appeal to middle-class values.

3. **(D)** Women did not need men to complete themselves in ukiyo-e prints. Many fine series of ukiyo-e artworks feature women in domestic roles.

4. **(A)** Traditional Japanese architects use wood.

5. **(D)** This building is the Phoenix Hall.

6. **(B)** This building was built as a kondo, that is, a building used to spread Buddhist teachings.

7. **(C)** Japanese architecture is known for being one with its environment.

8. **(B)** Ukiyo-e prints are not known for their simplicity of design.

9. **(A)** The *Shaka Triad* was commissioned to assist in the recovery of an ailing prince.

10. **(D)** Japanese art is depersonalized, sometimes with minimal facial features and expressions.

Rubric for Short Essay
4: The student describes the Japanese influence on nineteenth-century European art by examining characteristics within this print that can be directly related to European examples. There are no major errors.
3: The student describes the Japanese influence on nineteenth-century European art by mentioning characteristics in this print, but is less specific and speaks in general terms. There may be minor errors.
2: The student describes Japanese art in general terms and mentions the influence on European works, but does not detail examples. There may be major errors.
1: The student mentions only one characteristic of Japanese art and speaks in general terms about its European influence. There may be major errors.
0: The student makes an attempt, but the response is without merit.

Short Essay Model Response

Beginning in the mid-19th century, Japanese art began to influence European painters. This movement was referred to as Japonism (Japonisme in French) because it first influenced French painters. Traditional Japanese woodcuts began to influence the new movements of Art Nouveau, and perhaps most directly, Impressionism.

This painting displays typical Japanese characteristics: simple curved, lines, flatness, bright colors, and an odd sense of perspective (evident behind the open screen, the floorboards, and the bridge) that influenced European painters. Perhaps most unusual (and perhaps, influential) is the tilted perspective evident at the intersection of various planes. For example, the floor meets the door at a point in space that does not suggest depth but rather verticality. Similarly, the floorboards themselves do not seem to recede into the painting, they rather seem to move upward into space. The collective effect of the twisted perspective of the screen and floorboards is that the women stand on a floor that seems to slant upward, and thus, is not parallel to the screen. This odd perspective also makes it seem as if the woman seated directly behind the screen is not parallel or behind the other women but rather at an elevated location. The bridge in the background is also painted using the same distorted perspective; it fails to suggest any depth whatsoever. In fact, the bridge seems so close to the screen that it seems to be touching the other side of the screen. Lastly, this painting has writing

placed in what seems to be a cloud that does not harmonize with the painting; this writing seems to intrude upon the artwork. These characteristics directly influenced the 19th-century work of European painters who began to use realist subject matter, abstraction of nature, and stylization characteristics of this and many other Japanese works.

—Sara T.

Analysis of Model Response

Sara points out general characteristics of Japanese art that Europeans found inspiring, and particularly cites several relevant examples in the painting. A fuller discussion is added, for example, about the tilted perspective used in the intersecting planes of various grids contained in the screen, the floorboards, and the bridge in the distance. Her summary tells us that these characteristics were important in the development of late nineteenth-century European art. **This essay merits a 4.**

Art of the Americas

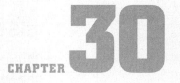

CHAPTER **30**

TIME PERIOD: 3500 B.C.E.–1492 C.E. and beyond

Some of the main periods are these:

Civilization	Date	Location
Olmec	1200–400 B.C.E.	Mexico, around the Gulf of Mexico
Nazca	200 B.C.E.–600 B.C.E.	Coastal Peru
Moche	1 C.E.–700 C.E.	Coastal Peru
Teotihuacán	1 B.C.E.–800 C.E.	Near Mexico City
Mayan	300–900 C.E. and later	Belize, Guatemala, Honduras, Yucatán
Anasazi	550–1400 C.E.	American Southwest
Mississippian	800–1500 C.E.	Eastern United States
Aztec	1400–1521	Central Mexico, centered in Mexico City
Inca	1438–1532	Peru
Northwest Coast Native American	18th century to present	Pacific Northwest

KEY IDEAS

- Ancient American civilizations developed huge city-states that prominently featured temple complexes rivaling any on earth.
- Sculptures vary from the monumental used as centerpieces in great plazas to intimate works of jewelry for private adornment.
- Local materials play a large role in the creation of works of art: wood for Northwest Coast Indians, adobe for Southwestern Indians, stone in Mesoamerica, and so on.
- Old civilizations form foundations for new ones: that is, pyramids often encase small structures the way cultures build upon preexisting sites.

HISTORICAL BACKGROUND

Humans are not native to the "New World"; Americans do not have an ancestry dating back millions of years, the way they do in Africa or Asia. People migrated from Asia to America over a span of perhaps 30,000 years, crossing over the Bering Strait when the frozen winters made the way walkable. Eventually this population understood that the climate was good enough to raise crops, particularly in what is today Mexico and Central America, and the population boomed.

As in other parts of the world, local rivalries and jealousies have played their part in the ebb and flow of American civilizations. Some civilizations are intensely cultivated and technological, refining metal ore and developing a firm understanding of astronomy and literature. Others remained nomadic and limited their activities as hunter–gatherers. In any case, when the European colonizers arrived at the end of the fifteenth century, they encountered in some ways a very sophisticated society, but in others, one that did not even possess a functioning wheel and refined metals mostly for jewelry rather than for use.

Each succeeding civilization buried or destroyed the remains of the civilization before, so only the hardiest ruins have survived the test of time. Most of what can be gleaned about pre-Columbian American society is ascertained by archaeologists working on elaborate burial grounds or digging through the ruins of once-great ancient cities.

Patronage and Artistic Life

Artists were commoners, as was true in most societies in the ancient world. Because of their special abilities, however, artists were employed by the state to work at important sites instead of doing menial labor. Artists were trained in an apprenticeship program, and reached fame through the rendering of beautifully crafted items.

Ancient Americans used an extremely wide variety of materials in their artwork, usually capitalizing on what was locally available. Since they did not have draught animals, and since wheeled carts were unknown, artists were reliant on what was locally produced, or small enough to trade and carry. Even so, Aztecs, for example, carved in obsidian, jade, copper, gold, turquoise, basalt, sandstone, granite, rock crystal, wood, limestone, and amethyst, among many other media.

Tropical cultures profited from the skins of animals and feathers of birds and produced great works using brilliant plumage. Featherwork became a distinguished art form in the hands of Pre-Columbian artists.

CHARACTERISTICS OF OLMEC ART

The Olmecs are sometimes called "the mother civilization of the Americas" because they represent the first organized community of Indians in the Americas. Olmecs are famous for their sculptures of gigantic heads, but also produced smaller objects, most of which also emphasized the head. It is common to see Olmec objects blend animal and human forms in a complex mythological web. The characteristic feature of Olmec works is a snarling frown that dominates most sculpture. Olmec figures have fully rounded volumes underlining their mass and proportions. Bodies are short and stocky with thick necks.

Major Work of Olmec Art

Colossal Head, 900–400 B.C.E., basalt, La Venta, Mexico (Figure 30.1)

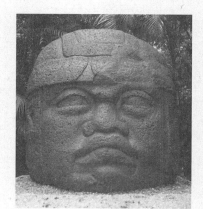

Figure 30.1: Colossal Head, 900–400 B.C.E., basalt, La Venta, Mexico

- About sixteen survive; different facial features
- Weigh ten tons each, moved sixty miles over swampy grounds to site
- Depicts Olmec rulers or at least ideal representations of them; adult males
- Wear headgear
- Pugnacious face, frowning expression, full checks, fleshy lips, deeply set heavy-lidded eyes
- Deliberately mutilated, all heads have come down to us marred
- Backs were flattened and undecorated—heads meant to be displayed against a wall

Characteristics of Nazca Art

Nazca culture is centered in coastal Peru. Artists produced exceptionally fine polychrome pottery done in four or more colors. However, the Nazca culture is most famous for lines drawn in the surface of the plateau that have remained preserved for centuries due to the dry climate.

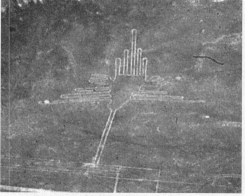

Figure 30.2: Nazca Lines, c. 100 B.C.E.– 700 C.E., Peru

Major Work of Nazca Art

Nazca Lines, c. 100 B.C.E.–700 C.E., Peru (Figure 30.2)

- Extremely arid plain in southwest Peru where huge earthworks were drawn
- Together add up to 800 miles of lines
- Communal artwork, probably done over large expanses of time
- Many animal images including hummingbirds, monkeys, ducks, spiders, etc.
- Many groups of parallel lines that stretch for 12 miles; other geometric shapes abound
- Unknown purpose but likely a religious meaning, marking pilgrimage centers and important shrines and emphasizing water sources

CHARACTERISTICS OF MOCHE ART

Moche pottery (Figure 30.3) survives in considerable abundance. These portable ceramics feature a flat bottom, so that the piece can easily rest on a shelf or table. Heads are emphasized and dramatically oversized. The handles have an inverted U-shape with a spout attached in the center. Moche art is done in a limited range of colors, most only using two shades. Moche figures were placed in graves as part of an offering to spirits of the dead.

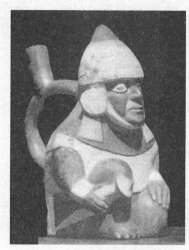

Figure 30.3: Moche ceramic, 200 B.C.E.–600 C.E., Peru

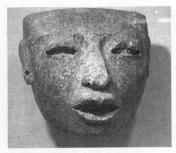

Figure 30.4: Teotihuacán Mask, 3rd–7th century C.E., Metropolitan Museum of Art, New York

CHARACTERISTICS OF TEOTIHUACÁN ART

Little is known about the ethnic group that lived at Teotihuacán, Mexico, or the language they spoke. The city was one of the largest in the world during its heyday, flourishing in an ample basin north of Mexico City, and sustaining an enormous pyramid complex along the two-mile-long Avenue of the Dead. The pyramids, unlike those in Egypt, were living monuments, not tombs. As such, they were ceremonial centers of the city, where civic and religious rituals were played out before the citizenry.

Masks from Teotihuacán survive in considerable numbers. They were not intended to be worn by the living, but represent spirits of the dead or the netherworld. The somewhat violent aspects of Mesoamerican religions can be seen in the formidable snarling faces of these works (Figure 30.4).

Major Work of Teotihuacán Art

Pyramid of the Sun, c. 200, Teotihuacán, Mexico (Figure 30.5)

- Flat-topped pyramid with expansive staircase leading to the top
- Name is an Aztec term that may or may not have had anything to do with its original function
- Staircases are unusually steep, as they are in all American pyramids
- Staircases rise and reach landings, then rise again, creating a layering effect in the pyramid; people rise as they mount the staircase to the top then vanish as they walk on the landing and rise again; patterns of spaces and voids
- Pyramid built of six platforms of decreasing size, all decorated identically

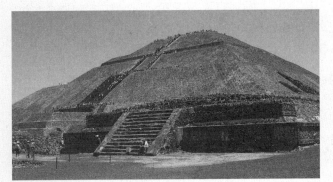

Figure 30.5: Pyramid of the Sun, c. 200, Teotihuacán, Mexico

CHARACTERISTICS OF MAYAN ART

Mayan sculpture is easy to recognize, because of the unusual Mayan concept of ideal beauty. The model seems to have been a figure with an arching brow, with the indentation above the nose filled in as a continuous bridge between forehead and nose. Most well-to-do Mayans put their children in head braces to create this symbol of beauty if the child was not born with it. Facial types are long and narrow, with full lips and mouths ready to speak (Figure 30.6). It is common to see figures elaborately dressed with costumes composed of feathers, jade, and jaguar skin. The Mayans preferred narrative art done in relief sculpture. Their relief work has crisp outlines with little attention given to modeling.

Mayan sculpture is typically related to architectural monuments: Lintels, facades, jambs, and so on. Figures of gods are stylized and placed in conventional hieratic poses possessing symbols of beauty, most notably tattooing and crossed eyes. Most Mayan sculptures were painted.

A typical work that appears everywhere in Mayan cities is the **chacmool** (Figure 30.7), a figure that is half-sitting and half-lying on his back. The unusual pose of the figure is balanced by the face which turns 90 degrees from the body.

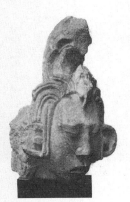

Figure 30.6: Mayan Head, stone, c. 250–900, Copan, Honduras

Elbows firmly rest on the ground, lending a sloping sense to the body. On his stomach is a plate, which has made some scholars deduce that the figure was meant to receive offerings. Sculptures such as these influenced modern artists such as Henry Moore (Figure 25.32).

Mayan pyramids are set in wide plazas as a center of civic focus. Grandly proportioned temples accompany pyramids, although their interiors are narrow and tall, giving a certain claustrophobic effect enhanced by the use of corbelled vaulting. Temples had long roof combs on the roof to accentuate their verticality.

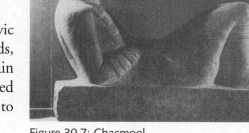

Figure 30.7: Chacmool

Major Works of Mayan Art

Castillo, 9–13 B.C.E., Chichén-Itzá, Mexico (Figure 30.8)

- Temple dedicated to Kukulkan on top of pyramid
- Steep-sided pyramids, built over and encasing older pyramid inside
- Built in commemoration of the year: 4 staircases, one on each side; one staircase has 92 steps, the others 91, equaling 365 days in the year

Shield Jaguar and Lady Xoc, 725, limestone, British Museum, London (Figure 30.9)

- Originally set above a doorway in a temple
- Commissioned by Lady Xoc, one of the rare examples of female patronage in Mesoamerica; Mayans are unusual in allowing women prominent positions of authority at court
- Shows the bloodletting ritual of the king of Yaxchilán, Shield Jaguar II, and his wife, Lady Xoc
- King holds a flaming torch above his wife
- Lady Xoc, in a ritual, pulls a rope containing spikes through a hole in her tongue, the blood drops around her mouth and down into a basket filled with papers; the papers will be burned as an offering to the gods

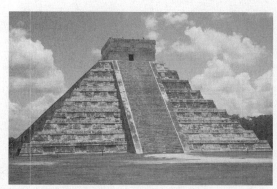

Figure 30.8: Castillo, 9–13 B.C.E., Chichén-Itzá, Mexico

CHARACTERISTICS OF ANASAZI ART

Anasazi is a term that means "ancient ones" or "ancient enemies" in the Navajo language. They are most famous for their meticulously rendered **pueblos**, which are composed of local materials. A core of rubble and mortar is usually faced with a veneer of polished stone. The thickness of the base walls were used to determine the size of the overall superstructure, with some pueblos daring to raise themselves five or six stories tall. All pueblos faced a well-defined plaza that was the religious and social center of the complex.

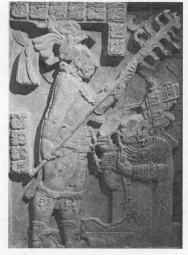

Figure 30.9: *Shield Jaguar and Lady Xoc*, 725, limestone, British Museum, London

Figure 30.10: Pueblo Bonito, 900–1230, Chaco Canyon, New Mexico

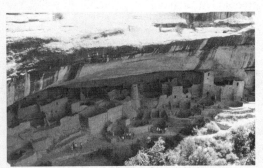

Figure 30.11: Cliff Palace, 1150–1300, Mesa Verde National Park, Colorado

Figure 30.12: Great Serpent Mound, c. 1070, Ohio

Figure 30.13: Great Serpent Mound, c. 1070, Ohio

Major Works of Anasazi Art

Pueblo Bonito, 900–1230, Chaco Canyon, New Mexico (Figure 30.10)

- Huge Anasazi pueblo of perhaps 800 rooms, built of adobe
- Interconnected interior walkways join rooms
- Doorways have characteristic T-shape, are short and low to retain heat in winter and support multistory dwellings

Cliff Palace, 1150–1300, Mesa Verde National Park, Colorado (Figure 30.11)

- Pueblo built into the sides of a cliff, housed about 250 people
- Clans moved together for mutual support and defense
- Top-ledge houses store all supplies, cool and dry area out of the way, accessible only by ladder
- Plaza in front of abode structure; kivas face the plaza
- Each family received one room in the dwelling
- Farming done on plateau above pueblo, everything had to be imported into the structure, including water

CHARACTERISTICS OF MISSISSIPPIAN ART

An increase in agriculture meant a population boom, as sustained communities evolved in fertile areas. Eastern Native Americans were mound-builders and created an impressive series of earthworks that survive in great numbers even today. Huge mound complexes, such as Cahokia, Illinois, were impressive city–states that governed wide areas. Other mounds, such as **Great Serpent Mound** (Figures 30.12 and 30.13), were built in effigy shapes of uncertain meaning. Many of these mounds have baffled archaeologists, because they clearly could only be fully appreciated from the air or a high vantage point, which mound builders did not possess. Look at the difference in viewpoints of these two views of Serpent Mound, one from the air (Figure 30.12) and the other from an elevated platform nearby (Figure 30.13).

Major Work of Mississippian Art

Great Serpent Mound, c. 1070, Ohio (Figures 30.12 and 30.13)

- Many mounds were enlarged and changed over the years, not built in one campaign
- Effigy mounds popular in Mississippian culture
- Influenced by comets? Astrological phenomenon? Head pointed to summer solstice sunset?

- Rattlesnake as a symbol in Mississippian iconography; could this play a role in interpreting this mound?
- Associated with snakes and crop fertility?
- There are no burials associated with this mound

CHARACTERISTICS OF AZTEC ART

Aztec art is most famously represented by gold jewelry that survives in some abundance, and jade and turquoise carvings of great virtuosity. The aggressive nature of Aztec religions, with its centering on violent ceremonies of blood-letting, was often manifest in great stone sculptures of horrifying deities such as **Coatlicue**, whose characteristics include human remains from bloody sacrifices.

Major Works of Aztec Art

Coatlicue, **fifteenth century, stone, National Museum of Anthropology, Mexico City (Figure 30.14)**

- Means "She of the Serpent Skirt"
- Massive figure of the earth goddess, mother of the gods
- Snarling features of the face, two serpent heads that are symbolic of flowing blood
- Necklace of human hearts, hands, and a skull; an insatiable goddess who feasts on people's bodies
- Hands and feet are claws, for digging graves
- Skirt of writhing snakes
- Theme of blood sacrifice is important in Aztec sculpture

Figure 30.14: *Coatlicue*, 15th century, stone, National Museum of Anthropology, Mexico City

Coyolxauhqui "She of the Golden Bells," 1469 (?), Museum of the Templo Mayor, Mexico City (Figure 30.15)

- So-called because of the bells she wears as earrings
- Aztecs similarly dismembered enemies and threw them down the stairs of the great pyramid to land on the disk of Coydolyauhqui
- Circular relief sculpture
- Coydolyauhqui and her many brothers plotted the death of her mother Coatlicue, who became pregnant after tucking a ball of feathers down her bosom. When Coydolyauhqui chopped off Coatlicue's head, a child popped out of the severed body fully grown, and dismembered Coydolyauhqui, who fell dead at the base of the shrine
- Represents the dismembered moon goddess who is placed at the base of the twin pyramids of Tenochtitlan

Figure 30.15: Coyolxauhqui "She of the Golden Bells," 1469 (?), Museum of the Templo Mayor, Mexico City

CHARACTERISTICS OF INCAN ARCHITECTURE

Incan architecture defies the odds by building impressive and well-designed cities in some of the most inaccessible or inhospitable places on earth. Typically Incan builders used **ashlar masonry** of perfectly grooved and fit-

Figure 30.16: Machu Picchu, 1450–1530, Peru

Figure 30.17: Machu Picchu, 1450–1530, Peru

Figure 30.18: Walls of the Temple of the Sun and the Church of Santo Domingo, 15th century, Cuzco, Peru

Figure 30.19: Detail of wall of the Temple of the Sun and the Church of Santo Domingo, 15th century, Cuzco, Peru

ted stones placed together in almost a jigsaw puzzle arrangement. All stones have slightly beveled edges that reemphasize the joints. The buildings tend to taper upward like a trapezoid, the favorite building shape of the American Indian.

Major Works of Incan Architecture

The impressive Incan empire stretched from Chile to Colombia and was well-maintained by an organized system of roads that united the country in an efficient communication network. The Incans had no written language, so much of what we know about the civilization has been deduced from archaeological remains.

Incan buildings are a marvel of **ashlar masonry** construction, with precisely fitted and beveled rocks placed with amazing accuracy next to and atop one another. The joints between the rocks are represented by hairline cracks of great precision.

Machu Picchu, 1450–1530, Peru (Figures 30.16 and 30.17)

- Originally functioned as a royal retreat
- So remote that it was probably not used for administrative purposes in the Inca world
- Buildings built of stone with perfectly carved rock rendered in precise shapes and grooved together; thatched roofs
- Two hundred buildings, mostly houses, some temples, palaces, baths, even an astronomical observatory; most using the basic trapezoidal shape
- People farmed on terraces

Walls of the Temple of the Sun and the Church of Santo Domingo, fifteenth century, Cuzco, Peru (Figures 30.18 and 30.19)

- Church of Santo Domingo built on the site of the temple that was leveled by the Spanish
- Temple displays Incan use of interlocking stonework of great precision
- Temple of the Sun part of an intricate calendar system used by the Inca
- Spanish chroniclers insist that the walls and floors of the temple were covered in gold

CHARACTERISTICS OF NORTHWEST COAST NATIVE AMERICAN ART

Wooden **totem poles** (Figure 30.20), the symbols of Northwest Coast Native Americans, are community and clan expressions of ancestry and culture. The wood itself, born from the sacredness of the forest, is carved into a series of images, one atop the other, in a sequence that represents stories, legends, and/or local spirits. Since symbols by their very nature are mutable, there is no defining interpretation or characteristic of a totem pole that would be acceptable to every culture.

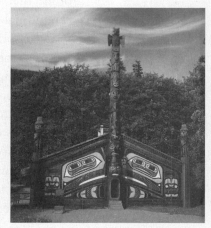

Figure 30.20: Totem Pole and Longhouse, 20th century, wood, British Columbia, Canada

Woodcarving is a highly refined art form in the Pacific Northwest, the wood itself easily accepting the skill of the carver. However, the wood surface has to be adequately prepared. Locally available woods have different properties; hence artists tried to use the wood that would be most permanent and paradoxically the most malleable—red cedar was highly desired because the grains are unusually straight and the wood is very workable.

Totem poles are not carved in the round and not meant to be appreciated from the back. Often the log is laid horizontally while being carved, the artist working out a pattern in charcoal on the surface, and then detailing the carving. Poles are always carved from a single log, although added pieces are permitted to indicate projecting wings or dorsal fins. They are never nailed into the pole but are joined by tongue and groove.

Poles are always painted, sometimes in very bright colors, and anchored securely in the ground. Whenever a totem pole is raised, a ceremony to commemorate it is often prescribed. Totem poles are never worshipped and do not act as idols.

A characteristic of Native American structure is the **longhouse**, which appeared everywhere in North America, most famously among the Iroquois in New York State, but also in the Northwest as well. Longhouses were created by putting wooden poles in the ground and placing slats as crossbeams around the structure. They, too, are made of wood and are often fancifully painted.

VOCABULARY

Ashlar masonry: carefully cut and grooved stones that support a building without the use of concrete or other kinds of masonry (Figure 30.18)

Chacmool: a Mayan figure that is half-sitting and half-lying on his back (Figure 30.7)

Coatlicue: an Aztec goddess who is characterized by a savagery only satisfied by human sacrifice (Figure 30.14)

Coyolxauhqui: an Aztec goddess who died when she tried to assassinate her mother, Coatlicue (Figure 30.15)

Kiva: a circular room wholly or partly underground used for religious rites

Longhouse: a long Native American communal dwelling made of wood. They are characterized by having supporting interior poles that create long interior corridors (Figure 30.20)

Pueblo: a communal village of flat-roofed structures of many stories that are stacked in terraces. They are made of stone or adobe (Figure 30.11)

Totem Pole: a wooden pole carved with ancestral spirits or symbols erected by Pacific Coast Native Americans (Figure 30.20)

Summary

It is difficult to condense into a simple format the complex nature of ancient American civilizations. Some societies were nomadic and produced portable works of art that were meant for ceremonial use. Others established great cities in which ceremonial centers were carefully designed to enhance religious and secular concerns.

Each society of Indians used the local available materials to create their works. Indians from rich forest lands produced huge totem poles that symbolized the spirit of the living tree as well as the gods or legends carved upon them. Those from drier climates made use of adobe for their building material, as in the desert Southwest, or earthenware for fancifully decorated jugs and pitchers, as the Moche in Peru. The great cities of Mesoamerica are hewn from stone to create a symbol of permanence and stability in cultures that were more often than not dynamic and in flux.

It is common in ancient America for societies to build on the foundations of earlier cultures. Thus new cities spring from the ruins of the old, as pyramids are built over smaller structures on the same site.

Practice Exercises

Questions 1–3 refer to Figure 30.21.

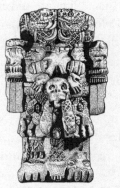

Figure 30.21

1. This figure is a representation of which ancient American spirit?

 (A) Quetzalcoatl
 (B) Great Serpent
 (C) Coatlicue
 (D) Chacmool

2. This figure represents a spirit that is

 (A) vengeful
 (B) placating
 (C) sweet
 (D) confused

3. What civilization is associated with this image?

 (A) Aztec
 (B) Maya
 (C) Incan
 (D) Teotihuacán

4. Totem poles could be used as

 (A) markers before a shrine
 (B) columns to be worshiped
 (C) a representation of ancestral spirits
 (D) intermediaries between men and the gods

5. Totem poles are typically made of

 CHALLENGE

 (A) mahogany
 (B) terra cotta
 (C) redwood
 (D) red cedar

6. Kivas are found in places that also have

 (A) mounds
 (B) pueblos
 (C) longhouses
 (D) pyramids

7. Mayan sculpture is characterized by

 CHALLENGE

 (A) deeply frowning faces
 (B) huge heads
 (C) arched brows that bridge to the nose
 (D) U-shaped handles

8. Machu Picchu probably functioned as

 (A) a royal retreat
 (B) a military headquarters
 (C) an administrative center
 (D) a ranching community

9. Incan architecture is unusual in that the

 (A) stones are rough hewn and precariously balanced
 (B) stone is mixed with mortar and wood for strength
 (C) smaller stones are placed beneath the larger ones
 (D) stones are perfectly grooved together

10. Longhouses were typically used by Native Americans living in

 (A) the United States
 (B) Mexico
 (C) Peru
 (D) Central America

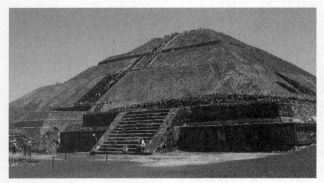

Figure 30.22

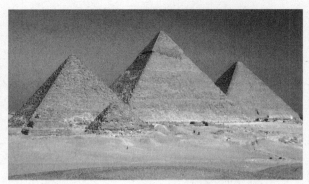

Figure 30.23

Short Essay

These two buildings look similar but were built by two different societies. Name both societies and tell how the buildings were used for different purposes. Use one side of a sheet of lined paper to write your essay.

Answer Key

1. **(C)**	3. **(A)**	5. **(D)**	7. **(C)**	9. **(D)**
2. **(A)**	4. **(C)**	6. **(B)**	8. **(A)**	10. **(A)**

Answers Explained

Multiple-Choice

1. **(C)** This figure is a representation of Coatlicue.

2. **(A)** Coatlicue is among the most vicious and vengeful spirits in mythology.

3. **(A)** This image is an Aztec creation.

4. **(C)** Totem poles represent a number of issues, including ancestral spirits.

5. **(D)** Red cedar was the favorite wood for totem pole carvers.

6. **(B)** Kivas, circular rooms for worship, are found most commonly in pueblos.

7. **(C)** Mayan figures have arched brows that bridge to the nose.

8. **(A)** Given its remote location, Machu Picchu probably served as a royal retreat rather than as a practical administrative or military center. Its location on a mountaintop made it impossible to herd livestock in great numbers.

9. (**D**) Incan architecture features perfectly grooved stones.

10. (**A**) Longhouses were built by Native Americans in the United States.

Rubric for Short Essay

4: The student identifies the two periods as Teotihuacán and Egyptian, and explains the differences between the two types of pyramids. Not every characteristic needs to be addressed, but the basic functions of the buildings should be delineated. There are no major errors.

3: The student identifies the two periods as Teotihuacán and Egyptian, and has explains some of the differences between the two types of pyramids. The student points to at least one major difference in use and function. There may be minor errors.

2: The student misidentifies one civilization, but provides a limited explanation of their differences, OR the student correctly identifies both civilizations and adds little else. There may be major errors.

1: The student misidentifies both civilizations, OR the student generally characterizes pyramids. There may be major errors.

0: The student makes an attempt, but the response is without merit.

Short Essay Model Response

The building on the left is called the Pyramid of the Sun and was built during the late Preclassic Mesoamerican period. The building consists of stacked platforms similar to the Stepped Pyramid of Djoser. The Teotihuacanos constructed the pyramid in order to perform sacrifices for their gods, thus there are long staircases that lead to the top. The pyramid also held many ceramic offerings, but unlike the pyramids on the right, these buildings were not built as tombs.

The three pyramids on the right are the Great Pyramids from the Old Kingdom in Egypt. They were constructed as tombs for the pharaohs of the Fourth Dynasty. These pyramids, unlike the one on the left, were built as burial chambers for royalty, as part of a necropolis. The pyramids were surrounded by various temples and outer buildings in a vast complex, whereas the Mexican pyramids were in the heart of the city and used for ceremonial occasions before a large gathering.

—Pamela P.

Analysis of Model Response

Pamela correctly identifies both structures and is accurate in her assessment of their functions. She is descriptive in analyzing some of their various characteristics and contrasts the buildings concisely and effectively. **This essay merits a 4.**

African Art

 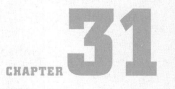

TIME PERIOD: From prehistoric times to the present

Some chief African civilizations include:

Civilization	Time Period	Location
Nok	500 B.C.E.–200 C.E.	Nigeria
Great Zimbabwe	11th–15th Centuries	Zimbabwe
Ife Culture	11th –12th Centuries	Nigeria
Aksum	1200–1527	Ethiopia
Benin	13th –19th Centuries	Nigeria
Mende	19th –20th Centuries	Sierra Leone
Kongo	19th –20th Centuries	Congo

KEY IDEAS

- Much African art is created around spirituality, the spirit world, and the role of ancestors in our lives.
- African artists prefer wood, but notable works are also done in ivory and metal.
- African art is rarely decorative, but made for a purpose, often for ceremonies.
- African architecture is predominantly made of mud-brick; stone is rare, but can be seen in Zimbabwe and in Ethiopian churches.

ISSUES AROUND WHICH AFRICAN ART IS CREATED

Despite the incredible vastness of the African continent, there are a number of similarities in the way in which African artists create art, stemming from common beliefs they share.

Africans believe that ancestors never die and can be addressed; hence a sense of family and a respect for elders are key components of the African psyche. Many African sculptures are representations of family ancestors and were carved to venerate their spirits.

Fertility, both of the individual and the land, is highly regarded. Spirits who inhabit the forests or are associated with natural phenomenon have to be respected and worshipped. Sculptures of suckling mothers are extremely common; it is implied that everyone suckles from the breast of God.

Patronage and Artistic Life

Since traditional Africans rely on an oral tradition to record their history, African objects are unsigned and undated. Although artists were famous in their own communities and were sought after by princes, written records of artistic activity stem principally from European or Islamic explorers who happened to encounter artists in their African journeys.

African artists worked on commission, often living with their patrons until the commission was completed. The same apprenticeship training that was current in Europe was the standard in Africa as well. Moreover, Africans also had guilds that promoted their work and helped elevate the profession.

As a rule, men were builders and carvers and were permitted to wear masks. Women painted walls and created ceramics. Both sexes were weavers. There were exceptions; for example, in Sierra Leone and Liberia women wore masks during important coming-of-age ceremonies.

The most collectable African art originated in farming communities rather than among nomads, who desired portability. To that end, the more nomadic people of East Africa in Kenya and Tanzania produced a fine school of body art, and the more agricultural West Africans around Sierra Leone and Nigeria achieved greatness with bronze and wood sculpture.

African art was imported into Europe during the Renaissance more as curiosities than as artistic objects. It was not until the early twentieth century that African art began to find true acceptance in European artistic circles.

CHARACTERISTICS OF AFRICAN ARCHITECTURE

Traditional African architecture is built to be as cool and comfortable as a building could get in the hot African sun, and therefore is made of mud-brick walls and thatched roofs. While mud-brick is certainly easy and inexpensive to make, it has inherent problems. All mud-brick buildings have to be meticulously maintained in the rainy season; otherwise, much would wash away. Nonetheless, Africans build huge structures of mud-brick with horizontally placed timbers as maintenance ladders.

In a culture that generally eschews stonework, both in its architecture and its sculpture, the royal complex at **Zimbabwe** (Figure 31.3) from the fourteenth century is most unusual. The sophisticated handling of this type of masonry implies a long-standing tradition of construction of permanent materials, traces of which have all but been lost.

Medieval Ethiopian Christian churches are in some ways even more amazing—they are cut from giant blocks of stone. In a sense these churches are excavated out of the ground and then hollowed out (Figure 31.1).

Major Works of African Architecture

Beta Giorghis (Church of Saint George), thirteenth century, Lalibela, Ethiopia (Figure 31.1)

- Cut out from a single block of tufa, a soft porous stone, which is easy to cut, but gradually hardens when exposed to air
- Roof is incised with crosses placed within one another
- King Lalibela commissioned 11 churches in this town named for him
- Churches were created for the Ethiopian Orthodox Christian rite
- Elaborate horizontal moldings and ogee-shaped windows animate the exterior surface
- Since all churches were, in a sense, excavated from the earth, the planners had to envision every detail before work was begun

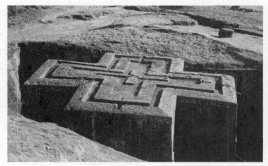

Figure 31.1: Beta Giorghis (Church of Saint George), 13th century, Lalibela, Ethiopia

Great Friday Mosque, thirteenth-century original, remodeled in 1907, Djenné, Mali (Figure 31.2)

- Made of adobe, a baked mixture of clay and straw
- Wooden beams act as permanent ladders for the maintenance of the building
- Vertical fluting drains water off the surfaces quickly
- Largest mud-brick mosque in the world

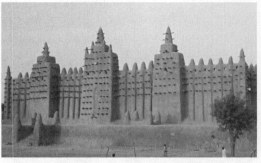

Figure 31.2: Great Friday Mosque, 13th century original, remodeled in 1907, Djenné, Mali

Great Zimbabwe, fourteenth century, Zimbabwe (Figure 31.3)

- Prosperous trading center and royal complex
- Stone enclosure, probably a royal residence
- Walls 30 feet high
- Conical tower modeled on traditional shapes of grain silos; control over food symbolized wealth, power, and royal largesse
- Walls slope inward toward the top, made of exfoliated granite blocks
- Internal and external passageways are tightly bounded, narrow, and long, forcing occupants to walk in single file, paralleling experiences in the African bush

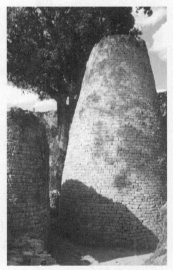

Figure 31.3: Great Zimbabwe, 14th century, Zimbabwe

CHARACTERISTICS OF AFRICAN SCULPTURE

Despite the number of sculptural traditions in Africa, there are certain similarities.

- African art is basically portable. Large sculptures, the kind that grace the plazas of ancient Egypt or Rome, are unknown.
- Wood is the favorite material. Trees were honored and symbolically repaid for the branches taken from them. Ivory is used as a sign of rank or prestige. Metal shows strength and durability, and is restricted to royalty. Stone is extremely rare.
- Figures are basically frontal, drawn full-face, with attention paid to the sides. Symmetry is occasionally used, but more talented artists vary their approach on each side of the object.

- Africans did no preliminary sketches and worked directly on the wood. There is a certain stiffness to all African works.
- Heads are disproportionately large, sometimes one-third of the whole figure. Sexual characteristics are also enlarged. Bodies are immature and small. Hands and feet are very small; fingers are rare.
- Multiple media are used. It is common to see wood sculptures adorned with feathers, fabric, or beads.
- African sculpture prefers geometrization of forms. It generally avoids physical reality, representing the spirits in a more timeless world. Proportions are therefore manipulated.

Important sculpture is never created for decoration, but for a definite purpose. African masks are meant to be part of a costume that represents a spirit, and can only come alive when ceremonies are initiated. Every mask has a purpose and represents a different spirit. When the masks are worn in a ceremony, the spirit takes over the costumed dancer and his identity remains unknown—every part of his body is hidden from view. Moved by the beat of a drum, the masked dancer connects with the spirit world and can transmit messages to villagers who are witnesses.

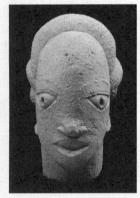

Figure 31.4: Nok Head, 500 B.C.E.–200 C.E., terra-cotta, Hamill Gallery of African Art, Boston, Massachusetts

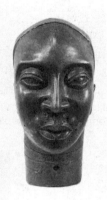

Figure 31.5: Ife Head, 20th–century reproduction, bronze, Hamill Gallery of African Art, Boston

Major Works of African Sculpture

Nok Head, 500 B.C.E.–200 C.E., terra-cotta, Hamill Gallery of African Art, Boston (Figure 31.4)

- May have been part of full-sized figure
- High arching eyebrows parallels sagging underside of eyes; voids of the irises draws attention of viewer
- Mouth indicates speech; nose barely modeled—widely spaced flaring nostrils
- Holes for airing out large ceramics during firing in eyes, nostrils, mouth
- Human head appears cylindrical

Ife Head, twenieth-century reproduction, bronze, Hamill Gallery of African Art, Boston (Figure 31.5)

- Head emphasized as seat of intelligence
- Scarification on sculptures imitates scarification as tribal identification

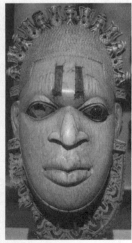

Figure 31.6: Ivory Belt Mask, c. 1550, ivory, iron, Metropolitan Museum of Art, New York

Ivory Belt Mask, c. 1550, ivory, iron, Metropolitan Museum of Art, New York (Figure 31.6)

- Worn by the king or "Oba" Esigie, King of the Benin, as a belt-buckle
- May have been made to honor King's mother, Idia, at a commemorative ceremony
- Around the crown are stylized Portuguese heads alternating with mudfish. Mudfish represent royalty because they live on both land and sea, as a king is both human and divine.
- On bottom: more stylized Portuguese heads

Benin Head of a Woman, sixteenth century, brass, British Museum, London (Figure 31.7)

- Classically refined beauty; idealized naturalism
- High collars
- Imported metal from Europe
- Many placed on altars in royal homes
- Scarification above the eyebrows and between the eyes

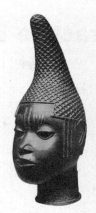

Figure 31.7: Benin Head of a Woman, 16th century, brass, British Museum, London

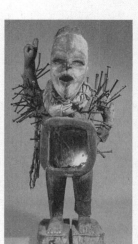

Figure 31.8: Kongo Power Figure, c. 1875–1900, wood, nails, blades, shells, Kinshasa, Congo

Kongo Power Figure, c. 1875–1900, wood, nails, blades, shells, Kinshasa, Congo (Figure 31.8)

- Spirits are embedded in the images
- Spirits can be called upon to bless or harm others, cause death or give life
- In order to prod the image into action, nails or blades are often inserted into the image or removed from it

Mende Mask of Sierra Leone, twentieth century, wood, Hamill Gallery of African Art, Boston (Figure 31.9)

- Female ancestor spirits
- High forehead indicates wisdom
- Used for initiation rites to adulthood
- Symbolic of the chrysalis of a butterfly; young woman entering puberty
- Shiny black surface
- Small horizontal features

VOCABULARY

Ciré perdue: the lost wax process. A bronze casting method in which a figure is modeled in clay and covered with wax and then recovered with clay. When fired in a kiln, the wax melts away, leaving a channel between the two layers of clay which can be used as a mold for liquid metal (Figure 31.7)

Fetish: an object believed to possess magical powers

Scarification: scarring of the skin in patterns by cutting with a knife. When the cut heals, a raised pattern is created, which is painted (Figure 31.6)

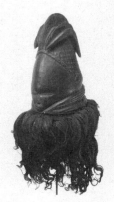

Figure 31.9: Mende Mask of Sierra Leone, 20th century, wood, Hamill Gallery of African Art, Boston

Summary

African artists operated under the same general conditions of artists everywhere—learning their craft in a period of apprenticeship, working on commission from the powerful and politically connected, and achieving a measure of international fame. However, because African artists relied on the oral tradition, little written documentation of their achievements has been recorded.

Africans achieved great distinction in the carving of masks, both in wood and metal. Costumed dancers don the mask and assume the powers of the spirit that it represents. The role of the mask, therefore, indeed the role of African art, is never merely decorative, but functional and spiritual; works are imbued with powers that are symbolically much greater than the merely visible representation.

Practice Exercises

1. European artists were influenced by African artwork around the year

 (A) 1700
 (B) 1800
 (C) 1900
 (D) 2000

2. What makes Great Zimbabwe unusual in African architecture is the fact that it is

 (A) large
 (B) small
 (C) a seat for royalty
 (D) made of stone

3. The ciré perdue process is used for creating sculptures made of

 (A) terra-cotta
 (B) ivory
 (C) wood
 (D) metal

4. African sculptures are characterized by their

 (A) unusual size
 (B) fluid and natural movements
 (C) many preliminary drawings to create a finished product
 (D) use of mixed media

5. The largest feature on an African figure

 (A) is the head
 (B) are the arms
 (C) are the fingers
 (D) are the feet

6. Kongo power figures are

 (A) worn as masks in ceremonies
 (B) used to bring harm to others
 (C) created for decoration
 (D) meant to amuse and entertain

7. Scarification is

 (A) from raised knifing patterns in the skin
 (B) a scarring in sculpture but not on human beings
 (C) a way of identifying males from females
 (D) a way of identifying slaves

Question 8 refers to Figure 31.10.

8. This building is typical of African architecture in that

 (A) the emphasis is vertical
 (B) it is made of mud-brick
 (C) people are not encouraged to enter
 (D) there are small windows

Figure 31.10

9. African artists

 (A) achieved success through the guild system
 (B) signed their works
 (C) dated their compositions
 (D) held gallery shows where artworks could be purchased

10. African women specialized in

 | CHALLENGE |

 (A) carving masks
 (B) working in metal
 (C) making ceramics
 (D) ivory sculptures

Short Essay

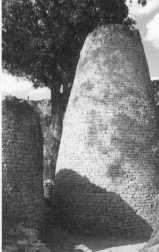

Identify the building in Figure 31.11. Discuss how it is uncharacteristic of African architecture. Use one side of a sheet of lined paper to write your essay.

| CHALLENGE |

Figure 31.11

Answer Key

1. **(C)**	3. **(D)**	5. **(A)**	7. **(A)**	9. **(A)**
2. **(D)**	4. **(D)**	6. **(B)**	8. **(B)**	10. **(C)**

Answers Explained

Multiple-Choice

1. **(C)** African art was taken seriously by European artists around the year 1900.

2. **(D)** Great Zimbabwe is one of the few traditional African buildings to be made of stone.

3. **(D)** Ciré perdue is a process that uses clay molds to make metal sculptures.

4. **(D)** African artists like to mix media when they create objects. A wooden mask, for example, might be adorned with feathers or beads.

5. **(A)** Africans emphasize heads in their sculptures.

6. **(B)** Kongo power figures can be used to conjure evil on enemies. Usually they are hammered to spur the spirits onto revenge.

7. **(A)** Scarification is done by raising the skin through knife wounds and then painting the scars.

8. **(B)** This building is made from mud-brick.

9. **(A)** Many artists achieved success through the guild system, which was common throughout Africa.

10. **(C)** African women were exceptional ceramicists.

Rubric for Short Essay

4: The student identifies the building as Great Zimbabwe. The student recognizes with great specificity how this building is markedly different from traditional African structures. There are no major errors.

3: The student identifies the building as Great Zimbabwe. The student recognizes how this building is markedly different from traditional African structures. There may be minor errors.

2: This is the highest score that a student can earn without identifying the name of the building. The student explains the contrast between the traditional African mud-brick buildings and the stone structure at Zimbabwe. There may be major errors.

1: The student identifies only the name of the building, OR the student gives a passing explanation of African architecture.

0: The student makes an attempt, but the response is without merit.

Short Essay Model Response

This building is the conical tower at Great Zimbabwe. This building distinguishes itself from other African architecture in that it is built of stone and is monumental in size. Most traditional African architecture uses mud-brick and thatched roofs. The tower is also skillfully done; it tapers off toward the top, making the top thinner than the bottom. This suggests sophisticated architecture, not thought to have been made in other parts of the continent. In addition, the entire structure is done without the use of mortar and cement (the latter not being used in any African buildings). The curving lines of the entire complex allow it to harmonize with nature and break from rectilinear forms. Although the purpose of the distinctive tower is unknown, it seems to be part of a complex that is symbolic of the king's power.

—Sara T.

Analysis of Model Response

Sara correctly identifies the structure as the conical tower at Great Zimbabwe. She then analyzes how this tower, and the entire Zimbabwe complex, differs from traditional architecture, mentioning specific methods of African construction. **This essay merits a 4.**

Pacific Art

TIME PERIOD: From ancient times to the present

Except for the Easter Island sculptures, which date from the tenth century, most surviving Pacific Art dates from the nineteenth and twentieth centuries. The art of the Pacific people is also referred to as Oceanic Art.

KEY IDEAS

- Clearly defined gender roles determine which genres could be produced by which sex.
- Oceanic people are great woodcarvers, using this material to make everything from masks to bisj poles to meetinghouses.
- Oceanic artists use intricate lines to create masterpieces on tapa or bark or in tattooing.
- The Art of Easter Island, with its giant stone carvings, is unusual in Oceanic Art.

HISTORICAL BACKGROUND

Certain areas of the Pacific are some of the oldest inhabited places on earth, and yet, paradoxically, some areas are among the newest. Aborigines reached Australia around 50,000 years ago, but the remote islands of the Pacific, like Hawaii, Easter Island, and New Zealand were occupied only in the last thousand years or so.

Patronage and Artistic Life

Men and women had clearly defined roles in Pacific society, including which sex could create works of art in which media. Men carved in wood, woman sewed and made pottery.

One of the most characteristic works still done by Pacific women is the weaving of barkcloth, or **tapa** (Figure 32.1). The inner bark of the mulberry tree is harvested and small strips are made malleable by repeated soakings. Each strip is placed in a pattern and then beaten in order to fuse them together. Designs were added by stenciling or painting directly onto the surface. The result is a cloth of refined geometric organization and intricate patterning.

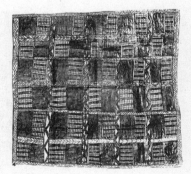

Figure 32.1: Tapa

CHARACTERISTICS OF ASMAT ART

The Asmat people of New Guinea understood the universe to be composed of powerful invisible forces or spirits that could not be controlled, but should be honored, celebrated, and contacted. To these ends, Asmat artists made masks and totems for a single use during a great ceremonial occasion. Afterward, they were quickly discarded.

Wood was the favorite carving material. At first, Asmat artists carved the wood using shells or animal teeth, but after European contact, metal became the favorite carving tool. Wooden masks were augmented with features and costumes characteristically used for elaborate ceremonial garments and weapons.

Major Work of Asmat Art

Asmat People, Bisj Poles (also spelled Bis), early twentieth century, wood, New Guinea (Figure 32.2)

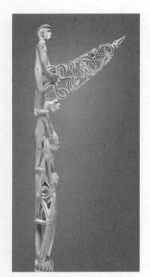

Figure 32.2: Asmat People, Bisj Poles, early 20th century, wood, New Guinea

- Tall slender poles cut from mangrove trees; layered figures one atop the other, all representing the dead
- Asmat believed death was not natural, but caused by an enemy, usually through evil spells
- Mangrove trees were symbolically hunted and cut down in a reenactment of the headhunt
- Poles were erected before a men's house, and a mock battle between men and women took place
- Death had to be avenged; therefore the Asmat went head-hunting, and placed the heads in a spot at the bottom of the pole; celebrations followed; after the function had been fulfilled, the poles were left to decompose, fertilizing other plants
- Poles are canoe-shaped with phallic symbols projecting from the main trunk; canoe shape is symbolic of a "soul ship"
- Animal symbols abound; fruit-eating animals are symbols of head-hunting, since fruit grow at the tops of trees and heads are at the top of a body
- Squatting figures are characteristic of Pacific art
- Carved from a single piece of wood that is planted upside down with all but one of the roots removed

CHARACTERISTICS OF ABORIGINAL ART

Using a limited range of materials, Australian Aborigines produced a wide variety of artistic expression. Usually their paintings displayed an extremely complex mythological formula, closely intertwined with singing, dancing, and storytelling. Sometimes painted images were invested with spiritual powers that gather greater importance when sung to. The power of dreams and what they can suggest and create was central to the process of making Aboriginal art. Artists sometimes envisioned what they paint in dream sequences, and used these as the creative principals for their works.

Paintings were done in black and white on the ochre background of tree bark. Extremely fine brushes were used to yield complex and intricate geometric designs, generally in horror vacui. Many were done in what has been called the x-ray style, which shows the principal bones and organs of the animals.

Major Work of Aboriginal Art

Kangaroo, nineteenth–twentieth century, tree bark, Australia (Figure 32.3)

- Intricate white-line design in complex geometric patterns
- Figure swallowed by kangaroo seen in upper chest
- Kangaroo holding a didgeridoo
- Spine emphasized

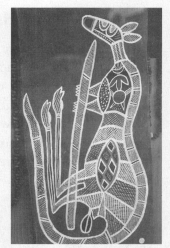

Figure 32.3: Kangaroo, 19th–20th century, tree bark, Australia

CHARACTERISTICS OF MAORI ART

New Zealand is a youngster in terms of world cultures, populated less than a thousand years ago. Native Maori carry on a rich Polynesian tradition of woodcarving that is indigenous to people throughout the Pacific. Tattooing is a Maori specialty (Figure 32.4), people often covering their whole body with spiral designs to signify rank or status.

Both men and women were tattoo artists traveling from place to place and working on commission. Their tool set contained a number of differently shaped bone chisels used for varying designs. The chisels created a deep gouge in the flesh that was then filled with pigment. Men began to acquire tattoos at puberty; the artistic process was always accompanied by rites and rituals. Tattoos served to make men more attractive to women. As important events occurred during a man's life, additional tattoos were added, so that the process extended over a person's lifetime. Women were also tattooed, but theirs were more subdued, often used to enhance a beautiful feature. Persons without tattoos had no social status.

Figure 32.4: Maori tattoo

The Maori design meetinghouses that are thought of as the symbolic embodiment of an ancestor, whose spirit is enclosed in the structure. Entering the meetinghouse, therefore, is like symbolically entering the deceased's body. Because ancient traditions must be respected, Maori meetinghouses are meant to be entered with deference and humility.

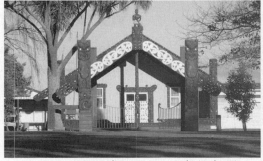

Figure 32.5: Meetinghouse, Parewahawaha Marea, 20th century, Bulls, New Zealand

Major Work of Maori Art

Meetinghouse, Parewahawaha Marea, twentieth century, Bulls, New Zealand (Figure 32.5), and Traditional Maori meetinghouse (Figure 32.6)

- Since the building represents the body of the ancestor, the huge central beam running the length of the roof represents the spine; the lateral rafters are ribs; the exterior gable boards are outstretched arms; gable ornament on top is the face
- Relief sculptures sit totemlike on outside and inside of meetinghouses
- Squat figures one atop the other
- Colorful decorative patterns

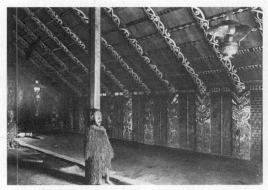

Figure 32.6: Interior of traditional Maori meetinghouse

CHARACTERISTICS OF EASTER ISLAND ART

One of the most isolated places on earth has produced one of the most memorable images in the history of art. There are no counterparts in Pacific art to the great statues on Easter Island—the nearest civilization that could produce these large-scale objects is in South America. This has led more than one archaeologist to pose a link between Mesoamerican and Pacific cultures. However, the extreme remoteness of Easter Island and the unlikelihood that other cultures could actually find this place increase the probability that Easter Islanders undertook these monuments themselves.

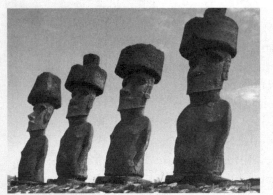

Figure 32.7: Moai, 10th–12th centuries, stone, Easter Island

Major Work of Easter Island Art

Moai, tenth–twelfth centuries, stone, Easter Island (Figure 32.7)

- About nine hundred statues in all, mostly male, almost all facing inland; fifty tons apiece
- Erected on large platforms of stone mixed with ashes from cremations; the platforms are as sacred as the statues on them
- Images represent personalities deified after death, or commemorated as the first settler-kings
- Prominent foreheads, large broad noses, thin pouting lips, ears that reach to the top of their heads
- Short thin arms falling straight down, hands across lower abdomen below navel
- Chests and navels delineated
- Topknots added to some statues

VOCABULARY

Moai: large stone sculptures found on Easter Island (Figure 32.7)
Tapa: a cloth made from bark that is soaked and beaten into a fabric (Figure 32.1)

Summary

The great expanses of the Pacific were peopled gradually over thousands of years. Indeed, the vast stretch of ocean is matched by the immense variety of artwork produced by disparate people speaking a myriad of languages.

A few generalities about Oceanic Art can be stated with foundation. Many items are portable, usually created for use in a ceremony, and made of wood or bark. When large wooden objects are introduced, they are carved with great precision using the whole of a wooden log. Intricately woven fabrics made of natural materials are a particular Pacific specialty. In all cases, intricate line definition is a hallmark of Oceanic artistic output.

None of these characteristics apply to the art of Easter Island, a unique place in which giant stone sculptures dominate a windswept landscape. These large torsos and heads find their closest artistic affinities with the cultures of ancient America, but the connection between the two cultures is still largely unproven.

PART FOUR

PRACTICE TESTS

Answer Sheet
PRACTICE TEST 1

Section I, Part A

1. Ⓐ Ⓑ Ⓒ Ⓓ
2. Ⓐ Ⓑ Ⓒ Ⓓ
3. Ⓐ Ⓑ Ⓒ Ⓓ
4. Ⓐ Ⓑ Ⓒ Ⓓ
5. Ⓐ Ⓑ Ⓒ Ⓓ
6. Ⓐ Ⓑ Ⓒ Ⓓ
7. Ⓐ Ⓑ Ⓒ Ⓓ
8. Ⓐ Ⓑ Ⓒ Ⓓ
9. Ⓐ Ⓑ Ⓒ Ⓓ
10. Ⓐ Ⓑ Ⓒ Ⓓ

11. Ⓐ Ⓑ Ⓒ Ⓓ
12. Ⓐ Ⓑ Ⓒ Ⓓ
13. Ⓐ Ⓑ Ⓒ Ⓓ
14. Ⓐ Ⓑ Ⓒ Ⓓ
15. Ⓐ Ⓑ Ⓒ Ⓓ
16. Ⓐ Ⓑ Ⓒ Ⓓ
17. Ⓐ Ⓑ Ⓒ Ⓓ
18. Ⓐ Ⓑ Ⓒ Ⓓ
19. Ⓐ Ⓑ Ⓒ Ⓓ
20. Ⓐ Ⓑ Ⓒ Ⓓ

21. Ⓐ Ⓑ Ⓒ Ⓓ
22. Ⓐ Ⓑ Ⓒ Ⓓ
23. Ⓐ Ⓑ Ⓒ Ⓓ
24. Ⓐ Ⓑ Ⓒ Ⓓ
25. Ⓐ Ⓑ Ⓒ Ⓓ
26. Ⓐ Ⓑ Ⓒ Ⓓ
27. Ⓐ Ⓑ Ⓒ Ⓓ
28. Ⓐ Ⓑ Ⓒ Ⓓ
29. Ⓐ Ⓑ Ⓒ Ⓓ
30. Ⓐ Ⓑ Ⓒ Ⓓ

31. Ⓐ Ⓑ Ⓒ Ⓓ
32. Ⓐ Ⓑ Ⓒ Ⓓ
33. Ⓐ Ⓑ Ⓒ Ⓓ
34. Ⓐ Ⓑ Ⓒ Ⓓ
35. Ⓐ Ⓑ Ⓒ Ⓓ
36. Ⓐ Ⓑ Ⓒ Ⓓ
37. Ⓐ Ⓑ Ⓒ Ⓓ

Section I, Part B

38. Ⓐ Ⓑ Ⓒ Ⓓ
39. Ⓐ Ⓑ Ⓒ Ⓓ
40. Ⓐ Ⓑ Ⓒ Ⓓ
41. Ⓐ Ⓑ Ⓒ Ⓓ
42. Ⓐ Ⓑ Ⓒ Ⓓ
43. Ⓐ Ⓑ Ⓒ Ⓓ
44. Ⓐ Ⓑ Ⓒ Ⓓ
45. Ⓐ Ⓑ Ⓒ Ⓓ
46. Ⓐ Ⓑ Ⓒ Ⓓ
47. Ⓐ Ⓑ Ⓒ Ⓓ
48. Ⓐ Ⓑ Ⓒ Ⓓ
49. Ⓐ Ⓑ Ⓒ Ⓓ
50. Ⓐ Ⓑ Ⓒ Ⓓ
51. Ⓐ Ⓑ Ⓒ Ⓓ
52. Ⓐ Ⓑ Ⓒ Ⓓ
53. Ⓐ Ⓑ Ⓒ Ⓓ
54. Ⓐ Ⓑ Ⓒ Ⓓ
55. Ⓐ Ⓑ Ⓒ Ⓓ
56. Ⓐ Ⓑ Ⓒ Ⓓ
57. Ⓐ Ⓑ Ⓒ Ⓓ

58. Ⓐ Ⓑ Ⓒ Ⓓ
59. Ⓐ Ⓑ Ⓒ Ⓓ
60. Ⓐ Ⓑ Ⓒ Ⓓ
61. Ⓐ Ⓑ Ⓒ Ⓓ
62. Ⓐ Ⓑ Ⓒ Ⓓ
63. Ⓐ Ⓑ Ⓒ Ⓓ
64. Ⓐ Ⓑ Ⓒ Ⓓ
65. Ⓐ Ⓑ Ⓒ Ⓓ
66. Ⓐ Ⓑ Ⓒ Ⓓ
67. Ⓐ Ⓑ Ⓒ Ⓓ
68. Ⓐ Ⓑ Ⓒ Ⓓ
69. Ⓐ Ⓑ Ⓒ Ⓓ
70. Ⓐ Ⓑ Ⓒ Ⓓ
71. Ⓐ Ⓑ Ⓒ Ⓓ
72. Ⓐ Ⓑ Ⓒ Ⓓ
73. Ⓐ Ⓑ Ⓒ Ⓓ
74. Ⓐ Ⓑ Ⓒ Ⓓ
75. Ⓐ Ⓑ Ⓒ Ⓓ
76. Ⓐ Ⓑ Ⓒ Ⓓ
77. Ⓐ Ⓑ Ⓒ Ⓓ

78. Ⓐ Ⓑ Ⓒ Ⓓ
79. Ⓐ Ⓑ Ⓒ Ⓓ
80. Ⓐ Ⓑ Ⓒ Ⓓ
81. Ⓐ Ⓑ Ⓒ Ⓓ
82. Ⓐ Ⓑ Ⓒ Ⓓ
83. Ⓐ Ⓑ Ⓒ Ⓓ
84. Ⓐ Ⓑ Ⓒ Ⓓ
85. Ⓐ Ⓑ Ⓒ Ⓓ
86. Ⓐ Ⓑ Ⓒ Ⓓ
87. Ⓐ Ⓑ Ⓒ Ⓓ
88. Ⓐ Ⓑ Ⓒ Ⓓ
89. Ⓐ Ⓑ Ⓒ Ⓓ
90. Ⓐ Ⓑ Ⓒ Ⓓ
91. Ⓐ Ⓑ Ⓒ Ⓓ
92. Ⓐ Ⓑ Ⓒ Ⓓ
93. Ⓐ Ⓑ Ⓒ Ⓓ
94. Ⓐ Ⓑ Ⓒ Ⓓ
95. Ⓐ Ⓑ Ⓒ Ⓓ
96. Ⓐ Ⓑ Ⓒ Ⓓ
97. Ⓐ Ⓑ Ⓒ Ⓓ

98. Ⓐ Ⓑ Ⓒ Ⓓ
99. Ⓐ Ⓑ Ⓒ Ⓓ
100. Ⓐ Ⓑ Ⓒ Ⓓ
101. Ⓐ Ⓑ Ⓒ Ⓓ
102. Ⓐ Ⓑ Ⓒ Ⓓ
103. Ⓐ Ⓑ Ⓒ Ⓓ
104. Ⓐ Ⓑ Ⓒ Ⓓ
105. Ⓐ Ⓑ Ⓒ Ⓓ
106. Ⓐ Ⓑ Ⓒ Ⓓ
107. Ⓐ Ⓑ Ⓒ Ⓓ
108. Ⓐ Ⓑ Ⓒ Ⓓ
109. Ⓐ Ⓑ Ⓒ Ⓓ
110. Ⓐ Ⓑ Ⓒ Ⓓ
111. Ⓐ Ⓑ Ⓒ Ⓓ
112. Ⓐ Ⓑ Ⓒ Ⓓ
113. Ⓐ Ⓑ Ⓒ Ⓓ
114. Ⓐ Ⓑ Ⓒ Ⓓ
115. Ⓐ Ⓑ Ⓒ Ⓓ

Practice Test 1

SECTION I

Part A

TIME: 20 MINUTES

> **Directions:** Questions 1–37 are divided into five sets of questions based on color pictures in a separate booklet. In this book the questions are illustrated by black-and-white photographs at the top of each set. Select the multiple-choice response that best completes each sentence, and put the correct response on the answer sheet. You will have 20 minutes to answer the questions in Part A. You are advised to spend 4 minutes on each set of questions, although you may move freely among each set of questions.

Questions 1–7 are based on Figures 1 and 2. Four minutes.

Figure 1

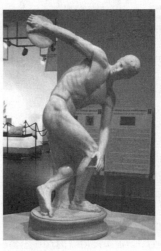

Figure 2

1. The work on the left was originally positioned

 (A) on a building
 (B) on a mountain
 (C) on a fountain
 (D) in a river

2. The work on the left is a representation of

 (A) Nike
 (B) the Spear Bearer
 (C) Aphrodite
 (D) caryatid

3. The theatrical feeling of the work on the left is enhanced by all of the following EXCEPT the

 (A) twisting movement of the figure
 (B) clinging drapery
 (C) ability to view the figure from many angles
 (D) use of classical composure

4. Like many Greek sculptures, the work on the right is known to us through copies made by

 (A) the Greeks themselves
 (B) Etruscans
 (C) Romans
 (D) the Renaissance

5. The original sculpture of the work on the right was probably made of

 (A) ivory
 (B) bronze
 (C) iron
 (D) granite

6. The work on the right is a copy that differed from the original in that the copy has

 (A) no facial features
 (B) a tree stump
 (C) no negative space
 (D) many viewpoints

7. Which period is the work on the right from?

 (A) Geometric
 (B) Archaic
 (C) Classical
 (D) Hellenistic

Questions 8–14 are based on Figures 3 and 4. Four minutes.

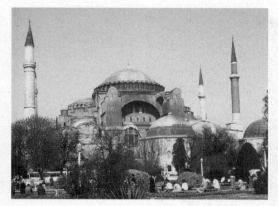

Figure 3

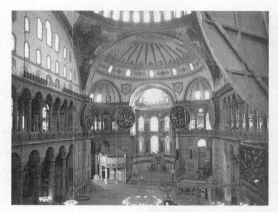

Figure 4

8. This building is located in

 (A) Ravenna
 (B) Rome
 (C) Istanbul
 (D) Jerusalem

9. The patron(s) of this building

 (A) was Constantine
 (B) was Basil II
 (C) was Suleyman the Magnificent
 (D) were Justinian and Theodora

10. A key architecture feature first developed in this building is the

 (A) squinch
 (B) pendentive
 (C) nave
 (D) narthex

11. Originally this building was constructed for the worship of

 (A) Christians
 (B) Protestants
 (C) Buddhists
 (D) Jews

12. Later, this building was converted by the Turks into a mosque, and the towers visible in the left photograph were added to the outside to

 (A) watch for enemies
 (B) fire down on the populace
 (C) call people to prayer
 (D) point the way to Mecca

13. The interior, as is visible in the photograph on the right, is greatly changed from its original condition. Originally, the interior was filled with

 (A) fresco
 (B) stained glass
 (C) tempera
 (D) mosaic

14. The interior of this building, as visible in the photograph on the right, reflects

 (A) a typical axially planned structure
 (B) a typical centrally planned structure
 (C) a combination of an axial and a centrally planned structure
 (D) none of the above

Questions 15–22 are based on Figures 5 and 6. Four minutes.

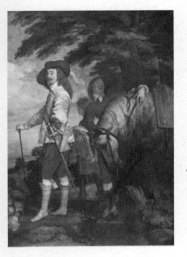

Figure 5

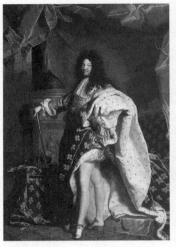

Figure 6

15. Both of these paintings portray rulers from the

 (A) fourteenth century
 (B) fifteenth century
 (C) seventeenth century
 (D) nineteenth century

16. The painting on the left is by

 (A) Peter Paul Rubens
 (B) Anthony van Dyck
 (C) Nicolas Poussin
 (D) Titian

17. In contrast to the work on the right, the work on the left shows

 (A) royalty at ease
 (B) the King as peasant
 (C) a scene at court
 (D) royalty commanding all

18. Both of these paintings are from which art historical period?

 (A) Baroque
 (B) Neoclassicism
 (C) Renaissance
 (D) Rococo

19. The painting on the right is of

 (A) Henry IV
 (B) Francis I
 (C) Napoleon
 (D) Louis XIV

20. The setting of the painting on the right is

 (A) Invalides
 (B) Fontainebleau
 (C) the Louvre
 (D) Versailles

21. Both of the monarchs depicted here are representations of

 (A) benevolent despots
 (B) the ruler as humanist
 (C) the divine right of kings
 (D) military dictatorships

22. The pose of both monarchs symbolizes their

 (A) religious standing
 (B) young life as dancers
 (C) union with the common people
 (D) haughtiness

Questions 23–30 are based on Figures 7 and 8. Four minutes.

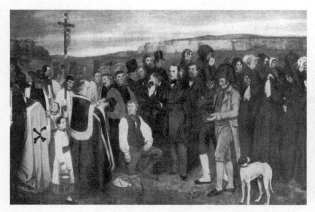

Figure 7

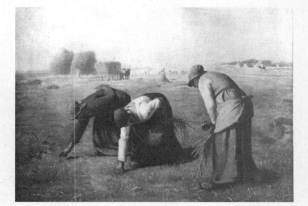

Figure 8

23. Both of these paintings represent a movement in nineteenth-century painting called

 (A) Realism
 (B) Impressionism
 (C) the Hudson River School
 (D) Romanticism

24. This movement was influenced by positivism, a philosophical theory that praised

 (A) the return to rural values and the basic goodness of common people
 (B) a scientific approach to understanding all things
 (C) experience as the greatest teacher in life
 (D) the power of positive thinking

25. The painting on the left is by

 (A) Édouard Manet
 (B) Gustave Courbet
 (C) Jean Ingres
 (D) Éugene Delacroix

26. The painting on the left horrified critics because

 (A) a dog was placed prominently in the foreground
 (B) scenes of death and burial did not belong in great paintings
 (C) a cross was used in a nonreligious work
 (D) the burial was not elevated to a higher meaning

27. Nineteenth-century paintings such as these were first exhibited in

 (A) a salon
 (B) an art gallery
 (C) a church
 (D) a department store

28. The composition of the painting on the right

 (A) has no depth
 (B) repeats a rhythm of three
 (C) is symmetrical
 (D) is abstract

29. A contemporary of these artists was

 (A) Henri de Toulouse-Lautrec
 (B) James McNeill Whistler
 (C) Honoré Daumier
 (D) William Blake

30. Works like these, which dealt with the lower classes, inspired which of the following artists from the twentieth century?

 (A) Willem de Kooning
 (B) Dorothea Lange
 (C) Donald Judd
 (D) Frida Kahlo

Questions 31–37 are based on Figures 9 and 10. Four minutes.

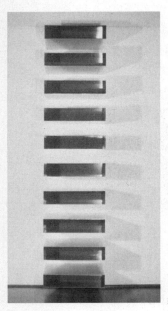

Figure 9

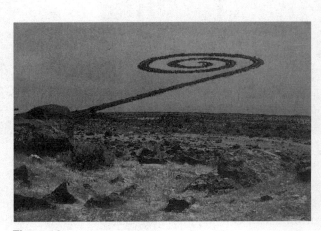

Figure 10

31. Works like these were produced in the

 (A) 1950s
 (B) 1970s
 (C) 1990s
 (D) 2000s

32. The work on the left has

 (A) spaces placed at even intervals for the display of objects
 (B) a relationship to its patron to give it meaning
 (C) rough-hewn surfaces
 (D) a nonrepresentational format

33. The artist of the work on the left is

 (A) Maya Lin
 (B) Donald Judd
 (C) Andy Warhol
 (D) Cindy Sherman

34. In contrast to the work on the left, the work on the right makes historical references to art from

 (A) American Indian earthworks
 (B) Japanese prints
 (C) African masks
 (D) Chinese calligraphy

35. The work on the right is in situ meaning it

 (A) is made of man-made products
 (B) can be seen with the use of a special device
 (C) changes color depending on the time of day
 (D) is in its original location

36. Both works were inspired by a movement in modern art called

 (A) Op Art
 (B) Minimalism
 (C) Digital Art
 (D) the New York School

37. Works like the one on the right were also done by other artists like

 (A) Christo and Jeanne-Claude
 (B) Roy Lichtenstein
 (C) Louise Nevelson
 (D) Barbara Kruger

SECTION I

Part B

TIME: 40 MINUTES

Directions: You have 40 minutes for Questions 38–115. Select the multiple-choice response that best completes each sentence, and put the correct response on the answer sheet.

38. David's painting of *The Death of Marat* shows the artist's attachment to the

 (A) power of the aristocracy over the common people
 (B) goals of the French Revolution
 (C) ideals of Rococo painting
 (D) use of Greek mythology as a mirror of the present

39. The Harlem Renaissance refers to a period that

 (A) spurned African art and promoted the African-American experience instead
 (B) aggressively rejected modernism
 (C) promoted African-American aesthetics in all the arts
 (D) encouraged African-Americans to conform to white standards of art production

Question 40 is based on Figure 11.

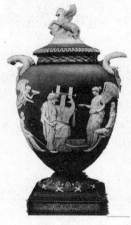

Figure 11

40. Pottery such as the one in this illustration were produced in

 (A) Greece
 (B) Rome
 (C) England
 (D) China

41. Velázquez's *Las Meninas* was meant to hang in

 (A) a chapel
 (B) the artist's workshop
 (C) the throne room of the king
 (D) the king's private study

Question 42 is based on Figure 12.

Figure 12

42. This painting is an example of

 (A) Der Blaue Reiter
 (B) Fauvism
 (C) DeStijl
 (D) Cubism

Questions 43 and 44 are based on Figure 13.

Figure 13

43. These sculptures are done in an imperial stone called

 (A) marble
 (B) granite
 (C) limestone
 (D) porphyry

44. Depicted here are four

 (A) emperors
 (B) generals
 (C) soldiers
 (D) warrior angels

45. An unusual characteristic about the architecture at the Palace at Knossos is

 (A) the columns are wider at the top than at the bottom
 (B) the stairwells are spirals
 (C) the building is twenty stories high
 (D) there are no interior courtyards for light and air

46. Egyptian sculpture from the Middle Kingdom is different from other Egyptian periods in that Middle Kingdom art

 (A) shows a frontal head
 (B) is cut from many stones and put together as one
 (C) has pouty or worried expressions on their faces
 (D) has long noses and small mouths

47. Giant rock-cut figures of Buddha are commonly found in

 (A) Mongolia
 (B) Indonesia
 (C) Persia
 (D) China

48. The subconscious world of sleep is explored by all of the following artists EXCEPT

 (A) Francisco de Goya
 (B) Henry Fuseli
 (C) Henri Rousseau
 (D) Claude Monet

49. Pablo Picasso's *Guernica* was painted for the

 (A) Prado Museum in Madrid
 (B) Crystal Palace Exhibition in London
 (C) World's Fair in Paris
 (D) Museum of Modern Art in New York

50. The first large-scale use of iron architecture was designed by

 (A) Abraham Darby and Thomas Pritchard
 (B) Gustave Eiffel
 (C) Henri Labrouste
 (D) Sir Joseph Paxton

51. Michelangelo's *Creation of Adam* expresses the Renaissance interpretation of humanism in that

 (A) man is physically a beautiful creation with innate integrity
 (B) God is the supreme being; man is nothing
 (C) humans need to have their behavior corrected by a stern, judging God
 (D) God has created his equal in man

Question 52 is based on Figure 14.

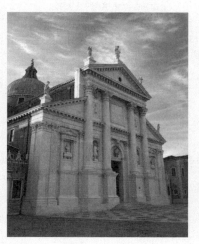

Figure 14

52. This building defies the conventions of architectural construction of the time by

 (A) placing tall columns on the façade
 (B) having a dome over the crossing
 (C) having a pediment placed behind the columns
 (D) putting the columns on bases

Question 53 is based on Figure 15.

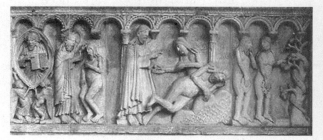

Figure 15

53. This group is unusual for its time because the artist studied and used the style of sculpture from

 (A) ancient Rome
 (B) ancient Greece
 (C) Early Christian art
 (D) Islamic art

Questions 54 and 55 are based on Figure 16.

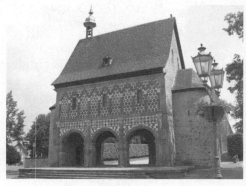

Figure 16

54. This building was probably inspired by buildings like the

 (A) Arch of Titus
 (B) Arch of Constantine
 (C) Pantheon
 (D) Colosseum

55. Even though it has elements of Roman inspiration, this building is very unclassical in its

 (A) shape of the arches
 (B) use of engaged columns
 (C) use of hexagons and star-shaped surface ornament
 (D) design of the front and the back as identical

Question 56 is based on Figure 17.

Figure 17

56. This schematic plan represents an ideal rendering of a

 (A) palace
 (B) castle
 (C) monastery
 (D) villa

57. In which culture is calligraphy an important artistic expression?

 (A) Byzantine
 (B) Islam
 (C) Roman
 (D) Etruscan

58. What is the subject of the Gothic paintings in the Arena Chapel by Giotto?

 (A) The life of Mary and Jesus
 (B) Good and bad government
 (C) The life of Noah and Moses
 (D) The story of Creation

Question 59 is based on Figure 18.

Figure 18

59. This painting by Jacob Lawrence is one of a series about

 (A) African-Americans and the rise of the middle class
 (B) African-Americans and the return to Africa
 (C) famous African-Americans and their contribution to American culture
 (D) the migration of African-Americans from the plantations in the South to the industrial North

Questions 60–62 are based on Figure 19.

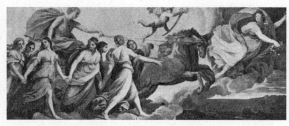

Figure 19

60. This kind of ceiling painting is called

 (A) tromp l'oeil
 (B) di sotto in sù
 (C) quadro riportato
 (D) metope

61. This work is painted by

 (A) Annibale Carracci
 (B) Pietro da Cortona
 (C) Guido Reni
 (D) Anthony van Dyck

62. Depicted in this scene is

 (A) a triumphant procession through Rome
 (B) a chariot race among the gods
 (C) the winds overtaking the earth
 (D) Apollo bringing up the dawn

63. Islamic art is particularly rich in

 (A) monumental sculpture
 (B) stained glass
 (C) carpets and tapestries
 (D) mosaics

64. The Protestant Reformation deeply affected the work of

 (A) Raphael
 (B) Hieronymus Bosch
 (C) Albrecht Dürer
 (D) Jan van Eyck

Question 65 is based on Figure 20.

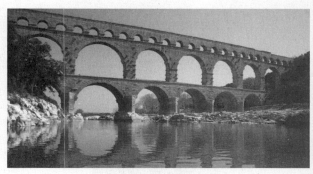

Figure 20

65. This building is typical of Roman structures built of ashlar masonry in that it

 (A) carefully balances the stones one atop the other without mortar
 (B) uses concrete to mold and form into special shapes
 (C) uses three blocks of stone for each one that was used before
 (D) is ideal for the corbelled arches used here

Question 66 is based on Figure 21.

Figure 21

66. What order is this capital from?

 (A) Doric
 (B) Ionic
 (C) Corinthian
 (D) Tuscan

Questions 67 and 68 are based on Figure 22.

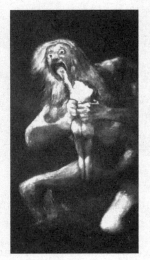

Figure 22

67. This painting is a scene from

 (A) the Bible
 (B) mythology
 (C) ancient Roman history
 (D) the artist's own times

68. The art-historical period associated with paintings such as these is

 (A) Romanticism
 (B) Neoclassicism
 (C) Impressionism
 (D) Post-Impressionism

69. The artist who maintained that he wanted to "do Poussin over entirely from nature" was

 (A) Claude Monet
 (B) Eugène Delacroix
 (C) Vincent van Gogh
 (D) Paul Cézanne

Question 70 is based on Figure 23.

Figure 23

70. This type of photograph is called a

 (A) salt print
 (B) calotype
 (C) daguerreotype
 (D) photogram

71. Sculpted glazed terra-cotta was a specialty of

 (A) Andrea del Verrocchio
 (B) Giovanni da Bologna
 (C) Luca della Robbia
 (D) Lorenzo Ghiberti

72. Georgia O'Keeffe specialized in paintings of

 (A) animals
 (B) vegetables
 (C) flowers
 (D) abstract design

73. Robert Smithson's *Spiral Jetty* is an example of

 (A) performance art
 (B) a ready-made
 (C) a found object
 (D) an earthwork

74. Frank Lloyd Wright's early buildings, such as the Robie House, are known as

 (A) townhouses
 (B) Prairie houses
 (C) examples of Romanesque Revival homes
 (D) examples of an Art Deco building

75. Which of the following artists specialized in images of herself in provocative poses?

 (A) Louise Nevelson
 (B) Barbara Kruger
 (C) Cindy Sherman
 (D) Maya Lin

76. Paul Gauguin was influenced by non-Western art, particularly objects from

 (A) ancient Mexico
 (B) China
 (C) Islam
 (D) Oceania

Questions 77 and 78 are based on Figure 24.

Figure 24

77. This work is an example of

 (A) Surrealism
 (B) Pop Art
 (C) Expressionism
 (D) Die Blaue Reiter

78. The combination of objects in this work has a dramatic effect that is

 (A) erotic
 (B) photographic
 (C) colossal
 (D) simplistic

Questions 79–81 are based on Figure 25.

Figure 25

79. The figures who are balanced on the outside panels of this painting are

 (A) saints
 (B) representations of the common person
 (C) donors
 (D) anamorphic images

80. The two figures posed as statues in the center panels are done in a technique known as

 (A) grisaille
 (B) atmospheric perspective
 (C) maniera greca
 (D) encaustic

81. These panels are part of a much larger work called

 (A) *The Garden of Earthly Delights*
 (B) *The Ghent Altarpiece*
 (C) *Maestà*
 (D) *The Portinari Altarpiece*

Questions 82 and 83 are based on Figure 26.

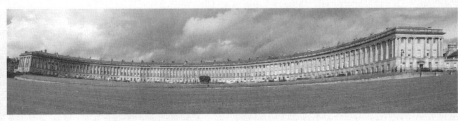

Figure 26

82. This illustration shows

 (A) a large factory
 (B) a university
 (C) homes
 (D) a spa

83. This building is located in

 (A) Bath
 (B) London
 (C) Paris
 (D) Bruges

Question 84 is based on Figure 27.

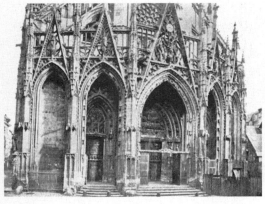

Figure 27

84. The style of architecture seen on the façade of this building is called

 (A) Early Gothic
 (B) High Gothic
 (C) Rayonnant
 (D) Flamboyant

85. Mud-brick was used as a building material for the

 (A) Stepped Pyramid of King Djoser
 (B) Ziggurat at Ur
 (C) Palace at Persepolis
 (D) Palace at Knossos

86. Etchings are different from engravings in that etchings

 (A) require a metal plate as a ground
 (B) use a tool to cut into a surface
 (C) must be realized by passing paper over the impression
 (D) must be immersed in acid to achieve an image

87. Originally, Michelangelo's *David* was carved for placement

 (A) in the Pantheon
 (B) in Notre Dame, Paris
 (C) on Florence Cathedral
 (D) on Saint Peter's, Rome

88. Leonardo da Vinci's *Last Supper* is in a ruined condition today because

 (A) Leonardo experimented with different types of paint
 (B) the patrons were angry at the outcome and had the work mutilated
 (C) tastes change, and the work was going to be replaced because it looked out of fashion
 (D) there was an iconoclasm in Milan, and the work was damaged

89. Rembrandt's *Night Watch* shows great interest in all of the following EXCEPT

 (A) concentration on intricate details
 (B) great modulations of dark and light
 (C) a dynamic arrangement of a group portrait
 (D) psychological portrayals of the principal figures

Question 90 is based on Figure 28.

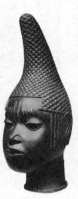

Figure 28

90. Sculptures like these were produced by which African tradition?

 (A) Benin
 (B) Dogon
 (C) Mende
 (D) Egyptian

91. Animal forms and interlace patterns can be seen in the art of the

 (A) Mayans
 (B) Renaissance
 (C) Vikings
 (D) Aztecs

92. Traditional Chinese painting formats include all of the following EXCEPT

 (A) handscrolls
 (B) hanging scrolls
 (C) woodblock prints
 (D) fans

93. Prior to the twentieth century, female artists were generally banned from academies and art schools. Artemisia Gentileschi learned to paint

 (A) by dressing as a man and entering art school
 (B) from her father
 (C) in a convent
 (D) under the tutelage of a queen

94. Peter Paul Rubens's great narrative cycle of twenty-one huge allegorical paintings was done to celebrate the life of

 (A) Maria Theresa
 (B) Marie Antoinette
 (C) Catherine the Great
 (D) Marie de'Medici

Questions 95–98 are based on Figure 29.

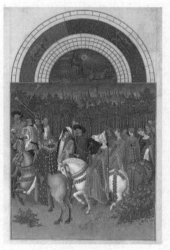

Figure 29

95. This illustration comes from the

 (A) Bible
 (B) Book of Hours
 (C) Psalter
 (D) Gospels

96. This painting is an example of

 (A) the International Gothic Style
 (B) Mannerism
 (C) the Florentine School of painting
 (D) the Venetian Renaissance

97. The patron of this book is

 (A) Francis I
 (B) Abbot Suger
 (C) Henry VIII
 (D) Duc de Berry

98. This work was painted in the

 (A) twelfth century
 (B) thirteenth century
 (C) fourteenth century
 (D) fifteenth century

99. Pottery that has stirrup-shaped handles comes from

 (A) North America
 (B) South America
 (C) Africa
 (D) Oceania

100. The Dome of the Rock in Jerusalem is built on the site where

 (A) Islam was founded
 (B) Muhammad rose to heaven
 (C) the Virgin Mary died
 (D) Muhammad was born

Questions 101 and 102 are based on Figure 30.

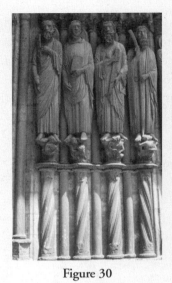

Figure 30

101. The Royal Portals at Chartres are so-named because

 (A) kings were crowned here
 (B) Old Testament kings and queens are depicted on the jambs
 (C) the kings of France are depicted on the jambs
 (D) French kings came to worship here

102. Contextually, these figures

 (A) physically and morally support the church behind them
 (B) act as an interpreter for those who are not Christian
 (C) are in the spot where royalty must pray
 (D) are symbols of the revival of the Catholic faith during the Counter-Reformation

Questions 103–105 are based on Figure 31.

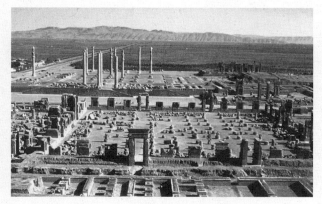

Figure 31

103. What was the political context for this building?

 (A) A storage facility for grain in times of war
 (B) The ceremonial heart of the kingdom
 (C) A large area for royal burials
 (D) The barracks to house an army and its weapons

104. The civilization who constructed this building is the

 (A) Sumerians
 (B) Assyrians
 (C) Persians
 (D) Hindus

105. A unusual feature of the top of this building's columns are capitals that are shaped like

 (A) bells
 (B) palm trees
 (C) mice
 (D) bulls

106. People who took the Grand Tour in the eighteenth century normally visited

 (A) England
 (B) Italy
 (C) Spain
 (D) Russia

107. High Renaissance paintings are noted for which kind of compositional structure?

 (A) Pyramid
 (B) Circular
 (C) Rectangular
 (D) Wavy

108. Video and digital art is common in which of the following modern movements?

 (A) Postmodern art
 (B) Conceptual art
 (C) Pop art
 (D) Abstract Expressionism

109. In the Middle Ages female artists specialized in

 (A) stained glass
 (B) mosaic
 (C) oil painting
 (D) tapestries

110. An iconostasis is put up in a

 (A) French Gothic cathedral
 (B) Byzantine church
 (C) Persian mosque
 (D) German Romanesque church

111. Rock-cut temples are a specialty in

(A) Spain
(B) Japan
(C) India
(D) Russia

Question 112 is based on Figure 32.

Figure 32

112. This manuscript page is inspired by artists working in which of the following media?

(A) Mosaic
(B) Oil
(C) Tempera
(D) Stained glass

113. A lively debate developed in French royal academies of the eighteenth century comparing the various merits of Nicolas Poussin with

(A) Jean-Antoine Watteau
(B) Rembrandt van Rijn
(C) Judith Leyster
(D) Peter Paul Rubens

Questions 114 and 115 are based on Figure 33.

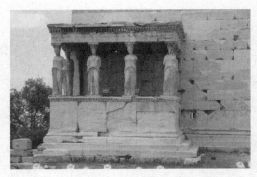

Figure 33

114. This building was erected on the site where

(A) a contest between Athena and Poseidon took place
(B) Zeus punished Ixion
(C) the great plays of ancient Greece were performed
(D) the Battle of Issus took place

115. This building is called the

(A) Parthenon
(B) Choragic Monument of Lysikrates
(C) Tholos sanctuary
(D) Erechtheion

SECTION II
Part A

TIME: 60 MINUTES
2 QUESTIONS

> **Directions:** You have 1 hour to answer the two questions in Part A; you are advised to spend 30 minutes on each question. Use lined paper for your responses; a 30-minute essay generally fills three pages.

Question 1: Many works beyond the European tradition have influenced European and American artists. Choose and fully identify two such works from two different cultures, and explain how the style of each work is reflected in the artwork of a Western artistic movement. (30 minutes)

Question 2: Nudity has often been used as a way of expressing ideal human forms. Fully identify two works of art that have figures represented as nude, or almost completely nude, each from a different period or culture. For each work, discuss how the nude body is rendered to create an ideal form in the context of the culture that produced it. (30 minutes)

SECTION II
Part B

TIME: 60 MINUTES
6 QUESTIONS

> **Directions:** The six questions in Part B are based on color photographs in a separate booklet. In this book the questions are illustrated by black-and-white photographs adjacent to each question. Each question is timed at 10 minutes, but you may move freely among all the questions in this part. The total time for all these essays is 1 hour. Use lined paper for your responses; each response should be about a page.

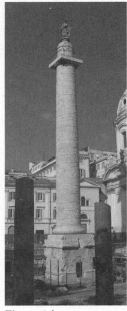

Figure 34

Question 3: For whom was the column in Figure 34 built? How does the artistic style reflect the culture's political position and values? (10 minutes)

Figure 35

Question 4: The painting in Figure 35 by Parmigianino illustrates a traditional theme in art history: the Madonna and Child. E.H. Gombrich has said in his *Story of Art*, "I can well imagine that some may find [Parmigianino's] Madonna almost offensive because of the affectation and sophistication with which a sacred object is treated." Identify the title of this work. What would have prompted Gombrich's remarks? Discuss whether you agree or disagree with Gombrich and tell why. (10 minutes)

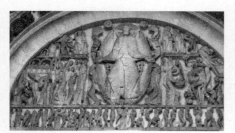

Figure 36

Question 5: What art-historical period is the work in Figure 36 from? What is the setting of the sculpture and its purpose? (10 minutes)

Figure 37

Question 6: Attribute the painting in Figure 37 to an artist you know. Compare this painting to another work by the same artist. Discuss the characteristics of this artist's work that has led to your attribution. (10 minutes)

Figure 38

Question 7: What modern movement is the work in Figure 38 from? What characteristics does this work have that place it in this period? (10 minutes)

Figure 39

Question 8: Baroque architecture can be characterized by its royal associations. Identify the building and its patron in Figure 39 and explain how the building reflects the patron's political beliefs. (10 minutes)

Answer Key
PRACTICE TEST 1

Section I, Part A

1. C	11. A	21. C	31. B
2. A	12. C	22. D	32. D
3. D	13. D	23. A	33. B
4. C	14. C	24. B	34. A
5. B	15. C	25. B	35. D
6. B	16. B	26. D	36. B
7. C	17. A	27. A	37. A
8. C	18. A	28. B	
9. D	19. D	29. C	
10. B	20. D	30. B	

Section I, Part B

38. B	58. A	78. A	98. D
39. C	59. D	79. C	99. B
40. C	60. C	80. A	100. B
41. D	61. C	81. B	101. B
42. D	62. D	82. C	102. A
43. D	63. C	83. A	103. B
44. A	64. C	84. D	104. C
45. A	65. A	85. B	105. D
46. C	66. B	86. D	106. B
47. D	67. B	87. C	107. A
48. D	68. A	88. A	108. A
49. C	69. D	89. A	109. D
50. A	70. C	90. A	110. B
51. A	71. C	91. C	111. C
52. C	72. C	92. C	112. D
53. C	73. D	93. B	113. D
54. B	74. B	94. D	114. A
55. C	75. C	95. B	115. D
56. C	76. D	96. A	
57. B	77. A	97. D	

ANSWERS EXPLAINED

Section I

1. **(C)** The *Nike of Samothrace* was a centerpiece in a civic fountain that emulated the prow of a ship.

2. **(A)** The figure represents Nike, the goddess of Victory.

3. **(D)** The theatrical feeling of the work is enhanced by the figure's twisting movement, clinging drapery, and multiple viewpoints. There is no classical composure seen here.

4. **(C)** The Romans copied many Greek works.

5. **(B)** Greek originals were often done in bronze.

6. **(B)** Original bronzes have no tree stumps; they are necessary to stabilize much heavier marble sculptures.

7. **(C)** The *Discus Thrower* is from the Classical period.

8. **(C)** The Hagia Sophia is located in Istanbul.

9. **(D)** The patrons were Emperor Justinian and Empress Theodora.

10. **(B)** The pendentive was invented at the Hagia Sophia to support a round dome by having triangular transitions pass the weight down to flat walls.

11. **(A)** The original worshippers at the Hagia Sophia were Christian.

12. **(C)** Minarets are used to call Muslims to prayer.

13. **(D)** The interior still has some original mosaic left, but most of it has been destroyed.

14. **(C)** The interior is a combination of the axial plan and the central plan.

15. **(C)** Both paintings portray kings who ruled in the seventeenth century, although the Rigaud painting was executed in 1701.

16. **(B)** The painting on the left was painted by Anthony van Dyck.

17. **(A)** The graceful easy posture of Charles I portrays royalty in dignified repose.

18. **(A)** Both of these paintings are from the Baroque period.

19. **(D)** The painting on the right is of Louis XIV of France.

20. **(D)** The setting of the painting is a fanciful rendering of Versailles, Louis's home.

21. **(C)** Both monarchs display an arrogance that is symbolized by the divine right of kings.

22. **(D)** Both poses, which are strikingly similar, suggest haughtiness.

23. **(A)** Both of these paintings are from the Realist period in the nineteenth century.

24. **(B)** The positivist movement stressed the logic of scientific understanding, and applied it to most endeavors.

25. **(B)** Gustave Courbet painted the *Burial at Ornans.*

26. **(D)** Critics came to expect that paintings of ordinary scenes should have a "higher meaning," such as in the *Burial of Count Orgaz* by El Greco.

27. **(A)** Nineteenth-century painters wanted recognition from the officially approved French Salon.

28. **(B)** There are subtle rhythms of three in the figures and haystacks.

29. **(C)** Honoré Daumier was a contemporary of Courbet and Millet.

30. **(B)** Dorothea Lange specialized in photographs of the lower classes in the Great Depression.

31. **(B)** Donald Judd's *Untitled* is from 1974. Most of his works were done around this time.

32. **(D)** As much as possible, Judd avoids associations in his work. Even his title is as abstract as possible. This is a very nonrepresentational work.

33. **(B)** Donald Judd is the artist.

34. **(A)** This work resembles American Indian earthworks such as *Serpent Mound* in Ohio.

35. **(D)** Works that are in situ are in their original location. In this case *Spiral Jetty* is in Great Salt Lake, Utah.

36. **(B)** Both works are spare in their ornamentation. They are influenced by Minimalism, which seeks to reject as much decoration as possible.

37. **(A)** The works of Christo and Jeanne-Claude are similar in that they are outdoor works that rely on their site to be understood.

38. **(B)** *The Death of Marat* idealizes the life of a fallen member of the French Revolution.

39. **(C)** The Harlem Renaissance is a general term that encourages the development of African-American expression across the arts.

40. **(C)** This example of Wedgwood pottery is from England.

41. **(D)** Velázquez's famous *Las Meninas* was originally meant to hang in the king of Spain's study.

42. **(D)** This painting by Juan Gris is from the Cubist period.

43. **(D)** *The Tetrarchs* are done in porphyry, a purple-colored stone with imperial connotations.

44. **(A)** *The Tetrarchs* were emperors of ancient Rome.

45. **(A)** The Palace of Knossos is unusual in that the columns are wider at the top than they are at the bottom.

46. **(C)** Egyptian Middle Kingdom sculpture has a pouty and moody expressiveness about the face.

47. **(D)** The Chinese cut giant stone figures of Buddha from cliff walls.

48. **(D)** Claude Monet did not paint images of sleep. Goya's *Sleep of Reason Produces Monsters*, Fuseli's *Nightmare*, and Rousseau's *Sleeping Gypsy* are three examples of artist's exploring the unconscious.

49. **(C)** Picasso's *Guernica* was first seen at the Spanish Pavilion of the 1938 World's Fair in Paris.

50. **(A)** Abraham Darby and Thomas Pritchard designed the Coalbrookdale Bridge in England, the first large-scale use of iron in architecture.

51. **(A)** Michelangelo's grand conception of Adam is in harmony with the humanist ideals of Renaissance painting, and rejects the stern unforgiving God of the Middle Ages.

52. **(C)** Mannerist buildings such as San Giorgio Maggiore reject Renaissance conventions and place a second pediment behind the columns on the façade.

53. **(C)** This Romanesque frieze by Wiligelmo draws inspiration from Early Christian sarcophagi.

54. **(B)** The Lorsch Gatehouse somewhat resembles the Arch of Constantine in Rome, which may have served as an overall inspiration for the building.

55. **(C)** The surface patterning on the gatehouse is decidedly unclassical.

56. **(C)** This is a plan for a medieval monastery.

57. **(B)** Islam produced elaborate calligraphy.

58. **(A)** The Giotto frescoes in the Arena Chapel are based on the life of Mary and Jesus.

59. **(D)** Jacob Lawrence painted a series of paintings called *The Migration of the Negro* that chronicle the movement of African-Americans from the rural South to the industrial North after World War I.

60. **(C)** This ceiling painting is done in quadro riportato.

61. **(C)** This work is painted by Guido Reni.

62. **(D)** Apollo is bringing up the dawn in a work entitled *Aurora.*

63. **(C)** Islamic art specializes in carpet and tapestry production.

64. **(C)** Albrecht Dürer was deeply affected by the Protestant Reformation, converting to Lutheranism and casting his sacred works in that guise.

65. **(A)** Ashlar masonry carefully cuts stones so they fit into spaces neatly without the use of mortar as a supporting agent.

66. **(B)** This is an Ionic capital.

67. **(B)** This is a Francisco de Goya painting of *Saturn Devouring His Children,* a scene from mythology.

68. **(A)** Goya's painting is Romantic.

69. **(D)** Paul Cézanne claimed he wanted to "do Poussin over entirely from nature."

70. **(C)** This type of photograph is a daguerreotype, perhaps the oldest to survive.

71. **(C)** Luca della Robbia specialized in glazed terra-cotta sculpture.

72. **(C)** Georgia O'Keeffe specialized in large paintings of single flowers.

73. **(D)** *Spiral Jetty* is an earthwork in the Great Salt Lake, Utah.

74. **(B)** Frank Lloyd Wright's early buildings are examples of Prairie houses.

75. **(C)** Cindy Sherman photographed herself in a series called *Untitled Film Stills*, which are provocative and suggestive.

76. **(D)** Paul Gauguin's trips to Tahiti introduced him to Oceanic art.

77. **(A)** Meret Oppenheim's *Object* is a work of Surrealist art.

78. **(A)** The unusual combination of objects has created an erotic sense about the work.

79. **(C)** The outside figures are donors.

80. **(A)** The two figures in the center are painted in grisaille, which imitates sculpture.

81. **(B)** This is part of the outside panels of *The Ghent Altarpiece* by Jan van Eyck.

82. **(C)** These homes are part of the Royal Crescent in Bath.

83. **(A)** Royal Crescent is located in Bath, England.

84. **(D)** St.-Maclou is an example of Flamboyant Gothic architecture.

85. **(B)** Mud-brick is the basic building material for ancient Mesopotamian architecture, including the Ziggurat at Ur.

86. **(D)** Etchings have to be immersed in acid to produce an image. Engravings share all the other properties in choices A, B, and C.

87. **(C)** Originally, Michelangelo's *David* was conceived as a project for one of the buttresses of Florence Cathedral, but when completed the city fathers thought it too grand to be placed so high, and removed it to a main square in Florence.

88. **(A)** Leonardo da Vinci's constant experimenting caused the *Last Supper* to deteriorate almost immediately.

89. **(A)** Rembrandt is not like Jan van Eyck and other Northern painters who relished in intricate details. He preferred the general effect to minute details.

90. **(A)** Bronzes or brasses from Africa are generally Benin.

91. **(C)** Viking artists used a combination of animal forms and interlace patterning.

92. **(C)** Woodblock prints were a specialty of the Japanese.

93. **(B)** Artemisia Gentileschi learned to paint in the workshop of her father, Orazio.

94. **(D)** Rubens' great cycle is allegorically based on the life of Marie de'Medici.

95. **(B)** This painting is a page of the Book of Hours from the *Very Rich Hours of the Duke of Berry.*

96. **(A)** This painting is a fine example of the courtly nature of the International Gothic Style.

97. **(D)** The patron of this book is the Duc de Berry.

98. **(D)** This work was painted in the early fifteenth century.

99. **(B)** Stirrup handles are trademarks of Moche pottery from South America.

100. **(B)** Muslims believe that the Dome of the Rock houses the site where Muhammad rose to heaven.

101. **(B)** The Royal Portals are so-named because Old Testament kings and queens are carved on the door jambs.

102. **(A)** Symbolically, the kings and queens physically and morally support the Christian church.

103. **(B)** The Palace of Darius at Persepolis was built as a ceremonial center for the Persian Empire.

104. **(C)** This building was constructed by the Persians.

105. **(D)** Bull-shaped capitals are a unique feature of Persian architecture.

106. **(B)** Although people on the Grand Tour in the eighteenth century went to many places, Italy was the preferred destination because it contained landmarks from the ancient and the Renaissance worlds.

107. **(A)** High Renaissance painting favors pyramidical forms, as in the Madonnas by Raphael.

108. **(A)** Video and digital technology is extensively used in Postmodern art.

109. **(D)** Female artists in the Middle Ages specialized in tapestries.

110. **(B)** An iconostasis was erected in Byzantine churches to separate the main aisle from the apse.

111. **(C)** Rock-cut temples, particularly those in hollowed-out caves, are frequently seen in India.

112. **(D)** Stained glass often served as an inspiration for manuscript illuminators of the Middle Ages.

113. **(D)** Nicolas Poussin and Peter Paul Rubens were considered artistic opposites by the French Academy.

114. **(A)** This building is where the ancient Greeks believed Athena and Poseidon contested with one another for leadership over Athens.

115. **(D)** This building is the Erechtheion.

Section II

Rubric for Question 1

8–9: The student makes two appropriate choices of art beyond the European tradition, fully identifies them by title, artist, and civilization, and explains how characteristics of each work can be found in Western examples. The question does not require students to identify specific Western examples, so no points can be earned or lost if Western works are identified. There are no major errors.

6–7: The student makes two appropriate choices, fully identifies them by title, artist, and civilization, and with less specificity discusses the influences these works have on Western examples. The discussion may be imbalanced or have some errors.

5: The student makes only one appropriate choice and fully discusses the characteristics and its effect on Western art OR the student gives two examples that are either weakly identified, or whose characteristics are not fully explained. There may be minor errors.

3–4: The student identifies two appropriate examples but gives minimal discussion, OR the student identifies one appropriate example with some pertinent discussion. There may be major errors.

1–2: The student simply identifies the works, OR the student presents one work with minimal discussion. There may be major errors.

0: The student makes an attempt, but the response is without merit.

Model Response for Question 1

It is important to recognize the effect that non-Western art has had on the West. African art has provided a reminder of the importance of simplicity. Geometric shapes and quiet forms play a large role in their culture, and Picasso drew on this for influence, particularly in his Cubist period. Japanese art played a major role in influencing Impressionism. Japanese art valued nontraditional angles and symmetry. This was a big change from Western conventional representations. These new compositional elements and approaches have brought Western art to the point it is now, and much is owed to the non-Western influences and innovators.

Pablo Picasso's *Guernica* (1937) appears to be greatly influenced by African art, such as the tribal masks and sculptures like the *Belt Mask of Queen Mother* (16th century). Geometry and form are the main focus of African masks. There was less emphasis on the realistic representation of reality and

more on geometric expression. The face on the belt pendent is clear and simply represented, with large eyes and a well-defined nose and mouth. She looks almost angry, perhaps touched with a hint of haughtiness. There is a look of dissatisfaction on her near perfectly symmetrical face. Scarification is present on the figure's forehead.

The geometric order and precision seen in African works such as the Belt Mask can be seen in some of Picasso's works, such as Guernica or Les Demoiselles d'Avignon. The Cubism philosophy of breaking down the forms of the face into many facets is somewhat influenced by African geometrization. Not only are the heads of Picasso's figures influenced by African art, but the whole bodies are extensions of this philosophy. Picasso was inspired by African qualities, such as simplicity, geometry, and a kind of primitiveness for a maximum emotional and public effect.

Japanese Art, or Japonisme, strongly influenced the Impressionist movement. After opening to trade with the West, Japan sent over prints, fans, kimonos, silk, and various other pieces. French artists found this newly discovered culture refreshing, and took to using qualities of Japanese art in their paintings. An example of Japanese art exhibiting qualities related to that culture is Station of Otsu: from the Fifty-Three Stations of the Tokaido (The "Reisho Tokaido"), by Ando Hiroshige. This work is done at an unusual angle, instead of being at eye-level with the subject matter, we're looking in from above. The work is asymmetrical with the blue ground taking up much of the view. The figures are simple and are in a muted color scheme with a range of colors, none too bright. Edgar Degas borrowed his favorite parts of Japanese Art: Asymmetrical compositions, approaching the picture from different angles, a focus on pure lines and color, and careful attention to elaboration of one singular theme. Ballet Rehearsal (1875) by Degas, for example, is one example of Degas borrowing these Japanese elements. Rather than showing the ballet rehearsal in the conventional, straightforward way he had before, he took an nontraditional angle. Instead of looking at the rehearsal as a whole, standing either in front of or behind of the dancers, we are to the side, looking in, as a secret spectator would be. The focus is on these two dancers, particularly the one in movement, as the group carefully and critically watches her. The figures are caught off guard; this isn't meant to be seen by the public. Rather than seeing all of the figures, the angle of this work makes the background and floor take up the majority of the space.

Non-Western art has had a definite influence and effect on the Western world. Non-Western art can remind Western artists of the value of the primitive, or serve as an introduction to the sophistication of a faraway culture.

—Karen G.

Analysis of Model Response for Question 1

Karen's essay is a solid 30-minute response. In discussing African arts' influence on the work of Picasso, Karen chooses an ivory mask from Benin that contains some of the stylization that Picasso would have enjoyed; however, a better choice would have been a mask that shows the complete geometrization of figures such as those from Cameroon, Mali, or the Congo. The Hiroshige print is an excellent choice, showing how artists, particularly Degas, were taken with the asymmetry and muted color schemes. Even though there is a slight imbalance in the essay, it is still a solid response. **This essay merits an 8.**

Rubric for Question 2
8–9: The student makes two appropriate choices from different periods or cultures. The student discusses how nudity, or near nudity, is presented as a representation of the ideal. The student makes a solid analysis of how a society's view of the ideal is represented in this work. There are no major errors.
6–7: The student makes two appropriate choices from different periods or cultures. The student discusses how nudity, or near nudity, is presented as a representation of the ideal; however, the discussion is unbalanced or not as a complete. There may be minor errors.
5: This is the highest score a student can earn if he or she makes only one appropriate choice. There may be major errors in the discussion of the two appropriate choices.
3–4: The student discusses one work fairly well but the second choice is inappropriate, OR the two choices are appropriate but little support is given for each choice. There may be major errors.
1–2: The student identifies the two choices but provides almost no support for his or her choices. There may be major errors.
0: The student makes an attempt, but the response is without merit.

Model Response for Question 2

As evidenced through the course of history, the portrayal of the human nude in art has tended to reflect various aesthetics and ideals valued by the culture that produced it. It is through the representation of the human nude that people are able to express the very notions of their ideals concerning beauty and perfection, which is subject to change based on both the place and time period in which the artwork was produced. These notions of the perfect human nude were highly influenced by the values of

the specific society and whether it was more secularly or religiously based. These ideas are evidenced in the sculptures of <u>David</u> and <u>Seated Buddha Preaching the First Sermon</u>.

During the period of the early Renaissance, known as the Quattrocento, the various aesthetic traditions of representing the human nude in classical antiquity experienced an exultant revival. The Renaissance in Italy embodied the aesthetics of portraying the human nude in both an idealized and perfect form, which is demonstrated in Donatello's sculpture entitled <u>David</u>. In this representation of the Old Testament story of David and Goliath, David is shown triumphantly holding his sword while standing on top of the slain head of Goliath. Donatello has strategically placed David's arms and legs into a classic contrapposto pose, which creates a sense of movement and energy along with incredible symmetry and balance among the composition. The figure of David is made of black bronze, creating a smooth polish and shiny finish, which provides him with an overall feminine appearance by heightening the curving contours of his body. It is evident that David is rendered to look like a typical prepubescent male who lacks muscular strength and virility, due to the soft and polished finish of the black bronze. As a result, he is depicted to look smaller and younger than his foe, providing a degree of realism, which was one of the key foundations of Renaissance art. In this particular portrayal of the subject, David is seen wearing a hat that a typical gentleman of the Renaissance would have worn, with laurel leaves in it, which are the plants of the poet. This is the first statue since the ancients that is completely nude, thereby demonstrating the reestablished emphasis on the beauty and form of the human body and the reawakening of the classical aesthetic traditions that were established in this period.

Further evidence of the notion that the nude human form reflects the ideals of the culture that produced it is seen in the work entitled <u>Seated Buddha Preaching the First Sermon</u>. This sculpture, produced during the Gupta Period in India, reflects the particular principles that the religion of Buddhism is built upon. Buddha is very serene and his eyes are closed to show that he is in a constant state of meditation. His garments are very tight fitting and cling to his body, which creates the "wet Buddha look," primarily seen in the Gupta Period. This stylistic representation of portraying the Buddha emphasizes the curves and contours of his body and in so doing, gives him an epicene appearance. As a result, Buddha embodies certain feminine characteristics of having a smooth and supple body, while still being portrayed as a male. The sculpture is made of red sandstone, which further gives the sculpture a realistic appearance by creating a fleshy look to the Buddha's body. Therefore, certain aspects of Buddhism are

encompassed in this sculpture reflecting an idea of balance between opposite forces, in this case between those of male and female. It is evident that other aspects in this sculpture further represent the fundamental ideas of Buddhism, in that there is a circle behind Buddha, which is the circle of becoming to show how everything turns. In the predella on the bottom are Buddha's followers. They are spinning the wheel of reincarnation, and this circular pattern is further repeated in the Buddha's hair. It is also apparent that the Buddha has all of the proper elements of iconography to identify him, such as the urna, which is the knot of wisdom on his head, the third eye, or ushnisha, and the particular hand gesture he makes, called a mudra. This iconography further demonstrates how the people of India during the Gupta Period viewed the ideal body, and therefore chose to represent the Buddha, who is the symbol of the perfect human, with the ideal nude body.

Throughout the course of history, it is evident that the representation of the human nude in various cultures reflects the particular ideals and aesthetic values of the people who produced it. Evidence of this concept can be seen in the works entitled <u>David</u> and <u>Seated Buddha Preaching the First Sermon</u>, where both works represent the particular values and ideals of the culture that produced them by reflecting the perfect notion of beauty in the human nude. Both sculptures also utilize the materials they are made of in order to provide the figures with a sense of the ideal body respective to their two separate cultures. This demonstrates that the notion of the ideal human nude typically varies in different historical periods and cultures based on the particular aesthetic values.

—Jessica E.

Analysis of Model Response for Question 2

This is a superb essay. Jessica chooses two appropriate choices and carefully guides the discussion of each in view of the respective society's view of idealization through nudity. The Donatello *David* is analyzed through the lens of the originality of nudity in early Renaissance art. The *Sarnath Buddha*, though not technically nude, has see-through tight-fitting clothes that render a nude look, allowing for certain Buddhist characteristics to show through. In both cases, nudity espouses elements of idealization through a careful study of the human form seen in its most fundamental manner. **This essay merits a 9.**

Rubric for Question 3

4: The student identifies the column as being built for Roman Emperor Trajan. It connects the fact that the column represents Roman glory and military might with the narrative of scenes spiraling around its sides. The student may also mention that this is Trajan's tomb and connect the Roman victory with Trajan's view of his most important accomplishments in life. There are no major errors.

3: The student identifies the column as being built for Roman Emperor Trajan and connects the narrative of the column with its purpose with less specificity. There may be minor errors.

2: The student fails to identify for whom the column was built, but otherwise includes a narrative of the scenes. There may be major errors.

1: The student fails to identify for whom the column was built, and speaks only in a general way about Roman glory OR the student simply identifies the work with no other relevant comment. There may be major errors.

0: The student makes an attempt, but the response is without merit.

Model Response for Question 3

The column was built for Emperor Trajan after his defeat of Dacia. The column reflects the culture's political position in that it stands tall above other buildings in the city. It has a spiral staircase on the inside that one may climb and see a breathtaking view of Rome. This column is meant to show the greatness of the city and the Roman defeat over other lands. It depicts everything from war preparation to the battle scenes against the Dacians. It was topped with a sculpture of Trajan himself, as great conqueror. War, the acquiring of land, and the glory of victory were things that were valued by the Romans. They built a whole structure dedicated to their victory that was meant to stand the test of time and tell of their high status and superior military.

—Barbara H.

Analysis of Model Response for Question 3

Barbara correctly identifies the column as being built for the Roman Emperor Trajan. She connects the function of the building with its spiral staircase to the viewing platform on top. She also connects the narrative with the theme of the work. Although Barbara does not remark on this being Trajan's tomb, she does point out that his statue once stood atop the monument. **This essay merits a 4.**

Rubric for Question 4

4: The student identifies the title of the work and also relates the quotation to the pose of Mary and the Mannerist artistic conventions. There are no major errors.

3: The student identifies the title, but is less specific about relating the quotation to Mannerist artistic conventions. There may be minor errors.

2: This is the highest score a student can earn if he or she does not identify the name of this painting. The student interprets Gombrich's quotation in light of some knowledge of Mannerism. There may be major errors.

1: The student connects the quotation to Mannerism in a superficial way, OR the student identifies the title of the painting.

0: The student makes an attempt, but the response is without merit.

Model Response for Question 4

In the 16th century, artist Parmigianino painted <u>Madonna with a Long Neck</u> during the Mannerist period. During this period, works of art were elongated, distorted, and exaggerated. In fact, some of the figures, such as the Madonna herself and the baby Jesus, are in twisted and unbalanced poses.

According to E.H. Gombrich, "I can well imagine that some may find [Parmigianino's] Madonna almost offensive because of the affection and sophistication with which a sacred object is treated." What prompted Gombrich to say this was because the way Madonna's gestures emphasize her gracious pose and self-conscious expression. The position of Jesus's body, nearly falling off the lap of his mother, seems to suggest an improper way to hold a child.

I agree with Gombrich's quote because people who look at this painting may be offended in the way holy figures are represented—as vain and self-absorbed with exaggerated bodies. This exaggeration shows a sense of sophistication and yet distortion at the same time. Gombrich makes a good point that people of the Mannerist period may find this work of art almost offensive.

—F.D.

Analysis of Model Response for Question 4

Although this essay is in need of reshaping, it does explain the basic principles of Mannerist painting and how unusual it would have seemed to the public to view this work as a religious painting at all. F.D. is careful to identify the title of the work and unite the quotation into the fabric of the argument. An emphasis is placed on the Mannerist qualities of the painting. **This essay merits a 3.**

Rubric for Question 5

4: The student identifies the period as Romanesque, knows the placement of the work above the doors of the cathedral, and tells the purpose of the work. There are no major errors.

3: The student identifies the period, knows the placement, and tells the purpose. Discussion is less full and there may be minor errors.

2: The student provides two of the three requirements: Period, placement, or purpose. There may be major errors.

1: The student provides only one of the requirements for a complete answer. There may be major errors.

0: The student makes an attempt, but the response is without merit.

Model Response for Question 5

This sculpture was placed above the doors that were the entrance to a cathedral. On the right side of the piece, the <u>Last Judgment</u>, demons and angels are weighing the souls of mortals, deciding their fate. People who were heavy with sin are condemned to Hell, and others are saved by angels. People would enter under the right-hand side of the sculpture because they had sins to confess or had souls that needed cleansing, and would leave the church through the left doors where the elect have been selected and are rising to heaven. This piece is from is the Romanesque period.

—Alex D.

Analysis of Model Response for Question 5

Students have three tasks: to identify the period, give the setting of the work, and tell its purpose. Alex knows that the sculpture is placed above a set of cathedral doors and that the purpose is to express how the damned will be punished and the virtuous saved. It also expresses how the people would walk beneath the damned entering the church, and exit under the saved. The period is correctly mentioned as Romanesque. **This essay merits a 4.**

Rubric for Question 6

4: The student correctly identifies the artist and another work by the same artist. The student supplies two solid reasons for the attribution with a full discussion. There are no major errors.

3: The student correctly identifies the artist and another work by the same artist or supplies another Rococo artist with a correctly identified work. The student supplies two reasons for the attribution with limited discussion, or supplies only one reason but it is fully developed. There may be minor errors.

2: The student correctly identifies only the artist or another work by the same artist or another Rococo artist. The student supplies a valid reason for this choice. There may be major errors.

1: The student correctly identifies only the artist or another work by the same artist or another Rococo artist. The student does not supply an analysis. There may be major errors.

0: The student makes an attempt, but the response is without merit.

Model Response for Question 6

This work of art can be attributed to much of Fragonard's work. This work of art can be compared to Fragonard's The Swing. This work is related to The Swing because it contains the style of fête galante. This painting has aristocratic subjects that are in an open landscape. Which is similar to The Swing because it has that soft pastel style that the The Swing also has. Both works have that sensual feel of the Rococo era in art.

—Arthur E.

Analysis of Model Response for Question 6

Arthur is mistaken in his identification of the painting as by Fragonard; it is by Watteau. However he correctly attributes the painting to a work by another Rococo artist, and is correct when he says that Fragonard painted *The Swing*. He also supplies two reasons for his attribution: the painting is a fête galante, and contains the same "soft pastel style" that Rococo works, and the works by Fragonard, are particularly noted for. **This essay merits a 3.**

Rubric for Question 7

4: The student identifies the modern movement as Futurism. The student accurately describes three characteristics of the Futurist movement that can be seen in this work. There are no major errors.

3: The student identifies the modern movement as Futurism or Cubism. The student accurately describes two characteristics of the Futurist or Cubist movement that can be seen in this work. There may be minor errors.

2: This is the highest score a student can earn if Futurism or Cubism is not mentioned as the movement depicted in this work. The student accurately describes one characteristic of Futurism or Cubism and names the movement, OR the student describes two characteristics of Futurism or Cubism without naming the movement. There may be major errors.

1: The student identifies the modern movement as Futurism but does not identify characteristics seen in this work OR the student identifies one characteristic, but does not name Futurism or Cubism. There may be major errors.

0: The student makes an attempt, but the response is without merit.

Model Response for Question 7

Figure 38 is Boccioni's <u>Unique Forms of Continuity in Space</u>. This work by Boccioni is a sculpture done in bronze. This bronze casting portrays a strong human figure that appears to have movement and shows the affect of wind blowing on it. This work was meant to be viewed from every direction and has many different shapes to it, giving it an abstract look. This sculpture by Boccioni is from the art movement called Futurism. Futurism art glorified the machine age and portrayed the life during the 20th century. Futurism left behind the past and focused on the current machine age. These characteristics are portrayed in Boccioni's <u>Unique Forms of Continuity in Space</u> because the sculpture seems to be stepping forward, showing a step towards the future. The affects of the machine age are shown on the sculpture because of the twisting and turning of the figure. The figure also depicts the machine age because the figure is very muscular and shows strength. It shows that humans are progressing forward. This futuristic sculpture was most probably influenced by the Greeks' <u>Nike of Samothrace</u>. The <u>Nike</u> was more realistic and the drapery gave the effect that she was wet. But the <u>Nike</u> was meant to be viewed from only the frontal view. But Boccioni's sculpture showed a step forward and emphasized the machine age and 20th century.

—Kaynat K.

Analysis of Model Response for Question 7

Kaynat correctly identifies the movement as Futurism. She illustrates the fact that Futurism "glorifies the machine age" by pointing to specific elements in this work. She demonstrates a strong grasp of the principle tenets of Futurism. There is a slight misstep when Kay says that the Nike of Samothrace was meant to be seen only from the front; however, this is not enough to detract from the grade. **This essay merits a 4.**

Rubric for Question 8

4: The student identifies the building as Versailles, names the patron as Louis XIV, and gives at least two examples of how this building functions as an expression of the patron's belief and his world. There are no major errors.

3: The student identifies the building as Versailles, names the patron as Louis XIV, and gives at least one example of how this building functions as an expression of the patron's belief about himself and his world. There may be minor errors.

2: The student supplies only two of the following: The name of the building, the patron, or two examples of how this building functions as an expression of the patron's beliefs about himself and his world. There may be major errors.

1: The student supplies only one of the following: The name of the building, the patron, or one example of how this building functions as an expression of the patron's beliefs about himself and his world. There may be major errors.

0: The student makes an attempt, but the response is without merit.

Model Response for Question 8

The building shown in Figure 39 is the palace at Versailles. Built by Hardouin-Mansart, the palace shows many beliefs of the patron, Louis the fourteenth. Louis the 14th was an absolute ruler that wanted to show off his power and status through this palace. The center stands out like most Baroque buildings. The size of this palace is also huge, overwhelming the viewer. The palace was built for all of the King' court to live. This way the king controlled them. Louis the fourteenth was called the Sun King, which explains why his bedroom was built in the center. All of the other rooms radiate around this room like light radiates from a sun.

His power is even shown off by the gardens that surround the palace. The garden that surrounds the whole palace stretches out far and way beyond the eye of the viewer. This shows a control of nature that is seen in many

French gardens and also shows Louis the fourteenth's control. Behind the palace, a body of water is seen behind the trees. There seems to be no end to his water, like the greenery.

—Rene A.

Analysis of Model Response for Question 8

Rene supplies the name of the building, Versailles, and the principal patron, Louis XIV. Although she knows the architect, this does not earn a point, since it was not asked for in the question. There are many ways in which the palace reflects the political beliefs of the ruler, including the setting ("The garden that surrounds the whole palace stretches out far and way beyond the eye of the viewer. This shows a control of nature that is seen in many French gardens and also shows Louis the fourteenth's control") and the placement of the king's bedroom ("All of the other rooms radiate around this room like light radiates from a sun."). The requirements of the question have been met and the answer is fully developed. **This essay merits a 4.**

EVALUATION OF PRACTICE TEST 1

Multiple-Choice Section

Your practice test score can now be computed. The multiple-choice section of the actual test is scored by computer, but it uses the same method you will use to compute your score manually. Each correct answer earns one point. Each incorrect answer has no value, and cannot earn or lose points. Omitted questions or questions that the computer cannot read because of smudges or double entries are not scored at all. Go over your answers and mark the ones correct with a "C" and the ones incorrect with an "X."

Total number of correct answers: _____

Conversion of Raw Score to Scaled Score

Your raw score is computed from a total of 115 questions. In order to coordinate the raw score of the multiple-choice section with the free-response section, the multiple-choice section is multiplied by a factor of .69565. For example, if the raw score is 90, the weighted score is 62.6. Enter your weighted score in the box on the right.

> **Enter your weighted multiple-choice score:**
> _____

Long-Essay Section

When grading your long-essay section, be careful to follow the rubric so that you accurately assess your achievement. Grade each essay on a scale of 0–9 and total the scores for this section. The highest point total for this section is 18.

Score on Question 1: _____

Score on Question 2: _____

Total Raw Score on Long-Essay Question: _____

In order to weight this score appropriately, multiply your score by 2.7778. For example, a raw score of 15 will yield a weighted score of 41.7. Total possible scoring for this section is 50.

> **Enter your weighted long-essay score:**
>
> _____

Short-Essay Section

When grading your short-essay section, be careful to follow the rubric so that you accurately assess your achievement. Grade each essay on a scale of 0–4 and total the scores for this section. The highest point total for this section is 28.

Score on Question 3: _____

Score on Question 4: _____

Score on Question 5: _____

Score on Question 6: _____

Score on Question 7: _____

Score on Question 8: _____

Total Raw Score on Short-Essay Section: _____

In order to weight this section appropriately, the raw score is multiplied by 2.92, so that the highest weighted score is 70.

> **Enter your weighted short-essay score:**
>
> _____

Final Scoring

Add your weighted scores. A perfect score is 200. Although the weighting changes from year to year, a general rule of thumb is that 75% correct is a 5, 67% is a 4, and 56% is a 3. Use the following table as an estimate of your achievement.

> **Enter your total weighted score:**
>
> _____

5	150 points
4	133 points
3	112 points
2	91 points
1	74 points

> **Enter your AP score:**
>
> _____

Answer Sheet
PRACTICE TEST 2

Section I, Part A

1. Ⓐ Ⓑ Ⓒ Ⓓ
2. Ⓐ Ⓑ Ⓒ Ⓓ
3. Ⓐ Ⓑ Ⓒ Ⓓ
4. Ⓐ Ⓑ Ⓒ Ⓓ
5. Ⓐ Ⓑ Ⓒ Ⓓ
6. Ⓐ Ⓑ Ⓒ Ⓓ
7. Ⓐ Ⓑ Ⓒ Ⓓ
8. Ⓐ Ⓑ Ⓒ Ⓓ
9. Ⓐ Ⓑ Ⓒ Ⓓ
10. Ⓐ Ⓑ Ⓒ Ⓓ

11. Ⓐ Ⓑ Ⓒ Ⓓ
12. Ⓐ Ⓑ Ⓒ Ⓓ
13. Ⓐ Ⓑ Ⓒ Ⓓ
14. Ⓐ Ⓑ Ⓒ Ⓓ
15. Ⓐ Ⓑ Ⓒ Ⓓ
16. Ⓐ Ⓑ Ⓒ Ⓓ
17. Ⓐ Ⓑ Ⓒ Ⓓ
18. Ⓐ Ⓑ Ⓒ Ⓓ
19. Ⓐ Ⓑ Ⓒ Ⓓ
20. Ⓐ Ⓑ Ⓒ Ⓓ

21. Ⓐ Ⓑ Ⓒ Ⓓ
22. Ⓐ Ⓑ Ⓒ Ⓓ
23. Ⓐ Ⓑ Ⓒ Ⓓ
24. Ⓐ Ⓑ Ⓒ Ⓓ
25. Ⓐ Ⓑ Ⓒ Ⓓ
26. Ⓐ Ⓑ Ⓒ Ⓓ
27. Ⓐ Ⓑ Ⓒ Ⓓ
28. Ⓐ Ⓑ Ⓒ Ⓓ
29. Ⓐ Ⓑ Ⓒ Ⓓ
30. Ⓐ Ⓑ Ⓒ Ⓓ

31. Ⓐ Ⓑ Ⓒ Ⓓ
32. Ⓐ Ⓑ Ⓒ Ⓓ
33. Ⓐ Ⓑ Ⓒ Ⓓ
34. Ⓐ Ⓑ Ⓒ Ⓓ
35. Ⓐ Ⓑ Ⓒ Ⓓ
36. Ⓐ Ⓑ Ⓒ Ⓓ
37. Ⓐ Ⓑ Ⓒ Ⓓ

Section I, Part B

38. Ⓐ Ⓑ Ⓒ Ⓓ
39. Ⓐ Ⓑ Ⓒ Ⓓ
40. Ⓐ Ⓑ Ⓒ Ⓓ
41. Ⓐ Ⓑ Ⓒ Ⓓ
42. Ⓐ Ⓑ Ⓒ Ⓓ
43. Ⓐ Ⓑ Ⓒ Ⓓ
44. Ⓐ Ⓑ Ⓒ Ⓓ
45. Ⓐ Ⓑ Ⓒ Ⓓ
46. Ⓐ Ⓑ Ⓒ Ⓓ
47. Ⓐ Ⓑ Ⓒ Ⓓ
48. Ⓐ Ⓑ Ⓒ Ⓓ
49. Ⓐ Ⓑ Ⓒ Ⓓ
50. Ⓐ Ⓑ Ⓒ Ⓓ
51. Ⓐ Ⓑ Ⓒ Ⓓ
52. Ⓐ Ⓑ Ⓒ Ⓓ
53. Ⓐ Ⓑ Ⓒ Ⓓ
54. Ⓐ Ⓑ Ⓒ Ⓓ
55. Ⓐ Ⓑ Ⓒ Ⓓ
56. Ⓐ Ⓑ Ⓒ Ⓓ
57. Ⓐ Ⓑ Ⓒ Ⓓ

58. Ⓐ Ⓑ Ⓒ Ⓓ
59. Ⓐ Ⓑ Ⓒ Ⓓ
60. Ⓐ Ⓑ Ⓒ Ⓓ
61. Ⓐ Ⓑ Ⓒ Ⓓ
62. Ⓐ Ⓑ Ⓒ Ⓓ
63. Ⓐ Ⓑ Ⓒ Ⓓ
64. Ⓐ Ⓑ Ⓒ Ⓓ
65. Ⓐ Ⓑ Ⓒ Ⓓ
66. Ⓐ Ⓑ Ⓒ Ⓓ
67. Ⓐ Ⓑ Ⓒ Ⓓ
68. Ⓐ Ⓑ Ⓒ Ⓓ
69. Ⓐ Ⓑ Ⓒ Ⓓ
70. Ⓐ Ⓑ Ⓒ Ⓓ
71. Ⓐ Ⓑ Ⓒ Ⓓ
72. Ⓐ Ⓑ Ⓒ Ⓓ
73. Ⓐ Ⓑ Ⓒ Ⓓ
74. Ⓐ Ⓑ Ⓒ Ⓓ
75. Ⓐ Ⓑ Ⓒ Ⓓ
76. Ⓐ Ⓑ Ⓒ Ⓓ
77. Ⓐ Ⓑ Ⓒ Ⓓ

78. Ⓐ Ⓑ Ⓒ Ⓓ
79. Ⓐ Ⓑ Ⓒ Ⓓ
80. Ⓐ Ⓑ Ⓒ Ⓓ
81. Ⓐ Ⓑ Ⓒ Ⓓ
82. Ⓐ Ⓑ Ⓒ Ⓓ
83. Ⓐ Ⓑ Ⓒ Ⓓ
84. Ⓐ Ⓑ Ⓒ Ⓓ
85. Ⓐ Ⓑ Ⓒ Ⓓ
86. Ⓐ Ⓑ Ⓒ Ⓓ
87. Ⓐ Ⓑ Ⓒ Ⓓ
88. Ⓐ Ⓑ Ⓒ Ⓓ
89. Ⓐ Ⓑ Ⓒ Ⓓ
90. Ⓐ Ⓑ Ⓒ Ⓓ
91. Ⓐ Ⓑ Ⓒ Ⓓ
92. Ⓐ Ⓑ Ⓒ Ⓓ
93. Ⓐ Ⓑ Ⓒ Ⓓ
94. Ⓐ Ⓑ Ⓒ Ⓓ
95. Ⓐ Ⓑ Ⓒ Ⓓ
96. Ⓐ Ⓑ Ⓒ Ⓓ
97. Ⓐ Ⓑ Ⓒ Ⓓ

98. Ⓐ Ⓑ Ⓒ Ⓓ
99. Ⓐ Ⓑ Ⓒ Ⓓ
100. Ⓐ Ⓑ Ⓒ Ⓓ
101. Ⓐ Ⓑ Ⓒ Ⓓ
102. Ⓐ Ⓑ Ⓒ Ⓓ
103. Ⓐ Ⓑ Ⓒ Ⓓ
104. Ⓐ Ⓑ Ⓒ Ⓓ
105. Ⓐ Ⓑ Ⓒ Ⓓ
106. Ⓐ Ⓑ Ⓒ Ⓓ
107. Ⓐ Ⓑ Ⓒ Ⓓ
108. Ⓐ Ⓑ Ⓒ Ⓓ
109. Ⓐ Ⓑ Ⓒ Ⓓ
110. Ⓐ Ⓑ Ⓒ Ⓓ
111. Ⓐ Ⓑ Ⓒ Ⓓ
112. Ⓐ Ⓑ Ⓒ Ⓓ
113. Ⓐ Ⓑ Ⓒ Ⓓ
114. Ⓐ Ⓑ Ⓒ Ⓓ
115. Ⓐ Ⓑ Ⓒ Ⓓ

Practice Test 2

SECTION I

Part A

TIME: 20 MINUTES

Directions: Questions 1–37 are divided into five sets of questions based on color pictures in a separate booklet. In this book the questions are illustrated by black-and-white photographs at the top of each set. Select the multiple-choice response that best completes each sentence, and put the correct response on the answer sheet. You will have 20 minutes to answer the questions in Part A. You are advised to spend 4 minutes on each set of questions, although you may move freely among each set of questions.

Questions 1–8 are based on Figures 1 and 2. Four minutes.

Figure 1

Figure 2

1. The painting in Figure 1 was painted by

 (A) Pietro Perugino
 (B) Luca Signorelli
 (C) Andrea Mantegna
 (D) Raphael

2. The painting in Figure 2 was painted by

 (A) Domenico Ghirlandaio
 (B) Sandro Botticelli
 (C) Leonardo da Vinci
 (D) Paolo Uccello

3. The painting in Figure 1 is located in

 (A) the Pantheon
 (B) Saint Peter's Basilica
 (C) the Sistine Chapel
 (D) a Cathedral in Florence

4. The painting in Figure 1 shows Jesus handing keys to Saint Peter. This has been interpreted as

 (A) a memorial to the dead Saint
 (B) a transition of authority from Jesus to the pope
 (C) an understanding that keys are needed for success in life
 (D) Jesus unlocking the hearts of his followers

5. Both paintings are exercises in

 (A) sfumato
 (B) linear perspective
 (C) chiaroscuro
 (D) tenebroso

6. The structure in the center of the painting in Figure 1 resembles

 (A) the dome of Florence Cathedral
 (B) Saint Peter's Basilica
 (C) Notre Dame in Paris
 (D) the Hagia Sophia

7. The buildings on the extreme left and right of the painting in Figure 1 resemble

 (A) the Arc de Triomphe
 (B) the Arch of Constantine
 (C) the Arch of Titus
 (D) none of the above

8. The painting in Figure 2 tells the story of

 (A) a medieval joust
 (B) a tournament of medieval knights
 (C) the legend of King Arthur
 (D) a contemporary battle

Questions 9–14 are based on Figure 3. Four minutes.

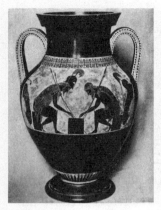

Figure 3

9. The Greek pot in Figure 3 was painted by

 (A) Exekias
 (B) Klietias
 (C) Euphronios
 (D) Douris

10. The two main figures on the pot are

 (A) Castor and Pollux
 (B) Hercules and Antaeus
 (C) Ajax and Achilles
 (D) Hermes and Dionysos

11. This vessel was probably used for

 (A) drinking
 (B) funeral rites
 (C) storing water or wine
 (D) fermenting wine

12. Such pots are called

 (A) geometric
 (B) orientalizing
 (C) red figure
 (D) black figure

13. Compositionally, the arrangement of forms of the pot relates to

 (A) a movement and expression of speed
 (B) symmetry and diagonals
 (C) the intricate contrasted with the monumental
 (D) an interrelationship of various rectangular forms

14. This type of pottery often required artists to seal and gloss their work in a process called

 (A) matting
 (B) glazing
 (C) ceramics
 (D) etching

Questions 15–22 are based on Figures 4 and 5. Four minutes.

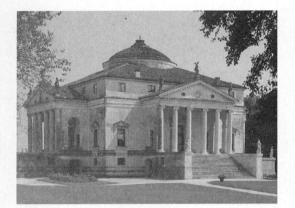

Figure 4

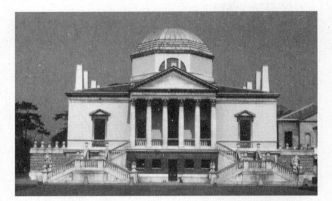

Figure 5

15. The building on the left is by

 (A) Giovanni di Paolo
 (B) Filippo Brunelleschi
 (C) Giulio Romano
 (D) Andrea Palladio

16. The building on the right is by

 (A) John Wood II
 (B) Inigo Jones
 (C) Thomas Jefferson
 (D) Robert Boyle and William Kent

17. Both buildings were influenced by which of the following ancient buildings?

 (A) The Colosseum
 (B) The Pergamon Altar
 (C) Hadrian's Villa
 (D) The Pantheon

18. Contextually, the buildings had the intended function of being

 (A) libraries
 (B) country homes
 (C) ballrooms
 (D) palaces

19. The building in Figure 5 differs from the building in Figure 4 because it has

 (A) symmetry
 (B) pediments over windows
 (C) one principal façade
 (D) the main floor lifted off the ground

20. Both of these buildings formed inspiration for which of the following American buildings?

 (A) Monticello
 (B) The White House
 (C) Independence Hall
 (D) The Alamo

21. These two buildings were built approximately how far apart?

 (A) 100 years
 (B) 300 years
 (C) 500 years
 (D) 1000 years

22. Both buildings suggest an acquaintance with the ancients and express

 (A) the idea that the ancient gods should be worshipped today
 (B) a revival of learning about ancient philosophies and ideas
 (C) the ability of modern societies to bemoan the loss of an ideal world
 (D) how the old world made buildings that the modern world could not improve on

Practice Test 2

Questions 23–30 are based on Figures 6 and 7. Four minutes.

Figure 6

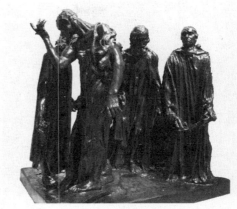

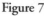

Figure 7

23. Both of these sculptures were done in the late nineteenth century by different artists. The artist of Figure 7 is

 (A) Georges Braque
 (B) Paul Gauguin
 (C) Auguste Rodin
 (D) Jean-Baptiste Carpeaux

24. Both sculptures are war memorials. The sculpture in Figure 6 commemorates the

 (A) War of the Roses
 (B) American Civil War
 (C) War of 1812
 (D) Crimean War

25. The sculpture in Figure 7 commemorates the

 (A) Franco-Prussian War
 (B) War of Spanish Succession
 (C) War of Greek independence
 (D) Hundred Years' War

26. Compared to Figure 7, Figure 6 is

 (A) biomorphic
 (B) conventional
 (C) powerful
 (D) innovative

27. Both works were meant to be placed in

 (A) a government building for the military
 (B) a veteran's museum
 (C) a city center
 (D) an art museum

28. The men portrayed on the work on the right are

 (A) city fathers
 (B) industrialists
 (C) soldiers
 (D) generals

29. The work on the left was unusual for its time in that it

 (A) commemorates fallen heroes
 (B) praises the general, but not the troops
 (C) represents the accomplishments of African-Americans
 (D) dignifies efforts on the home front

30. Both works are made of

 (A) bronze
 (B) clay
 (C) marble
 (D) granite

Practice Test 2

Questions 31–37 are based on Figure 8. Four minutes.

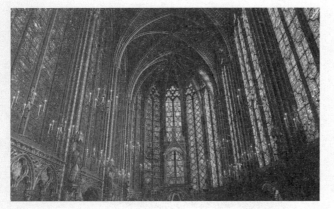

Figure 8

31. This Gothic building was built in which of the following periods?

 (A) Early Gothic
 (B) Perpendicular
 (C) Rayonnant
 (D) Flamboyant

32. One of the characteristics of buildings like these is the use of

 (A) stained glass
 (B) tapestries
 (C) mosaics
 (D) frescoes

33. This building is called

 (A) Notre-Dame
 (B) Saint-Chapelle
 (C) Salisbury Cathedral
 (D) Chartres Cathedral

34. This building was meant to house

 (A) royal tombs
 (B) royal robes
 (C) the crown jewels
 (D) sacred relics

35. The patron of this building is

 (A) Justinian
 (B) Louis IX
 (C) Charlemagne
 (D) Abbot Suger

36. This building achieves its architectural style through the use of

 (A) groin vaults
 (B) rib vaults
 (C) domes
 (D) pediments

37. This building was located next to a

 (A) royal palace
 (B) military institution
 (C) cathedral
 (D) hospital

SECTION I

Part B

TIME: 40 MINUTES

Directions: You have 40 minutes for Questions 38–115. Select the multiple-choice response that best completes each sentence, and put the correct response on the answer sheet.

Questions 38–40 are based on Figure 9.

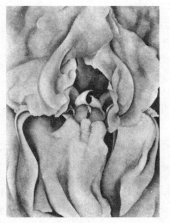

Figure 9

38. This painting is by

 (A) Georgia O'Keeffe
 (B) Barnett Newman
 (C) Frida Kahlo
 (D) Joan Miró

39. This artist stressed

 (A) simplified organic forms
 (B) intricate botanical details
 (C) big things made small
 (D) ecology and meteorology

40. In addition to the fact that this is a flower, it also has the overtones of being

 (A) mechanical
 (B) scientific
 (C) erotic
 (D) whimsical

41. Claude Monet did a series of paintings on all of the following EXCEPT

 (A) haystacks
 (B) sunrises
 (C) Rouen Cathedral
 (D) poplar trees

42. A mastaba was the precursor to a

 (A) pyramid
 (B) catacomb
 (C) temple
 (D) basilica

43. The Pergamon Altar depicts the battle between the gods and the giants, but also symbolically represents the

 (A) building of the Acropolis
 (B) rise of Greek power under Alexander the Great
 (C) Greek defeat of the Persians
 (D) Roman defeat of the Greeks

44. Praxiteles's sculptures are different from his predecessors in Greek art, because he stressed

 (A) a more emotional and lively approach
 (B) powerful and overwhelming nudes
 (C) suggestive figures with lightly veiled bodies
 (D) the humanization of the gods

Practice Test 2

Questions 45 and 46 are based on Figure 10.

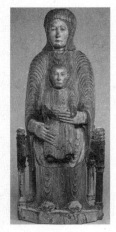

Figure 10

45. In this sculpture, the Virgin Mary functions as the

 (A) throne of wisdom
 (B) seat of love
 (C) marriage of heaven and hell
 (D) immovable object and the irresistible force

46. This sculpture is from which period?

 (A) Romanesque
 (B) Gothic
 (C) Northern Renaissance
 (D) Italian Renaissance

47. The term pietà refers to a work that

 (A) shows the Crucifixion of Jesus
 (B) is pitiful to behold
 (C) shows a grieving Virgin Mary mourning over a crucified Christ
 (D) illustrates any work of art that elicits pity from the viewer

48. The Russian Revolution of 1917 brought about an immediate artistic wave in Russia that permitted

 (A) abstraction
 (B) surrealism
 (C) icon production
 (D) fresco painting

49. Which of the following modern photographers promoted photography as an art form equal to painting by hanging photographs in a modern art gallery?

 (A) Louis Daguerre
 (B) Dorothea Lange
 (C) Alfred Stieglitz
 (D) Jacob Riis

50. Which modern movement is marked by a dramatic contrast of high keyed colors?

 (A) Organic
 (B) Fauvism
 (C) Dada
 (D) Art Deco

Questions 51–54 are based on Figure 11.

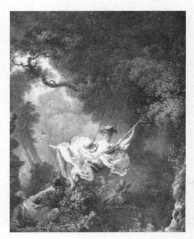

Figure 11

51. The artist of this work is

 (A) Jean-Antoine Watteau
 (B) Hyacinth Rigaud
 (C) Élisabeth Vigée-Lebrun
 (D) Jean-Honoré Fragonard

52. This painting was painted during which of the following centuries?

 (A) Sixteenth
 (B) Seventeenth
 (C) Eighteenth
 (D) Nineteenth

53. What period is this work from?

 (A) Baroque
 (B) Neoclassicism
 (C) Romanticism
 (D) Rococo

54. This painting is called an "intrigue painting" because

 (A) the principal figures are intriguing to behold
 (B) there is a suggestion of a love affair
 (C) the overall tonalities stress femininity
 (D) the colors are applied with an impasto technique

Questions 55 and 56 are based on Figure 12.

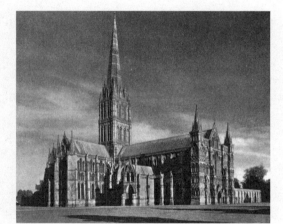

Figure 12

55. This building is English Gothic rather than French Gothic in that it

 (A) has no flying buttresses
 (B) has no stained glass
 (C) is surrounded by a park called a close
 (D) has sculpture on the façade

56. This building is located at

 (A) Salisbury
 (B) Canterbury
 (C) London
 (D) Ely

57. Group portraits were the specialty of

 (A) Jacob van Ruisdael
 (B) Rosalba Carriera
 (C) Frans Hals
 (D) Judith Leyster

Question 58 and 59 are based on Figure 13.

Figure 13

58. This painting is by

 (A) Hans Holbein
 (B) Matthias Grünewald
 (C) El Greco
 (D) Pieter Bruegel

59. This work was painted as part of a series about

 (A) landscapes
 (B) astrology
 (C) country life
 (D) the months of the year

Questions 60–62 are based on Figure 14.

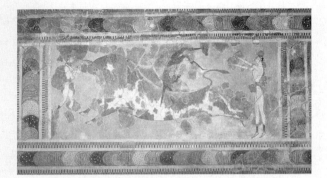

Figure 14

60. This painting was done in which of the following periods?

 (A) Etruscan
 (B) Minoan
 (C) Archaic Greek
 (D) Egyptian New Kingdom

61. This painting possibly represents

 (A) a religious ritual
 (B) a political message
 (C) a scene of animal husbandry
 (D) an episode in the Bible

62. One of the hallmarks of this style is the

 (A) use of linear perspective
 (B) cubistic forms
 (C) narrow-waisted figures
 (D) presence of an animal

Questions 63 and 64 are based on Figure 15.

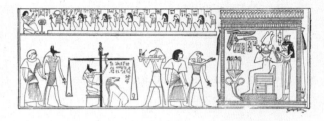

Figure 15

63. This is a typical Egyptian work in that it was

 (A) found in a mummy
 (B) given to a pharaoh as a present
 (C) painted on the wall of a tomb
 (D) painted on papyrus

64. The scene taking place here illustrates

 (A) the judging of a soul before admission to eternal life
 (B) the unification of upper and lower Egypt
 (C) the fortieth anniversary of the reign of Ramses II
 (D) figures preparing for a hunt

65. The impluvium is where Romans gathered

 (A) in the Forum to celebrate
 (B) for baths
 (C) to conduct business
 (D) water

66. The spirit of the Counter-Reformation can be seen in the work of

 (A) Hans Holbein
 (B) Matthias Grünewald
 (C) El Greco
 (D) Antonio Correggio

67. Which of the following art movements had artists who intentionally and actively campaigned for the initiation of World War I?

 (A) Art Nouveau
 (B) Futurism
 (C) Cubism
 (D) Expressionism

Questions 68–70 are based on Figure 16.

Figure 16

68. This sculpture of David is by

 (A) Michelangelo
 (B) Gianlorenzo Bernini
 (C) Andrea del Verrocchio
 (D) Donatello

69. This sculpture is true to the Biblical story of David in that

 (A) David wore this type of hat and had long hair
 (B) David was nude when he slew Goliath
 (C) the body represents the Biblical age of David
 (D) the head of Goliath was placed at David's feet

70. This sculpture was originally displayed in a

 (A) city square
 (B) private palace courtyard
 (C) church
 (D) synagogue

Questions 71 and 72 are based on Figure 17.

Figure 17

71. This building originally functioned as a palace chapel for

 (A) Charlemagne
 (B) Nefertiti
 (C) Constantine
 (D) Ottonian emperors

72. This building is unusual in that the columns

 (A) are from ancient Egypt
 (B) cannot be seen from the ground floor
 (C) have no support function
 (D) are made of iron

73. Judy Chicago's *Dinner Party* is an example of

 (A) a computer-generated image
 (B) a photo-montage
 (C) an installation
 (D) digital art

74. A kiva is most likely to be found in a

 (A) pueblo
 (B) pyramid complex
 (C) longhouse
 (D) meetinghouse

75. Ancient Roman' houses in Pompeii were painted with scenes

 (A) of mythological gods
 (B) of the afterlife
 (C) of the victories of Roman emperors
 (D) representing a procession of Roman nobles

Questions 76 and 77 are based on Figure 18.

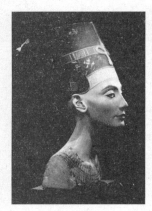

Figure 18

76. This bust was probably made

 (A) as a diplomatic gift
 (B) as a demonstration model
 (C) for an Egyptian temple
 (D) for the Queen's throne room

77. This is a portrait bust of

 (A) Tiye
 (B) Hatshepsut
 (C) Cleopatra
 (D) Nefertiti

Questions 78–81 are based on Figure 19.

Figure 19

78. The scene shown here represents

 (A) the Sacrifice of Noah
 (B) the Sacrifice of Isaac
 (C) the Flagellation
 (D) Cain and Abel

79. The format of this work is called

 (A) poesia
 (B) polyptych
 (C) quatrefoil
 (D) foreshortening

80. The sway to the body of the principal figure is similar to that seen in works like

 (A) the *Old Testament Trinity*
 (B) Royal Portals at Chartres
 (C) *The Virgin of Paris*
 (D) *The Last Judgment* by Gislebertus

81. The classical preferences in the body of the nude youth suggest an increased interest in

 (A) the enlightenment
 (B) humanism
 (C) modernism
 (D) the aristocracy

82. Vanitas paintings are usually

 (A) religious paintings
 (B) landscapes
 (C) portraits
 (D) still lifes

83. John Constable's landscapes represent

 (A) the serenity of the English countryside
 (B) awe of the American wilderness
 (C) the tempestuous side of nature
 (D) man's domination over the landscape

Question 84 is based on Figure 20.

Figure 20

84. The area in light grey in this diagram is an example of a

 (A) pendentive
 (B) trigylph
 (C) spandrel
 (D) metope

85. Most Egyptian capitals were based on

 (A) animals
 (B) plant leaves
 (C) vegetables and fruit
 (D) the Doric tradition

86. Because of its ground plan, the Palace of Knossos inspired the myth of

 (A) Midas
 (B) the Sacrifice of Iphigenia
 (C) Jupiter and Io
 (D) the Minotaur

87. To relieve the dullness of mud-brick construction, ancient Mesopotamians used which of the following as surface material?

 (A) Granite
 (B) Glazed brick
 (C) Limestone
 (D) Metal

88. Giambattista Tiepolo is an artist most associated with

 (A) ceiling paintings
 (B) landscapes
 (C) group portraits
 (D) still lifes

Questions 89–91 are based on Figure 21.

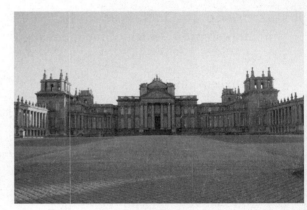

Figure 21

89. This building is known as

 (A) Versailles
 (B) the Escorial
 (C) Blenheim
 (D) Buckingham Palace

90. This palace was built for

 (A) George III
 (B) Louis XIV
 (C) the Duke of Marlborough
 (D) Charles IV

91. This building's design relies on architectural features seen in buildings from which of the following periods?

 (A) Spanish Romanesque
 (B) French Gothic
 (C) English Gothic
 (D) Italian Baroque

92. Religions that generally avoid figural images in their art include all of the following EXCEPT

 (A) Orthodox Christianity
 (B) Judaism
 (C) Protestantism
 (D) Islam

93. Painters who were influenced by the sublime were from which of the following periods?

 (A) Romanesque
 (B) Romanticism
 (C) Neoclassicism
 (D) Rococo

94. A cylinder seal was probably used

 (A) as ornaments on sculptures of gods
 (B) on the vaulting system of medieval churches
 (C) in the manufacture of textiles
 (D) to bind and seal documents

95. The Minimalist movement of the late twentieth century took inspiration from which of the following earlier movements?

 (A) Art Deco
 (B) Art Nouveau
 (C) Pop Art
 (D) DeStijl

Question 96 is based on Figure 22.

Figure 22

96. Which Roman Emperor is represented here?

 (A) Constantine
 (B) Marcus Aurelius
 (C) Nero
 (D) Caracalla

Questions 97 and 98 are based on Figure 23.

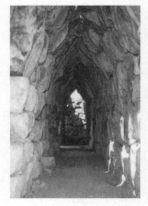

Figure 23

97. This gallery space is arched in a way called a

 (A) barrel vault
 (B) corbel vault
 (C) squinch
 (D) groin vault

98. The stonework construction is called

 (A) repoussé
 (B) Cyclopean
 (C) a relieving triangle
 (D) a cantilever

Questions 99–101 are based on Figure 24.

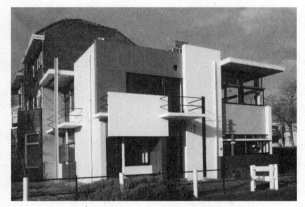

Figure 24

99. This building is called

(A) Monticello
(B) Schröder House
(C) Villa Savoye
(D) Robie House

100. This building was built in the

(A) 1920s
(B) 1940s
(C) 1960s
(D) 1980s

101. This building makes direct reference to which modern movement in painting?

(A) DeStijl
(B) Regionalism
(C) Cubism
(D) Metaphysical painting

102. The synagogue at Dura Europos is unusual in that

(A) it contains Christian imagery
(B) mosaics adorn the walls
(C) religious compositions dominate the walls
(D) there is no torah niche

Questions 103 and 104 are based on Figure 25.

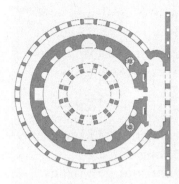

Figure 25

103. This is the ground plan for a building that is

(A) centrally planned
(B) axially planned
(C) longitudinally planned
(D) basilican plan

104. The oblong area on the right refers to the

(A) ambulatory
(B) narthex
(C) rib vault
(D) bay

105. John Ruskin's comment that a painting was "a pot of paint...flung in the public's face" was directed at a work by

(A) Edouard Manet
(B) Paul Cézanne
(C) Pablo Picasso
(D) James Whistler

106. William Blake was an English painter most famous for

(A) drawing scientific treatises
(B) illustrating his poems
(C) painting ghoulish nightmares
(D) painting full-length portraits

107. The Guggenheim Museo Bilbao is characterized by its

 (A) amorphous shapes
 (B) linearity
 (C) geometric forms
 (D) masses of concrete

108. Iconoclasm refers to the

 (A) exploration of iconography
 (B) making of icons
 (C) modern usage of icons
 (D) destruction of images

Questions 109–111 are based on Figure 26.

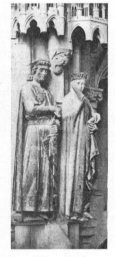

Figure 26

109. These two figures represent

 (A) a king and queen reviewing their troops
 (B) storybook characters from a medieval legend
 (C) founders of a cathedral
 (D) crusaders returning from the Holy Land

110. This sculpture is done in which of the following periods?

 (A) Byzantine
 (B) Romanesque
 (C) Baroque
 (D) Gothic

111. The woman in the sculpture can be characterized as

 (A) affectionate in a motherly way
 (B) cross and dismissive
 (C) aloof and shy
 (D) snobby and irritated

Questions 112–114 are based on Figure 27.

Figure 27

112. The Vietnam Veteran's Memorial in Washington, D.C., was designed by

 (A) Donald Judd
 (B) Maya Lin
 (C) Barbara Kruger
 (D) Frida Kahlo

113. The walls of the Memorial

 (A) symbolically point toward the Lincoln and Washington Memorials
 (B) contain printed messages of hope from the survivors
 (C) have illustrations that describe the horrors of war
 (D) are made of metal to reflect the sky

114. The monument is cut into the ground to symbolize

 (A) man's denuding of the environment
 (B) the destruction of agent orange and napalm
 (C) how underfunded the Vietnam War was
 (D) how a scar could be cut into a surface that would eventually heal

115. The patron of Raphael's *School of Athens* was

 (A) Lorenzo the Magnificent
 (B) Pope Julius II
 (C) Cardinal Farnese
 (D) Giuliano de'Medici

SECTION II
Part A

TIME: 60 MINUTES
2 QUESTIONS

> **Directions:** You have 1 hour to answer the two questions in Part A; you are advised to spend 30 minutes on each question. Use lined paper for your responses; a 30-minute essay generally fills three pages.

Question 1: A sculptor's choice of carving material often reveals his or her approach to the subject matter. Examine two works of sculpture from different periods, at least one of which must be from beyond the European tradition, and tell how the choice of material enhances the interpretation of the work. (30 minutes)

Question 2: Choose two works by two different artists in which a genre scene is depicted. Discuss how the artist has reached beyond the ordinary depiction of everyday life to a timeless artistic expression. (30 minutes)

SECTION II
Part B

TIME: 60 MINUTES
6 QUESTIONS

> **Directions:** The six questions in Part B are based on color photographs in a separate booklet. In this book the questions are illustrated by black-and-white photographs adjacent to each question. Each question is timed at 10 minutes, but you may move freely among all the questions in this part. The total time for all these essays is 1 hour. Use lined paper for your responses; each response should be about a page.

Figure 28

Figure 29

Question 3: Figure 29 is a detail of Figure 28. Identify the sculpture. In what ways does the artist reveal the royal and divine aspirations of the main figure? (10 minutes)

Figure 30

Question 4: "Raphael's greatest paintings seem so effortless that one does not usually connect them with the ideas of hard and relentless work. . . . We see cheap reproductions of these works in humble rooms and we are apt to conclude that paintings with such a general appeal must surely be a little 'obvious'. In fact, their apparent simplicity is the fruit of deep thought, careful planning, and immense artistic wisdom."—Gombrich, *The Story of Art*, 1950

To what movement in art history does Raphael belong? Refer to the Raphael work in Figure 30 and defend the claim by Gombrich that this work is more than "a little obvious." (10 minutes)

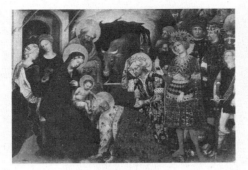

Figure 31

Question 5: Identify the art-historical period of this painting (Figure 31). What characteristics support your placement of the painting in the period you have selected? (10 minutes)

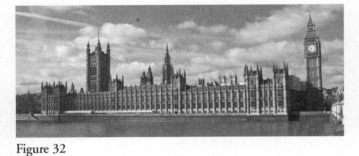

Figure 32

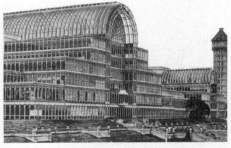

Figure 33

Question 6: Both of these buildings (Figures 32 and 33) were built in the same city only a few years apart. One building looks to the past and one looks forward to the future. Name the city in which these buildings are located and explain which building looks historical and which looks progressive, and why. (10 minutes)

Figure 34

Question 7: Identify the object in Figure 34 and the culture that produced it. What characteristics of this work identify it with that culture? (10 minutes)

Figure 35

Question 8: The painting in Figure 35 created a stir at the 1913 New York Armory Exhibition, which introduced modern art to Americans. What traditions in modern art is the painting drawing upon? (10 minutes)

Answer Key
PRACTICE TEST 2

Section I, Part A

1. **A**	11. **C**	21. **B**	31. **C**
2. **D**	12. **D**	22. **B**	32. **A**
3. **C**	13. **B**	23. **C**	33. **B**
4. **B**	14. **B**	24. **B**	34. **D**
5. **B**	15. **D**	25. **D**	35. **B**
6. **A**	16. **D**	26. **B**	36. **B**
7. **B**	17. **D**	27. **C**	37. **A**
8. **D**	18. **B**	28. **A**	
9. **A**	19. **C**	29. **C**	
10. **C**	20. **A**	30. **A**	

Section I, Part B

38. **A**	58. **D**	78. **B**	98. **B**
39. **A**	59. **D**	79. **C**	99. **B**
40. **C**	60. **B**	80. **C**	100. **A**
41. **B**	61. **A**	81. **B**	101. **A**
42. **A**	62. **C**	82. **D**	102. **C**
43. **C**	63. **D**	83. **A**	103. **A**
44. **D**	64. **A**	84. **C**	104. **B**
45. **A**	65. **D**	85. **B**	105. **D**
46. **A**	66. **C**	86. **D**	106. **B**
47. **C**	67. **B**	87. **B**	107. **A**
48. **A**	68. **D**	88. **A**	108. **D**
49. **C**	69. **C**	89. **C**	109. **C**
50. **B**	70. **B**	90. **C**	110. **D**
51. **D**	71. **A**	91. **D**	111. **C**
52. **C**	72. **C**	92. **A**	112. **B**
53. **D**	73. **C**	93. **B**	113. **A**
54. **B**	74. **A**	94. **D**	114. **D**
55. **C**	75. **A**	95. **D**	115. **B**
56. **A**	76. **B**	96. **B**	
57. **C**	77. **D**	97. **B**	

ANSWERS EXPLAINED

Section I

1. **(A)** *Christ Giving the Keys of the Kingdom to Saint Peter* was painted by Pietro Perugino.

2. **(D)** *The Battle of San Romano* was painted by Paolo Uccello.

3. **(C)** The painting is located on the walls of the Sistine Chapel.

4. **(B)** Because the Sistine Chapel is the place where popes are elected, this painting takes on the significance of Jesus handing his keys of the earthly and spiritual kingdom to the first pope, Peter, and to all the elected popes thereafter.

5. **(B)** Both paintings are exercises in linear perspective. Figure 1 has one-point perspective with a vanishing point that terminates in the door of the central building. Fallen lances in Figure 2 draw the viewer deeper into space.

6. **(A)** The structure in the center has a dome that resembles the one recently built on Florence Cathedral by Filippo Brunelleschi.

7. **(B)** The buildings on the extreme left and right represent updated versions of the Arch of Constantine in Rome.

8. **(D)** *The Battle of San Romano* is a contemporary event.

9. **(A)** This Greek pot was painted by Exekias.

10. **(C)** The two main figures on the pot are Ajax and Achilles. They are playing a round of drafts.

11. **(C)** This type of vessel, an amphora, was used for storing water or wine.

12. **(D)** Such pots are done in black figure style.

13. **(B)** Strong diagonals lead the eye to the center of the composition which is dramatically composed using the symmetrical forms of the figures.

14. **(B)** Pots like these were glazed to preserve their surface texture.

15. **(D)** Andrea Palladio is the architect of the Villa Rotonda.

16. **(D)** Robert Boyle and William Kent are the architects of Chiswick House.

17. **(D)** Both buildings were influenced by the Pantheon, which has a similar pedimental front with a dome behind it.

18. **(B)** The buildings are both country homes, or villas.

19. **(C)** Chiswick House has only its garden façade. The Villa Rotonda has four equal façades.

20. **(A)** Both of these buildings, with their pediments, columns, domes, and symmetry resemble Monticello.

21. **(B)** These two buildings were built about 300 years apart.

22. **(B)** Both buildings were built during revivals of interest in antiquity. The Villa Rotonda was built during the Renaissance, Chiswick House during the Enlightenment.

23. **(C)** Auguste Rodin sculpted the *Burghers of Calais.*

24. **(B)** The *Shaw Memorial* by Augustus Saint-Gaudens commemorates the American Civil War.

25. **(D)** The *Burghers of Calais* commemorates the Hundred Years' War.

26. **(B)** The *Shaw Memorial* is more traditional and more conventional than the *Burghers of Calais.*

27. **(C)** Both works were originally designed for a downtown location.

28. **(A)** The Burghers were city fathers.

29. **(C)** The *Shaw Memorial* commemorates the first African-American troops to fight on the union side during the Civil War.

30. **(A)** Both works are made of bronze.

31. **(C)** The Rayonnant style is characterized by great sheets of glass dissolving the wall spaces.

32. **(A)** These buildings are characterized by their extensive use of stained glass.

33. **(B)** This building is Saint-Chapelle in Paris.

34. **(D)** This building was built expressly to house sacred relics from the Holy Land, collected by the king.

35. **(B)** Louis IX was the patron of Saint-Chapelle.

36. **(B)** The visible ribs on the ceiling indicate that this building employs rib vaults to stabilize the structure.

37. **(A)** Saint-Chapelle was located next to the royal palace, so this became the royal chapel.

38. **(A)** This painting is by Georgia O'Keeffe.

39. **(A)** Georgia O'Keeffe is known for enlarging botanical specimens.

40. **(C)** There are erotic overtones, which Georgia O'Keeffe denied, in her work.

41. **(B)** Claude Monet painted series of paintings about Rouen Cathedral, poplar trees, and haystacks, but not sunrises.

42. **(A)** A mastaba is an early Egyptian tomb, which formed the basis for the pyramid.

43. **(C)** The Pergamon Altar celebrates the victory of the gods over the giants, but also symbolically represents the Greek victory over the Persians.

44. **(D)** Praxiteles's sculptures, like *Hermes and Dionysos* and *Aphrodite of Knidos* are very human renderings of the gods.

45. **(A)** The Virgin Mary supports Christ on her lap and acts as a throne of wisdom.

46. **(A)** This sculpture is from the Romanesque period.

47. **(C)** The term pietà refers to any sculpture or painting that shows the Virgin Mary grieving over a crucified Christ, who is customarily placed in her lap.

48. **(A)** The Russian Revolution brought about a short-lived period of free expression in the arts, in which abstraction flourished.

49. **(C)** Alfred Stieglitz owned an art gallery that housed both paintings and photographs framed equally as works of art.

50. **(B)** Fauvism is known for its dramatic contrasts of color.

51. **(D)** Jean-Honoré Fragonard is the painter of *The Swing*.

52. **(C)** *The Swing* is an eighteenth-century painting.

53. **(D)** *The Swing* was painted during a movement called the Rococo.

54. **(B)** *The Swing* is an intrigue painting because it captures an evocative moment between a hiding lover admiring a young lady swinging over him. The man pulling the swing has no idea that the woman is being flirtatious.

55. **(C)** English Gothic buildings are in parklike settings called a close.

56. **(A)** This building is Salisbury Cathedral.

57. **(C)** Franz Hals is famous for painting lively group portraits.

58. **(D)** *Hunters in the Snow* is a painting by Pieter Bruegel.

59. **(D)** *Hunters in the Snow* was painted as part of a series of works about the months of the year.

60. **(B)** *The Toreador Fresco* is a Minoan work.

61. **(A)** This work represents a religious rite.

62. **(C)** Minoan figures have extremely narrow waists.

63. **(D)** *The Judgment of Osiris* was painted on papyrus.

64. **(A)** The scene describes the judgment of a person's soul after death but before admission into eternal life.

65. **(D)** The impluvium in Roman homes gathered rainwater.

66. **(C)** El Greco's paintings of intense religious zeal are compatible with the spirit of the Counter-Reformation.

67. **(B)** The Futurists wanted Italy to declare war in World War I. They saw war as an exciting experience that represented the wave of the future.

68. **(D)** This sculpture is Donatello's *David*.

69. **(C)** The body of David is of a "lad," or a child the age described in the Biblical story.

70. **(B)** This sculpture was originally displayed in a private palace courtyard.

71. **(A)** This building is the Palatine Chapel at Aachen built for Charlemagne.

72. **(C)** The interior columns between the arches have no support function and are used to fill the space.

73. **(C)** Judy Chicago's *Dinner Party* is an installation.

74. **(A)** A kiva is a round room used for religious rituals in a pueblo.

75. **(A)** Scenes of the stories of the mythological gods, among other things, are commonplace in Pompeiian villas.

76. **(B)** This bust was a prototype, so that others could be made from this model.

77. **(D)** This is a bust of Nefertiti.

78. **(B)** This scene is the Biblical story of the Sacrifice of Isaac.

79. **(C)** The fanciful shape of the bronze plaque is called quatrefoil.

80. **(C)** The sway of Abraham is reminiscent of the S-curve in Gothic works such as *The Virgin of Paris.*

81. **(B)** The classically nude figure of Isaac shows the marriage of antiquity and Christianity in a spirit called humanism.

82. **(D)** Most Dutch vanitas paintings are still lifes.

83. **(A)** John Constable's landscapes depict the serenity of the English countryside, as in his *Haywain.*

84. **(C)** The light grey areas between the arches are called spandrels.

85. **(B)** Most Egyptian capitals are based on plant forms: i.e., palm, papyrus, and lotus.

86. **(D)** The legend of the Minotaur tells of the labyrinth that Theseus had to walk through to kill the monster. Such a labyrinth springs from the rambling ground plan of the Palace of Knossos.

87. **(B)** Glazed brick, such as those on the Ishtar Gate, hide the mud construction of Mesopotamian buildings.

88. **(A)** Giambattista Tiepolo painted a large number of ceiling paintings for which he is most famous.

89. **(C)** This building is Blenheim by John Vanbrugh.

90. **(C)** This palace was built for the Duke of Marlborough by the English as a thank you for winning an important battle at Blenheim in the War of Spanish Succession.

91. **(D)** The design, with its massive interplay of undulating forms, is inspired by Italian Baroque buildings.

92. **(A)** Orthodox Christians, such as Greek Orthodox and Russian Orthodox, use many images in their churches.

93. **(B)** The Sublime is associated with the Romantic period.

94. **(D)** A cylinder seal was used to bind and seal documents in the Ancient Near East.

95. **(D)** Because Minimalism is abstract and relies on pure shapes and linear forms, it is most closely associated with the works of Piet Mondrian in the DeStijl school.

96. **(B)** This is an equestrian statue of Marcus Aurelius.

97. **(B)** This gallery space is a corbelled vault.

98. **(B)** This massive stonework is called Cyclopean.

99. **(B)** This building is the Schröder House, built by Gerrit Rietveld.

100. **(A)** The Schröder House was built in 1924–1925.

101. **(A)** The flat planes of interlocking primary colors and neutrals in the Schröder House are noticeably reminiscent of DeStijl painting.

102. **(C)** Religious compositions dominate the walls of Dura Europos, a Jewish synagogue that usually eschews religious imagery.

103. **(A)** This is a centrally planned building, with the altar in the middle.

104. **(B)** The oblong area is the entrance lobby, or narthex, of the building.

105. **(D)** John Ruskin was criticizing James Whistler's *Nocturne in Black and Gold: The Falling Rocket.*

106. **(B)** William Blake was most famous for illustrating his own poems.

107. **(A)** The Guggenheim Museo Bilbao has spiraling amorphous shapes.

108. **(D)** Iconoclasm refers to the destruction of images.

109. **(C)** *Ekkehard and Uta* are two figures who are founders of Naumburg Cathedral.

110. **(D)** *Ekkehard and Uta* are two Gothic sculptures.

111. **(C)** Uta's coy gesture is aloof and shy.

112. **(B)** Maya Lin is the designer of the Vietnam Veteran's Memorial.

113. **(A)** The walls of the Vietnam Veteran's Memorial point to the monuments of the two greatest presidents of the United States, George Washington and Abraham Lincoln.

114. **(D)** Maya Lin said that the monument should cut into the ground the way a scar would mark the earth, but eventually heal. Symbolically, the effects of the war marred the nation, but it will also heal.

115. **(B)** Pope Julius II was the patron of Raphael's *School of Athens.*

Section II

Rubric for Question 1

8–9: The student chooses two appropriate choices and identifies them completely. The student explains the relationship between the sculpted image and the medium and uses that as the foundation for the essay. The lower mark is given if the discussion is unbalanced. There are no major errors.

6–7: The student chooses two appropriate choices and identifies them. The student explains the relationship between the sculpted image and material, but the discussion may be unbalanced, or lacks completeness. The lower mark is given if the discussion is disorganized. There may be minor errors.

5: The student chooses two appropriate choices and identifies them. The student gives some explanation of the role the medium plays in conceiving an image. There may be minor errors. A 5 is the highest mark a student can earn if only one appropriate choice is made and it is fully discussed.

3–4: The student chooses one appropriate choice and identifies it. The student explains the role material plays in conceiving an image, but discussion is weak and unbalanced, OR the student chooses two appropriate choices, but does not answer the question in a significant way. There may be major errors.

1–2: The student writes an insubstantial essay that manages to gather one appropriate choice and writes something to address the question. There may be major errors.

0: The student makes an attempt, but the response is without merit.

Model Response for Question 1

When an artist chooses to make a sculpture many elements are taken into consideration, including the material he or she will use. Many times the choice of carving material is just as important as the subject matter, for it can help the viewer interpret the work on a higher level, or can help to learn about the culture which produced it. Two such examples are Michelangelo's *Pietà* completed in the 16th century, carved in marble, and the *Bust of Queen Nefertiti* completed in 1345 B.C.E. carved in limestone during the New Kingdom period of Egyptian history.

Michelangelo was commissioned to carve his *Pietà* by a high-ranking Church official during the High Renaissance. This was a time when religion meant a lot to the people of Italy and played a huge role in their lives. Michelangelo chose to depict the scene of the Virgin Mary holding Christ's

dead body in a single piece of white marble. This choice of material is important because it helps the viewer understand the divine nature of the subject as well as the importance of the scene to Catholicism.

The single piece of marble is a pure, white, polished material. This directly correlates to the scene in which the pure Virgin Mary holds her dead son in her arms who sacrificed his life for the salvation of others. Also, the fact that this work of art was carved out of a single piece of material further emphasizes the gravity of the story and the divine nature of Christ's sacrifice, his mother's love, and Michelangelo's talent.

Michelangelo was fortunate enough to live in a society capable of shipping such materials. The Egyptians, on the other hand, living in an earlier time and most likely unaware of certain materials, were forced to use those indigenous to the region. For example, the *Bust of Queen Nefertiti* is carved from limestone and gypsum, two materials readily available in the Egyptian kingdom. Hers and similar busts were created to be lasting remembrances of the ruling class and their grandeur. They were to be venerated for years since the Egyptians believed that their kings and queens were gods.

It is logical then, that the *Bust of Queen Nefertiti* was carved of this material because of limestone's durability; it is so durable that it remains intact even at present, thousands of years later. Limestone can be painted, which one can gather from this statue in particular, which is decorated with bright paint to highlight Queen Nefertiti's famous beauty. The fact that the sculpture still remains today and that its decorative qualities are directly related to the use of limestone and gypsum in its creation, helps the viewer to understand the importance of these features to the Egyptians, as well as their knowledge of certain materials' qualities.

It is important to examine and understand the choice of material when looking at a sculpture because many times the material can, and will, enhance the viewer's interpretation of the work. This can be seen in Michelangelo's choice of pure marble for his *Pietà*, as well as the Egyptians' choice of limestone for their royal busts. In both examples the viewer is better able to understand the work in both the religious and cultural aspects by noting the material used. Studying this, and all aspects of a work, is crucial for fully understanding and appreciating it.

—Tara P.

Analysis of Model Response for Question 1

Tara chooses two appropriate choices, Michelangelo's *Pietà* and the Egyptian New Kingdom *Bust of Nefertiti*. The second choice fulfills the requirement of selecting a work from beyond the Western tradition. Both analyses are solid, paralleling the work's meaning and interpretation to the medium the artist sculpted in. Among the

important points Tara raises include Michelangelo's selection of marble to symbolize the purity and virginity of Mary, and the Egyptian use of limestone as a symbol of permanence and durability. **This essay merits a 9.**

Rubric for Question 2

8–9: The student chooses two appropriate choices, fully identifies them, and explicitly addresses the question, pointing out how the works transcend ordinary depictions of everyday life. The lower mark is given if the discussion is unbalanced. There are no major errors.

6–7: The student chooses two appropriate choices, identifies them, and addresses the question. However, the discussion may be unbalanced, or lack completeness. The lower mark is given if the discussion is disorganized. There may be minor errors.

5: This is the highest mark a student can earn if his or her essay has only one appropriate choice, and that choice is fully discussed, OR the student chooses two appropriate choices and identifies them, but gives a limited explanation of how genre scenes can transcend the ordinary. There may be minor errors.

3–4: The student chooses one appropriate choice and identifies it. The student explains what genre scenes are, but does not detail how their chosen works transcend the ordinary. Discussion may be weak and unbalanced, OR the student chooses two appropriate choices, but does not answer the question in any significant way. There may be major errors.

1–2: The student writes an insubstantial essay that manages to give one appropriate choice and writes something to address the question. There may be major errors.

0: The student makes an attempt, but the response is without merit.

Model Response for Question 2

Peasant Wedding, by Pieter Bruegel (c. 1568)

Girl Reading a Letter at an Open Window, by Johannes Vermeer (c. 1657)

Genre scenes are mainly northern European in origin, though examples abound from many countries at various points throughout art history. Two examples from the Netherlands are Bruegel's *Peasant Wedding*, from the sixteenth century, and Vermeer's *Girl Reading a Letter at an Open Window*, from the seventeenth century. They both illustrate an intent to exceed the simple representation of everyday life in order to accomplish a work of art.

Bruegel's painting employs a number of artistic devices to construct and communicate a powerful narrative to the viewer. He is sympathetic to his peasant subjects, whose charm and simplicity are always in evidence; this was a rare concern in Bruegel's time. In this painting, a large number of figures and personalities are depicted, filling the frame. Seated and standing are villagers, peasants, bakers, musicians, and officials. Their expressions are naturalistic, evincing emotion and individual character. Color is rich, almost primary, evoking the festive aspect of the celebration. Vivid color and line help to evoke a good deal of detail in the dress of the figures, distinguishing the villagers by class and trade. Perspective separates the main groupings of people: some are in the extreme foreground with others ranging farther back or center. The setting is inside a barn, in which simple wooden tables have been set up; these aspects help to organize the representation. The eye is immediately led to the seated bride, who is highlighted by a wall hanging and a crownlike object above her head. The narrative is told in the action of the subjects eating, laughing, carrying food, or pouring beer. Wheat on the wall reminds us of the harvest; the abundant food and celebration are meant to evoke the fruits of peasant labor. Within this scene are many mininarratives: countless conversations, gestures, and glances dazzle our eyes. Bruegel multiplies our possibilities of reading and understanding the working classes of the time with his humanizing and detailed genre scenes.

As bustling and alive as Bruegel's canvas, Vermeer's painting is one of reflection, stillness, and interiority. Vermeer uses various techniques to form a compelling example of the genre scene. The lone subject of the girl appears in profile, facing left, head bent slightly as she reads her letter. The window appears to cast light on her face, highlighting her central position in the painting. Luxuriously rendered fruit and fabric on the table in the foreground surround her. Above her head, a long, red curtain is draped on the open window, extending the length of the scene. Most astonishingly, in the extreme foreground is a green curtain that fills the vertical space of the frame; it appears to be drawn on the very painting itself. Vermeer uses perspective and the arrangement of objects to place the girl in her own three-dimensional, intimate space—shut off from the world and absorbed in her letter. The lush colors evoke Italian influence and bathe the canvas in a vibrant light; the trompe l'oeil devices evoke natural space, perspective, and depth. The girl's reflection appears in the windowpane beside her, showing us her pensive, contemplative mood. All these elements render the scene most convincing: We are made to wonder what she is reading and how it makes her feel, and above all, who she might be. The painting is less a depiction of an anonymous girl than a careful study of the stillness of a private moment.

—Nader U.

Analysis of Model Response for Question 9

This superb response does everything a student needs to do to earn full credit. It carefully lists two appropriate choices so that the reader can identify the direction of the essay immediately. It then opens with a short paragraph showing a thorough understanding of the question. Each paragraph fully describes one painting, making sure that the description addresses the question at all times. Lines like "Bruegel multiplies our possibilities of reading and understanding the working classes of the time with his humanizing and detailed genre scenes" prove to the reader that this genre scene transcends the ordinary. This response earns full credit, even though there is a slight error in calling the Bruegel a canvas, when indeed it is oil painted on wood. **This essay merits a 9.**

Rubric for Question 3

4: The student identifies the sculpture and discusses three ways in which the main figure reveals a royal and divine presence in the work. There are no major errors.

3: The student identifies the sculpture and discusses two ways in which the main figure reveals a royal and divine presence in the work. There may be minor errors.

2: The student identifies the sculpture and discusses one way in which the main figure reveals a royal and divine presence. This is the highest mark one can earn if the student does not identify the work, but presents two solid reasons for royal and divine associations. There may be minor errors.

1: The student identifies only the sculpture OR the student remarks only on one royal or divine association. There may be major errors.

0: The student makes an attempt, but the response is without merit.

Model Response for Question 3

The sculpture is the *Victory Stele of Naram-Sin* from the Akkadian period. Through the use of hierarchy of style the artist gives the impression that the central large isolated figure at the top of the mountain is a powerful, royal, and even divine person. All of the other figures in the sculpture are focusing their attention on the one large figure with his great horned helmet, giving a further impression of royalty. The figure directly to the right of Naram-Sin is kneeling with what looks to be a spear in his neck. This figure seems to be a subdued enemy, one of many depicted in the sculpture, debased at the feet of the king. Naram-Sin rules with the blessings of the gods, symbolized by the suns above, shining down on him.

—Leonid M.

Analysis of Model Response for Question 3

Leonid fully identifies the sculpture and lists at least three characteristics of royalty or divinity that are associated with this work, such as hierarchy of scale, subdued figures at his feet, and the gods in the form of stars shining above. **This essay merits a 4.**

Rubric for Question 4
4: The student recognizes the period as Renaissance or High Renaissance, and addresses the stylistic qualities of the work that explain Gombrich's quotation, for example, triangular composition or contrapposto. There are no major errors.
3: The student recognizes the period as Renaissance or High Renaissance, and addresses the stylistic qualities of the work that explain Gombrich's quotation, for example, triangular composition or contrapposto, but the essay is generalized and may contain errors.
2: This is the highest score a student can earn if the period is not identified as Renaissance or High Renaissance. Some attempt is made to address the relationship of the quotation to the painting, but the answer lacks specificity. There may be some errors.
1: The student simplify identifies Renaissance or High Renaissance, but has nothing else of merit to add, or there is a generalized comment about the relationship of the quotation to the painting.
0: The student makes an attempt, but the response is without merit.

Model Response for Question 4

Raphael belongs to the High Renaissance period. According to Gombrich, his work is more than "a little obvious." This is primarily because of the use of the High Renaissance triangle and chiaroscuro. The triangle is used for the woman, Madonna, and the children at her legs. Her head is the top point and it could be formed into a perfect triangle. Another technique used is chiaroscuro. The sky goes from lighter to dark. The dark and light is contrasted tremendously as shown in the grass with the rocks behind her. The trees stick out and are bold compared to the sky. Raphael's use of the High Renaissance triangle and chiaroscuro show that it is from the High Renaissance, hence, making it indeed "a little obvious."

—Shafak I.

Analysis of Model Response for Question 4

Shafak's response identifies High Renaissance as the correct period. She goes on to explain how the High Renaissance characteristics seen in this work include the triangular composition and chiaroscuro. Shafak never loses sight of the quotation and is careful to address the question. **This essay merits a 4.**

Rubric for Question 5

4: The student identifies this period as International Gothic. Gothic alone is not a full enough identification to earn a 4. The student explains the chief characteristics of this movement by pointing to specific passages in the painting that illustrate these characteristics. Identifying the painting is usually a sign that the student knows the subject matter, but in this question does not add points. There are no major errors.

3: The student identifies this period as International Gothic. Gothic alone is not a full enough identification to earn a 3. The student explains some of the characteristics of International Gothic and writes generally about the painting and these traits.

2: The student fails to identify the period as International Gothic, or simply labels it Gothic or Renaissance. The student gives some explanation of the characteristics of this period, but the argument in insubstantial. There may be major errors.

1: The student fails to identify the period, but gives a broad explanation of the characteristics, OR the student identifies only the period and adds nothing of substance.

0: The student makes an attempt, but the response is without merit.

Short Essay Model Response for Question 5

This piece is of the International Gothic period. This style, spearheaded by Simone Martini, was largely developed to cater to aristocrats. The elements that place this piece with the International Gothic are the heavy use of gold and the aristocratic look of the figures. This altarpiece also has a predella, which is typical of Sienese Gothic altarpieces. The royal-looking patterns on the robes of the figures and even on the reins of the horses give an aristocratic feel to the piece. Mary is elegantly draped and shows courtly modesty in her appearance. These characteristics place the altarpiece in the International Gothic period.

—Neha M.

Analysis of Model Response for Question 5

Neha immediately correctly identifies the period as International Gothic. International Style would also be acceptable. Gothic would not be enough. She understands that the International Gothic is in the aristocratic taste of the time, and that includes "royal-looking patterns on the robes" and Mary being "elegantly draped." A nice touch is the added fact that Mary shows "courtly modesty." This essay looks intently at the piece and understands the stylistic features of International Gothic. **This essay merits a 4.**

Rubric for Question 6

4: The student identifies the city as London and knows that the Houses of Parliament, with its Gothic formula and classical underpinnings, represents the conservative will of Parliament in the construction of their capitol. The student also recognizes that the exposed use of glass and cast iron are key to understanding the progressive spirit expressed in the Crystal Palace by Sir Joseph Paxton. There are no major errors.

3: The student identifies London and knows that Parliament is the historical-looking building and the Crystal Palace is the progressive. The student supplies an explanation with less specificity. There may be minor errors.

2: The student fails to address one of the major requirements of the question: The city, the knowledge as to which piece is historical and which is progressive, or the reasons why. There may be major errors.

1: The student fails in two regards to answer the requirements of the question. There may be major errors.

0: The student makes an attempt, but the response is without merit.

Model Response for Question 6

The Houses of Parliament by Barry and Pugin and the Crystal Palace by Joseph Paxton are both works built in the city of London. The Houses of Parliament is a work that reminisces on the past. In contrast, the Crystal Palace was an engineering feat looking toward the future.

The Houses of Parliament is a product of Barry's classical architecture combined with Pugin's perpendicular Gothic style. The size of the structure and the presence of towers throughout reflect the splendor of Victorian England. It clearly looks toward the past by incorporating Gothic details onto a classical frame. This was deemed to be fitting for England's capitol, which was required to be a building in what was considered a native style of architecture.

The Crystal Palace was a building developed to house an international exposition. The visibility of its iron frame was unique in its time. For the first time, an engineering masterpiece served a purpose beyond that of utility. This work looks toward the future by embracing a style that would inspire the construction of future buildings by having walls of exposed glass and cast iron.

—Farhan C.

Analysis of Model Response for Question 6

Farhan focuses on the requirements for a high score on this essay and directly responds to the question. He scores one point immediately for knowing the city is London, and while not required in the question, he appears informed by naming the buildings and the architects. He then explains that the Houses of Parliament were inspired by both the Classical and Perpendicular Gothic traditions, therefore looking to the past. He also discusses how the Crystal Palace, with its use of exposed cast iron and glass confronts modern architecture. This is a concise response to a question that could cause a well-informed student to meander past the requirements for the highest score. **This essay merits a 4.**

Rubric for Question 7
4: The student identifies the Animal Head Post and understands that it was found in the grave of two royal women. The student identifies at least two of the major characteristics of this piece, for example the animal style and the interlace patterns. There are no major errors.
3: The student identifies the Animal Head Post and understands that it was found in the grave of two royal women. The student identifies at least one of the major characteristics of this piece. There may be minor errors.
2: The student does two of the following correctly: understands the context, identifies the piece or gives a characteristic. There may be major errors.
1: The student does one of the following correctly: understands the context, identifies the piece or gives a characteristic. There may be major errors.
0: The student makes an attempt, but the response is without merit.

Model Response for Question 7

The object shown is the <u>Animal Head Post</u> from the <u>Oseburg Ship Burial</u>. It is a piece of artwork produced by the Vikings in the ninth century. The use of animal style and interlacing patterns on the head are clearly Viking. The fact that his head is an animal to begin with also indicates that this object was produced by the Vikings. The Vikings usually produced functional objects which means that this head post was probably used for something. However, the specific use of this object is unknown.

—Victoria S.

Analysis of Model Response for Question 7

This short but precise response names the Vikings as the culture, and the *Animal Head Post* as the name of this object. Several of the pertinent characteristics include interlace, animal style, and adorned functional object. **This essay merits a 4.**

Rubric for Question 8

4: The student explains that the painting was inspired by at least two modern traditions and then explains how by pointing out specific characteristics in the work. There are no major errors.

3: The student explains that the painting was inspired by at least two modern traditions, but explains how specific characteristics relate to only one movement. There may be minor errors.

2: The student names and discusses only one major movement that the painting was inspired by. There may be major errors.

1: The student names only one major movement the work was inspired by. There is minimal discussion, and there may be major errors.

0: The student makes an attempt, but the response is without merit.

Model Response for Question 8

The painting shown is Marcel Duchamp's <u>Nude Descending a Staircase No. 2</u>. It was introduced into the 1913 New York Armory Show, which was an exhibition that introduced Americans to modern art. This work was representative of the Futurism movement. Futurists used gaudy effects of representation, rendering a shattered look to the work which was also seen in Cubism. This work depicts an assumed nude going down a flight of stairs. It had a limited color range and was influenced by motion pictures and multiple-exposure photography.

—Dan F.

Analysis of Model Response for Question 8

Dan correctly identifies the artist as Marcel Duchamp, earning a point. The artist was indeed inspired by Cubism and Futurism, as this response points out. It is not clear if Dan understands what "gaudy effects" are because he seems to equate them with "a shattered look to the work." The question asks the student to explain how characteristics of this work are representative of this movement, and his response is that the work has a "limited color range," which while true, does not address a characteristic of this movement as a whole. Because the essay does not address the last question fully, it does not earn a 4. **This essay merits a 3.**

EVALUATION OF PRACTICE TEST 2

Multiple-Choice Section

Your practice test score can now be computed. The multiple-choice section of the actual test is scored by computer, but it uses the same method you will use to compute your score manually. Each correct answer earns one point. Each incorrect answer has no value, and cannot earn or lose points. Omitted questions or questions that the computer cannot read because of smudges or double entries are not scored at all. Go over your answers and mark the ones correct with a "C" and the ones incorrect with an "X."

Total number of correct answers: _____

Conversion of Raw Score to Scaled Score

Your raw score is computed from a total of 115 questions. In order to coordinate the raw score of the multiple-choice section with the free-response section, the multiple-choice section is multiplied by a factor of .69565. For example, if the raw score is 90, the weighted score is 62.6. Enter your weighted score in the box on the right.

> **Enter your weighted multiple-choice score:**
> _____

Long-Essay Section

When grading your long-essay section, be careful to follow the rubric so that you accurately assess your achievement. Grade each essay on a scale of 0–9 and total the scores for this section. The highest point total for this section is 18.

Score on Question 1: _____

Score on Question 2: _____

Total Raw Score on Long-Essay Question: _____

In order to weight this score appropriately, multiply your score by 2.7778. For example, a raw score of 15 will yield a weighted score of 41.7. Total possible scoring for this section is 50.

> **Enter your weighted long-essay score:**
> _____

Short-Essay Section

When grading your short-essay section, be careful to follow the rubric·so that you accurately assess your achievement. Grade each essay on a scale of 0–4 and total the scores for this section. The highest point total for this section is 28.

Score on Question 3: _____

Score on Question 4: _____

Score on Question 5: _____

Score on Question 6: _____

Score on Question 7: _____

Score on Question 8: _____

Total Raw Score on Short-Essay Section: _____

In order to weight this section appropriately, the raw score is multiplied by 2.92, so that the highest weighted score is 70.

> **Enter your weighted short-essay score:**
> _____

Final Scoring

Add your weighted scores. A perfect score is 200. Although the weighting changes from year to year, a general rule of thumb is that 75% correct is a 5, 67% is a 4, and 56% is a 3. Use the following table as an estimate of your achievement.

> **Enter your total weighted score:**
> _____

5	150 points
4	133 points
3	112 points
2	91 points
1	74 points

> **Enter your AP score:**
> _____

Glossary

Abstract: works of art that may have form, but have little or no attempt at pictorial representation (Figure 25.22)

Academy: an institution whose main objects include training artists in an academic tradition, ennobling the profession, and holding exhibitions

Acropolis: literally, a "high city," a Greek temple complex built on a hill over a city

Action painting: an abstract painting in which the artist drips or splatters paint onto a surface like a canvas in order to create his or her work (Figure 26.8)

Aerial perspective: *see* **Perspective**

Allegory: work of art that possesses a symbolic meaning in addition to a literal interpretation. In literature, a fable is an example of an allegory (Figure 14.11)

Altarpiece: a painted or sculpted panel set atop an altar of a church (Figure 14.5)

Ambulatory: a passageway around the apse or an altar of a church (Figure 12.3)

Amphora: a two-handled Greek storage jar (Figure 5.33)

Anamorphic image: an image that must be viewed by a special means, such as a mirror, in order to be recognized (Figure 19.9)

Animal style: a medieval art form in which animals are depicted in a stylized and often complicated pattern, usually seen fighting with one another (Figure 11.1)

Apadana: an audience hall in a Persian palace (Figure 2.16)

Apotheosis: a type of painting in which the figures are rising heavenward (Figure 21.7)

Apse: the end point of a church where the altar is

Aqueduct: an aboveground water system (Figure 7.10)

Arabesque: a flowing, intricate, and symmetrical pattern deriving from floral motifs (Figure 10.2)

Arcade: a series of arches supported by columns (Figure 12.4); when the arches face a wall and are not self-supporting, they are called a **blind arcade**.

Arcadian: a simple rural and rustic setting used especially in Venetian paintings of the High Renaissance; it is named after Arcadia, a district in Greece to which poets and painters have attributed a rural simplicity and an idyllically untroubled world (Figure 17.21)

Archaeology: the scientific study of ancient people and cultures principally revealed through excavation

Architrave: a plain nonornamented lintel on the entablature (Figure 5.27)

Archivolt: a series of concentric moldings around an arch (Figure 12.14)

Ashlar masonry: carefully cut and grooved stones that support a building without the use of concrete or other kinds of masonry (Figures 7.10 and 30.18)

Assemblage: a three-dimensional work made of various materials such as wood, cloth, paper, and miscellaneous objects

Atmospheric perspective: *see* **Perspective**

Atrium (plural: **atria):** a courtyard in a Roman house or before a Christian church (Figure 8.4)

Avant-garde: an innovative group of artists who generally reject traditional approaches in favor of a more experimental technique

Axial plan (Basilican plan, Longitudinal plan): a church with a long nave whose focus is the apse, so-named because it is designed along an axis (Figure 8.4)

Baldacchino: a canopy placed over an altar or a shrine (Figure 20.13)

Baptistery: in medieval architecture, a separate chapel or building in front of a church used for baptisms (Figure 12.5)

Barrel vault: *see* **Vault**

Basilica: in Roman architecture, a large axially planned building with a nave, side aisles, and apses (Figure 7.18). In Christian architecture, an axially planned church with a long nave, side aisles, and an apse for the altar (Figure 8.4)

Bay: a vertical section of a church that is embraced by a set of columns and is usually composed of arches and aligned windows (Figure 12.2)

Benday dots: named for inventor Benjamin Day; this printing process uses the pointillist technique of colored dots from a limited palette placed closely together to achieve more colors and subtle shadings (Figure 26.13)

Bi: a round ceremonial disk found in ancient Chinese tombs; they are characterized by having a circular hole in the center, which may have symbolized heaven (Figure 28.10)

Biomorphism: a movement that stresses organic shapes that hint at natural forms (Figure 25.16)

Bodhisattva: a deity who refrains from entering nirvana to help others (Figure 27.7)

Book of Hours: a book of prayers to be said at different times of day, days of the year (Figure 15.3)

Bottega: the studio of an Italian artist

Buddha: a fully enlightened being; there are many Buddhas, the most famous of whom is Shakyamuni, also known as Gautama or Siddhartha (Figure 27.1)

Bust: a sculpture depicting a head, neck, and upper chest of a figure (Figures 7.27 and 7.28)

Calligraphy: decorative or beautiful handwriting (Figure 10.3)

Calotype: a type of early photograph, developed by William H. F. Talbot, that is characterized by its grainy quality; a calotype is considered the forefather of all photography because it produces both a positive and a negative image

Camera obscura: (Latin, meaning "dark room") a box with a lens which captures light and casts an image on the opposite side (Figure 23.25)

Campanile: bell tower for an Italian building (Figure 12.5)

Cantilever: a projecting beam that is attached to a building at one end and suspended in the air at the other (Figure 25.27)

Canvas: a heavy woven material used as the surface of a painting; first widely used in Venice (Figure 17.25)

Capital: the top element of a column (Figure 2.17)

Caryatid (male: **atlantid**): a column in a building that is shaped like a female figure (Figure 5.26)

Catacomb: an underground passageway used for burial (Figure 8.1)

Cathedral: the principal church of a diocese, where a bishop sits (Figure 9.10)

Cella: the main room of a Greek temple where the god is housed

Central Plan: a church having a circular plan with the altar in the middle (Figure 8.5)

Chacmool: a Mayan figure that is half-sitting and half-lying on its back (Figure 30.7)

Chaitya: a rock-cut shrine in basilican form with a stupa at the endpoint (Figure 27.5)

Chalice: a cup used in a Christian ceremony

Chateau: *see* **Villa**

Chevet: the east end of a Gothic church (Figure 13.2)

Chiaroscuro: a gradual transition from light to dark in a painting; forms are not determined by sharp outlines, but by the meeting of lighter and darker areas (Figure 17.22)

Choir: a space in a church between the transept and the apse for a choir or clergymen (Figure 13.2)

Cinquecento: the 1500s, or sixteenth century, in Italian art

Ciré perdue: the lost-wax process. A bronze casting method in which a figure is modeled in clay and covered with wax and then recovered with clay. When fired in a kiln, the wax melts away leaving a channel between the two layers of clay that can be used as a mold for liquid metal (Figure 31.7)

Clerestory: the third, or window, story of a church (Figure 8.2)

Cloissonné: enamelwork in which colored areas are separated by thin bands of metal, usually gold or bronze (Figure 11.1)

Cloister: a rectangular open-air monastery courtyard with a covered arcade surrounding it

Close: an enclosed gardenlike area around a cathedral (Figure 13.12)

Coatlicue: an Aztec goddess who is characterized by a savagery only satisfied by human sacrifice (Figure 30.14)

Codex (plural: **codices**): a manuscript book (Figures 11.2 and 11.3)

Coffer: in architecture, a sunken panel in a ceiling (Figure 7.5)

Collage: a composition made by pasting together different items onto a flat surface

Colophon: 1) a commentary on the end panel of a Chinese scroll; 2) an inscription at the end of a manuscript containing relevant information on its publication (Figure 11.2)

Color field: a style of abstract painting characterized by simple shapes and monochromatic color (Figure 26.11)

Compound pier: a pier that appears to be a group or gathering of smaller piers put together (Figure 13.11)

Confucianism: a philosophical belief begun by Confucius that stresses education, devotion to family, mutual respect, and traditional culture

Contrapposto: a graceful arrangement of the body based on tilted shoulders and hips and bent knees (Figure 5.12)

Corbel arch: a vault formed by layers of stone that gradually grow closer together as they rise until they eventually meet (Figure 4.1)

Coyolxauhqui: an Aztec goddess who dies when she tries to assassinate her mother, Coatlicue (Figure 30.15)

Cornice: a projecting ledge over a wall (Figure 5.27)

Cromlech: a circle of megaliths (Figure 1.4)

Cubiculum (plural: **cubicula**): a Roman bedroom flanking an atrium; in Early Christian art, a mortuary chapel in a catacomb

Cuneiform: a system of writing in which the strokes are formed in a wedge or arrowhead shape

Cupola: a small dome rising over the roof of a building. In architecture, a cupola is achieved by rotating an arch on its axis

Cyclopean masonry: a type of construction that uses rough massive blocks of stone piled one atop the other without mortar. Named for the mythical Cyclops (Figure 4.9)

Cylinder seal: a round piece of carved stone that when rolled onto clay produces an image (Figure 2.1)

Daguerreotype: a type of early photograph, developed by Daguerre, which is characterized by a shiny surface, meticulous finish, and clarity of detail. Daguerreotypes are unique photographs; they have no negative (Figure 23.23)

Daoism: a philosophical belief begun by Laozi that stresses individual expression and a striving to find balance in one's life

Darshan: in Hinduism, the ability of a worshipper to see a deity and the deity to see the worshipper

Di sotto in sù: *see* **Quadro Riportato**

Documentary photography: a type of photography that seeks social and political redress for current issues by using photographs as a way of exposing society's faults (Figure 25.33)

Donjon: an inner stronghold of a castle complex (Figure 29.4)

Donor: a patron of a work of art who is often seen in that work (Figure 15.4 left panel)

Earthwork: a large outdoor work in which the earth itself is the medium (Figure 26.16)

Embroidery: a woven product in which the design is stitched into a premade fabric (Figure 12.19)

Encaustic: an ancient method of painting using colored waxes that are burned into a wooden surface

Engaged column: a column that is not freestanding but attached to a wall (Figure 3.2)

Engraving: a printmaking process in which a tool called a **burin** is used to carve into a metal plate, causing impressions to be made in the surface. Ink is passed into the crevices of the plate, and paper is applied. The result is a print with remarkable details and finely shaded contours (Figure 15.12)

Entablature: the upper story of a Greek temple (Figure 5.27)

Etching: a printmaking process in which a metal plate is covered with a ground made of wax. The artist uses a tool to cut into the wax to leave the plate exposed. The plate is then submerged into an acid bath, which eats away at the exposed portions of the plate. The plate is removed from the acid, cleaned, and ink is filled into the crevices caused by the acid. Paper is applied and an impression is made. Etching produces the finest detail of the three types of early prints

Exemplum virtutis: a painting that tells a moral tale for the viewer (Figure 22.7)

Façade: the front of a building

Fan vault: a type of vault so-named because a fanlike shape is created when the vaults spring from the floor to the ceiling, nearly touching in the space directly over the center of the nave. They are usually highly decorated and filled with rib patterns (Figure 13.4)

Ferroconcrete: steel-reinforced concrete. The two materials act together to resist building stresses

Fête galante: an eighteenth-century French style of painting that depicts the aristocracy walking through a forested landscape (Figure 21.3)

Fetish: an object believed to possess magical powers

Flying buttress: a stone arch and its pier that support a roof from a pillar outside the building. Flying buttresses also stabilize a building and protect it from wind sheer (Figure 13.1)

Foreshortening: a visual effect in which an object is shortened and turned deeper into the picture plane to give the effect of receding in space (Figures 7.21 and 7.22)

Forum (plural: **fora**): a public square or marketplace in a Roman city (Figure 7.6)

Fresco: a painting technique that involves applying water-based paint onto a freshly plastered wall. The paint forms a bond with the plaster that is durable and long-lasting (Figure 4.6)

Frieze: a horizontal band of sculpture

Frottage: a composition made by rubbing a crayon or a pencil over paper placed over a surface with a raised design

Genre painting: painting in which scenes of everyday life are depicted (Figure 20.21)

Glazes: thin transparent layers put over a painting to alter the color and build up a rich sonorous effect

Gopura: a monumental entrance or gateway to an Indian temple complex (Figure 27.14)

Gospels: the first four books of the New Testament that chronicle the life of Jesus Christ (Figure 11.2)

Grand Manner: a style of eighteenth-century painting that features large painting with figures posed as ancient statuary or before classical elements such as columns or arches (Figure 21.12)

Grand Tour: in order to complete their education young Englishmen and Americans in the eighteenth century undertook a journey to Italy to absorb ancient and Renaissance sites.

Grisaille: (pronounced "gri-zahy") a painting done in neutral shades of gray to simulate the look of sculpture

Groin vault: *see* **Vault**

Ground plan: the map of a floor of a building

Haboku (splashed ink): a monochrome Japanese ink painting done in a free style in which ink seems to be splashed on a surface (Figure 29.7)

Haniwa: (from the Japanese meaning "circle of clay") Japanese ceramic figures that were placed on top of burial mounds (Figure 29.10)

Harlem Renaissance: a particularly rich artistic period in the 1920s and 1930s that is named after the African-American neighborhood in New York City where it emerged. It is marked by a cultural resurgence by African-Americans in the fields of painting, writing, music, and photography

Henge: a Neolithic monument, characterized by a circular ground plan; used for rituals and marking astronomical events (Figure 1.4)

Hierarchy of scale: a system of representation that expresses a person's importance by the size of his or her representation in a work of art (Figure 2.8)

Hieroglyphics: Egyptian writing using symbols or pictures as characters (Figure 3.22)

Horror vacui: (Latin, meaning "fear of empty spaces") a type of artwork in which the entire surface is filled with objects, people, designs, and ornaments in a crowded, sometimes congested, way (Figure 11.3)

Humanism: an intellectual movement in the Renaissance that emphasized the secular alongside the religious. Humanists were greatly attracted to the achievements of the classical past and stressed the study of classical literature, history, philosophy, and art

Hypostyle: a hall in an Egyptian temple that has a roof supported by a dense thicket of columns (Figure 3.18)

Icon: a devotional panel depicting a sacred image (Figure 9.19)

Iconostasis: a screen decorated with icons, which separates the apse from the transept of a church (Figure 9.11)

Ignudi: nude corner figures on the Sistine Chapel ceiling (Figure 17.12)

Impasto: a thick and very visible application of paint on a painting surface

Impluvium: a rectangular basin in a Roman house that is placed in the open-air atrium in order to collect rainwater (Figure 7.8)

In situ: a Latin expression that means that something is in its original location

Installation: a temporary work of art made up of assemblages created for a particular space, like an art gallery or a museum

International Gothic style: a style of fourteenth- and fifteenth-century painting, begun by Simone Martini. The style is characterized by elegant and intricate interpretations of naturalistic subjects and minute detailing and patterning in drapery and color, catering to an aristocratic taste (Figure 14.9)

Jali: perforated ornamental stone screens in Islamic art

Jamb: the side posts of a medieval portal (Figure 12.14)

Japonisme: an attraction for Japanese art and artifacts that were imported into Europe in the late nineteenth century

Ka: the soul, or spiritual essence, of a human being that either ascends to heaven or can live in an Egyptian statue of itself

Keystone: the center stone of an arch that holds the other stones in place (Figure 12.4)

Kiln: an oven used for making pottery

Kiva: a circular room wholly or partly underground used for religious rites

Kondo: a hall used for Buddhist teachings (Figure 29.3)

Koran: the Islamic sacred text, dictated to the Prophet Muhammad by the Angel Gabriel

Kouros (female: **kore**): an archaic Greek sculpture of a standing youth (Figures 5.1 and 5.4)

Krater: a large Greek bowl used for mixing water and wine (Figure 5.31)

Kufic: a highly ornamental Islamic script

Kylix: a Greek drinking cup (Figure 5.35)

Lamassu: a colossal winged human-headed bull in Assyrian art (Figure 2.14)

Lantern: a small structure with openings for light that crowns a dome (Figure 16.2)

Linear perspective: *see* **Perspective**

Literati: a sophisticated and scholarly group of Chinese artists who painted for themselves rather than for fame and mass acceptance. Their work is highly individualized (Figure 28.9)

Lithography: a printmaking technique that uses a flat stone surface as a base. The artist draws an image with a special crayon that attracts ink. Paper, which absorbs the ink, is applied to the surface and a print emerges

Loculi: openings in the walls of catacombs to receive the dead (Figure 8.1)

Longhouse: a long Native-American communal dwelling made of wood. Characterized by having supporting interior poles that create long interior corridors (Figure 30.19)

Lunette: a crescent-shaped space, sometimes over a doorway, which contains sculpture or painting

Maestà: a painting of the Virgin Mary as enthroned Queen of Heaven surrounded by angels and saints (Figure 14.8)

Mandorla (Italian, meaning "almond"): a term that describes a large almond-shaped orb around holy figures like Christ and Buddha (Figure 29.11)

Maniera greca: (Italian, meaning "Greek manner") a style of painting based on Byzantine models that was popular in Italy in the twelfth and thirteenth centuries (Figure 14.4)

Martyrium (plural: **martyria**): a shrine built over a place of martyrdom or a grave of a martyred Christian saint (Figure 17.2)

Mastaba: (Arabic, meaning "bench") a low flat-roofed Egyptian tomb with sides sloping down to the ground (Figure 3.1)

Mecca, Medina: Islamic holy cities; Mecca is the birthplace of Muhammad and the city all Muslims turn to in prayer; Medina is where Muhammad was first accepted as the Prophet, and where his tomb is located

Megalith: a stone of great size used in the construction of a prehistoric structure

Megaron: a rectangular audience hall in Aegean art that has a two-column porch and four columns around a central air well

Menhir: a large uncut stone erected as a monument in the prehistoric era

Metope: a small relief sculpture on the façade of a Greek temple (Figure 5.27)

Mihrab: a central niche in a mosque, which indicates the direction to Mecca (Figure 10.1)

Minaret: a tall slender column used to call people to prayer (Figure 10.12)

Minbar: a pulpit from which sermons are given

Mithuna: in India, the mating of males and females in a ritualistic, symbolic, or physical sense

Moai: large stone sculptures found on Easter Island (Figure 32.8)

Mobile: a sculpture made of several different items that dangle from a ceiling and can be set into motion by air currents

Modernism: a movement begun in the late nineteenth century in which artists embraced the current at the expense of the traditional in both subject matter and in media; modernist artists often seek to question the very nature of art itself

Moralized Bible: a Bible that pairs Old and New Testament scenes with paintings that explain their moral parallels (Figure 13.16)

Mortise and tenon: a groove cut into stone or wood called a **mortise** that is shaped to receive a tenon, or projection, of the same dimensions

Mosaic: a decoration using pieces of stone, marble, or colored glass, called **tesserae**, that are cemented to a wall or a floor (Figure 5.40)

Mosque: a Muslim house of worship (Figure 10.8)

Mudra: a symbolic hand gesture in Hindu and Buddhist art (Figure 27.1)

Muezzin: an Islamic official who calls people to prayer traditionally from a minaret

Muhammad (570?–632): the Prophet whose revelations and teachings form the foundation of Islam

Muqarnas: a honeycomb-like decoration often applied in Islamic buildings to domes, niches, capitals, or vaults; the surface resembles intricate stalactites (Figure 10.11)

Narthex: the closest part of the atrium to the basilica, it serves as a vestibule or lobby of a church

Nave: the main aisle of a church (Figure 8.2)

Necropolis (plural: **necropoli**): literally, a "city of the dead," a large burial area

Negative space: empty space around an object or a person, such as the cut-out areas between a figure's legs or arms in a sculpture

Nirvana: an afterlife in which reincarnation ends and the soul becomes one with the supreme spirit

Oculus: a circular window in a church or a round opening at the top of a dome (Figure 7.15)

Ogee arch: an arch formed by two S-shaped curves that meet at the top (Figure 13.3)

Orans figure: a figure with its hands raised in prayer

Orthogonal: lines that appear to recede toward a vanishing point in a painting with linear perspective

Pagoda: a tower built of many stories. Each succeeding story is identical in style to the one beneath it, only smaller. Pagodas typically have dramatically projecting eaves that curl up at the ends (Figure 28.1)

Pantocrator: literally, "Ruler of the World," a term that alludes to figures of Christ placed above the altar or in the center of a dome in a Byzantine church (Figure 9.17)

Papyrus: a tall aquatic plant used as a writing surface in ancient Egypt (Figure 3.22)

Pastel: a colored chalk that when mixed with other ingredients produces a medium that has a soft and delicate hue

Pediment: the triangular top of a temple that contains sculpture (Figure 5.27)

Pendentive: a construction shaped like a triangle that transitions the space between flat walls and the base of a round dome (Figure 9.1)

Peristyle: (1) an atrium surrounded by columns in a Roman house (Figure 7.8); (2) a colonnade surrounding a Greek temple (Figure 5.28)

Perspective: having to do with depth and recession in a painting or a relief sculpture. Objects shown in **linear perspective** achieve a three-dimensionality in the two-dimensional world of the picture plane. All lines, called **orthogonals**, draw the viewer

back in space to a common point called the **vanishing point**. Paintings, however, may have more than one vanishing point, with orthogonals leading the eye to several parts of the work. Landscapes that give the illusion of distance are in **atmospheric** or **aerial perspective**

Pharaoh: a king of ancient Egypt (Figure 3.19)

Photogram: an image made by placing objects on photo-sensitive paper and exposing them to light to produce a silhouette

Pier: a vertical support that holds up an arch or a vault (Figure 7.3)

Pietà: a painting or sculpture of a crucified Christ lying on the lap of a grieving Mary (Figure 13.21)

Pilaster: a flattened column attached to a wall with a capital, a shaft, and a base (Figure 16.7)

Pinnacle: a pointed sculpture on piers or flying buttresses

Plein-air: painting in the outdoors to directly capture the effects of light and atmosphere on a given object (Figures 24.14, 24.15, and 24.16)

Pointillism: a painting technique that uses small dots of color that are combined by the eye at a given distance (Figure 24.26)

Polyptych: a many-paneled altarpiece

Porcelain: a ceramic made from clay that when fired in a kiln produces a product that is hard, white, brittle, and shiny

Portal: a doorway. In medieval art they can be significantly decorated (Figure 12.4)

Positivism: a theory that expresses that all knowledge must come from proven ideas based on science or scientific theory philosophy, promoted by French philosopher Auguste Comte (1798–1857)

Post-and-lintel: a method of construction with two posts supporting a horizontal beam, called a **lintel** (Figure 1.3)

Poussinistes and **Rubénistes:** admirers and imitators of Poussin and Rubens. The former felt that Poussin's mastery of drawing, composition, and emotional restraint were superior. The latter found greater value in Rubens's use of color, rich textures, and highly charged emotions

Predella: the base of an altarpiece that is filled with small paintings, often narrative scenes (Figure 14.7)

Propylaeum (plural: **propylaea**): a gateway leading to a Greek temple

Psalter: a book containing the Psalms, or sacred sung poems, of the Bible (Figure 11.7)

Pueblo: a communal village of flat-roofed structures of many stories that are stacked in terraces. They are made of stone or adobe (Figure 30.10)

Puja: a Hindu prayer ritual

Pylon: a monumental gateway to an Egyptian temple marked by two flat, sloping walls between which is a smaller entrance

Qiblah: the direction toward Mecca which Muslims face in prayer

Quadro riportato and **Di sotto in sù:** both are types of ceiling paintings. Quadro riportato is a wall mural that is executed on a curved ceiling vault (Figure 20.19). To view a quadro riportato work, one must stand in a particular spot in order for it to appear right side up. The Sistine Chapel ceiling was done in quadro riportato (Figure 17.11). In contrast, di sotto in sù ("from the bottom up") works are ceiling paintings

in which the figures seem to be hovering above the viewers, often looking down at us (Figure 20.20). Mantegna's *Room of the Newlyweds* is painted in di sotto in sù (Figure 16.17)

Quattrocento: the 1400s, or fifteenth century, in Italian art

Quoins: an exterior angle on the façade of a building that has large dressed stone forming a decorative contrast with the wall (Figure 17.3)

Ready-made: a commonplace object selected and exhibited as a work of art

Regionalism: an American art movement from the early twentieth century that emphasized Midwestern rural life in a direct style (Figure 25.36)

Relief sculpture: sculpture which projects from a flat background. A very shallow relief sculpture is called a **bas-relief** (pronounced: bah-relief) (Figure 2.9)

Reliquary: a vessel for holding a sacred relic. Often reliquaries took the shape of the object they held. Precious metals and stones were the common material

Repoussé: (French, meaning "to push back") a type of metal relief sculpture in which the back side of a plate is hammered to form a raised relief on the front (Figure 4.12)

Reserve column: a column that is cut away from rock but has no support function

Rib vault: a vault in which diagonal arches form rib-like patterns. These arches partially support a roof, in some cases forming a weblike design (Figure 12.1)

Rose window: a circular window, filled with stained glass, placed at the end of a transept or on the façade of a church (Figures 13.6 and 13.8)

Rückenfigur: in Romantic painting, a figure seen from the back, often in the contemplation of nature (Figure 23.19)

Rusticate: to deeply and roughly incise stones to give a rough and rustic texture to its appearance (Figure 16.5)

Sacra conversazione: an altarpiece in which the Madonna and Child are accompanied by saints and engaged in a "holy conversation" (Figure 17.20)

Salon: a government-sponsored exhibition of artworks held in Paris

Sarcophagus (plural: **sarcophagi**)**:** a stone coffin

Scarification: scarring of the skin in patterns by cutting with a knife. When the cut heals, a raised pattern is created, which is painted (Figure 31.6)

School: a group of artists sharing the same philosophy who work around the same time, but not necessarily together

Scriptorium (plural: **scriptoria**)**:** a place in a monastery where monks wrote manuscripts

Sfumato: a smoke-light or hazy effect that distances the viewer from the subject of a painting (Figure 17.9)

Shaft: the body of a column (Figure 5.27)

Shiva: the Hindu god of creation and destruction (Figure 27.12)

Skeleton: the supporting interior framework of a building

Spandrel: a triangular space enclosed by the curves of arches (Figure 7.4)

Spolia: in art history, the reuse of architectural or sculptural pieces in buildings generally different from their original contexts

Squinch: the polygonal base of a dome that makes a transition from the round dome to a flat wall (Figure 9.2)

Stele (plural: **stelai**)**:** a stone slab used to mark a grave or a site (Figure 2.9)

Still life: a painting of a grouping of inanimate objects, such as flowers or fruit

Stringcourse: a horizontal molding

Stucco: a fine plaster used for wall decorations or moldings

Stupa: a dome-shaped Buddhist shrine (Figure 27.3)

The Sublime: any cathartic experience from the catastrophic to the intellectual that causes the viewer to marvel in awe, wonder, and passion (Figure 23.19)

Synagogue: a Jewish house of worship (Figure 8.12)

Tapa: a cloth made from bark that is soaked and beaten into a fabric (Figure 32.1)

Tapestry: a woven product in which the design and the backing are produced at the same time on a device called a **loom**

Tempera: a type of paint employing egg yolk as the binding medium that is noted for its quick drying rate and flat opaque colors

Tenebroso/Tenebrism: a dramatic dark-and-light contrast in a painting (Figure 20.15)

Terra-cotta: a hard ceramic clay used for building or for making pottery (Figures 6.5 and 6.8)

Tessellation: a decoration using polygonal shapes with no gaps (Figure 10.4)

Tholos tomb: (1) an ancient Mycenaean circular tomb in a beehive shape (Figure 4.11); (2) an ancient Greek circular shrine (Figure 5.25)

Torah: first five books of the Old Testament, traditionally ascribed to Moses

Torana: a gateway near a stupa that has two upright posts and three horizontal lintels. They are usually elaborately carved (Figure 27.3)

Totem pole: a pole carved with ancestral spirits or symbols erected by Pacific Coast Native Americans (Figure 30.19)

Transept: an aisle in a church perpendicular to the nave (Figure 8.4)

Trecento: the 1300s, or fourteenth century, in Italian art

Triforium: A narrow passageway with arches opening onto a nave, usually directly below a clerestory (Figure 12.2)

Triglyph: a projecting grooved element alternating with a metope on a Greek temple (Figure 5.27)

Triptych: a three-paneled painting or sculpture (Figure 9.21)

Trompe l'oeil: (French, meaning "fools the eye") a form of painting that attempts to represent an object as existing in three dimensions, and therefore resembles the real thing (Figure 16.17)

Trumeau (plural: trumeaux): the central pillar of a medieval portal that stabilizes the structure. It is often elaborately decorated (Figure 12.11)

Tympanum (plural: tympana): a rounded sculpture placed over the portal of a medieval church (Figure 12.15)

Ukiyo-e: translated as "pictures of the floating world," a Japanese genre painting popular from the seventeenth to the nineteenth centuries (Figure 29.8)

Urna: a circle of hair on the brows of a deity sometimes represented as the focal point (Figure 27.1)

Ushnisha: a protrusion at the top of the head, or the top knot of a Buddha (Figure 27.1)

Vanitas: a theme in still life painting that stresses the brevity of life and the folly of human vanity

Vault: a roof constructed with arches. When an arch is extended in space, forming a tunnel, it is called a **barrel vault** (Figure 7.1). When two barrel vaults intersect at right angles it is called a **groin vault** (Figure 7.2) *See also* **rib vault**

Veristic: sculptures from the Roman Republic characterized by extreme realism of facial features (Figures 7.27 and 7.28)

Villa (Italian) or **Chateau (French;** plural: **chateaux):** a large country estate or manor house (Figure 18.12)

Voussoir (pronounced "view-swar"): a wedge-shaped stone that forms the curved part of an arch. The central voussoir is called a **keystone** (Figure 12.4)

Wat: a Buddhist monastery or temple in Cambodia (Figure 27.13)

Westwork: a monumental entrance to a Carolingian church in which two towers flank a lower central entrance

Woodcut: a printmaking process by which a wooden tablet is carved into with a tool, leaving the design raised and the background cut away (very much as how a rubber stamp looks); ink is rolled onto the raised portions, and an impression is made when paper is applied to the surface; woodcuts have strong angular surfaces with sharply delineated lines (Figure 19.5)

Yakshi (masculine: **yaksha):** female and male figures of fertility in Buddhist and Hindu art (Figure 27.4)

Yin and yang: complementary polarities; the yin is a feminine symbol that has dark, soft, moist, and weak characteristics; the yang is the male symbol that has bright, hard, dry, and strong characteristics (Figure 28.6)

Zen: a metaphysical branch of Buddhism that teaches fulfillment through self-discipline and intuition

Ziggurat: a pyramidlike building made of several stories that indent as the building gets taller; ziggurats have terraces at each level (Figure 2.5)

Zoopraxiscope: a device that projects sequences of photographs to give the illusion of movement (Figure 24.12)

Photo Credits

The author gratefully acknowledges the contributions of many individuals who have given permission to have their work reproduced in this volume. Any inadvertent errors will be corrected in the next edition.

Abtei-st-hildegard 12.18, 1CD19; **Ali Zingstra** 31.3, 31.11; **Allan T, Kohl, Art Images for College Teaching** 3.10, 5.1, 5.5, 5.7, 5.31, 5.34, 6.3, 11.10, 11.11, 11.12, 12.9, 12.12, 12.15, 12.16, 16.28, 18.1, 1PT36, 1CD4; **Author** Intro 3, DT1, DT9, DT15, DT22, 2.6, 2.8, 2.9, 2.15, 2.21, 3.16, 4.9, 4.13, 5.4, 5.20, 5.22, 5.27, 5.32, 5.39, 7.11, 7.13, 7.17, 7.18, 7.30, 7.31, 7.32, 7.34, 9.6, 9.21, 12.4, 12.21, 13.5, 13.6, 13.7, 13.23, 13.25, 14.1, 16.2, 16.4, 16.5, 16.14, 16.26, 16.27, 17.3, 17.4, 17.6, 18.2, 19.2, 20.1, 20.3, 20.4, 20.5, 20.6, 20.7, 20.8, 20.9, 20.10, 20.25, 20.37, 21.7, 22.1, 22.4, 22.11, 23.2, 23.4, 23.20, 23.23, 23.26, 24.6, 24.33, 24.36, 24.37, 24.38, 25.28, 25.30, 26.3, 26.4, 26.5, 26.6, 26.17, 29.3, 29.13, 30.4, 30.10, 30.11, 30.13, 1PT1, 1PT10, 1PT15, 1PT30, 1PT34, 1PT39, 2PT5, 2PT6, 2PT16, 2PT23, 2PT27, 2PT28b, 1CD1, 1CD6, 1CD.31, 2CD2, 2CD10, 2CD23, 2CD30; **Aysegul Ozkan** 27.11; **Carlos Rodriguez** DT21, 1.3, 3.1, 3.2, 3.3, 3.7, 4.1, 5.24, 5.27, 7.1, 7.2, 7.3, 7.4, 7.5, 7.7, 7.21, 7.22, 8.4, 8.5, 8.14, 9.1, 9.2, 9.3, 12.1, 12.2, 12.3, 12.11, 13.1, 13.2, 13.3, 16.1, 17.5, 18.9, 18.10, 18.11, 18.15, 25.27, 27.1, 28.2, 28.4, 28.5, 1PT21, 2PT20, 2PT25, 1CD16; **Cleveland Museum of Art, Leonard C. Hanna Jr. bequest** 28.8; **Clipart.com** Intro2, Intro5, DT2, DT3, DT6, DT7, DT11, DT12, DT13, DT14, DT17, DT18, DT19, DT20, DT23, DT24, DT25, DT26, DT27, DT29, DT31, 2.1, 2.2, 2.3, 2.13, 2.18, 3.4, 3.9, 3.12, 3.14, 3.18, 3.22, 4.11, 5.9, 5.13, 5.15, 5.16, 5.17, 5.33, 5.35, 5.36, 5.37, 5.38, 5.43, 6.1, 6.7, 7.6, 7.8, 7.23, 7.25, 7.26, 7.27, 7.28, 7.33, 7.38, 8.1, 8.3, 8.9, 8.10, 9.14, 9.20, 9.22, 10.1, 10.2, 10.3, 10.4, 10.8, 10.15, 11.2, 11.4, 11.6, 11.7, 11.9, 11.13, 11.15, 11.16, 11.17, 12.5, 12.6, 12.7, 12.10, 12.13, 12.14, 12.22, 13.11, 13.12, 13.15, 13.16, 13.19, 13.21, 13.22, 13.26, 14.5, 14.6, 14.7, 14.13, 14.14, 14.15, 14.18, 15.1, 15.2, 15.4, 15.5, 15.6, 15.7, 15.8, 15.9, 15.11, 15.12, 15.13, 15.14, 15.15, 16.3, 16.6, 16.8, 16.10, 16.11, 16.12, 16.13, 16.15, 16.16, 16.18, 16.19, 16.21, 16.22, 16.23, 16.24, 16.30, 16.31, 16.33, 16.35, 17.8, 17.9, 17.10, 17.15, 17.16, 17.18, 17.20, 17.21, 17.22, 17.24, 17.25, 18.5, 18.7, 18.12, 19.1, 19.3, 19.4, 19.5, 19.6, 19.7, 19.8, 19.11, 19.12, 19.14, 19.15, 20.12, 20.14, 20.16, 20.19, 20.21, 20.24, 20.26, 20.27, 20.28, 20.30, 20.31, 20.32, 20.33, 21.3, 21.4, 21.5, 21.6, 21.8, 21.9, 21.10, 21.11, 21.12, 21.13, 22.5, 22.6, 22.8, 22.9, 22.12, 23.4, 23.5, 23.6, 23.8, 23.9, 23.11, 23.12, 23.14, 23.16, 23.17, 23.22, 23.23, 23.24, 23.25, 24.1, 24.4, 24.5, 24.7, 24.8, 24.9, 24.10, 24.12, 24.13, 24.19, 24.21, 24.24, 24.26, 24.28, 24.34, 24.39, 24.40, 25.8, 25.9, 25.10, 25.11, 25.12, 25.13, 25.14, 25.18, 25.19, 25.20, 25.21, 25.22, 25.25, 25.26, 25.31, 25.32, 25.33, 25.35, 25.37, 25.38, 25.39, 27.2, 27.5, 27.6, 27.7, 27.12, 28.6, 28.7, 28.10, 28.15, 29.2, 29.5, 29.6, 29.7, 29.8, 29.10, 29.11, 29.12, 29.14, 30.3, 30.6, 30.7, 30.12, 30.14, 30.15, 30.16, 30.17, 30.20, 31.7, 31.10, 32.1, 32.3, 32.4, 32.6, 32.7, 32.8, 1PT5, 1PT7, 1PT8, 1PT9, 1PT11, 1PT12, 1PT17, 1PT18, 1PT19, 1PT22, 1PT23, 1PT24, 1PT25, 1PT27, 1PT28, 1PT32, 1PT35, 1PT37, 1PT38, 2PT1, 2PT2, 2PT3, 2PT6, 2PT7, 2PT9, 2PT11, 2PT12, 2PT13, 2PT15, 2PT19, 2PT26, 2PT29, 2PT30, 2PT32, 2PT33, 2PT34, 1CD2, 1CD5, 1CD6, 1CD10, 1CD11, 1CD13, 1CD23, 1CD24, 1CD26, 1CD27; 1CD15, 2CD5, 2CD6, 2CD8, 2CD11, 2CD15, 2CD24, 2CD26, 2CD28, 2CD29; **Cowan's Auctions** 32.2, 1CD14; **Daumier.org** 24.2; **David Skerrett** 28.11; **Dreamstime.com** 2.16 and 1PT31 Stefan Baum, 6.6 Ron Chapple Studios, 8.2 Gian Marco Valente, 8.8 Valeria Cantone, 9.5 and 1PT4 Mehmet Can, 9.10 Cleaper, 9.11 Jarnogz, 9.13 and 9.24 Tomas Marek 9.18 Hugo Rosseels, 10.10 Rainer Walter Schmeid, 10.11 Jennifer Stone, 10.12 Sinan Durdu, 11.5

and 23.1 and 1PT16 and 2PT31 Irish1983, 12.8 Mick1980, 13.4 Lightphoto, 13.14 and 2CD19 Alysta, 13.17 and 13.27 and 2CD27 Philippehalle, 13.24 Patrickwang, 14.2 Christian Mueringer, 14.3 Miroslav Novotny, Intro6 and 16.7 Valeria Sangiovanni, 16.25 and 1CD3 Evgeniapp, 16.32 Andrew Burns, 17.1 Janaka Dharmasena, 17.7 Juergen Schnnop, 17.11 Feoff, Intro4 and 17.12 and 17.17 Marsana, 17.19 and 17.26 Aprescindere, 18.8 Dragoneye, 20.2 Vladimir Sazonov, 20.13 Andrejs Pidjass, 21.2 Val Thoermer, 22.2 and 1CD32 Jack Tade, 22.3 and 1PT26 Rixie, 22.11 Asier Villafranca, 24.35 Dan Breckwoldt, 25.23 and 2PT24 Place-to-be, 25.24 Halpand, 26.7 Matthi, 27.3 Northernexposure, 27.4 Francesca Braghetta, 27.8 Ivonne Wiernick, 27.14 Rafal Cichawa, 28.13 Contax 66, 29.4 Nathanphoto, 29.9 and 30.9 Swisshippo, 30.1 Carlos Sanchez Pereyra, 30.5 and 30.19 Ragne Kabanova, 30.8 Patlemay, 30.18b Giampalo Terrosi; **Free Stock Photos** DT8, 2.14, 3.19, 3.24, 4.2, 5.10, 5.12, 5.18, 5.23, 5.45, 7.14, 7.15, 7.41; **Galen Frysinger** DT10, 4.10, 5.2, 5.3, 5.8, 5.30, 7.39, 7.42, 9.17, 11.8, 16.17, 16.34, 24.31, 34.41, 27.9, 28.3, 28.14, 30.2, 31.1, 31.7, 1PT13, 2PT17, 2CD21; **Eileen Krest** 5.6, 5.14, 5.19, 5.41, 5.44, 1CD12; **Emilios Petrou** 9.7, 9.8, 9.9; **Günter Schneider** 7.19; **Hamill Gallery of African Art, Boston** 31.4, 31.5, 31.9; **Ian Lloyd** 4.4, 4.5; **Iran Chamber Society** 10.16; **Istockphotos.com** 2.17, 7.10, 7.16, 9.12, 10.13, 13.10, 13.18, 16.29, 17.2, 18.13, 18.14, 18.16, 20.11, 20.38, 26.1, 27.7, 27.10, 27.13, 28.12, 28.14, 31.2, 1PT6, 1PT14, 1PT20, 2Pt4, 2PT21, 2CD10, 1CD19, 2CD20, 2CD27; **J Norman Dobbs** 28.1; **Leonid Mikinberg** 12.17, 24.15, 24.18, 31.6; **Livius.org** 2.10, 2.15, 3.13, 5.11, 7.20, 2CD25; **Maria Manara** 18.4; **Mark Tyner** 9.15; **Morguefile.com** 1.4, 17.13; **Peter Hoffer/Artifice Images** 21.1, 2CD17; **Photos.com** Intro1, DT4, DT5, DT6, DT16, DT30, 1.1, 2.11, 3.5, 3.6, 3.8, 3.11, 3.15, 3.17, 3.20, 3.21, 3.23, 4.12, 5.25, 5.28, 5.32, 5.40, 6.2, 6.4, 6.8, 7.12, 7.24, 7.40, 9.4, 9.19, 9.23, 10.5, 10.6, 10.7, 10.14, 11.3, 12.19, 12.20, 13.8, 13.13, 14.4, 14.8, 14.9, 14.10, 14.11, 14.12, 14.16, 14.17, 15.3, 15.10, 16.20, 16.25a, 17.14, 19.10, 20.22, 20.23, 20.34, 20.35, 20.36, 23.13, 23.19, 24.3, 24.14, 24.16, 25.14, 25.16, 26.2, 27.15, 29.1, 30.20, 1PT3, 1PT29, 2PT18, 1CD18, 1CD28, 1CD36, 21CD, 2CD12, 2CD13, 2CD14, 2CD26; **Raimond Spekking** 10.9; **Richard Nici** 5.26, 5.29, 5.42, 1PT33; **Romanhomes.com** 17.7; **Sergey Kolchinskiy** 4.3, 5.21, 31.8; **Sgt Forster** DT28, 2.5, 2.20; **Smr Travel** 2.12, 2.19; **Sue Way** 32.5; **Tim deChassaing** 1.2; **Torah Shrine Composite, Dura-Europos Collection, Yale University Art Gallery** 8.12, 2CD3; **Universal Art Images** 2.4, 4.7, 6.5, 9.16, 11.1, 11.14, 13.20, 16.9, 16.36, 17.23, 18.3, 18.6, 19.9, 19.13, 20.15, 20.17, 20.18, 20.20, 20.29, 23.7, 23.10, 23.15, 23.18, 24.11, 24.17, 24.20, 24.22, 24.23, 24.25, 24.27, 24.29, 24.30, 24.32, 25.1, 25.2, 25.3, 25.4, 25.5, 25.6, 25.7, 25.12, 25.15, 25.16, 25.17, 25.34, 25.36, 26.8, 26.9, 26.10, 26.11, 26.12, 26.13, 26.14, 26.15, 26.16, 26.18, 26.19, 26.20, 28.9, 2PT10, 1CD7, 1CD9, 1CD20, 1CD22, 1CD25, 1CD30, 1CD33, 1CD34, 2CD7, 2CD16, 2CD18, 2CD22, 2CD31, 2CD32; **Virginia Museum of Fine Arts, The Adolph D. and Wilkins C. Williams Fund, Photo: Katherine Wetzel** 22.7; **W. Clark** 7.9, 12.19, 13.9; **Western Pennsylvania Conservancy** 25.29, 1CD17; **William Storage Photo** DT32, 7.29, 7.35, 7.36, 7.37, 7.43, 8.6, 8.7, 8.11, 8.13, 8.15, 28.3, 2PT22, 2CD4; **W. Sheppard Baird, Minoan Atlantis.com** 4.6, 4.8, 4.14, 2PT14

Index

How to Use the CD-ROM

The software is not installed on your computer; it runs directly from the CD-ROM. Barron's CD-ROM includes an "autorun" feature that automatically launches the application when the CD is inserted into the CD-ROM drive. In the unlikely event that the autorun feature is disabled, follow the manual launching instructions below.

Windows®

1. Click on the Start button and choose "My Computer."
2. Double-click on the CD-ROM drive, which will be named **AP_Art_History.exe**.
3. Double-click **AP_Art_History.exe** to launch the program.

MAC®

1. Double-click the CD-ROM icon.
2. Double-click the **AP_Art_History** icon to start the program.

SYSTEM REQUIREMENTS

(Flash Player 10.2 is recommended)

Microsoft® Windows®	MAC® OS X	Linux® and Solaris™
Processor: Intel Pentium 4 2.33GHz, Athlon 64 2800+ or faster processor (or equivalent). Memory: 128MB of RAM. Graphics Memory: 128MB. Platforms: Windows 7, Windows Vista®, Windows XP, Windows Server® 2008, Windows Server 2003.	Processor: Intel Core™ Duo 1.33GHz or faster processor. Memory: 256MB of RAM. Graphics Memory: 128MB. Platforms: Mac OS X 10.6, Mac OS X 10.5, Mac OS X 10.4 (Intel) and higher.	Processor: Intel Pentium 4 2.33GHz, AMD Athlon 64 2800+ or faster processor (or equivalent). Memory: 512MB of RAM. Graphics Memory: 128MB. Platforms: Red Hat® Enterprise Linux (RHEL) 5 or later, openSUSE® 11 or later, Ubuntu 9.10 or later. Solaris: Solaris™ 10.